From Schongauer to Holbein

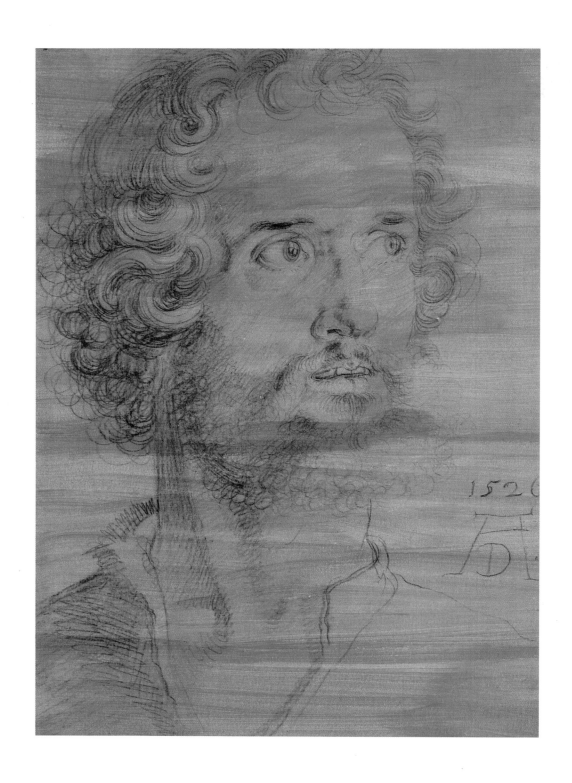

From Schongauer to Holbein

MASTER DRAWINGS FROM
BASEL AND BERLIN

NATIONAL GALLERY OF ART, WASHINGTON

HATJE CANTZ PUBLISHERS

The exhibition is made possible by UBS AG

Additional support has been provided by the
Samuel H. Kress Foundation

The exhibition is supported by an indemnity from the
Federal Council on the Arts and the Humanities

The English translation of the manuscript was made possible by
Pro Helvetia, Arts Council of Switzerland

The Washington exhibition was organized by the National Gallery
of Art in collaboration with the Öffentliche Kunstsammlung Basel
and the Kupferstichkabinett, Staatliche Museen zu Berlin–
Preussischer Kulturbesitz

Exhibition dates
National Gallery of Art
24 October 1999–9 January 2000

English edition of *Dürer Holbein Grünewald. Meisterzeichnungen der
deutschen Renaissance aus Berlin und Basel.* © 1997 Öffentliche
Kunstsammlung Basel; Staatliche Museen zu Berlin–Preussischer
Kulturbesitz; Hatje Cantz Publishers, Ostfildern-Ruit; the authors
and photographers

Produced by the National Gallery of Art,
editor-in-chief, Frances P. Smyth
Edited by Julie Warnement,
with assistance from Jody Shiffman
Designed by Patricia Inglis
Translations by Jack Horn

Typeset in Monotype Bembo
by Duke & Company, Devon, Pennsylvania

Printed in Germany

Distribution in the U.S. by
D.A.P., Distributed Art Publishers, Inc.
155 Avenue of the Americas
New York, N.Y. 10013-1507

First German edition by
Hatje Cantz Publishers
Senefelder Str. 12
73760 Ostfildern

Library of Congress Cataloguing-in-Publication Data

Öffentliche Kunstsammlung Basel. Kupferstichkabinett.
[Dürer, Holbein, Grünewald. English]
From Schongauer to Holbein: master drawings from Basel
and Berlin.
 p. cm.
Early German and Swiss drawings from the internationally
renowned print collections in the Öffentliche Kunstsammlung
Basel and in the Staatliche Museen zu Berlin–Preussischer
Kulturbesitz.
Includes bibliographical references.
ISBN 3-7757-0848-0 (cloth). — ISBN 0-89468-246-6 (pbk.)

1. Drawing, German Exhibitions. 2. Drawing, Swiss
Exhibitions. 3. Drawing, Renaissance—Germany Exhibitions.
4. Drawing, Renaissance—Switzerland Exhibitions. 5. Drawing—
Switzerland—Basel Exhibitions. 6. Drawing—Germany
—Berlin Exhibitions.
I. National Gallery of Art (U.S.) II. Staatliche Museen zu Berlin–
Preussischer Kulturbesitz. Kupferstichkabinett—Sammlung der
Zeichnungen und Druckgraphik. III. Title.

NC85.034 1999
741.943'074'43155-dc21 99-36741
 CIP

COVERS: cat. 100 *(front)*, cat. 68 *(back)*
FRONTISPIECE: cat. 78
PAGE 5: cat. 6
PAGE 23: cat. 191
PAGE 448: cat. 10

CONTENTS

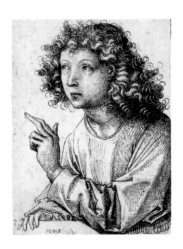

FOREWORD

It is not unusual today for great art collections to enjoy temporary visiting privileges in museums of other countries, other cultures, or distant cities. For a limited time span, the collections may enhance local holdings or promote their permanent domicile.

The collaborating institutions may also benefit in another way from such a visit if their holdings have a common focus yet vary in strength. By combining individual collections, a more representative theme may develop. The combined forces of the superb drawings collections of Berlin and Basel present, in panoramic view, works of the highest quality from a seminal period in the graphic arts of Germany, Austria, and Switzerland. Light-sensitive works on paper can be made accessible to the public only for short periods of time. It is therefore all the more edifying that the strong representation of Basel's collection of fifteenth- and early-to-mid-sixteenth-century drawings—Holbein, Baldung, and the Swiss artists Graf and Manuel Deutsch—is here seen with highlights from the Kupferstichkabinett in Berlin, whose greater variety of works includes not only Dürer, Grünewald, and Altdorfer, but also other leading artists from Schongauer to Wolf Huber. The works of many of these artists, for example Hans Holbein the Elder or Hans Baldung, complement the other collection superbly; for others, the joint showing of the drawings makes a comparison between closely related works possible.

The Kunstmuseum Basel held this exhibition in 1997 to mark the opening of festivities celebrating the fifth centennial of Hans Holbein the Younger's birth; one year later in Berlin, the 1998 exhibition marked the opening of a new building for the Gemäldegalerie. For the National Gallery of Art, the exhibition presents the opportunity of sharing with its visitors nearly 200 quintessential examples of early German and Swiss drawings.

The exhibition and catalogue are the result of a concerted effort. While the director of the Öffentliche Kunstsammlung Basel took the initiative to plan an exhibition comprising 180 works of art, the director of the Kupferstichkabinett in Berlin responded most generously.

In Basel, Christian Müller was responsible for the organization and overall coordination of the exhibition, as well as the production and publication of the catalogue. In Berlin, Hans Mielke must be named first among his colleagues; until his death in the spring of 1994, he was the curator of the early German drawings of the Berlin Kupferstichkabinett. When in February 1993 Dieter Koepplin and Christian Müller joined their colleagues, they were encouraged—guided piece by piece by Hans Mielke—to select fully half of the Berlin examples, including numerous drawings of the highest quality by Dürer and Altdorfer. After Mielke's untimely death, Renate Kroll and Holm Bevers assumed the coordination of the project in Berlin. In 1995 Christian Müller and Dieter Koepplin selected the second half of the works from Berlin and the works from Basel, thus rounding out the conception for the planned exhibition. Christian Müller, assisted by Irene Schubiger as well as Dieter Koepplin, undertook the scholarly editing of the catalogue for the drawings from Basel. For the larger number of Berlin drawings, the team consisted of Renate Kroll, Hans Mielke, Holm Bevers, and Fedja Anzelewsky, as well as Stefan Morét. In Washington, Andrew Robison, working closely with his colleagues in Basel and Berlin, selected nineteen additional works for the exhibition at the National Gallery and the English edition of the catalogue.

Both in Basel, with Paul Berger, Caroline Wyss, and, in special cases, Erwin Oberholtzer, as well as in Berlin, with Eveline Alex, Cordula Severit, and Reinhard Wittich, many sheets were expertly restored and separated from their backings, which made the identification of watermarks possible.

We owe a great debt of gratitude for the realization of this exhibition. The Rat der Stadt Basel, the Regie-

rungsrat, the Kunstkommission, and, in Berlin, the Stiftung Preussischer Kulturbesitz agreed to the project and made the necessary resources available. We especially thank the president of the Erziehungsdepartement Basel-Stadt, Stefan Cornaz, the president of the Kommission, Peter Böckli, as well as the former and current presidents of the Stiftung Preussischer Kulturbesitz, respectively, Werner Knopp and Klaus-Dieter Lehmann, and the former and current general directors of the Staatliche Museen zu Berlin, Wolf-Dieter Dube and Peter-Klaus Schuster.

In Basel, the generous financial support of Credit Suisse Banking made the exhibition and catalogue possible. In Basel and Berlin, the ready support of Pro Helvetia, Arts Council of Switzerland was a significant contribution, for which we are much obliged to the director, Bernard Cathomas, and the head of the department of visual art, Christoph Eggenberger.

In Washington, the generosity of UBS AG made the exhibition possible. Additional support was provided by the Samuel H. Kress Foundation and by an indemnity from the Federal Council on the Arts and the Humanities. The English translation of the manuscript for the catalogue was made possible by Pro Helvetia, Arts Council of Switzerland.

We thank both the Dr. Cantz'schen Press as well as Gerd Hatje Publishers, of Ostfildern-Ruit, for their effective collaboration on the German edition of the exhibition catalogue, especially Bernd Barde and Annette Kulenkampff, as well as Ute Barba, who compiled the bibliography, and Gerhard Brunner, who designed the book. We also thank those in Washington who produced the English edition.

Our most profound debt is to our colleagues at all three museums, who contributed to and brought the project to fruition with great enthusiasm.

ALEXANDER DÜCKERS
Director
Kupferstichkabinett
Staatliche Museen zu Berlin–Preussischer Kulturbesitz

KATHARINA SCHMIDT
Director
Öffentliche Kunstsammlung Basel

EARL A. POWELL III
Director
National Gallery of Art

Contributors to the Catalogue

F.A. Fedja Anzelewsky

H.B. Holm Bevers

D.K. Dieter Koepplin

R.K. Renate Kroll

H.M. Hans Mielke

S.M. Stefan Morét

C.M. Christian Müller

Ursula Mielke revised catalogue entries by Hans Mielke (H.M.).

Stefan Morét (S.M.) adapted and, in some cases

(F.A./S.M.), edited the Albrecht Dürer entries by Fedja Anzelewsky (F.A.).

FROM SCHONGAUER TO HOLBEIN
Master Drawings from Basel and Berlin

Christian Müller

THE KUPFERSTICHKABINETTS of the Kunstsammlung Basel and the Staatliche Museen zu Berlin, Preussischer Kulturbesitz, have jointly organized this exhibition of works from their rich, internationally renowned collections of German drawings. The relative strengths of the museums—Dürer in Berlin, Holbein in Basel—ideally complement each other. These two artists have a special place in the exhibition—each is represented by a large group of works; however, more than thirty other artists are also presented. Together, their works—nearly 200 drawings—reveal the full spectrum of that art in Germany and Switzerland between 1465 and 1545.

Sacred and profane art north of the Alps blossomed after 1400, and new types of images were invented, from winged altarpieces to private images. Social and economic conditions created stronger cities and a middle class, which became increasingly more important as patrons. A special role fell to Emperor Maximilian, who after 1500 employed the most outstanding artists of the day for his own commissions. Drawings played an important role in the dissemination of works of art from the early fifteenth century onward. The content of these works became more complex, and the study of nature, as well as creativity in the depiction, became more relevant in the exchange between artists and patrons. Originality in works of art was also viewed as increasingly more significant because of the popularization of art from antiquity and from Italy. The intensified discourse with works from antiquity, in particular their focus on the human body and their subject matter, can be observed in the north in about 1500, especially in Dürer and his contemporaries. Art theories reflecting on the proportions of the human body and perspective were another factor. There was awareness of the development of a new formal language, derived from examples of antiquity or from Italian art.[1] The examination of nature and the environment, the study of nature, the comprehension of one's reality and its rendering, were

phenomena seen since 1400 in the north in the new panel paintings. These efforts may be compared to the Renaissance, for a renewal in the arts was underway.

The Reformation and its attendant social upheavals, for example the Peasant Wars, influenced the production of art in very different ways. The iconoclasm and other tendencies hostile to art must be mentioned. The medium of print gained a new importance for political purposes, in book illustrations as well as in the form of illustrated flyers and pamphlets. Drawings and prints had long functioned independently from other crafts and had become emancipated as separate works of art. Increasingly, they became essential to man's search for self-determination in a more complex world and in the growing separation between the private and the public sphere.

The term master drawing seems more appropriate for art of the distant past and probably brings to mind the artist-craftsman rooted in late medieval tradition. Then, masterworks were presented to the guilds before an artist could be proclaimed a master. Yet the same determination of value, primarily oriented on aesthetics, underlies the term master drawing. Not only do we expect a high level of quality overall, but the work must also assume a high rank within an artist's oeuvre. Thus this term, as an aesthetic category, goes back to the fifteenth and sixteenth centuries, during which time the drawing experienced a distinct appreciation by artists, patrons, and collectors. Drawings were created as separate from functional boundaries, as independent works of art. This could be expressed by a certain technique or execution, for example in Albrecht Dürer's or Hans Baldung Grien's chiaroscuro drawings, or in the pictorial works by the masters of the Danube school. Others betrayed their artistic ambitions in the calculated use of stylistic means, for example Urs Graf's pen drawings, in which the graphic form often takes on a reciprocal relationship with the content of the image. In the fifteenth and early sixteenth centuries,

craftsmen and artists can be identified as personalities who were capable of critical reflection about themselves and their actions. This new consciousness of the individual style of the artist and of the artist's own conception of the meaning of the work can also be seen, particularly with Dürer, in the new custom of signing drawings.

Dürer's admiration of Martin Schongauer (c. 1450–1491), who was active in the Upper Rhine region, had several bases. In Schongauer, Dürer found someone who was very close to his own ideas about the role of the artist and the versatility of artistic creation. Schongauer was a goldsmith, graphic artist, and copper engraver, as well as a significant painter. The influence Schongauer exerted on the young Albrecht Dürer is clearly visible in his early drawings. Schongauer's crosshatching technique became exemplary and definitive for Dürer and his circle. Schongauer's drawing style is based on goldsmith's techniques and copper engravings, which he signed without exception and which helped propagate his name. They made him the most important proponent of Netherlandish art, with its dictum to capture reality. We know that the young Dürer intended to visit Schongauer in Colmar in 1491, but the older master died just before his arrival. Nevertheless Dürer was still able to see drawings and prints, shown to him by Schongauer's brothers. He was even able to acquire a few, among them perhaps the drawing of the peony attributed to Schongauer by Fritz Koreny.[2] The close, exact study of nature, therefore, is not a phenomenon of Dürer's time; even here Schongauer was exemplary. In many ways he prepared the ground for Dürer. Schongauer's copper engravings and several of his drawings—executed with precision and in great detail, for example, his *Madonna with a Pink* (cat. 5)—have a pictorial, finished quality. We may wonder if such drawings were preparatory works for engravings or if they were created as individual works of art, sought by collectors or artists. Yet they also had the character of models and were samples used in the workshops of masters, as is documented by numerous copies after drawings by Schongauer (which, for example, may be found in large numbers in the Amerbach-Kabinett).

The Master of the Housebook, active in the Middle Rhine region between 1470 and 1500, and named for the drawings in the so-called Housebook in the possession of the princes of Waldburg-Wolfegg, may be ranked with Schongauer. Not only were they contemporaries, but they also shared interests in profane themes and disseminated works in the print media. Recently Daniel Hess has attempted once more to ascribe the drawings in the Housebook to at least two hands.[3] In all probability the Master of the Amsterdam Cabinet, thus named because

his prints are found almost exclusively in the Amsterdam collection of prints and drawings, drew only the planetary images of Mars, Sol, and Luna. For his prints he employed drypoint, which more nearly approximates drawing than engraving. Characteristic of this technique is modeling with mainly parallel strokes of great refinement, which, when closely spaced, can produce tonal values. The same master's silverpoint drawing of a pair of lovers, located in the Berlin Kupferstichkabinett (cat. 15), clearly shows very similar qualities. With his drypoint engravings, from which he evidently made only a few impressions, he may have intended to reproduce his drawings, which were sought after and treasured by collectors.[4]

Hans Holbein the Elder (c. 1460/1465–1524) is often viewed as an artist who remained loyal to the late medieval tradition, that is, as a craftsman who nonetheless did not fully shun innovation. Numerous drawings that have come down to us from the large workshop that he headed in Augsburg are now preserved in the Basel Kupferstichkabinett. Especially characteristic are the sometimes large-scale designs for altars, two of which are represented in the exhibition. A great many silverpoint drawings are kept in Basel and Berlin, almost all pages from sketchbooks, which have generally been completely disbound. These drawings—mainly portraits, as well as occasional studies after nature—were created in immediate relationship to painted works, especially religious altarpieces. In rare instances they are preparatory drawings for painted portraits—a practice later employed by Holbein's sons Ambrosius and Hans Holbein the Younger. For the most part, these drawings served to individualize the figures depicted in religious panel paintings and to enliven the standard portrait types normally kept by a late medieval workshop as an archive of motifs.

Like Hans Holbein the Elder, Hans Burgkmair was a leading artist of Augsburg. He was greatly influenced by Italian art and had actually traveled to Italy. Burgkmair (1473–1531) received his training from his father, Thoman Burgkmair, and from Martin Schongauer. His drawings, which are executed either in energetic pen strokes or in chalk and charcoal, are often directly related to altarpieces; otherwise, they are isolated studies for prints. Burgkmair created an extensive graphic oeuvre. Numerous woodcuts and book illustrations were commissioned by Emperor Maximilian I. Burgkmair's work reveals a consummate use of the pictorial vocabulary of the Italian Renaissance.

Matthias Grünewald (1480/1483–1528), a painter of religious panels, was primarily active in the area around Frankfurt, and in Mainz. Ten of his drawings appear in the exhibition. His drawing technique and his primarily

religious paintings, with their somewhat obscure iconographic content, have earned him a special place within the spectrum of art under consideration. He favored a technique well suited to large-scale studies: namely, chalk drawing heightened in white in order to achieve a pronounced painterly effect. He often used these works as individual studies in preparing his large altarpieces. In contrast to Schongauer and Dürer, Grünewald left no known prints; his drawings appear to have been done primarily in the service of paintings.[5] Nothing is known about Grünewald's training, although there have been attempts to link him with Hans Holbein or with Dürer. In addition to his ventures as a painter, he was active as a designer and builder of waterworks and fountains, and as a superintendent of works and construction foreman, the latter at the castle of Aschaffenburg. From 1516, after the completion of his Isenheim altar, he was in the service of Cardinal Albrecht of Brandenburg, archbishop of Mainz and Magdeburg. He probably left Albrecht's court service in 1525 and went to Frankfurt am Main. Matthias Grünewald died in Halle in 1528.

Albrecht Dürer (1471–1528) of Nuremberg is a Renaissance artist in the most comprehensive sense, including an involvement with the antique, the study of nature, and reflections on theories of art. Building on the achievement of Schongauer, he made the latter's creations accessible through his wide-ranging graphic oeuvre. This included the dissemination of mythological themes, which offered new possibilities for self-reflection to the student of drawings, prints, and painted works, including religious ones. We will here pass over Dürer's technical achievements in woodcuts and engravings. Naturally, examining Dürer's drawings—a medium that he fully mastered in every possible technique and category, from the compositional sketch to the picturelike and completely finished final drawing—yields an incomplete conception of Dürer's oeuvre. But the large body of his extant drawings allows us to recognize that they played a major role in his creative process and in his preparation of works, as well as in his lifelong struggle with artistic problems. Even Dürer's early self-portrait of 1485 in Vienna's Graphische Sammlung Albertina, which depicts him as a thirteen- or fourteen-year-old boy, constitutes an exceptional achievement. Dürer, the son of a goldsmith, began his training as a painter early on. He joined the workshop of Michael Wolgemut, where, at the latest, he became acquainted with Martin Schongauer's engravings and familiar with printmaking techniques, especially that of the woodcut. The numerous illustrations for Schedel's *Weltchronik,* to which Dürer may have contributed, originated in Wolge-

mut's workshop. In 1491, Dürer's student travels, his so-called *Wanderjahre,* brought him to Colmar, where his hopes to meet Martin Schongauer were disappointed. About 1491/1492 he was in Basel, presumably attracted by the publishing industry flowering there. He created numerous woodcuts for Basel publishing houses; the most famous and mature of these creations are the illustrations to Sebastian Brant's *Narrenschiff (Ship of Fools),* published in 1494 by Johann Bergmann von Olpe. By accident a large number of woodblocks, intended for an illustrated edition of the comedies of Terence, have come down to us. For the most part, these blocks were never cut; therefore, Dürer's autograph preparatory drawings have survived (see cats. 45–48). Dürer became acquainted with Italian works of art even before he left, in the fall of 1494, for his first journey to Italy. Drawings with mythological themes after engravings by Andrea Mantegna are evidence of the kind of interest that Dürer brought to this field (Graphische Sammlung Albertina, Vienna, W. 59f). Dürer's watercolor landscape drawings, which originated during his journey to Venice, belong to the most impressive early nature studies, not least on account of their painterly effect. One could argue for a parallel in the works of Wolfgang Katzheimer (cat. 18), who was active as court painter to the bishops of Bamberg near the end of the fifteenth century. The function of these drawings, consisting of costume studies partly worked out in color and of watercolor landscapes, is not always clear. Although they do possess the character of finished works of art, and consequently appear modern—perhaps because Dürer provided them with date and monogram—he used them as patterns in graphic and painterly works, and thus in a traditional sense. This dichotomy seemingly became a characteristic of drawing—not just with Dürer—as it began to free itself from the utilitarianism of work drawing. However, one practice is virtually unique to Dürer: he signed his drawings, even his study sheets, including those preparatory to altar paintings, such as the studies on green prepared paper for the Heller altarpiece of about 1509 (cat. 65). The accountability and self-awareness that may be deduced from this practice finds a direct counterpart in Dürer's literary efforts. His new interest in art theory, which was fostered by Dürer's engagement with Italian art, found expression in his studies of proportions, which he pursued with scientific meticulousness. The female gestural study and the so-called *Aesculapius* are but two examples of a large number of drawings (see cats. 56, 57) that Dürer rendered in this context. These early examinations, facilitated by Jacopo de'Barbari, who was active in Nuremberg for a while, may have occurred there before

Dürer's second Italian journey, which, dating from 1505 to 1507, again took him to Venice. There he created, among other works, the *Adoration of the Holy Rosary* for the chapel of the German merchants. In this period he appears to have been particularly occupied with perspectival problems.

Between 1512 and 1515, Dürer and his shop executed extensive commissions for Emperor Maximilian I, including the renowned *Triumphal Arch of Emperor Maximilian,* which is composed of 192 large-scale woodcuts. The leading artists of the day were charged with the marginalia of the emperor's Prayer Book, which may have been preparatory to woodcuts. These artists were—besides Dürer—Hans Baldung Grien, Albrecht Altdorfer, Hans Burgkmair, Jörg Breu the Elder, and Lucas Cranach the Elder. Dürer also designed art objects for the emperor, and, finally, figures for the latter's funerary monument in Innsbruck. Between 1520 and 1521 Dürer undertook a journey to the Netherlands, this time accompanied by his wife. In Antwerp he received the homage of local artists. During the last years of his life Dürer prepared a series of theoretical writings. In 1523 he completed the *Theory of Proportions. The Teaching of Measurements* came out in 1525, and in 1528, the year of his death, the first of his *Four Books on Human Proportions* was published.

Hans Baldung (1484/1485–1545) was the most important artist of Dürer's circle. From 1503, after a training stint in Swabia, he worked as an apprentice in Dürer's shop, which he led from 1505 to 1507. Hans Süss von Kulmbach, who worked in Dürer's shop about 1500, Hans Schäufelein, who entered the workshop at about the same time as Baldung and who settled in Nördlingen in 1515, and Hans Springinklee (cats. 79–85, 116) also belonged to Dürer's circle. Baldung's drawn self-portrait in the Basel Kupferstichkabinett (cat. 100) was begun in 1502, even before his stay with Dürer and before he knew of the latter's self-portraits, which may be seen as the first steps in the development of the genre. The portrait presents impressive evidence of the self-awareness of the young artist, who had not proceeded from the tradition of a late medieval painter's workshop, then still represented by Hans Holbein the Elder. Baldung, the issue of a humanistic background, came into contact with intellectuals of his time, such as physicians, lawyers, and theologians, but he nevertheless remained active as a painter of religious altarpieces. The high altar of Freiburg cathedral ranks among the most important commissions of his Freiburg period. The Basel and Berlin Kupferstichkabinetts have some early pen drawings by Baldung that give a sense of his proximity to Dürer as well as of the temperament and individual character of the still youthful artist. During the

production of the high altar of Freiburg, which fell to the shop of Baldung, his effusive energy, which had already found expression in the relatively high standard of draftsmanship of the early drawings, achieved a clarification and composure that manifested itself in predominantly parallel lines with a relatively open structure. Early on, starting with his self-portrait, Baldung paid close attention to the technique of the chiaroscuro drawing. The broad spectrum of themes that Baldung addressed in his paintings, drawings, and prints—predominantly woodcuts, including early ones in the chiaroscuro technique—invites comparison with those of Albrecht Dürer. Baldung took a particular interest in the depiction of death and the macabre, and in the theme of witches, subjects located on the outer edges of human and social experience. This is also evident in his portraits whenever he worked out the character traits of the sitter in particular detail.

The masters of the Danube school—we name only Albrecht Altdorfer and Wolf Huber, its most prominent adherents, both represented in this exhibition with important bodies of drawings—represent a style that manifested itself in the southeastern reaches of the empire, in Vienna and lower Austria, and that therefore became known as the Danube style or school. Albrecht Altdorfer (c. 1480–1538), shown to have been active in Regensburg from 1505, was a painter, draftsman, engraver, designer of woodcuts, and master builder. Wolf Huber, who was born about 1480/1485, lived in Passau and was court painter to the prince bishops.

Lucas Cranach the Elder (1472–1553) played a role in the development of this so-called Danube style. The element that links these artists is their interest in nature. They emphasized one aspect in particular, nature's untamed and uncivilized character, paying special attention to the depiction of the forest. The relationship between man and surrounding nature is emphasized differently in their work than in that of other masters, such as those active around Dürer. Nature and its forces seem directly manifest. Perspective, the faithful representation of a particular landscape, and the normative relationship in size of the individual motifs became ever more subjective factors. Men are as much dominated by the forces of nature as are the gnarled tree trunks and branches, which are usually garnished with long braids of moss. Huber's landscapes, which appear to be more true-to-life than those by Altdorfer, are occasionally bathed in bright sunlight or implausible manifestations of light, as with his drawing *Burg Aggstein in der Wachau* (cat. 134). Human beings enter into a relationship with these powers, as in a drawing by Albrecht Altdorfer of a pair of lovers who have settled

themselves in a hay field, sheltered in burgeoning nature. It is not surprising, therefore, that Altdorfer's figures do not embody an ideal of beauty in a Düreresque sense. Altdorfer's pen strokes, even more than Wolf Huber's, take on a calligraphic life of their own. Altdorfer preferred to draw in the chiaroscuro technique on colored prepared paper, which contributed to the heightening of the picturelike effect of the drawings and to an intensification of the rendering of light. These drawings are not, as is occasionally the case with Dürer, studies that originated in connection with a painting. Rather, they are picturelike, finished drawings—sometimes produced in several shop versions—that could be sold as small, independent works of art. This drawing technique was greatly admired in the first years of the new century.

Lucas Cranach was active between 1501 and 1504/1505 in Vienna, in the circle of humanists around Conrad Celtis, and in 1505 became court painter to the electors of Saxony in Wittenberg. The drawings of his Vienna years, done on colored prepared paper, may have influenced Altdorfer. Little remains of Cranach's drawn work, and his early work remains virtually unknown. During his Viennese period he created his thieves on the cross drawings on reddish tinged paper. They belong to the preparatory work for an early Crucifixion (cats. 86, 87). Such paper, prepared in red chalk, provided still another means of obtaining a painterly effect and an exceptionally soft and variegated modeling with heightening added in white. Cranach's drawings frequently show a tendency toward a fully pictorial quality. *Head of a Peasant* of about 1525 (cat. 90) is characteristic in its broad paint application that at once captures the attention of the spectator. It is a study that may well have originated in connection with one of Cranach's panel paintings depicting courtly hunting scenes for the elector Frederick the Wise.[6]

Drawings and graphic work by artists of the so-called Danube school radiated artistically not only to Nuremberg, as may be seen in a drawing by Hans Springinklee (cat. 116), but also to the Upper Rhine region.[7] The landscapes usually feature people (mercenaries and hermits) or demonic beings (witches and wild people). A uniting factor is a predilection for chiaroscuro drawing. Isolated motifs in the landscapes, such as the characteristic tree formations, especially gnarled trees with dangling lichens, and the tendency toward surrendering objective spatial structure, point to the influence of the masters of the Danube school, or to a similar orientation. With Baldung, such motifs cropped up early on in his woodcuts and drawings. Hans Leu the Younger (c. 1490–1531) was, in the end, affected stylistically and thematically by Cranach

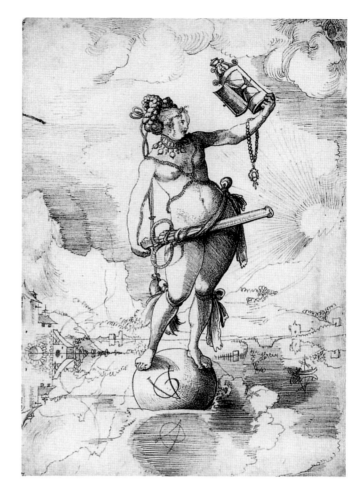

Urs Graf, *Allegory of Fortune,* 1516

even though he later appears to have had more direct contact with drawings by Albrecht and Erhard Altdorfer.

In the work of Urs Graf we can detect reflections of works by the masters of the Danube school. Hans Leu the Younger may have served as an intermediary. Graf's martyrdom of St. Sebastian (cat. 144), with its physically similar trunks of the dead man and the dead tree from which he hangs, and, finally, its associative juxtaposition of the dangling branches with the long hair of the dead man, shows a calligraphic interplay that might be compared to the drawings of Albrecht Altdorfer. Drawings by Urs Graf occasionally possess light effects similar to the ones Wolf Huber used, as in Graf's 1516 drawing of an *Allegory of Fortune* (U.X.102; see ill.).

Most of the drawings by Urs Graf, who was born in Solothurn in about 1485 and who can be traced to Basel by 1509, are independent works that did not serve any

preparatory function. They are highly personal testimonials from the artist, who, in general, appears to have either kept them to himself or made them accessible only to his closest circle. This may be concluded from the fact that the majority of the drawings in Basel are from the Amerbach-Kabinett, to which they came from the studio legacy of the artist by way of only a few intermediary owners. This fact is somewhat surprising as Graf had pursued training as a goldsmith and was active in Basel as a numismatic die-cutter. He also made engravings and designed numerous woodcuts, primarily as book illustrations. His marked predilection for a calligraphic and dynamic play of line not only expressed itself in the sphere of ornament but also became a fundamental trait of his drawing style. Graf had repeatedly participated in military campaigns and employed this subject matter again and again in his drawings. He did this straightforwardly, in a narrative, anecdotal fashion, but then often took pitiless or sarcastic aim at some individual aspects or outgrowths of this activity, or else idealized them. His study of the engravings and woodcuts of Dürer and Baldung, and of engravings by Italian artists, enriched his vocabulary, and not just with respect to ornament. On occasion they formed the background to his allusions and allegories, which revolve around themes of love and lust.[8]

Thematically and stylistically related are the drawings by Niklaus Manuel Deutsch, of which a large group are again found in the Basel Kupferstichkabinett. However, Manuel displays a more measured temperament than does Graf. Niklaus Manuel Deutsch (1484–1530) was probably trained in Basel as a glass painter and can be identified as an artist only from 1507. He was active as a painter of altarpieces and of pictures with profane themes, and as draftsman and designer for woodcuts. His first drawings are from the middle of the first decade of the sixteenth century; as a painter he does not appear until 1515. Like Graf, who was about the same age, Manuel took part in military campaigns. After 1520 he was no longer active as a painter, probably as a consequence of the Reformation. In 1523 he became bailiff of Erlach and active as a diplomat and author. Manuel's so-called *Schreibbüchlein* is unusual. These small wooden panels with drawings on both sides, usually in silverpoint, served as pattern sheets or, collectively, as a pattern book and may be regarded as offshoots of a late medieval tradition. They could be shown to a prospective patron, and they also served as models in Manuel's shop (cat. 154).

Between 1515 and 1530, Hans Holbein the Younger (1497/1498–1543), like Hans Baldung before him, was a predominant artist in Basel and the Upper Rhine region.

He became active as a painter and draftsman in Basel in 1515, immediately upon arriving there with his slightly older brother Ambrosius. They had both been attracted by Basel's flowering publishing industry, and they soon designed numerous woodcuts and engravings for Basel publishing houses. Holbein established new standards, not only with his decorative frames and title pages, which he furnished with antique motifs, but also in the genre of *Scheibenrisse* (designs for stained glass), which was flourishing in the Upper-Rhine region, as well as with large-scale wall paintings. These works are marked by his interest in the representation of architecture as a compositional device or framing element. His facade paintings in Lucerne and Basel continued to inspire many southern German and Swiss artists into the seventeenth century (cats. 162, 166). Holbein's drawing technique is based on the customs of his father's atelier, where Hans and Ambrosius probably underwent their earliest training. It was there that they learned to draw in silverpoint and—this applies especially to Hans—in the technique of the washed pen drawing, which, in the father's workshop, was used for large altar designs in particular. The son mastered both techniques with sovereign command early on, as is convincingly demonstrated by the two silverpoint drawings for the 1516 double portraits of the Basel burgomaster Jakob Meyer zum Hasen (cat. 161) and his wife and by the earliest stained glass designs of 1517 and 1518 in Brunswick and Basel. From about 1520 no additional major stylistic changes can be observed.

A group of chiaroscuro drawings from about 1518 to 1521 is an exception to the rule concerning technique and character. These drawings were most likely not designs but picturelike, finished works (cats. 163–165). Presumably, a dearth of commissions soon caused Holbein to embark on a search for new patrons. With the approach of the Reformation, which came to Basel in 1529, he no doubt enjoyed fewer church commissions. About 1524, after a journey to France, Holbein began to use black and colored chalks for his larger studies for portraits (cats. 174, 181). They often formed the immediate model for a painting or were transferred directly to the prepared ground. During his second English period, he utilized paper tinted in red more frequently for such studies. Holbein's renown as a portrait painter rests primarily on his later activity in England. His gift for quickly capturing a person's essential character traits was fully realized in this genre. Even so he did not forget his Basel years. Exhibiting the full scope of his talent, he created large-scale decorative paintings as well as numerous designs for goldsmith works. His sketched designs for Henry VIII

and Anne Boleyn (cat. 186), including those for table fountains, are fascinating. These designs have been seen on occasion as an end point in the development of German drawing, and also as an antipode to works by artists of primarily Düreresque cast using calligraphic elements and systems of crosshatching. Yet Holbein's stroke, despite its pronounced freedom, retains the artist's characteristic regard for close description of reality.

1. Especially Katharina Krause, "Hans Holbein d.Ä. und Hans Burgkmair—Alternativen in der Augsburger Malerei um 1500," in: *ZAK,* 55, 1998, 111–112.

2. Koreny 1991.

3. Hess 1994.

4. Hess 1994, 27.

5. Schade 1995, 321–329.

6. Schade 1972, 33ff.

7. D. Koepplin, "Altdorfer und die Schweizer," *Alte und Moderne Kunst* 84 (1966), 6–14.

8. See Andersson 1978.

The Berlin Kupferstichkabinett

Hans Mielke, 1994[1]

THE CORE OF THE HOLDINGS of German drawings in the Berlin Kupferstichkabinett is the collection of Matthäus Merian the Younger (died 1687), son of the renowned topographer. Although presumably acquired by the great elector Friedrich Wilhelm, Merian's roughly 480 drawings can only be verified as first appearing in the collection of King Friedrich Wilhelm I, but this parsimonious "soldier king" certainly did not sacrifice any money to art. The collection included drawings of all schools. Among the German works were particular gems, such as the *Standing Lovers* by the Housebook Master (cat. 15), Albrecht Altdorfer's *Pyramus,* done on dark blue prepared paper (cat. 125), or Hans Schäufelein's most beautiful drawing, his *Portrait of a Bearded Man*. Still, viewed in its entirety, the Prussian collection was threadbare, and the rank of the Berlin collection today was gained only through carefully planned acquisitions in subsequent years. A mere glance at the great collections of Vienna, Dresden, or Munich, which inherited a great deal more from the rulers of yesteryear, establishes just how unusual Berlin's collection is. In 1825 a large donation from Count Lepell to the king brought the first Grünewald drawing to the collection in Berlin. The Kupferstichkabinett, which was founded in 1831, became truly important four years later, when it was able to acquire the fifty thousand or so prints and drawings that made up the collection of the postmaster general Von Nagler, who specialized in German art, both drawings and prints: fifteenth-century sheets; Schongauer's *Madonna with a Pink* (cat. 5); four first-rate Dürer drawings; and a fragment of his personal notebook (cat. 59), in which he writes about such events as the death of his mother; in addition, seventy silverpoint portraits by Hans Holbein the Elder, which were then still believed to be by Dürer (cats. 35, 37, 38); two Grünewald drawings (cats. 96, 98); Baldung (cat. 111); Altdorfer (cat. 126)—an incomparable complement of names, including minor masters through the eighteenth century. When verifying the provenance of the German drawings, no name turns up nearly as often as Nagler's. He was interested in the work of artists right up to his immediate contemporaries (Hackert, Rosenberg).

In the following decades the collection of German drawings in the Berlin Kupferstichkabinett continued to grow steadily. In 1844 the greater part of the Blenz Collection was bought at auction. It included the charcoal drawing of Dürer's *Head of the Virgin* and a copy of his *Dead Toller* by Hans Hoffmann. Although the Pacetti Collection, acquired in the same year, was of fundamental importance for Berlin's Italian drawings, it also included such important German drawings as Wolf Huber's gouache *Alpine Foothills*. From Karl Friedrich von Rumohr, a forerunner of the modern art historian, came Lucas Cranach's design of an altarpiece on paper (cat. 89). An additional sheet (the fourth) by Grünewald came to the print room as part of the Von Radowitz Collection (cat. 95), which the king purchased in its entirety in 1856. The first important acquisition by Wilhelm von Bode, in 1874, was the collection of Barthold Suermondt, a collector born in Utrecht and active in Aachen. This collection strengthened the holdings in all schools, especially that of the Netherlands, but the German school also benefited: Altdorfer's *Pair of Lovers,* formerly attributed to Cranach (cat. 119), Berlin's only portrait drawing by Hans Holbein the Younger, three sheets by Dürer (cat. 55), and a male portrait in opaque paints by Lucas Cranach the Younger. In the next year, 1875, Bode bought a collection consisting largely of German art from the merchant and civil servant Bernhard Hausmann of Hanover. Hausmann's Dürer drawings were not included; they remained in the hands of his heirs.

In 1877 the Berlin collection was enriched when its director, Friedrich Lippmann, secured no fewer than thirty-five Dürer drawings of the highest importance, purchased in Paris from the collector-dealer Hulot. These

works included *Wire Drawing Mill, Valley near Kalchreuth, near Nuremberg* (cat. 53), brush studies for the Heller altar (cat. 65), the drawing of a ninety-three-year-old man and other sheets from his Netherlandish journey, and, finally, the *St. Mark* (cat. 78), which is a preparatory study for the Munich *Four Apostles.* Ten years earlier, Hulot had bought Alexander Posonyi's precious collection, which the Vienna dealer had assembled over many years, almost as if he had wished to heal the wounds suffered by the Albertina (protectress of Dürer's legacy) during the Napoleonic occupation of Vienna, when unscrupulous custodians had shamelessly sold drawings from the overflowing collection for their personal enrichment. It is astonishing that even after the extraordinary addition of the Posonyi-Hulot collection, Berlin continued to actively search for other Dürer drawings. Also in 1877, at the Paris auction of the Firmin-Didot Collection, Dürer's *Portrait of His Mother* was acquired, along with two silverpoint drawings from the sketchbook of the Netherlandish journey (cats. 72, 73). The artist's *St. Apollonia,* from the J.C. Robinson Collection (cat. 74), followed in 1880, and in 1882, the *Portrait of an Architect,* drawn in Venice in 1506 (cat. 62). The silverpoint drawing of *Angels Playing the Lute,* and the *St. Paul,* pendant of the aforementioned *St. Mark,* were acquired in 1890 from Mitchell. In the same year came *Spring in a Forest* (cat. 54) and the *Rest on the Flight into Egypt* (cat. 67) from Klinkosch; in 1899, the divine early work of the Virgin and the sleeping Joseph in a landscape (cat. 50) from Rodriques; and in 1901, the charcoal portrait of *Willibald Pirckheimer* (cat. 60). After such directed acquisitions of single sheets or of smaller groups, it proved possible in 1902 to again acquire still another large collection of drawings (almost 3,500 sheets from the Berlin collector Adolph von Beckerath), which enriched the holdings in all schools at the highest level. For German drawings, this collection brought a multitude of names: Strigel (cat. 25), Cranach (cat. 91), Huber, and Dürer, including three sheets and the proportion study of Aesculapius (cat. 57). At the 1910 Stuttgart sale of the collection of the Freiherr von Lanna of Prague, the Kupferstichkabinett again acquired German sheets of the very highest quality: two drawings on brown prepared paper by Altdorfer, a *St. Margaret* and a *St. George; Christ Taking His Leave from the Apostles* by Jörg Breu; the thieves on the cross, two early works by Cranach the Elder (cats. 86, 87); the *Saxon Princesses,* done in opaque paints by Cranach the Younger; *Witches* by H. Franck; sheets by Urs Graf, Wolf Huber, Hans Schäufelein (cat. 83); a sheet drawn on both sides by the Housebook Master (cat. 17); and four drawings by Dürer. As might be expected, World

War I brought a decrease in growth. Nevertheless, one should mention Dürer's drawn portrait of Jakob Fugger (unfortunately poorly preserved), bought in 1916 from Alfred von Wurzbach. The Kupferstichkabinett's most important postwar acquisition was added by Max J. Friedländer, who in 1925 purchased from the Frankfurt Savigny family an album in which German and Netherlandish drawings had been pasted. This volume included six autograph works by Grünewald, including a particularly impressive *St. Dorothy* (cat. 94). When one considers the rarity of drawings by this master, the acquisition was as much a stroke of luck as the addition of the Dürer bundle from Posonyi-Hulot had been almost fifty years earlier. Berlin easily became the richest Grünewald collection when another drawing of his was added in 1926 and when, in 1938, Friedrich Winkler acquired two more sheets from the Ehlers Collection in Göttingen. Finally, three unknown works, which had been glued into a Bible and discovered in the former East Berlin (cat. 92), were added. The Ehlers Collection yielded other important early German drawings, including sheets by Veit Stoss (cat. 22), Zasinger, Holbein the Elder, Huber (cat. 130), and Dürer. Winkler, the most important German Dürer biographer, clearly kept his eye on the Dürer drawings in the Ehlers Collection, the same group that had not been sold with the Hausmann Collection back in 1875. They were finally added to the Berlin collection in two installments in 1935 and 1952. These sheets included three watercolors (cat. 52), a silverpoint drawing of Pirckheimer, and a brush drawing of a female nude on blue venetian paper, which originated in Venice in 1506 (cat. 63). This absorption of the Blasius holdings into the Berlin Kupferstichkabinett brought an apparently permanent end to the fruitful form of collecting of its earlier days, when time and again it proved possible to buy existing collections in their entirety, with hundreds, even thousands of drawings entering the collection at one stroke. The more laborious custom of our times is to grope from single purchase to single purchase as systematically as possible. German drawings appear on the market only very rarely; however, in 1974 it was possible to buy Dürer's watercolor, *Christ Bound to the Column.* And in 1987 the most recently discovered Dürer drawing came to the Berlin collection: *A Standing Knight Ottoprecht,* an ancestor of the Habsburgs who is supposedly represented in bronze on the Innsbruck grave monument of Emperor Maximilian.

1. Reprint of a text in: *Handbuch Berliner Kupferstichkabinett* 1994, 82ff.

The Basel Kupferstichkabinett

Christian Müller

ABOUT TWO-THIRDS OF THE two thousand old master drawings in the Basel Kupferstichkabinett came from the collection of the Basel jurist Basilius Amerbach (1533–1591). The Amerbach-Kabinett is one of the first collections north of the Alps that we owe not to the initiative of a ruler, but to the interests of an educated, humanistic burgher. In addition to a sizable library, the collection included sculpture, paintings, drawings, prints, goldsmith models, tools, coins, and natural history specimens. The city of Basel acquired the Amerbach-Kabinett in 1661, saving the collection from dispersal on the Amsterdam art market. With its transfer to the university in 1662 and its installation in the House "Zur Mücke" on the Münsterplatz in 1671, the collection was soon open to the public.[1]

Amerbach's activities as a collector apparently began about 1562. This may be concluded from the list of expenses drawn up by his nephew, Ludwig Iselin, after Amerbach's death. In April 1562 Basilius had lost his wife and newborn son. His father, Bonifacius Amerbach (1495–1562), also died in the same month. These harsh experiences may have accentuated his natural interest in collecting. Amerbach made his largest acquisitions between 1576 and 1578. During those years he directed the architect Daniel Heintz to build a *Kunstkammer* (a special room for displaying works of art) in his house, "Zum Kaiserstuhl," on the Rheingasse in Basel, which he had occupied in 1562. This was the original Amerbach-Kabinett. Here his drawings were housed in two cupboards, and he began to carefully register parts of his collection in his first inventories.

Amerbach was especially interested in the period of the fifteenth and early sixteenth centuries, when the Upper Rhine region had enjoyed a rich artistic production. Ludwig Schongauer, Hans Holbein the Elder, Hans Baldung Grien, Hans Leu the Younger, Niklaus Manuel Deutsch, Urs Graf, Ambrosius Holbein, and Hans Holbein the Younger were some of the most important names

in his collection. Aside from works by Hans Bock the Elder—who was bound to Amerbach by friendship, and who worked for him, occasionally advised him, and portrayed him as late as 1591—the holdings of the Basel Kupferstichkabinett include astonishingly few drawings from the second half of the sixteenth century that come, with any certainty, from the Amerbach-Kabinett. Neither Hans Brand, nor Virgil Solis, nor Jost Amman, nor Tobias Stimmer are found among the Amerbach provenances. Amerbach also paid little attention to Joseph Heintz the Elder, the son of the architect Daniel Heintz and later court painter to Rudolf II in Prague. Amerbach's antiquarian interests focused decisively on the drawings of a past period, whose artistic creativity he valued more than that of his own time. Although he occasionally took an interest in drawings by Raphael, Michelangelo, or Titian, and attempted to purchase them with the help of Joseph Heintz or Ludwig Iselin, his eye fell again and again, as if meant to do so, on the territory of the Upper Rhine and the artists active there. These draftsmen, whom he knew personally, by name, or through their contacts with his family, included such artists as Albrecht Dürer, Hans Baldung, Hans Holbein the Younger, Jakob Clauser, Hans Hug Kluber, and Hans Bock the Elder.

Amerbach's focus on what was near and affordable must certainly have been influenced by the relatively limited financial means at his disposal. But he understood how to grasp opportunities and maintain contacts with artists and their descendants. Amerbach was able to buy a large number of drawings in Basel from the estates of artists who had died there of the plague. In 1578 he probably bought the workshop estate of Rudolf Schlecht, who had been married to the goldsmith Jörg Schweiger's niece. The Basel painter Hans Hug Kluber (born c. 1535/1536) died in the same year, and it was from his widow that Amerbach bought one of Hans Holbein the Elder's sketchbooks as well as drawings by Kluber and other

artists. The Basel glass painter Balthasar Han (born 1505) also died during the 1578 plague. He probably owned parts of the workshop estate of Hans Holbein the Younger, which Amerbach may have acquired at that time. The homogeneous groups of drawings by Upper Rhenish artists of the late fifteenth and early sixteenth centuries came into his possession in similar fashion.

In many respects, these circumstances explain the character of the collection, with its strengths and lacunae. Thus, perhaps contrary to expectations, we miss drawings by Martin Schongauer, as these were probably no longer available at that time. However, Amerbach did succeed in assembling the largest collection of drawings by Hans Holbein the Younger from the latter's Basel period and from his stay in England, many drawings by Hans Holbein the Elder, and almost the entire drawn oeuvre of the Swiss artists Urs Graf and Niklaus Manuel Deutsch. Drawings by Hans Baldung and his workshop constitute another major portion of the collection. Amerbach acquired not just individual, outstanding drawings from these estates, but, in some instances, the entire inventory of the workshops before they could be dispersed. This practice explains why his collection includes not only autograph works by these artists but also a large number of drawings from their workshops and circle. The largest groupings within Amerbach's collection of drawings include about 50 sheets by Hans Holbein the Elder, 12 by Hans Baldung, 115 by Urs Graf, about 70 by Niklaus Manuel Deutsch, and about 220 by Hans Holbein the Younger (including the *Praise of Folly,* which contains 82 margin drawings primarily by Hans Holbein, and the so-called English Sketchbook).

In marked contrast to the detailed listing of the antique coins and medals, the Amerbach inventories give us only a few concrete indications on several drawings; Amerbach generally entered them only summarily, according to artist. On the other hand, his correspondence with the Zurich painter Jakob Clauser gives us a good idea of the methods he used upon occasion to obtain individual objects. To avoid coming forward as an interested party himself, Amerbach attempted to acquire a copy of Erasmus of Rotterdam's *Praise of Folly,* with margin drawings by the brothers Hans and Ambrosius Holbein, with Clauser's aid. Even though we are not precisely informed about the outcome of Clauser's efforts as a middleman, an entry in inventory D of 1585/1587 shows that Amerbach finally achieved his goal. Drawings by artists who worked outside the Upper Rhine region are encountered only occasionally and in small numbers, as with Albrecht Altdorfer and Wolf Huber. Amerbach tried to

buy Dürer drawings, but he succeeded in only one instance, the *Monkey Dance* (cat. 77). He did, however, own (though probably through inheritance) almost 140 drawings on woodblocks that Dürer rendered in Basel, in 1492, for an illustrated edition of the comedies of Terence (cats. 45–48). The publication did not materialize, and the blocks, which may have been commissioned by Basilius' grandfather, the printer Johannes Amerbach, remained, for the most part, uncut.

The next expansion of the Basel collection came in 1823, with the takeover of the "Faesch Museum." The jurist Remigius Faesch (1595–1667), much like Amerbach, had built up a kind of art or rarities room—a *Kunstkammer*—in his private residence on the Petersplatz in Basel. He called his collection a "museum" and composed a theoretical text about it, the *Humanae Industriae Monumenta,* on which he worked and to which he made changes and corrections from 1628 until shortly before his death.[2] Drawings played a subordinate role in his collection. Tilman Falk estimated its size at about 220 to 230 sheets.[3] In addition to stained glass designs—mainly of the sixteenth and seventeenth centuries, going back to the Basel glass-painting Wannenwetsch family and to the Bern artist, Hans Rudolf Lando—Faesch owned only a few drawings of the fifteenth century; the most important works in his collection were the portrait drawings by Hans Holbein the Younger, which had come down to him from his family: the double portrait of the Basel burgomaster Jakob Meyer zum Hasen of the year 1516 (cat. 161) and those for the *Darmstadt Madonna* (cat. 174).

Remigius Faesch had stipulated in his will that the collection should not be sold or dispersed and should, in due time, be passed on to a male family member with a doctorate in jurisprudence. If this clause were to prove inoperable, the collection was to go to the University of Basel. This occurred, after a legal challenge, in 1823. However, the takeover of the Faesch collection did not alter the overall character of the Basel collection.

In 1858/1859, a large number of seventeenth- and eighteenth-century prints and a portfolio with fifty-seven early drawings entered the collection of the Kupferstichkabinett from the estate of the painter and art dealer Samuel Birmann (1793–1847). He had bequeathed all of his property to the university in 1844, including items that went back to his company, Birmann and Sons. Besides some fifteenth-century sheets and some stained glass designs, a chalk drawing by Hans Baldung Grien deserves special mention.[4]

In the nineteenth century, strategic acquisitions were not possible. Still, the Basel collection continued to

expand through occasional donations. Special mention should be made of gifts from a Basel alderman, Peter Vischer-Passavant, and from Emilie Linder of Basel.

In the twentieth century, after the collection could be tended by its own curators or directors of the Kupferstichkabinett, drawings were purchased, including works by Lucas Cranach the Elder, Urs Graf, Niklaus Manuel Deutsch, Hans von Kulmbach, Ambrosius Holbein, Hans Holbein the Younger, Jost Amman, and Daniel Lindtmeyer. The collection was further enriched with donations. Noteworthy benefactors are Tobias Christ, Robert von Hirsch, Heinrich Sarasin-Koechlin, and Edmund Schilling. It was from the bequest of Edmund and Rosy Schilling that Tobias Stimmer's drawing *Phaeton Driving the Chariot of the Sun* came to the Basel collection in 1996.

The Basel Kupferstichkabinett owes its most important growth of recent decades to the CIBA-Jubilee donation of 1959. It consisted of fifteen first-rate drawings by Martin Schongauer (now attributed to his workshop, cat. 8), Hans Fries (cat. 136), Albrecht Dürer (cat. 70), Hans Schäufelein (cat. 85), Hans Baldung Grien, Hans Springinklee (cat. 116), and Albrecht Altdorfer (cat. 127). In 1984 the Ciba-Geigy firm gave the Kupferstichkabinett an additional drawing, a portrait of a young man, then still attributed to Hans Holbein the Younger, which is now ascribed to Ambrosius Holbein.

Only rarely could further acquisitions be undertaken in the area of old master drawings. In 1976 a portrait drawing of a man with a cap and fur collar by Urs Graf came to the Kupferstichkabinett on a permanent loan from the Eidgenössische Gottfried Keller-Stiftung, with funds provided by the Verein der Freunde des Kunstmuseums und des Kantons Basel-Stadt. Finally, in 1978, again using special means, Basel was able to buy a portrait drawing by the same artist from the Robert von Hirsch Collection (cat. 140).

1. See Exh. cat. *Amerbach* 1991, *Beiträge / Gemälde / Goldschmiederisse / Objekte / Zeichnungen*.

2. See Major 1908, 26ff.

3. Falk 1979, 24ff.

4. Falk 1979, 27f.

CATALOGUE OF DRAWINGS

MASTER E.S.

*(active in the Upper Rhine region, presumably
in Strassburg, c. 1450–1467)*

Most important engraver north of the Alps before Martin
Schongauer. Master E.S. created more than three hundred
prints with sacred and profane themes. Through the wide
dispersion of his engravings, he exerted a profound influence on the painting and sculpture of his time.

1 GIRL WITH A RING, c. 1450–1460

Berlin, Kupferstichkabinett, KdZ 4308
Pen and black ink; light red wash; gray wash
262/267 x 188/180 mm (irregularly cut)
No watermark

PROVENANCE: Heinrich Lempertz Sr. Coll., Cologne; auction
Lempertz-Heberle, Cologne, 10.17.1905 and following days, no.
239; acquired in 1905 through Artaria, Vienna

LIT.: Lehrs, "Eine Handzeichnung des Meisters ES," in: *Jb. preuss.
Kunstslg.,* 27 (1906), 70–74 – *Zeichnungen* 1910, no. 131 – Bock
1921, 68 – Exh. cat. *Deutsche Zeichnungen 1400–1900,* 1956, no. 12 –
Shestack, "Master E.S. Five Hundredth Anniversary Exhibition,"
in: Exh. cat. *Philadelphia* 1967, no. 82 – Bevers, "Meister E.S. Ein
oberrheinischer Kupferstecher der Spätgotik," in: Exh. cat.
Munich/Berlin 1986/1987, 16ff. – Andersson, "Master E.S. in
Munich and Berlin" (review of Bevers, *Master E.S.,* Exh. cat.
Munich/Berlin 1986/1987), *The Print Collector's Newsletter* 18
(1987), 167–170 – Naß, *Meister E.S. Studien zu Werk und Wirkung*
(Frankfurt am Main 1994), 143ff. – Bevers, "The Master E.S.,
Review of M. Naß, *Meister E.S.,*" *Print Quarterly* 13 (1996),
316–323, esp. 322

This drawing, with its subtle technical execution and
the graceful figure of the girl, is one of the most beautiful
examples of the refined sensibility of the German late
Gothic, the "waning Middle Ages." Lehrs questioned
whether the young lady could be St. Catherine. The ring
could be the attribute of the saint, but our sitter wears
a foliated wreath, indicating a profane figure, such as a
bride. Andersson emphasized the slightly lascivious expression of the maiden and suggested a Garden of Love context.

Auctioned in 1905 under the name of Urs Graf (trial
marks at the upper left were presumably mistaken for a
signature), the sheet was identified by Lehrs as a work by
Master E.S.[1] Lehrs based his attribution on the similarity of
the head to those in engravings of the master, for instance,
The Great Hortus Conclusus (Lehrs 83). The features, the
design of the folds, and the gracious disposition of the
hands are nearly identical. Also typical of the master's style
is the drawing's reliance on delicately hatched lines in combination with more severe crosshatching in the drapery.

The purpose of the drawing remained a mystery until
recently. Its format rules out any function as a preparatory
work for an engraving such as *The Baptism of Christ*
(Louvre; see note 1). Naß interpreted *Girl with a Ring* as an
autonomous masterwork because of its virtuoso execution.
That notion is not viable; the art of drawing north of the
Alps before Dürer was fundamentally subservient in nature;
its purpose was as a preparation for other works of art. Our
work was probably a design for a glass painting, as is confirmed by a closely related stained glass window design of a
young, female figure carrying a coat of arms (Basel Kupferstichkabinett).[2] This drawing, from Strassburg or Basel
about 1460/1470, was executed using similar hatching.
Here, too, the refined pen and brush modeling was supplemented by subtle coloring, and even the type of the head
and the drapery configuration are truly close to those by
Master E.S. Considering that the Upper Rhine region,
especially Strassburg, was a center for glass paintings, the
proposed function of our sheet as a stained glass window
design gains credibility, as does a possible origin in the
workshop community of the Strassburg glass painter Peter
Hemmel von Andlau (active c. 1447–1501).[3] The generally
accepted early dating of about 1450/1455 and the attribution
to Master E.S. should also be critically reexamined. An
origin about 1460/1470 cannot be excluded. And we ought
to remember that the style of Master E.S. was widely dispersed and paradigmatic in the Upper Rhine region during
the third quarter of the fifteenth century. H.B.

1. See also Lehrs, "Über einige Zeichnungen des Meisters E.S." in:
Jb. preuss. Kunstslg., 11 (1980), 79–87. Of all the sheets once ascribed
to the engraver, only the present Berlin sheet and a *Baptism of Christ*
(Louvre) are accepted today.
2. Falk 1979, no. 19; Hp. Landolt 1972, no. 10; Exh. cat. *Amerbach*
1991, *Zeichnungen,* no. 5; Roth, in: Exh. cat. *Bilder aus Licht und Farbe*
1995, no. 43.
3. See Exh. cat. *Bilder aus Licht und Farbe* 1995.

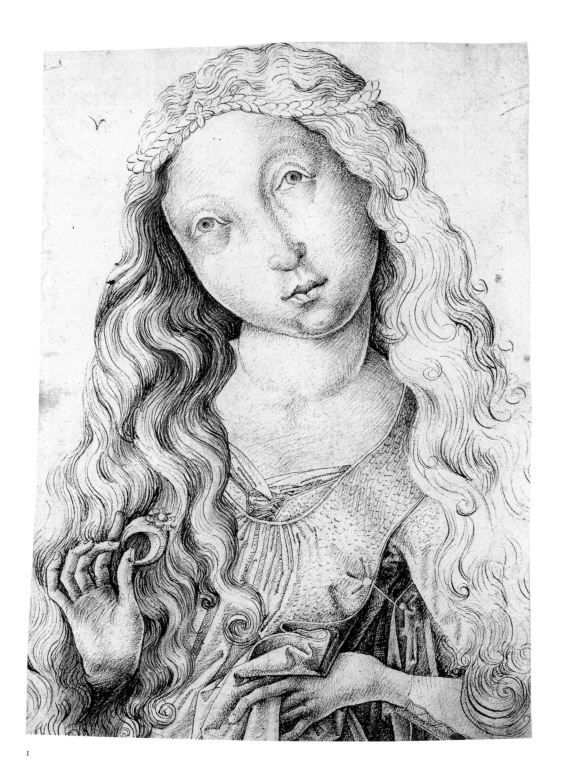

I

ANONYMOUS UPPER RHINE

2 HALF-LENGTH PORTRAIT OF A
WOMAN TURNED TO THE RIGHT WITH
EYES RAISED, C. 1470/1480

Verso: Eyes, nose, and mouth of an incomplete face
Basel, Kupferstichkabinett, U.VIII.92
Pen and black ink
184 x 144 mm
No watermark
Paper somewhat spotted

PROVENANCE: Amerbach-Kabinett

LIT.: E. Müntz, *L'Art* 40 (1886), 115 – D. Burckhardt, in: *Rep. f.
Kwiss.* 13, 1890, 444 – *Handz. Schweizer. Meister* 3, no. 31a (text
by E. Major) – Falk 1979, no. 34 – John Rowlands, with Giulia
Bartrum, *Drawings by German Artists . . . : The Fifteenth Century,
and the Sixteenth Century by Artists Born before 1530* (London 1993),
no. 43.

3 HALF-LENGTH PORTRAIT OF A
WOMAN TURNED TO THE LEFT WITH
EYES RAISED, C. 1470/1480

Basel, Kupferstichkabinett, U.VIII.91
Pen and black ink
186 x 145 mm
No watermark
Paper somewhat spotted

PROVENANCE: Amerbach-Kabinett

LIT.: E. Müntz, *L'Art* 40 (1886), 115 – D. Burckhardt, in: *Rep. f.
Kwiss.* 13 (1890), 444 – *Handz. Schweizer. Meister,* 3, no. 31b (text
by E. Major) – Falk 1979, no. 33 – John Rowlands, with Giulia
Bartrum, *Drawings by German Artists . . . : The Fifteenth Century,
and the Sixteenth Century by Artists Born before 1530* (London 1993),
no. 43.

Both drawings depict women whose poses and inventive
dress suggest that they are sibyls. The existence of two
similar depictions also supports this conclusion, as do the
gestures and format, which conform to the type of the
half portrait.[1] Our drawings are only slightly trimmed.
They may therefore have belonged to a series of sibyls that
were placed next to prophets, wise men, or philosophers.

In the late fifteenth century, pictorial series of this
kind were beloved as illustrations to published theological
treatises or as components of the sculptural or painted
decoration in churches or town halls. One could refer
to the choir stalls of the Ulm cathedral, which Jörg Syrlin
the Elder created in 1474, and to the early sixteenth-

century accoutrements of the Goslar town hall. Sibyls,
seers whose origins go back to antiquity, are young
women whose divine inspiration is indicated by their
raised, forward-looking eyes. They announced Christ's
coming, earthly life, and sacrificial death.[2]

Sibyls and wise men portrayed in half-length, often
with arms and hands raised in gestures indicating discus-
sion or argument, sometimes with attributes, are found,
for instance, in the work of the Master of the Banderoles,
who was active in the Netherlands about 1460.[3] The
relationship of his depictions to the c. 1470/1480 colored
woodcuts with sibyls and wise men in the Basel Kupfer-
stichkabinett is only partially elucidated.[4] In both series,
the sitters are located in nichelike interiors or situated
before architectural coulisses. Their identification is made
possible in part by their attributes or the inscriptions.
The lack of such indications and of settings in our two
depictions could indicate that they were created as in-
struction aids for budding artists or, more likely, as addi-
tions for the archive of models and pictorial types kept
in a painter's workshop.

The style of the Basel drawings, with their somewhat
hard parallel lines and crosshatching, as well as their de-
ployment of short, hook-shaped strokes that model the
surfaces, is reminiscent of Martin Schongauer's engravings
and drawings. And details from the Basel sheets—such
as the narrow hands with slim fingers and the treatment
of the long hair, in which isolated locks stand out like
schematic circles along the contours of the head—are
also found in Schongauer's engravings, for instance, in
his *Wise Virgins* (Lehrs, 5, nos. 76, 77). These observa-
tions, as well as the provenance of the drawings, under-
score their origins in the Upper Rhine region, most likely
between 1470 and 1480. This dating is supported by the
(few) watermarks found on other drawings that belong to
the same stylistic group. These sheets are mainly preserved
in the Basel Kupferstichkabinett.[5] C.M.

1. On the engraving by Master E.S. (Lehrs, 2, no. 192) depicting the
Tiburtine Sybil with the Emperor Augustus, the sibyl is represented in
full length with her head in a similar position and her eyes raised. Our
drawing, however, must have been intended as a half-length portrait
from the very beginning because the termination of the strokes is visible
in several places at the bottom. This is not unequivocally the case with
the somewhat earlier British Museum drawing with a sibyl, who wears
an elaborate head adornment comparable to that on our woman. See
Rowlands, with Bartrum, 1993, no. 43. Also related in type is a draw-
ing, probably of a sibyl, in the Lahmann Collection in the Dresden
Kuperferstichkabinett. See Edmund Schilling, *Altdeutsche Handzeich-
nungen. Aus der Sammlung Johann Friedrich Lahmann zu Dresen* (Munich
1925), no. 1.

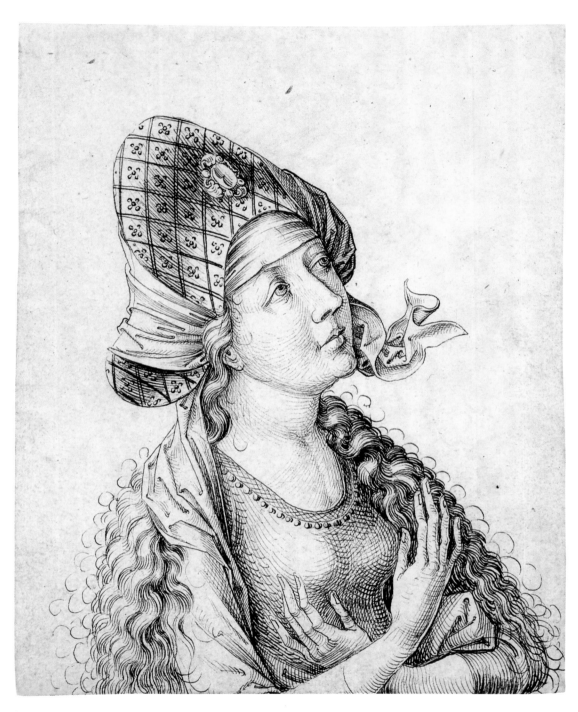

2

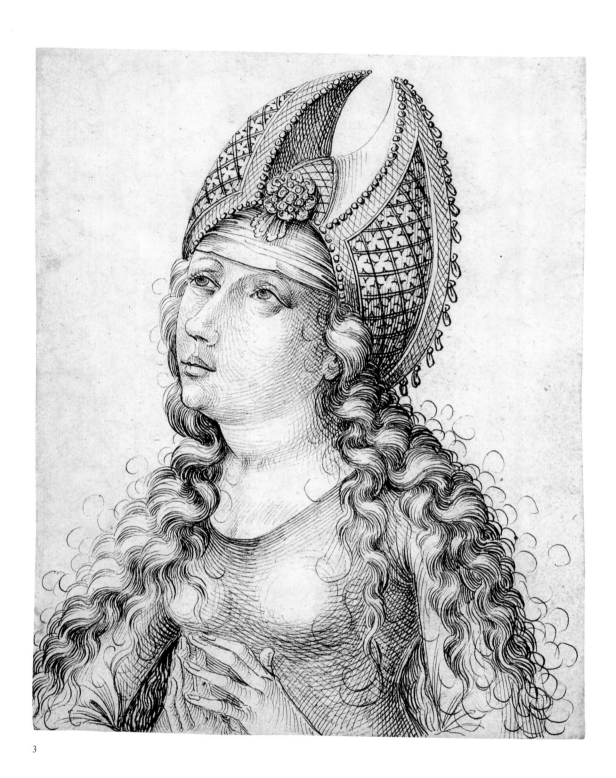

3

2. See Anneloes Smits, "Zu den Zyklen mit Sibyllen und Heidnischen Propheten von Ludger d.Ä. und Hermann tom Ring," in Exh. cat. *Die Maler tom Ring,* Westfälisches Landesmuseum für Kunst und Kulturgeschichte Münster, vol. 1 (Münster 1996), nos. 77–87.

3. Lehrs, 4 (1921), nos. 75–79; Anneloes Smits 1996, 2: nos. 34–37.

4. Exh. cat. *Einblattholzschnitte des XV. Jahrhunderts aus dem Kupferstichkabinett Basel* (Basel 1994), nos. 12–17 by Mariantonia Reinhard-Felice; Anneloes Smits 1996, nos. 28–33.

5. Falk 1979, nos. 24–34.

MARTIN SCHONGAUER
(Colmar c. 1450–1491 Colmar)

Painter and engraver. One of the most important late Gothic artists before Dürer. Little is known about his life. Apprenticed as a goldsmith to his father Caspar in Colmar. Entered as a student in the register of the University of Leipzig in 1465. Subsequently active in Colmar; became a citizen of Breisach in 1489. Little remains of his paintings, which incorporate the latest achievements of Netherlandish painting in figure style and landscape at a level of mastery hitherto unknown for Germany: *The Madonna in a Rose Arbor* (Colmar) dated 1473, the Orlier altar (Colmar), three small cabinet pictures (Berlin, Munich, Vienna), in addition to the late, poorly preserved frescoes of *The Last Judgment* in Breisach. The highly influential engraved oeuvre, consisting of both sacred and profane subjects, is of the finest quality. Schongauer systematized and perfected the crosshatching system of engraving, and he was the first artist to sign all of his engravings with a monogram. He enjoyed great fame throughout much of Europe in his own lifetime, in part thanks to the dissemination of his prints and of his paintings, which are thought to have reached Italy and Spain. Albrecht Dürer himself traveled to Colmar specifically to visit the famous master, who had died by the time Dürer arrived in 1491. Schongauer was highly influential in the Upper Rhine region. Many drawings once believed to be his are the works of followers. The known graphic oeuvre comprises fewer than twenty drawings.

4 ST. DOROTHY, C. 1475

Berlin, Kupferstichkabinett, KdZ 1015
Pen and gray brown and light brown ink
175 x 165 mm
No watermark
Upper left corner restored; later borderlines in black ink

PROVENANCE: old inventory

LIT.: Bock 1921, 77 – Rosenberg 1923, 36 – Winzinger 1962, no. 37 – Rosenberg 1965, 401 – Exh. cat. *Dürer* 1967, no. 1 – E. Starcky, in: Exh. cat. *Schongauer* Colmar 1991, no. D30 – Koreny 1991, 595 – Exh. cat. *Schongauer* Berlin 1991, ill. 67 – Koreny 1996, 142ff.

Closely related to Schongauer's *Madonna with a Pink* (cat. 5) is this depiction of St. Dorothy, who, before her execution, was visited by a celestial messenger boy with a basket of apples and roses from the garden of the heav-

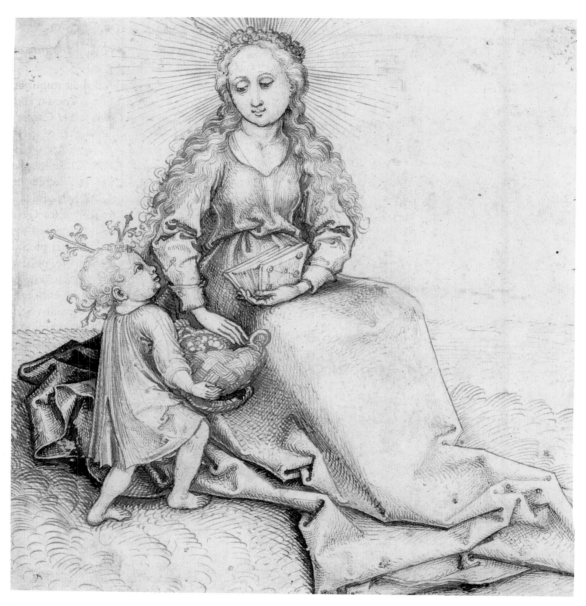

4

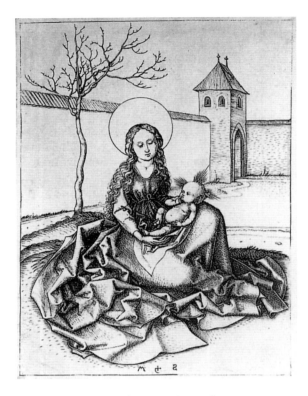

Martin Schongauer, *Madonna in a Courtyard*, c. 1475–1480

enly bridegroom. The execution is similarly delicate; here too the subtlest reflections of light on the clothes, faces, and hair are rendered only by means of gradations in the pen strokes. The drawing has met with a varying response in the literature. Although Bock catalogued it as an autograph work in 1921, Rosenberg's fundamental 1923 catalogue of Schongauer drawings calls the *St. Dorothy* mere shopwork. He believed that the brightly lit parts of the saint's robes were too uniformly modeled. In his review of Winzinger 1962, who considered the sheet to be autograph, Rosenberg (1965) maintained his earlier opinion. But what he found objectionable in the drawing is in fact evidence for the considered graphic execution of Schongauer, for in bright light a smoothly falling fabric does not have the appearance of being heavily modeled. Moreover, close observation reveals that extremely fine strokes, slightly faded by later exposure to light, softly model the cloth just below the knees. Rosenberg also criticized the clumsy, flatly bent arm of the saint. But it is an indication of authenticity, for comparable arms and hands are encountered elsewhere in Schongauer's engravings

(for example, the *Woman Holding a Coat of Arms,* Lehrs 97). As recently affirmed by Koreny, the drawing shows Schongauer's traits in every respect. The bold crosshatching in the drapery folds at the left, which resemble those of *The Madonna with a Pink,* also speak for his authorship. Despite the color of the darker brown ink, which differs from the gray brown ink used in the rest of the drawing (there are also fine strokes in other parts of the robes!), these strokes are not by a later hand, as Starcky supposed. Also characteristic is the preliminary sketching of the composition, with very fine lines that remain visible where the subsequent rendering shifted a little, as beneath the boy's feet.

With respect to style, composition, and facial type, there are close parallels between *St. Dorothy* and the engraving *Madonna in a Courtyard* (Lehrs 38; see ill.). Also related is the system of hatching. The lines of the halo that continue beyond the edges of the sheet, as well as the truncated tip of drapery at the bottom right, demonstrate that the sheet has been substantially cut. The original relationship of the figures to the surrounding space may be inferred from a comparison with the engraving.

Some authors believed that if the direction of the light is from the right, it indicates that the drawing was used as a model for an engraving. But the engravings of the Colmar master also include prints in which the light comes from the right (such as his *St. John the Baptist,* Lehrs 59; Apostle series, Lehrs 41–52). Furthermore, it is doubtful that Schongauer prepared his engravings in this way.

Winzinger dated *St. Dorothy* later; Koreny rightly ranked the drawing with Schongauer's early work. It may have been done a little earlier than the *Madonna with a Pink* and, like that drawing, could have served as a design for a panel painting.

The supple and rich system of tonal effects achieved through hatching, which is not encountered in German drawing before Schongauer, had a major influence on the drawing style of the young Dürer. H.B.

5 THE MADONNA WITH A PINK, c. 1475–1480

Berlin, Kupferstichkabinett, KdZ 1377
Pen and brown ink; traces of squaring in black chalk
227 x 159 mm
No watermark
Corners damaged

PROVENANCE: Von Nagler Coll. (verso, collector's mark, Lugt 2529); acquired in 1835

LIT.: Lippmann 1882, no. 76 – Lehrs 1914, no. 4 – Bock 1921, 77 – Rosenberg 1923, 27ff. – Parker 1926, no. 8 – E. Buchner, *Martin Schongauer als Maler* (Berlin 1941), 98ff. – Baum 1948, 45ff., 60 – Winzinger 1953, 26, 29 – Winzinger 1962, no. 33 – Rosenberg 1965, 401 – F. Anzelewsky, in: *Kunst der Welt* 1980, no. 6 – Exh. cat. *Schongauer* Berlin 1991, ill. 66 – E. Starcky, in: Exh. cat. *Schongauer* Colmar 1991, no. D29 – J. P. Filedt Kok, "Review of the Schongauer Exhibitions in Colmar and Paris," *Burl. Mag.* 134 (1992), 203–206, 204ff. – H. Mielke, in: *Handbuch Berliner Kupferstichkabinett* 1994, no. III.11 – Koreny 1996, 139ff.

With its balanced, pictorially rich composition and subtle execution, this is Martin Schongauer's most beautiful surviving drawing. It is also a key work of northern drawing before Dürer. The pen here serves not only to capture the structure of objects but also to precisely render light reflections on figures and surfaces. Light slants inward from the left; highlighted passages—the draperies flowing downward from Mary's knees, the body of the Christ child, the face of the Mother of God—are modeled in delicately rendered strokes of the pen. By contrast, the shadowed drapery passages lending stability to the figure of the Virgin are modeled in stronger, denser pen strokes. The alternating play of light and dark is wonderfully observed in the flower basket, through the long cascading hair of the Virgin, and in the shadow that the child's right arm casts on his body. Schongauer's working method is readily discernible: the initial outlines are prepared with the most delicate of strokes. The lines of the first framework are visible where Schongauer deviated from them during later elaboration: for instance, to the left of the head and shoulder of Mary, at the middle and index fingers of her right hand, at the right foot of the infant and the corners of the swaddling cloth below it, as well as in the tips of the drapery, to the left and right, on the ground. He then drew the contours and interior modeling with a broader pen, using soft strokes that are almost reminiscent of brushwork. Finally, he firmed up

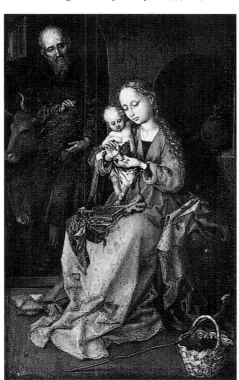

Martin Schongauer, *Holy Family*, c. 1475–1480

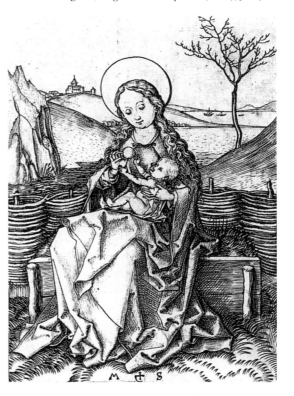

Martin Schongauer, *Virgin on a Grassy Bench*, c. 1475–1480

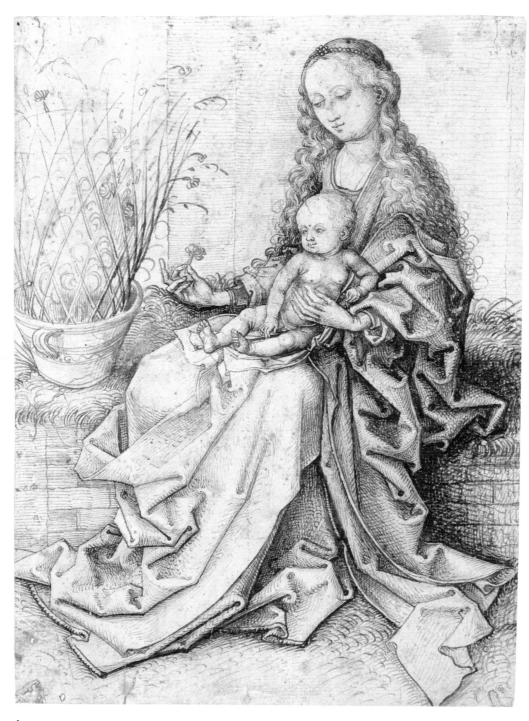

5

some of the outlines and hatching. The combination of soft strokes and hatches with powerfully swelling parallel hatching and crosshatching is reminiscent of the burin work of Schongauer's engravings. The engraving *Virgin on a Grassy Bench* (Lehrs 36; see ill.) is closely related, both in theme and composition.

The theme of the Madonna on a grassy bench was especially beloved around the Upper Rhine. The grassy bench refers to the *hortus conclusus* (closed garden), a symbol for Mary's virginity. In Schongauer's drawing, a curtain—emblematic of sovereignty—is suggested in delicate strokes behind Mary. She has just picked a pink, a symbol for the nails of the cross. Schongauer had previously taken up this theme in his grandiose Colmar painting of 1473, *The Madonna in a Rose Arbor,* which is stylistically entirely under the spell of Rogier van der Weyden. The modeling of the sweet features of Mary in the Berlin drawing is also witness to the marked influence that the Madonnas of the great Netherlandish artist exerted on the master of the Upper Rhine during his formative years. The Berlin *Madonna with a Pink* could have originated several years after the painted key work, that is, about 1475 to 1480, like the Vienna panel with the Holy Family and the engraving *Virgin on a Grassy Bench.*

Winzinger and other authors judge our sheet to be an autonomous work of art on account of its finished execution, but there are many signs of wear that point to its being a working drawing. All four corners show wear and damage that have evidently been caused by the insertion of nails. Did the drawing hang as a pattern sheet in Schongauer's shop, ready to be imitated? In addition we can readily discern the traces of a (contemporary?) grid in black chalk, which is usually an aid in the transfer of a composition to another support. Rosenberg, Buchner, and Baum did not exclude a possible function as a preparatory drawing for a painting. In this connection, Rosenberg referred to Schongauer's small panel with the Holy Family, in Vienna's Kunsthistorisches Museum (see ill.), which corresponds to the drawing with respect to the drapery folds and facial types. The proportions are also virtually identical when we consider that the Berlin sheet was trimmed on all four sides (drapery tip and flower basket to the left, drapery tip, below). Falk (Exh. cat. *Schongauer* Colmar 1991, 100) rightly established that Schongauer must have often prepared designs for compositions, as is shown by drawn copies and shop replicas. *The Madonna with a Pink* could have been a preparatory study as well. A small panel from the circle of Schongauer, *Madonna in a Garden* (London, National Gallery; Baum 1948, 60, ill. 195), is related in style and composition. H.B.

6 ANGEL OF THE ANNUNCIATION, C. 1470

Berlin, Kupferstichkabinett, KdZ 1019
Pen and brown ink
140 x 99 mm
No watermark
Lower left, in another hand, Schongauer monogram in brown ink
M + S

PROVENANCE: Marquis de Lagoy Coll. (collector's mark, Lugt 1710); date of acquisition unknown

LIT.: Bock 1921, 77 – Rosenberg 1923, 18ff. – Parker 1928, no. 8 – Schilling 1934, no. 6 – Winzinger 1962, no. 12 – Rosenberg 1965, 399ff. – Exh. cat. *Schongauer* Colmar 1991, no. D8 – Koreny 1996, 124, 127

Angel of the Annunciation is one of Martin Schongauer's earliest drawings. The pen strokes are harder, and the sharper, finer lines look more metallic than on the later sheets *Madonna with a Pink* (cat. 5) and *St. Dorothy* (cat. 4). *Angel of the Annunciation* is stylistically related to early engravings by Schongauer, such as his *Adoration of the Magi* (Lehrs 6) and the *Death of the Virgin* (Lehrs 16). Characteristic of such works is the use of both fine parallel hatching and small rounded hooks, which are laid over the hatching. The faces and hands are worked out plastically with exceptionally thin and pliant strokes. Other early drawings by the master, such as *Head of a Bearded Man* in Copenhagen (Winzinger 1962, no. 8) and *Christ as Judge* in the Louvre (Winzinger 1962, no. 4), are also done in the same technique. The latter sheet carries the date 1469 in Dürer's hand. Even if Dürer acquired the drawing only after Schongauer's death in 1491, one need not doubt the correctness of the date he proposed. Following Winzinger and Koreny, the Berlin *Angel of the Annunciation* may therefore also be dated about 1470, in the first phase of Schongauer's creative activity.

Altogether typical of Schongauer's working method is the preparatory drawing executed in hairline pen strokes, which, in this and other instances, are easily discernible in several places. The left hand raised in blessing, at first loosely outlined with two or three spirited, curved lines, was later moved closer to the angel's body. The rendering of the light, especially in the face and hair, has a wonderful clarity. The splendidly turned locks are not characteristic for Schongauer, but are encountered with the standing king in his *Adoration of the Magi* (Lehrs 6).

Winzinger identified a related *Head of an Angel,* executed only in incomplete outlines (formerly Collection Koenigs, Haarlem; Winzinger 1962, no. 11), as a preparatory study for the more detailed Berlin drawing. The attribution of this related work to Schongauer is not certain; one would sooner think in terms of a student copy

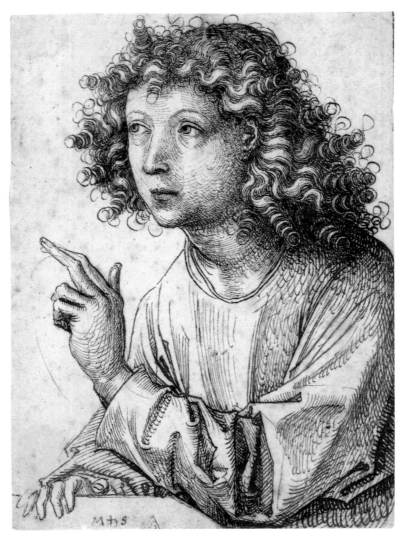

6

after our sheet.[1] A similar school drawing with a half-length youth, probably based on an original by Schongauer, is in the Basel Kupferstichkabinett (Winzinger 1962, no. 55; Falk 1979, no. 54). Rosenberg pointed out that the youthful angel in the present sheet holds up his left hand in blessing rather than his right hand, as would traditionally be the case. He therefore suspected that the Berlin drawing was conceived as a model for an engraving whose reversed impression would have shown a right hand raised in blessing. Parker and Winzinger accepted Rosenberg's thesis.

The identification of the subject as Gabriel, the angel of the Annunciation, is not altogether plausible. The youthful, half-length figure fills the sheet, and his right hand rests on a balustrade (or a book?). Depictions of Annunciations typically show Mary and Gabriel as full-length figures, and the angel as winged and holding a lily or scepter in the left hand, as in Schongauer's engravings (Lehrs 1–3). Schilling concluded that the present subject was probably a "blessing" young Christ. A better interpretation might perhaps be the young Christ teaching in the temple (Luke 2:42–52). H.B.

1. Rosenberg 1965, 399, no. W. 11.

7 MAN WEARING A FUR HAT, C. 1480

Berlin, Kupferstichkabinett, KdZ 4917
Pen and brown ink
104 x 71 mm
No watermark
Lower center, by another hand, Schongauer's monogram in black ink *M + S*
Upper right corner restored; later borderline in black ink

PROVENANCE: Firmin-Didot Coll. (verso, collector's mark, Lugt 119); J. P. Heseltine Coll. (verso, collector's mark, Lugt 1507); Colnaghi, London; acquired in 1913

LIT.: *Catalogue des Dessins et Estampes composant la Collection de M. Ambroise Firmin-Didot,* Paris, Hotel Drouot, 4.16–5.12.1877, no. 41 – *Original Drawings Chiefly of the German School in the Collection of J. P. H.* (Heseltine) (London 1912), no. 31 – Lehrs 1914, no. 7 – Bock 1921, 77 – Rosenberg 1923, no. 21 – Baum 1948, 45 – Winzinger 1953, 30 – Winzinger 1962, no. 27 – Rosenberg 1965, 400 – Exh. cat. *Dürer* 1967, no. 2 – E. Starcky, in: Exh. cat. *Schongauer* Colmar 1991, no. D26 – T. Falk, in: Exh. cat. *Schongauer* Colmar 1991, 99 – Exh. cat. *Schongauer* Berlin 1991, ill. 68 – H. Mielke, in: *Handbuch Berliner Kupferstichkabinett* 1994, no. III.12 – Koreny 1996, 128ff., 139

This man, with his wide-eyed gaze, was apparently drawn from life, a theory also borne out by the bold but sure

strokes that model even the fine wrinkles on the forehead and around the eyes, as well as the stubbly beard. Every aspect appears to have been directly observed. Winzinger thought it possible that this could be a self-portrait but nothing vindicates this thesis. The assumption that the sheet is directly based on nature is also questionable, as it belongs to a group of related studies of heads whose similarity and recurring types do not suggest the representation of specific individuals. At issue are nine bust portraits of Orientals and young girls (Winzinger 1962, nos. 18–26; Exh. cat. *Schongauer* Colmar 1991, nos. D11–D13, D15, D18–D22). All these sheets, including the one in Berlin, have the same format and, with one exception, possess an old but false Schongauer monogram in black ink. Five sheets are in the Louvre; they come from the collection of Everhard Jabach, which was acquired by Louis XIV of France in 1671. Schongauer's monogram, which is identical on all drawings, must therefore date from before the separation of several sheets from the Jabach group, that is, before the middle of the seventeenth century. All the studies of heads, therefore, come from the same source, which, ultimately, must have been Schon-

7

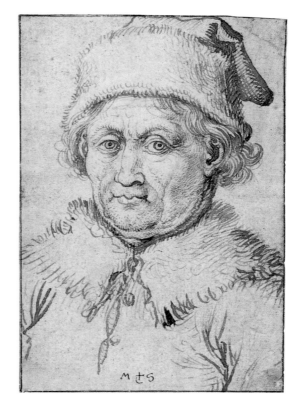

gauer's shop. Rosenberg knew only the two sheets in Basel (cat. 8) and Berlin. In 1953 Winzinger published the whole group and attempted to reconstruct their original condition. On the basis of an early copy in the Basel Kupferstichkabinett (Falk 1979, no. 53), which shows the same head used in a sheet in the Louvre (Winzinger 1962, no. 18) but which is combined with another study, he concluded that the heads were originally paired on larger sheets. He posited that these were variations after lost silverpoint works in a small sketchbook. Winzinger's thesis that these studies of heads were executed in Spain was hardly convincing.[1]

Despite the uniformity of the sheets in size, general appearance, and monogram, it is apparent that the Berlin *Man Wearing a Fur Hat* differs from the other heads. Whereas they appear to reflect the same scheme and type, the emphasis in the Berlin sheet lies much more decisively on the individual and portrait aspect. Koreny established convincingly that the execution of the Berlin drawing is superior to that of the others. The pen strokes are finer, more varied, and better able to convey the textures of fabrics (fur collar, fur hat!). Of all the sheets in this group, only the one in Berlin can be ascribed to Schongauer. The other heads must be workshop copies. Nevertheless, all the studies probably came from one and the same pattern book. For instance, similar physiognomies are encountered in a design for the composition of *The Judgment of Solomon,* which survives only in a copy in Weimar (Winzinger 1962, no. 73).

Hans Holbein the Elder, who was active one generation later than Schongauer, is one of the first artists whose portrait drawings are extant (cats. 31–39). Whether Schongauer's *Man Wearing a Fur Hat* also represents a specific person is difficult to tell. But when we pose the question, we should remember that we owe the earliest known plant studies produced north of the Alps to Schongauer.[2] H.B.

1. On the controversial Spanish journey of Schongauer, see F. Koreny, "Notes on Martin Schongauer," *Print Quarterly* 10 (1993), 385–391, 386; F. Anzelewsky, "Schongauer in Spanien?" in: Schongauer-Kolloquium 1991, 51–62.
2. Koreny 1991.

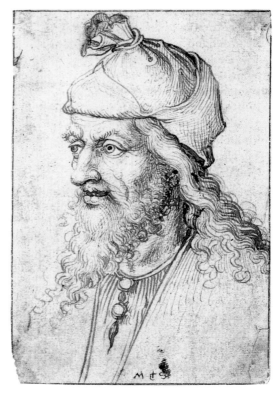

8

Workshop of Martin Schongauer
8 HEAD OF A BEARDED ORIENTAL, c. 1480 – 1490

Basel, Kupferstichkabinett, Inv. 1959.101
Pen and brown ink
104 x 69 mm
No watermark
Lower center, in a later hand, Schongauer's monogram in black ink *M + S*

PROVENANCE: Fr. Lippmann; Freiherr von Lanna Coll., Prague (verso, collector's mark, Lugt 2773); Gutekunst, Stuttgart, auction 67, II, 5.6.–5.11.1910 (Lanna Coll.), no. 502; Artaria, Vienna; Prince of Liechtenstein Coll., Vienna; Walter Feilchenfeldt, Zurich, 1949; gift of the CIBA AG Basel, 1959

LIT.: Schönbrunner/Meder, no. 1287 – Lehrs 1914, no. 23 – Rosenberg 1923, no. 18 – Baum 1948, 46 – Winzinger 1953, 30 – Schmidt 1959, 10 – Winzinger 1962, no. 21 – Rosenberg 1965, 400 – Hp. Landolt 1972, no. 9 – Falk 1979, no. 49 – A. Châtelet, in: Exh. cat. *Schongauer* Colmar 1991, no. D13 – Koreny 1996, 128ff.

This sheet belongs to a group of heads of Orientals and young girls (see cat. 7) that Winzinger first attributed to

Schongauer. In a review of Winzinger, Rosenberg (1965) expressed reservations about the attribution of this group to Schongauer and assigned only two drawings autograph status, the Berlin head (cat. 7) and the present Basel *Oriental*. Koreny was the first to reject all of these drawings—save the one in Berlin—as works by Schongauer. Whereas the *Man Wearing a Fur Hat* is distinguished by his individual and portraitlike features, the faces of the Orientals and girls look stereotypical and schematic.

The dynamic and pliant pen strokes of the Berlin head register all the material details (skin with creases, stubbly beard, fur hat, and so forth), whereas in the case of the other heads, the use of lines is more schematic and dry.

Schongauer normally used a system of finely modulating crosshatching that is reminiscent of his engravings. In the Basel head, however, the crosshatching lies schematically and flat on the neck and its nape, without endowing the rounded form of the neck with any plasticity. The draftsman of this sheet—and of the other busts—must have worked in Schongauer's shop: he emulated the Colmar master not only in the type of head but also in the style of drawing, though without being able to achieve his subtle strokes. Koreny correctly pointed out the close relationship between this study head and the heads of the Colmar Dominican altar from Schongauer's workshop.

H.B.

Workshop of Schongauer
9 SNAIL, SNAKE, LIZARD, AND FROG, c. 1495

Berlin, Kupferstichkabinett, KdZ 695
Pen and black ink; traces of green watercolor
217 x 184 mm
Watermark: upper center right (cut), cardinal's hat (similar to Briquet 3404, but brim width differs; same brim width and hat size are found in the tracing paper of Dürer's proportion study of a woman in the Hamburg Kunsthalle)[1]
Text in thicker pen and brown ink, inscribed in various directions; above the snail *den schnecken dy groß/vnd ander zwey ie einen/cleiner dan der andre*; to the right, next to the snail *an d[er] hornly/stat sol newrt/dy kolben gezagt/werden*; the long horns with eyes were crossed out with the same pen and dark feelers were applied directly to the head; above the snake *item dy schlang halb als/groß vnd darnach zwu/andre ie eine cleiner/dan dy ander*; below the snake *das maul umb ein/zwechenvinger offen*; above the lizard *item das edexlen dy groß vnd zwey/ander ie ein cleiner dan der ander*; below the lizard *item dy fuß auf/gensfus gemacht*; swimming webs indicated on all four feet with the same pen; below the frog *item der frosch auch dreij/vnd der grost halben wek/als groß als der/vnd/dy fus auch auf gensfus gem[acht]*; along the left edge *item dy poslen sollen alle gestracks*

sein nicht verpogen; on the right edge *XXVIIII wochen tragend frawen/zu lassen zu der habt oder auf/der rechten hant bej dem daumen*
Verso, inscribed by a later hand, *Burgkmair*
Trimmed irregularly on all sides; formerly folded twice (once horizontally, with drawn areas facing out, once vertically), with the frog on the outside of the sheet; this area heavily spotted in brown; lower left, on the edge, a trace of glue?; verso, upper left, traces of glue

PROVENANCE: Von Nagler Coll. (verso, lower left, estate stamp, Lugt 2529); acquired in 1835

LIT.: H. A. Schmid, in: *TB* 5 (1911), 252–258, esp. 255 – Rupé 1912, 65–67 – Bock 1921, 18, pl. 21 – E. Schilling, "Hans Burgkmair the Elder (1473–1531)," *Old Master Drawings* 11, 42 (September 1936), 36, n. 1 – Halm 1962, 153, n. 52 – F. Winzinger, "Unbekannte Zeichnungen Hans Burgkmairs d. Ä.," *Pantheon* 25 (1967), 12–19, esp. 14, n. 5 – T. Falk, "Naturstudien der Renaissance in Augsburg," *Jahrbuch der Kunsthistorischen Sammlungen in Wien* 82/83, n.s., 46/47 (1986/1987), 79–89, esp. 84, n. 18, ill. 74

Heinrich A. Schmid first drew attention to this drawing because he believed the frog corresponded to the one in Burgkmair's 1518 altar panel *St. John on the Island of Patmos,* in the Munich Alte Pinakothek.[2] Rupé saw additional proof for the original authorship of Burgkmair in the many handwritten notes. If, however, he had consulted the long inscriptions on the small washed pen drawings in which Burgkmair depicted himself first as fiancé, in 1497, and then as bridegroom, in 1498,[3] he could not have helped but notice that these are not by the same hand.

Burgkmair was an apprentice of Martin Schongauer in Colmar in 1488. He may have learned the style of pen drawing in Schongauer's shop—the precise execution of lines with the sharp quill, the delicacy of the ink strokes, and the elaboration of important passages with a broader pen, as well as the indication of a ground by shadows portrayed through small parallel strokes. These characteristics are also found in other drawings attributed to Burgkmair.[4]

These animal drawings were not executed after live models, as is revealed by the careful execution in pen and ink without any perceptible preparatory drawing in pencil. Judging from its posthorn-shaped house, the snail must be a so-called *teller* snail. That is to say, it is a kind of water snail that inhabits ponds and puddles and—unlike land snails that have a high, spiral house—has eyes without stalks and only two feelers. The confusion of the characteristics of land and water snails and the uncomprehending rendering of the body, which emerges from a horn wound counterclockwise, like a cornucopia, attest to a faulty observation of nature. Evidently the draftsman had

to make do with an empty snail house as a study object. He had a better model for the snake, whose characteristic, wormlike locomotion he captured in addition to the typical structure of the viper's head. The ornamental coiling of the front part of the body suggests that a dead animal served as a model. The detailed representation of the lifelike lizard is also hardly imaginable without study of a dead specimen. The drawn version looks remarkably emaciated, which suggests the use of a dried specimen of the type favored in folk medicine of the day. Although the scaled hide with its markings and the head with its protective horn plates are depicted correctly, as are the short, slightly spread legs with toes equipped with sharp talons, the number of the latter has been reduced, counter to nature, from five to three per foot. A dried animal must also have served as model for the slightly collapsed frog. The artist then combined his observations in the present finished drawing. That he must necessarily have been Burgkmair was already doubted in 1986/1987 by Tilman Falk.

Rupé viewed the drawing as student work that was corrected and annotated by the master. The inscriptions read, in sentence form:

Snail:

The snail in this size / and two others one / smaller than the other.

Instead of the horns / only the places into which the horns are attached should be shown.

Snake:

In addition the snake half / as big and then two / others one smaller / than the other.

The mouth opened a finger width.

Lizard:

Similarly the lizard in this size and two / others one smaller than the other.

Also the feet like goose feet (with webbing).

Frog:

The same with the frog, also three (frogs) / and the largest half as large as this one and / the feet again like goose feet.

To the left, in the margin:

In addition the animals should have the right shape and not be deformed.

To the right, in the margin:

to be placed on the head of a 29-week pregnant woman, or on / the right hand at the thumb.

The notations were probably by a goldsmith, who eliminated the details that were not useful for a plastic conversion and who recorded his arrangement with the patron. While the notation on the left margin refers to the correct execution of the models, the right one refers to the finished product, amulets.[5] The Alemannic dialect of the writer and the style customary in Schongauer's shop point to a genesis of the sheet on the Upper Rhine in the circle of Martin Schongauer and his three goldsmith brothers, Caspar, Paul, and Jörg.

The Frits Lugt Collection of the Institut Néerlandais in Paris has a study sheet with four animals (lizard, butterfly, and two frogs) and a metal knob.[6] It is drawn in pen and dark brown ink. The frogs depicted on the Paris and Berlin drawings look very much alike, although the two drawings can hardly be by the same hand, suggesting a common origin in the same workshop. The monogram of Dürer, added in different ink to the Paris sheet, prompted the perusal of his work for depictions of frogs. These actually exist in two variants in both drawings of *The Virgin with a Multitude of Animals,* in Vienna[7] and Paris.[8] In addition, Dürer drew a frog in 1513, as illustration to Willibald Pirckheimer's Latin *Horus-Apollo* translation.[9] Its form reveals that it derives from the same Upper Rhenish workshop tradition in which the Berlin sheet is also rooted. R.K.

1. E. Schaar, *Master Drawings* 4 (1996).

2. The frog in the Munich panel is seen from a higher angle than in the Berlin drawing, with the result that the shanks of both retracted hind legs are visible, as on a study sheet in the Frits Lugt Collection in the Institut Néerlandais in Paris, which comes from Dürer's circle (see note 6). In no. 47 of his book *Albrecht Dürer und die Tier- und Pflanzenstudien der Renaissance* (Munich 1985), which has Hoffmann's *Hare Surrounded by Flowers* as its subject, Koreny refers to a detail study, a frog by Hoffmann in the graphic collection of the Museum für Bildende Kunst in Budapest. According to Koreny, it is "combined in this sheet with lizards and snakes, precisely as in the aforementioned St. John altar of Burgkmair, the frog of which—in a remarkable coincidence— it resembles to an astonishing degree." If one follows G. Goldmann ("Münchner Aspekte der Dürer-Renaissance unter besonderer Berücksichtigung von Dürers Tier- und Pflanzenstudien," *Jahrbuch der Kunsthistorischen Sammlungen in Wien* 82/83, n.s., 46/47 [1986/1987], 179–188), the frog on Burgkmair's altar panel is an addition of the time of the Dürer-Renaissance, with Burgkmair having painted only three birds and the lizard.

3. Formerly, Kunstsammlung des Benediktinerstiftes Seitenstetten/ Niederösterreich, today Vienna, Graphische Sammlung Albertina, inv. no. 3127/28, 157 x 73 and 154 x 74 mm; first published by H. Röttinger, "Burgkmair im Hochzeitskleide," *Münchner Jahrbuch der bildenden Kunst* 3 (1908), part 2: 48–52.

4. For example, *Soothsaying Gypsy and Market Woman,* Stockholm, Nationalmuseum, inv. no. NM 132/1918, pen and almost black ink, 215 x 318 mm.

5. Snails were treasured as animals that protect against the evil eye. Snakes—dried, pulverized, or burned to ashes—played a role in the treatment of eye diseases, as did their shed skins. A snake skin, placed on or bound around the body of a woman giving birth, was supposed to ease labor. In Germany and France lizards had a reputation as bearers of good fortune. Frogs were considered to be creatures of the devil, and, in dried state or as an amulet in the shape of a frog, could deflect all evil from the wearer. They also played a major role in gynecology. In 1659 midwives were still instructed in the church statutes of Hanau not to use toad benedictions to ease labor. In the Middle Ages people believed the womb was an independent creature, which could move about in the human body. In southern Germany, the Alpine lands, and in Alsace, the womb was thought to be a toad that could bite, scratch, and hit while traveling about in the body of its victim. The afflicted women sought a cure at pilgrimage centers and, if successful, in Old Bavaria and Austria, donated a silver or wax toad. In Alsace barren women used to bring an iron toad to the St. Vitus Chapel near Zabern on St. Vitus' Day, 16 June. See *Handwörterbuch des deutschen Aberglaubens,* Ed. H. Bächthold-Stäubli, with E. Hoffmann-Krayer et al., 10 vols. (Berlin and Leipzig 1927–1942).

6. Strauss 1974, no. 1494/8; F. Winzinger, Review of W. L. Strauss' "The Complete Drawings of Albrecht Dürer," *Pantheon* 39, 4 (1981), 372–374, esp. 372; F. Anzelewsky, "Pflanzen und Tiere im Werk Dürers. Naturstudien und Symbolik," *Jahrbuch der Kunsthistorischen Sammlungen in Wien* 82–83, n.s., 46/47 (1986/1987), 33–42, esp. 34f., ill. 25; K. G. Boon, *The Netherlandish and German Drawings of the XVth and XVIth Centuries of the Frits Lugt Collection,* 3 vols. (Paris 1992), 1: 485f., no. 281; 3: pl. 302 (school of Dürer).

7. Vienna, Albertina, inv. 3066 (D 50): frog in the lower right corner, turned to the left. Compare to Strauss 1974, no. 1503/22; F. Koreny 1985, 114, no. 35 with color ill.

8. Paris, Musée du Louvre, inv. 18603, dated 1503: frog in the lower right corner, turned to the right. Compare Strauss 1974, no. 1503/23; Exh. cat. *Dessins Renaissance germanique* 1991, no. 38.

9. Nuremberg, Germanisches Nationalmuseum, Hz 5494. Compare *Kataloge des Germanischen Nationalmuseums Nürnberg. Die deutschen Handzeichnungen,* Vol. 1: *Die Handzeichnungen bis zur Mitte des 16. Jahrhunderts,* Ed. F. Zink (Nuremberg 1968), no. 61, ill. on 85; Strauss 1974, no. 1513/12.

LUDWIG SCHONGAUER
(Colmar? c. 1450–1494 Colmar)

Painter, engraver, and draftsman. Artistically dependent on his more famous brother, Martin Schongauer. Almost nothing is known about his origins, life, and work. Possible apprenticeship with Caspar Isenmann in Colmar; first mentioned in 1479 in Ulm, where he obtained citizenship and married. Member of the painter's guild in Augsburg in 1486; took over Martin's shop in Colmar after his death in 1491. It is doubtful that he was trained as a goldsmith and engraver, as was his brother: we know of only four monogrammed engravings that have survived in unique impressions; moreover, the handling of the burin is to all appearances schematic and unpracticed. The scope of his drawn work is also very small. There is still widespread disagreement about the nature of his painted oeuvre.

10 RECLINING STAG, C. 1490

Basel, Kupferstichkabinett, U.VIII.98
Pen and brown ink over preparatory drawing in light brown ink
145 x 104 mm
No watermark
Inscribed, upper right, in Basilius Amerbach's hand *Antiq. inon.*

PROVENANCE: Amerbach-Kabinett

LIT.: Burckhardt 1888, 84 – Falk 1979, no. 42 – A. Châtelet, in: Exh. cat. *Schongauer* Colmar 1991, no. L5 – C. Müller, in: Exh. cat. *Amerbach* 1991, *Zeichnungen,* no. 11 – D. Müller, "Zur Ludwig Schongauer-Problematik," in Schongauer-Kolloquium 1991, 307–314, esp. 310, n. 21 – Koreny 1996, 144

The major portion of Ludwig Schongauer's body of drawings, which was first reconstructed by Daniel Burckhardt, is found in the Basel Kupferstichkabinett (Falk 1979, nos. 38–45, probably also nos. 46–48). Of the additional attributions to the artist, the drawing, published by Winzinger, *Wild People on Horseback* in St. Petersburg is convincing.[1] The present sheet is closely related to Ludwig's engravings, especially his *Reclining Cow* (Lehrs 2; see ill.). Comparable are the emphasis on outline as well as the manner of modeling with parallel strokes and crosshatching. In the engraved work, because of the more unyielding material, these lines are harder and more schematic, while in the pen drawing they are delicate and elastic. Also characteristic of both works is the rendering of the animal's forehead, with its seemingly human eyes. There is no need to doubt the attribution of this drawing to the same artist respon-

10

Ludwig Schongauer, *Reclining Cow,* c. 1490

sible for the engravings. Basilius Amerbach, through his inscription *Antiq. inon.* (anonymous old master), grouped the Basel works together. The ubiquitously recognizable preliminary sketching in mostly bright, reddish brown ink is also a characteristic feature of Ludwig's mode of drawing.

Falk pointed out the great similarity to representations of reclining stags on mid-fifteenth-century printed playing cards by the Master of the Playing Cards; a virtually identical animal, which also turns its head, is reproduced in stag-three, stag-four, and stag-nine.[2] The drawing is therefore not a nature study but a pattern-book-like depiction derived from the pictorial tradition. Certainly the partially erased lines that are visible on the head and the antlers establish that Ludwig Schongauer did not copy his model slavishly but tried to arrive at his own formal solution. He further breathed life into this traditional motif with his subtle representation of the animal skin's texture, which he achieved with a varied handling of the pen. H.B.

1. F. Winzinger, "Altdeutsche Meisterzeichnungen aus sowjetrussi-schen Sammlungen," *Pantheon* 34 (1976), 102–108, esp. 104ff.; J. I. Kusnezow, Exh. cat. *Zeichnungen aus der Ermitage zu Leningrad. Werke des XV. bis XIX. Jahrhunderts,* Kupferstichkabinett der Staatlichen Museen (Berlin [Ost] 1975), no. 5; A. Châtelet, in: Exh. cat. *Schongauer* Colmar 1991, no. L3.

2. M. Geisberg, *Das älteste gestochene deutsche Kartenspiel* (Strassburg 1905), pl. 9, pl. 11; M. Geisberg, *Die Anfänge des Kupferstiches,* Meister der Graphik 2 (Leipzig 1923), pl. 2.

11 STUDIES FOR THE CRUCIFIXION OF CHRIST, c. 1490

Basel, Kupferstichkabinett, U.VIII.22/23 (= U.XVI.10)
Pen and black ink over a preparatory drawing in gray ink (left half) and brown ink (right half)
212 x 297 mm
No watermark
Two sections joined together; c. 3 mm of the left sheet glued over the blank margin of the right sheet

PROVENANCE: Amerbach-Kabinett

LIT.: Burckhardt 1888, 45ff. – C. Glaser, *Hans Holbein der Ältere* [Kunstgeschichtliche Monographien, 11] (Leipzig 1908), 167, 187, no. 3 – K. Bauch, "Dürers Lehrjahre," *Städel-Jahrbuch* 7–8 (1932), 80–115, esp. 104ff. – P. Rose, "Wolf Huber and the Iconography of the Raising of the Cross," *Print Review* 5 (1976) [Tribute to Wolfgang Stechow], 131–141, esp. 133ff. – Falk 1979, no. 44 – A. Châtelet, in: Exh. cat. *Schongauer* Colmar 1991, no. L2 – C. Müller, in: Exh. cat. *Amerbach* 1991, *Zeichnungen,* no. 12 – Koreny 1996, 144 – H. van Os, "Mediteren op Golgotha. 'O devote siele slaet dyn gemerck hierop dinen bruidegom,'" *Bulletin van het Rijksmuseum* 44 (1996), 361–380, esp. 370ff.

The Gospels tell only of the Crucifixion, not of the events that preceded it after Christ had carried the cross to the hill of Golgotha. In the late Middle Ages the need arose to represent these last stations of the cross, which believers wished to emulate inwardly in the sense of an *imitatio*

Ludwig Schongauer, *Descent from the Cross,* c. 1490

II

Christi (the imitation of Christ). For instance, the course of Christ's Passion was expanded with pictures showing the preparations for the Crucifixion and the nailing of Christ to the cross. The motif of the preparations for the Crucifixion was often bound up with the contemplative theme of the "Christ in Repose," in which Christ, stripped and deserted, is seated on the cross (see cat. 164). The present drawing shows him in this way. All around Christ, however, the preparations for the Crucifixion and Raising of the Cross are taking place. One man drills holes in the crossbeam; another sinks a pickax into the earth to prepare a hole into which the base of the cross can be sunk. Soldiers gamble for Christ's cloak (this scene, mentioned in the Bible, was normally depicted with the Crucifixion), soldiers and Jewish scribes observe events, and to the right, on horseback, Pontius Pilate dictates the text for the cross' mocking inscription to a seated scribe. In the midst of Christ's enemies appear the only ones to partake in the sorrow of the Lord: the holy women, with Mary and St. John.

The blank central strip, which divides the depiction into two complementary halves, indicates that this is a design for the outer panels of an altar. It is the closed position of the side wings that is depicted. The central panel of the opened altarpiece may well have been a Crucifixion. For instance, a point of comparison is offered by a triptych of about 1520 by the Dutchman Cornelis Engebrechtsz., which has a multifigured Calvary on its center panel, while the outer wings in the closed position depict the preparations for the Crucifixion.[1]

The strong Schongauer-like elements of the drawing have always been pointed out: these include both the figure types as well as the construction of the composition, which is reminiscent of Martin Schongauer's engraving, *Carrying of the Cross* (Lehrs 9). The sheet was therefore attributed to the artist from the Upper Rhine himself or to his immediate circle. Glaser proposed that the author was Hans Holbein the Elder, possibly basing his work upon a design by Martin Schongauer. Burckhardt, Bauch, and Rose suspected that a panel with a lost Passion cycle by Martin served as the model. Falk was the first to ascribe the imposing sheet to Martin's brother, Ludwig Schongauer. In this artist's graphic oeuvre, which consists primarily of depictions of animals (Kupferstichkabinett Basel; Falk 1979, nos. 40–45), this piece is an exception by virtue of its large size and religious theme. Nonetheless the attribution is convincing. The Basel animal drawings as well as the *Studies for the Crucifixion of Christ* are distinguished by a similar fine-lined preparatory sketch in

bright, reddish-brown ink, a hue noticeably different from that of the final execution. In the proportions of the figures, the types of the heads, as well as the structure of the drapery folds, there are close correspondences to the *Descent from the Cross* (see ill.), one of a group of four engravings monogrammed by Ludwig Schongauer (Lehrs 1; Exh. cat. *Schongauer* Colmar 1991, no. L1). The same inflexible, somewhat stark crosshatched areas that are characteristic for Ludwig's engraving technique are also found in the tights of the soldiers gambling for Christ's cloak. Finally, the close confines and overlapping structure of the image and its figure types invite comparison with two panels from a Passion cycle in the Metropolitan Museum of Art, New York, which Koreny recently attributed provisorily to Ludwig Schongauer (Koreny 1996, 145, ill. 39f.). The Basel drawing *Studies for the Crucifixion of Christ* may serve as a key work for further attributions to Martin Schongauer's unknown brother. H.B.

1. Compare to J. P. Filedt Kok, "Over de Calvarieberg: Albrecht Dürer in Leiden, omstreeks 1520," *Bulletin van het Rijksmuseum* 44 (1996), 335–359, esp. 348, ill. 17f.

ANONYMOUS UPPER RHINE

12 WILD WOMAN AND A LADY WITH
UNICORNS, LATE 15TH CENTURY

Basel, Kupferstichkabinett, U.VIII.77
Pen and brown ink
197 x 288 mm
No watermark
Paper foxed

PROVENANCE: Amerbach-Kabinett

LIT.: Burckhardt 1888, 84, n. 1 (as Ludwig Schongauer) – *Handz.
Schweizer. Meister* 3, no. 46a (detail; text by E. v. Meyenburg) –
Bock 1921, 68 – Lehrs, 6, 69 – Parker 1928, no. 19 (detail) –
J. Mathey, *Bildnis und Gestalt der Frau in Meisterzeichnungen aus
fünf Jahrhunderten* (Frankfurt 1936), II: no. 17 – Hp. Landolt
1972, no. 11 – R.R. Beer, *Einhorn, Fabelwelt und Wirklichkeit*
(Munich 1972), 143f. – Falk 1979, no. 79 – Exh. cat. *Amerbach
1991, Zeichnungen*, no. 18 – J.W. Einhorn, *Spiritalis unicornis: Das
Einhorn als Bedeutungsträger in Literatur und Kunst des Mittelalters*,
2d ed. (Munich 1998), 430, no. 134

The two depictions in this drawing represent a theme
that enjoyed great popularity in the Upper Rhine region:
the subduing, taming, and control of animals. Such works
belong to the pictorial category of late medieval allegories
of love, and found a response not only in literature but
also in virtually every aspect of the applied arts. The
fifteenth-century tapestries from the same region as our
drawing are probably the best-known examples of this
genre.[1] The unicorn was a frequently depicted wild ani-
mal, whose popularity was also due to the Christian inter-
pretation of a fable, with Oriental roots, which claimed
that the animal could only be captured in the lap of a
virgin. This scene was interpreted in the Physiologus as
a reference to the Immaculate Conception of the Virgin.[2]

The moralizing undertones that are apparent from the
inscriptions of numerous examples of the fifteenth century
establish that the taming of wild animals was seen as an
emblem of the self-control of man, who must constantly
strive to restrain his passions. Such emblems provided a
model of conduct that goes back to the love poetry of
the Middle Ages.

It is not really possible to draw a distinction, as Lan-
dolt (1972) proposed, between the positive and negative
morals of the two women depicted in our drawing. We
may assume that both women are pure, and, following
the legend, the animal could approach or nestle in the
lap of either one. The girl's nudity is related to depictions
of wild people, who kept body and soul together in the
forest. These beings do not always have a densely haired

body; they can also be nude or only slightly hairy.[3] Nor
should they necessarily be interpreted negatively as, for
instance, unruly nature demons. On numerous tapestries
of the Upper Rhine and on the so-called love chests
of this time, wild people were idealized and rendered
as human beings who retain their original purity precisely
through their remoteness from the world. They conduct
their life in the wilderness following courtly decorum
or else they, like peasants, perform rural tasks.[4] Both
depictions in our drawing may therefore represent a single
theme. The garbed woman may represent patrons who
purchased such works of art and furnished their homes
with them.

The erotic content of the unicorn scenes is not at
all contradictory to the original theme of virginity, as the
taming of the wildness of the masculine animal and the
self-control of the woman did not aim at virginity, but
at marital fidelity. Paradoxically, fifteenth-century depic-
tions of courtly love complain about marital fidelity
because love and marriage were originally thought to
be mutually exclusive.

On the one hand, the tightly outlined indications
of the terrain and the rocks on which the women sit may
be related to the habitat of wild animals and wild people:
the forest, the wilderness, the wasteland, the uncivilized
land. They are beautiful and terrible at the same time, and
always stand in contradiction to the civilized world, which
people sought to escape. On the other hand, the vignette-
like quality of these two images and the use of ornaments
in the left depiction indicate that they are pattern-book-
like formulations of symbolic subjects, which could be
included in different contexts, and which therein through
inscriptions or contrasts might acquire a specific meaning.

Although the drawing is reminiscent of works by
Ludwig Schongauer in the delicacy of its thin preparatory
contours and the concomitant accentuation of the outlines
(see cats. 10, 11), it is nevertheless by another artist, one
active in the circle of Ludwig and Martin Schongauer.
The nude young woman constitutes a motif that can be
related to Martin Schongauer's engraving of wild women
(Lehrs 99). C.M.

1. Timothy Husband, with the assistance of Gloria Gilmore-House,
Exh. cat. *The Wild Man, Medieval Myth and Symbolism,* The Cloisters,
The Metropolitan Museum of Art (New York 1980), esp. no. 15. For
an overview of depictions of unicorns in various contexts, see J. W.
Einhorn 1998, 387ff. For the Minnedarstellungen, see Christian Müller,
*Studien zur Darstellung und Funktion wilder Natur in deutschen Minnedar-
stellungen des 15. Jahrhunderts,* Ph.D. diss. (Tübingen 1981), (Karlsruhe
1982), esp. 24–35. On the tapestries, A. Rapp and M. Stucky Schürer,

12

Exh. cat. *Zahm und wild. Basler und Strassburger Bildteppiche des 15. Jahr-hunderts.* Historisches Museum Basel (Mainz 1990), nos. 19–21, 25, 49, 65, 73, and 75.

 2. J. W. Einhorn 1998, 63ff.

 3. See Husband, with Gilmore-House 1980, nos. 27, 37.

 4. On wild people, Richard Bernheimer, *Wild Men in the Middle Ages* (Cambridge 1952), esp. 121–175. Husband, with Gilmore-House 1980, esp. nos. 27, 30, and 31. See also Christian Müller, "Wilde Män-ner, wilde Frauen," *Lexikon der Kunst,* vol. 7 (Leipzig 1994), 802–803. See also Rapp and Stucky-Schürer 1990.

MASTER OF THE DRAPERY STUDIES

(active in Strassburg c. 1485–1500)

Collective name for the creator of the largest surviving collection of late Gothic workshop drawings from north of the Alps, about 120 sheets, many of which are in the Berlin Kupferstichkabinett. A second name, Master of the Coburg Roundels, was coined after window designs that are mainly kept at the Veste Coburg. The drawings origi-nated in the circle of the stained glass workshop of Peter Hemmel von Andlau, about 1485–1500.

13 WINGED ALTAR WITH THE VIRGIN CROWNED BY ANGELS, AND SAINTS, c. 1485/1490

Verso: design for the lower edge of a frame for a winged altar, c. 1485/1490
Berlin, Kupferstichkabinett, KdZ 1203
Recto, pen and brown ink with traces of black pencil; verso, pen and brown ink with black pencil
255 x 264/270 (irregularly cut)
Watermark: crowned coat of arms with lilies
(not in Briquet)
Various inscriptions by the artist *ein halp buoch uff die flogel / IX span hoch / III dieff / ein span hoch / acht wit*; by a later hand, Dürer's monogram (subsequently erased) *AD*

PROVENANCE: acquired in 1880 from A.W. Thibaudeau, London

LIT.: F. Lippmann, "Amtliche Berichte aus den Königlichen Kunstsammlungen," in: *Jb. preuss. Kunstslg.* 1 (1880), 49 – Lippmann 1882, no. 101 – *Zeichnungen* 1910, no. 134 – Bock 1921, 91 – Huth 1923, 47ff., 94 – F. Winkler, "Skizzenbücher eines unbekannten rheinischen Meisters um 1500," *Wallraf-Richartz-Jahrbuch,* n.s., 1 (1930), 137ff., 150 – Roth 1988, no. 79 – Roth in: Exh. cat. *Bilder aus Licht und Farbe* 1995, no. 66

In the late Middle Ages, painting and wood sculpture played an important role in the execution of elaborate altarpieces, which served as part of church furnishings. Sculpture and painting workshops often worked hand in hand on such projects. A few surviving altar designs provide an indication of the nature and manner of prepa-ration of such works (see also cat. 14). The present pen drawing shows a so-called triptych, a tripartite altar. The Madonna, crowned by angels, and the child are enthroned in the middle of the shrine. The three-dimensional con-ception of the figures, which are located behind an ogive decorated with Gothic tracery, and the perspective lines

13

indicate that this group was meant to be sculpted. The frame, the shrine, and the wings of the panel painting are depicted in lesser detail: on the left wing, several male saints including the apostles Peter and Paul in the foreground; on the right wing, an outline of St. Catherine. Inscriptions indicate the dimensions in height, width, and depth: the center shrine measures, in *Spannen* (an old unit, about one hand length, or "as far as the hand reaches"), nine high, three deep, and eight wide, with the predella (base) one span high. The unit of measurement used for the wings, which must be as high but only half as wide as the center section, is not clear.

The altar design, which Lippmann, Bock, and Winkler initially classified as a work from the Lower Rhine region, belongs to an expansive compendium of drawings from an Upper Rhenish workshop that Anzelewsky and Roth placed close to the glass painting workshop of Peter Hemmel von Andlau.[1] This collection of drawings is predominated by models for domestic windows, studies of drapery segments, and studies for prints, paintings, and sculptures, but it also includes, as here, some altar designs. The Berlin drawing has long been considered a typical design for an altar, especially because of the precise dimensions that are indicated. Roth pointed to typical elements of Ulm altar architecture of the late Middle Ages, and he assumed that the present sheet is a copy of a finished, possibly Ulm, model sheet. It is in any case difficult, given the period in question, to distinguish between traditional, imitative appropriations of form and independent new designs. The boundaries between these two kinds of artistic endeavor are often in flux, for even a composition taken over from another hand served the function of creating a new pictorial work, which would generally deviate from the prototype in some way or another. H.B.

1. Anzelewsky, "Peter Hemmel und der Meister der Gewandstudien," in: *Zs. Dt. Ver. F. Kwiss.*, 18 (1964); Roth in: Exh. cat. *Bilder aus Licht und Farbe* 1995.

ANONYMOUS UPPER RHINE

14 DESIGN FOR AN ALTARPIECE, C. 1500

Basel, Kupferstichkabinett, U.III.1
Pen and dark brown ink; dark brown wash over chalk; altar interior, yellow wash applied in places
626 x 299 mm (center panel)
268 x 158 mm (left wing)
269 x 155 mm (right wing)
Watermark: four small bulls' heads with tau cross (according to T. Falk, similar to Piccard 1966, X, 406; Constance, Überlingen, et al. 1497–99)
Center section with shrine, predella, and projecting side frame cut out and pasted on the support; three pieces, the lower (predella) and the upper piece, from the shoulders of Christ, attached; drawings of wings attached so that they can be opened and closed
Tears and holes; oil and paint stains and foxing

PROVENANCE: old inventory, presumably Amerbach-Kabinett

LIT.: Meder 1919, 334 – H. Huth, *Künstler und Werkstatt der Spätgotik* (Augsburg 1923), 45 – Perseke 1941, 218ff. – Falk 1979, no. 85

This design depicting a winged altarpiece[1] was, for the most part, drawn freehand; a straightedge was used only in the area of the shrine and in the projecting side frame. The altar consists of a shrine, which was intended to hold fully sculpted figures; a predella, on which the cupboard-shaped shrine stands; two hinged wings; as well as an elaborate frame that flanks the shrine. A pictorial, painted decoration may have been planned for the backs of the shrine and the predella. The retable, which stands on the altar, could be opened or closed according to the requirements of the church calendar—that is, the church feasts—so that one may speak of a feast-day side or a workday side. During Lent, or the time of Christ's Passion, the retable was usually kept closed. Proceeding inward, the painterly richness of the depictions, including a greater amount of gilding, increased, as did their plasticity, which progressed from painting to low relief, or a combination of the two media, to the nearly freestanding sculpture in the shrine. In this way, we should think of the Annunciation to the Virgin on the exterior of the wings as a painting, whereas we assume that the interior with the apostles is in relief. The yellow wash visible there indicates that the area was intended to be gilded. In such a pictorial ensemble, various artists participated, including those who also found frequent employment in creating the accoutrements of a late Gothic church, from its choir benches down to the housing for the Sacrament, pulpit,

14 Closed

14 Open

epitaphs, wall paintings, and glass paintings. The altar is therefore a work to which craftsmen from distinct guilds—painter, sculptor, joiner, and locksmith—contributed.[2] The contract between patron and workshop was usually signed by the painter, who took responsibility for the execution of the work right up to its completion; occasionally, however, arrangements were made between the patron and individual craftsmen. The bases for the execution were renderings, that is, designs or plans, that captured both the iconographic program and the form of the structure. The contracts specified the material to be used—gold leaf, paints, and pigments.

The sketchlike quality of our drawing could indicate that it represents some stage of the design process, possibly one that first laid down the combined structure and the iconographic program. There may have been additional designs—ones that were more detailed and that, for instance, also indicated the colors of the paintings (see cat. 30)—but this need not necessarily have been the case, as these items could have been part of the contract. The themes of the retable are the Incarnation of Christ and his Passion: Christ as Man of Sorrows and *Vera Icon*. The interior centers on the prophets and emulators of Christ's life and Passion, namely Sts. Vincent and Lawrence, who were worshiped like siblings, and, in the center, most probably, St. Ulrich as principal patron.

On the basis of the figure types and style of drawing, it is generally assumed that the design originated in the Upper Rhine, or else near the Lake Constance region. Thus far, an actual retable that corresponds to this design has not been identified. With the identification of the central saint as Ulrich of Zell, as proposed here, a localization on the Upper Rhine becomes even more compelling. The retable may have been intended for the no-longer extant church of St. Ulrich, located to the south of Freiburg im Breisgau, where the bones of the saint were preserved, or for a church in the immediate area of influence of the nearby Cluniac priory. The workshop may have been located in Freiburg im Breisgau, in Strassburg, or in Basel. St. Ulrich of Zell,[3] who was born in Regensburg in 1029 and died in the priorate named after him in 1093, became archdeacon and provost of Freising in 1045, and Cluniac monk and priest in 1061. He later became prior of the Cluniac establishment in Grüningen and in 1087 he founded the Cluniac priory of St. Ulrich, in the Black Forest. He compiled the *Consuetudines Cluniacenses*, a work alluded to by the book he holds as his attribute. He is said to have blessed and healed a lame boy, represented here by the lad kneeling at the saint's feet with a snake wound about his neck as an expression of his illness.

Depictions of the saint blessing or healing a boy are encountered in the parish church of St. Ulrich (eighteenth century)[4] and in the retable of the St. Jodocus chapel in Galgenen (Switzerland, Kanton Schyz, fifteenth century).[5] Both the attributes and the raiment, which could point to a member of the Benedictine order (an abbot?), vouch for the identity of the saint. C.M.

1. With the wings closed, the altar shows The Annunciation to the Virgin, divided between the two wings; with opened wings, in the shrine, under the tracery baldachin, Sts. Vincent (left), Lawrence (right), and Ulrich of Zell (center); on the left wing, St. Andrew and John the Baptist; on the right wing, Sts. Thomas(?) and Bartholomew; in the projecting frame, Christ as Man of Sorrows; on the predella, the sudarium displayed by two angels.

2. See Michael Baxandall, *The Limestone Sculptures of Renaissance Germany* (New Haven and London 1980), 1–163; Astrid von Beckerath, Marc Antoni Nay, Hans Rutishauser, eds., *Spätgotische Flügelaltäre in Graubünden und im Fürstentum Liechtenstein* (Chur 1998), esp. 45–56, 127–136; Lucas Heinrich Wütrich, "Ein Altar des ehemaligen Klosters Sankt Maria Magdalena in Basel, Interpretation des Arbeitsvertrags von 1518 und Rekonstruktionsversuch," *ZAK* 35, 1978, 108–119.

3. A. Zimmermann, "Ulrich von Zell," *Lexikon für Theologie und Kirche,* vol. 10 (1938), cols. 370–371; L. Schütz, *Lexikon für Theologie und Kirche,* vol. 8 (1976), col. 511.

4. *Die Kunstdenkmäler des Grossherzogtums Baden,* Frans Xaver Kraus, ed., vol. 7 (1904), 448–460; 452, ill. 186.

5. Linus Birchler, *Die Kunstdenkmäler des Kantons Schwyz,* vol. 1 (Basel 1927), ill. 391.

MASTER OF THE HOUSEBOOK
Master of the Amsterdam Cabinet and Master of the Genre Scenes of the Housebook

(active in the Middle Rhine c. 1470–1500)

Collective name for two or more artists who contributed to the so-called Housebook, an illustrated manuscript depicting planetary children, courtly genre scenes, and war implements. It is now in the possession of the Counts of Waldburg-Wolfegg. One master was once considered the creator of all drawings in the Housebook; also attributed to that artist were eighty-nine drypoint engravings, the earliest in this technique; various panel paintings; stained glass; miniatures; woodcuts; as well as drawings. Based on the stylistically related woodcuts in Bernhard von Breydenbach's *Peregrinationes in Terram Sanctam* (Mainz 1486), the Housebook Master was long identified with the painter and wood engraver Erhard Reuwich of Mainz.

At present the work of at least two hands has been identified in the Housebook: 1. Master of the Amsterdam Cabinet—named after rare drypoint engravings, almost all of which are in the Rijksprentenkabinet of the Rijksmuseum, Amsterdam—who was also responsible for three of the images of planetary children (Mars, Sol, Luna) in the Housebook, as well as for the silverpoint drawings in Berlin (cat. 15) and Leipzig; 2. Master of the Genre Scenes, who created the remaining planetary children, the numerous genre scenes in the Housebook, as well as sundry miniatures and drawings, including the Berlin sheet with events from Maximilian's imprisonment in Bruges (cat. 17).

Paintings and stained glass once considered works of the Housebook Master are now attributed to other artists in his circle. Leaving aside the fine distinctions between the works of the Master of the Amsterdam Cabinet and those of the Master of the Genre Scenes, it may be maintained that both artists must have been active around the Middle Rhine, in the area of Mainz/Heidelberg, and certainly in a courtly atmosphere. The uniting element, moreover, is a predilection for the rendering of courtly life and its values. Despite the outstanding quality of their work, however, the personalities behind it remain a mystery. Positioned outside the development of the systematic engraving, the drypoint engravings of the first of the two masters are truly testimony of an unconventional artistic effort (perhaps by a dilettante-courtier) that fascinated Albrecht Dürer, among others.

Master of the Amsterdam Cabinet
15 STANDING LOVERS, c. 1480–1485

Berlin, Kupferstichkabinett, KdZ 735
Silverpoint over lead or lead-tin point on thinly prepared white paper
195 x 135 mm
No watermark
Inscribed *1342* in the upper right by another hand in gray metalpoint; upper middle *297* in red ink

PROVENANCE: Matthäus Merian the Younger Coll. (red numbering *297* upper middle, by the same hand); Friedrich Wilhelm I. Coll. (verso, collector's mark, Lugt 1631)

LIT.: Lippmann 1882, no. 51 – M. Lehrs, "Bilder und Zeichnungen vom Meister des Hausbuches," *Jb. preuss. Kunstslg.* 20 (1899), 173–182, esp. 180 – Bossert/Storck 1912, 45 – Bock 1921, 71 – Count of Solms-Laubach 1935/1936, 42ff. – K. H. Mehnert, Ihle/Mehnert 1972, with no. 31 – Dreyer 1982, no. 3 – J. P. Filedt Kok, in: Exh. cat. *Hausbuchmeister* 1985, no. 121 – K. H. Mehnert, *Museum der bildenden Künste Leipzig. Meisterzeichnungen* (Leipzig 1990), with no. 1 – H. Bevers, in: *Handbuch Berliner Kupferstichkabinett* 1994, no. III.20 – Hess 1994, 24ff., 143, no. 3 – D. Hess, *Das Gothaer Liebespaar. Ein ungleiches Paar im Gewand höfischer Minne,* [Fischer Kunststück] (Frankfurt am Main 1996), 36ff. – König in: *The Medieval Housebook* 1997, 196ff.

This youth, with his handsome tresses and elegant, courtly dress, turns lovingly to his lady, who is also beautifully turned out. While he boldly looks at her, she directs her glance modestly downward. It seems as if the young woman is about to hand the man his feathered hat, possibly as a lover's gift, a symbol of her affection and fidelity. The motifs of the sheet show close correspondences to those of certain drypoint engravings by the Master of the Housebook, above all to his depiction of a seated pair of lovers (Lehrs 75; see ill.), as well as to the bust portrait *Gothaer Lovers,* the only known painting by this artist (Hess 1996). As Moxey and Hess have shown,[1] the sweet, lyrical mood of his love scenes is in the High Medieval tradition of the ideal of courtly love, which was again taken up by the nobility at the close of the Middle Ages. We could put forward models for the pictorial type of our drawing in medieval manuscripts, for example, illuminations in the *Manessische Liederhandschrift* (Heidelberg University Library), a collection of love songs from the years 1315 to 1330, in which individual troubadours are shown standing next to their ladies. The Count of Solms-Laubach, for instance, proposed as a point of comparison the similar pose of a pair in the Ulm Aesop edition of 1477. As regards theme, technique, and drawing style, the Berlin sheet is very similar to a silverpoint drawing in Leipzig, in which a pair of lovers is seen from behind. Also

15

Master of the Housebook, *Pair of Lovers,* c. 1485

comparable are the format (the Leipzig drawing may have been cut by about one centimeter at the top and bottom) and the structure of the paper, which suggests that both works were created at about the same time and may even have belonged to the same sketch or pattern book.

With silverpoint, which requires a primed paper or parchment working surface—in the case of the sheets in Berlin and Leipzig the priming is remarkably thin so that the structure of the paper shows through—it was possible to achieve a soft, modulated line-based drawing. The Housebook Master modeled with fine, parallel strokes of varying length that are either straight or slightly curved. He accentuated contours and shaded areas with a vigorous cluster of lines. The silverpoint drawings resemble the master's drypoint engravings in their delicate line structure. Hess' thesis—that the prints, which have survived in very few impressions, served as a replacement for the drawings that were treasured by court aficionados and collectors—is convincing.

In contrast to the related Leipzig sheet, the Berlin drawing remained incomplete in the lower area. The beginnings of modeling the ground with the silverpoint are evident only to the left behind the train of drapery, between the lady and the youth, as well as under his pointed shoes. Under ultraviolet light, however, sketch

lines for the ground with stones lying on it, executed with other graphic means and later erased, may be clearly seen. Of these, two horizontal lines in gray, located between the legs of the young man, have been preserved. The draftsman also used the same gray metalpoint for the preparatory drawing of the figures, as some lines along the legs of the youth and on the dress of his companion clearly show. The artist may well have used a lead or lead-tin point, the usual tool for such preparatory drawings in the late Middle Ages.[2] The breaks along the contours, described by Hess, are a result of drawing with the lead point, which tends to leave a sharp-edged impression in the paper. Closer investigation is necessary to determine if the gray contour lines of the Leipzig drawing, which are more reminiscent of additions in brush, are also preparatory work.

The Berlin drawing, like the *Gothaer Lovers,* probably dates from about 1480 to 1485. The closely related motifs of the two works raise the possibility that the Master of the Housebook created his drawings not only as collector's items, but also for personal use as pattern sheets, as study material for other work. Konrad Hoffmann pointed out that the Leipzig drawing apparently also served as a model for figures of the planetary children of Sol in the Housebook.[3] H.B.

1. K. P. F. Moxey, in: Exh. cat. *Hausbuchmeister* 1985, 65–79; Hess 1996.
2. Meder 1919, 72ff.
3. Hoffmann 1989, 58; Bossert/Storck 1912, pl. 12.

16

Master of the Amsterdam Cabinet or Master of the Genre Scenes of the Housebook

16 THREE MEN IN DISCUSSION, C. 1480

Berlin, Kupferstichkabinett, KdZ 4291
Pen and black ink
162 x 104 mm
No watermark
Small, repaired hole in the cloak of the standing man at the right

PROVENANCE: unknown collection (verso, collector's mark, not in Lugt); E. Rodrigues Coll. (lower right, collector's mark, Lugt 896); acquired in 1904

LIT.: J. Springer, "Eine neue Zeichnung vom Meister des Hausbuchs," in: *Jb. preuss. Kunstslg.* 26 (1905), 68 – *Zeichnungen* 1910, no. 137 – Bossert/ Storck 1912, 45 – Bock 1921, 71 – Exh. cat. *Dürer* 1967, no. 8 – J. P. Filedt Kok in: Exh. cat. *Hausbuchmeister* 1985, no. 123 – Hess 1994, 49ff. – König in: *The Medieval Housebook* 1997, 197ff.

Since its acquisition in 1904, this sheet has passed for a characteristic work by the Housebook Master, which is to say, by the artist to whom the illustrations in the so-called Housebook have been attributed. Hess, who identified different hands within this substantial group of works, gave *Three Men in Discussion* to the second artist responsible for the Housebook, the Master of the Genre Scenes (see cat. 17). The motifs and style of our drawing are undeniably paralleled by those in the Housebook's *Planet Venus,* which, according to Hess, was also by this master (fol. 15r; Bossert/Storck 1912, 14; *The Medieval Housebook* 1997). In both sheets, figures are somewhat stocky despite their long, thin limbs; eyes are strikingly large; and mouths are thin strips. Also comparable are the accentuation of broad outlines and the modeling with regularly spaced diagonal parallel hatching. However, similarities may be found with works in the Housebook that, according to recent insights, go back to the hand of the so-called Master of the Amsterdam Cabinet, such as *Planet Sol* (fol. 14r; Bossert/Storck 1912, pl. 12; *The Medieval Housebook* 1997) and *Luna* (fol. 17r; Bossert/Storck 1912, pl. 18; *The Medieval Housebook* 1997). The figures are constructed in an altogether similar way, and the soft, tonal use of strokes, as represented in the Berlin sheet by the shock of hair of the youth at the left, occurs in nearly identical form in the youths playing wind instruments among the children of the Sun. Here, too, the draftsman modeled with parallel hatching. In addition, the drypoint engravings of the Master of the Amsterdam Cabinet are very close to our sheet in drawing technique, particularly in the rendering of the drapery and folds. This impression is reinforced by two thematically related engravings, *The Falconer and*

Companion (Lehrs 75; Exh. cat. *Hausbuchmeister* 1985, no. 70) and *Two Men in Discussion* (Lehrs 76; Exh. cat. *Hausbuchmeister* 1985, no. 71). Because the Berlin drawing reveals the influence of both masters, it is difficult to attribute the sheet to either one.

The subject has not yet been adequately elucidated. Judging from their dress and gestures, the figures move in courtly circles. A middle-aged man, wearing a long cloak with ermine collar and a tasseled cap, forms a circle with two younger men and places a hand on each of their shoulders. The laying of the hands motif is also encountered in the drypoint engraving *Two Men in Discussion*. In the older literature (Springer 1912), the subject was interpreted as a paternal admonition to two sons setting out in life. According to Hess, the youth at the left, who appears to have both hands on his sword, is awarded the rank of manhood by his two companions because only full-grown men were permitted to carry swords. H.B.

Master of the Genre Scenes of the Housebook?

17 MAXIMILIAN AT THE PEACE BANQUET IN BRUGES IN 1488, C. 1500

Verso: Maximilian at the Peace Mass in Bruges in 1488, c. 1500
Berlin, Kupferstichkabinett, KdZ 4442
Pen and black brown ink; verso, pen and black brown ink
275 x 190 mm
No watermark
Verso, lower right, *1511* by a later hand; below it, possibly an erased, false Dürer monogram

PROVENANCE: Freiherr von Lanna Coll. (verso, collector's mark, Lugt 2773); auction Gutekunst, Stuttgart, no. 67, 5.6.–11.1910, no. 27; acquired in 1910 from Amsler & Ruthardt, Berlin

LIT.: A. Warburg: "Zwei Szenen aus König Maximilians Brügger Gefangenschaft auf einem Skizzenblatt des sogenannten 'Hausbuchmeisters'" (foreword by Max J. Friedländer), *Jb. preuss. Kunstslg.* 32 (1911), 180–184 – Bossert/Storck 1912, 46 – Bock 1921, 71 – Count of Solms-Laubach 1935/1936, 33ff., 57ff. – Exh. cat. *Dürer* 1967, no. 7 – J. P. Filedt Kok, in: Exh. cat. *Hausbuchmeister* 1985, no. 124 – Hoffmann 1989, 47ff. – Hess 1994, 50ff., 147, no. 6

One year after the acquisition of this important drawing in 1910, Aby Warburg, the founder of iconological methodology in art history, published an interpretation of both recto and verso subjects. Warburg interpreted the two scenes as "snapshots" of the last day of the more than three-month-long imprisonment of King Maximilian in Bruges in 1488.

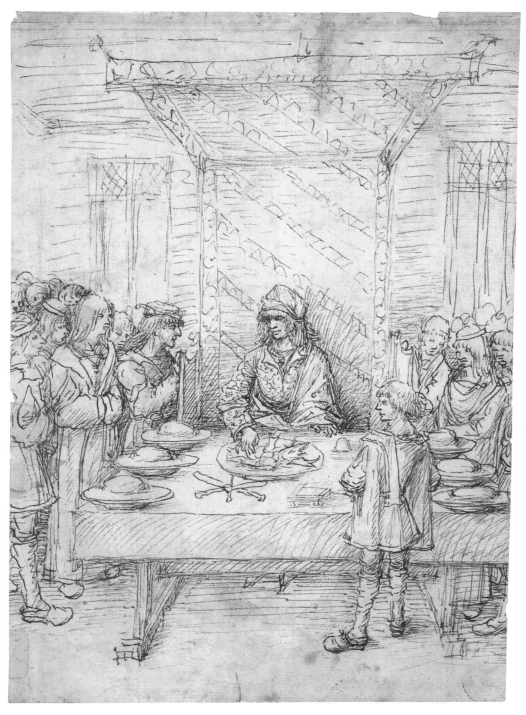

17

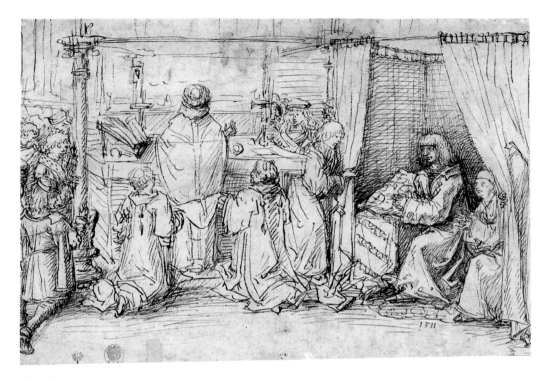

Verso (17)

By his marriage to Mary of Burgundy in 1477, Maximilian inherited the Burgundian Netherlands but was not recognized as sovereign by the rebellious Flemish cities. When in 1488 Maximilian summoned the Estates of the Netherlands to Bruges to support his policies, he was taken prisoner by the citizenry on 1 February. His humiliation included having to watch the execution of some of his counselors. He was released on 16 May, only after he had made far-reaching concessions to local privileges. The chronicles relate that the Habsburg king and future emperor ratified his settlement with the Flemish cities with a most solemn ceremony in the market square of Bruges. To this end, an altar had been erected there, on which stood precious relics, among them one of St. Donatian, the patron saint of the city. The chronicles further tell of the ensuing peace banquet in the residence of one Jan Caneel. According to Warburg, these two events are commemorated here. The (present) verso depicts the mass celebrated in the Bruges market square in the presence of Maximilian, who is seated in a curtained enclosure. The recto depicts the festive banquet, with Maximilian enthroned under a baldachin, surrounded by members of the Bruges citizenry. The young man with the napkin slung over his shoulder is thought to be the king's personal cook and taster.

Warburg's interpretation, which is followed by most later authors, is at first attractive: The similarity of the long-haired young man on both sides of the sheet to portraits of Maximilian is undeniable. Furthermore, the scenes depicted correspond in great measure to the events related in the chronicles. Even the headdress of the king at the festive banquet appears to correspond to the surviving descriptions of the event. Thus the content of the drawings may have been correctly depicted. It may be doubtful, however, that we have here an immediate eyewitness record of events, a thesis that Warburg thought to be supported by the bold, sketchlike strokes that he called "characteristic style of observing at a glance." Max Friedländer voiced guarded reservations in his preface to Warburg's article; he favored a later dating to about 1500 on stylistic grounds. In addition it may be argued, as Solms-Laubach and Anzelewsky have shown, that both compositions derive from older pictorial models in the tradition of Franco-Flemish manuscript illumination, following an established repertoire for depictions of princely personages at a table and attending mass.[1] Konrad Hoffmann voiced fundamental objections to the manner and way in which some scholars in our century, seduced by the sketchlike, quick style of the Master of the Housebook, classify his work as direct, unfiltered

depictions of the world around him. If, indeed, it is Maximilian in Bruges in 1488 who is depicted here, it is likely to be an event reproduced from memory or based on report. Warburg's objection that the humiliating context must rule out the possibility of this being an illustration for a chronicle of Maximilian, who was forever engaged in adjustments to his image in order to establish his legitimacy, can also be countered. Hoffmann emphasized that successfully repulsing an enemy attack during longstanding hostilities was particularly suited to the stylization of a hero. It should further be noted that Maximilian's secretary, Marx Treitzsaurwein, discussed the Bruges imprisonment in his text to the *Weisskunig* of 1514.[2] And in the *Historia Friderici et Maximiliani,* a biography of Emperor Frederick III and his son that has survived in a manuscript in Vienna (compiled about 1510 to 1515 by the humanist Joseph Grünpeck), a drawing by the Master of the Histories (Albrecht Altdorfer?) renders just such a scene of Maximilian's imprisonment. The illustration even shows how he was made to witness the execution of his advisors in the Bruges market square.[3]

It is difficult to place the drawing in the oeuvre of the second Housebook Master on account of the rapid pen strokes. Even so, there are points of contact with the Berlin study of three men in conversation (cat. 16), which may well be by the same master as the genre scenes of the Housebook. Here, as well as there, we encounter the same wrinkled hands with widespread fingers, similar facial types, and striking modeling by generous parallel hatching. Despite lingering doubts, the Berlin sheet of Maximilian's Bruges imprisonment may be attributed to this artist, as Hess had done. It may have been created shortly before 1500, possibly in connection with a biography of Maximilian and as a *modello* for a miniature or woodcut illustration. H.B.

1. For purposes of comparison, the Count of Solms-Laubach reproduced a miniature by Jean le Tavernier from the year 1457, which shows Philip the Good before a prie-dieu, in a provisory tent during a mass in a chapel chamber. Anzelewsky (Exh. cat. *Dürer* 1967, no. 7) pointed to related depictions of princely feasting such as the month of January in the calendar pages of the *Très riches heures* of the duke of Berry. Cannot indications of columns, which close off a choir, be made out on the back of the Berlin sheet? In that case the drawing would not show a mass on an open market square, as proposed by Warburg.

2. *Kaiser Maximilians I. Weisskunig,* ed. H. Th. Musper, with R. Buchner, H. O. Burger, and E. Petermann (Stuttgart 1956), 1:366.

3. O. Benesch and E. M. Auer, *Die Historia Friderici et Maximiliani* (Berlin 1957), 123, no. 30, pl. 30; for general information on the *Historia,* Mielke 1988, no. 30.

WOLFGANG KATZHEIMER
(traceable to Bamberg c. 1465–1508)

Painter, glass painter, and draftsman for woodcuts in Bamberg, where he is mentioned in documents concerning his activities for the court of the prince bishops. Various panel paintings and glass paintings mentioned in the account lists of the court financial administration, as well as twenty-two woodcuts for the *Halsgerichtsordnung,* published by Hans Pfeyll in Bamberg in 1507. Stylistically related to the contemporary art of Wolgemut and Pleydenwurff in nearby Nuremberg. Little is known, with any certainty, about the nature and scope of his work. The attribution to Katzheimer of the six Berlin watercolors with views of Bamberg remains hypothetical. Rather, one should speak of anonymous Bamberg views of about 1470–1485.

Traditionally Attributed to Wolfgang Katzheimer

18 VIEW OF THE BENEDICTINE MONASTERY OF ST. MICHAEL IN BAMBERG, C. 1470

Berlin, Kupferstichkabinett, KdZ 15345
Pen and brown ink; watercolor; traces of black chalk
278 x 437 mm
Watermark: high crown (compare to Briquet 4894/4895)
Verso, old inscription *das barfußer closer vnd Sant . . .*

PROVENANCE: acquired in 1935 from the Herzogliche Anstalt für Kunst und Wissenschaft, Gotha

LIT.: F. Winkler, "Tätigkeitsbericht des Kupferstichkabinetts April 1934–März 1935," *Berliner Museen. Berichte aus den preussischen Kunstsammlungen* 56 (1935), 79–85, esp. 85 – M. Müller/F. Winkler, "Bamberger Ansichten aus dem XV. Jahrhundert," *Jb. preuss. Kunstslg.* 58 (1937), 241–257 – H. Muth, *Aigentliche Abbildung der Statt Bamberg. Ansichten von Bamberg aus vier Jahrhunderten* (Bamberg 1957), 32, 43, no. 3f. – F. Anzelewsky, "Eine spätmittelalterliche Malerwerkstatt. Studien über die Malerfamilie Katzheimer in Bamberg," *Zs. Dt. Ver. f. Kwiss.* 19 (1965), 134–150, esp. 140 – Exh. cat. *Dürer* 1967, with nos. 12–14 – K. H. Mehnert, Ihle/Mehnert 1972, with no. 34 – Wood 1993, 209ff. – H. Mielke, in: *Handbuch Berliner Kupferstichkabinett* 1994, no. III.22 – M. Imhof, "Die topographischen Ansichten des Domberges um 1470 bis 1480," in: Exh. cat. *Der Bußprediger Capestrano auf dem Domplatz in Bamberg. Eine Bamberger Tafel um 1470/75* (Bamberg 1989), 69–86, esp. 72ff. – M. Imhof, "Die Bamberg-Ansichten des 15. Jahrhunderts aus dem Berliner Kupferstichkabinett und ihre kunsthistorische Einordnung," in: *Bericht des Historischen Vereins für die Pflege der Geschichte des Ehemaligen Fürstbistums* 128 (Bamberg 1992), 7–73

18

Traditionally attributed to Wolfgang Katzheimer, *View of Michaelsberg* (detail), c. 1470

In the course of the fifteenth century, landscape became a standard theme in Northern art. In place of the gold background of religious depictions, views of the country-side or of cities increasingly appear. A Swiss artist, Konrad Witz, created one of the first true-to-life representations in his *Miraculous Draft of Fishes,* with its splendid view of Lake Geneva. Franconia played a leading role in the growth of this pictorial genre in Germany. There, in Nuremberg and neighboring Bamberg, the earliest watercolor landscapes comprising both fantastic views as well as topographically accurate ones, were born. And there, in 1493, the Nuremberg humanist Hartmann Schedel published his famous *Weltchronik,* with its woodcut illustrations of city prospects. About 1490 the young Dürer also painted his first water-color landscapes in this intellectual climate.

A group of six watercolor drawings in the Berlin Kupferstichkabinett, partially executed on both sides with views of churches and buildings of the cathedral hill in Bamberg, has traditionally been ascribed to the painter Wolfgang Katzheimer, who was active in the Franconian city about 1465–1508. This attribution rests on correspondences with motifs found in paintings that were given to him. The *View of the Former Imperial Palace* (KdZ 15346) resembles in great part the background scenery of *The Test by Fire of St. Cunegunda.* Similar views are found in other Bamberg paintings of that time. The *View of the St. Michael Cloister Seen from the Rose Garden,* another drawing of the Berlin group (KdZ 15344 verso), turns up in almost identical fashion in the 1485 *Crucifixion* in St. Sebald, Nuremberg. As the authorship of the paintings

is not certain, the attribution of the watercolors must likewise remain hypothetical. The name of Katzheimer is a mere apology. It is better to talk of anonymous Bamberg works of about 1470–1485. Winkler determined that there are certain differences in the execution of the sheets and postulated two or three separate hands. He was followed by Imhof. However, all the works seem to come from the same workshop, where they served as a kind of pattern file for landscape backdrops for paintings.[1]

The present sheet differs slightly from the others in its attractive opposition of unfinished passages that are only loosely sketched and ones that are carefully elaborated. In addition the color, geared to the atmospheric mood, is more subtle and delicate than in the other works. As the underdrawing indicates, the draftsman must have first established the general outlines in black chalk before the watercolor was added in the workshops. He stood on the right bank of the Regnitz and looked across the river at the timber-framed houses on the far bank, with the boats at anchor and the tree-covered hill of the monastery of St. Michael. The buildings on the hill were torn down for new church buildings in the seventeenth century (see ill.).

Winkler dated the Berlin sheets early, from 1480 to 1485; Imhof proposed an earlier date, about 1470, for some, including the exhibited drawing. Related, con-temporary watercolor landscapes are found elsewhere, including in Leipzig and Malibu.[2] H.B.

1. For Bamberg painting of that time see M. Hörsch, "Zur Bamberger Malerei in der Jugendzeit Lucas Cranachs d.Ä.," in: Exh. cat. *Lucas Cranach. Ein Maler-Unternehmer aus Franken* (Kronach/Leipzig 1994), 96–110. With thanks to Dr. M. Hörsch for his suggestions.

2. K. H. Mehnert, in: Ihle/Mehnert 1972, no. 34; G. R. Goldner and L. Hendrix, *European Drawings, 2: Catalogue of the Collections,* The J. Paul Getty Museum (Malibu 1992), no. 126.

NUREMBERG MASTER

19 GROUP OF MEN ON HORSEBACK: STUDY FOR A CRUCIFIXION, C. 1480

Berlin, Kupferstichkabinett, KdZ 1049

Pen and black ink over black chalk

217/210 x 283/294 mm (irregularly cut)

Watermark: Gothic P with flower (see Briquet 8606)

PROVENANCE: Von Nagler Coll. (Lugt 2529); acquired in 1835

LIT.: W. F. Storck, "Die Zeichnungen des Hausbuch-Meisters," *Monatshefte für Kunstwissenschaft* 2 (1909), 264–266, esp. 265 – *Zeichnungen* 1910, no. 140 – Bock 1921, 89 – Winkler 1947, 10ff.

This study for a Crucifixion depicts the group of men and soldiers that is traditionally located to the right of the crucified Christ. The rider seen in profile, wearing a pointed hat and holding a ruler's staff in his right hand, could be Pontius Pilate or the centurion who repents of his sins at the moment of Christ's death. His hat carries an unidentified inscription in Gothic capital letters *INASG* [=Gamma]. *NOR.*

In 1909 Storck related this pen drawing, which until recently has been largely ignored in the literature, to the Housebook Master. Bock was the first to recognize its similarity to works in the Nuremberg-Pleydenwurff-Wolgemut circle. Several features of our drawing indeed vouch for a provenance in this sphere. Most closely related—in figure types and drawing style—is the Budapest Crucifixion of Christ, which originated about 1480, by a follower of Hans Pleydenwurff.[1] In both drawings, figures are starkly outlined with firm strokes and modeled with soft, lightly curved, parallel hatching and crosshatching that reveal the artist's intent to confirm the figures' plasticity and to capture the specific textures and characteristics of individual objects. Executed with wild, zigzag incisions or strokes running parallel to the rounded, cylindrical trees, the boldly sketched landscape backgrounds are also characteristic of both drawings, as are the long, parallel lines, which are made up of short pen strokes that serve to suggest the ground. The correspondences between the two sheets are so overwhelming that they must have come from one hand or the same workshop. Only in the Berlin *Group of Men on Horseback,* however, can we discern a preparatory, black chalk drawing, which was corrected in several places during the subsequent execution in pen (right arm of the rider in the left background, horses' hooves, outlines of the upper heads).

There are also numerous correspondences—in composition, figural types, and gestural language—between our sheet and paintings by Hans Pleydenwurff. A fragment of a *Crucifixion* in Breslau and a *Calvary* panel in Munich's Alte Pinakothek have been proposed as examples.[2] Especially characteristic of this Nuremberg master is the serious but somewhat forced attempt to represent three-dimensional space with intersecting gestures and bodies. Thus the horses in his paintings as well as in the present sheet were represented in distinct views, severely frontal or in pure profile. Finally, the sharply foreshortened rider at the left of the drawing must derive from an Italian model. Created in the tradition of Hans Pleydenwurff, the Berlin *Group of Men on Horseback* is an important testament to the art of drawing in about 1480 in Nuremberg, where the young Albrecht Dürer matured.

H.B.

1. Gerszi in: Exh. cat. *Leonardo to Van Gogh: Master Drawings from Budapest, Museum of Fine Arts,* National Gallery of Art, Washington, The Art Institute of Chicago, Los Angeles County Museum of Art (1985), no. 84; K. Achilles-Syndram in: Exh. cat. *Das Praunsche Kabinett* 1994, no. 1.

2. Stange 1934–1961, 42ff., ills. 72–73; Strieder 1993, nos. 38–39.

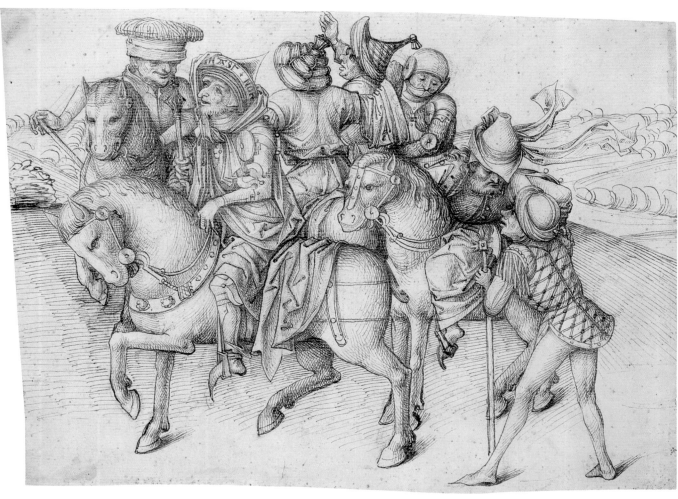

19

WILHELM PLEYDENWURFF
Master of the Stötteritz Altar
(Nuremberg c. 1460 – 1494 Nuremberg)

Painter and designer of woodcuts. Son of the Nuremberg painter Hans Pleydenwurff. Collaborated in the workshop of Michael Wolgemut, with whom Albrecht Dürer also studied. Collaborated on the woodcuts of Hartmann Schedel's *Weltchronik* (Nuremberg 1493) and *Schatzbehälter* (Nuremberg 1491). The panel paintings attributed to him are in the late Gothic tradition of Nuremberg painting and show the strong influence of early Netherlandish painting. The scope and nature of the work have as yet been little studied.

Verso (20)

20 DESIGNS FOR A TRIPTYCH WITH CHRIST ON THE MOUNT OF OLIVES, THE CRUCIFIXION, AND THE RESURRECTION, c. 1480–1490

Verso: sketch for the man standing to the right below the cross
Berlin, Kupferstichkabinett, KdZ 1031
Pen and brown ink; retouched in one area (Christ figure, left panel) in pen and black ink; traces of black chalk and gray blue wash; verso, pen and brown ink
210 x 315 mm
No watermark
Occasional color indications on the robes in brown ink *grien, w* and others; verso, lower right, old numbering *37* in pen and brown ink
Upper right corner restored

PROVENANCE: King Friedrich Wilhelm I. Coll. (verso, collector's mark, Lugt 1631)

LIT.: *Zeichnungen* 1910, no. 138 – Bock 1921, 78 – F. Winkler: "Ein spätgotischer Altarentwurf im Kupferstichkabinett," *Jb. preuss. Kunstslg.* 60 (1939), 212–216 – Exh. cat. *Dürer* 1967, no. 9 – W. Schade, in: Exh. cat. *Deutsche Kunst der Dürerzeit,* Staatliche Kunstsammlungen Dresden (Dresden, 1971), nos. 459–461 – Dreyer 1982, no. 4 – H. Mielke, in: *Handbuch Berliner Kupferstichkabinett* 1994, no. III.17 – F. Anzelewsky, "Der Meister des Stötteritzer Altars und Wilhelm Pleydenwurff," in: *Anzeiger des Germanischen Nationalmuseums* (Nuremberg 1997), 7–30

Friedrich Winkler was able to identify this drawing, which had been attributed in Bock's catalogue to the circle of Martin Schongauer, as a preparatory drawing for an altarpiece in the church of Leipzig-Stötteritz. Werner Schade definitively assigned the altar, a work of Nuremberg painting, to the circle of the teachers of Albrecht Dürer. In a recent study, Anzelewsky was able

Wilhelm Pleydenwurff, Stötteritz altar, c. 1480–1490

to demonstrate, on the basis of a meticulous comparison with the woodcuts of the Wolgemut workshop, that Michael Wolgemut's stepson, Wilhelm Pleydenwurff, created the Stötteritz altar (see ill.). Of particular significance was the representation of the Nuremberg castle, seen from the north, in the center panel of the Stötteritz altar, as it corresponds closely in style to a number of views in Schedel's *Weltchronik,* whereas the figural style corresponds closely to that of the *Schatzbehälter.* In both cases we have works that are today unanimously attributed to Wilhelm Pleydenwurff.

The draftsman obviously began on the left side with the Prayer on the Mount of Olives, and executed this scene in considerable detail. He also worked out the left side of the center panel, including the cross, in relatively

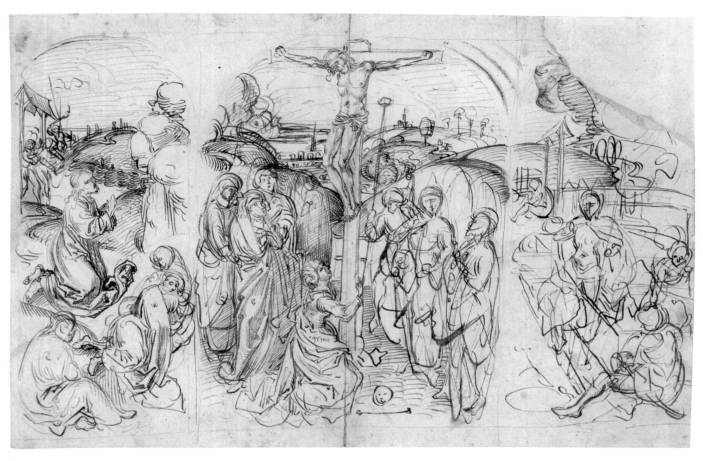

20

great detail, whereas in the right half he became more hasty and indicated the rear figures only with upright ovals. The draftsman indicated the Resurrection of the right panel in broad lines, with only the resurrected Christ and the anterior guardian of the tomb worked out with somewhat greater precision. Such a working method indicates that this is a design drawing and not—as might be supposed—a *modello* to be shown to the patron.

The same meaning may be attached to the figure on the verso of the drawing, which came to light during the preparations for this exhibition. It is a man at the edge of the Crucifixion who is depicted once more by the painter, in somewhat clearer form, in almost the same place as on the recto. F.A.

NUREMBERG MASTER

21 WOMAN IN HALF LENGTH, C. 1480

Berlin, Kupferstichkabinett, KdZ 4464
Pen and brown ink
134 x 103 mm
No watermark

PROVENANCE: Koller Coll. (Lugt 2632/33); Freiherr von Lanna Coll., Prague (Lugt 2773); Gutekunst, Stuttgart, Auction 67, 5.6–11.1910 (Lanna Coll.), no. 507; gift of Louis Meder, Berlin

LIT.: Schönbrunner/Meder, no. 1284 – Bock 1921, 89 – M. Weinberger, "Zu Dürers Lehr- und Wanderjahren," *Münchner Jahrbuch der Bildenden Kunst,* n.s., 6 (1929), 124–146, 125ff. – F. Anzelewsky in: Exh. cat. *Dürer* 1967, no. 5

Schönbrunner/Meder attributed this small, half-length portrait of an old woman wearing a hood and chin cloth to the Schongauer school, whereas Bock, Weinberger, and Anzelewsky placed it in the circle of Wolgemut. The last of these scholars pointed to the related physiognomy of the sitter in Wolgemut's Kassel *Portrait of Ursula Tucher.*

It is not possible to attribute the drawing with unequivocal certainty. Its dependency on Martin Schongauer's drawing style, again observed by Weinberger and Anzelewsky, manifests itself in numerous characteristics: the soft, flexible pen hatching as well as the preparatory sketch of fine pen lines (see, for instance, the outlines of the arms). These delicately applied lines, which frequently, as in the modeling of the face, end in lively hooks, belong to the tradition of draftsmanship of this master of the Upper Rhine. A good comparison is the head of Schongauer's *Angel of the Annunciation* in Berlin's Kupferstichkabinett (cat. 6). Draftsmen in Wolgemut's circle, not the least of whom was the young Dürer, certainly fell under Schongauer's influence during the 1480s; therefore we may propose a Nuremberg artist as the creator of our sheet. The present drawing differs in its flowing incisions from the more regular pen strokes of the Berlin *Group of Men on Horseback* (cat. 19) of about 1480. It becomes evident, if we accept that these sheets originated in Nuremberg, that the young Dürer could have modeled his drawing style after Nuremberg sheets in the manner of Schongauer as well as after Schongauer's autograph works.

The realism of our sheet is reminiscent of portraits, but that impression is controverted by the lowered glance. In sixteenth-century portraits such as the *Ursula Tucher* that Anzelewsky cited for purposes of comparison,[1] the sitter's glance, which is normally raised, is directed at a real or imagined pendant. Nevertheless the features of the woman in our sheet have an individual character. She

21

was probably drawn from life but not as an actual portrait. Is it a figure study? If so, for what? The lower portion of the drawing is incomplete, which affirms the impression of its spontaneous notation. The right arm of the woman seems to rest on a balustrade defined by the lower edge of the drawing. The left hand is raised, in a demonstrative gesture, with the thumb and index finger combining to form a circle. In this position, they could hold a flower or, perhaps, a rosary.[2] H.B.

1. See E. Buchner, *Das deutsche Bildnis der Spätgotik und der frühen Dürerzeit* (Berlin 1953), pl. 140; Strieder 1993, no. 48.

2. For examples of flowers or necklaces held in hands in similar positions, see Buchner 1953, pls. 12, 24, 98, and 136.

VEIT STOSS

(Horb am Neckar c. 1445/1450–1533 Nuremberg)

Wood-carver, sculptor, engraver, and painter. With Tilman Riemenschneider, the most important German sculptor of his time. The stages of his life and work are well documented. Apparently descended from a family of goldsmiths. Studied in the Upper Rhine, possibly with Nicolaus Gerhaert in Strassburg. Reported in Nuremberg in about 1476. Active in Cracow from 1477 to 1496; numerous commissioned works for nobility and the church in Poland. Chief work of these years: the many-figured Mary altar in Cracow (1477–1489), the most powerful carved altar of the late Gothic period. Again resident in Nuremberg from 1496 on. Branded and incarcerated in 1503 for forging documents. Audience in 1507 with Emperor Maximilian I in Ulm; apparently planned was Stoss' collaboration on Maximilian's funerary monument in Innsbruck. Key works of his Nuremberg period: the *Annunciation* in St. Lawrence (1517/1518) and the Bamberg altar (1520–1523). Stoss' plastic works are characterized by great realism as well as by unusual expressive powers. Typical are the rich, curvilinear, flaring drapery folds of his figures. His virtuosity in wood and stone was already renowned in his own time and even brought him commissions from Italy. In the mid-sixteenth century, Giorgio Vasari called a work of his a "miracle in wood." Of his work in paint only the panels of the Münnerstadt altar (c. 1504/1505) have survived. In addition, five drawings have survived as well as ten engravings—although in only a few impressions that are idiosyncratic and experimental creations in the graphic arts.

22

Verso (22)

22 PRESENTATION IN THE TEMPLE, 1505

Berlin, Kupferstichkabinett, KdZ 17653
Pen and brown ink
114 x 178 mm
No watermark
Lower left in pencil by a later hand 53; verso, signed and dated in brown ink *feyt stwos 1505 in,* with the artist's cipher
Lower left corner damaged

PROVENANCE: Campe Coll. (lower right, collector's mark, Lugt 1391); Ehlers Coll.; acquired in 1938

LIT.: E. Baumeister, "Eine Zeichnung von Veit Stoß," *Münchner Jahrbuch der bildenden Kunst,* n.s. 4 (1927), 386–388 – E. Schilling 1929, no. 8 – F. Winkler, *Altdeutsche Meisterzeichnungen aus der Sammlung Ehlers im Berliner Kupferstichkabinett* (Berlin 1939), 11ff., pl. III – F. Winkler, "Die Sammlung Ehlers," *Jb. preuss. Kunstslg.* 60 (1939), 21–46, no. 13 – G. Arnolds, "Altdeutsche Meisterzeichnungen. Neuerwerbungen des Berliner Kupferstichkabinetts," *Pantheon* 23 (1939), 57–62 – G. Török, "Eine unbekannte Veit Stoß-Zeichnung (Anmerkungen zum Problem der Bildhauerzeichnung und zur Bedeutung des Bußzettels)," *Acta Historiae Academiae Scientiarum Hungaricae* 17 (1971), 63–76, esp. 69 – Exh. cat. *Dürer 1967,* no. 11 – F. Koreny, "Die Kupferstiche des Veit Stoß," *Veit Stoß. Die Vorträge des Nürnberger Symposiums,* Munich 1985, 141–168, esp. 148ff. – J. Rowlands, "A Charcoal Drawing by Veit Stoss," *Festschrift to Erik Fischer. European Drawings from Six Centuries* (Copenhagen 1990), 295–298, esp. 297 – G. Seelig, in: *Handbuch Berliner Kupferstichkabinett* 1994, no. III.23

Drawings by German, late Gothic sculptors are exceedingly rare; for instance, no drawn work by Tilman Riemenschneider has survived. What we have are a few sketches of altars, that is *Altarvisierungen* (designs for an altar's overall appearance). Nevertheless a handful of drawings by Veit Stoss, the greatest German sculptor besides Riemenschneider at the beginning of the sixteenth century, have come down to us: two hasty sketches of an *Anna Selbdritt* (Anne, Mary, and Christ combined) in Budapest,[1] the pen sketch *Hand with the Mirror of Human Salvation* (formerly Munich, art trade), the design for the Bamberg altar in Cracow, as well as the present sheet.[2]

The *Presentation in the Temple* is more pictorially finished than the other works. The bold, somewhat tangled and awkward linear system of long parallel strokes, dense crosshatching, as well as short, hooked strokes is striking. There are direct parallels to this graphic structure in the rare engravings by Stoss, for instance *Christ and the Adulterous Woman* (Lehrs 2). There too we miss the severe hatching style of a Schongauer. The explanation is readily apparent: Stoss was a skilled sculptor, unpracticed in the laborious burin work of the engraver as well as in the pen

work of the painter. In short, he was a dilettante in the art of the line. Why, then, did he create the present drawing? We might at first think of it as a model for an engraving, but the spontaneity and immediate expressiveness of Stoss' engravings vouch for a working of the plate without preparatory stages. The engravings as well as the present sheet are constructed in relief: the figures stand in a narrow space, limited at the rear. The lack of perspectival accuracy is characteristic. The space is shown in a slight upward perspective (the altar table!); the vista at the left, in abrupt, steep foreshortening. All this may be related to the specific problems of attaining in relief, as in painting, an illusionistic space. Stoss' drawing may have originated as a study for a plastic work, although certainly of a different kind than the Cracow working drawing of 1520 to 1523, which is rendered in pure outline. The Berlin sheet was possibly meant as a presentation drawing for a patron. It is signed on the back, dated, and provided with Stoss' mark (see ill.). Unexpectedly, the inscription (in the same ink as the recto drawing) is located exactly in the middle of the sheet, in a thinly outlined subsidiary pictorial field whose points of intersection show puncture holes. Observed under ultraviolet light, this field is more discolored than the rest of the paper surface. Presumably traces of glue are responsible, as are, perhaps, traces of an earlier seal or a sewn-on scrap of paper. When we consider that drawings could be part of the contract negotiations between sculptor and patron, it is not implausible that our sheet might also have served as a record of a contract for a relief.[3]

H.B.

1. Z. Takács, "Federskizzen von Veit Stoß," *Mitteilungen der Gesellschaft für vervielfältigende Kunst, Beilage der "Graphischen Künste"* 25 (1912), 27–30 (still without knowledge of the Berlin drawing).

2. The attribution of a chalk drawing of the Virgin's head (Prague, Národni Galeri) to Stoss by Rowlands 1990 is not convincing.

3. For instance, the contract between Stoss and the Nuremberg cloister of the Carmelites concerning the Bamberg altar includes the *Visierung* (design drawing) as part of the agreement. It states there that both sides closed the agreement "zu warer urkundt und sicherheit" (for true record and surety) with their "bethschofften" (seals). Compare to M. Loßnitzer, *Veit Stoß. Die Herkunft seiner Kunst, seine Werke und sein Leben* (Leipzig 1912), 61, no. 132a.

MASTER OF THE AACHEN ALTAR

(active in Cologne c. 1480 – c. 1520)

Most important Cologne master of the late Gothic period, named after the Passion triptych today preserved in Aachen. Stylistically close to other contemporary representatives of the Cologne school, such as the Master of St. Severain and the Master of St. Bartholomew; also influenced by Netherlandish art.

23 THE RAISING OF LAZARUS, C. 1510

Berlin, Kupferstichkabinett, KdZ 12045
Pen and brown and gray black ink; light brown wash
287 x 200 mm
Watermark: coat of arms with three lilies, staffs, flower, and T (see Briquet 1743)

PROVENANCE: Dr. Von Jurié Coll., Vienna; acquired in 1925 from Gustav Nebehay, Vienna

LIT.: M. J. Friedländer, "Der Meister des Aachener Altars," *Amtliche Berichte aus den Königl. Kunstsammlungen* 38 (1917), cols. 221–226, esp. col. 225 – M. J. Friedländer, "Der Kölnische Meister des Aachener Altars," *Wallraf-Richartz-Jahrbuch* 1 (1924), 101–108, esp. 103 – M. J. Friedländer, "Eine Zeichnung von dem Meister des Aachener Altars," *Wallraf-Richartz-Jahrbuch* 2 (1925), 228–230 – Winkler 1932a, no. 46 – Stange 1934–1961, 5:121 – Exh. cat. *Kölner Maler der Spätgotik,* 1961, no. 43 – F. Anzelewsky, "Zum Problem des Meisters des Aachener Altars," *Wallraf-Richartz-Jahrbuch* 30 (1968), 185–299, esp. 187ff.

The Raising of Lazarus is set in a crowded marketplace. As is customary, the faithful, including Lazarus' sisters Mary and Martha, surround Christ, while those who do not believe stand at the far side of the grave, covering their noses and mouths against the stench of the corpse.

Friedländer identified the Master of the Aachen Altar as the draftsman of this sheet. Here, as in his paintings, the composition is crowded and moves toward the top of the drawing, and we encounter intersecting, crisscrossing movements and gestures. Also comparable are the figures, with their long, slender limbs, and the individualized, portraitlike features. Friedländer also pointed to the master's fresco with the *Raising of Lazarus* (destroyed, formerly of Hardenrath chapel, Church of St. Mary in Kapitol, Cologne), whose composition, though reversed and horizontal, is fundamentally related. Our drawing is not an immediate design for the wall painting. Anzelewsky noted

the reversal of some of the gestures and motifs. Here, contrary to Christian tradition, Christ blesses with his left hand, and the man standing at the left edge of the picture carries his sword on his right side. Anzelewsky concluded that the sheet was a mirror-image model for an engraving. In addition, he established parallels in style and in motif between the work of the Master of the Aachen Altar and engravings by the Cologne Master PW, and concluded that the two artists were one and the same.

The Master of the Aachen Altar probably used a panel from the *Kalkar* altar (1506 – 1508) by Jan Joest van Kalkar,[1] or a common prototype, as his model for our sheet: the composition and the gestures of the individual figures are closely related. In the Kalkar picture, however, Christ blesses with his right hand, which supports Anzelewsky's thesis.

Late Gothic drawings from Cologne are rare. Only three works on paper by the Master of the Aachen Altar are known: our sheet; a design (Louvre, Paris) for an *Adoration of the Kings* (Berlin Gemäldegalerie); and a small sketch in Copenhagen.[2] The latter two are sketchier than our *Lazarus,* and they lack its supplementary wash. Nevertheless, attributing all three works to the same master seems justified given our sheet's free, boldly outlined background figures; its generally detailed, precise execution could be related to its function as a model for engravings.

Our *Lazarus'* variation in ink colors is striking. Heads and other uncovered body parts are executed in gray black, with drapery and background scenery in brown. This variation probably resulted from later changes done in two different inks whose tones were originally identical. Therefore, the parts of the hands and heads that today look black were probably originally indicated in the same brown ink that the artist used in the rest of his drawing. H.B.

1. Stange 1934–1961, 6:64ff., ill. 121.
2. Exh. cat. *Kölner Maler der Spätgotik* 1961, nos. 37 and 44; Exh. cat. *Dessins Renaissance germanique* 1991, no. 121.

23

BERNHARD STRIGEL

(Memmingen 1460–1528 Memmingen)

Painter from a dynasty of Swabian painters, probably the son of painter Hans Strigel the Younger. Active all of his life in Memmingen, where he was invested with several public offices. First works datable to the late 1480s, still influenced stylistically by the Swabian painter Bartholomäus Zeitblom. Contacts with the court of Emperor Maximilian I. Journeys to Vienna in 1515 and 1520; mentioned as imperial court painter in 1520. His many surviving, predominantly religious altar panels in the tradition of late Gothic Swabian painting of the fifteenth century show, in part, the influence of early Netherlandish painting, but remain largely untouched by the more recent painterly achievements of Dürer and the masters of the Danube school. Important portrait painter, esteemed as such in his own lifetime (portrait of the Cuspinian family, Vienna; portraits of Emperor Maximilian). Just over ten drawings, including designs for surviving altarpieces, are known.

24 THE ILL-MATCHED LOVERS WITH DEVIL AND CUPID, 1503

Berlin, Kupferstichkabinett, KdZ 4256
Black and gray black wash; heightened with point of the brush in white and pinkish red on gray violet prepared paper
225 x 176 mm
No watermark
Inscribed upper center with brush in white
. DISCITE . A . ME . QUIA . NEQUAM .
SV(M) . ET . PESSIMO . CORDE . 1503 .
Numerous creases and spots; abrasions; lower right, small areas replaced

PROVENANCE: Rodrigues Coll.; acquired in 1903

LIT.: *Zeichnungen* 1910, no. 165 – *Handzeichnungen,* pl. 93 – Bock 1921, 87 – Parker/Hugelshofer 1928, 30 – Parker 1932, 28 – Winkler 1947, 49ff. – Otto 1964, 30, no. 97 – Rettich 1965, 209ff. – A. Shestack, "A Drawing by Bernhard Strigel," *Master Drawings* 4 (1966), 21–25 – Rettich 1967, 104ff. – A. G. Stewart, *Unequal Lovers. A Study of Unequal Couples in Northern Art* (New York 1977), 86ff., 98, no. 61 – Falk 1978, 222 – H. Mielke, in: *Handbuch Berliner Kupferstichkabinett* 1994, no. III.26

A young, fashionably dressed woman and her companion, a bearded and toothless old man, are being dragged along by a nude boy, who is probably intended as a reference to Cupid, the god of love (only the little wings are lacking). Importuned by him, the couple are unaware of the devil,

who clings to their shoulders. The devil's genitals are exposed, a clear indication that the pleasures to which Cupid invites them are of a damnable character. Strigel's depiction belongs to the iconographic category of the ill-matched lovers, which was immensely popular in German art at the beginning of the sixteenth century, especially in print media. The misalliance between young women and grizzled lechers, but also between youths and old women, is displayed in a droll and crass manner before our eyes, rarely without moralizing condemnation. A related theme frequently associated with this is venal love, as is also the case with Strigel: the beautiful maiden has robbed the old man of his dagger—a sign of masculinity according to notions of the time—as well as of his moneybag. *Learn from me, for I am frivolous and bad to the core,* warns the Latin inscription. Both the hussy as well as the lecher could be speaking these words, which are addressed to the observer of the sheet. Inscriptions in the vernacular predominate in depictions of unequal couples. Strigel's sheet forms an exception, from which one may conclude that it was intended for a patron with a humanistic education. Additional proof to this effect is that it can hold its own as an independent work of art thanks to the careful chiaroscuro execution on prepared paper (which has lost much of its original effect through later damage). Despite the moralizing intention, there are humorous undertones. Erasmus of Rotterdam also attacked unequal love with biting irony in his *Praise of Folly.* Strigel's drawing is comical in effect in the lecher's clumsy wooing, and the distorted face on the devil's shank seems to caricature the old man.

The drawing is considered the earliest surviving example of a depiction of a mismatched couple outside the realm of the graphic print. The motif of Cupid encouraging physical love—the god's appearance may have been borrowed from a Renaissance engraving—constitutes an exception within the iconography of the theme and confirms Strigel's status as an individualistic creator of images.

There are barely more than ten drawings by Bernhard Strigel, who was active in Swabian Memmingen as the court painter of Emperor Maximilian I (whose features are preserved for us in several paintings by Strigel). None of his drawings are signed, but Strigel's authorship can be ascertained thanks to the stylistic proximity to his paintings. The Berlin sheet shows all the characteristics that are typical for the Memmingen painter: the broad, curved, swinging outlines of drapery with long, tubular folds; the heavy emphasis on dark outlines, which contrast with the reflected lights in white and pinkish red (heightenings in pink are a typical stylistic element of drawings from

24

Württembergian Swabia, compare to cat. 100); and the somewhat awkward, flat movements. The facial types also reappear in Strigel's paintings. H.B.

25 DOUBTING THOMAS, C. 1520

Berlin, Kupferstichkabinett, KdZ 5548

Black and gray black wash; heightened with point of the brush in white and pinkish red on paper broadly washed in red; border in black and white watercolor

379 x 272 mm

No watermark

Lower center (faintly visible on the small tablet), monogram *AG* and date *1524* by a later hand; verso *Quinting Mesius von Antorff/ Inventie* in brown ink by a later hand

PROVENANCE: Mayor Coll. (lower right, collector's mark, Lugt 2799); Von Beckerath Coll.; acquired in 1902

LIT.: *Zeichnungen* 1910, no. 197 – Bock 1921, 95 – Parker/ Hugelshofer 1925, 39ff. – Exh. cat. *Dürer* 1967, no. 94 – Otto 1964, 52, no. 99 – Rettich 1965, 213 – Rettich 1967, 106ff.

The Apostle Thomas is represented with deep emotion, at the very moment that he becomes aware of his mistaken doubts concerning the Resurrection of Christ: "Then he said to Thomas, 'Put your finger here and see my hands. Reach out your hand and put it in my side. Do not doubt but believe.' Thomas answered him, 'My Lord and my God!' Jesus said to him, 'Have you believed because you have seen me? Blessed are those who have not seen and yet have come to believe'" (John 20:27–29).

Bock classifed the drawing among the unknown masters of the upper-German school (Augsburg?). Parker and Hugelshofer convincingly attributed it to Strigel. Stylistically it invites comparison with the paintings of about 1520 by the Memmingen painter. A comparison may be made, for instance, to the panels of the former Isny altar in Berlin and Karlsruhe (Otto 1964, nos. 102– 105). Here, as there, we encounter voluminous drapery with long, curved hems of the cloaks, and powerful, gnarled figures. The muscular legs and crude feet of the resurrected Christ in our drawing are rendered analogously to the Christ in the *Disrobing* of the Isny altar in the Berlin Gemäldegalerie (see ill.). The facial types are also comparable. The arrangement of the figures within a shallow stagelike space—effectively achieved in the drawing by the black wall rendered in powerful brushstrokes that abuts abruptly onto the light-colored floor at the left—is also typical for Strigel. His drawing method, which is also apparent in his other works, is determined by the modeling of forms from dark to light. First of all,

the outlines were rendered in grayish black on the colored paper with a brush (over sketched pen work?). The interior drawing followed, in broad, gray-black washes, over which the white and reddish-pink highlights were applied to the illuminated drapery passages or the flesh tones.

Our sheet must have served as *modello* for the patron of a lost altarpiece. This is suggested by the careful, painterly execution, which conveys an apt impression of the overall effect of a painting. Also, the slightly trimmed contour lines in black and white are clearly not, as is so often the case, the work of a later hand. They are executed in the same ink as the drawing itself, and the depiction does not extend beyond them. In this context, we should also mention a surviving contract of 1507 between Strigel and the Salem cloister, which proves that the painter customarily supplied his patron with drawings of the overall design.[1] H.B.

1. The precise text of the contract is printed in K. Obser, "Bernhard Strigels Beziehungen zum Kloster Salem," *Zeitschrift für die Geschichte des Oberrheins,* n.s., 31 (1916), 167–175, 169; compare, also, Parker/Hugelshofer 1925, 43.

Bernhard Strigel, *Disrobing,* c. 1520

25

HANS HOLBEIN THE ELDER

(Augsburg c. 1460/1465–1524)

About his artistic formation, which probably took place in the area near Ulm and in the Rhineland, little is known. Above all a painter of religious altarpieces and portraits, also a draftsman for works produced by goldsmiths, glass paintings, and woodcuts. His works show the influence of Netherlandish painting, especially of Rogier van der Weyden, and, presumably, he traveled to the Netherlands as well. From 1490 on, though with several interruptions, he was active in Augsburg, where he continued to live until about 1515 (altar panels, St. Afra, 1490); in 1493 Holbein bought a house in Augsburg, and was mentioned as Hans Holbein the painter, citizen of Ulm; presumably he was temporarily a citizen of this town during work on the Weingartner altarpiece (with the sculptor Michel Erhart, Augsburg cathedral, 1493). Birth of sons Ambrosius in 1494 and Hans in 1497/1498. From about 1495 on he headed a large workshop with which he was active in 1501 in Frankfurt am Main (altar in the Dominican church) and elsewhere. In 1502, together with the sculptors Gregor Erhart and Adolf Daucher, he created the altar panels of the Dominican church of Kaisheim. In 1499 and 1504 Holbein painted pictures of the basilicas of S. Maria Maggiore and S. Paolo fuori le Mura (the latter with portraits of Hans the Elder, Ambrosius, and Hans the Younger) for the Catherine Cloister in Augsburg (see cat. 37). About 1509/1510 Holbein was in Alsace, where he was occupied with the altarpiece for the Hohenburg cloister church on the Odilienberg; after returning to Augsburg, he painted the St. Catherine altar in 1512 and the St. Sebastian altar in 1516, both presumably for the convent of Dominican nuns in Augsburg. After 1516 he can be traced to Isenheim. In 1517 he was probably working in Lucerne together with his son Hans on the decoration of the Hertenstein house. In 1519 he painted the so-called *Lebensbrunnen (Fountain of Life)* on commission for an Augsburg merchant couple. In the years before his death he is repeatedly mentioned in Augsburg. He died in 1524 in an unknown location.

26 TWO GROUPS OF THE HOLY KINSHIP, c. 1495

Basel, Kupferstichkabinett, U.VII.99a
Pen and brown ink; gray brown wash; opaque blue background
127 x 82 mm
Watermark: indecipherable
Mounted; paper somewhat spotted

PROVENANCE: Amerbach-Kabinett (from U.VII)

LIT.: Woltmann 2: 68, no. 59 – His, VIII, pl. XXXV – Glaser 1908, 188, no. 13 – Lieb/Stange 1960, 81, no. 77 – Falk 1979, no. 148

The elaboration of the blue background, the washes, and the outlines give both drawings a highly picturelike appearance. They invite comparison with compositional designs for altars even though such works are generally larger (see cats. 28–30). Perhaps these drawings are small, model-like renderings of panel paintings, such as those that have come down to us in several examples from Holbein's workshop. They are also related to depictions in pattern books, which belonged to the work material of a shop. The Basel Kupferstichkabinett has drawings with scenes of the life of Mary and Christ that are done in even smaller format. They are by Holbein himself or his workshop (Falk 1979, no. 149; see ill.). Most authors date these drawings, which are done in freer strokes and may date a little later, before 1500. The dot-shaped rendering of eyes, noses, and mouths in our drawings also point to an earlier date.

The consoles above and below, which are indicated in outline, could belong to a frame or housing of an altar, or an epitaph.

The scene in the upper drawing, which depicts a woman with four children, cannot be identified with

Hans Holbein the Elder, *Scenes from the Life of Mary and Christ,* c. 1495

26

certainty. She is accompanied by two men, who stand to her left and right, and turn toward the children sitting on her lap. Possibly it is Mary Cleophas with her children, accompanied by her father and husband. But the two men cannot be clearly identified either. One of them could be Cleophas, who is sometimes identified as her husband, but also as her father (John 19:25). Her children were James the Younger, Simon the Zealot, Judas Thaddaeus, and Barnabas. The lower scene depicts *Anna Selbdritt* (the three generations of Anne): Anne, the mother of Mary, with the Christ child on her lap and Mary at her side, on a smaller scale, as is Joachim to her left and Joseph to her right. C.M.

27 SKETCH OF A SPRING, C. 1500

Basel, Kupferstichkabinett, Inv. 1662.203

White, gray, and light green wash on gray prepared paper

104 x 132 mm

No watermark

Trimmed on all sides; upper corners cut; mounted on paper; several vertical tears and breaks

PROVENANCE: Amerbach-Kabinett (formerly U.XVII.106)

LIT.: Woltmann 2: 72, no. 105 – Glaser 1908, 207, no. 222 – Exh. cat. *Holbein* 1960, no. 54 – Lieb/Stange 1960, 88, no. 134 – Falk 1979, no. 169 – Bushart 1987, 22, ill. 11 – T. Falk, "Naturstudien der Renaissance in Augsburg," *Jahrbuch der kunsthistorischen Sammlungen in Wien* 82/83 (1986/1987), 83

The drawing comes from the so-called English Sketch-book of Hans Holbein the Younger. This booklet is wrongly labeled a sketchbook, for it is in fact a picture album, which was probably not compiled until the nineteenth century. It contained mainly small designs by Hans Holbein the Younger from the time of his second sojourn in England, in addition to several drawings by other artists, including Hans Holbein the Elder, that had mistakenly been introduced to this context. The volume was completely disbound at the beginning of the twentieth century. In all probability its contents came from the Amerbach-Kabinett. This context suggests the possibility that the *Sketch of a Spring* could be by Holbein the Elder, even though his remaining oeuvre does not include closely comparable drawings. Hans Holbein the Younger hardly qualifies on stylistic grounds; while he did create chiaroscuro drawings, none of these are finished in color.

The sheet, which is trimmed on all sides, depicts a spring from which, fountainlike, four water jets spout and pour into two small, pondlike bodies of water and onto the surrounding land. The movement of the water, the

Geertgen tot Sint Jans, *The Adoration of the Magi* (detail), c. 1480

wave formation, and the splashes where the jets of water fall and the spring pours forth are meticulously observed. The draftsman strongly emphasized the play of light and shadows, and the reflections on the surface of the water. Visible in the background, only barely indicated with the brush, is a tree, whose trunk is reflected in the water below. The banks of the small ponds are also steeped in soft shadows. In immediate proximity to the spring, as well as on a cliff in the left foreground, the draftsman used thinly applied green, a naturalistic trait that seems unusual for a pure chiaroscuro drawing. Finally, two fish swim in the very foreground in the rivulet formed by the draining water.

The depiction ends abruptly at the right and is bordered by an unfinished strip on which a coat of arms with a rearing lion has been applied. The animal appears once more, without a coat of arms, below. To the left the depiction is lost in schematic indications. There, especially, emerges the impression of an incomplete work. This must be a study, one that may well have been part of a large sheet with other such depictions. The coat of arms points to a connection with either a specific commission or a painting after which Holbein could have drawn *Sketch*

27

28

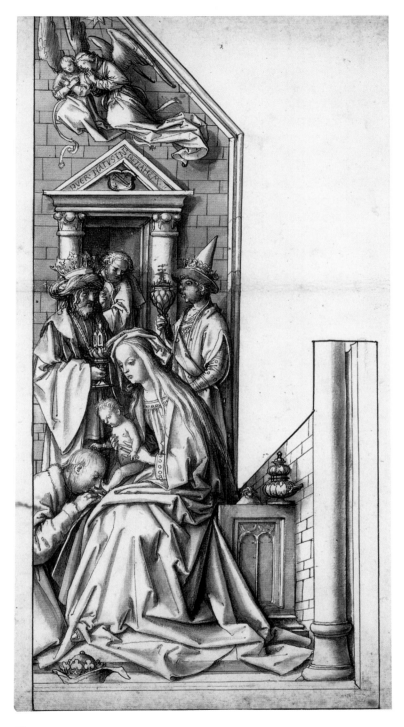

29

of a Spring. In particular, the termination of the depiction at the right supports the notion that Holbein did not render a study after nature but created some kind of model, perhaps for a landscape vignette that would be the background in a painting. The landscape in *The Adoration of the Magi* (cat. 30) invites comparison in terms of scale. Also, a similar spring is found in the background of *The Adoration of the Magi* of about 1480 ascribed to Geertgen tot Sint Jans. The painting is in the Oskar Reinhart Collection in Römerholz in Winterthur (see ill.).

A silverpoint drawing of four rose twigs in the Basel Kupferstichkabinett (Falk 1979, no. 167) more closely approximates an immediate study after nature. Holbein was interested not just in botanical details but also in their spatial presence, which is evoked by light.

Given the limited basis of comparison, the dating of the *Sketch of a Spring* is difficult. However, the drawing was probably created at about the turn of the century.

C.M.

28 DESIGN FOR THE LEFT ORGAN SHUTTER OF THE KAISHEIM MONASTERY: THE NATIVITY, C. 1502

Basel, Kupferstichkabinett, U.III.12
Pen and brown ink, gray brown wash with blue-tinged white heightening on Mary's face and the donkey's head
349 x 181 mm
Watermark: scales in a circle, with star above
(related to Briquet 2542)
On the scroll held by angels *Gloria in excels . . .* ; on the door pediment *ALELVIA* (repeated); below, arms of the Cistercian abbey of Kaisheim
Horizontal fold above the middle; paper somewhat spotted

PROVENANCE: Amerbach-Kabinett

LIT.: His, VI, pl. XIX – Glaser 1908, 190, no. 34 – L. Baldass, "Niederländische Bildgedanken im Werke des älteren Hans Holbein," *Beiträge* 2 (1928), 167 – Lieb 1952, I: 248, 401 – Lieb/ Stange 1960, 80f., no. 76 – Exh. cat. *Holbein* 1960, no. 25b – H. Werthemann, "Die Entwürfe für zwei Orgelflügel von Hans Holbein d. Ä.," *Öff. Kunstslg. Basel. Jahresb.* (1959/1960), 137ff. – P. H. Boerlin, "Die Orgelflügel-Entwürfe von Hans Holbein d. Ä.," *Öff. Kunstslg. Basel. Jahresb.* (1959/1960), 141ff. – Landolt MS 1961, 51f., note 71 – T. Falk, "Noti-zen zur Augsburger Malerwerkstatt des Älteren Holbein," *Zs. Dt. Ver. f. Kwiss.* 30 (1976), 11, n. 31 – Falk 1979, no. 162 – Bushart 1987, 26, ill. 13 – Exh. cat. *Amerbach* 1991, *Zeichnungen,* no. 29

29 DESIGN FOR THE RIGHT ORGAN SHUTTER OF THE KAISHEIM MONASTERY: THE ADORATION OF THE MAGI, C. 1502

Verso: The Nativity (sketch), c. 1502?
Basel, Kupferstichkabinett, U.III.11
Pen and brown ink, gray brown wash; verso, black chalk or charcoal
343 x 181 mm
Watermark: scale in a circle, star above (see cat. 28)
Inscribed on the pediment *PVER NATVS IN BETLAHEM*; below, arms of Abbot Georg Kastner (1490–1509) of Kaisheim
Horizontal fold above center; paper somewhat spotted

PROVENANCE: Amerbach-Kabinett

LIT.: His, VIf., pl. XX – Glaser 1908, 190, no. 35 – L. Baldass, "Niederländische Bildgedanken im Werke des älteren Hans Holbein," *Beiträge* 2, 1928, 167 – Lieb 1952, I: 248, 401 – Lieb/Stange 1960, 80f., no. 76 – Exh. cat. *Holbein* 1960, no. 25a – H. Werthemann, "Die Entwürfe für zwei Orgelflügel von Hans Holbein d. Ä.," *Öff. Kunstslg. Basel. Jahresb.* (1959/1960), 137ff. – P. H. Boerlin, "Die Orgelflügel-Entwürfe von Hans Holbein d. Ä.," *Öff. Kunstslg. Basel. Jahresb.* (1959/1960), 141ff. – Falk 1979, no. 163 – Landolt MS 1961, 51f., note 71 – Bushart 1987, 13, ill. 14 – Exh. cat. *Amerbach* 1991, *Zeichnungen,* no. 30

The elaborate contours of the left and right edges reflect the shape of an organ case. Much like triptychs, organs were outfitted with hinged wings that could be closed. They served the purpose of protecting the instrument not only from dust and dirt, but also from animals. Both the exterior and the interior of the wings could be decorated with paintings. Various aspects—such as the pictorial elements that are foreshortened inward, the rendering of the frame as termination of the pictorial field, and the chronological sequence of scenes from left to right— suggest that the designs were intended for the interior of the wings, which could be seen in the opened state. This means that the organ was located in the middle, between the two depictions. Boerlin offered proof that *The Nativity* and *The Adoration of the Magi,* scenes that announce the coming of the Redeemer, were commonly depicted on the inside of organ wings during the fifteenth and sixteenth centuries. For instance, they could serve as pictorial and ideological counterweights to the representation of the sacrificial death of Christ on an altarpiece.

The organ shutters were intended for the cloister church of the Cistercian abbey of Kaisheim, near Donauwörth. We know from the cloister chronicle, composed in about 1530 by Johann Knebel the Elder, that Abbot Georg Kastner had a new organ built in the year 1502 (see Boerlin, *Öff. Kunstslg. Basel. Jahresb.* 1959/1960, 141). Georg

Verso (29)

for the organ shutter (1502) and *The Adoration of the Magi* (about 1504), satisfied the same basic requirements. They are pen drawings with wash that are very precisely executed. Thus the spectator, or the patron, could gain a good idea of the themes and composition. Drawings of this kind also served as a model for the execution, which was normally left to Holbein's workshop.

The sketchlike drawing on the back of the Adoration is of an entirely different character. The figures and architecture are indicated in outline with rapid, repetitive, and correcting strokes. It could be a design for a Nativity of Christ. As we have no closely comparable drawings by Holbein, this one can be attributed to him only with reservations.

<div align="right">C.M.</div>

30 THE ADORATION OF THE MAGI, C. 1504

Basel, Kupferstichkabinett, Inv. 1662.217
Pen and brown and black brown ink; gray brown wash;
corrections and occasional heightening in opaque white; yellow,
green, and blue watercolor
386 x 537 mm (overall)
384 x 264 mm (left image)
382 x 261 mm (right image)
Watermark: on the right sheet, high crown with cross; above it,
flowers (compare Piccard 1961, XIII, 22; northern Italy, Bolzano,
Schwaz and others 1492–1505)
Both halves signed below with *H*
Two parts; glued on old paper and backed by an additional sheet
(18th century?); vertical tear down middle; horizontal creases
and shorter tears; blue in the background somewhat faded

PROVENANCE: Amerbach-Kabinett (out of U.II)

LIT.: *Photographie Braun,* pl. 75/76 – Woltmann 2: 67f., no. 57 –
His, Vf., pl. VIf. – Glaser 1908, 57f., 123, 168ff., 189, no. 33 – H.
Kehrer, *Die Heiligen Drei Könige in Literatur und Kunst* 2 (Leipzig
1909), 240f. – C. Glaser, "Die Anbetung der Könige des Hugo
van der Goes im Berliner Kaiser-Friedrich-Museum," *Zs. f.
bildende Kunst (Kunstchronik)* 25 (1914), cols. 233ff. – L. Baldass,
"Niederländische Bildgedanken im Werke des älteren Hans
Holbein," *Beiträge* 2 (1928), 163f., 172 – Schmid 1941/1942,
15, 23 – Schilling 1954, 12, no. 5f. – Beutler/Thiem 1960, 59f. –
Lieb/Stange 1960, 23, 80, no. 74 – Landolt MS 1961, 52 – Exh.
cat. *Amerbach* 1962, no. 19 – F. Winkler, *Das Werk des Hugo van
der Goes* (Berlin 1964), 19ff., 198 – Exh. cat. *Holbein d. Ä.* 1965,
no. 74 – D. Koepplin, in: *Das grosse Buch der Graphik* (Brunswick
1968), 101 – C. Eisler, "Aspects of Holbein the Elder's Heritage,"
Festschrift Gert von der Osten (Cologne 1970), 154 – Hp. Landolt
1972, no. 16 – F. Koreny, in: Exh. cat. *Israhel van Meckenem und
der deutsche Kupferstich des 15. Jahrhunderts* (Bocholt 1972), 56f.,
62f. – Falk 1979, no. 164 – Bushart 1987, ill. 63f. – Exh. cat.
Amerbach 1991, *Zeichnungen,* no. 31 – Krause 1997, 179

Kastner, whose coat of arms is located at the top of the drawing of the Adoration, was in charge of the monastery from 1490 to 1509. He must have charged Holbein with the design and execution about 1502. Organ and shutters have not survived. They used to be located on the western wall of the church, in a choir loft above the main entrance. Immediately before that, Holbein had executed the high altar for the cloister church, painting sixteen panels for the altar's wings (today Munich, Alte Pinakothek; see cat. 31).

The character of the drawings and specific iconographic details approximate Holbein's large altar design with the Adoration of the Magi (see cat. 30). The motif of the king kissing the feet of the Christ child is also encountered there. The position of the body of this king is inspired by the Adoration of the Magi on the Montforte altar by Hugo van der Goes, which Holbein could have seen during a journey in the Netherlands (today Berlin, Gemäldegalerie; see cat. 30). Both drawings, the design

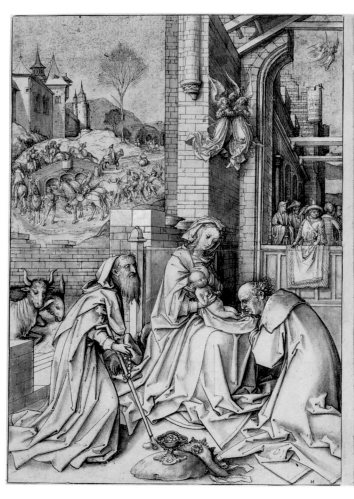
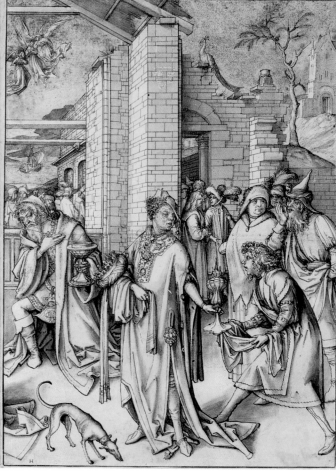

30

These two large drawings by Hans Holbein the Elder were designs for the exterior wings of an altar. The drawings are about the same size, and each has drawn borderlines. Perhaps it was the artist himself who pasted them about twelve millimeters apart on a sheet of paper. The space between the drawings was intended for the frames that were to enclose both works. Mary with the infant Jesus on the left, and the tall figure of the Moorish king on the right constitute the dominant motifs. The genuflecting Joseph and the kneeling king correspond formally to one another. Behind the main figures on both sides, the pillar-like wall segments of the architecture provide additional accents. Common elements, such as the architecture, which is depicted as a ruin reminiscent, in some of its details, of a Romanesque church, emphasize the connection. The dilapidated building could be an allusion to the synagogue, or "Old Church," in front of which Mary and the Christ child sit representing *Ecclesia,* the "New Church." The architecture, like a stage backdrop, sets the Adoration scene off from the landscape in the rear, in which we can see the arrival of the kings. In the middle, spatially the deepest and most remote section, a fully laden sailing ship approaches the land. On the left, horsemen from the retinue of the kings wind along a serpentine path, which finally leads through the ruin behind the balustrade toward the right, where Caspar, Melchior, and Balthasar have gone through a portal and mounted the stage. Beginning with illuminated manuscripts of the fifteenth century and then also in panel paintings, one of the kings, either Balthasar or Caspar, has been depicted as a black man.

The character of the two designs conforms to finished drawings, called *Visierungen* in German. These are not the initial designs, which on occasion the master drew sketchily, but picturelike finished ones, which closely approach the final version. On the one hand, they gave the patron a good idea of the final work and thus made it possible to take into account any desired modifications. (Instances of such corrections, carried out with the brush in white, may be seen on the wall at the left and on the roof structure at the upper right.) Alternatively, the renderings served as models for the workshop, which was usually charged with the execution of large altarpieces. Such requirements placed a limit on the freedom of the drawing: some of the drapery folds look as if they had been drawn with a ruler. Lines that have been accentuated by repeated and careful tracing contributed to the realization of the drapery and figures. In addition to the precise representation of details, of the purely objective, such a drawing provided the observer with a good idea of the composition, of the placement and mass of the figures on the surface. With the subsequently added wash, that is, the modeled rendering with the brush and the indication of light and shade, the figures finally received their spatial presence. In the case of our rendering, it is evident that Holbein employed color only in the background, in the landscape, but left the foreground architecture and figures largely in monochrome. The color of the landscape was originally more pronounced; it has now faded because of exposure to light. The contrast between color and monochrome does not just facilitate a clearer differentiation between foreground and background, but also offers the possibility of judging the arrangement of the main figures and their mass, as well as details of content, more neutrally and clearly, independent of any color arrangement in the final work. The use of colors for the figures was, much like the choice of pigments, a matter of further negotiation between patron and workshop.

The large format of the two designs also presented an opportunity to represent the physiognomy of the figures accurately. That Holbein paid especially close attention to this matter is shown by the numerous portrait drawings in his sketchbooks. They closely approach altar designs of this kind and size not only in technique, but also in scale.

Glaser first pointed out that Holbein was substantially influenced by the center panel of a triptych by Hugo van der Goes, the so-called Montforte altar (see ill.). This altar, which dates from the early 1470s, has been in Berlin since 1914, when it was purchased from the Montforte cloister in northern Spain. The patron and original location are not known. Holbein must have seen this altar during a journey through the Netherlands, which he may have undertaken about 1500. Winkler pointed out that

Hugo van der Goes, *Adoration of the Magi,* Montforte altar, c. 1470/1475

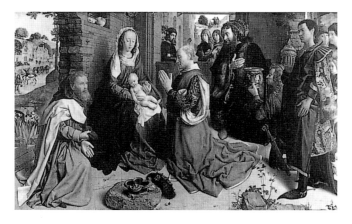

Holbein's design was probably inspired by at least one other work by Hugo van der Goes, namely another Adoration of the Magi. The connections with the Montforte altar are obvious, not only in main motifs and figures, but also in details, such as the chalice standing on a stone in the foreground and the crown, leaning against a stone, of the king kneeling before the baby Jesus. That Holbein definitely did not make a copy is demonstrated most of all by the independent composition, by the division of the event into two panels, by its narrative richness—despite the reduction of the still-life elements that are found in Hugo van der Goes' painting (such as omission of the representation of the ground, of plants, and so forth)—and, ultimately, by the altogether differently conceived faces (with their pronounced mimicry) making eye contact with each other. C.M.

31 First Silverpoint Sketchbook in the Basel Kupferstichkabinett, c. 1502

Basel, Kupferstichkabinett, U.XX. (1–20)

PROVENANCE: Amerbach-Kabinett

LIT.: Hp. Landolt 1960 – Beutler/Thiem 1960, 186f., 190 – P. Strieder, "Rezension Landolt 1960," *Zs. f. Kg.* 24 (1961), 88ff. – P. Strieder, "Hans Holbein d. Ä. zwischen Spätgotik und Renaissance," *Pantheon* 19 (1961), 98f. – Exh. cat. *Holbein d. Ä.* 1965, no. 73, no. 86f. – Landolt 1972, no. 18f. – C. Marks, *From the Sketchbooks of Great Artists* (New York 1972), 73ff. – Falk 1979, no. 174 – Krause 1997, 173ff.

Basilius Amerbach owned two sketchbooks by Hans Holbein the Elder. The so-called first sketchbook still gives an idea of the original appearance of the small book. The original covers have survived, but the binding of the pages is not authentic. Five single leaves were removed from the small volume in the late nineteenth and early twentieth centuries. Today it contains fifteen drawings, mainly figure studies and portrait drawings, some of these on both sides of a page. Seven other silverpoint drawings in the Basel Kupferstichkabinett also originally belonged to the sketchbook. They were removed from the volume early on, or else they were only loosely connected to it. For the most part the drawings are related to the high altar, completed in 1502 by Hans Holbein the Elder, for the Church of St. Mariä Himmelfahrt of the Cistercian cloister in Kaisheim near Donauwörth (today Munich, Alte Pinakothek). Most of the drawings must therefore date to about that time. Before Amerbach acquired the book, it was in the possession of the Basel painter Hans Hug Kluber (1535/1536–1578), who drew and wrote odds and ends in it.

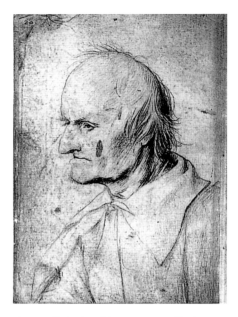

Hans Holbein the Elder, *Man in Profile, View to the Left,* fol. 1v, First Sketchbook, c. 1502

The second silverpoint sketchbook, which also comes from the Amerbach-Kabinett, was fully disassembled prior to 1833 (Falk 1979, 82f., nos. 175–185). It contained at least twelve sheets—drawn, for the most part, on both sides—that were almost exclusively portrait drawings. The drawings were probably made between 1512 and 1515. Falk estimated that the dimensions of the book were at least 141 by 107 millimeters. It was not possible to reconstruct the original sequence of the sheets.

Sketchbooks like the one described here were widespread in the fifteenth century. They were created for the personal use of the artist. The small format and the drawing technique, silverpoint, made it possible to carry such books everywhere and to make drawings as the need arose. With Holbein, portraits dominated the drawings, with occasional nature and plant studies, as well as figure compositions and detail studies of all kinds. With these the artist created a treasury of figures and forms on which he could draw at any time.

The large number of portrait studies in the Basel sketchbooks by Holbein, as well as among the drawings from a variety of sketchbooks in the Berlin Kupferstichkabinett, shows how much Holbein was interested in precisely this field. They are by no means part of commissions for painted portraits, which the artist prepared with a silverpoint drawing. Rather, he appears to have captured

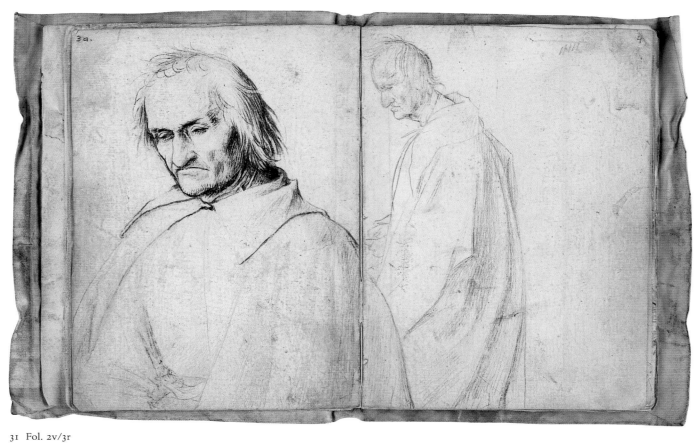

31 Fol. 2v/3r

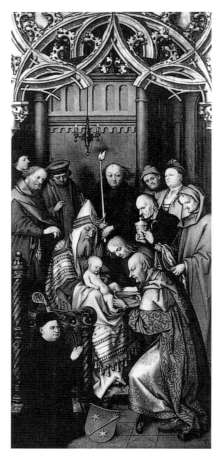

Hans Holbein the Elder, *Circumcision,*
Kaisheim altar, 1502

these people from life, following his own inclination.

How such drawings were used is shown by the silver-
point drawings of the first Basel sketchbook, for a series of
these are closely related to the 1502 high altar of the Kais-
heim monastery, near Donauwörth, which is today in
the Alte Pinakothek, Munich. Several heads that Holbein
had drawn in the sketchbook recur among the secondary
figures of the wings, as do details that go back to the study
sheet depicting feet and a book. From this it may be de-
duced that the drawings originated in or just before 1502,
the date of the altar's execution. On occasion, when exe-
cuting the paintings, Holbein introduced changes relative
to the drawing. These alterations confirm that the draw-
ings were definitely not based on the paintings, as could
have been the case. The idea could therefore occur that
studies of hands in particular positions, such as Holbein
drew, were not simply drawn after nature, but presumably

were made in view of a future application. For instance,
hands holding sticks often occur in paintings of the
Crowning with Thorns (see cat. 33).

A great many of the silverpoint drawings from Hol-
bein's sketchbooks, both from the Basel as well as from
the Berlin holdings, show revisions in black or gray pen,
with brush and black pencil. Others, the drawings from
the second Basel sketchbook and numerous Berlin sheets,
show revisions in red chalk and white heightening. That
Holbein himself made these changes in pen and chalk,
which are mostly encountered in the eyes, nose, and
mouth as well as in the contours, is hardly plausible.
Close examination shows that these interventions do not
help to define the features or to emphasize specific parts
of the faces or their structure. They often have an irritat-
ing effect or distort or obscure a facial expression. It is
difficult to tell what may have been the purpose of these
alterations, which are the work of several hands. Micro-
scopic examination shows that they were introduced not
in modern times, but most probably in the sixteenth cen-
tury. The most logical thesis is that collaborators in Hol-
bein's workshop or, more probably, later owners, made
these changes. These could have been young artists in
training, who copied individual drawings for practice, but
who also made changes to the original, especially when
some drawings had faded or been rubbed out. Nor is it
a convincing thesis that they are by the hand of Holbein's
son Hans while he worked in his father's shop. The late
portrait drawings by Hans Holbein the Younger in the
Royal Collection in Windsor Castle, which were primar-
ily created during his second English stay (see Exh. cat.
Holbein 1987), show similar changes, but most of these
can hardly be deemed to be autograph. It is therefore
impossible to draw conclusions related to the drawings
by Hans Holbein the Elder.

Drawing in silverpoint required a practiced hand.
Corrections on the specially prepared paper were nearly
impossible. The ground, which the painter often prepared
himself (it was usually made up of chalk, bone meal, and
binders), was necessary so that the metal tip of the stylus
would abrade during drawing.

FOL. 2V/3R: TOOTHLESS OLD MAN IN HALF LENGTH, IN THREE-QUARTER VIEW TO THE LEFT, c. 1502

Silverpoint and dark gray wash (by another hand?) on gray white prepared paper

c. 142 x 101 mm

LIT.: Glaser 1908, 68f. – G. Thiem, "Marienfenster des älteren Holbein," *Das Münster* 7 (1954), 354f. – Landolt 1960, 85f. – Falk 1979, with no. 174 – Bushart 1998, 153, ill. 6

The drawing continues onto the opposite page (fol. 3r), on which the man is depicted once more. Holbein drew him the first time on fol. 1v of the sketchbook (see ill.). He served as model for the man with the ointment jar in the Circumcision of the Kaisheim altar, where he appears with his head slightly more inclined (see ill.). The head was used a second time in the 1502 stained glass window depicting Mary in the mortuary of Eichstätt cathedral, specifically at the upper left of the right section, though he is there represented looking up. C.M.

32 PORTRAIT OF A MONK WITH DOWNCAST EYES, IN THREE-QUARTER VIEW TO THE LEFT, c. 1502

Basel, Kupferstichkabinett, Inv. 1662.187
Silverpoint on gray white prepared paper (both sides)
97 x 122 mm
Watermark: indecipherable
Parallel to the lower edge of the sheet, broken crease in the preparation

PROVENANCE: Amerbach-Kabinett

LIT.: Woltmann 2: no. 50 – His, VIII, pl. LXIV – Glaser 1908, 194, no. 96 – Landolt 1960, 120, no. 23 – Beutler/Thiem 1960, 190 – Falk 1979, 82

The drawing comes from the first silverpoint sketchbook. The sitter is most probably a Benedictine monk. Holbein depicted a monk in the same habit on fols. 10v and 11r of his sketchbook. Thiem (1960) drew attention to the use of the same model in the glass painting of the Last Judgment in Eichstätt cathedral, a work that was produced in 1502 after designs by Holbein. A similar monk with downcast eyes appears there among the blessed, to the right of the pole of the banner (ill. in Glaser 1908, pl. XXIV). C.M.

33 STUDY SHEET WITH SEVEN HANDS, c. 1502

Verso: small sketch of a pair of hands, c. 1502
Basel, Kupferstichkabinett, Inv. 1662.195
Silverpoint on blue gray prepared paper; verso, silverpoint
141 x 100 mm
Watermark: indecipherable
On the back *26* and *blass* (=blatt?) in Holbein's hand

PROVENANCE: Amerbach-Kabinett

LIT.: *Photographie Braun*, no. 78 – His, VIII, pl. LXII – Woltmann 2: no. 35 – Glaser 1908, 207, no. 220 – Schilling 1937, XII, no. 11 – Landolt 1960, 121ff., no. 25 – Lieb/Stange 1960, no. 143 – Falk 1979, 82 – Bushart 1987, 140, ill. 44 – Exh. cat. *Amerbach* 1991, *Zeichnungen*, no. 35

The drawing belongs to the sheets that were removed from the first sketchbook. Another drawing in the Basel Kupferstichkabinett, depicting three hands, most probably belongs in the same context (Landolt 1960, no. 26), even though that drawing was cut down and pasted, along with other drawings by Hans Holbein the Younger, into the so-called English Sketchbook (Kupferstichkabinett Basel, inv. 1662.200; see ill.). However, the annotations on it by Hans Hug Kluber, who owned the sketchbook of Hans Holbein the Elder for some time, stress the connection.

Six of the seven sketches of hands reappear in the panels of the Kaisheim altar. The studies may have originated with reference to depictions of the Passion of Christ. Thus the top hand, which holds a piece of cloth,

Hans Holbein the Elder, *Study of Three Hands,* 1502

32

33

Hans Holbein the Elder, *Crowning with Thorns, Ecce Homo,* and *Christ before Pilate,* Kaisheim altar, 1502

is nearly identical to a henchman's hand in the *Ecce Homo* panel. There the entire fist grabs Christ's cloak, while in the drawing a fold of fabric appears between the middle and ring finger of the hand. Such deviations contradict the idea that the drawings repeat motifs from the completed altar. The pointing hand in the lower right on our drawing occurs in the same panel with Pilate (see ill.).

The pair of hands holding a stick is used in the *Crowning with Thorns* with the almost absentminded bearded tormentor to the upper left of Christ. The other hand holding a stick appears with the almost absentminded tormentor whose hand is located immediately below the window frame. The fist at the lower left is found in the panel *Christ before Pilate,* with the man behind Christ.

<div align="right">C.M.</div>

34 BUST OF A YOUTH WITH LOWERED EYES, c. 1508

Basel, Kupferstichkabinett, Inv. 1662.192
Silverpoint on blue gray prepared paper; retouching by another hand in gray wash on the hair and facial contour
136 x 101 mm
No watermark
Upper left and lower right corners torn off; right, crease

PROVENANCE: Amerbach-Kabinett

LIT.: *Photographie Braun,* pl. 48 – Woltmann 2: 67, no. 43 – His, X, pl. LXXIV – Glaser 1908, 205, no. 203 – Hes 1911, 14 – Schilling 1937, XI, no. 9 – F. Thöne, *Die Malerfamilie Holbein. Selbstbildnisse und Bildnisse* (Burg bei Magdeburg 1942), 15, 23 (as Ambrosius Holbein) – G. Schmidt, "Hans Holbein d. Ä., Bildnis einer 34-jährigen Frau," *Öff. Kunstslg. Basel. Jahresb.* (1958), 101 (dated around 1518) – Exh. cat. *Holbein* 1960, no. 27 – Lieb/Stange 1960, 91, no. 155 – Falk 1979, no. 170

The depicted individual displays a certain resemblance to Ambrosius Holbein, as he is portrayed in both the Baptism scene on the basilica panel *S. Paolo fuori le Mura* of

34

1504 by Hans Holbein the Elder (Augsburg, Staatsgalerie; Bushart 1987, ill. on 98, detail on 8; see ill. to cat. 37) and the Berlin silverpoint drawing by Hans Holbein the Elder from 1511, which represents Hans the Younger and Ambrosius (see cat. 37). Judging by the age of the sitter, the drawing probably dates to about 1508. It is, however, impossible to identify the sitter as Ambrosius Holbein with complete certainty. Glaser has pointed to a related head in the 1508 drawing, *The Death of the Virgin,* in the Basel Kupferstichkabinett (Falk 1979, no. 165), a John the Baptist in this instance. The head served once more as a St. John in a depiction of the Death of the Virgin in a lost altarpiece for the St. Moritz Church in Augsburg, as demonstrated by the surviving designs, which are kept in Augsburg and St. Petersburg, pointed out by Falk (the sheet is described and illustrated in Hermann Boekhoff and Fritz Winzer, eds., *Das Grosse Buch der Graphik* [Brunswick 1968], 302, 312). C.M.

35 JAKOB FUGGER (JAKOB FUGGER THE RICH), C. 1509

Berlin, Kupferstichkabinett, KdZ 2518
Silverpoint on light gray prepared paper (both sides?); some pen and black ink and gray wash; touches of heightening in opaque white
134 x 93 mm
Watermark: indecipherable
Above in pen and brown ink *Jacob Furtger*; upper right, in black pencil *155*; upper left, a trimmed inscription; verso, in pen and black ink *Her Jacob fuger vo augspurgk*
Trimmed slightly on all sides and glued onto cardboard; later reworked in gray wash and pen and black ink; border added in pen and black ink

PROVENANCE: Von Nagler Coll. (Lugt 2529); acquired in 1835

LIT.: Woltmann 2: no. 118 – Weis-Liebersdorf 1901, 23, ill. 15 – Glaser 1908, 199, no. 138 – Bock 1921, 48f., no. 2518 – Lieb 1952, 267 (c. 1509), 411, ill. 184 – N. Lieb, *Die Fugger und die Kunst im Zeitalter der hohen Renaissance* (Munich 1958), 478f. – Lieb/Stange 1960, no. 263 – Exh. cat. *Dürer* 1967, no. 97

Holbein repeatedly portrayed members of the Fugger family in his sketchbooks. Two portrait drawings of Jakob Fugger the Rich are preserved in the Berlin Kupferstichkabinett: first, the one introduced here, of which a copy is kept in Copenhagen; and second, another that shows Jakob Fugger in profile, seen from the right (KdZ 2517). It is not clear whether these drawings were preparatory to painted portraits or whether they were done for study purposes. In any case, no paintings can be identified that are directly based on these drawings.

The Fuggers became the bankers of the Habsburgs thanks to their fortune, which they amassed mainly in the wool, silk, cotton, and spice trade as well as in mining enterprises, in which they played a leading role. They financed ventures such as the wars against Italy, France, and the Turks and, in 1519, the imperial election of Charles V. The family name gained its greatest renown under Jakob Fugger (1459–1525).

Judging from the age of the sitter, the Berlin drawing may date to about 1509. The same date applies to the Copenhagen copy of the drawing. To a greater degree than is immediately evident—that is, not only in the hat—the Berlin drawing shows changes, mainly executed in gray brush and black quill. The silverpoint seems to have been used very subtly and with great differentiation. Some strokes are now hardly visible, for instance around the eyes and lips, which only stand out clearly thanks to the additions in black pen and gray brush. A refined play of light and dark unfolds on the cheeks, brow, and fur collar. In some areas the extremely thin contours of the headdress show through the brushed-on wash. This refinement stands in clear contrast to the reworking of the drawing, which not only bestows greater presence on the sitter but also conveys an unpleasant harshness that imposes itself on the characterization of the person. There is much to suggest that these additions are by another hand. The copy of the drawing in the Royal Print Cabinet in

Hans Holbein the Elder, *Jakob Fugger the Rich,* 1509

35

36

Copenhagen goes one step further. This drawing, which was also worked over in pen and brush, is not only harsher in the corrections, but even in the use of the silverpoint. In addition, the draftsman favors a schematic approach. This is revealed by the widely spaced parallel hatching lines on the fur, to the right, as well as by the modeling of the face with sometimes hook-shaped strokes. Neither technique is found in the Berlin portrait. The question of who executed the Copenhagen drawing, which is signed with an x-shaped logogram next to the head—Holbein himself or a member of his workshop—cannot be pursued here (see ill.; see also the drawings in Copenhagen, Lieb/Stange 1960, nos. 202, 224, 226).

<div align="right">C.M.</div>

36 PORTRAIT OF A YOUNG MAN WITH A HAT, C. 1510

Berlin, Kupferstichkabinett, KdZ 2568
Silverpoint; brown wash; red chalk; heightened in lead white on gray prepared paper (both sides)
139 x 101 mm
Watermark: indecipherable
Lower right, *95* in black pencil; verso *168* and *2274* in black pencil
Trimmed on all sides; revisions in brush with brown wash and opaque white by another hand

PROVENANCE: Von Nagler Coll. (Lugt 2529); acquired in 1835

LIT.: Woltmann 2: no. 178 – Glaser 1908, 205, no. 189 – Bock 1921, 52, no. 2568 – Lieb/Stange 1960, no. 233

Holbein may well have created this portrait study during preparations for an altarpiece depicting the Crucifixion. The young man who looks up could have appeared there—in altered clothing—among the spectators. It is also possible that the sitter served as a model for a young St. John the Evangelist, standing below the cross. It has thus far proved impossible to find a direct use of this head in any painting by Holbein. The drawing must date to about 1510.

<div align="right">C.M.</div>

37 AMBROSIUS AND HANS HOLBEIN THE YOUNGER, 1511

Berlin, Kupferstichkabinett, KdZ 2507
Silverpoint on gray prepared paper, some black pencil and, on Hans' portrait, some touches of pen and black ink
103 x 154 mm
Watermark: indecipherable
Upper middle *1511*; above Ambrosius *[Am]bro[s]ÿ*; above Hans *Hanns* and *14*; center, below, connected to the names by arches *Holbain*; below *99* and *100* in pencil
Slightly trimmed on all sides and glued on cardboard; particularly abraded at the right; additions in black pencil and brush by another hand; traces of a later black borderline

PROVENANCE: Von Nagler Coll. (Lugt 2529); acquired in 1835

LIT. (selected): Woltmann 2: no. 107 – Weis-Liebersdorf 1901, 41ff. – Glaser 1908, 201, no. 153 – Hes 1911, pl. 1 – Bock 1921, 48, no. 2507 – H. Koegler, in: *TB* 17 (1924), 327 – H.A. Schmid, in: *TB* 17 (1924), 336 – E. Schilling, "Zur Zeichenkunst des Älteren Holbein," *Pantheon* 12 (1933), 315ff., 322, ill. on 320 – Lieb/Stange 1960, no. 237 – Exh. cat. *Dürer* 1965, no. 100 – *Handbuch Berliner Kupferstichkabinett* 1994, no. III.25 – Bushart 1998, 151, ill. 2

Among the numerous portrait drawings by Hans Holbein, the present double portrait demands particular attention because of the names of the sitters. Although the drawing certainly held a special importance for Hans Holbein the Elder, he assigned it a place in the sequence of other portraits in the sketchbooks, and the sitters are represented

Hans Holbein the Younger, Marginalia to *Praise of Folly,* with Hans the Elder (Brutus), Ambrosius (Caesar), and Hans the Younger (Anthony), 1515

37

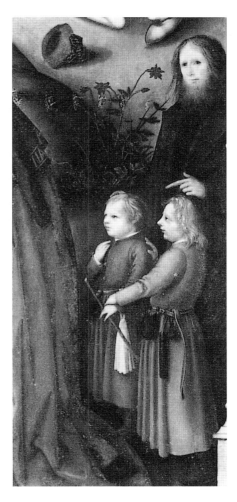

Hans Holbein the Elder, *S. Paolo fuori le Mura,*
1504

to emphasize that he recognizes Hans' great gift and sees him as his successor.

The divergent characters of Hans the Younger and Ambrosius were emphasized by later additions in black ink to Hans, which—perhaps more strongly than originally intended—change his glance and expression. The differences are more clearly apparent in the 1504 basilica panel, with an introspective Ambrosius and an open and determined little Hans, whose spirited temperament is calmed by father and brother.

Portraits of Hans Holbein the Elder, Ambrosius Holbein, and a self-portrait by Hans Holbein the Younger also occur in the marginalia to *Praise of Folly* by Erasmus of Rotterdam, from the year 1515 (see ill.). Hans may possibly be alluding to the sibling rivalry between himself and Ambrosius, for he depicts his brother as a king (Julius Caesar) and himself as a fool (Anthony), to whom Ambrosius turns lovingly, as he also does in the Augsburg painting (see Müller 1996, no. 83). C.M.

38 EMPEROR MAXIMILIAN ON HORSEBACK, c. 1510/1515

Verso: horseman in imperial procession,
c. 1510/1515
Berlin, Kupferstichkabinett, KdZ 2509
Silverpoint on gray prepared paper (both sides); touches of white heightening (by another hand?), especially on the reins, horse's bridle, and upper body
154 x 94 mm
Watermark: indecipherable
In red chalk *Der groß Kaiser maximilian;* lower left *151* in black pencil; verso, lower left, *109* in black pencil
Trimmed on all sides; ground flattened in places, especially at the upper and lower border; somewhat rubbed and soiled; yellow discoloration of the verso because of glue; abraded

PROVENANCE: Von Nagler Coll. (Lugt 2529); acquired in 1835

LIT.: Woltmann 2: no. 109 – Weis-Liebersdorf 1901, 23, ill. 12 – Glaser 1908, 198, no. 133 – L. Baldass, "Die Bildnisse Kaiser Maximilians I.," *Jahrbuch der kunsthistorischen Sammlungen des allerhöchsten Kaiserhauses* 31 (1913/1914), 247ff., 290 – Bock 1921, 48 – Schilling 1934, 13 – Schilling 1954, 14, no. 13 – Lieb/Stange 1960, no. 158 – Exh. cat. *Dürer* 1967, no. 98 – Exh. cat. *Kaiser Maximilian I.,* Innsbruck 1969, no. 567 – Bushart 1987, 19, ill. 7 – Exh. cat. *Hispania–Austria, Kunst um 1492. Die Katholischen Könige, Maximilian I. und die Anfänge der Casa d'Austria in Spanien,* Schloss Ambras (Innsbruck 1992), no. 161 – *Handbuch Berliner Kupferstichkabinett* 1994, no. III.24

with the same sobriety that characterizes most of his portraits. Only the inscriptions, which specify age and name, betray the personal interest of the painter for the sitters.

Hans Holbein the Younger was fourteen years old when this drawing was made in 1511, as is evident from the inscription added by the father. Hans was probably born in the winter of 1497/1498, and Ambrosius, probably in 1494 or 1495; the inscription indicating his age is no longer legible. Further portraits of Hans the Younger and a self-portrait are found on the so-called basilica panel *S. Paolo fuori le Mura,* completed in 1504, now in the Staatsgalerie in Augsburg (see ill.). In the left picture are three reverential witnesses of the baptism of Saul. Hans the Elder places his right hand on Hans' head and points to him with the index finger of his left hand, as if he wishes

Without the inscription, which must be in Holbein's hand, it would hardly be possible to identify the equestrian

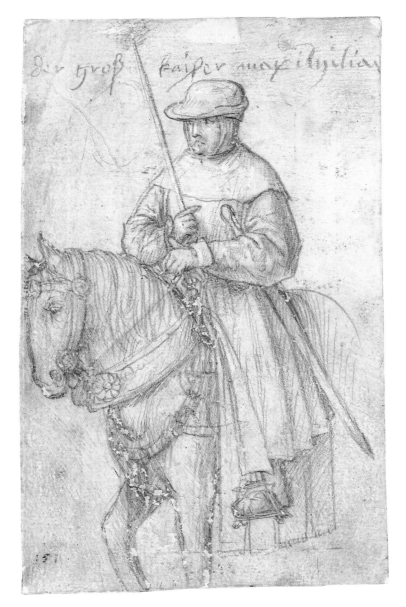

38

as Emperor Maximilian I. The figure wears simple garb, probably a traveling or hunting cloak, and a hat. He is armed with a sword, possibly a hunting sword or a "hand-and-half sword" that hangs at his side. With the reins in his left hand, his right holds a stafflike object whose upper end terminates in a hastily sketched, tufted blossom. This object could be a scepter, which would underscore the identification of the sitter, but it could also be a standard that continues upward and has a shaft decorated with cloth or cords. The bridle and stirrups of the horse are rendered with care. The meaning of the right-hand gesture, with the extended index finger, remains unclear. It could be intended for an attendant of Maximilian, just as his glance to the left suggests a dialogue with a person next to him. Directly in front of Maximilian we can discern a head, which is only indicated in very thin outlines. The sketchily indicated hindquarters of the horse may possibly denote that the drawing was done in a great hurry and was based on direct observation. We can discern the first indications of the outline of rider and horse, as Holbein attempted to grasp the form, and then the more powerful and broader lines that accentuate the contours and interior structure of the figure. The impression of a sketch concentrating on the head and gestures of the rider dominates. It is only slightly limited by the indications of a narrative context.

The drawing may have been created in Augsburg, which the emperor visited often and where he participated in imperial diets. Probably Holbein once witnessed the emperor's arrival after a long journey or a hunting expedition. Maximilian I (born 22 March 1459; elected king of the Romans in 1486; proclaimed Holy Roman Emperor in Trent cathedral in 1508; died 12 February 1519) maintained regular contacts in Augsburg with the Fugger family, especially with Jakob Fugger II, called "the rich," who greatly supported the emperor's enterprises by granting him large loans.

The rider sketched on the verso is also seen from a high vantage point and probably belongs in the same context. He could be a member of the emperor's retinue. He too holds a staff in his hand. The type of head and headgear remind us of Holbein's portrait studies in the Berlin Kupferstichkabinett, which, according to the old but not autograph inscriptions, represent Kunz von Rosen (c. 1455–1519), who had served Maximilian from 1478 (see Lieb/Stange 1960, no. 257, no. 272; Bock 1921, 48; KdZ 2511f., pl. 63).

The drawing has generally been dated, without additional evidence, to the period between 1508 and 1513.

Even if there is no concrete historical event on which to hinge a date, the style and connection with the Berlin sketchbook sheets suggest a genesis date of about 1510/ 1515. The Berlin silverpoint drawings, coming from several sketchbooks, have yet to be examined closely enough to allow the proposal of a more precise date. C.M.

39 PORTRAIT OF A YOUNG GIRL, "ANNE," 1518

Basel, Kupferstichkabinett, Inv. 1662.207
Silverpoint on white prepared paper; face partially gone over with pen and black ink
218 x 159 mm
Watermark: walking bear (fragment, possibly Briquet 12268)
Upper right, inscribed and dated *ANNE/1518*
Mounted on 18th-century paper; surface soiled in spots; left and below, original paper edge visible

PROVENANCE: Amerbach-Kabinett

LIT.: Woltmann 2: 93, no. 6 (Ambrosius Holbein) – *Handz. Schweizer. Meister,* pl. III, 6 – Frölicher 1909, 15 – Hes 1911, 113ff. – Chamberlain 1: 61 – Koegler 1924, 329 (Hans Holbein the Elder) – Schilling 1934, XVII, no. 50 (Ambrosius Holbein) – Exh. cat. *Holbein* 1960, no. 75 – Lieb/Stange 1960, 113, 298 – Bushart 1977, 62 – Landolt 1961 MS, 96 – Falk 1979, no. 173 – Bushart 1987, 52, ill. 36 – Exh. cat. *Amerbach* 1991, *Zeichnungen,* no. 41 – Bushart 1998, 159, ill. 18

The portrait drawing of a young girl wearing a scarf around her head, in the Basel Kupferstichkabinett (Falk 1979, no. 172, see ill.), and the portrait of Anne are, compared to other silverpoint drawings in Basel by Hans Holbein the Elder, unusual for the artist. This is true of the format, the sketchy treatment of the body, as well as the ample and freely drawn strokes of the portrait of Anne. For this reason, the attribution to Hans the Elder did not come easily—Ambrosius and Hans Holbein the Younger have also been proposed as authors. Hans Koegler was the first to attribute the drawings to Hans the Elder. He recognized in them a late stage in the master's development, expressed in a free and painterly style. This proposition appears to be the most convincing, for the drawings hardly present the reticent and somewhat shy appearance of the sitter, as may be encountered with Ambrosius, even though there is a certain similarity to the painterly, soft modeling that marks Ambrosius' portraits (see Müller 1996, no. 2f.). With Hans the Younger, however, we recognize a more precise rendering of contour lines, which suggest spaciousness. The less pronounced

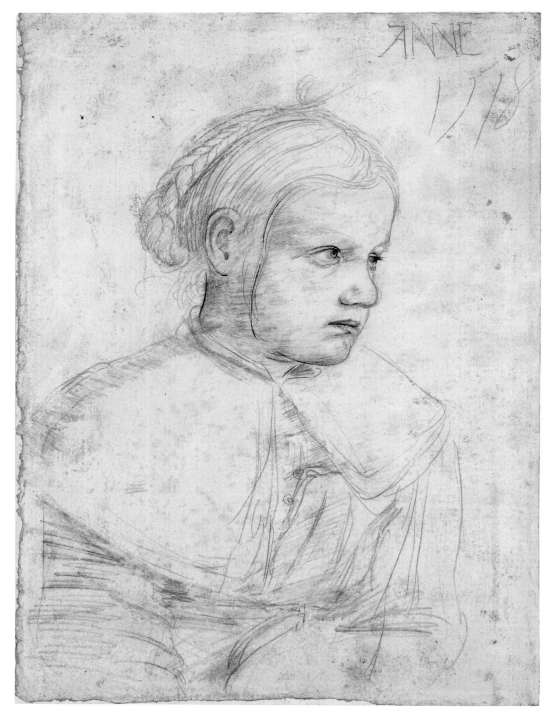

39

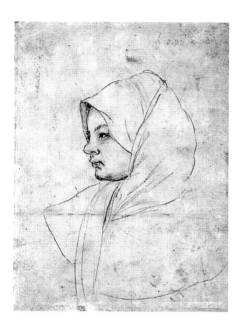

Hans Holbein the Elder, *Portrait of a Young Girl,*
c. 1518

left-handedness expressed by the direction of the strokes
also contradicts an attribution to Hans the Younger.

The facial expression of the girl was substantially
influenced by later alterations in black ink to the eyes,
mouth, and hair, which can hardly be by Holbein
himself (see cats. 34, 35, 37). C.M.

HANS BURGKMAIR
THE ELDER
(Augsburg spring 1473–1531 Augsburg about midyear)

Son of painter Thoman Burgkmair, a pupil of Hans
Baemler. After initial instruction from his father about
1489/1490, became a pupil of Martin Schongauer in
Alsace. After his return to Augsburg, his extensive activity
as a designer of woodcuts for Augsburg publishers began
with his work for the printer Erhardt Ratdolt.

Married on 3 July 1498. Matriculated as a painter
on 29 July 1498. Purchased his own premises in 1501.

From 1501 to 1504 participated with Hans Holbein
the Elder in a cycle of paintings for the chapter room of
the Dominican cloister of St. Catherine in Augsburg.
Journey to the Lower Rhine in 1503. As of 1504, associ-
ated with the poet Conrad Celtis. Thanks to the media-
tion of Konrad Peutinger, commission for an altar for the
castle church of Wittenberg, delivered in 1505. In 1507
possibly journeyed to Italy, with a stay in Venice.

In 1508 first colored woodcuts on commission from
Peutinger *(St. George, Equestrian Portrait of Emperor Maxi-
milian I),* serving as introduction to extensive activity
as designer for the emperor: 97 ancestral portraits for the
Genealogy of the Habsburgs, 118 woodcuts for the *Weiss-
kunig,* 13 for *Theuerdank.* In 1516 granted a coat of arms
in recognition of his performance. From 1516 until 1518
work on the *Triumphal Procession of Emperor Maximilian.*
From 1518 until 1522 again primarily active as a painter—
St. John altar (center panel) and Crucifixion altar (both
altars, Munich, Alte Pinakothek)—then renewed involve-
ment with woodcuts (21 apocalypse illustrations and
11 initials for Martin Luther's translation of the New
Testament, Augsburg: Silvan Otmar, 3.21.1523). From
1524 to 1527, large-scale woodcuts with religious themes.
From 1528 to 1529, last paintings.

As draftsman, Burgkmair had a share, in 1515, in three
pen-and-ink drawings for the decoration of the Prayer
Book of Emperor Maximilian I. In his early years he used
drawings to help capture reality; on his journey to the
Lower Rhine, for retaining foreign pictorial concepts;
and later, for the preparation of his own works.

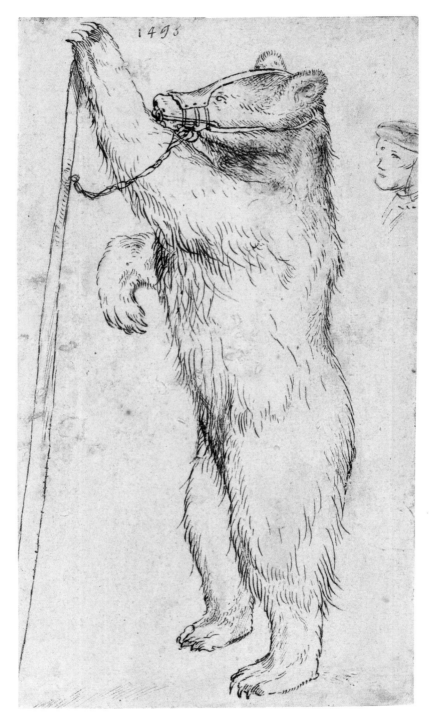

40

40 DANCING BEAR, 1496?

Berlin, Kupferstichkabinett, KdZ 26076
Pen and brown ink; reworked in places with pen and dark gray ink; light wash on right ear, neck, hind legs of bear, and on bear tamer's cap
249 x 138 mm
No watermark
Upper edge, inscribed *149.* in the same dark gray ink (the last numeral damaged); upper left, remnants of writing
Paper surface damaged on the left edge and in the center; losses partially restored; sheet trimmed on all sides; lining discolored brown and water stained, damaged in the center (glue with remnants of color visible on the verso); sheet presumably once glued to a wood tablet at the edges

PROVENANCE: private collection, Paris; Ludwig Rosenthal, Bern; L. V. Randall, Esq.; auction Sotheby's & Co., 5.10.1961; Kupferstichkabinett Berlin (inv. no. 85-1961, verso, rectangular stamp of the Kupferstichkabinetts Berlin-Dahlem)

LIT.: E. Schilling, "Hans Burgkmair the Elder (1473–1531). A Performing Bear," in: *Old Master Drawings* 11, 42 (September 1936), 36, pl. 30 – Exh. cat. *Masterpieces of Drawing*, 1950, no. 23 with ill. – Auct. cat. Sotheby's & Co.: *Catalogue of Important Old Master Drawings. The Property of L. V. Randall, Esq. of Montreal*, part 1, 5.10.1961, 5, no. 3 with ill. – T. Falk, "Zu Burgkmairs Zeichnung des Tanzbären," *Berliner Museen. Berichte aus den ehem. preussischen Kunstsammlungen*, n.s. 12, 1 (1962), 1–3 – Halm 1962, 117f. with ill. 50, 156, n. 93, 160 – F. Anzelewsky, "Hans Burgkmair," *Apollo* 80 (8.1.1964), 150, ill. 5 – F. Winzinger, "Unbekannte Zeichnungen Hans Burgkmairs d. Ä.," *Pantheon* 25 (1967), 12–19, esp. 16f., ill. 6 – Falk 1968, 23, 91, n. 111f. – F. Anzelewsky, in: Exh. cat. *Neuerworbene und neubestimmte Zeichnungen* 1973, no. 18 with ill. – Koreny 1985, cat. no. 4 with color pl. – T. Falk, "Naturstudien der Renaissance in Augsburg," *Jahrbuch der Kunsthistorischen Sammlungen in Wien* LXXXII/LXXXIII, n.s. 46/47 (1986/1987), 79–89, esp. 80f. – G. Seelig, in: *Handbuch Berliner Kupferstichkabinett* 1994, no. III.49 with ill.

Ever since its publication by Edmund Schilling, this drawing, which is not signed, has been solidly placed within Burgkmair's oeuvre. The date at the upper edge, just to the left of center, written in the same ink used to rework the drawing in several sections,[1] is considered to be autograph. The damaged last numeral leaves only a little room for discussion of its date.[2] As a consequence, the drawing is one of the earliest surviving studies from north of the Alps of a living animal.[3]

As such, one would expect a silverpoint drawing, not a drawing in pen and ink, which one can barely imagine being done at an annual fair, where dancing bears could be seen on occasion. Burgkmair was probably able to draw the animal when the bear tamer, who was hauling the animal through the streets, stopped at his parental

home and, letting go of the shaft that was chained to the animal's muzzle, had the bear stand on its hind feet as a thank-you for donations. The artist observed the bear from an open window on the ground floor and recorded his appearance on paper. There was only a small distance between him and the furry creature; therefore its upper body, seen from just below, seems especially massive, while the paws of the hind legs were viewed from above.

The draftsman had to work quickly. He composed the outlines of the bear with many small, slightly arched pen strokes, without preparation in silverpoint. These strokes vary in length and spacing, evoking the impression of short- and long-haired patches of fur. The economy of the pen work is altogether admirable. With a seemingly minimal effort, the artist captured the huge animal as it raised itself full-length on the thin pole. The head of the bear trainer establishes the scale.

The spontaneity of this study after nature is convincing even though minor details were not precisely observed because of the necessary haste.[4] The head of the bear claimed most of the draftsman's attention. We owe this drawing, which is based on the direct observation of nature, to Burgkmair's interest in the migrant gypsies who traveled through middle Europe at the end of the fifteenth century. Although genre scenes were popular at the time,[5] Burgkmair avoided a genrelike treatment of the subject here.

It is hardly surprising that, as Tilman Falk established, this convincing rendering of an animal was still reproduced in the middle of the seventeenth century in a scientific work, together with sixteenth-century representations of animals, including Dürer's *Rhinoceros*. Burgkmair's bear, however, appears as only one of two animals held on a chain by the bear trainer.[6] R.K.

1. See, especially, the head, neck, back, and right hind leg of the bear as well as the tip of the pole.

2. 1493: E. Schilling; 1495: F. Winzinger; 1496: H. Möhle, F. Anzelewsky, P. Halm, T. Falk, F. Koreny; possibly 1498: E. Schilling, T. Falk, G. Seelig.

3. Albrecht Dürer had left for Italy in 1494, where the strange sea creatures of Venice fascinated him so much that in 1495 he captured lobsters (cat. 51) and crabs (Strauss 1495/22) in life-size pen drawings with wash that, beyond the actual appearance of the animals, convey something of their individuality. After Dürer had painted his renowned *Hare* of 1502 in watercolors and opaque paints, he did a study of a hare in pen and ink: London, The British Museum, Department of Prints and Drawings, inv. Sloane 5218-157; ill. in Koreny 1985, 135, no. 42. As with Burgkmair, the loose style of drawing was necessitated by the rapidly changing position of the animals. Dürer used this study in 1504 for his engraving *The Fall of Man* (Hollstein German 1). In 1521 Dürer

drew a sketchbook sheet with many animals in the Brussels zoo: Williamstown, Sterling and Francine Clark Art Institute, inv. 1848; ill. in Koreny 1985, 167f., no. 57.

4. Only three of the five toes of the bear paw are drawn.

5. For instance, foot soldiers, musicians, and peasant couples.

6. J. Jonstonius, *Historia Naturalis de Quadrupedibus* (Frankfurt am Main, heirs of Matth. Merian, n.d. [c. 1650]), pl. LV.

41 CHRIST ON THE MOUNT OF OLIVES, AFTER 1507

Berlin, Kupferstichkabinett, KdZ 4068
Pen and brown black ink over pencil
233 x 199 mm
No watermark
On the upper cornice of the base, monogram *HB*; on the sides of the base, coats of arms of Bernhard Rehlinger and his spouse Richardis, born Misbeck; verso, center, at the height of the upper cornice of the base, *10 –* in thick black pen; below, to the left, in thin pen *hance hollbean* and two lines of writing covered in opaque white, on top of which, in thick black pen *6 –*; above, to the left, collector's mark (Lugt 1610) with acquisition number 272-1897; under the stamp over erased handwriting in pencil *Hans Burckmair*
Trimmed to edges of the base
Wormhole at lower right of the base

PROVENANCE: acquired 1897 from Amsler & Ruthardt, Berlin

LIT.: J. Springer, *Zwanzig Federzeichnungen altdeutscher Meister aus dem Besitz des königl. Kupferstichkabinettes zu Berlin* (Berlin 1909), pl. XI – *Zeichnungen* 1910, no. 173 (IV.G.) – H. A. Schmid, in: *TB* 5 (1911), 253 – Rupé 1912, 67, n. 1 – G. Pauli, "Die Sammlung Alter Meister in der Hamburger Kunsthalle," *Zs. F. bildende Kunst,* n.s., 31 (1920), 183 with 2 ill. – Bock 1921, 18, pl. 23 – C. Koch, *Zeichnungen altdeutscher Meister zur Zeit Dürers* [Arnolds Graphische Bücher, 2d series, vol. 3] (Dresden 1922), 28, ill. 51; 2d ed. 1923, 24f., ill. 52 – K. T. Parker, "Weiteres über Hans Burgkmair als Zeichner," *Augsburger Kunst der Spätgotik und Renaissance,* ed. E. Buchner/K. Feuchtmayr (Augsburg 1928), 208–223, esp. 218 – Exh. cat. *Burgkmair* 1931, no. 34 – Exh. cat. *Handzeichnungen Alter Meister* 1961, 13 – Halm 1962, 118 – Falk 1968, 26, 37f., 43–45, 90, n. 102, ill. 22 – Mielke 1988, no. 219 with ill.

In 1909 Jaro Springer proposed that this drawing was a study for a fragment of a panel painting, inscribed *H. BVRGKMAIR BINGEBAT 1505,* that was then in the Weber collection in Hamburg and, in 1912, in the Hamburger Kunsthalle.[1] Only in 1968 did Tilman Falk refute this connection, for by then an additional fragment of the altarpiece had turned up in an Italian private collection.[2] It shows the group of hunched-up, sleeping apostles at the far left, in the middle ground of the picture. In addition

Falk thought that 1505 was too early a date for the Berlin drawing in view of its developed style and the Renaissance form of the base. The general configuration of the drawing, as well as the placement of the figures in the landscape, strongly suggest exposure to north Italian art, which Burgkmair must have seen in 1507 during his visit to an exhibition of reliquaries (9 May 1507) in the town hall in Tirol. The base of the Berlin drawing has its counterpart in a Venetian throne bench in a 1609 painting of the Virgin and child, in the Germanisches Nationalmuseum in Nuremberg.[3] The arched top of this work was also planned for our Mount of Olives in Berlin. This work probably came about in connection with a commission from an Augsburg patrician family, the Rehlingers, whose coat of arms is located at the left of the base. According to Feuchtmayr, the coat of arms at the right belongs to the Misbeck family of Alsace. The two families became connected in 1503 through the marriage of Bernhard Rehlinger and Richardis Misbeck.[4]

The depiction of the Mount of Olives is highly unusual for an independent altar painting, whereas it is familiar as a subject in Passion altars. In the context of fifteenth-century mysticism, it was also painted as a single *Andachtsbild* (a devotional picture intended for close contemplation), which was intended to help believers immerse themselves in the suffering of Christ. That is why the Savior was always shown in fear of death, as is the case with Burgkmair's panel dated 1505, in which the bloody sweat runs from his face, hands, and knees. That Burgkmair adapted the type for his Christ, who kneels against a stone face while leaning on a stone block, from a Passion altar is proved by a sketchbook leaf in the Würzburg University Library.[5] Where he saw this altar has yet to be explained.

The Berlin design repeats the figure of Christ in every detail except for the position of the head, which is here tilted into pure profile to make the open cleft of the rock wall more clearly visible, so that one can almost hear Christ cry out. Peter, who wakes from his sleep, reaches for his sword and stares at the angel open mouthed, while John, who is the only one of the three apostles without a halo, sleeps soundly in the left foreground, supported by a low wall. James, in the middle ground, has also nodded off. In the background, a soldier appears at the garden gate. His weapon, depicted diagonally, ties together the foreground and the background.

The drawing depicts a design for an *Andachtsbild* that was probably intended for a Rehlinger family chapel in an Augsburg church. St. Peter, who has woken up only just in time and, astounded, observes the angel carrying a cross

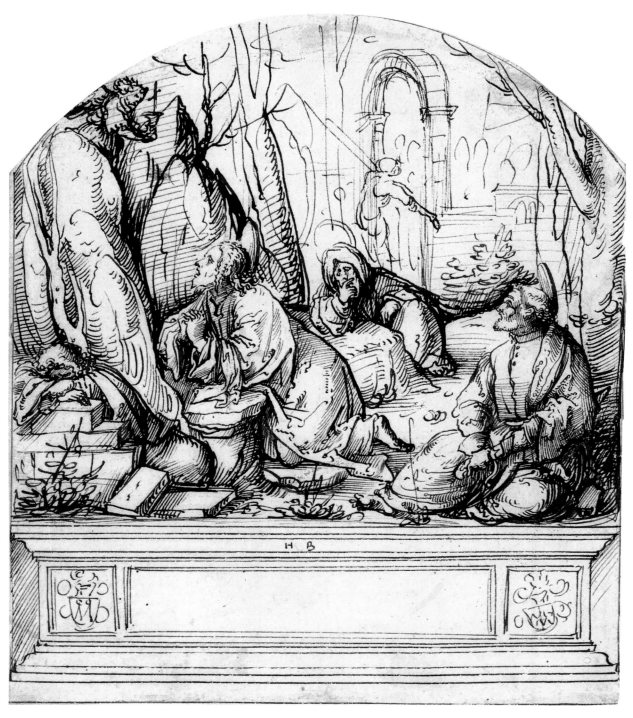

41

and chalice, has become witness to the atonement offered by God, in which only those who believe can partake.

It is unlikely that the central area of the base was actually intended to remain empty. In 1524 Burgkmair added the following prayer to a space, comparable in shape to this base, found in a Mount of Olives scene on one of his large-size woodcuts: "Oh Lord Jesus Christ, for Thou poured forth bloody sweat on the Mount of Olives, when Thou contemplated thine fearful sorrow [and] death and our great ingratitude, make our will always conform to thy Godly will. Amen" (in translation).[6] This prayer reveals the meaning and function of the kind of *Andachtsbild* that was used by the Rehlingers. R.K.

1. In Lemberg before 1886, "Vereinigte Gesellschaft der Schönen Künste," *Kunstchronik* 21 (1885/1886), no. 38, 1 July, cols. 647/648; no. 39, 15 July, col. 663; 1886–1912 Weber Coll., Hamburg; Auct. cat. Rudolph Lepke (Berlin 1912), no. 45; Hamburger Kunsthalle, inv. no. 394; Exh. cat. *Burgkmair 1931*, no. 7, ill. 18.

2. E. Buchner, "Der Meister des Seyfriedsberger Altars und Hans Burgkmair," *Zs. f. Kwiss.* 10 (1956), 35–52, esp. 43–46, ill. 8.

3. Nuremberg, Germanisches Nationalmuseum, property of the city of Nuremberg, inv. no. 1; Exh. cat. *Burgkmair 1931*, no. 12, ill. 26.

4. According to Falk 1968, 90, n. 102.

5. Halm 1962, 85f., ill. 12, in a picture album from Ebrach monastery.

6. "O Herr Jesu Christe, der Du an dem Ölberg hast blutigen Schwaiß / vergossen, als Du deien ängstlichen Schmertzen, Tod und unser große / Undanckbarkeit betracht hast, mach unsern Willen allzeit gleich zu ordnen deinen göttlichen Willen. Amen." Exh. cat. *Hans Burgkmair. Das graphische Werk* (Augsburg 1973), no. 146, ill. 117 – Exh. cat. *Hans Burgkmair 1473–1531. Holzschnitte, Zeichnungen, Holzstöcke*, Staatliche Museen zu Berlin (Berlin 1974), no. 51.1, ill. on 88.

Circle of Hans Burgkmair the Elder

42 Harnessed Horse and Rider, Three Views, 1510

Verso: horse's harness, three details
Berlin, Kupferstichkabinett, KdZ 65
Pen and brown ink
313 x 426 mm
Watermark: imperial orb (similar to Briquet 3074)
Lower right, false monogram *A D* by front saddlebow detail; upper right, underlined *maximilian(us). 1510 / kaysser zuten (?) kopf* above details of a Burgundian helmet; an illegible inscription to its left; by rider's right knee plate, front view *oben / gresser*; lower edge *I* (right) and *II* (left) penciled by another hand; verso, left edge *12 st ck 2*; left of center fold *54 stück gerissen 20* Trimmed on all sides; halved by sharp vertical center fold; center fold and upper and lower edges discolored by dust; paper spotted; several small tears at the edges, especially where missing areas were repaired; upper right corner damaged; verso, on the fold, traces of glue

PROVENANCE: old inventory (verso, collector's mark, Lugt 1606)

LIT.: *Dürers Handzeichnungen im Königlichen Museum zu Berlin*, 2d part (Nuremberg 1871), with photolithographic reproduction of the recto (Berlin KdZ 65) in original size on two sheets – Ephrussi 1882, 217f. and 256 – Frans Wickhoff, "Review of Ephrussi 1882," *Zs. f. bildende Kunst* 17 (1882), 218 – Bock 1921, 35 – Halm 1962, 128–130, ills. 66 and 67 – Fedja Anzelewsky, "Ein unbekannter Entwurf Hans Burgkmairs für das Reiterdenkmal Kaiser Maximilians," in: *Festschrift für Peter Metz* (Berlin 1965), 295–304, with 5 ill. – Falk 1968, 77f.

Because this sketch sheet was published with a selection of Dürer's drawings in 1871, the quatercentenary of his birth, Ephrussi (1882) included it in his compilation of the master's drawings, though not without pointing out that Dürer drew on Burgkmair's 1508 woodcut *Emperor Maximilian* for the head of the emperor. Wickhoff (1882) responded that the sheet shows Burgkmair's hand, not Dürer's. Although Bock (1921) placed it with works after Dürer, he did observe that the drawing might be after Burgkmair, given the similarities to his woodcuts *St. George* and the aforementioned *Maximilian*. Ignoring this interpretation, Halm (1962) gave the sheet to Burgkmair based on a comparison to his 1508 *Maximilian* woodcut and to his drawing, located in the Albertina, for the emperor's equestrian monument, which was planned for the space next to the choir of the Augsburg Benedictine church of Sts. Ulrich and Afra. He saw the "thin and loosely sketched Berlin study" and the "perfectly finished modello in Vienna," which he dated to 1509/1510, as the two poles in Burgkmair's range as a draftsman. Anzelewsky (1965) interpreted the sheet as an unknown design

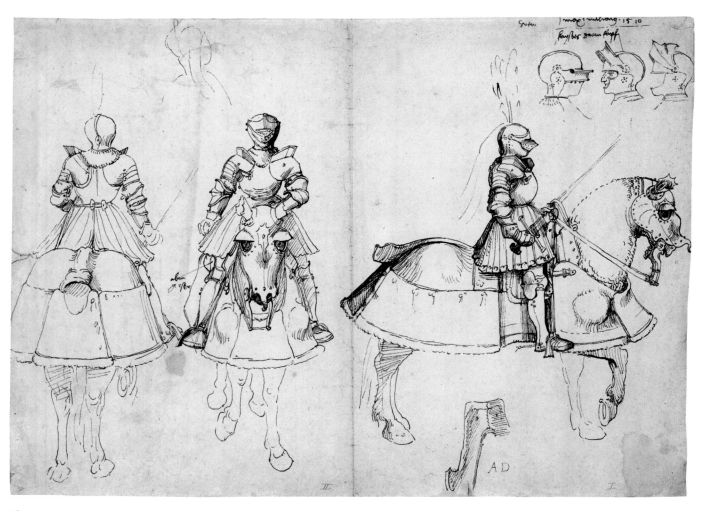

by Burgkmair for this monument. Falk, however, declined to accept the sheet as an autograph work by Burgkmair, "though it may belong within his circle."

I am not able to think of these sketches as designs. They must be studies prepared in an armory, as they show a wooden horse as support for the harnesses of a horse and its rider. The animal lacks the characteristic muzzle of a horse as well as the long tail, whose sleeve in the horse's harness is visible in four of the sketches. The draftsman was apparently interested in the appearance of the rider, as well as parts of the armor, from various viewpoints. The sketches were probably preparatory studies for a sculpture. The helmet sketches at the upper right depict three different helmets: one with closed visor (left) and two with open visors (right). The addition of a portrait of Emperor Maximilian I, complete with inscription, to the center helmet helps clarify the purpose of these sketches. The monogram *A D*, which has nothing in common with Dürer's monogram, presumably stands for Adolf Daucher the Elder, Gregor Erhart's brother-in-law—whom the emperor entrusted with the execution of the Augsburg equestrian monument—or else for Daucher's eldest son, Adolf the Younger, who, born about 1485, was probably active in the Daucher workshop until his father's death.

R.K.

ALBRECHT DÜRER
(Nuremberg 1471–1528 Nuremberg)

Painter, engraver, designer for woodcuts and decorative arts, and art theoretician.

Son of the goldsmith Albrecht Dürer the Elder. Beginning in 1486, after being trained in his father's craft, he underwent an additional three years of instruction as a painter in the workshop of Michael Wolgemut. The student travels (*Wanderjahre*) followed, taking him to the Upper Rhine and elsewhere. In 1491/1492 he was in Basel; in 1492 he reached Colmar, where he hoped to meet Martin Schongauer, who had died the year before. After Pentecost of 1494 he returned to Nuremberg and married Agnes Frey in July. Before year's end he set out on his first journey to Venice, where his encounter with the art of the Italians—Mantegna, Giovanni Bellini, Pollaiuolo—channeled his artistic development into new paths. In 1495, by then a master, he settled down in his native city of Nuremberg and devoted himself to the graphic arts, which spread his fame well beyond the frontiers of Germany in the following years. His involvement with theories about human proportion may be dated to the years shortly before 1500, and related issues occupied him to the end of his life. From 1505 to early 1507 he traveled to Italy a second time. In Venice he painted the *Adoration of the Holy Rosary*, an altarpiece for the Church of St. Bartholomew, on commission from German merchants and the Fugger family. From Venice, he undertook journeys to Bologna, Florence, and, probably, Rome. In the years following his return home from his second Italian journey he received important commissions for paintings (Heller altarpiece, Landau altarpiece), as well as major graphic commissions from Emperor Maximilian I, namely the *Triumphal Arch* (1515–1517) and the *Triumphal Procession* (1516–1518). In 1519 Dürer traveled to Switzerland and, in 1520/1521, together with his wife, to the Netherlands. The journey to the Netherlands is well documented thanks to a journal and sketchbook. He devoted the last years of his life mainly to preparation of his theoretical writings (*The Teaching of Measurements*, 1525; *The Art of Fortification*, 1527; *Four Books on Human Proportions*, 1528, published posthumously).

Dürer's drawn oeuvre comprises more than one thousand sheets. His substantial written works allow a unique insight into his personality and thinking. His far-reaching interests and his unlimited creative drive characterize him as a Renaissance artist in the most comprehensive sense.

43 MADONNA AND CHILD ENTHRONED WITH TWO MUSIC-MAKING ANGELS, 1485

Berlin, Kupferstichkabinett, KdZ 1
Pen and brown ink; flesh tones tinted slightly red with
watercolor; oxidized white heightening
210 x 147 mm
No watermark
Lower center, monogram *Ad*; dated below, under the framing
line *1485*

PROVENANCE: Posonyi-Hulot Coll. (Lugt 2040/41); acquired
in 1877

LIT.: Posonyi 1867, 47, no. 306 – Ephrussi 1882, 4 – Thausing
1884, 59 – Friedländer 1896, 18 – Lorenz 1904, 7f. – Dornhöffer
1906, 84 – Heidrich 1906, 8 – Weisbach 1906, 15 – Weixlgärtner
1906, 88 – Seidlitz 1907, 3 – Stadler 1913, 223 – Bock 1921, 21 –
Weinberger 1921, 113 – W. 18 – Waetzoldt 1950, 123 – Musper
1952, 214 – Winkler 1957, 9 – Exh. cat. *Dürer* 1967, no. 17 –
Winzinger 1968, 170 – Anzelewsky 1970, no. 2 – Strauss 1485/1
– Anzelewsky/Mielke, no. 1 – Exh. cat. *Dürer* 1991, no. 1 – K.
Achilles-Syndram in: Exh. cat. *Das Praunsche Kabinett* 1994, no. 5

No one has ever questioned that this highly finished
drawing is a work by the fourteen-year-old Dürer.
Upon closer examination of the drawing, however, the
question arises if it is an independent invention of the
young Dürer or a more or less free translation of a model.

As a direct model has not been identified, scholars
have repeatedly referred to related compositions—panel
paintings by Hans Memling and Gerard David as well as
an engraving by Master E.S.[1]—which proves that Dürer
adopted a ubiquitous Dutch and German type for his
depiction of the Virgin. Today a majority of scholars are
inclined to accept a Nuremberg work, or even one from
the circle of Wolgemut as the inspiration behind the
drawing of 1485.

The exceptionally great variation in the width of
the lines, from hair-thin to broad; the covering of the
surfaces with delicate parallel hatching or energetic cross-
hatching, which results in a rich variety of steps between
the darkest dark and the brightest light reflections; and the
characterization of curves with hooks are hallmarks of
the drawing technique that the young Dürer learned from
engravings by Martin Schongauer.

Even though Schongauer's prints provide no direct
iconographic model, several motifs from Schongauer's
two versions of the Coronation of the Virgin (B. 71f.)—
the podium with its round projection and monogram;
the throne parallel to the picture plane, whose side pieces
recede steeply; the way her hair is drawn—must have
been of genuine interest for Dürer's composition. How-
ever, Schongauer's Virgin in the crook inside the top

Martin Schongauer, *Bishop's Crosier,* c. 1480

of a bishop's crosier (B. 106; see ill.) seems to have had
a particularly strong influence on the central figure of
Dürer's drawing.

The fourteen-year-old Dürer, who created this draw-
ing while still training as a goldsmith under his father,
produced a kind of Madonna that had been widely dis-
seminated in German painting and graphic arts. As was
often the case, the iconography of this type of Virgin had
its roots in Netherlandish art. In the execution of several
details, the young artist was inspired by several of Schon-
gauer's engravings. F.A./S.M.

1. The pictorial formula of the enthroned Virgin with angels making
music is found, for instance, in a Memling panel of the 1460s; compare
M. J. Friedländer, *Early Netherlandish Painting* (New York 1967), 6, 1:
pl. 102, pl. 104f., as well as Exh. cat. *Hans Memling,* D. de Vos, ed., with
contributions by D. Marechal and W. Le Loup (Bruges 1994), 32f.; for
the engraving by Master E.S., see Exh. cat. *Meister E. S. Ein oberrhein-
ischer Kupferstecher der Spätgotik,* H. Bevers, ed. (Munich 1986), 49.

43

44

44 THREE WARRIORS, 1489

Berlin, Kupferstichkabinett, KdZ 2

Pen and brown black ink

220 x 160 mm

Watermark: right edge of sheet, three hills (similar to Briquet 11894); fragmentary

Top, dated *1489*; monogram and cross by another hand; old inscription, lower right, cut off

Some brown spots

PROVENANCE: Von Praun Coll. (Nuremberg, see Heller 1827, 87); Esterhazy Coll. (Lugt 1965/66); Posonyi-Hulot Coll. (Lugt 2040/41); acquired in 1877

LIT.: Murr 1797, 65, 107f. – Heller 1827, 2,1: 87, no. 15 – Bock 1921, 21 – Weinberger 1921, 113 – W. 18 – Winkler 1947, 14 – Schilling 1948, no. 2 – Winkler 1957, 14f. – Exh. cat. *Dürer* 1967, 48, no. 18 – Strauss 1489/7 – Piel 1983, pl. 33 – Anzelewsky/ Mielke, no. 2 – Exh. cat. *Dürer* 1991, no. 2 – Exh. cat. *Westeurop. Zeichnungen* 1992, 84f.

In the eighteenth and nineteenth centuries this sheet had the fantastical title *Conspiracy on the Rütli: Werner Stauffacher, Arnold von Melchtal, and Walter Fürst.*[1] It would be more to the point to identify the group of three soldiers as mercenaries below the cross, as is suggested by the gesture of the center figure and the upward glance of the left soldier. The ungainly and overlarge, lancelike weapons make it clear that these are not contemporary foot soldiers. The absence of the cross is striking, and presumably the reason for the early appellation.

This sheet by the eighteen-year-old artist is closely related stylistically to the drawings *Company on Horseback* (W. 16; until 1945 in Bremen, now in the Hermitage, St. Petersburg) and *Fighting Horsemen* (W. 17; London). All three sheets date to the end of Dürer's apprenticeship with Michael Wolgemut but are clearly not at all in his style. They are characterized by Dürer's concern for the anatomically correct rendering of the bodies and their mass. Much like the *Madonna with Music-Making Angels* (cat. 43), the technique of drawing with a fine, pointed pen in parallel hatching and crosshatching is indebted to the engravings of Martin Schongauer. In its motifs, however, especially the depicting of the bodies with greater mass, the drawing moves beyond Schongauer.

A sketch by Dürer in Frankfurt, *Soldiers below the Cross* (W. 12; see ill.),[2] which is undated but could well belong to the same year, is closely related to the Berlin sheet.[3] At the left of the Frankfurt drawing, in which, Strauss believed, Dürer recorded part of a painting, appears a soldier leaning on his halberd and, next to him, another who holds a long lance in his right hand. Both figures are closely related to the left and center warriors of the Berlin sheet. Dürer may have modified the figure motifs of the Frankfurt sheet in his Berlin drawing, abandoning the explicit thematic context along the way. The genrelike character that the figures gain as a consequence is strengthened by the picturelike organization and execution of the drawing. S.M.

1. Compare Anzelewsky/Mielke, 8, with the earlier literature.
2. Strauss 1489/1.
3. Schilling had already pointed out this circumstance (E. Schilling, "Zu Dürers Zeichnungen," *Beiträge* 1: 130).

Albrecht Dürer, *Soldiers below the Cross*, c. 1489

Drawings on Woodblocks for a Woodcut-Illustrated Edition of the Comedies of Terence, c. 1492 (cats. 45–48)

LIT.: Burckhardt 1892 – G. von Térey, *Albrecht Dürers venetian-ischer Aufenthalt 1494–1495* (Strassburg 1892) – Werner Weisbach, *Der Meister der Bergmannschen Offizin und Albrecht Dürer's Bezie-hungen zur Basler Buchillustration* [Studien zur Deutschen Kunst-geschichte, 6] (Strassburg 1896) – M. J. Friedländer, "Rezension Weisbach 1896," *Repertorium für Kunstwissenschaft* 19 (1896), 383–389 – S. M. Peartree, "Eine Zeichnung aus Albrecht Dürers Wanderjahren," *Jahrbuch der königlichen Preussischen Kunstsamm-lungen* 25 (1904), 119–124, esp. 122 – Wölfflin 1905, 32, 311f. – Weisbach 1906 – A. Weixlgärtner, "Rezension Weisbach (1906)," *Mitteilungen der Gesellschaft für vervielfältigende Kunst* [Beilage Graphische Künste] (1906), 65f. – Seidlitz 1907, 3–20 – M. Herrmann, *Forschungen zur Deutschen Theatergeschichte des Mittelalters und der Renaissance* (Berlin 1914), esp. 329–346 – E. Schilling, *Dürers graphische Anfänge, die Herleitung und Entwicklung ihrer Ausdrucksformen,* unpublished Ph.D. dissertation (Kiel 1919), esp. 69–89 – A. Weixlgärtner, "Bemerkungen zu den umstrit-tenen Jugendarbeiten Albrecht Dürers, angeregt durch die Dürer-Ausstellung der Münchener Graphischen Sammlung im Frühjahr 1920," *Mitteilungen der Gesellschaft für vervielfältigende Kunst* [Beilage Graphische Künste] (1920), 37–52 – O. Lenz, *Die Geschichte der Terenz-Illustration. Eine Studie über die Wandlung der bildlichen Darstellung dramatischer Erzählung,* unpublished Ph.D. dissertation (Munich 1924), 159–168 – E. Römer, "Dürers ledige Wanderjahre," *Jahrbuch der preussischen Kunstsammlungen* 47 (1926), 118–136; 49; (1927), 77–119, 156–182 – E. Römer, "Dürer in Basel," *Albrecht Dürer. Festschrift der internationalen Dürer-Forschung,* ed. Georg Biermann (Leipzig/Berlin 1928), 75–84 – Tietze/Tietze-Conrat 1928, 104, 297ff., no. A22, M., 14ff., 272, V – M. Geisberg, *Geschichte der deutschen Graphik vor Dürer* [Forschungen zur Deutschen Kunstgeschichte, 32] (Berlin 1939) – Panofsky 1945, 27ff. – F. Winkler, "Der sogenannte Doppel-gänger und sein Verhältnis zu Dürer," *Münchner Jahrbuch der bildenden Kunst* 1 (1950), 177–186 – F. Winkler, "Meister der Bergmannschen Offizin, auch Meister des Terenz genannt," *TB* 37 (Leipzig 1950), 42f. – F. Winkler, "Dürers Baseler und Strassburger Holzschnitte. Bemerkungen über den Stand der Forschung," *Zeitschrift für Kunstwissenschaft* 5 (1951), 51–56 – F. Winkler, *Dürer und die Illustrationen zum Narrenschiff. Die Baseler und Strassburger Arbeiten des Künstlers und der altdeutsche Holzschnitt* [Forschungen zur deutschen Kunstgeschichte, 36], ed. Deutschen Verein für Kunstwissenschaft (Berlin 1951), 57ff., 64f. – F. Anzelewsky, *Motiv und Exemplum im frühen Holzschnittwerk Dürers,* unpublished Ph.D. dissertation (Berlin 1955), 29–44 – Winkler 1957, 33, 35 – H. Lüdecke, *Albrecht Dürers Wanderjahre. Ein Beitrag zur Geschichte des Realismus in der deutschen Graphik* (Dresden 1959), 11f., 18ff. – A. Stange, "Ein Gemälde aus Dürers Wanderzeit? Studien zur Kunst des Oberrheins," *Festschrift für Werner Noack* (Freiburg im Breisgau 1959), 113–117 – L. Sladeczek, *Albrecht Dürer und die Illustrationen zur Schedelchronik*

[Studien zur Deutschen Kunstgeschichte, 342], Strassburg 1965 – D. Allen/L. Allen (eds.), *Terence, "The Brothers,"* Kentfield/California 1968 – Fritz Kredel, "Die Zeichnungen Albrecht Dürers zu dem Lustspiel 'Andria' von Terenz," *Philobiblon. Eine Vierteljahresschrift für Buch- und Graphiksammler* 15, 4 (1971), 262–276 (with ill.) – G. Mardersteig, *Nachwort zu Andria oder das Mädchen von Andros. Übertragen von Felix Mendelssohn Bartholdy mit 25 Illustrationen von Albrecht Dürer* (Verona 1971) – L. von Wilckens, "Begegnungen. Basel und Strassburg," *Albrecht Dürer 1471–1971,* [exh. cat. Germanisches Nationalmuseum] (Nuremberg 1971), 88–101, no. 15 – P. Amelung, *Konrad Dinckmut, der Drucker des Ulmer Terenz. Kommentar zum Faksimiledruck 1970* (Zurich 1972), 39, 41 – G. Mardersteig, "Albrecht Dürer in Basel und die illustrierten Terenz-Ausgaben seiner Zeit," *Philobiblon. Eine Vierteljahresschrift für Buch- und Graphiksammler* 16, 1 (March 1972), 21–33 – H. Reinhardt, "Dürer à Bâle," *Hommage à Dürer. Strasbourg et Nuremberg dans la première moitié du XVI siècle, Actes du Colloque de Strasbourg 19./20.11.1971,* Publications de la Société savante d'Alsace et des régions de l'est. Collection Recherches et Documents, XII (Strassburg 1972), 63–66 – Strauss, 1492/4–1492/128 – H. Kunze, *Geschichte der Buchillustration in Deutschland. Das 15. Jahrhundert* (Leipzig 1975), 220, 382ff., 397 – Hp. Landolt, "Sebastian Brants Gedicht an den heiligen Sebastian, ein neu entdecktes Basler Flugblatt. Der Holzschnitt," *Basler Zs. Gesch. Ak.* 75 (1975), 38–50 – R. Schefold, "Gedanken zu den Terenz-Illustrationen Albrecht Dürers," *Illustration 63. Zeitschrift für die Buchillustration* 12 (1975), 16–20 (with ill.) – A. Wilson, "The Early Drawings for the Nuremberg Chronicle," *Master Drawings* 13, 2 (1975), 115–130, esp. 117 and n. 16 – Talbot 1976, 287–299, esp. 291 – Mende 1976, 42f. – Strieder 1976, 9 – A. Degner, *Albrecht Dürer. Sämtliche Holzschnitte* (Ramerding 1980), 6 – Ramerding 1980, 6 – Strauss 1980, 41ff. – Strieder 1981, 94 ff. – F. Hieronymus, *Oberrheinische Buchillustration 1. Inkunabelholz-schnitte aus den Beständen der Universitätsbibliothek, Nachdruck des Kataloges der Ausstellung von 1972 mit Ergänzungen und Korrekturen* (Basel 1983), 9, 156f., no. 136 – Piel 1983, 23 – Reinhardt 1983, 135–150, 139f. – V. Sack, in: Exh. cat. *Sébastian Brant, 500ᵉ anni-versaire de la Nef des Folz,* published by the University Libraries of Basel and Freiburg im Breisgau, the Badische Landesbibliothek in Karlsruhe and the Bibliothèque Nationale et Universitaire de Strasbourg (Basel 1994), no. 47

In all probability these blocks were the property of the Amerbach family before the middle of the sixteenth cen-tury. Basilius inscribed some of the backs with act and scene numbers. He probably began to write on them even as a child and occasionally scribbled on the fronts and backs.[1] These are good arguments for a provenance from the Amerbach-Kabinett, even though the blocks do not appear in any of the inventories. Ludwig August Burck-hardt first introduced them to the general inventory of the Öffentliche Kunstsammlung for the years 1852 to 1856.[2]

One hundred thirty-two blocks have survived, with five of them cut. Seven additional engraved blocks are

known only from nineteenth-century impressions. The old inscriptions on the backs establish a loss of eight additional blocks. Originally, there must have been at least 147 blocks.

Basilius' grandfather, the publisher Johannes Amerbach (died 1514), may have commissioned the edition. It is not just the provenance from the Amerbach-Kabinett that suggests this, but also the contact that Dürer had with Amerbach during his stay in Basel.[3] Another thesis is that Johann Bergmann von Olpe planned the edition and that the young Dürer worked not only on the woodcuts for the *Narrenschiff* (*Ship of Fools*, M. VII) and the Prayer Book (M. VIII), but also on those for the Terence edition.[4] The jurist, poet, and editor Sebastian Brant played a decisive part in the undertaking. His editorial collaboration may be deduced from the first inscriptions on the backs, which name the comedies, number the illustrations, and establish the concomitant textual passages.[5] Why the project made no progress and most of the blocks remained uncut is not known. Possibly the Latin edition of the *Comedies,* which Johann Trechsel published in Lyon in 1493, caused a delay of the scheme or its cancellation.[6] The plague, which raged in Basel in 1492, may have held up the work if, for instance, it carried off a woodcutter or someone else in the service of the publishing house. Why, in the end, the edition did not materialize remains a mystery. The incomplete cutting of the occasional block was probably continued up to the end of the fifteenth century. The incomplete parts were probably intended to accommodate the names of the actors.

In 1892 Daniel Burckhardt published the illustrations to the comedies *Andria* and *Eunuch,* and attributed them to the young Dürer. Since then they have been a standard component of the discourse concerning Dürer's early work.

Today it is widely accepted that Dürer traveled to Basel and Colmar, perhaps when returning from the Netherlands. During his Basel stay of 1491 to 1493, he created a large body of illustrations. In addition to the illustrations to the comedies of Terence (M. V), he did the title woodcut to an edition of the *Epistles* of St. Jerome (Nikolaus Kessler, 1492; M. II), from which the signed woodblock is in the Basel Kupferstichkabinett (inv. 1662.169, Amerbach-Kabinett). His other works include the illustrations to the *Ritter vom Turn* (Michael Furter, 1493; M. VI), the majority of the illustrations to the *Narrenschiff* (Bergmann von Olpe, 1494; M. VII), a woodcut for a broadsheet by Sebastian Brant (Bergmann von Olpe, 1494; Kupferstichkabinett Basel, inv. 1975.2), and woodcuts for the Prayer Book (M. VIII). In 1493 he was probably in Strassburg. There he created a canon sheet for a missal (Johann Grüninger, 1493; M. IX) and

the title page for the *Opera* of Johannes Gerson (Strassburg, Martin Flach, 1502).

Burckhardt (1892) accepted only a part of the illustrations to *Andria* and *Eunuch* as autograph works by Dürer. Uncertainties in the handling of the strokes and deficient proportions would seem to point to the participation of other artists. Accordingly, Burckhardt attributed the major part of the drawings for the comedies *Heautontimorumenos, Adelphoi, Phormio,* and *Hecyra* to a less gifted master, Dominicus Formysen, whose signature he believed he had discovered on the back of Z. 486. This master was influenced by Schongauer and Dürer. The inscription is not a signature, however, but a text citation. Hence the author of the text has yet to be identified.

The notion that the young Dürer should have created such a large body of illustrations in such a relatively short time was not at once accepted by scholars. That is why the literature of the following years is characterized by an at times bitter discussion of the attribution of drawings and woodcuts, which were attributed both to Dürer and to several close followers.

When Edmund Schilling (1919) studied the Terence drawings in depth, he emphasized the stylistic connection between "Terence," *Ritter vom Turn,* and *Narrenschiff,* and referred to the diverse demands that the draftsman set out for himself. Although Schilling never clearly enunciated an attribution, he considered only Dürer as draftsman of the series.

Römer (1926, 1927) published the combined blocks, including the cut ones and those that have come down to us in impressions only. He pointed out the dependence of the drawings on the medieval illustrated Terence manuscripts, and compared them to illustrated editions from Ulm, Lyon, Strassburg, and Venice.[7] Although Römer did relate the drawings to Dürer, the artist supposedly drew only a part of the blocks himself. The majority stem from copyists and imitators, who also relied frequently on tracings. For Römer, these attributions explained the uncertainties in draftsmanship and stylistic variations within the series.[8]

In 1950 and 1951, Winkler came out decisively in support of the Dürer thesis. In his investigations of the *Narrenschiff,* he estimated Dürer's contribution relative to other masters and, at the same time, presented a comprehensive state of the question, which he understood as a fundamental vindication of Dürer's authorship. He completely rejected the contributions of the Master of the Bergmann Workshop and of Dürer followers. He assigned the controversial Nuremberg woodcuts to Dürer, his shop, and Hans von Kulmbach (*Opera Hrosvite* and *Quatuor libri*

amorum, vols. XIV and XV). But not even Winkler resolved to give the Terence drawings to Dürer himself. He was inclined (also in 1957) to see him merely as the designer. He believed that the executed drawings were a product of a workshop organized along medieval lines, in which several draftsmen were active.

Anzelewsky (1955) also studied the drawings in depth. He traced all of them back to Dürer, who used tracings, which could explain some of the inconsistencies. Unlike Römer, Anzelewsky assumed that a workshop organization with specialized draftsmen simply did not exist. Anzelewsky explained irregularities as the natural variations in the work of a young artist. He saw no reason not to attribute them to Dürer. Later, Anzelewsky again assigned all the drawings to Dürer, without analyzing them anew in any detail.

No new insights have been reached in subsequent years.[9] Again and again, scholars have returned to the positions of Burckhardt and Römer. Thus, Wilckens (1971) had a "circle of illustrators" working on the series along with Dürer.[10] For Talbot (1976), Dürer was the principal designer, but he did not transfer the drawings onto the blocks. Degner (1980) and Strieder (1981) allowed for Dürer's participation in the drawings.[11] Hieronymus (1972, 1983) adopted Römer's viewpoint.[12] Amelung (1972) instead named Dürer as draftsman, as did Landolt (Exh. cat. *Amerbach* 1962, 1972, 1975), Mende (1976), and Piel (1983). Schefold (1975) came to the same conclusion on the basis of her artistic experience with woodcuts and a sample of the originals.

Reinhardt (1983) accepted the participation of another draftsman. He surmised that Hans Herbster, a painter active in Basel, collaborated on the drawings. In this way Reinhardt returned to his own thesis of 1972, which, given the uncertain nature of Herbster's work, is not convincing.

A few years ago another woodcut could be added to the group, the *Martyrdom of St. Sebastian* in Sebastian Brant's broadsheet with an ode to the saint (Bergmann von Olpe, 1494). Landolt (1975) and Hieronymus (1977) published the broadsheet and attributed the woodcut to Dürer.[13] An additional woodblock with a drawing by Dürer is in the Berlin Kupferstichkabinett. The block, only recently published (no. 10.3 in the German edition of this volume), is associated with illustrations for Hartmann Schedel's *Weltchronik,* which was produced by Anton Koberger in Nuremberg in 1493. Dürer probably executed the drawing, entitled *Blessing of the Seventh Day* (D. 186), in about 1488/1490.

THE DRAWINGS

Several factors determined the work of a draftsman and the aesthetic impression of his drawings. One unusual circumstance was the need to render preparatory drawings for woodcuts. This denied the draftsman a completely free hand, as he had to take the limitations of the woodcutter into consideration. Dürer had been able to acquire a comprehensive knowledge of this craft while in the workshop of Michael Wolgemut in Nuremberg.

The materials had an immediate impact on the drawing. The hard, prepared, polished surface of the blocks hardly allowed for rapid strokes and brought with them the danger of slips of the pen. It is conceivable that a gifted woodcutter could to some degree compensate for such "errors" and corrections, as he had to decide on a solution as he was cutting. In addition, the drawings look hard, as the pigment could not penetrate the surface of the wood, but remained on it.

Drawing an extensive series of similar illustrations made different demands on the artist than those made by individual images in the *Ritter vom Turn* and *Narrenschiff,* which allowed the draftsman greater scope for his pictorial invention. Once the main figures of the comedies were designed, the imagination of the draftsman was limited to variations in the dialogue and landscape motifs. In particular, these landscape backgrounds—village and city backdrops—are inventions of an artist for whom a possible medieval model of the eleventh or twelfth century would not have been helpful. That the draftsman used tracings, as several authors have supposed, remains to be proved. It may be assumed, however, that Dürer or Brant drew sketchlike designs for individual scenes that were essential for editorial purposes. The rejected concept sketch for a scene that remains on the back of Z. 455 is presumably by the hand of Brant. It gives an approximate idea of the appearance of such designs, which may have been the immediate point of departure for Dürer's drawings.

The higher pictorial format of the *Ritter vom Turn* and *Narrenschiff* made it possible to integrate the figures more thoroughly with the landscape backdrops and to attenuate the stagelike appearance of the construction as one encounters it in the Terence illustrations. Although elongated figures occasionally stand out in the *Narrenschiff* (chapters 39, 85, 102, 107, and others), in the case of Terence, especially with the comedy *Phormio,* one encounters short figures with large heads and abbreviated bodies. It almost seems as if the format had impressed itself on the appearance of the figures, but Dürer's early drawings offer other examples of comparable variations, which could be interpreted as his yet uncertain draftsmanship or as an

expression of his intrepid temperament.

The *Poet Terence in a Landscape* (cat. 45) is found at the beginning of the illustrations and probably belongs to the first drawings. The figure was apparently drawn with great confidence. Dürer laid down the outlines, the recession, and the disposition of the drapery folds with very thin lines. We encounter fold formations that return in later drawings. They consist of brackets and hooks, and of short lines that end in small circles or points. Dürer almost certainly used Martin Schongauer's engraving *St. John on Patmos* (B. 55) as a model for the portrait of the versifying Terence. During his stay in the Upper Rhine between 1491 and 1494, when he met Martin Schongauer's brothers, Dürer had the opportunity to see drawings by the master, who had just died. Before that, he must have been able to study Schongauer's, or Michael Wolgemut's, engravings in the shop of his father. As opposed to Martin Schongauer's drawings, which are modeled in little hooks, hatching, and crosshatching, with outlines that are in part composed of several superimposed strokes, the Terence drawings consist of contours determined by energetic, occasionally vibrating, and curved lines. In addition, Dürer generally avoided crosshatching. In this respect they are differentiated from some of his early drawings, in which he more closely approached Schongauer on occasion. In not only the first, but also the subsequent Terence drawings, it becomes more and more apparent how much Dürer accounted for the fact that they were meant to be cut. Z. 430 and Z. 431 show a clear increase in this way of drawing. The figures seem almost transparent, as if made of glass. Dürer employed less hatching; broad pen strokes predominate. Often they are very short, or else they are only points of the kind that we see on the surface of Charinus' cloak (Z. 430). That Dürer concurrently employed a freer working method is clarified by Z. 431, in which several approaches are juxtaposed: The figure of Charinus (left) reveals thin lines and carefully placed strokes, especially in its upper body and legs. But the raised arm is quite different. There Dürer supplemented the already existing drawing with broad and flowing strokes. In the same way, he corrected the left knee and the lower thigh. Finally, he drew the figure of Pamphilus with similar speed and a few broad strokes. Every new application of the pen is visible, as is the mistake at the right foot, which he corrected.

The technique does not change fundamentally in the subsequent drawings. On occasion his method became even freer, which certainly favored errors in drawing. Often the mistakes are not erased, but simply remain as they are. Dürer left the corrections to the woodcutters.

It is hardly to be expected that he should always have worked in the same way, with such a large number of drawings. Again and again he returned to a simpler approach, which was in part forced on him by the pictorial requirements. In this way, for instance, the dynamics of the drawing of Z. 484 have been restrained. Traces of the first, searching preparatory drawing remain visible. Possibly the requirement of accommodating five figures in a confined space had a calming or restricting effect.

These phenomena, which appear to be characteristic for the entire series, argue for the thesis that only one draftsman worked on the illustrations. They are in harmony with the stylistic unity that Schilling (1919) and Weixlgärtner (1920) observed in connection with the woodcuts being discussed and with our drawings.

THE MODELS

Lenz (1924) and Römer (1926, 1927) supported the thesis that the drawings were created after models that may be traced back to antique Terence illustrations.[14] No one has yet managed to identify a specific codex that could have been accessible to Dürer or Sebastian Brant.

Contrary to the medieval illustrations of the ninth to twelfth centuries, which are based on an antique tradition, the Basel Terence follows the principle of pictures with a unity of time, space, and action. Each scene has a framing line that underscores its picturelike character. Most reminiscent of the ancient-medieval tradition are the figures standing side by side, with their distinct gestures. Whereas the figures of the medieval manuscript illuminations stand on a line that indicates the ground, Dürer was concerned with creating an illusion of spatial depth and an integration of figures in a landscape that looks natural and of equal importance. With one exception (Z. 445), Dürer avoided the repetition of figures in one frame, as was common in late medieval illustration. He took the reversal caused by the printing process into consideration even when making his drawings. The sequence of the figures in print corresponds to their appearance in the scenes. In this respect they largely correspond to the method of illustration found in the surviving Terence manuscripts of the ninth to twelfth centuries. Whether Dürer and Brant actually knew of an illustrated manuscript from this time, however, remains an open question. The draftsman of the Basel Terence was in any case familiar with the illustrations in a German language edition of the comedy *Eunuch,* which was printed in 1486 in Ulm by Conrad Dinckmut. In some instances he fell back on these woodcuts. Dürer may also have been inspired by the Ulm *Eunuch* for occasional figures and their dress (see Anzelewsky

1955, 40ff.), as is shown by a comparison of Pamphila in Z. 453 with the corresponding figure in the Ulm *Eunuch* (Schramm 153). Dürer's drawings *Striding Pair* (W. 56) and *Woman with a Long Train* (W. 55) establish that the study of nature must also have played a role in his work. In this way it was possible for an observer of the Terence drawings to relate the social discrepancies between actors of a remote past with his own experience of reality.[15]

The theory that the Basel drawings depend on an edition of the comedies that appeared in Lyon in 1493 (Johannes Trechsel, 29 August 1493), as postulated by Herrmann (1914) and Römer (1926, 1927) for a few scenes, is not convincing. Lenz (1924) pointed to the coincidence of possible correspondences, once isolated from the quite different overall conception of the illustrations to the Lyon edition. The Lyon figures act as if on a stage and the method of continuous narration, with multiple-event scenes, rules. Dürer's apparent intention to root the events in contemporary reality looks forward to the illustrations for the *Ritter vom Turn* and the *Narrenschiff*. C.M.

1. We are grateful to Beat R. Jenny, Basel, for the identification of the hand of Basilius Amerbach.

2. Collective inventory of 1852–1856, 289, U.8: "140 Holzstöcke, meist zum Schnitt gezeichnet einige auch geschnitten: Bilder zum Terenz." See Falk 1979, 27f., n. 82, n. 86. The identification, proposed by Major in 1908, of the "Sechs und neunzig Stuck alte Holzstücklein von unterschiedlichen Meistern, auch von albrecht Dürer," mentioned in Inventory C (Museum Faesch) is not tenable.

3. This was presumed by Burckhardt 1892, 17f.; Römer 1926, 121, and Landolt, Exh. cat. *Amerbach* 1962. On Dürer's letter of 10.20.1507 to Johannes Amerbach in Basel, which is of relevance regarding contact between the two during Dürer's stay in Basel, see Rupprich 1, 61, no. 11.

4. This is assumed by Weisbach 1896, 55f.; Friedländer 1896; Römer 1927, 84, n. 2, and Hieronymus 1983, 9.

5. The writings have been attributed to Brant since Burckhardt's investigation of 1892, which only Römer 1927, 74, n. 4, has questioned. Thomas Wilhelmi was able to vindicate this attribution (conversation in fall 1990).

6. On the Terence publications, see D. E. Rhodes, "La Publication des Comédies de Térence au XVᵉ Siècle," *Le Livre dans l'Europe de la Renaissance*. Actes du XXVIIIᵉ Colloque international d'Etudes humanistes de Tours (Promodis 1988), 285–296.

7. Lenz 1924, 168, also concerned himself with the transmission. He concluded that Dürer should not be considered the block's draftsman. The qualitatively insignificant drawings show no development and instead demonstrate the carelessness of the draftsman.

8. In 1928 Römer once again stressed the connection of the Basel series and attributed them to Dürer and collaborators under his influence.

9. In 1959 Stange recognized at least one "imitating hand" in addition to Dürer. K. A. Knappe 1964 dated the drawings before the Jerome woodcut, in 1491. Without commentary, Hütt 1970 and Strauss 1974, 1980 illustrated the drawings as works of Dürer.

10. The publication of D. and L. Allen 1968 occupies an exceptional place. In the commentary of their bibliophile edition, they identified Dürer as leader of a group of draftsmen. In G. Mardersteig 1971, 1972 (see also F. Kredel 1971), a second draftsman, probably Domenic Formysen, worked with Dürer after the latter's originals. In addition H. Lüdecke 1959 and H. Kunze 1975 require mention. They were of the opinion that various draftsmen collaborated. Kunze found the search for individual personalities inappropriate. It contradicts a shop organization in which many "hands" and "heads" worked together.

11. Sack 1994 thought it possible that Dürer participated in the drawings for Terence.

12. Just as Reindl 1977.

13. Hp. Landolt 1975, 38–50; F. Hieronymus, "Sebastian Brant's 'Sebastians-Ode,' illustriert von Albrecht Dürer," *Gutenberg Jahrbuch* (1977), 271–308; Reinhardt 1983 questioned the attribution.

14. See also Panofsky 1945. The comparison of individual scenes has been made much easier thanks to the publication by Jones and Morey. L. W. Jones and C. R. Morey, *The Miniatures of the Manuscripts of Terence*, Illuminated Manuscripts of the Middle Ages, a Series Issued by the Department of Art and Archeology of Princeton University, 1, 2 vols. (Princeton 1931).

15. See Peartree 1904; Anzelewsky 1955, 40f.; H. Zwahr, *Herr und Knecht. Figurenpaare in der Geschichte* (Leipzig, Jena, and Berlin 1990), esp. 219f.

45

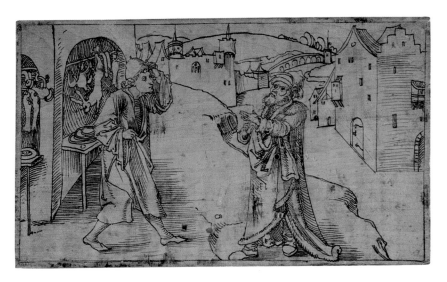

46

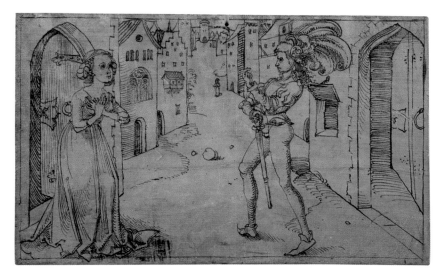

47

48

45 THE POET TERENCE IN A LANDSCAPE, PORTRAIT OF THE AUTHOR

Basel, Kupferstichkabinett, Inv. Z. 425
Pen and black ink on pearwood
93 x 147 x 24 mm
Right narrow edge, embossed stamp in circle; verso, inscribed
by S. Brant *primu*
Wormholes and scratches

PROVENANCE: Amerbach-Kabinett

LIT.: Römer 1926, pl. 1; 1927, 97 – Anzelewsky 1955, 29f. – Exh.
cat. *Amerbach* 1962, no. 25a, ill. 9 – C. I. Minott, "Albrecht Dürer,
The Early Graphic Works," *Record of the Art Museum Princeton
University* 30, 2 (1971), 20f., ill. 1 – Hp. Landolt 1972, no. 25 –
Landolt 1975, 48, pl. 3 – Strieder 1976, ill. 9 – Anzelewsky 1980,
35, ill. 19 – Exh. cat. *Amerbach* 1991, *Zeichnungen,* no. 47

This work was influenced by Martin Schongauer's engraving *St. John on Patmos* (B. 55). Anzelewsky (1955, 1980) interpreted the laureated Terence as Dürer's response to the humanist Conrad Celtis' coronation as poet, which Emperor Frederick III performed in 1487 in Nuremberg castle. In any case, even in the fifteenth century ancient authors could be depicted with the poet's laurels (see the Terence bust in the Ulm choir stall; compare W. Vöge, *Jörg Syrlin d.Ä. und seine Bildwerke,* 2 [Berlin, 1950], pl. 31f.). The representation of the versifying Terence is in the tradition of antique author portraits that show the poet writing or reflecting (see K. Weitzmann, *Ancient Book Illumination* [Cambridge 1959], 116–127; P. Bloch, "Autorenbild," *Lexikon der christlichen Ikonographie,* 1 [1968], cols. 232–234). C.M.

46 SIMO AND DAVUS BEFORE A BUTCHER, *ANDRIA,* ACT 1, SCENE 2

Basel, Kupferstichkabinett, Inv. Z. 426
Pen and black ink on pearwood
91 x 148 x 24 mm
Right narrow edge, embossed stamp in circle; verso, inscribed by
S. Brant *Andrie 2* (crossed out by Basilius Amerbach) / *No dubiu
est quin uxore nolit filius;* by Basilius Amerbach *Andr: actus 1. scen:
2.;* by a child's hand *Am . . .* and tower, upside down; on the
lower narrow edge *Sioceris* [?]
In the center, scratches, impressions, and wormholes

PROVENANCE: Amerbach-Kabinett

LIT.: Römer 1926, pl. 3,1; 1927, 100, n. 1 – Exh. cat. *Amerbach*
1991, *Zeichnungen,* no. 48

The illustration to *Andria,* act 1, scene 1, has been lost. The action takes place in Athens. In the first scene Simo, an old gentleman, speaks with the freed slave Sosia. Simo is preparing a mock wedding to put his son to the test. The latter, Simo fears, loves Glycerium, the sister of a deceased courtesan of Andros. Simo would have his son marry Philumena, the daughter of Chremes. In our illustration, Simo warns the slave Davus to thwart the wedding with Philumena. C.M.

47 MYSIS AND PAMPHILUS BEFORE THE HOUSE OF GLYCERIUM, *ANDRIA,* ACT 1, SCENE 5

Basel, Kupferstichkabinett, Inv. Z. 429
Pen and black ink on pearwood
92 x 147 x 23 mm
Right narrow edge, embossed stamp in circle; upper narrow
edge, scribbling in a child's hand; verso, inscribed by S. Brant
Andrie 5 [?] / *Hoccine est humanu factu aut inceptu*
Wormholes and scratches; lower left, black spots; verso, trial
marks in pen

PROVENANCE: Amerbach-Kabinett

LIT.: Römer 1926, pl. 3,4; 1927, 101, n. 4 – Exh. cat. *Amerbach*
1991, *Zeichnungen,* no. 49

Mysis, on her way to see the midwife, meets Pamphilus, who pours out his heart to her. C.M.

48 MENEDEMUS AND CHREMES CONVERSE IN A FIELD, *HEAUTONTIMORUMENOS,* ACT 1, SCENE 1

Basel, Kupferstichkabinett, Inv. Z. 472
Pen and black ink on pearwood
92 x 146 x 23 mm
Verso, inscribed by S. Brant *Heau 1.;* by Basilius Amerbach
Heau. Act. 1. scen: 1.; glued-on label, inscribed *act I. 1.
Chremes & Menedemus*
Wormholes and spots; rubbed

PROVENANCE: Amerbach-Kabinett

LIT.: Römer 1927, pl. 16, 1

The action is set in a village near Athens. Chremes, an Athenian citizen, asks his neighbor Menedemus why he torments himself by working the land. Menedemus explains that he purchased the property and is exhausting himself because he feels responsible for his son Clinia's enlistment and subsequent departure to Asia. Clinia had become a soldier after Menedemus had ruined his love affair. C.M.

49 A Couple on Horseback, c. 1493/1494

Berlin, Kupferstichkabinett, KdZ 3

Pen and black ink; watercolor

215 x 165 mm

Watermark: Gothic p with flower (variant of Briquet 8675)

Top, inscribed *1496*; bottom, monogram by another hand

PROVENANCE: Andreossy Coll.; Posonyi-Hulot Coll. (Lugt 2040/41); acquired in 1877

LIT.: Seidlitz 1907, 4 – Friedländer 1919, 32 – Friedländer/Bock 1921, 22 – Tietze/Tietze-Conrat 1928, 204–206 – Stadler 1929, 54, n. 1 – Flechsig 2: 61f. – W. 54 – Winkler 1957, 36, 38f. – Oehler 1959, 143ff. – Strauss XW 54 – Anzelewsky/Mielke, no. 8 (with the earlier literature) – Exh. cat. *Dürer* 1991, no. 4

An elegantly accoutered and closely intertwined pair ride on a horse, accompanied by a dog, toward the edge of a forest. In the background is a castle, from which both riders may have come.

The authenticity of the drawing has often been questioned.[1] The Schongauer-like element observed by Von Seidlitz and so typical for the young Dürer, and the undeniable connection to the later woodcut *Knight and Landsknecht* (B. 131) as well as the close stylistic relationship to Dürer's woodcut illustrations made during his *Wanderjahre* allow no doubt about the autograph status of the sheet.[2]

The sheet's connection to these works also provides an indication for its approximate dating. Although Winkler (1957) pointed out that the confidence of the drawing could indicate that it was created in the years 1495/1496, the extremely slim figures and the lack of any Italianate elements justify a dating to about 1493/1494, as does the correspondence to the *Galloping Rider* in London (W. 48) and to the costumes of the Hamburg *Pair of Lovers* (W. 56). The date *1496,* apparently applied later, is in a different ink from the rest of the drawing and apparently does not indicate the year of origin. Flechsig suspected that the first owner of the drawing recorded the year he acquired the sheet.

The drawing owes its picturelike qualities to the four-sided framing line in black ink, which is emphasized even more by the watercolor. Presumably because of this pictorial effect, Panofsky saw the sheet as a copy after a work of the young Dürer or as a copy made by the young Dürer after a work of his own, and Flechsig arrived at the opinion that it is an independent Dürer drawing made after one of his lost sketches. Close examination shows, however, that this is a spontaneously created composition, for the hind legs of the horse clearly reveal that the draftsman later moved the legs of the animal back. Here and there we encounter other, smaller, corrections.

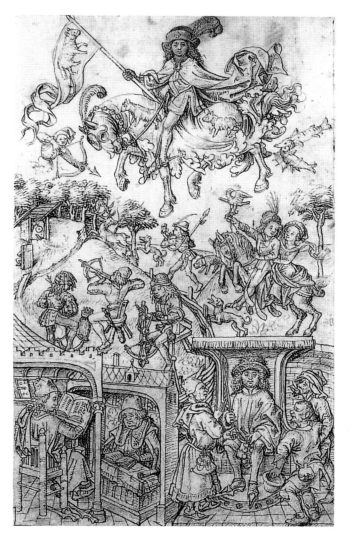

Master of the Housebook, *The Planet Jupiter,* c. 1466/1470

With his pair of lovers on horseback, Dürer engaged a motif from an old tradition. Such pairs, riding out on the hunt together or taking part in a May excursion, surface in depictions of the month of May in Flemish and French Books of Hours of the fifteenth and early sixteenth centuries.[3] The riding pair in the representation of the planet Jupiter in the "Medieval Housebook" (see ill.), who closely resemble our riding couple (without our being able to prove that Dürer saw the Housebook), could well derive from such a calendar miniature.

Behind the horse, on the right edge, grows a sea holly *(Eryngium).* This plant repeatedly occurs in Dürer's works from his *Wanderjahre,* as in, for instance, the Paris

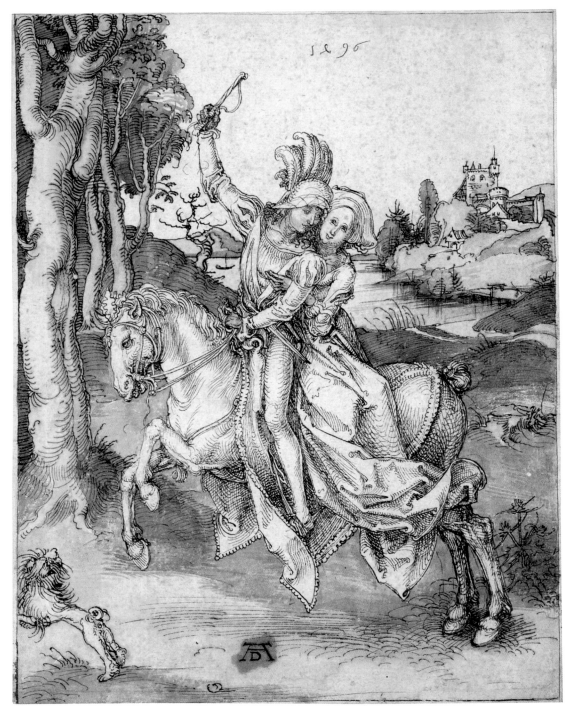

49

Self-Portrait of 1493 (A. 10) and in the background of the Karlsruhe *Man of Sorrows* (A. 9). As Grote has shown,[4] the *Eryngium* in both paintings has christological significance. In association with this riding couple, however, the plant, more likely, is a symbol of love. F.A./S.M.

1. For instance, by Strauss; compare to Anzelewsky/Mielke, 13f.
2. Although Friedländer had already convincingly clarified the temporal relationship between woodcut B. 131 and the drawing, ten years later Stadler again raised the notion that the drawing was created after the woodcut.
3. Compare to W. Hansen, *Kalenderminiaturen der Stundenbücher. Mittelalterliches Leben im Jahreslauf* (Munich 1984), 57f., with numerous examples in catalogue.
4. L. Grote, "Dürer-Studien," *Zeitschrift des Deutschen Vereins für Kunstwissenschaft* 19 (1965), 151–169.

50 HOLY FAMILY, 1492/1493

Berlin, Kupferstichkabinett, KdZ 4174
Pen and black brown ink
290 x 214 mm
No watermark
Left, a Schongauer monogram added later and effaced
Trimmed at the top and right edges; copy in the Berlin Kupferstichkabinett, KdZ 23321

PROVENANCE: Esdaile Coll. (Lugt 2617); Galichon Coll. (Lugt 1061); Rodrigues Coll. (Lugt 897); acquired in 1899

LIT.: Bock 1921, 22 – W. 30 – Schürer 1937, 137ff. – Winkler 1947, 16 – Panofsky 1948, 1: 23, 66 – Schilling 1948, no. 3 – Secker 1955, 217 – Winkler 1957, 38 – Winzinger 1968, 169 – Anzelewsky 1970, 12 – Exh. cat. *Dürer* 1971, no. 142 – Exh. cat. *Dürer in America* 1971, 113, with no. 2 – White 1971, no. 4 – Strauss 1492/1 – Anzelewsky/Mielke, no. 5 (with further literature) – Exh. cat. *Dürer* 1991, no. 3

Winkler emphasized that the *Holy Family* is the only unsigned drawing in Dürer's early work that has been universally recognized and unanimously dated to 1492/1493.[1]

Because the connection with the composition of Schongauer's engraving *Virgin on a Grassy Bench* (B. 30) is not to be ignored, the strong Schongaueresque aspect of the sheet has repeatedly been stressed in the process of its assessment; Winkler (1957), however, felt that, "the sharply earnest realization" belies Schongauer's ideal of beauty with every stroke.

It is not so easy to assess the influence of the Master of the Housebook, whose drypoint engraving *Holy Family* (Lehrs 27; see ill.) obviously shares with our drawing the motif of Joseph sitting on the ground. It is conceivable that the young Dürer saw one of the few impressions

Geertgen tot Sint Jans, *St. John the Baptist,* c. 1490

Master of the Housebook, *Holy Family,* c. 1490

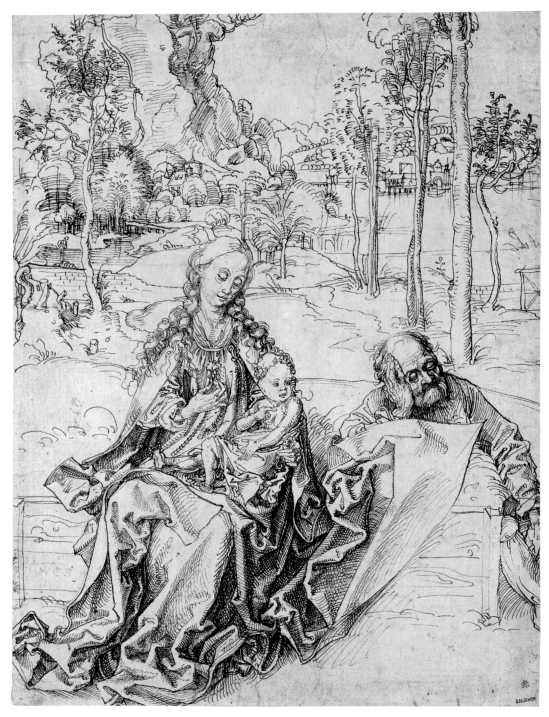

50

that could be pulled from the very soft metal plate. This assumption is supported by the wall and the lake or sea landscape of his scene, which appear in similar combination in the engraving by the Housebook Master.

A third element that influenced Dürer's composition was Netherlandish landscapes of the late fifteenth century, as Schürer pointed out. In the Berlin painting *St. John the Baptist* by Geertgen tot Sint Jans (see ill.), for instance, a clearly readable transition into depth is established by a sequence of slender trees, much as in our drawing. By this adaptation of a Netherlandish model, Dürer succeeded for the first time in integrating figures and space, a problem that had already occupied the young artist with his *Crucifixion* of 1490 (Louvre; W. 19).

In the earlier literature, the drawing is often called a depiction of *The Rest on the Flight into Egypt.* The wall with a gate, located in the middle ground at the right edge of the sheet must instead be identified as a reference to the *hortus conclusus,* or closed garden. The pink, which Mary is handing to the child, should be interpreted as a symbol of the Passion.[2]

The drawing has often been viewed as a final study immediately preceding the engraving *Holy Family with a Butterfly* (B. 44). Bock questioned this notion in the twenties, but we can agree with Panofsky when he claims that the engraving represents the result of a long-lasting involvement with the theme of the Holy Family, to which the drawings W. 23–25, 30, and 35 bear witness. Of these five drawings, the Berlin sheet approaches the engraving most closely. F.A./S.M.

1. Only Flechsig proposed a divergent dating to the year 1494, before the first Italian journey.

2. See Anzelewsky, 71 and passim.

51 LOBSTER, 1495

Berlin, Kupferstichkabinett, KdZ 4942
Pen and brown ink; light brown and black wash; heightened in white
246 x 428 mm
Watermark: bow and arrow (Briquet 817/818)
Below, signed with Dürer's monogram *Ad* and dated *1495*
Paper discolored; surface abraded

PROVENANCE: acquired in 1879

LIT.: Bock 1921, 36 – Stadler 1926, 89 – W. 91 – Panofsky 1948, I: 37 – Winkler 1951, pl. 7 – Tietze 1951, 35 – Winkler 1957, 47, 181 – Strauss 1495/21 – Anzelewsky/Mielke, no. 10 (with further literature) – Exh. cat. *Dürer* 1985, 22f. – Exh. cat. *Dürer* 1991, no. 8 – C. Eisler, *Dürer's Animals* (Washington/London 1991), 133 – E. M. Trux, *Untersuchungen zu den Tierstudien Albrecht Dürers* (Würzburg 1993), 37–43

Even though it is poorly preserved, this exceptionally large nature study, which Dürer dated *1495* and signed *Ad* using a form of his monogram that is primarily associated with his stay in Venice, has never been seriously doubted as a work by the artist. Elfried Bock, who first published the sheet in the Berlin catalogue of 1921 and who was most reticent about his assessment, considered the possibility of a Venetian genesis. Once Winkler demonstrated that this kind of lobster is mainly found in the Adriatic sea, the Venetian origins of the sheet could be taken for granted. The unusual size of the animal relative to the sheet; the malicious, beady eyes; the active legs and the open, monumental claws endow the animal, which was drawn from life, with a truly menacing presence and give the sheet a picturelike character. Similar in effect is Dürer's *Crab* (W. 92), today in Rotterdam, which he also drew in Venice. Trux has recently emphasized that Dürer's *Lobster* and *Crab* are not preparatory studies for specific works, but rather are freely rendered study material. F.A./S.M.

51

52

Albrecht Dürer, *Knight, Death, and Devil*, 1513

52 A QUARRY, c. 1498

Berlin, Kupferstichkabinett, KdZ 15388
Watercolor
215 x 168 mm
Watermark: crown, cross, and triangle (Meder 1932, no. 24)
Upper right, inscribed with monogram and dated *1510* by
another hand

PROVENANCE: J. D. Böhm Coll. (Lugt 1442), Hausmann Coll.
(Lugt 378); Blasius Coll. (Lugt 377); acquired in 1935

LIT.: Klebs 1907, 416 – Pauli 1927, 34–40 – Flechsig 2: 75, 302 –
Winkler 1929, 216 and passim – Lauts 1936, 398 – Winkler 1936,
9–12 – W. 111 – Winkler 1947, 31f. – Tietze 1951, 38 – Winkler
1957, 72 – *Ottino della Chiesa* 1968, no. 43 – Koschatzky/Strobl
1971, no. 22 – Herrmann-Fiore 1971, 31–36 – Strauss 1495/40 –
Piel 1983, pl. 16 – Anzelewsky/Mielke, no. 16 – Exh. cat. *Dürer*
1991, no. 9

In the earlier literature, this sheet was generally dated
to 1510 because of the inscription, which was assumed
to be authentic. Only when Flechsig, who followed the
example of Pauli in studying the monograms and other
inscriptions on Dürer's drawings, proved that the mono-
graph and date could possibly be by Hans von Kulmbach,
as opposed to Dürer, did scholars begin to recognize the
connection with Dürer's watercolor landscapes, especially
with the group of studies of quarries (W. 106–112). Flech-
sig himself dated the drawing to 1498. Today the work in
gray and brown tones is dated, with the other study sheets
of quarries, to the period after Dürer's first stay in Venice,
between 1495 and 1497. However, Strauss proposed a date
in the spring of 1495, during Dürer's return from Italy,
because the watermark and the gray tones of the paint
reminded him of the watercolors of the Italian journey.

As Klebs recognized, Dürer used the motif of the
withered shrubs—recorded with particular accuracy in
his 1513 engraving *Knight, Death, and Devil* (B. 98, see
ill.)—which is characteristic of his working method and
of the importance that he attached to his own watercolor
studies. F.A.

53 VALLEY NEAR KALCHREUTH, C. 1500

Berlin, Kupferstichkabinett, KdZ 5
Watercolor and gouache
103 x 316 mm
Watermark: bull's head with rod, flowers with attached triangle (similar to Briquet 14873)
Upper center, monogram in brown ink by another hand

PROVENANCE: Festetis Coll. (Lugt 926); Böhm Coll. (according to Posonyi, yet no corresponding collector's mark); Posonyi Coll. (Lugt 2041); an otherwise unknown Wimmer Coll. in Vienna; acquired in 1877

LIT.: Posonyi 1867, no. 335 – Thausing 1884, 1: 126 – Wölfflin 1905, 262 – Klebs 1907, 417 – Friedländer/Bock 1921, 29 – Mitius 1924, 103 – Höhn 1928, 10 – Winkler 1929, 137 – Brinckmann 1934, 12f. – W. 117 – Panofsky 1948, 1: 37f. – Waetzoldt 1950, 182 – Tietze 1951, 44 – Musper 1952, 212 – Winkler 1957, 87 – Hilpert 1958, 101 – Dressler 1960, 267 – *Ottino della Chiesa* 1968, no. 133 – Anzelewsky 1970, no. 9 – Koschatzky/Strobl 1971, no. 32 – Herrmann-Fiore 1971, 103f. – Strauss no. 1500/9 – Anzelewsky/Mielke, no. 17 – Exh. cat. *Dürer* 1991, no. 10 – Exh. cat. *Westeurop. Zeichnung* 1992, 96f.

A local historian named Mitius identified the site of this watercolor as a valley near the village of Kalchreuth, about fourteen kilometers to the east of Nuremberg.[1] A view of Kalchreuth itself (W. 118) is presently preserved in St. Petersburg (until 1945, Bremen, Kunsthalle).

The spaciousness of this sliver of landscape and the colorful aspect of the sheet, with its predominant dark blue greens, rust reds, and ochers, have led to heated disputes about the dating of this and the Bremen watercolor. Opinions range from 1499/1500 to 1518/1520.[2] There is agreement on one point only, namely that both sheets are stylistically the most advanced and, concomitantly, the latest among Dürer's watercolor landscapes.

One important point of reference for any chronological placement is provided by the watermarks, which help to date the paper between 1492 and 1495.[3] Accordingly, the drawing could not have been created substantially later than that, which is to say that it must be from before 1500. Thus, following Winkler, the two Kalchreuth sheets may be grouped among the watercolor landscapes that Dürer created upon his return from his first Italian journey.

For Dürer, the watercolor landscapes, which today appear so timeless, constituted working material that he transformed for use in his paintings, engravings, or woodcuts. One example of this approach to nature studies is *Quarry* (cat. 52), which the artist reused in his 1513 *Knight, Death, and Devil.* F.A./S.M.

1. Ten years later, however, Brinckmann was of the opinion that Dürer had drawn a section of the valley of the Main River near Banz.

2. See Anzelewsky/Mielke, 21f., with the earlier literature, especially with respect to the thesis of Herrmann-Fiore.

3. Following a written communication of 30 May 1980 from the Piccard watermark files at the main state archive in Stuttgart, the watermark must belong to Piccard type 789 or 790.

54 SPRING IN A FOREST, WITH ST. PAUL AND ST. ANTHONY, C. 1500

Berlin, Kupferstichkabinett, KdZ 3867
Pen and black ink
186 x 185 mm
Watermark: high crown with doubled arch, cross, and five pearls (not in Briquet and Piccard)
Below, monogram inscribed by another hand

PROVENANCE: Drexler Coll.; von Klinkosch Coll. (Lugt 577); acquired in 1890

LIT.: Bock 1921, 24 – Friedländer 1925, no. 5 – Weismann 1928, 11 – W. 182 – Winkler 1947, 32 – Waetzoldt 1950, 181 – Tietze 1951, pl. 26 – Winkler 1957, 123 – Exh. cat. *Dürer* 1967, no. 27 – Strauss 1504/2 – Anzelewsky/Mielke, no. 23 – Exh. cat. *Dürer* 1991, no. 13

Ever since Weismann, this drawing of a forest clearing with a well surrounded by stratified stone blocks has been recognized as a representation of the Kehlbrünnlein in the forest to the west of Kalchreuth. Thausing had already suspected that this sheet represents a nature study, which Dürer may have drawn in the so-called Schmausenbuck, near Nuremberg. The searching and brilliant rendering of the edge of the forest places the drawing in the proximity of the landscape studies (compare W. 109; St. Petersburg, formerly Bremen). The two monks, who sit on the edge of the well in the left foreground, can be identified as Sts. Anthony and Paul only by the raven that was subsequently inserted with a few hasty strokes above their heads. As described in the *Legenda aurea,* when St. Anthony visited St. Paul in the Theban desert, a raven brought the two hermits their daily bread, which they forgot to eat because of their edifying discussions.

The inconspicuous, easily overlooked detail of the raven relates the work to a woodcut, *Sts. Anthony and Paul* (B. 107), for which our study, according to widespread opinion, was a first concept sketch. In a drawing in Nuremberg (W. 183), the landscape motifs have been reduced considerably in importance relative to the composition of the figures—this ultimately reflects their portrayal in the final woodcut. The motif of the enclosed well,

53

53 (detail)

54

at which the two saints have settled down for their discussion, survives.

The question of the precise dating of the sheet is controversial.[1] It depends on how one dates the so-called *Schlechtes Holzwerk* (modest woodcuts). Scholars have dated this group of eleven woodcuts depicting religious subjects, of which the mentioned woodcut with the two saints is one of the latest, between 1500 and 1504.[2] When we recall that the wing painted by Matthias Grünewald for the 1503 Lindenhardt altar reveals an awareness of a woodcut, *The Holy Bishops Nikolaus, Ulrich, and Erasmus* (B. 118) that belongs to the latest of the *Schlechtes Holzwerk,* we realize that the entire group must have been available in printed form by that time. If we then consider the stylistic and thematic relationship of the drawing with the very similar landscape studies of before 1500, we have no choice but to date the Berlin sheet to about 1500. F.A./S.M.

1. In the Berlin catalogue of 1921, Friedländer, who later (1925) placed the drawing at about 1498, dated it in the last years of the fifteenth century, with reference to the *Holy Family* of Dürer (Berlin Kupferstichkabinett, KdZ 4174). Tietze (1951) and Strauss placed the sheet in 1504, whereas Flechsig and Winkler advanced a dating of about 1502.

2. Winkler, who in 1928 had still dated the entire group between 1500 and 1505, later (1957) leaned toward a chronological placement of about 1500/1501. Panofsky and Strauss assumed—at least for the present sheet—that it was created in 1504.

55 VIRGIN OF SORROWS IN A NICHE, TO THE RIGHT, PETER AND MALCHUS, LAMENTATION BELOW THE CROSS, c. 1498–1500

Berlin, Kupferstichkabinett, KdZ 2155
Pen and dark gray ink; reworked in black ink
311 x 159 mm
No watermark
Below, by another hand, inscribed and dated *1512 6A;*
verso *um zwen weis pfennig.*

PROVENANCE: Andreossy Coll.; Suermondt Coll. (Lugt 415); acquired in 1874

LIT.: Thausing 1884, 1: 83 – Bock 1921, 35 – Beenken 1928, 113 – W. 150 – Musper 1952, 50 – Winkler 1957, 83 – Anzelewsky 1971, 132 – Oehler 1972, 98 – Strauss 1502/32 – Vaisse 1974, 117–128 – Anzelewsky/Mielke, no. 18 (with the earlier literature) – Kutschbach 1995, 98

Since Bock recognized its connection with the panel painting *Mater dolorosa* (A. 20), this drawing has been considered a preparatory work for the *Seven Sorrows of the Virgin,* a panel that Dürer painted in 1496 for the elector Frederick the Wise of Saxony. Only Flechsig dated the sheet to 1502 because he observed a relationship with the Virgin of the *Annunciation* on the exterior of the Paumgartner altarpiece (A. 53 W.). Strauss also thought this later dating of the drawing more probable than the one mentioned earlier. But work on the Paumgartner altar may have commenced immediately after the brothers Stephan and Lukas Paumgartner returned from their pilgrimage to the Holy Land about 1498, and work on the exterior wings, which were painted by an assistant, may have commenced first—as with the Heller altarpiece. Even this scenario leads to a date of before 1500 for the drawing.

The combination of a large standing Virgin in a niche with smaller Passion scenes to its side vouches unequivocally for a connection with the panel *Seven Sorrows of the Virgin* and against any relationship to the Paumgartner altarpiece. Dürer's use of a diagonally placed cross, which he probably encountered in Cologne during his *Wanderjahre,* makes the connection between this sheet and *Seven Sorrows* altogether incontrovertible.

Nevertheless repeated attempts have been made to divorce the sheet from Dürer's oeuvre. Lisa Oehler, for instance, gave the drawing to Beham. Earlier, in 1884, Thausing had considered it a work by Wolgemut, from whom Dürer presumably purchased the sheet for the amount mentioned on the verso. F.A.

55

56 PROPORTION STUDY OF A NUDE WOMAN WITH SHIELD, C. 1500

Verso: nude woman with shield
Berlin, Kupferstichkabinett, KdZ 44
Recto, pen and brown ink; verso, pen and brown ink; blackish brown wash around the figure
303 x 205 mm
No watermark

PROVENANCE: C. A. Boerner; Posonyi-Hulot Coll. (recto, lower left, collector's mark, Lugt 2040/41); acquired in 1877

LIT.: Posonyi 1867, no. 352 – Exh. cat. Berlin 1877, no. 44, no. 44a – Ephrussi 1882, 68 – Thode 1882, 111 – Justi 1902, 15ff. – Weixlgärtner 1906, 30ff. – Seidlitz 1907, n. on 13.– Exh. cat. Liverpool 1910, no. 195 – Exh. cat. Bremen 1911, no. 212f. – Panofsky 1915, 85ff., 90, 95, n. 1f. – Panofsky 1920, 113, n. 2 – Bock 1921, 24 – Kurthen 1924, 103 – Exh. cat. Berlin 1928, no. 37 – Giesen 1930, 36f. – W. 413f. – Panofsky 1940, 113, n. 2 – Musper 1952, 112 – Winkler 1957, 145, 194 – Exh. cat. *Dürer* 1967, no. 36 – Strauss 1500/27, 28 – Anzelewsky/Mielke, no. 30 – Exh. cat. *Dürer* 1991, no. 15 – Eckhard Schaar, "A Newly Discovered Proportional Study by Dürer in Hamburg," *Master Drawings* 1 (1998), 59–66

Dürer first constructed this figure using a compass and straightedge (ruler), establishing the contours of the separate forms with turns of the compass (see recto ill.). He then traced the outlines and all the actual body forms through to the back, where he elaborated on the tracing. In the process, the artist left out the lamp, which, in the initial construction, had provided the justification for the raised arm. Dürer constructed the drawing using his original geometric system for human proportion (in opposition to the later anthropometric system).

Scholars have long disagreed on the dating of our drawing,[1] which belongs to a whole group of female proportion studies (W. 411f., W. 415–W. 418). Today's widely accepted date of c. 1500 is largely based on Panofsky's arguments.[2] There are in any case several engravings of standing female nudes (B. 63, 75–78) that can be dated to 1496–1498 and that together testify to Dürer's interest in female proportion studies even before 1500.[3] The Paris study of a nude of 1495 (W. 85, W. 89), in which the outline of the body is traced through to the back of the sheet, as with the Berlin drawing, points to a very early interest in the female nude. It is therefore difficult to understand how Dürer could have drawn the female nude for almost five years without having made an attempt to track down the secrets of human proportion. A further—indirect—confirmation for the early origins of Dürer's investigations into proportion is provided by a poem by Conrad Celtis,

Recto (56)

which can be dated to before 1500 and in which the artist is celebrated for his proportion studies.[4]

An additional female proportion study was recently discovered in the Hamburger Kunsthalle and attributed to Dürer. The sheet is a tracing of the verso of the Berlin drawing; however, unlike the latter, it was finished in watercolor. It also deviates slightly from the Berlin sheet in the execution of the head and shield.[5]

We cannot be certain that Dürer based his early female proportion studies, as he did the male ones, on an antique statue, as Henry Thode surmised with reference to the Medici Venus.[6] This notion is vindicated by the fact that in a design for the introduction of his textbook on painting, Dürer recommends not only Apollo and Hercules as models for the figure of Christ and Samson, but also Venus as a prototype for Mary.[7] F.A./S.M.

Verso (56)

1. Compare Anzelewsky/Mielke, 32f., with the older literature; Winkler and Flechsig dated the sheet to after 1506.

2. Panofsky 1915, 84–90, n. 1.

3. With the engravings B. 71 and 73 of about 1500, however, one must accept that Dürer used foreign, presumably Italian models for the reclining figures, so that these prints cannot be used to help date the proportion study.

4. See D. Wuttke, in: *Zs. f. Kg.* (1967), 321ff.

5. Schaar (1998) dated the drawing in 1519 on the basis of the watermark.

6. Thode 1882, 111.

7. Rupprich 2: 104; text cited in cat. 57.

57 NUDE MAN WITH GLASS AND SNAKE (AESCULAPIUS), C. 1500

Verso: sketch of a nude man in profile to the right, c. 1500
Berlin, Kupferstichkabinett, KdZ 5017
Pen and brown ink; golden green and blue gray wash around the figure; verso, black chalk
325 x 207 mm
Watermark: crown with cross and attached triangle (similar to Briquet 4773)
Below, monogram by another hand; lower left, numbered *89*; lower right, numbered *94* (crossed out)

PROVENANCE: Gigoux Coll. (Lugt 1164); von Beckerath Coll. (Lugt 2504); acquired in 1902

LIT.: Lehrs 1881, 285f. – Grimm 1881, 189ff. – Thode 1882, 106ff. – Justi 1902, 10ff. – Panofsky 1915, 82ff. – Panofsky 1920, 366ff. – Panofsky 1921, 54ff. – Hauttmann 1921, 48ff. – Panofsky 1921/1922, 43–92 – Parker 1925, 252 – Giesen 1930, 36 – Flechsig 2: 144ff. – W. 263 – Friend 1943, 40ff. – Waetzoldt 1950, 312ff. – Tietze 1951, 46 – Kauffmann 1951, 141 – Musper 1952, 111 – Winkler 1957, 146 – Ginhart 1962, 129ff. – Winner 1968, 188f. – Koschatzky/Strobl 1971, with no. 49a – White 1971, 100 – Strauss XW 263 – Talbot 1976, 292f. – Anzelewsky 1983, 169ff. – Anzelewsky/Mielke, no. 31 – Exh. cat. *Dürer, Holbein* 1988, 78ff. – Exh. cat. *Dürer* 1991, no. 14

Like the female proportion study (cat. 56), this drawing, which is constantly referred to in the earlier literature as *Aesculapius,* belongs to Dürer's earliest essays in this field. That the figure was originally intended as a proportion study is still clearly recognizable from the scored, dotted construction lines that were introduced to the head, chest, and knees with a ruler and compass. (These lines were partially filled with ink and watercolor during the execution of the drawing and thus became visible.)

The sheet forms a group together with three drawings of Apollo (W. 261f. and 264).[1] Once again it is the ancient sun god who is depicted here, and specifically— following Parker's exegesis—the Apollo Medicus.[2] In

1881 Max Lehrs published the claim that this group of drawings is closely related to the Apollo Belvedere in Rome, setting off a half century of scholarly altercations between the supporters and opponents of his thesis. The controversy was finally put to rest in 1943 by A. M. Friend Jr., who was able to demonstrate, with the help of the drawings W. 419f. (today in a Nuremberg private collection), that Dürer was familiar with another antique sculpture, the Hercules Borghese-Piccolomini,[3] which was also known by 1500. As drawn copies of both the Apollo Belvedere and the Hercules Borghese-Piccolomini are found in the *Codex Escurialensis,* proving that the statues were already known by 1500, the appearance of both figures in the work of the artist cannot be pure coincidence. It is much more plausible to assume that Dürer was familiar with reproductions of both works of ancient sculpture. Together with indications in Vitruvius, they served as the basis for his construction of his male nudes.[4] In this context, Panofsky had already suspected in 1920 that the *Aesculapius* and the *Apollo* in London (W. 261) could be attempts at a reconstruction of the Apollo Belvedere.

Panofsky took the Berlin drawing for the earliest of the group. Following Friend, the Hercules sheet W. 419f. may have originated at the same time or a little earlier. There are few true points of reference for the dating of the drawing. A *terminus ante quem* is offered by the renowned engraved *Fall of Man* of 1504, in which the figure of Adam reflects the male proportion studies. The manner of construction with the aid of grids and circle segments, which Dürer did not employ in his later proportion studies, also argue for a genesis at the inception of Dürer's involvement with human proportion. Finally we have the previously mentioned poem of shortly before 1500 by Conrad Celtis, in which Dürer is praised for his proportion studies.[5]

Why Dürer chose to use antique works that were very famous in about 1500 as points of departure for his proportion studies is something he explained indirectly himself, in his design for the introduction to his textbook on painting:

> Then, at the same time, as they [the artists of antiquity] attributed the most beautiful human figure to their idol Apollo, we would most praise Christ the Lord, who is the most beautiful in all the world. And as they praised Venus as the most beautiful woman, we would ourselves set forth the gracious figure of the most pure maiden Mary, the Mother of God. And for Hercules we would substitute Samson, and we would do the same with all the other [gods].[6]

F.A./S.M.

1. Strauss had rejected the drawing as a Dürer, a decision that was contested on good grounds by Anzelewsky; compare Anzelewsky/Mielke, 34.

2. See Winner 1968, 188.

3. On the Borghese-Piccolomini Hercules, see Bober/Rubinstein 1987, 71f. There is good reason to believe that the Apollo Belvedere was already known about 1495; the first known copy, a small bronze, by Antico, can be dated to 1497, see: Exh. cat. *Von allen Seiten schön* 1995, 166.

4. In the dedication letter to the *Theory of Proportions,* addressed to Willibald Pirckheimer, Dürer himself reported in 1523 how he studied "den Fitrufium" (works by Vitruvius); see Rupprich 1: 101f.

5. See Wuttke 1967, 321ff.

6. "Dan zw gleicher weis, wy sy [die Künstler der Antike] dy schönsten gestalt eines menschen haben zw gemessen jrem abgot Abblo [Apollo], also wollen wyr dy selb mos prawchen zw Crysto, dem herren, der der schönste aller welt is. Und wy sy prawcht haben Fenus als das schönste weib, also woll wir dy selb tzirlich gestalt krewschlich darlegen der aller reinesten jungfrawen Maria, der muter gottes. Vnd aws dem Erculeß woll wir den Somson machen, des geleichen wöll wir mit den andern allen tan." For the complete text see Rupprich 2: 103f.; the dating of the text varies between about 1500 (Panofsky 1915, 137) and 1512/1513 (Rupprich 2, 104).

58 BIRTH OF THE VIRGIN, 1502/1504

Verso: sketches of a Crucifixion, 1502/1504
Berlin, Kupferstichkabinett, KdZ 7
Pen and black ink
288 x 213 mm
No watermark
Lower right, monogram inscribed by another hand

PROVENANCE: His de la Salle Coll. (Lugt 1333); Posonyi-Hulot Coll. (Lugt 2040/41); acquired in 1877

LIT.: Exh. cat. Liverpool 1910, no. 282 – Wölfflin 1914, 8, no. 11 – Bock 1921, 25 – Friedländer 1925, no. 6 – Tietze/Tietze-Conrat 1928, no. 207 – Winkler 1929, 148 – Flechsig 2: 267 – W. 292f. – Winkler 1957, 152, 156 – Kuhrmann 1964, n. 26 – Anzelewsky 1970, no. 47 – Strauss 1502/22, 23 – Anzelewsky/Mielke, no. 38r, no. 38v – Exh. cat. *Dürer* 1991, no. 19

The main problem with this drawing, which is an initial concept for the woodcut *Birth of the Virgin* of the Life of the Virgin series (B. 80), is the question of dating. It varies between 1502 and 1504.[1] In the Life of the Virgin, as with the Apocalypse series, we can differentiate between an early group with many small figures, to which *Birth of the Virgin* belongs, and a later one with fewer large figures. We must therefore agree with Strauss that the sheet is the oldest (surviving) sketch for the Life of the Virgin series and place it immediately after the *Flagellation of Christ* (W. 185), which is dated 1502. To be sure, the composition of the drawing already contains the most important elements of the later woodcuts, but—as Flech-

Verso (58)

sig had already established—it must have repeatedly been reworked while leading up to the final version.

The hastily indicated perspective of the barrel vault of the room's ceiling is in simple central perspective. It is not depicted accurately, whether in the sketch or in the woodcut, but formed purely intuitively, so that when the construction in the woodcut version is checked, a significant error in the rear left corner is revealed.

VERSO

As almost all scholars agree, the hasty drawing is closely connected with the woodcut *The Hill of Calvary* (B. 59), one of the so-called *Schlechtes Holzwerk* (modest woodcuts). Whether or not this sketch originated earlier than the study for the *Birth of the Virgin,* as many connoisseurs have assumed, can hardly be established. A date that differs substantially from that of the front cannot be justified on stylistic grounds, especially those concerning the manual skill of the artist. F. A.

1. 1502: Flechsig, Strauss; 1502/1503: Panofsky; 1503/1504: Winkler; 1504: Wölfflin, Conway (Exh. cat. Liverpool 1910, no. 282).

58

sy hat dir auch vor den sterben gered vnd dy gotlich seit ʒerömet vnd vill sterer ber auch das sy mich vor sünd bebüten
sy beret auch for dz ʒ richen sant Johans sten als ir dan wil vnd sy sorgt der tot war ober sy sagt sie wort ʒe kume süchter
sie sich nit sein auch hert gestorben vnd ich merckt das sy etwas garsamer sach dan sy sortt dz rich wuste vnd hat dar for
lang nit geredt als gemeyt ʒe dy mey ich sie auch noch ʒe dz tot wey was stu and has dem gred vnd mey sy vnd das august ʒe ir
vnd vel sy sich nit gerüret ich petet ir for do sor hal ich solch schmerʒen gehabt dz ich mich was sprech für gott sey ʒe barmherʒig

Dy grost wunderwerck dy ich all mein dey gesehen hab ist das sich ir meüste
gesehen Jm 1503 jor als auch vil kreüʒ gefallen sind sunderlich hat dy mist schalter
mer auch dy kind den anders lent sunder den allen hab ich ein geworst sey
gesehen Jn der gestalt wie ich hernoch gemalt hob vnd es gut ʒeackter
was gefallen auff eines magt der Jns pirkamers hynderhawes das sagen dz es
haust Jns hemt Jm lünen dueg vnd sy was so betrübt das sy im dz so sey
weinet vnd sie klackte wan sy forcht sy müst dron sterben

noch hab ich in kumst
wy hy mitt gesehen

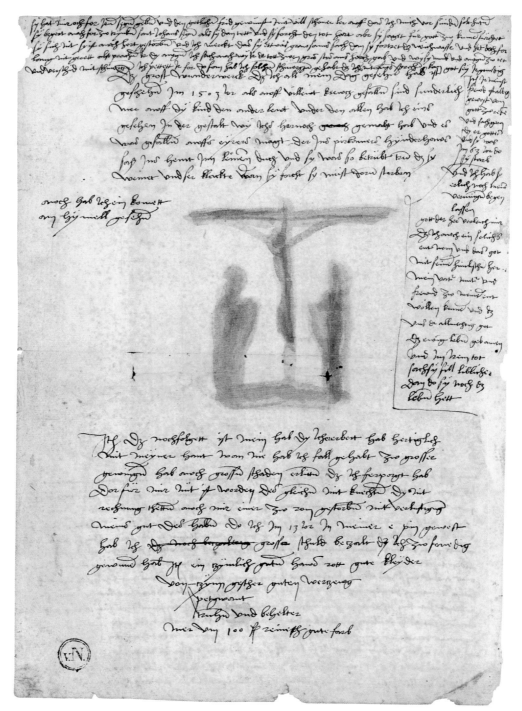

Vnd ich habs
selig noch med
wenigen begen
lassen
gott der her verlang im
Ich gewiesch ein seligs
end wan vnd das gott
mit seiner himlischer her…
mein vnd aller het
freind ʒo meim ler
wölley kumd vnd dz
vnd ir allmechtig gott
Dz ewig leben geb ancy
vnd dy kern tot
sorhsy fell biblichee
dey do sy noch dz
leben hett

Ich dz nochfolgett ist mein hab dy schreiber hab hertiglich
mit meyner hant wan mir hab ich fast gehabt ʒo grosse
gewoned hab auch grossd schaden erlitan dz ich ferpoʒet hab
dor für mir mit ist wordig des gleichen mit kunsch dy mit
rechnung hetten auch mir einer ʒo wey gestorben mit weheftyng
mines gut des halb do ich Jn 13 jor Jn meiner ê pin gewest
hab ich dy noch bezahlet grossa schuld bezalt dz ich ʒo fewrdig
gewund hab Jch ein ʒimlich gubd hand ʒoh gute klayder
vor ʒweyn gülden guter werʒeugg
pepromet
kunlen vnd beheltten
mit dem 100 fl ʒimlich gute forb

59 CRUCIFIXION FROM DÜRER'S PERSONAL NOTEBOOK, 1502, 1503, 1506/1507, 1514

Berlin, Kupferstichkabinett, Cim. 32
Brown and gray wash; text, pen and brown ink
311 x 215 mm
No watermark

PROVENANCE: c. 1790 belonged to Joh. Ferd. Roth, deacon, St. Jakob's, Nuremberg; until 1824 belonged to Hans von Derschau; Von Nagler Coll. (Lugt 2529); acquired in 1835

LIT.: Lippmann 1880, 30 – Ephrussi 1882, 366 – W., 2: *Anhang* pl. X – Panofsky 1943, 1: 90 – Musper 1952, 143 – Rupprich 1: 35–38 – Jürgens 1969, 69 – B. Deneke, in: Exh. cat. *Dürer* 1971, 214 – Mende 1976, 41f. – Anzelewsky/Mielke, no. 39 – Exh. cat. *Dürer* 1991, no. 18

This sheet is a page from Dürer's personal notebook *(Gedenkbuch),* a large, lost manuscript, in which the artist noted memorable events of his life. As the content and organization of the sheets establish, he used the same sheet repeatedly to record notations from different years. Dürer himself reported the existence of this book, in his *Family Chronicle,* when he wrote that he had described the death of his father in 1502 "at length in another book."[1] This account constitutes the earliest communication on the verso of our sheet. Twelve years later Dürer added the thematically related report describing the death of his mother (16 May 1514), which constitutes the latest entry on the sheet. Because of the detailed nature of his account, he had to accommodate about half of it on the front of the sheet, which had already been used by this time. We encounter, on the lower half of the page, an entry, dating from 1506/1507, concerning Dürer's fortune. Above that he described a rain of crosses that took place in 1503, and to which the drawing applies as well:

> The greatest marvel I have seen in all my days happened in the year 1503, when crosses fell on many people, curiously, more on children than on others. Among them all, I saw one in the form that I have made after it, and it fell on our maid who sat at the back of Pirckheimer's house, in her linen shirt. And she was so saddened by this that she cried and greatly lamented, as she feared she therefore had to die. I also saw a comet in the heavens.[2]

According to Gunther Franz[3] this phenomenon first occurred in the Netherlands in 1501; from there it spread over western Germany. The causes of these remarkable manifestations have never been explained. F.A.

1. See Rupprich 1: 31, Z. 220–224, 34, n. 55f.
2. "Daz grost wunderwerck, daz ich all mein dag gesehen hab, is geschehen jm 1503 jor, als awff vil lewt krewcz gefallen sind, sunderlich mer awff dy kind den ander lewt. Vnder den allen hab jch eins gesehen in der gestalt, wy ichs hernoch gemacht hab, vnd es was gefallen awffs Eyrers magt, der jns Pirkamers hynderhaws sazs, jns hemt jnn leinnen duch. Vnd sy was so betrübt trum, daz sy weinet vnd ser klackte; wan sy forcht, sy müst dorum sterben. Awch hab ich ein komett am hymmell gesehen."
3. *Der deutsche Bauernkrieg,* 10th ed. 1975, 64; compare moreover, Rupprich 1, 36, n. 10, and D. Wuttke, "Sebastian Brants Verhältnis zu Wunderdeutung und Astrologie," *Studien z. dt. Literatur und Sprache des Mittelalters. Festschrift f. Hugo Moser* (1974), 280.

60 WILLIBALD PIRCKHEIMER, 1503

Berlin, Kupferstichkabinett, KdZ 4230
Charcoal; below eyes and on brow, heightened in white
281 x 208 mm
No watermark
Lower left, dated *1503*; verso, inscribed by the hand of Willibald Imhoff the Elder, Pirckheimer's grandson *Meynes Anherrenn Wilbolden pirkhaimers Seligen Abcontrafactur durch Albrecht dürer 1503*

PROVENANCE: Imhoff Coll.; Zoomer (Lugt 1511); DeferDumesnil Coll. (Lugt 739); acquired in 1901

LIT.: Wölfflin 1914, 10f., no. 20 – Bock 1921, 25 – Rosenthal 1928, 43–45 – W. 270 – Panofsky 1943, 1: no. 1037 (medal) – Winkler 1947, 22f. – Winkler 1951, 34f. – Winkler 1957, 179 – Anzelewsky 1970, no. 43 – Mende 1983, 30–37 – Anzelewsky/Mielke, no. 34 (with earlier literature) – Anzelewsky 1991, 140, no. 42K – Exh. cat. *Dürer* 1991, no. 16

Willibald Pirckheimer, one of the most important German humanists of his time, was Dürer's best friend. It is generally accepted that this drawing is not a study from life, but that it was rendered by the artist after a silverpoint sketch now in the Berlin Kupferstichkabinett (KdZ 24623). In the process, Dürer ennobled the features of his friend without flattering him, as Panofsky so aptly explained. Scholars do not agree on whether or not Dürer had chosen the profile position with an eye to a portrait medal. Certainly the medal of the year 1517,[1] which shows few deviations, was not made without Dürer's drawn portrait of the humanist. It is far from certain that the drawing was created as a model for a medal cutter. The opposite sequence is also possible: antique coins showing the heads of Roman emperors[2] may have inspired Dürer to represent his humanist-friend in profile. F.A./S.M.

1. Ill. in: F. Winkler, ed., *Dürer. Des Meisters Gemälde, Kupferstiche und Holzschnitte.* Klassiker der Kunst 4, 4th ed. (Berlin and Leipzig n.d.), 402.
2. On collections of antique coins in Nuremberg, see Anzelewsky 1983, 181.

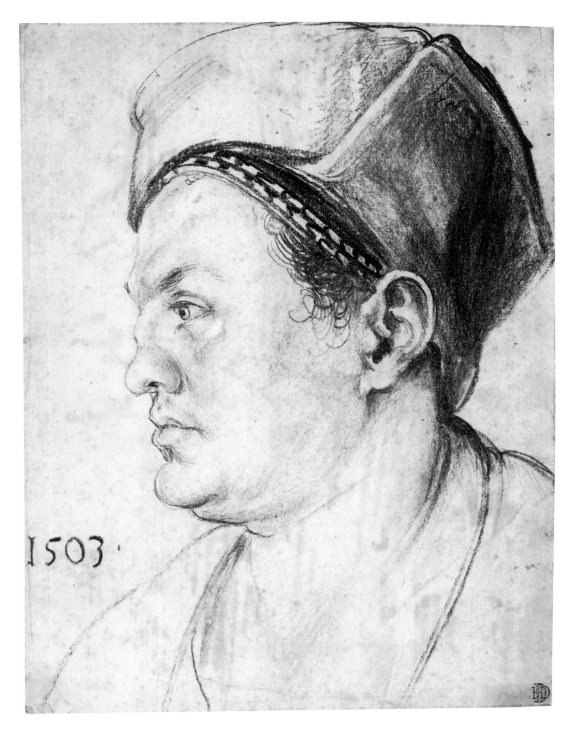

1503·

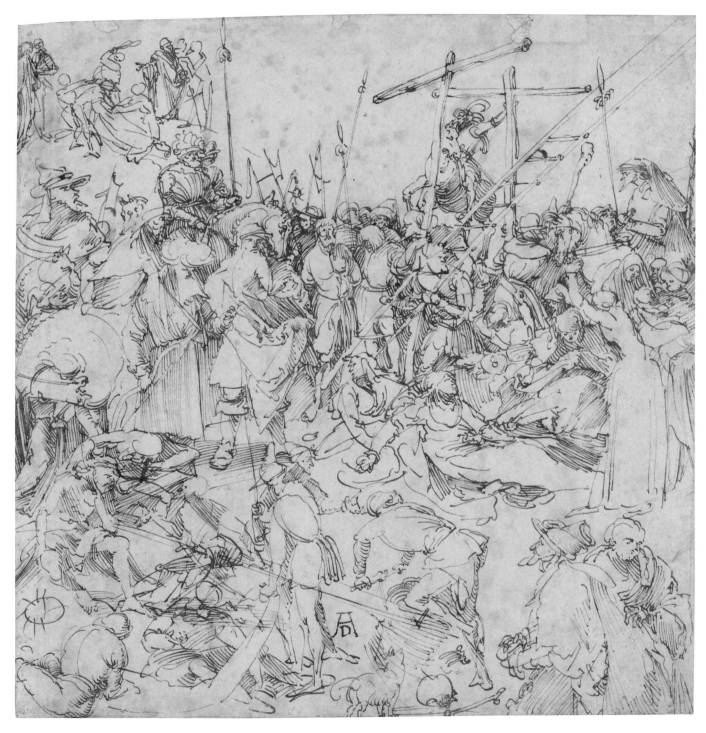

61

61 STUDIES FOR THE GREAT CALVARY, c. 1505

Berlin, Kupferstichkabinett, KdZ 16
Pen and brown ink
228 x 216 mm
No watermark
Lower center, monogram by another hand
Trimmed on all sides; brown spots; worm damage at the edges

PROVENANCE: Ottley Coll. (Lugt 2642, 2662/65); Lawrence
Coll. (Lugt 2445); His de la Salle Coll. (Lugt 1332/33); Posonyi-
Hulot Coll. (Lugt 2040/41); acquired in 1877

LIT.: Bock 1921, 26 – Winkler 1929, 164f. – Flechsig 2: 270 – W.
316 – Panofsky 1948, 1: 94 – Musper 1952, 142 – Winkler 1957,
175 – Oehler 1954/1959, 114 – Oettinger/Knappe 1963, 11 –
Strauss 1505/2 – Anzelewsky/Mielke, no. 43 (with the earlier
literature)

Jacob Matham after Dürer, *Great Calvary,* 1615

This drawing is generally believed to be a study for
Dürer's drawing, *Great Calvary* (W. 317), in the Uffizi in
Florence. The latter sheet is generally considered to be
closely related to the *Green Passion* in Vienna, which is
executed in the same technique (pen, heightened in white
with gray wash on green prepared paper) and which once
carried the date 1505, as may be seen on old copies or
from the engraving by Jacob Matham, which reproduced
Dürer's composition in reverse (see ill.). Some scholars
have even taken the *Great Calvary* for the center panel of
the *Green Passion.*

Like the latter drawing, the *Great Calvary* has been
questioned as a work of Dürer's (Tietze, Oehler),[1] which
fact has also had its effect on the appreciation of the Berlin
study sheet from time to time. The reservations expressed
about its authenticity are understandable insofar as the
drawing is exceptionally hasty. Thus, the scale of the fig-
ures is not always consistently foreshortened. For instance,
the two standing Orientals above the seated Christ look
larger than the foreground figures. The artist also added a
few figures—such as the soldier in the middle of the three
who gamble for Christ's cloak—only later. The small sub-
sidiary scene at the upper left, which Winkler identified
as the disrobing of Christ, is sketched in the same way as
the Crucifixion studies found on the back of the *Birth of
the Virgin* (W. 328; compare to cat. 58). This eliminates all
doubt about the authenticity of the *Studies for the Great
Calvary;* it is a work by Dürer.

In the elaborate composition of the Florence *Great
Calvary,* the story of the Passion is depicted simultaneously
with countless figures, from Christ's departure from Jeru-
salem to the Crucifixion. This side-by-side presentation of
chronological scenes also determines the character of the

present Berlin sheet; Christ, to the left, sits while waiting
to be raised on the cross, as mercenaries mock him and
three soldiers in the foreground gamble for his clothes.
To the upper right of Christ, before a great crowd of
people, including some on horseback, Mary has collapsed.
John and some women look after her. Mourning figures
approach from the right, one with a baby on her arm.
Two Jews come from the lower right. At the upper left,
rapidly sketched, is the disrobing of Christ.

With numerous changes, this drawing served as the
basis for the organization of the lower half of the *Great
Calvary.* For instance, the two Orientals and the tangled
group of the riders behind them were reduced to a figure
of a man, seen from the back, who speaks to another fig-
ure on horseback. In addition, Dürer moved the women
and the collapsed Virgin almost to the center of the com-
position and, at the same time, muted their excited ges-
tures. In much the same way, he prepared the upper part

of the present Crucifixion in an even more hasty study in Coburg (W. 315). F.A./S.M.

1. On this matter, see Winkler (W., 2: 24–30, esp. 29), who emphatically supported the autograph status and invention of the sheet.

62 PORTRAIT OF AN ARCHITECT, 1506

Berlin, Kupferstichkabinett, KdZ 2274
Brown gray wash; heightened in white on blue venetian paper
391 x 266 mm
Watermark: cardinal's hat (similar to Briquet 3391)
Lower left, signed with monogram and dated *1506*

PROVENANCE: Andreossy Coll.; Gigoux Coll. (Lugt 1164); acquired in 1882

LIT.: Ephrussi 1882, 117 – Thausing 1884, 346f. and passim – Lorenz 1904, 38, 42 – Wölfflin 1905, 180 – *Handzeichnungen,* 47, no. 23 – Wölfflin 1914, 12, no. 24 – Bock 1921, 26 – Friedländer 1925, no. 7 – W. 382 – Panofsky 1943, I: 111 – Waetzold 1950, 148f. – Tietze 1951, 25 – Winkler 1951, 36 – Winkler 1957, 194 – Heil 1969, 271 – Exh. cat. *Dürer* 1967, no. 35 – Anzelewsky 1970, no. 55 – Anzelewsky 1971, no. 93 – White 1971, no. 44 – Winzinger 1971, 69ff. – Strauss 1506/9 – Anzelewsky/Mielke, no. 52 – Exh. cat. *Dürer* 1991, no. 23

Dürer created this drawing, arguably the most impressive of his portrait studies, in 1506 in a technique taken over from the Venetians, the brush drawing in black and white watercolor on blue paper. He rendered it in connection with the *Adoration of the Holy Rosary,* which the German community in Venice, with support from the Fuggers, commissioned to serve as an altarpiece for the Church of St. Bartholomew.[1] The subject is identified as an architect by the square he holds. It is universally agreed that this individual drawn by Dürer and later represented at the right edge of his painting is the architect who led the reconstruction of the Fondaco de'Tedeschi, which had burned down in the winter of 1504/1505. As the senate of Venice approved a model by Hieronymus Thodescho,[2] the portrayed individual is today generally identified, following Thausing,[3] as Hieronymus of Augsburg. Unfortunately it has thus far proved impossible to find a trace, in Augsburg, Venice, or anywhere else, of this architect, so exalted by the Venetians, that might supply some information about his person and work. F.A.

1. Compare to Anzelewsky 1991, 191–202; Kutschbach 1995, 105ff.
2. Thausing 1884, 1: 364, n. 3.
3. Thausing 1884, 1: 347.

63 NUDE FEMALE FROM BEHIND, 1506

Berlin, Kupferstichkabinett, KdZ 15386
Gray wash heightened in white on blue venetian paper
381 x 223 mm
No watermark
Signed by Dürer with his monogram and dated *1506*

PROVENANCE: Imhoff; J. D. Böhm (Lugt 1442); Hausmann (lower right, collector's mark, Lugt 378); Blasius (Lugt 377); acquired in 1935

LIT.: Heller 1827, 2: 83, no. 68 – Lippmann 1883, no. 138 – *Handzeichnungen,* no. 22 – Tietze/Tietze-Conrat 1928, no. 328 – Flechsig 2: 37, 302 – W. 402 – Falke 1936, 330f. – Lauts 1936, 402 – Panofsky 1943, 119, no. 1188 – Winkler 1957, 199 – Anzelewsky 1970, no. 57 – White 1971, no. 45 – Exh. cat. *Dürer* 1971, no. 698 – Strauss 1972 – Strauss 1506/40 – Anzelewsky 1980, 137 – Strieder 1981, 160 – Anzelewsky/Mielke, no. 53 (with earlier literature) – Exh. cat. *Dürer* 1991, no. 22

The provenance of this drawing includes the Imhoff Collection probably because of a description by Heller— "a picture of a naked woman in gray"—even though the sheet was not unequivocally identified by this very general formulation. Nevertheless the provenance from Dürer's estate would fit this unusual drawing very well. Dürer remained in Venice throughout 1506. Thanks to surviving letters to his friend Willibald Pirckheimer (see cat. 60), we are exceptionally well informed about this time. This brush drawing of a female nude seen from the back, rendered on blue venetian paper, almost automatically excites the anecdotal imagination: the artist, having escaped from the confinements of the north, was happy in the southern land of art. The creation in Venice, the lively modeling, the play of light on the skin, the cap in the woman's hand: each of these invites us to understand this drawing as a study after nature. However, the lost profile of the woman, the broadly rendered shoulder zone (still similar to the *Witches* woodcut, B. 75, of 1497), the awkwardly bent right arm, the vague disappearance of the lower leg and foot, and the alteration at the left shoulder are somewhat lifeless for a nature study. As the position of the body clearly indicates, the drawing is a study for Dürer's investigations of proportion: viewed squarely from behind, one foot placed slightly before the other, one arm extended, the other disappearing behind the body. The unequivocal frontality is essential to assure the measurability of all dimensions; the Dresden Sketchbook contains many schematic nudes of this kind; it still remains a favored pose among the woodcuts of the proportion studies, published in 1528 (see ill.).[1]

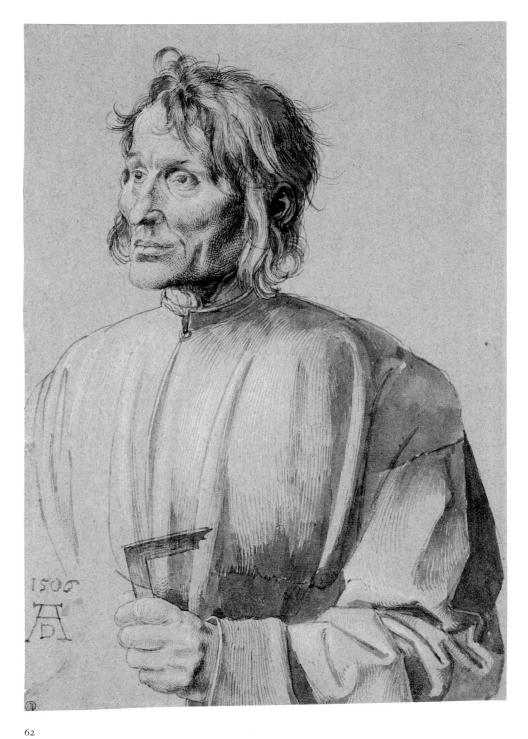

62

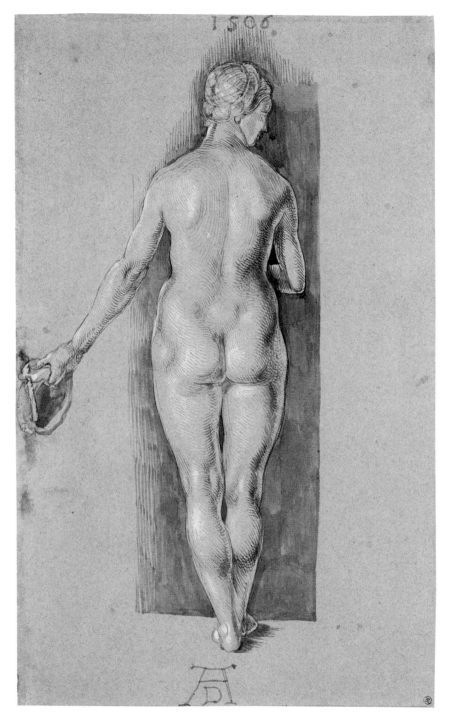

63

Albrecht Dürer, *Proportion Study* from *Four Books on Human Proportions,* Nuremberg, 1528

Possibly, this view was of central importance to Dürer's studies of the human body, which he therefore drew again and again. This made good sense, as an un-foreshortened representation of the body is fundamental to all investigations of proportion that depend on the ability to measure and compare all parts of the body.

The opinion expressed by all scholars, that our Venetian nude seen from behind is a nature study, becomes even more dubious when we compare the sheet to the probably only slightly earlier Weimar nude self-portrait (W. 267), which—also backed by a dark surface—has significantly more life (upper arm!). It is also possible that Dürer had his model take up the pose of his proportion studies so as to constantly compare the latter to reality.

Our drawing has repeatedly been taken as a model for a stone relief (Exh. cat. *Dürer* 1971, no. 698), the autograph execution of which was decisively championed by Otto von Falke 1936, but his argument is not convincing.

<div align="right">H.M.</div>

1. Albrecht Dürer, *Hierinn sind begriffen vier bücher von menschlicher Proportion [. . .],* Nuremberg, Hieronymus Andreae, 1528 (see ill.). Without the engraving based on our drawing, Sebald Beham's beautiful drawing in a private German collection is inconceivable; see Th. Le Claire, *Kunsthandel* 8 (1992), no. 1.

64 DESIGN FOR A WALL PAINTING, 1506

Berlin, Kupferstichkabinett, KdZ 5018
Pen and brown ink over black pencil; pen and
blue ink; part of right entablature covered with blue wash
130 x 420 mm
Watermark: upper part of high crown (Piccard XII, 16, 17)
Verso, badly abraded inscription by Dürer in black lead . . .
nch manch (?)
Paper spotted; browned; right, splatters of blue wash

PROVENANCE: Bought in Verona by A. von Beckerath (Lugt 2504); acquired in 1902

LIT.: Lippmann 1883, no. 182 – Ephrussi 1882, 13 – Bock 1921, 53 – Tietze/Tietze-Conrat 1928, no. A253 – Flechsig 2: 312 – W. 710 – Panofsky 1943, no. 1552 – Winkler 1957, 292 – Strauss 1506/57 – M. Mende, in: Exh. cat. *Das alte Nürnberger Rathaus* 1979, 410f. – Anzelewsky/Mielke, no. 91 – Exh. cat. *Dürer* 1991, no. 25

The architectural features of the facade were indicated in pen and brown ink: that is, the gate and window openings along the lower edge (clearly over a preparatory drawing in pencil) and, above, two console stones, which presumably are topped by two gables or one continuous balcony. The blue pen then sketches an airy, simulated architecture that decorates the wall and deliberately ignores its two-dimensional surface. The depiction is narrow, like a horizontal strip; in all probability further designs could be added for the upper and lower window zones. The present sheet is in any case uncut, for below the fool, as well as below the column located beneath the family, the horizontal brown pen stroke, which traces around the window and gate openings, runs continuously, without any part of the depiction shown below it. All brown lines that delineate apertures in the wall terminate close to the lower edge of the sheet and are therefore also uncut. At the upper edge, the brown strokes of the console do not continue to the edge of the sheet either, but end in a horizontally continuous pen stroke that was also rendered by the artist.

The 1979 published research undertaken by Mende with respect to the old Nuremberg city hall demonstrated that the custom of painted facades was an old Nuremberg tradition. Those remaining fragments, published by Mende, of the exterior painting of the city hall that can

64

64 (detail)

be traced back to Dürer agree with the present design in the perspective section of the wall as well as in many details. As a consequence, this type of sheet, which before Mende's exposition could probably not be attributed to Dürer,[1] can be shown to be related to his work. Stylistic comparisons also elucidate that the drawing is an integral part of Dürer's oeuvre.[2]

A date of about 1509/1510 is the most likely, though the Verona provenance of the drawing could be used as an argument for a genesis in Italy about 1506/1507. The iconographic question of whether the fool in our sheet is connected to the family on the left remains unresolved. In any case such a connection is possible, for Erasmus in his *Praise of Folly* also described marriage as an aspect of foolish behavior. On the other hand, the fool is decisively separated from the family. He does not look at family members, but instead looks emphatically downward, so that he may refer to a painted scene below or even admit people who are entering the house.

Whether Dürer himself executed facade paintings is a ticklish question. According to a notice from the Count Attem Archive, one "Albrecht Dürer, taken ill on his way to Italy, in Stein (near Laibach), was cordially received by a local painter and, in grateful remembrance for this, painted a picture on his house" (Rupprich 1: 246, l. 4). Since Ephrussi, this story has been relegated to the realm of artists' legends. However, as this information was supposedly handed down on a sixteenth-century sheet of paper, and as the Windisch peasant woman (Strauss 1505/27–28) would sooner be drawn in her homeland than in Venice, such a biographical detail should not be rejected out of hand because of its anecdotal character.

H.M.

1. The authenticity of the sheet has been questioned repeatedly, by, among others, Tietze/Tietze-Conrat 1928 (Georg Pencz?) and Panofsky.

2. An isolated comparison was carried out in Anzelewsky/Mielke, 94.

65 STANDING APOSTLE, 1508

Berlin, Kupferstichkabinett, KdZ 12
Gray wash heightened in white on green prepared paper
406 x 240 mm
Watermark: high crown (Briquet 4895)
Signed with monogram and dated *1508*

PROVENANCE: Andreossy Coll.; Hulot Coll.; acquired in 1877

LIT.: Bock 1921, 26 – Weizsäcker 1923, 196, 203, no. 1 – W. 453 – Waetzold 1950, 216 – Brande 1950, 31 – Winkler 1957, 204 – Oberhuber 1967, 233, no. 346 – Anzelewsky 1970, no. 60 – Anzelewsky 1971, 225 – Pfaff 1971, 55–58 – Strauss 1508/1 – Anzelewsky/Mielke, no. 56 (with earlier literature)

The drawing belongs to a group of eighteen surviving studies (W. 448–465; today in Vienna, Paris, St. Petersburg, and Berlin), which Dürer prepared in connection with the center panel of the great altar that the Frankfurt merchant Jakob Heller ordered in 1507.[1] The subject of the picture, which Dürer guaranteed to carry out without

Jobst Harrich after Dürer, Center panel of the Heller altar (copy), 1614

65

aid from his shop, was the Coronation of the Virgin by Christ and God the Father in the upper half, with apostles gathering around the empty grave in the lower half.[2] We are closely informed about the genesis of the ambitious project by nine letters from Dürer to his Frankfurt patron.[3] In 1509 the altar was set up in the Dominican church in Frankfurt and shortly later completed by the addition of two fixed wings in grisaille by Matthias Grünewald. In 1614, through its sale to Maximilian, duke of Bavaria, Dürer's center panel came to Munich, where it burned in 1729. The original was copied by Jobst Harrich (see ill.); this painting, which had been ordered by the buyer in 1614, hangs today in the Historisches Museum der Stadt Frankfurt.

The Berlin Kupferstichkabinett owns three additional studies for the Heller altarpiece. As Wölfflin established, all four sheets are part of the last stage of preparatory drawings for the final version. Our sheet is primarily a drapery study. Compared to the careful execution of the drapery, the apostle's head, which has its own dedicated study in the Berlin Kupferstichkabinett, is relatively summarily treated. Annette Pfaff therefore surmised, probably rightly so, that Dürer drew the present sheet after a draped dummy. The apostle's figure seems stockier in the final version (passed down to us by Harrich's copy), as the drapery there reaches down to the feet.

The fact that Dürer omitted attributes in both the present drawing and the concomitant study of a head has led scholars to question which apostle Dürer intended to represent in both studies. Winkler and Strauss suspected that it was St. Paul or St. James the Greater. However, the head on the Harrich copy differs from that on the drawing, for on the panel, the figure is identified as St. Peter by the locks on his brow. As Strauss and Winkler observed, this change could not be the work of a copyist. The proposition, forwarded by several scholars, that Dürer did not initially have the apostle Peter in mind should be rejected.[4] F.A./S.M.

1. On the genesis of the Heller altarpiece, see Kutschbach 1995, 71–80.

2. On the question of the models for this scheme, see Kutschbach 1995, 77–80.

3. See Rupprich 1, 64–74.

4. Anzelewsky/Mielke, 58.

66 SAMSON BATTLING THE PHILISTINES, 1510

Berlin, Kupferstichkabinett, KdZ 4080
Pen and black ink; black wash; heightened in white on olive green prepared paper; rounded at the top; upper corner segments covered in black
315 x 159 mm
No watermark
Inscribed, probably later, *MEMENTO MEI*; on otherwise empty tablet, Dürer's monogram

PROVENANCE: Beuth-Schinkel Coll.; transferred to the Kupferstichkabinett between 1911 and 1921

LIT.: Heller 1827, 2, 1: 79, no. 5 (80, no. 22) – Thausing 1884, 2: 60f. – R. Vischer, in: *Allgemeine Zeitung* 15.3.1886 – *Handzeichnungen*, no. 24 – Bock 1921, 27 – W. 483 – Lieb 1952, 135 and passim – Musper 1952, 142 – Winkler 1957, 249 – Oettinger/ Knappe 1963, 101, n. 182 – Anzelewsky 1970, no. 68 – Anzelewsky 1971, 42 – Strauss 1509/56 – Anzelewsky/Mielke, no. 61 (with earlier literature) – Bushart 1994, 115–142

Dürer supplied designs for the graves of Georg and Ulrich Fugger in the Fugger family chapel in St. Anna in Augsburg that were later carried out in simplified form by the sculptor Sebastian Loscher. Our sheet depicts the design for the memorial plaque of Georg Fugger, who died in 1506. The first indication of the existence of the drawing is supplied by a 1588 inventory of the Imhoff family collection that was published in 1827 by Heller: "The grave of the gentlemen Fuggo [Fugger] gray in gray." It was not until 1875, however, that Thausing discovered the sheet itself in the holdings of the Beuth-Schinkel Collection in Berlin. He did so without recognizing the connection with the Fugger graves, which was revealed a little later by R. Vischer.

The composition is divided into three registers: in the area of the base, putti, making music and riding dolphins, and satyrs romp to the right and left of a *tabula ansata* (tablet with handles). In the register above lies a corpse on a bier, wrapped in a burial shroud, in front of which two satyrs mourn to the left and right of a skull, while, farther to the right, two putti attempt to stick an enormous candleholder in a made-to-measure hole in the pedestal. The main pictorial field, which is rounded at the top, shows a huge Samson slaying the Philistines with the jawbone of an ass. In a smaller subsidiary scene in the left center, we see his struggle with a lion as well as the hero carrying the gates of Gaza. In the opening of the portal in the background on the right, Samson and Delilah can be made out.

Scholars have often stressed the Italianate element of

66

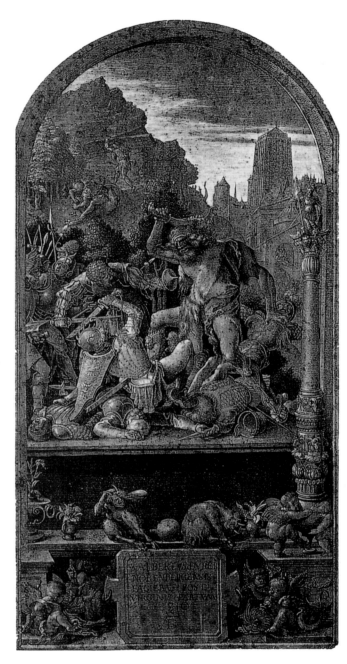

Albrecht Dürer, *Samson Battling the Philistines* (freehand copy), 1510

Dürer's funerary designs.[1] Even so, that is only visible in the ornamental forms. Both the representation of the dead man as *transi* in burial shrouds and the large relief above can instead be traced back to north European models.[2]

A total of six Dürer drawings for the Fugger graves have survived; four are related to the grave of Georg Fugger, whereas the other two originated in connection with the memorial plaque of Ulrich Fugger (died 1510). As a pen drawing in New York (W. 484; previously Lemberg) proves, Samson with the gates of Gaza was initially intended as the principal motif. Later, Dürer changed the theme to Samson and the Philistines. A sketch in Milan (W. 488) represents the preparatory work for the present Berlin design. The fourth sheet is a free copy of the design that is generally accepted (that is, by all scholars since Bock 1921) as an autograph work (KdZ 18; W. 486; see ill.) and is now also in the Berlin Kupferstichkabinett.[3]

Both the Milan sketch (W. 488), which precedes our design, and the copy that originated after it (W. 486; KdZ 18) carry the date 1510. Dürer must therefore have created the design in that year.

In the case of the grave of Ulrich Fugger, for which Dürer envisaged the Resurrection of Christ as the subject for the main pictorial field, only two drawings have survived. These are a preparatory study in Nuremberg (W. 485) and a drawing in Vienna (W. 487), the latter constituting a kind of counterpart to the Berlin copy (W. 486; see ill.). In the second Berlin version, Dürer avoided all references to the purpose of the sheet as a design for a grave. Thus, the shrouded corpse, the funeral lamps, and God the Father have been omitted. Much the same is true for the Vienna drawing, which also lacks all reference to the funerary context. This situation justifies the supposition that the Vienna sheet is a similarly reduced version of the lost design for the memorial plaque of Ulrich Fugger. This raises the question of the function of both copies.

The inventory cited by Heller establishes that, in 1588, both copies belonged to the Imhoff family. Without any reference to the Fugger graves, both drawings carry the inscription *Ein schwarz zu thuendes Täfelein hat Albrecht Dürer mit kleinen Figuren, Samsons Histori und des Herrn Christi Auferstehung gemahlt.* (Albrecht Dürer has painted a black-looking panel with small figures, the history of Samson and the Lord Christ's Resurrection). The two exceptional, finely drawn sheets bear an elaborate signature and dating, *ALBERTVS DVRER NORENBERGENSIS FACIEBAT POST VIRGINIS PARTUM 1510,* as well as the monogram, on the tablet in the lowest zone. Bushart supposed[4] that Dürer wanted to create *ricordi* of his complex designs

that were disconnected from the context of the commission's meaning, possibly because he had to leave the design, as *modello,* with the patron or with the craftsman charged with its execution. The elaborate inscriptions of the two copies anticipate almost to the word the proud self-consciousness of the signature of the *Adoration of the Holy Trinity* of 1511, thus proving Dürer's intention to convey the status of autonomous works of art on these sheets.

S.M.

1. For the latest elucidation, see Bushart 1994, 125ff.
2. Compare to Bushart 1994, 125ff., who attempted, in an unconvincing way, to derive the type of grave from Italian prototypes.
3. W. 486; since Bock 1921, 27, the relationship between design and copy has been solved. Anzelewsky (in: Anzelewsky/Mielke, no. 62) also took the sheet for an autograph copy, as did Bushart 1994, 121ff.
4. Bushart 1994, 132.

67 REST ON THE FLIGHT INTO EGYPT, 1511

Berlin, Kupferstichkabinett, KdZ 3866
Pen and brown ink
278 x 207 mm
No watermark
Upper left, signed with monogram and dated *1511*

PROVENANCE: Le Fevre Coll.; Festetis (Lugt 926); Von Klinkosch Coll. (Lugt 577); acquired in 1890

LIT.: Bock 1921, 28 – Beenken 1936, 91, 121 – W. 513 – Winkler 1947, 19 – Panofsky 1948, I: 517 – Winkler 1951, 34 – Musper 1952, 220 – Secker 1955, 217 – Winkler 1957, 245 – Exh. cat. *Dürer* 1967, no. 39 – Anzelewsky 1970, no. 70 – Strauss 1511/16 – Anzelewsky/Mielke, no. 67 – Exh. cat. *Dürer* 1991, no. 30 – Exh. cat. Berlin 1993, 115

This hasty conceptional sketch of the Flight into Egypt is well suited to refute the widespread notion of Dürer's overmeticulous working method. Not one stroke seems redundant, even the date and monogram serve a formal function within the composition.

Beenken felt that the motif of the sitting Virgin is related to Leonardo's *St. Anne, the Virgin, and Christ*; Panofsky believed that though the motif is truly Italianate, it can hardly be traced to Leonardo's painting, as it already occurs in Dürer's woodcut *The Birth of the Virgin* of about 1504 (B. 80). Joseph with a pilgrim flask already appears in the panel *Rest on the Flight* by Master Bertram.

F.A.

68 PORTRAIT OF A YOUNG WOMAN, 1515

Berlin, Kupferstichkabinett, KdZ 24
Charcoal
420 x 290 mm
No watermark
Above, inscribed with monogram and date *1515*
Upper left corner restored

PROVENANCE: Andreossy Coll.; Posonyi-Hulot Coll. (Lugt 2040/41); acquired in 1877

LIT.: Posonyi 1867, no. 329 – Exh. cat. Berlin 1877, no. 24 – Lippmann 1882, 13, no. 2 – Lippmann 1883, no. 46 – Bock 1921, 29 – Flechsig 2, 280, 462 – W. 562 – Panofsky 1943, no. 1109 – Winkler 1957, 267 – Exh. cat. *Dürer* 1967, no. 41 – White 1971, no. 64 – Strauss 1515/53 – Exh. cat. *Köpfe* 1983, no. 54 – Anzelewsky/Mielke, no. 78 (with earlier literature) – Exh. cat. *Dürer* 1991, no. 34

This portrait radiates such a heartfelt and personal feeling—the girl's childish, slightly sleepy face and her clothes were masterfully brought to life—that there has been endless speculation about the identity of the subject. The 1867 sales catalogue of the Posonyi Collection, from which the greater majority of Berlin's Dürer drawings come, offered the anecdotal opinion that the subject is Dürer's maid Susanna, who four years after the drawing was made accompanied Dürer and his wife on their journey to the Netherlands. Unfortunately, later, more serious attempts at identification have been no more successful. The mild eye affliction of the girl is encountered in the family of Dürer's wife, Agnes Frey, as well as in the family of his mother, Barbara Holper. Thus, Thausing believed he could recognize Dürer's niece, the daughter of Dürer's sister Agnes. An even less well-founded, more dubious identification was made by Flechsig, who proposed that the girl is the younger sister of the unknown sitter in a Stockholm portrait drawing of 1515 (W. 561).

A light stroke that arches above the hair of the girl reveals that Dürer's hasty preparatory sketch must have placed the head higher. An additional pentimento is visible above the right shoulder of the sitter.

H.M.

67

68

69

69 DESIGN FOR THE DECORATION OF A PIECE OF ARMOR, C. 1515

Berlin, Kupferstichkabinett, KdZ 29
Pen and brown ink
207 x 260 mm
No watermark
Above, Dürer's monogram in another hand
Probably trimmed on both sides and below

PROVENANCE: Andreossy Coll.; Posonyi-Hulot Coll. (Lugt 2040/41); acquired in 1877

LIT.: Böheim 1891, 179 – Bock 1921, 30 – W. 681 – Post 1939, 253 – Williams 1941, 73 – Tietze 1951, 30 – Musper 1952, 240 – Winkler 1957, 284 – Exh. cat. *Dürer* 1967, no. 44 – Anzelewsky/Mielke, no. 87 (with earlier literature) – Exh. cat. *Dürer* 1991, no. 37

This drawing forms a unified group in combination with another sheet in Berlin (W. 682), two sheets in Vienna (W. 678f.), and one in the Pierpont Morgan Library in New York (W. 680). According to Paul Post,[1] it is a design for the ornamentation of a silver suit of armor of Maximilian, which—according to Böheim—the latter had ordered from the famous Augsburg armorer Koloman Helmschmied. The group of five drawings is closely related in style to the Prayer Book of Maximilian of about 1515.

Ätzmalerei, the forerunner of the graphic technique known as engraving, was increasingly used in the late fifteenth century for decorating harnesses (armor). The etchings were generally blackened, but the particularly elaborate suits of arms were also gilded. The appellation "silver harness" could refer to the fact that the adornment was to be executed in silver on a dark ground if the entire armor was not meant to be plated in silver.[2] The Tower of London preserves such a silver harness, with gilded ornamentation, which once belonged to King Henry VIII of England. In any case, as Dürer's design proves, it must have been a truly lavish harness; after its completion, the emperor, who was constantly in financial trouble, was not able to pay for it.

The splendor of the imperial armor is demonstrated by the adornment of parts that normally remained undecorated. Thus, in Post's opinion, our drawing was intended as a model for the decoration of the upper edge of the upper thigh plate.

The choice of decorative motifs in Dürer's design provides no direct insight into who the patron was. That it was indeed Maximilian may be deduced from a Vienna sheet with decorations for the visor of the same suit (W. 679). The central motif of the present sheet is the bust of a warrior with a fantastic helmet, which is framed by a wreath of lilies of the valley. This central medallion is framed by fantastic animals to the left and right, respectively a dragon and a fish. The edges are bordered by branchlike staffs. An oak twig and a fantastic plant fill leftover spaces. The lilies of the valley could allude to the emperor, for in *Triumphal Arch* (B. 138), the giant woodcut created for Maximilian in the same year, a garland of these flowers hangs over the center portal.

F.A.

1. In: *Zeitschrift für historische Waffen- und Kostümkunde,* n.s., 6 (1939), 253ff.
2. See Koschatzky/Strobl 1971, no. 103.

70 CARDINAL MATTHÄUS LANG OF WELLENBURG, C. 1518

Basel, Kupferstichkabinett, Inv. 1959.106
Black chalk; background later washed in black
253 x 274 mm
Watermark: triangle with cross (not in Briquet)
Upper right, false Dürer monogram in white gouache, rubbed out
Cut at bottom; tear in the right edge; horizontal folds at the chin; foxed; right shoulder, brown smudge

PROVENANCE: art trade; Otto Wertheimer, 1951; CIBA-Jubiläumsschenkung 1959

LIT.: Ephrussi 1882, 260ff. – Thausing 1884, 2: 156 – Flechsig 2: 374, 601 – Tietze/Tietze-Conrat 1928, 2 (1937): 131, no. 709, ill. on 291 – M., 43 – Panofsky 1945, 2: 101, no. 1028 – Musper 1952, 292 – F. Winkler, "Dürerfunde," *Sitzungsberichte Kunstgeschichtl. Gesellschaft zu Berlin,* October 1954 – May 1955, 8f. – Winzinger 1956, 23–28 – Winkler 1957, 337, n. 2, ill. 170 – Schmidt 1959, 24 – Exh. cat. *CIBA-Jubiläums-Schenkung* 1959, no. 6 – Hp. Landolt, in: *Öff. Kunstslg. Jahresb.* (1959–1960), 24, 36 – E. Panofsky, "An Unpublished Portrait Drawing by Albrecht Dürer," *Master Drawings* 1 (1963), 35–41, n. 1, n. 11 – P. Strieder, "Bildnis des Kardinals Matthäus Lang von Wellenburg," exh. cat. Nuremberg 1971, no. 538 and ill. – Koschatzky/Strobl 1971, no. 116, ill. on 364 – M. Mende: 1471 – "Albrecht Dürer – 1971. A Great Exhibition in the Germanisches Nationalmuseum Nürnberg: May 21 to August 1," *The Connoisseur* 176 (1971), 166, ill. on 164 – Strauss 1974, 3: no. 1518/24 – Talbot 1976, 294 – Exh. cat. *Schenkungen von Altmeisterzeichnungen durch die CIBA-GEIGY. Zeichnungen schweizerischer und deutscher Meister des 15. und 16. Jahrhunderts,* Öffentliche Kunstsammlung Basel (Basel 1984), no. 6

This drawing, which was only discovered in 1951, portrays Matthäus Lang of Wellenburg (1468–1540). He was a car-

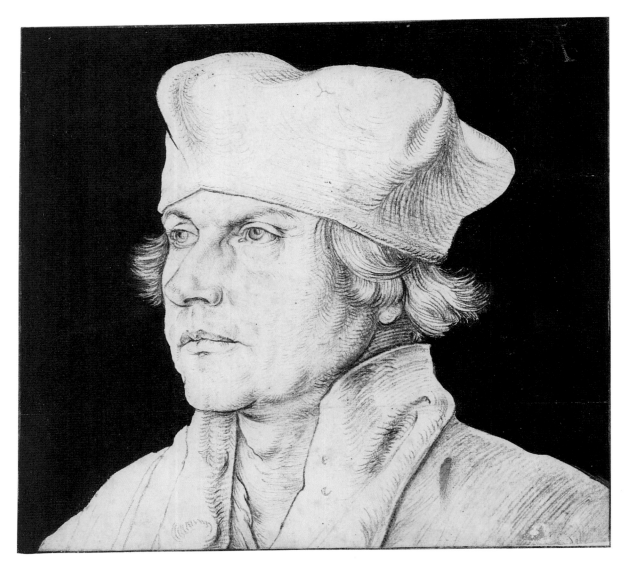

70

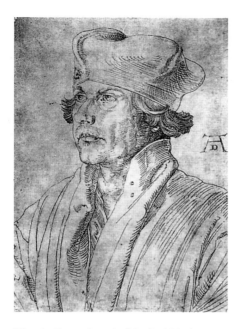

Albrecht Dürer, *Portrait of Cardinal Matthäus
Lang of Wellenburg,* c. 1518

Matthäus Lang of Wellenburg was in Augsburg for
the imperial diet of 1518. Dürer could have portrayed him
there. He also had an opportunity to draw the cardinal
after the Netherlandish journey of mid-1520 to mid-1521.
In 1521 Dürer rendered a throne design for him (W. 920).
Matthäus Lang of Wellenburg, by then archbishop of
Salzburg, was in Nuremberg again late in 1521, when the
diet convened, and from late 1522 to the beginning of
1523. Among the works connected with our drawing,
Winzinger gave prime place to the portraits that Dürer
drew during his Netherlandish journey, and therefore
dated it to about 1521. Winkler (1957) relegated it to the
years after the Netherlandish journey. On the other hand,
our sheet is very close to Dürer's drawing of Cardinal
Albrecht of Brandenburg (W. 568), whom Dürer por-
trayed in 1518 in Augsburg. In any case, Strauss thought
it possible that our sheet originated in 1518. He surmised
that Dürer interrupted his work on the woodcut when
he set out on his journey to the Netherlands.

C.M.

dinal by 1518, and he later became archbishop of Salzburg.
The subject can be unequivocally identified on the basis
of portrait medals (see Flechsig). A portrait drawing of
Matthäus Lang of Wellenburg (Graphische Sammlung
Albertina, Vienna; see ill., W. 911) is intimately connected
to the present drawing (now in Basel). The Vienna sheet
is a tracing that Dürer took from our drawing. He oiled
the paper for this purpose, making it transparent. The
drawing therefore had an altogether specific function:
it served as the immediate working model for a large-
format woodcut. Flechsig and Meder therefore spoke of
a working drawing. This woodcut, however, probably
never materialized. The Vienna drawing, which is in pen
and ink, repeats the portrait with only minor variations.
The impression of a more objective rendering of the sitter
and a recapturing of the individual features is due to not
just the different technique and the greater linearity of
the Vienna sheet, whose tendency to summary reproduc-
tion is opposite to the detailed, painterly execution of the
chalk or charcoal drawing in Basel. The different paper
format and the subsequently added black ground of the
Basel drawing contribute substantially to this effect. As
comparison with the Vienna drawing shows, the bottom
third of our sheet has been cut off. Naturally the gaze of
the Vienna tracing looks firmer and more decisive, and
the nose is somewhat shortened and rounded.

71 PORTRAIT OF A YOUNG MAN, 1520

Berlin, Kupferstichkabinett, KdZ 60
Black chalk; dark brown chalk at the collar, in the curls, and for
the date and monogram; cap, reddish brown chalk; image
reworked with point of the brush and gray wash
366 x 258 mm
No watermark
Upper edge of the strip left in white, autograph date *1520* and
furnished with the monogram
Upper corners restored in gray watercolor, with brushwork
merging into the dark ground; originally white paper irregularly
browned by glue

PROVENANCE: Coll. of the Swedish envoy Freiherr von
Hochschild in Berlin, 1853 (verso, signature); Robinson Coll.
(Lugt 1433); acquired in 1880

LIT.: Hausmann 1861, 115, no. 1 – Lippmann 1883, no. 53 –
Thausing 1884, 2: 198 – Veth-Muller 1918, 1: 37, pl. XXXVI –
Meder 1919, 592 – Bock 1921, 32 – Flechsig 2: 228, 331f. – W.
804 – Winkler 1947, 26 – Winkler 1951, 38 – Musper 1952, 276
– Winkler 1957, 302 – Exh. cat. *Dürer* 1967, no. 61 – Goris-
Marlier 1970, no. 53 – Strauss 1520/17 – Anzelewsky/Mielke, no.
103 (with earlier literature)

Although the technique of this drawing has been
repeatedly critiqued, it was only a few years ago that
Fedja Anzelewsky first discovered traces of brushwork
on it. Throughout the entire sheet, subtle accents were
applied in gray with a brush: along the turned-up edges

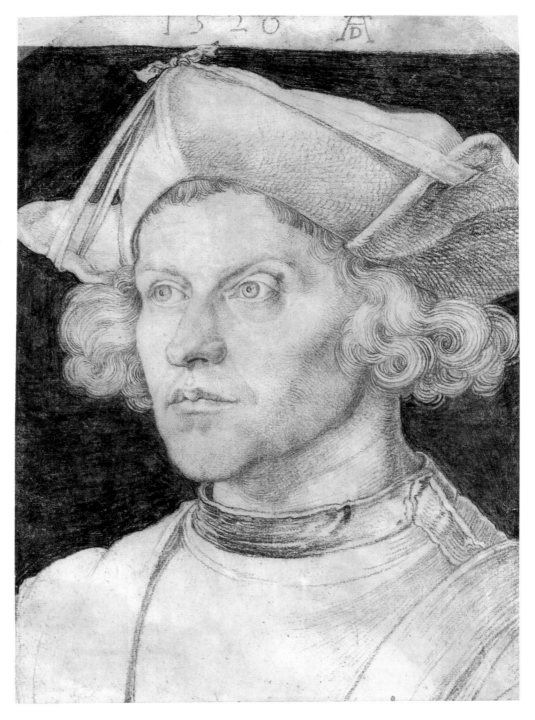

71

of the hat and in its ribbons, the locks of hair, especially along the line of the cheeks, the shadows under the nostrils and around the eyes, the eyebrows and temple, the neck, and the garment. In the dark collar the otherwise bright brushwork is a very dark gray. Traces of light and dark gray brushwork are also found on the restored corner at the upper left and are apparently also worked into the black background. As Dürer did not work up his charcoal or chalk drawings with the brush, the question arises of whether the reworking could be by another hand. The "rigidity" criticized by Winkler, which is primarily caused by the light and dark edges at the eyes, at the bridge of the nose, and at the nostrils, all indicated in brush, can be explained in this way. On the other hand, the brushstrokes are perfectly blended into the depiction. Dürer here made out-of-the-ordinary use of three different drawing pencils: the additional use of the brush could therefore be interpreted as an experimental attempt to heighten the expressive power of the portrait. Still, Flechsig called this charcoal portrait one of the most beautiful that Dürer made in the Netherlands, and for Winkler the beauty of its play of lines brought to mind a silverpoint drawing transposed to a large format.

The identification of the subject remains an insolvable problem. In the journal of the Netherlandish journey, Dürer named a large number of people whom he "portrayed in charcoal" (see Flechsig 2: 228). Not once, however, did he mention the addition of a brush. Flechsig's more problematic than astute attempt to identify the young man in the drawing as Rodrigo de Almada has encountered nothing but great skepticism among scholars and should be rejected. H.M.

FROM THE NETHERLANDISH SKETCHBOOK, 1520/1521 (cats. 72, 73)

The sketchbook (in his travel diary Dürer calls it "mein büchlein" or booklet) belongs to the most famous drawn documents of the Netherlandish journey. Its pages were covered in a white ground on which the artist drew in silverpoint *(mit dem stefft)*. This technique, inherited from the Middle Ages, yielded a soft, precise graphic image and demanded great sureness of hand, as corrections were almost impossible. Today the booklet is separated and divided among several collections, and the attempt to reconstruct the original sequence of the sheets in the volume is one of the most exciting but not altogether solvable problems of art history. We cannot be sure today which sides of the sheets faced front or back in the sketch-

book. Nor did Dürer sketch in a continuous sequence of front, back, front, back, and so forth; instead he filled several front pages first and would then use back pages that he had left untouched.

72 LAZARUS RAVENSBURGER AND THE SMALL TOWER OF THE VAN LIERE RESIDENCE IN ANTWERP, 1520

Verso: two girls in Netherlandish dress, 1520
Berlin, Kupferstichkabinett, KdZ 35
Silverpoint on white prepared paper
122 x 169 mm
No watermark
Recto, upper left, inscribed by the artist . . . *rus rafenspurger . . . gemacht zw antorff*; verso, upper left, inscribed by the artist almost illegibly *S(obl . . .)*
Verso, upper right corner, preparation transferred from the former facing sheet (W. 769; Chantilly)

PROVENANCE: unknown; recto, lower right, embossed stamp with a five-point star (Lugt 2882); Firmin-Didot (collector's mark, Lugt 119); acquired in 1877

LIT.: Lippmann 1882, 16, no. 32 – Lippmann 1883, no. 55 – Veth-Muller 1918, 1: 26 – Bock 1921, 31 – Schilling 1928, no. VIII – Flechsig 2: 217 – W. 774 – Rupprich 1 – Panofsky 1943, no. 1488 – Winkler 1947, 26 – Exh. cat. *Dürer* 1967, no. 48 – Strauss 1520/35 – Exh. cat. Brussels 1977, no. 65 – Anzelewsky/Mielke, nos. 95r and 95v (with earlier literature) – Anzelewsky 1988, fig. 19 – Mielke in: Exh. cat. *Antwerp, Story of a Metropolis* (Antwerp 1993), no. 21

In his diary of the Netherlandish journey, Dürer first mentioned "Mr. Lasarus, the great man" (Rupprich 1: 162, l. 53) in late November. Lazarus Ravensburger, a descendant of an Augsburg family, was, as of 1515, the Lisbon overseer for the Höchstetters (Rupprich 1: 190, n. 375). In a later entry of December 1520 (Rupprich 1: 164, Z. 22) Dürer wrote that he had "given [him] a portrayed face" *(geschenckt ein conterfet angesicht)*. Dürer probably meant Ravensburger's own portrait; Flechsig (2, 217) proposed that we read "his portrayal" *(sein conterfet)*. The "somewhat methodically scratched portrait that was, consequently, probably not directly drawn after nature" (Veth-Muller) and his "engraving-like execution" (Winkler) have occasioned the identification of our silverpoint drawing as a copy after the portrait presented to Ravensburger. That argument carries little weight, as more or less all portraits in the booklet are drawn in a precise way; Winkler, in any case, also applied his interpretation to the other portraits, "that they are copies by Dürer for his

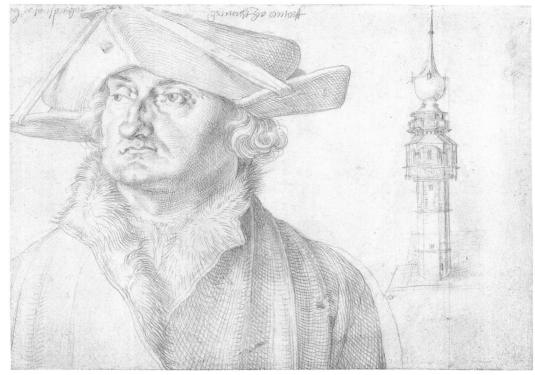

72

Verso (72)

73

Verso (73)

travel book, which were rendered after larger portraits."

The small tower at the right side of the sheet, drawn later than the portrait, belonged to the house of Arnold van Liere, the burgomaster of Antwerp. In Dürer's first stroll through the city on Sunday, 4 August 1520, his landlord, Jobst Planckfelt, took the newly arrived artist to the burgomaster's house on the Prinsenstraat, and Dürer praised the size and beauty of the house and gardens, even mentioning the "preciously decorated tower," finally calling it "in conclusion such a divine house, the likes of which I have not seen in all the German lands" (Rupprich 1: 151, Z. 8–15).

VERSO

The divergent dress of the two girls establishes unequivocally that these must be two different models, not two views of the same person. The girl who was drawn first is pushed close to the left edge of the page; Dürer's determination to save paper, which is constantly apparent in the sketchbook, is as obvious as his interest in costumes. H.M.

73 BUST OF A MAN FROM ANTWERP, THE KRAHNENBERG AT ANDERNACH, 1521

Verso: two studies of a lion, 1521
Berlin, Kupferstichkabinett, KdZ 33
Silverpoint on light prepared paper
121 x 171 mm
No watermark
Recto, upper right, inscribed by the artist *zw antorff 1521* and *pey andernach am rein*

PROVENANCE: unknown collector, recto, lower right, embossed stamp of a five-point star (Lugt 2882); Firmin-Didot (collector's mark, Lugt 119); acquired in 1877

LIT.: Lippmann 1882, 16, no. 31 – Lippmann 1883, no. 58f. – *Handzeichnungen*, no. 30 – Bock 1921, 31 – Schilling 1928, no. XI – W. 778 – Panofsky 1943, no. 1496 – Rupprich 1: 168 – Anzelewsky 1970, no. 92 – White 1971, no. 77 – Strauss 1521/ 60 – Anzelewsky/Mielke, 97r and 97v (with earlier literature) – F. Koreny, in: Exh. cat. *Tier- und Pflanzenstudien* 1985, 56 – Anzelewsky 1988, figs. 10, 21 – C. Eisler, *Dürer's Animals* (Washington/London 1991), 159, no. 6.40 – Exh. cat. *Dürer* 1991, no. 45 – *Handbuch Berliner Kupferstichkabinett* 1994, no. III.39

The captions on the sheet show that, for reasons of frugality, two unrelated motifs have been united on one sheet: above the portrait we read *zw antorff 1521,* above the landscape, *pey andernach am rein.* The landscape gives priority of place to the portrait and was therefore drawn later,

as the location establishes, during Dürer's journey home along the Rhine River, after 15 July 1521. At the right we see the Krahnenberg; at the left, in small scale, the opposite bank of the Rhine.

Dürer's travel diary helps to identify the portrait. For June 1521, at the end of his Antwerp stay, he stated: "I have diligently portrayed Art Praun and his housewife in black chalk, and I portrayed him one more time with the silverpoint" (Rupprich 1: 174, Z. 55). As silverpoint portraits are relatively rarely mentioned in the travel diary, and as the present one was apparently drawn shortly before Dürer's return home, the identification of the subject as Aert Praun has much to recommend it. However, it will only be proved when the lost charcoal portrait turns up.

VERSO

In April of 1521, while in Ghent, Dürer wrote in his Netherlandish travel diary (Rupprich 1: 168, Z. 73): "Afterward I saw the lions and portrayed one with the silverpoint." Only the sheet with the lion study in the Albertina (W. 781) carries the inscription *zw gent.* It is highly probable, however, that our lion study originated on the same occasion. As we must take Dürer's words at face value, the two lions on our sheet must be two studies after the same animal.[1] H.M.

1. Copy in Nuremberg; F. Zink, *Kataloge des Germanischen Nationalmuseums Nürnberg. Die deutschen Handzeichnungen, 1: Die Handzeichnungen bis zur Mitte des 16. Jahrhunderts* (Nuremberg 1968), no. 76.

74 ST. APOLLONIA, 1521

Berlin, Kupferstichkabinett, KdZ 1527
Black chalk on green prepared paper
414 x 288 mm
Watermark: high crown with cross (similar to Briquet 4895)
Right, inscribed with date *1521* and monogram

PROVENANCE: Robinson (Lugt 1433); acquired in 1880

LIT.: Lippmann 1882, 17, no. 137 – Lippmann 1883, no. 65 – Bock 1921, 33 – Tietze/Tietze-Conrat 1928, 853 – N. Busch, "Untersuchungen zur Lebensgeschichte Dürers," *Abh. d. Herder-Ges. u. d. Herder-Inst. zu Riga* 4 (1931), pl. IX – W. 846 – Panofsky 1943, no. 768 – Exh. cat. *Dürer* 1967, no. 53 – Exh. cat. *Dürer* 1971, no. 225 – White 1971, no. 95 – Strauss 1521/93 – Strieder 1976, 153 – Anzelewsky 1980, 229 – Strieder 1981, 135 – Anzelewsky/Mielke, no. 112 (with earlier literature) – Exh. cat. *Dürer* 1991, no. 48

This is a study for an unexecuted, monumental altarpiece of the Madonna with many saints, whose genesis can be

74

Albrecht Dürer, Sketch for an altarpiece of
Mary, 1521

it would reopen the old controversy of whether the large
study heads for the image of the Virgin Mary (W. 845–
849) were drawn after models or whether they represent
Düreresque ideal figures.[2]

As the sequence of production for the drawings
cannot truly be established, all attributions remain hypo-
thetical. The study of Apollonia by itself leads to the
conclusion that Dürer created an ideal portrait: the
divine head, her controlled, quiet face with lowered eyes,
breathes life, but her neck and the rendering of her bosom
show unequivocally that the artist was not looking at
a model while drawing. H.M.

1. Nicolaus Busch's hypothesis that the designs were intended for an
image of the Virgin in the Church of St. Peter in Riga, on which Dürer
had worked after his return from his Netherlandish journey and which
was destroyed during the iconoclasm in Riga in 1524, is not tenable.
Busch even challenged that all the designs belonged to one commission:
according to him it is inconceivable that Dürer would have been
allowed to decide so freely on the depiction or omission of individual
saints.
2. The scholarly opinions are reviewed in Anzelewsky/Mielke, 116.

deduced from six surviving general designs (Panofsky
1943, nos. 760–765). Beyond that, numerous individual
studies are known. As not a single indication has survived
with respect to the place and the patron for which the
work was intended, however, the acuity of the researchers
was given unlimited scope.[1]

In the course of its development, the appearance
of the altarpiece changed from a horizontal format with
many figures to a vertical format with space for only a
few saints.

The figure of St. Apollonia, whose noble and spiritual
expression is precisely recorded in our study, occurs only
on the two designs in horizontal format (W. 838f.). Dürer
had an astonishing ability to represent the faces of saints
in his rapid, summary compositional sketches in nearly
the same way that they would appear in his more finished
figure studies. Apollonia, for instance, is clearly recogniz-
able in the design in Paris (W. 838), as in the one in Ba-
yonne, where she holds the attributes of her martyrdom,
a pair of pliers with teeth (W. 839; see ill.). In this design
we see her face in an expression-heightening transition,
a consequence, according to Tietze/Tietze-Conrat, of the
creation of our individual study. But even on the design
in the Louvre, which is probably earlier than our sheet,
Apollonia was already clearly recognizable: the lines
around her neck, the rounded collarbone, the deep cleav-
age, the lowered eyes—everything corresponds closely
to our study. If, as Tietze/Tietze-Conrat assume, it really
originated between the two designs in horizontal format,

75 DRAPERY STUDY, 1521

Berlin, Kupferstichkabinett, KdZ 39
Black chalk on green prepared paper; faintly heightened in white
294 x 406 mm
No watermark
Above, dated *1521* by Dürer and inscribed with
his monogram

PROVENANCE: Andreossy Coll.; Lawrence Coll. (Lugt 2445);
Niels Bark Coll.; Thibaudeau Coll.; Coningham Coll. (Lugt
476); Posonyi-Hulot Coll. (Lugt 2440/41); acquired in 1877

LIT.: Lippmann 1883, no. 54 – *Handzeichnungen,* no. 35 – Bock
1921, 33 – Tietze/Tietze-Conrat 1928, no. 856 – Flechsig 2: 254
– W. 843 – Panofsky 1943, no. 779 – Strauss 1521/88 – Anzelew-
sky/Mielke, no. 109 – Exh. cat. *Dürer* 1991, no. 47

Dürer created this highly effective study of the folds of
thick, heavy, falling fabric in the second half of 1521, after
his return from the Netherlands. It cannot be proved, as
is generally assumed, that this drapery study is for a seated
figure in one of the preparatory studies for the great altar
of the Virgin (see cat. 74). Only a series of preparatory
works inform us about this altarpiece, without anything
being known about its patron and intended destination.

The stone on the ground, at the left, resembles a
skull. From this fact, Flechsig concluded that the study
could only be preparatory to a serious theme (Christ

75

76

as Man of Sorrows or a Virgin of Sorrows), and yet
the woodcut of the *Holy Family on a Grassy Bench* (B. 98)
shows a similar "skull"-stone beneath similarly folded
drapery. Therefore every depiction in which a carefree
Christ child seems to be playing has been seen as referring
to his death on the cross. H.M.

76 STUDY SHEET WITH NINE DEPICTIONS OF ST. CHRISTOPHER, 1521

Berlin, Kupferstichkabinett, KdZ 4477
Pen and black ink
228 x 407 mm
Watermark: fleur-de-lis coat of arms with crown, flowers, and
attached cross (similar to Briquet 1746)
Above, inscribed with monogram and date *1521*

PROVENANCE: Andreossy Coll.; Duval Coll.; acquired in 1910

LIT.: Veth-Muller 1918, 1: 42 – Bock 1921, 32 – Baldass 1928,
23f. – W. 800 – Musper 1952, 298 – Winkler 1957, 309, 327 –
Strauss 1521/14 – Anzelewsky/Mielke, no. 100 (with earlier
literature) – Exh. cat. *Dürer 1991*, no. 42

The authenticity of this drawing has never been ques-
tioned, as it has always been related to one of Dürer's
entries in his travel diary of his Netherlandish journey:
"I have sold Master Joachim 4 Christophers on gray
paper."[1] By "Master Joachim," Dürer meant the Antwerp
landscape painter Joachim Patinir. Ludwig Baldass was
able to show that in the Louvre chiaroscuro drawing with
the legend of St. Christopher, the figure of the saint was
modeled after the first sketch of the Berlin sheet. A sheet
in London (W. 801) and one in Besançon (W. 802) pre-
sumably also belong to Dürer's four designs.

Our sheet conclusively shows Dürer's inexhaustible
inventiveness as well as what he meant when he said that
a good artist must be "filled to the brim with figures."
F.A.

1. Rupprich 1, 172, ll. 8–10.

77 MONKEY DANCE, 1523

Verso: letter to Felix Frey
Basel, Kupferstichkabinett, Inv. 1662.168
Pen and gray ink
310 x 220 mm
No watermark
Inscribed upper center *1523/Noch andree zw/nornberg*; verso,
*+.1523. am Sundag noch andree zw Nörnberg/Mein günstiger liber her
Freÿ Mÿr is das püchlein so jr hern/Farnphulr vnd mir zwschickt/
worden So ers gelesen hat so/will jchs dornoch awch lesen/aber des affen
dantz halben so/jr begert ewch zw mach hab jch/den hymit vngeschickt
awff/gerissen Dan jch hab kein affen/gesehen Wolt also vergut
haben Vnd/wölt mir meine willige/dinst sagen heren Zwingle Hans
Lowen/Hans Vrichen vnd den/anderen meinen günstigen herren/E
u/Albrecht Dürer/teillent dis füff stücklen vnd vch jch hab sunst
nix news*
Vertical and horizontal center folds; flattened

PROVENANCE: Amerbach-Kabinett, formerly U.IX.1

LIT.: *Photographie Braun*, 3, 4 – C. G. von Murr, *Journal zur
Kunstgeschichte* part 3 (Nuremberg 1776), 27ff. – *Erwähnung der
Zeichnung und des Briefes* see Falk 1979, 26 – Ganz/Major 1907,
27 – Dodgson 1908, no. 26 – E. Ehlers, "Bemerkungen zu den
Tierabbildungen im Gebetbuche des Kaisers Maximilian,"
Jahrbuch der königlichen Preussischen Kunstsammlungen 38 (1917),
167 – A. A. Sidorow/M. Dobroklonsky, "Unbekannte Dürer-
zeichnungen in Russland," *Jahrbuch der Preussischen Kunstsamm-
lungen* 48 (1927), 223 – Lippmann 1883, 7 (1929): no. 864 –
Tietze/Tietze-Conrat 1928, 2 (1938): 50, no. 919, ill. 191 – W.
927 – Panofsky 1945, 2: 130, no. 1334 – H. W. Janson, *Apes and
Ape Lore in the Middle Ages and the Renaissance* [Studies of the
Warburg Institute, 20] (London 1952), 271f., pl. XLVIIa –
Winkler 1957, 344 – G. Bandmann, *Melancholie und Musik.
Ikonographische Studien* (Wissenschaftliche Abhandlungen der
Arbeitsgemeinschaft für Forschung des Landes Nordrhein-
Westfalen, 12) (Cologne 1960), 67ff., ill. 22 – Exh. cat. *Amerbach
1962*, no. 26 – D. Koepplin, "Basel. Kupferstichkabinett im
Kunstmuseum," *Das große Buch der Graphik* (Brunswick 1968),
98, ill. on 97 – Hütt 1970, no. 1074 – R. an der Heiden,
"Albrecht Dürer. Affentanz," exh. cat. Nuremberg 1971, no. 586,
ill. on 311 – Hp. Landolt 1972, no. 29 – A. Winther, "Zu
einigen Ornamentblättern und den Darstellungen des
Moriskentanzes im Werk des Israhel van Meckenem," in: Exh.
cat. *Israhel van Meckenem und der deutsche Kupferstich des 15.
Jahrhunderts*, Kunsthaus der Stadt Bocholt (Bocholt 1972), 96, ill.
123 – Strauss 1523/21 – Strieder 1976, ill. on 159 – R. L.
McGrath, "The Dance as a Pictorial Metaphor," *Gazette des
Beaux-Arts* 89 (1977), 87f., ill. 7 – Falk 1979, 18, 26, n. 43 –
M. A. Sullivan, "Peter Bruegel the Elder's 'Two Monkeys': A
New Interpretation," *Art Bulletin* 43 (1981), 125 – Hp. Landolt,
"Dürers herzerfrischender Affentanz," *Nordschweiz. Basler
Volksblatt* 19.7.1985, with ill. – Exh. cat. *Amerbach 1991, Zeich-
nungen*, no. 53

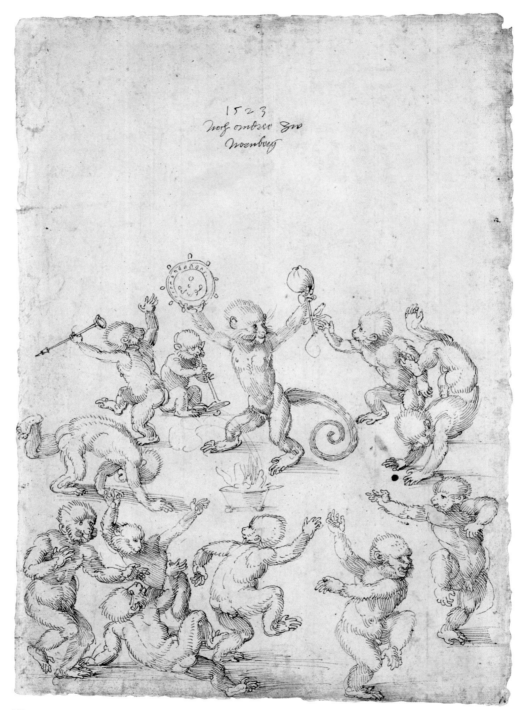

77

On the letter:

C. G. von Murr, in: *Journal zur Kunstgeschichte und zur allgemeinen Litteratur,* 10 (1781), 47f. – J. F. Roth, *Leben Albrecht Dürers, des Vaters der deutschen Künstler* [Anhang zum 42. Bande der Neuen Bibliothek der schönen Wissenschaften und der freyen Künste] (Leipzig 1791), 78f. – Heller, 1827, 34f. – F. Campe, *Reliquien von Albrecht Dürer, seinen Verehrern geweiht* (Nuremberg 1828), 52f. – A. von Eye, *Leben und Wirken Albrecht Dürers* (Nördlingen 1860), 457 – M. Thausing, *Dürers Briefe, Tagebücher und Reime nebst einem Anhange von Zuschriften an und für Dürer* [Quellenschriften für Kunstgeschichte des Mittelalters und der Renaissance, 3] (Vienna 1872), 50 – Thausing 1876, 473 – W. M. Conway, *Literary Remains of A. Dürer. With Transcripts from the British Museum Manuscripts and Notes upon them by Lina Eckenstein* (Cambridge 1889), 129 – A. von Eye, *Albrecht Dürers Leben und künstlerische Tätigkeit in ihrer Bedeutung für seine Zeit und die Gegenwart* (Wandsbek 1892), 133 (letter cited verbatim) – K. Lange/F. Fuhse, *Dürers schriftlicher Nachlass auf Grund der Originalhandschriften und theilweise neu entdeckter alter Abschriften* (Halle an der Saale 1893), 70 – E. Heidrich, *Albrecht Dürers schriftlicher Nachlass. Familienchronik, Gedenkbuch, Tagebuch der niederländischen Reise, Briefe, Reime, Auswahl aus den theoretischen Schriften* (Berlin 1908), 185 and ill. of the drawing – Rupprich 1: 106–108, 436f., no. 51, 3 – Exh. cat. Nuremberg 1971, no. 394 and ill. (letter) – K. Bühler-Oppenheim, "Zu einigen Handschriften Lukas Cranachs d. Ä. und Albrecht Dürers," in: Koepplin/Falk 1974/1976, 2 (Basel 1976), no. 660c

A letter to Felix Frey, the provost of the Grossmünsterstift in Zurich, informs us that Dürer drew *Monkey Dance* at Frey's request (for the biography of Felix Frey, see Rupprich 1: 106f.). Rupprich (3: 436f.) and Janson (1952, 155f.) referred to the literary tradition for a legend of the dance of monkeys, with which Dürer could have been familiar. In the story, dancing monkeys forget their training and fight each other when a spectator tosses nuts in their midst. The dance of the monkeys may therefore be seen as a metaphor for the inconstancy of man and the folly of earthly pleasures, and the mirror and apple held up by the ape in the center refer to vanity and greed. They can be attributes of "Lady Venus" and "Lady World." These personifications and comparable attributes are also encountered in depictions of Morris dancers, as in a drawing by Hans von Kulmbach in Dresden (Winkler 1942, 23) and on a woodcut by Hans Leinberger (Philipp M. Halm, *Erasmus Grasser* [Augsburg 1928], ill. 168).

Dürer's drawing was probably preceded by Italian models. The round dance *all'antica,* which nude men perform around a woman in a Florentine engraving, could have influenced the form of the dance as well as the poses of the monkeys (c. 1480; Hind, 2: A.II.12, pl. 97). Dürer's drawing (W. 83) with seven dancing children, which he

Verso (77)

created during his first Italian journey, betrays his awareness of an Italian model, probably one by Mantegna (see Sidorow 1927, 221, and Bandmann 1960, 67ff.). The movements and attitudes of the heads of the children do, in any case, remind one of the monkeys in our drawing. Unlike the impulsiveness of children, the deportment of monkeys is often compared to the sinfulness of human beings. The monkeys of Dürer's drawing look very human, which may explain Dürer's observation that he had seen no monkeys and therefore had drawn them ineptly. This humanity is expressed not just by the emphatic gestures, but also by the use of musical instruments and the ritual of the dance in the round. Finally, the smoking cauldron in the center, which intoxicates the monkeys with its fumes, recalls magic procedures, such as those found in Baldung's depictions of witches. Cauldron and fire are common metaphors for the female sex. This analogy is close to the thematic connection with the Morris

dance. It also crops up in contemporary treatises, such as Thomas Murner's *Narrenbeschwerung (Annoyance of the Fools),* Strassburg, 1518. In the *Narrenschiff* (chapter 13), Dürer had already depicted apes as prisoners of Venus. The monkey dance represents male capriciousness and lust, which finds expression most clearly in the excited monkey who holds the mirror and apple. This ape, who is a kind of counterpart to Lady World or Venus, directs the round dance of the monkeys. The number twelve and the circular form could also allude to the completion of the year, to the months, or, generally, to the world and the cosmos, whose order is turned topsy-turvy in an image of dancing monkeys. In his epigram "De chorea imaginum coelestium circa deam matrem," Conrad Celtis compared the circling of the planets around the earth with the Morris dance.[1] Dürer appears to be reaching back to a theme that he had already formulated in his engraving *The Witches* (M. 68). There the witch who rides backward on a billy goat and the four putti who are disposed in a circle refer to the upside-down world, which, along with the astrological sign of Capricorn, alludes to the coming of the new year.[2] The putto doing a somersault in the engraving closely resembles one of the monkeys in our drawing. It is probably no accident that our sheet originated at the same time of the year, on the first Sunday after St. Andrew's Day (30 November). Dürer probably got to know Felix Frey in 1519, during the artist's Swiss journey. As receiver of the book—according to Rupprich, probably Ludwig Hätzer's broadsheet "Ain urtail Gottes unsers eegemachels, wie man sich mit allen götzen und bildnussen halten soll" (Zurich, 24 September 1523)—Dürer mentioned Ulrich Varnbüler (1474 until about 1544), the imperial counselor and chancellor of Ferdinand I. He had been friends with Dürer and Pirckheimer since 1515. Dürer had portrayed him in 1522 (drawing in the Graphische Sammlung Albertina in Vienna; W. 908; woodcut M. 150). In his letter, Dürer extended greetings to Ulrich Zwingli, the Zurich painter Hans Leu the Younger, and Hans Urichen, perhaps the goldsmith Hans Ulrich Stampfer from Zurich.

<div align="right">C.M.</div>

1. See K. Simon, "Zum Moriskentanz," *Zeitschrift des Deutschen Vereins für Kunstwissenschaft* 5 (1938), 25–27.

2. See M. Préaud, "La sorcière de noël," in: *L'ésoterisme d'Albrecht Dürer* 1, Hamsa, 7 (1977), 47–50.

78 HEAD OF THE EVANGELIST MARK, 1526

Berlin, Kupferstichkabinett, KdZ 46
Lead-tin point; heightened in white on brown prepared paper
373 x 264 mm
Watermark: bear (similar to Meder 85–95)
Lower right, inscribed with monogram and date *1526*
Slightly trimmed on all sides

PROVENANCE: Andreossy Coll.; Lawrence (Lugt 2445); Posonyi-Hulot Coll. (Lugt 2040/41); acquired in 1877

LIT.: Bock 1921, 34 – Panofsky 1931, 34 – Flechsig 2: 286 – W. 870 – Waetzold 1950, 217 – Musper 1952, 312 – Winkler 1957, 333, 335 – Strauss 1526/3 – Anzelewsky/Mielke, no. 117 (with earlier literature) – Exh. cat. *Dürer* 1991, no. 49 – Anzelewsky 1991, no. 183f.

The drawing is a study for one of the two panels of the so-called *Four Apostles,* which Dürer donated in 1526 "in remembrance"[1] to the council of his native city Nuremberg (see ill.). Of the three surviving studies for the heads of the *Four Apostles,* which are today in the Alte Pinakothek in Munich, the one for St. Mark is the most interesting because, unlike the other two, it appears to be a study after nature. During the execution of the painting, the head took on a somewhat peasantlike coarseness and dullness.

This kind of ground, which was applied with a broad brush, is rarely found in Dürer's work. It is encountered only in two additional drawings in the Berlin Kupferstichkabinett: a sheet with drapery studies (W. 340; KdZ 32) and a study for the head of St. Paul (W. 872; KdZ 3875), which also originated in 1526 in connection with the *Four Apostles.* As a technical solution, Dürer used a soft lead-tin point that he had learned to use in the Netherlands.

The technique is grander than we generally expect from Dürer. It is hardly justified to diagnose the overall handling of the lead-tin point, as many researchers have done, as a serious deterioration of Dürer's artistic powers, brought on by physical decline. More likely, this is a severe and strongly simplified rendering, which Dürer, according to his own declaration, consciously strove to create.[2] Much of the calligraphy of the early years has survived, especially in the representation of the curly hair.

Given their inscriptions, the two apostle panels should be understood as Dürer's avowal of the Reformation as well as his endorsement of the theological position taken by the Nuremberg Council on Matters of Faith.[3] As Panofsky established in 1931, the two panels do not depict four of Christ's apostles, but three: John and Peter on the left panel and Paul on the right. The fourth figure, however, is the evangelist Mark. This unusual combina-

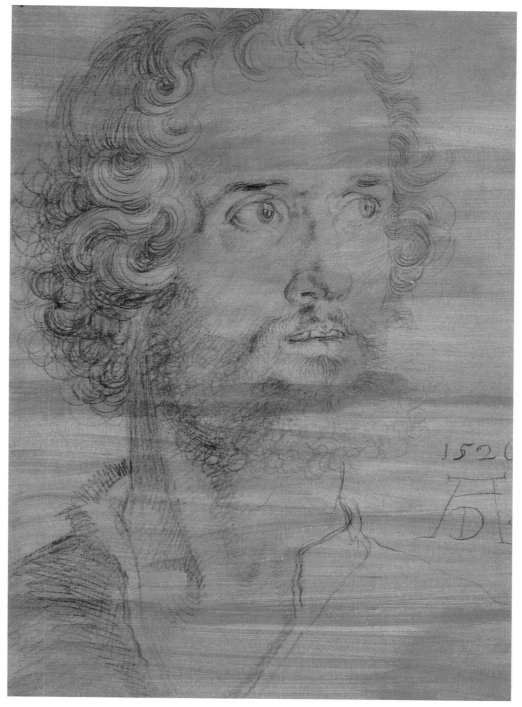

78

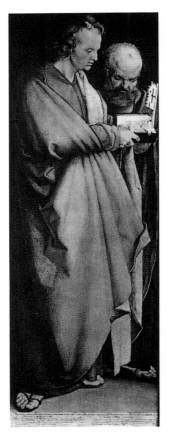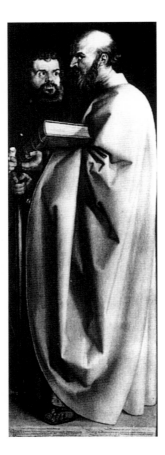

Albrecht Dürer, *Four Apostles*, 1526

tion derives from the theology of Luther.[4] An additional
meaning of the apostle panels is the evocation of the
Four Temperaments, as Neudörfer had already revealed
in 1547.[5] F.A./S.M.

1. Rupprich 1, 117.
2. See Rupprich 1, 325.
3. See Anzelewsky 1991, 283f.
4. See Anzelewsky 1991, 282f.
5. Neudörfer 1547 (1875 ed.), 132; see Anzelewsky 1991, 284.

HANS VON KULMBACH
(Kulmbach c. 1480–1522 Nuremberg)

Born in Kulmbach as Hans Wagner. Named after his city
of birth; went to Nuremberg to be trained in the shop
of Michael Wolgemut. After the customary period of stu-
dent travel, Hans served as assistant to Jacopo de'Barbari,
who stayed in Nuremberg as "portraitist and illuminator"
for Emperor Maximilian I from April 1500 to about 1503.
Next in Dürer's workshop. Many commissions from
Kulmbach thanks to his acquaintance with ex-citizen
and Cracow merchant Pankraz Gutthäter. In 1511 he
acquired citizenship in Nuremberg. His nickname Suess
("Hans Sues ein Maler") first appeared in the documents
with his entry into the new citizens' register "Sabbato
ante Reminiscere" (Saturday before Reminiscence). In
1515 he affixed the name Suess to the St. Catherine altar
of the Cracow church of St. Mary: "IOHANNES SUES,
NURMBERGENSIS CIVIS FACIEBAT," adding his
monogram, an H with an attached K below. The artist
died in Nuremberg between 29 November and 3 Decem-
ber 1522. Entered in the funeral bell-ringing register
of St. Sebald as "Hanns Suß, moler von Kulnnbach."

Hans von Kulmbach was highly esteemed as a painter
of altarpieces and a designer of glass windows, whom
(according to Joachim von Sandrart) Dürer "loved deeply
and advanced in everything." In 1511 Dürer entrusted
him with the execution of a votive panel for Prior Lorenz
Tucher (Nuremberg, St. Sebald; Dürer's design is in
the Berlin Kupferstichkabinett, KdZ 64;W. 508; Anze-
lewsky/Mielke 1984, no. 65), which he completed in
1513. Von Kulmbach also designed both the Emperor and
Margrave windows (1514) for the Nuremberg Church of
St. Sebald as well as the Welser window for the Church
of our Lady in that city. He was active as a designer
of woodcuts. As a portrait painter he stood out through
his sensitive capturing of the individuality of the model,
as in his portrait of Prince Casimir von Brandenburg-
Kulmbach of 1511, now in the Munich Pinakothek.

79 NAKED MAN BATTLING A DRAGON, c. 1502

Berlin, Kupferstichkabinett, KdZ 6
Pen and brown ink
195 x 191 mm
No watermark
Inscribed with the "tossed" Dürer monogram
Hole between the club and head of the man, backed by strip of paper; trimmed on all sides; black borderline

PROVENANCE: Posonyi-Hulot Coll. (verso, in the lower left corner, collector's mark, Lugt 2041); acquired in 1877 from Hulot (Posonyi no. 316; inv. no. 4831; upper left corner, museum stamp, Lugt 1632; verso, lower left, museum stamp, Lugt 1607, below that 2 handwritten in pencil)

LIT.: Ephrussi 1882, 60 – Lippmann 1883, 1: 3, pl. 9 – M. Thausing, "Literaturbericht: Zeichnungen von Albrecht Dürer in Nachbildungen herausgegeben von Dr. Friedrich Lippmann (. . .) Berlin 1883," *Repertorium für Kunstwissenschaft* 7 (1884), 203–207, esp. 206 – J. Meder, "Neue Beiträge zur Dürer-Forschung," *Jahrbuch der Kunsthistorischen Sammlungen des Allerhöchsten Kaiserhauses* 30 (1911/1912), 183–227, esp. 219, fig. 26, 214 – Bock 1921, 23, pl. 31 – Flechsig 2: 267f. – Winkler 1936, 1: 105, no. 156 with pl. – Exh. cat. *Dürer* 1967, no. 24 with ill. – Anzelewsky/Mielke 1984, 143, no. 150

For a long time this drawing passed for a work by Dürer. Fedja Anzelewsky first placed it in the oeuvre of Hans von Kulmbach, which Friedrich Winkler had already expanded in 1942 with the proportion study (KdZ 1276) in the Berlin Kupferstichkabinett.[1] Both drawings carry Dürer's "tossed" monogram, which Sebald Büheler added after 1553.[2] It is an indication that they once belonged to Hans Baldung, who about 1507/1508 left Nuremberg, where he had worked in the Dürer workshop together with Hans von Kulmbach.

Hans von Kulmbach, who was Jacopo de'Barbari's assistant before entering the Dürer workshop, had learned a canon for the construction of the human body from the Italian artist that was different from the one that Dürer used.

The fundamental unit for Hans von Kulmbach's Berlin proportion study is the distance from the bridge of the nose to the hollow of the neck. In the case of a man, the body length up to the hollow of the neck comprises eight such units.[3]

The proportions of the man with the club reflect this ideal of beauty. The position of the man is a variation on a scheme known since antiquity, one that Pollaiuolo and Mantegna used in their engravings and that Hans von Kulmbach must have learned from Jacopo de'Barbari.[4]

The drawing is a study of movement in which the draftsman claimed the antique motif as his own. The dragon is merely there to explain the position of the man.[5]

Man and animal were united into one complicated composition that seeks to suggest dimensionality through the interlacing of the forms. The depiction lacks all drama. It remains unclear whether or not the man sits on the neck of the monster. The physical exertion needed to keep the dragon, which squats on a slope, at a distance is only vaguely indicated by the left upper arm pressed against the body. Nor is the weak, raised, and bent right arm with the poorly drawn hand, which does not truly grip the club, convincing. If the man were to strike, he would sooner hit his own leg than the crocodile-headed dragon, whose body and wings are similar to those in depictions of dragons and monsters found in Nuremberg.[6] A curious feature of the club is the handle, which resembles the handle of a knife. R.K.

1. Winkler 1942, 46, no. 13: left half of a male nude within concentric circles, pen and pale brown ink over a preparatory drawing in pencil.

2. According to E. Flechsig, the drawings come from the estate of Hans Baldung, who died in Strassburg in 1545. The Strassburg painter Nicolaus Kremer, who bought the estate, died in 1553. His widow, a sister of the chronicler Sebald Büheler, gave it to her brother. In good faith, the latter marked the works of Schongauer, Dürer, and Baldung with the monogram of their presumed creator.

3. The lower leg measures three basic units. Its length corresponds to the distance from knee to navel, while the distance from navel to neck hollow makes up the remaining two units. The length of an extended arm amounts to four basic units.

4. Jacopo de'Barbari's most outstanding accomplishment was the dissemination of the northern Italian formal tradition by means of the graphic sheets in his possession.

5. It depicts neither the labors of Hercules nor the combat of a wild man with an animal. Nor is the drawing likely to be a decorative design in the latest taste. It merely records a motif of movement discovered through the study of the antique for later use when desired. Dürer had already become acquainted with this motif in 1494, as is shown by his drawing *The Death of Orpheus,* in Hamburg (W. 58; Strauss 1494/11), which according to Winkler is based on an example by Mantegna that has survived in only a single impression of an engraving in Hamburg (1936, 1:44, appendix pl. IX).

6. Albrecht Dürer's silverpoint drawing of a nude on a flying, two-legged dragon (W. 143; Strauss 1497/4) has just such wings with "eyes," which are typical for Jacopo de'Barbari. Dürer's woodcut of St. George, which originated between 1501 and 1504, shows a dragon of the same type (B. 111; M. 225; Hollstein 225).

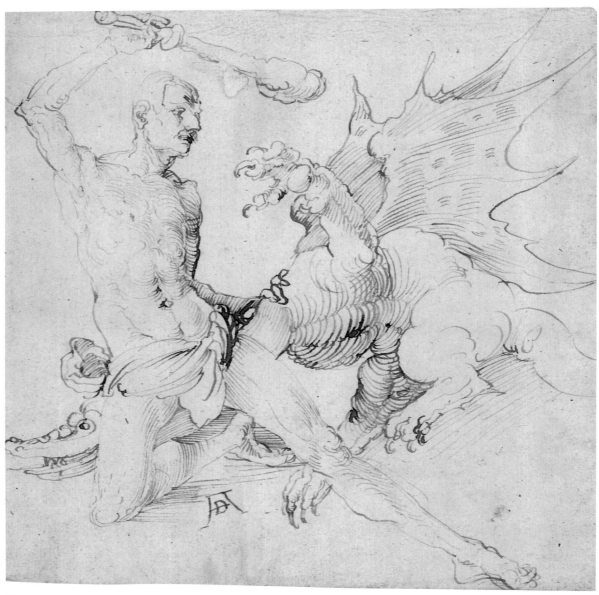

79

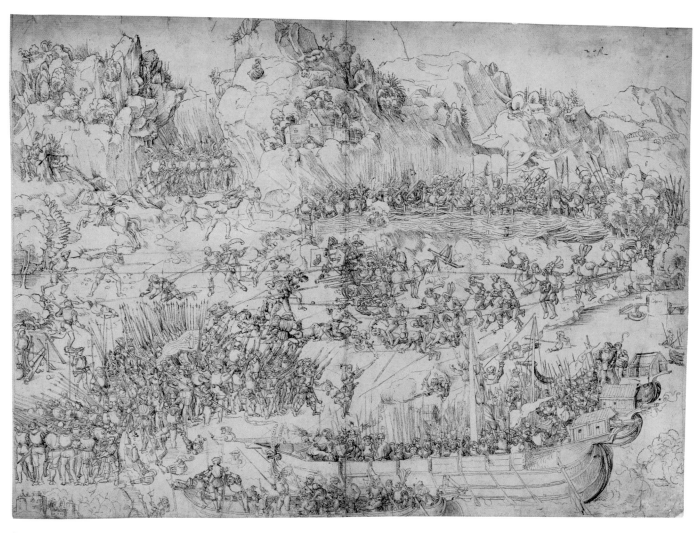

80

80 Ambush near Rorschach, c. 1502

Berlin, Kupferstichkabinett, KdZ 3140
Pen and gray and black ink
420 x 542 mm
Watermark: anchor in circle (Briquet 576)
Inscription on the right, on the loading bridge? *Costincz*
(Konstanz); upper right, in the sky *20 fl*; verso, in pen and black
ink on the upper right quarter *20 fl*; below it, in pencil *8 (?) fl*; in
lower left quarter, in pen *p. m.*; in the lower right quarter, trial
pen marks
Folded vertically and horizontally; trimmed above and below;
backed with japan paper

PROVENANCE: H. Gutekunst, Stuttgart; acquired in 1886 (inv. no.
37-1886)

LIT.: F. Lippmann, "Amtliche Berichte aus den Königlichen
Kunstsammlungen no. 4," in: *Jahrbuch der Königlich Preussischen
Kunstsammlungen* 7 (1886), col. LII – M. Lehrs, "Der Meister P.
W. von Cöln," in: *Repertorium für Kunstwissenschaft* 10 (1887),
254–270, esp. 268 – Bock 1921, 35, pl. 51 – H. Röttinger, *Dürers
Doppelgänger* [Studien zur deutschen Kunstgeschichte, 235]
(Strassburg 1926), 81 – M. Lehrs, *Geschichte und kritischer Katalog
des deutschen, niederländischen und französischen Kupferstichs im 15.
Jahrhundert* 7 (Vienna 1930), 292f. – O. Benesch, "Meister-
zeichnungen II. Aus dem oberdeutschen Kunstkreis," in:
Mitteilungen der Gesellschaft für vervielfältigende Kunst [Beilage der
"Graphischen Künste," Wien] 1 (1932), 9–18, esp. 12, no. 8a
with ill. on 11 – Exh. cat. *Baldung* 1959, no. 193 – F. Anzelew-
sky, "Eine Gruppe von Darstellungen aus dem Schweizerkrieg
von 1499 und Dürer," *Zeitschrift des Deutschen Vereins für Kunst-
wissenschaft* 25 (1971) 3–17, ill. 2 – Anzelewsky 1971 and 1991
(new ed.), no. 68K – Anzelewsky/Mielke 1984, 131f., no. 128

Depicted is an episode from the Swiss war of 1499, in
which the Swiss cantons attained their independence
from the Holy Roman Empire supreme court, with which
the separation of the Swiss league from the framework
of the Holy Roman Empire was sealed.

The ambush of the imperial forces near Rorschach on
20 June 1499 was an unfortunate action that ended with
an immediate retreat.[1] Ignoring the facts, Emperor Maxi-
milian declared in his *Weisskunig* that the campaign was
a successful punitive expedition in which "the white
company routed the company of the peasants [and] then
[captured] the artillery of the peasants."[2]

The drawing depicts the maneuvers of the German
infantry's landing barges, the organization of their battle
formations, and the beginning of hostilities. The imperial
troops find themselves facing the Swiss guns. From the
forest at the right the Swiss infantry pours out. Behind
a wattle fence the defenders await the assault. A second
Swiss contingent stands poised in the crevasse at the left,
ready to provide reinforcements. The background is filled
with an impressive mountain panorama.

At the time of its acquisition, Friedrich Lippmann
erroneously took this sheet for a preparatory drawing for
an engraving by Master PW, which it exceeds in its rich
detail. Elfried Bock recognized the drawing's style as be-
ing close to that of the young Dürer, but did not consider
the drawing to be autograph because of genuine weak-
nesses and classed it as a work "in the manner of Dürer."
In 1932, Otto Benesch attributed it to Hans Baldung
Grien, whose hand he also discerned in another drawing,
depicting another episode of the Swiss war in the
De Grez Collection (Brussels, Musée des Beaux-Arts).[3]
Fedja Anzelewsky first demonstrated that the calligraphic
and stylistic peculiarities of the Berlin drawing are defi-
nitely connected to the work of Hans von Kulmbach.
Neither the engraving by Master PW nor the drawing
by Hans von Kulmbach is an original invention. They
both are based on a common model.

Anzelewsky accepted in 1971 that the archetype
of our Swiss war drawing must have been a painting on
canvas, commissioned from Dürer by Emperor Maxi-
milian, which combined episodes of the Swiss wars in a
way then customary for paintings of historical subjects.
Since then, however, Anzelewsky came to the conclusion
that Jacopo de'Barbari, not Dürer, must have been the
creator of the prototype. Presumably the engraving by
Master PW reproduced it in simplified form.

The Berlin drawing, on the contrary, is a partial copy
of the lost painting, as it shows only the ambush near
Rorschach, and may have served as the model for a panel
that was in the possession of Willibald Imhoff in 1573.
At that time, it was believed that this painting was by
a follower of Albrecht Dürer,[4] with the name of Dürer's
collaborator replaced by that of the great master. Draw-
ings in London and Chatsworth[5] provide us with a frag-
mentary idea of the composition of the painted panel.
It is feasible, in view of these drawings, that the Berlin
drawing was cut, as the drawing in Chatsworth shows
the lower part of the ship, with the German infantry
jumping off its bow, fully surrounded by water. The
nearby village between the castle and lake is missing on
the Berlin drawing. Even so, the drawing in Chatsworth
does not include the lower edge of the panel painting,
while its upper end, which is lacking in the Berlin
drawing, may be seen in the London sheet.

In all probability Hans von Kulmbach prepared the
Berlin drawing in Jacopo de'Barbari's workshop even
before the painting was delivered to Emperor Maximilian;
however, he did not execute the panel painting until he
had joined Dürer's shop. R.K.

1. P. Etterlin, *Kronica von der loblichen Eydtgnossenschaft (. . .)* (Basel [Michael Furter] 1507), sheet CIX; W. Pirckheimer, *Bellum Helveticum,* Karl Rück, ed. (1895), bk. 2, ch. 6, 113ff. – D. Schilling, *Luzerner Chronik,* R. Durrer and P. Hilber, eds. (1932), 128 (cited after F. Anzelewsky, "Eine Gruppe von Darstellungen aus dem Schweizerkrieg von 1499 und Dürer," *Zeitschrift des Deutschen Vereins für Kunstwissenschaft* 25 [1971], 8f.).

2. "Die weyss geselschafft die geselschafft von den pauren in die flucht [schlug und] der pawren geselschafft dartzu ir veldtgeschutz [abnahm]." *Kaiser Maximilian I. Weisskunig* (Stuttgart 1956), 432, no. 141 (175), see 291f., no. 175.

3. Anzelewsky "Schweizerkrieg" 1971 (cited in note 1), ill. 5.

4. Anzelewsky "Schweizerkrieg" 1971, 16: Imhoff-Inventar 1573: "Die große tafel mit den Schiffen soll Albrecht Dürer nachgemalt haben kost mich selbst fl. 22." Willibald Pirckheimer, the chronicler of the Swiss war and the commander of the Nuremberg contingent, could have been its first owner.

5. London, British Museum, Sloane 5218/120: pen, 21 x 57.7 cm; Anzelewsky "Schweizerkrieg" 1971, ill. 3; Chatsworth: pen, 26.7 x 30.7 cm; Anzelewsky "Schweizerkrieg" 1971, ill. 4.

81 A PAIR OF SURPRISED LOVERS, C. 1510

Berlin, Kupferstichkabinett, KdZ 1560
Pen and pale brown ink over pencil
175 x 283 mm
Watermark: bull's head with staff, cross, and flower (variant of Briquet 14553)
Upper left corner, remains of writing in pen and grayish brown ink; lower right corner, *JCR* in black ink; verso, lower left *Lucas de Leyden* in ink on the edge of the backing
Stronger vertical and weaker horizontal center folds; tears inward from edges; two creases, lower left; lined; remains of a black borderline on the backing

PROVENANCE: J. C. Robinson Coll.; acquired 1880 (inv. no. 177-1880, verso, museum stamp, Lugt 1607 with the year 1880 and handwritten running number)

LIT.: Ephrussi 1882, n. on 52 – Bock 1921, 60, pl. 86 – H. Röttinger, "Handzeichnungen des Hans Süss von Kulmbach," *Münchner Jahrbuch,* n.s. 4,1, (1927), 8–19, esp. 11 – H. Tietze/E. Tietze-Conrat, "Über einige Zeichnungen des Hans von Kulmbach," *Zeitschrift für bildende Kunst,* n.s., 38 (1928/1929), 204–216, esp. 211f., ill. on 210 – E. Buchner, in: *TB* 22 (1929), 92–95, esp. 94 – Stadler 1936, 28, 121f., no. 85, pl. 37 – Winkler 1942, 54f., no. 24, pl. 24 – Exh. cat. *Deutsche Zeichnungen der Dürerzeit* 1951, no. 340 – Winkler 1959, 83, 100, pl. 65 – Exh. cat. *Handzeichnungen Alter Meister* 1961, 19

Charles Ephrussi was the first, in 1882, to draw attention to this drawing, which he took for a work by Dürer. Ever since Elfried Bock ascribed it to Hans von Kulmbach, it has had a fixed place in his oeuvre. The dating has raised little controversy. Franz Stadler placed its creation at the time of the Tucher panel, that is, at the beginning of the second decade. Friedrich Winkler agreed with this date, adding the observation that the sheet originated at the beginning of the artist's mature phase.[1]

The lively rendering of the scene, which represents the surprise of the couple as tellingly as the satisfaction of the observer, is based on close observation and fits effortlessly among Hans von Kulmbach's early genre scenes—*Lovers with an Old Woman* (W. 4)[2] and *Lovers with a Fool* (W. 5)[3]—except that the borrowings from Dürer have been supplanted by personal observation of nature.

The spatial relationships in this landscape, where this encounter occurs, are indicated only by the twist in the upper body of the seated woman and by her extended right hand. The small dog that jumps toward the observant man occupies the foreground with him. His inclined position as he leans on a rifle creates a spatial connection between him and the dog. The interrelationship between the two groups is established by the lover's turned-up face, the gesture of the woman, and the reciprocal glance of the spectator. We may assume that the dog served some hidden meaning in this interplay. The animal has been borrowed, in mirror image, from Dürer's woodcut *Knight and Landsknecht* (B. 131, which Meder dated to about 1498), but had already been used in Dürer's 1496 drawing of a couple on horseback (cat. 49).

Heinrich Röttinger assumed the drawing was an illustration for a work by a classical poet because the locks of the lady also grace Jacopo de'Barbari's depictions of Victory and of Cleopatra in various works. Nevertheless, the sheet, which was probably intended as a study for a stained glass design, most likely depicts a moralizing genre scene, similar to the pen-and-ink drawing, in the Bibliothèque Nationale in Paris (W. 96), of a pair playing a board game. R.K.

1. Winkler 1942: c. 1510; Winkler 1959: at the beginning of the middle creative period of the artist, which he put between 1511 and 1517.

2. Munich, Graphische Sammlung, inv. no. 1928:11, pen and brown ink over preparatory drawing in pencil; Winkler 1942, no. 4.

3. Paris, Louvre, inv. 19196, brush in bright bister.

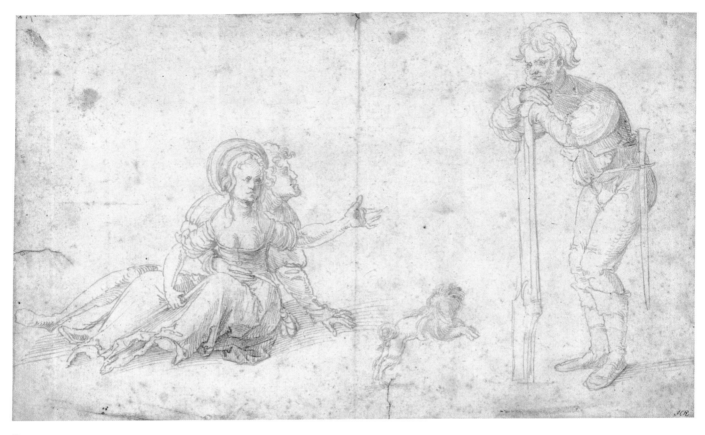

81

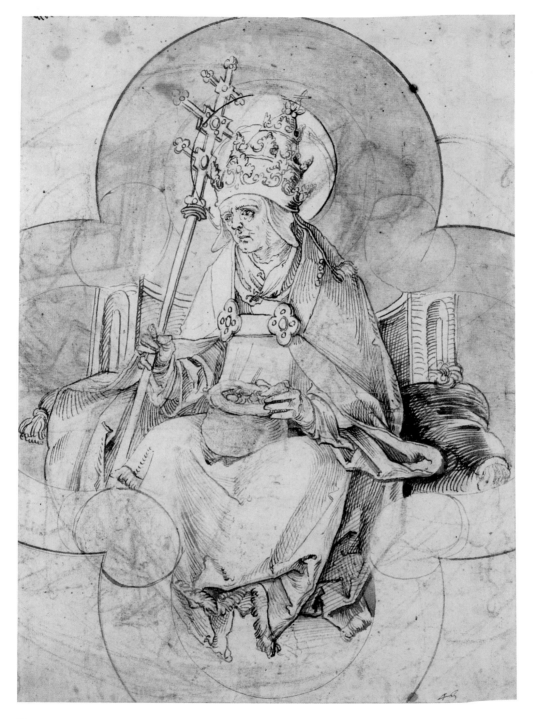

82

82 STAINED GLASS DESIGN: POPE SIXTUS II IN A QUATREFOIL, c. 1510

Basel, Kupferstichkabinett, Inv. 1962.48

Pen and brown and gray black ink; gray black and gray wash over black chalk

315 x 223 mm

Watermark: high crown with cross (similar to Piccard XII, 37, but larger)

Lower right, in another hand 43 in pen and brown ink; verso, trial pen marks

Compass pricks created during the construction of the quatrefoil are visible; trimmed on all sides; horizontal center fold with tears, paper spotted, especially upper left

PROVENANCE: Prof. A. Petrucci, Rome; art trade Berlin; C.G. Börner, Düsseldorf; acquired in 1962

LIT.: Auct. cat. Gerd Rosen, auction 36, part 1, Berlin April 1961, no. 285 with ill. – Exh. cat. *Meister um Albrecht Dürer* 1961, no. 211 – C. G. Börner, *Neue Lagerliste 34: Ausgewählte Handzeichnungen aus vier Jahrhunderten* (Düsseldorf 1962) no. 85 with ill. – Hp. Landolt, in: *Basler Nachrichten,* 286, 10.7.1962 – Hp. Landolt, in: *Jahresbericht 1962,* 20f., 25, 31ff., 34–36, 39ff.

In an expert's report addressed to Gerd Rosen, Friedrich Winkler described this drawing, which was being offered for sale as by "Hans Wechtlin," as an "unmistakable, highly characteristic work by Hans von Kulmbach."

The drawing shows a Pope sitting on a cathedra (throne). He is identified as Sixtus II by a money bag. Sixtus died a martyr during Emperor Valerian's persecution of Christians in the year 258. Lawrence, Sixtus' deacon, did not turn over the church treasure so coveted by the emperor but distributed it among the poor, whom he introduced to the emperor as the true treasure of the church.

By examining the drawing more closely, one may discern that a seated bishop was at first depicted because his miter and crosier are sketched with chalk. Also, the quatrefoil form was not originally intended, for at the left, the upper corner of the lobes cuts through indications of an interior and a wing. The change must have been in response to a specific request from the glass-painting workshop of Veit Hirschvogel, to which Hans von Kulmbach supplied numerous designs, for the holy Sixtus is not one of the commonly depicted saints. Perhaps the patron had been named after this saint.[1]

In addition to this example, Hans von Kulmbach produced five other stained glass designs with seated saints. The design with St. Sixtus is closest to the one with St. Augustine in the university library in Erlangen.[2] The saints sit on similar cushions with tassels in the corners; both have a lower body that is curiously under-developed, with the point of the left foot peeking out below the bundled dalmatic. Augustine sits in a study chamber in front of a bottle-glass window. The depiction is enclosed by a wide, quatrefoil decorative frame, with the individual parts showing different adornments as alternative solutions for the glass painter.[3] The splendid Basel window design with an enthroned Madonna in a quatrefoil[4] is closely related to the Erlangen decorative window through the decorative frame. It is the most beautiful of the series thanks to both its balanced composition and its execution. The corners of the four lobes (foils) are filled with tracery.

The seated saints of the remaining three stained glass designs are the Latin church fathers, Gregory, Ambrose, and Jerome, who record their works in the company of the symbols of the evangelists.[5] The originally rectangular designs were later trimmed and transformed into rounded forms. On the design depicting Ambrose of Milan with the eagle of St. John, the subsequently introduced, wider quatrefoil frame, which resembles that of the Sixtus design, was outlined with the compass in such a way that the eagle was eliminated.[6]

It appears that Hans von Kulmbach began with the rectangular, church-father design. While the work was in progress on the fourth stained glass design, an order must have come requiring quatrefoil windows. The artist redrew the design with St. Augustine in the new quatrefoil form, which he then also applied to the previously drawn design with St. Sixtus. The idea of laying out the lobes of the quatrefoils was indicated on both glass designs with sketched circular segments. The design with the enthroned Virgin was the last to be reshaped in the lobe (foil) solution with the tracery.

The designs with the church fathers, Gregory, Ambrose, and Jerome, served the glass painters of the Hirschvogel workshop as concept sketches for the design of the round windows in the chapel of the "House of the Golden Shield" in Nuremberg.[7]

The quatrefoil window design with St. Augustine was instead used as a model for a quatrefoil window that is today in the Germanisches Nationalmuseum in Nuremberg.[8] Its decorative frame with an angel, however, is based on the quatrefoil window with the enthroned Virgin; therefore the postulated connection between the two designs also exists in reality.

After satisfying the commission to which they owed their creation, these designs ended up in the pattern files of the Hirschvogel workshop, where they were recycled for other projects. R.K.

1. Sixtus as church patron is also rare; an example is a church in Merseburg.

2. M. Weinberger, *Nürnberger Malerei an der Wende zur Renaissance und die Anfänge der Dürerschule,* Studien zur deutschen Kunstgeschichte 217 (Strassburg 1921), 189, pl. XIII, 1; *Die Zeichnungen in der Universitätsbibliothek Erlangen,* Direktion der Universitätsbibliothek, ed., rev. by E. Bock, 2 vols. (Frankfurt am Main 1929), 73f., no. 235 (attribution to Hans von Kulmbach by Dornhöffer); F. Winkler, "Verkannte und unbeachtete Zeichnungen des Hans von Kulmbach," *Jahrbuch der Preussischen Kunstsammlungen* 50 (1929), 11–44, esp. 33 and 42, pl. 17; Stadler 1936, 30, 113, no. 44, pl. 17; Winkler 1942, 34, 89, no. 100 with pl. 100, 100a, and 100b; Winkler 1959, 79, 101; H. Scholz, *Entwurf und Ausführung. Werkstattpraxis in der Nürnberger Glasmalerei der Dürerzeit,* Corpus Vitrearum Medii Aevi, Deutschland Studien (Berlin 1991), 1: 199f. with n. 384, ill. 284. As the saint is depicted without attribute, Weinberger, in 1921, took him for St. Jerome.

3. The now oval-shaped stained glass design is made up of two kinds of construction lines: 1.) the preparatory drawing, sketched in chalk or charcoal, filling the areas where the circles overlap; 2.) the two penned circular lines that make it clear that the design can also be executed as a round window, with the inner circle establishing the size of the image and the outer one, which survives only in remnants, the width of the frame. Whether this idea was Hans von Kulmbach's is doubtful. See G. Frenzel, "Entwurf und Ausführung in der Nürnberger Glasmalerei der Dürerzeit," *Zeitschrift für Kunstwissenschaft* 15 (1961), 31–59, esp. 43.

4. *Catalogue de Dessins anciens du Moyen-Âge et de la Renaissance composant la Collection de M. A. Beurdeley, Vente Georges Petit* (June 1920), no. 8 (attributed to Burgkmair); M. Weinberger, "Über einige Jugendwerke von H. S. Beham und Verwandtes," *Mitteilungen der Gesellschaft für vervielfältigende Kunst* [suppl. in "Graphischen Künste," Vienna] 2/3 (1932), 33–40, esp. 40, ill. 12 (early work of Beham); Winkler "Kulmbach" 1929 (see note 2), 44 (Hans von Kulmbach); Stadler 1936, 129, no. 117, pl. 58; Winkler 1942, 34, 89, no. 99 with pl.; Winkler 1959, 79, 103, pl. 60; Hp. Landolt 1972, no. 36 with color pl. Scholz 1991, color pl. IV, before 268.

5. Dresden, Kupferstichkabinett. Winkler "Kulmbach" 1929, 41; Stadler 1936, 10, no. 27a–c, pl. 10; Winkler 1942, 34, 90, no. 103–105 with 3 plates; Winkler 1959, 79, 101. The connection of evangelists and Latin church fathers is not unusual, but neither is it common: Matthew—angel—St. Augustine; Mark—lion—St. Jerome; Luke—bull—St. Gregory the Great; John—eagle—St. Ambrose. Stadler and Winkler erroneously identified Gregory as Ambrose, and Ambrose as Augustine.

6. See Frenzel "Entwurf" 1961 (see note 3), 43.

7. Color reproductions of the once realized solution for a window in the "House of the Golden Shield" in: *Codex Monumenta Familiae Halleriana, Hallerarchiv, Grossgründlach* (cited after Frenzel "Entwurf" 1961, 35). Frenzel believed that for the first time in the history of glass painting, glass painters of the House of the Golden Shield began to relate the composition of the image to the surrounding glass-roundel glazing in order to achieve a more finished effect. The less than literal translation of models for glass painting is related to the workshop tradition, in which the glass painter was a largely independent creative artist.

8. Exh. cat. *Meister um Albrecht Dürer* 1961, no. 181, no. 211; Frenzel "Entwurf" 1961, 42f., ill. 4 (window rendering), ill. 5 (executed window in the Germanisches Nationalmuseum, Nuremberg), classified by Von Frenzel as "a frequently used pattern of the Hirschvogel workshop." The growing specialization of stained glass window painting for nonsacred buildings by painters in the Hirschvogel workshop first made possible the correct translation of designs by artists of the Dürer circle into glass painting, while conserving their stylistic individuality. Scholz 1991, ill. 285.

HANS SCHÄUFELEIN

(c. 1480–1539/1540 Nördlingen)

Painter, draftsman, designer of woodcuts and glass paintings. The painter's earliest period is wrapped in obscurity; his second Christian name, Leonhard, which is often mentioned in the early literature, does not appear in the sources. About 1502/1503, presumably after a period of travel that followed his training, the artist arrived in Nuremberg, where, next to Hans von Kulmbach and Hans Baldung, he worked in Dürer's workshop. In 1505, before Dürer's second Italian journey, he was entrusted with the execution of the Ober-St.-Veit altar after Dürer's own designs. After the completion of the altar in 1507/1508, Schäufelein left Nuremberg and moved to Augsburg, to work with Hans Holbein the Elder. During 1509/1510 he painted the panels of the Schnatterpeck altar in Niederlana, South Tirol. In the following years he was again in Augsburg. Numerous woodcut book illustrations ensued. In 1515 Schäufelein settled in Nördlingen, where, for the remainder of his life, a rich period of activity as a painter and designer of woodcuts unfolded. A large part of Schäufelein's ninety or so drawings that have survived originated primarily during the last fifteen years of his life.

83 LADY IN AN ELEGANT DRESS, c. 1507/1509

Berlin, Kupferstichkabinett, KdZ 4462
Pen and black ink
278 x 194 mm
No watermark
Lower center, monogram *HS* and small shovel; next to it, an inscription in brown ink, later effaced
Trimmed on all sides, including the train at the right; brown ink borderline added later

PROVENANCE: Lanna Coll. (Lugt 2733); acquired in 1910

LIT.: Bock 1921, 76 – Winkler 1942, 126, no. 23 – Exh. cat. *Meister um Dürer* 1961, no. 309 – Exh. cat. *Dürer* 1964, no. 75

Friedrich Winkler dated this sheet depicting a richly dressed woman, which is signed with a monogram and shovel, to about 1507/1509 on the basis of stylistic criteria—the balanced, Düreresque drawing technique, with hairline strokes sensitively placed next to broad ones. Later scholars accepted this dating as well as the title, "distinguished lady." The context of the drawing's origin has yet to be established.

Several details of the splendid gown give reason to doubt that the drawing truly represents a distinguished lady: the low veil, which hides the face of the young woman; the deeply cut bodice, which reveals her feminine bounty; and the long train, which a later owner trimmed off the drawing. Elaborate gowns with such trains were used for personal display and were censured in city sumptuary laws of the fifteenth and sixteenth centuries time and again as signs of vanity.[1]

A similar young and beautiful woman in a gown with a plunging neckline and long train is also found in a Dürer drawing in Weimar (W. 217). While the young woman strides to the right and seems completely self-assured, she has not yet noticed that Death rises from the ground immediately behind her, grasping her train, and is poised to reach for her with his raised arm.

Dürer's lady with Death as a train carrier may provide an indication of the meaning of our Schäufelein drawing. His lady, too, strides about freely in her eye-catching dress and does not see from beneath her fashionable veil what is happening around her. We may never know if Death also lounged nearby in the drawing before it was trimmed. S.M.

1. See L. C. Eisenbart, *Kleiderordnungen der deutschen Städte* (Göttingen 1962), 83, 98.

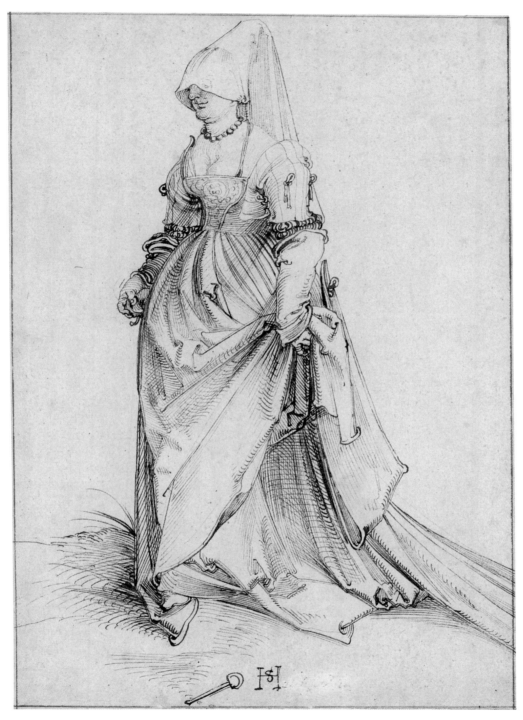

83

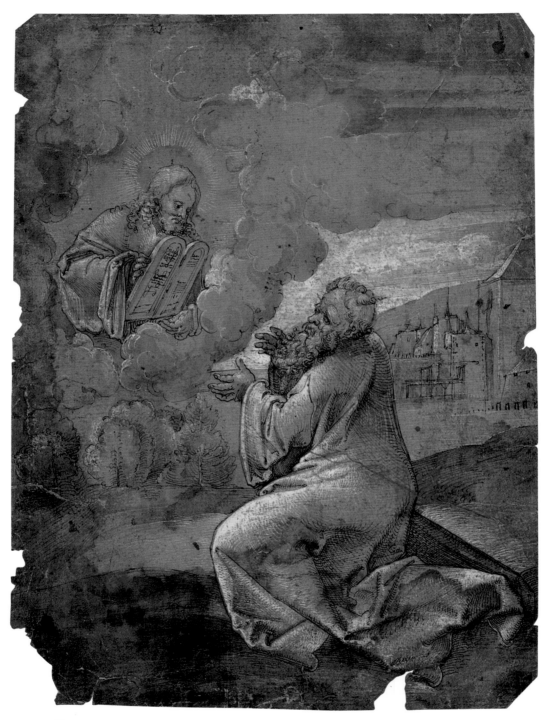

84

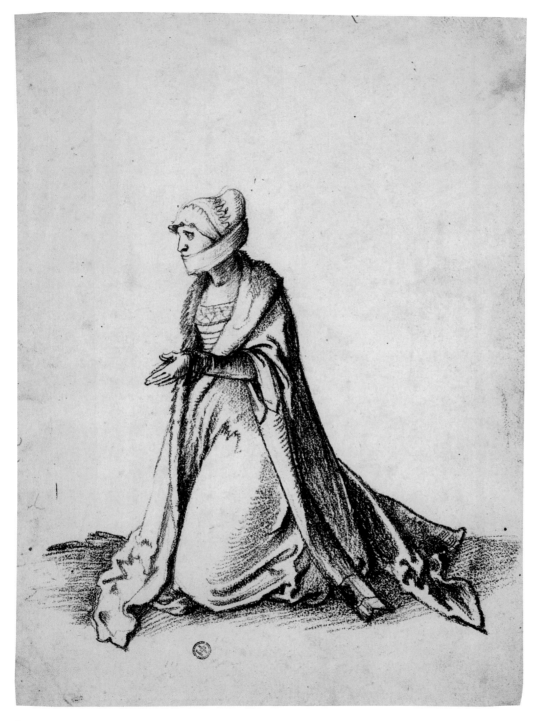

85

84 MOSES RECEIVING THE TABLETS OF THE LAW, c. 1508/1509

Basel, Kupferstichkabinett, Inv. U.I.22
Pen and black ink; black and gray wash; heightened in white on blue green prepared paper
284 x 208 mm
Watermark: indecipherable, as sheet is glued to backing
Below, monogram *HS* with shovel
Corners cut; tears and losses on left, right, and lower edges; prepared ground damaged; stained

PROVENANCE: Museum Faesch

LIT.: Thieme 1892, 34, 161 – Wallach 1928, 55 – Winkler 1942, 39 – Schilling 1955, 167 – Weih-Krüger 1986, 138

God the Father, appearing as a half figure wrapped in an aureole of clouds, holds the tablets and directs his gaze toward the prophet Moses, who is kneeling in a landscape. Beams of light from the figure of God fall upon the powerful figure of Moses, as the heightening in white on his robe demonstrates. To the right, next to Moses, we glimpse a castle or city in the background.

The drawing, which was introduced to the literature by Thieme in 1892 and which was dated by Wallach and Winkler to about 1509 on the basis of stylistic criteria, is based, in general, on the composition of Dürer's woodcut *The Annunciation to Joachim* (B. 78) from his Life of the Virgin series. The representation of Moses' robes is indebted in many details to the figure of an apostle in the foreground of Dürer's 1503 drawing of the Ascension and Coronation of the Virgin (W. 337). Despite these dependencies, Winkler classified the drawing in 1942 as a "commanding work by Schäufelein."

The technique of this drawing is similar to Dürer's *Green Passion* and his drawings for the Ober-St.-Veit altar, which Schäufelein carried out after Dürer's designs. These circumstances suggested to Thieme that the drawing was a preparatory work in connection with Schäufelein's Crucifixion with St. John and the psalmodizing David of 1508, which depicts Moses receiving the tablets of the law in the background. In 1986 Sonja Weih-Krüger contested this supposition, but did not propose a convincing alternative. However, even she did not doubt that the sheet was intended as a preliminary work for a painting. S.M.

85 KNEELING FEMALE DONOR, c. 1520

Basel, Kupferstichkabinett, Inv. U.I.31
Black chalk
293 x 208 mm
Watermark: snake with small crown (see Briquet 13815)
Verso, old numbering *17*

PROVENANCE: Museum Faesch

LIT.: Schmid 1898, 313 – H. A. Schmid, "Der Monogrammist H. F. and der Maler Hans Franck," *Jb. preuss. Kunstslg.* 19 (1898), 64–76, esp. 74, no. 4 – H. Kögler, "Ausstellung altdeutscher Handzeichnungen aus Karlsruhe im Basler Kupferstichkabinett," *Basler Nachrichten vom 4.5.1924* – Parker 1928, with no. 41 – Winkler 1942, no. 72 – Schilling 1955, 172 – K. Martin, *Altdeutsche Zeichnungen aus der Staatlichen Kunsthalle Karlsruhe* (Baden-Baden 1955), with no. 19 – Landolt 1972, no. 37

Schmid and Parker first attributed this chalk study of a lady kneeling in prayer to Hans Baldung. In addition, Schmid convincingly associated it with a stylistically related drawing executed in the same technique, depicting a praying woman in half figure, in the Karlsruhe Kunsthalle. The general appearance of the Karlsruhe sheet is more reminiscent of Baldung than is the Basel work. Kögler rejected an attribution to Baldung and proposed Schäufelein as author for both sheets. Winkler then placed them within the late works of Dürer's pupil from Nördlingen. This attribution may be a little puzzling, for Schäufelein's work consists largely of pen drawings, of which the early ones in particular are related in character to the work of Dürer himself. But the nature of the technique, with its straight or slightly bent parallel chalk strokes of varying thickness, approaches that of an *Anna Selbdritt* in Bremen, adduced by Winkler for purposes of comparison, which is fully signed and dated 1511 (Winkler 1942, no. 50). The somewhat restless and agitated rendering of outline and folds in the Bremen drawing has given way in the later Basel and Karlsruhe sheets to a broader, though softer, more tonal handling. Schilling suspected that Schäufelein's examination, about 1520, of Baldung's work caused this change in style.

This drawing could be a preparatory study for an altarpiece with female donors. Kneeling women and girls, for a donor panel, are also depicted in an early pen drawing by Schäufelein in Berlin (Winkler 1942, no. 2). H.B.

LUCAS CRANACH
THE ELDER
(Kronach 1472–1553 Weimar)

According to the 1556 testimony of Matthias Gunderam, Lucas Cranach, the son of a painter known only by name—Hans Moler or Moller (family name)—was born on 4 October 1472 in Kronach, Upper Franconia. To accept a later date of birth, as has recently been proposed (Exh. cat. *Cranach* 1994, 48), is unnecessary speculation and contradicts the information on Cranach's gravestone. Kronach lay in the bishopric of Bamberg, not far from the city of Coburg and its fortress, the Veste Coburg, which belonged to the sovereign territories of the electors of Saxony. Cranach's early years are wrapped in obscurity. The earliest dated works are from 1502. He made them in Vienna, where, about 1502/1503, Cranach portrayed the influential young physician and humanist Johannes Cuspinian and his wife. In 1504/1505 Cranach traveled through Nuremberg to Wittenberg, where in 1505 he succeeded the Italian artist Jacopo de'Barbari as court painter to the elector Frederick the Wise and his co-governing brother, John of Saxony. He built up a large workshop with pupils and collaborators. Early in 1508, the elector Frederick issued him a coat of arms in an official document. From then on Cranach used this coat of arms, a crowned snake with bat's wings (modified from 1537 on) and a ring in the mouth, as his signature. In the summer of 1508 he was in the Netherlands, sent by the electors of Saxony on a diplomatic mission to Emperor Maximilian. Cranach worked in the Veste Coburg and in other castles of the electors. He produced numerous woodcuts bearing the electorial arms: hunts, tourneys, scenes from the Passion, images of saints, and humanistic themes—subjects that also appear in paintings (*Venus,* 1509, *Nymph at a Spring,* 1518, and others). No earlier than 1509 and no later than 1513, he married Barbara Brengbier, daughter of a councilor of Gotha (she died in 1540). Two sons became painters: Hans (who died in Bologna in 1537) and Lucas Cranach the Younger (1515–1586). In 1519 Cranach became a member of the Wittenberg Council. He illustrated Reformation broadsheets and books with woodcuts. In 1520 Luther became godfather to Cranach's daughter Anna; in 1525 Cranach was witness to Luther's courtship and, in 1527, became godfather to the latter's first son. In 1528 he was the richest citizen in Wittenberg. He traveled with Elector John Frederick, his liege, and Melanchthon in 1534 to a religious disputation in Dresden that was requested by Cardinal Albrecht and Georg, duke of Sax-

ony. In 1537, after the death of Cranach's son Hans, Lucas Cranach the Younger probably took on heavier responsibilities in the Cranach workshop. In 1537/1538, 1540/1541, and 1543/1544 Cranach was burgomaster of Wittenberg. After John Frederick was defeated and captured by Emperor Charles V in 1547, Cranach lost his position as court painter until 1550, when, having drawn up his last will and testament, he joined John Frederick in his imprisonment in Augsburg. There, Cranach met Titian, whose portrait he painted (lost). Cranach died in Weimar on 16 October 1553.

86 THE GOOD THIEF ON THE CROSS,
c. 1501/1502

Berlin, Kupferstichkabinett, KdZ 4450
Black chalk on paper lightly prepared in red; heightened in white chalk
226 x 121 mm
Watermark: high crown with cross (not in Briquet)

PROVENANCE: F. Bamberger Coll.; V. Lanna Coll.; acquired in 1910

87 THE BAD THIEF ON THE CROSS,
c. 1501/1502

Berlin, Kupferstichkabinett, KdZ 4451
Black chalk on paper lightly prepared in red; heightened in white chalk
215 x 128 mm
Watermark: high crown with cross (not in Briquet)

PROVENANCE: F. Bamberger Coll.; V. Lanna Coll.; acquired in 1910

LIT.: Schönbrunner/Meder, no. 1097 (unknown master of the late 15th century) – M. J. Friedländer, "Literaturbericht (H. Voss: Der Ursprung des Donaustiles, 1907)," *Repertorium für Kunstwissenschaft* 31 (1908), 394 (Cranach, c. 1503) – Bock 1921, 19 – Glaser 1921, 18 – Benesch 1928, 98 (1502) – Bock 1929, no. 1267, pl. 256 (comparable drawing of a thief in Erlangen) – Weinberger 1933, 12 – Girshausen 1936, 7–9, no. 1f. – Burke 1936, 32 – Degenhart 1943, 177, ill. 67 – Winkler 1951, 47f. – Lüdecke 1953, 24, ill. 13 – Rosenberg 1960, no. 2f. (c. 1502) – Oettinger/Knappe 1963, 11, n. 56 – Thöne 1965, 9 – Exh. cat. *Dürer* 1967, no. 63f. – Schade 1972, 34 – Exh. cat. *Cranach* 1973, no. 33f. – C. Sterling, in: *Grünewald* 1974/1975, 136 – Schade 1974, 50 – U. Timann, in: Exh. cat. *Cranach* 1994, 303 – H. Mielke, in: *Handbuch Berliner Kupferstichkabinett* 1994, 124f.

Executed on two sheets that do not come from the same roll of paper (the watermarks are different), these draw-

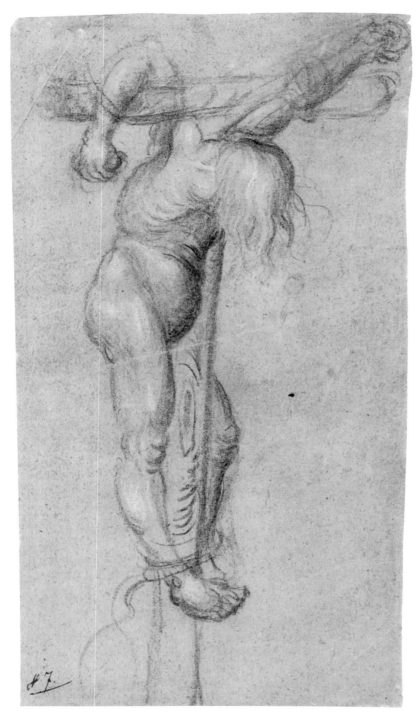

86

87

ings, which were probably both done in Vienna about 1501/1502, depict the thieves who were crucified to the left and right of Christ. Thief means robber (in Matthew and Mark) or lawbreaker (in Luke; the penitent thief asked for Christ's forgiveness: "Truly, I say unto you: Today you will be with me in paradise"). Both thieves hang on the cross with their elbows violently contorted. They are tied with cords to crude crosses fashioned of unhewn logs, whereas Christ, as the Crucifixion is usually depicted, is attached by three or four nails to a more or less finished cross. Such a hierarchy conformed to iconographic tradition, both in Franconian (Pleydenwurff, Wolgemut) and in Bavarian and Austrian painting of the late Middle Ages (up to Rueland Frueauf the Younger's *Crucifixion* panel of 1496 in Klosterneuburg near Vienna). In a painting executed in Vienna about 1501/1502 and in two Dürer-esque, large format Crucifixion woodcuts, one of which is dated 1502, Cranach went beyond the tradition and depicted the crucified thieves nailed to their crosses as Christ had been. Apparently Cranach did not want to heighten the represented pain as much as he wanted to emphasize the uniquely human drama of this tripartite crucifixion. The Berlin drawings appear as immediate preliminary stages to the depictions of thieves in Cranach's pictures and woodcuts of the Crucifixion created during his stay in Vienna, 1501/1502 to 1503: a consistent sequence with significant changes is evident from work to work.

Closest to Cranach's drawing of the penitent thief is a depiction of the "bad" thief in a work that Cranach may have known: a *Crucifixion* panel dated 1501 by Jörg Breu the Elder, part of a great altarpiece for the Carthusian monastery of Aggsbach, located on the Danube. This *Crucifixion* panel, on which the mounted Centurion/Longinus looks conspicuously like Maximilian I, is today found in the Germanisches Nationalmuseum in Nuremberg. Most of the other parts of the altar are in the Augustinian Prebendary Foundation of Herzogenburg.[1] As in Cranach's drawing, the hunched-over thief painted by Breu in 1501 is tied to the cross in such a way that he has to accommodate the vertical trunk between his legs while his upper body has slid in front of the trunk. With Breu as with Cranach, the head is entirely obscured by falling hair, a motif that Dürer repeated on a woodcut that can only be approximately dated 1501–1505.[2] Cranach differentiated between the texture of the hair, right down to its sheen, and the occasional divided, separately curved strands. His own invention (differing from Breu) is the countermovement of the diagonally raised, stiff, extended arm, which contrasts with the sunken head. Cranach attempted to downplay the plastic-spatial problem—that

is, the impossibility that one of the thief's arms should be attached to the front of the horizontal beam of the cross and the other to its back—by emphasizing the left extension of the beam with contoured strokes and shadows.

Both thieves, including the outward-thrusting "bad" one, are visually integrated with their crosses and, despite the quasi-painterly modeling in black and white on red prepared paper, resemble delineated figures on a surface. Space is suggested, not constructed. The same is true of the modeling of the bodies. Details, such as the curled toes of the bad thief, are executed only where they speak and create an impression. Everything appears to be in flux. A story is shown: the excruciating death of the two thieves, their execution almost complete. In both sheets, the light slanting from the left catches, here and there, just a few parts of the body, which are heightened in white, thereby achieving a flickering effect that is more concerned with increasing the disquiet than with modeling the figure.

The three stages of the chiaroscuro rendering (black and white on the red middle tone) certainly show that both sheets are not just preliminary studies for a painting but, to a certain degree, are independent, self-referential, as well as highly impulsive, drawings in small format (they were later cut). Both drawings, wrote Hans Mielke, "are expressive studies forged by the imagination without interest in anatomic correctness of the kind one might require from a nude after a model. Because of their unusual expressiveness, the drawings were at first attributed to Grünewald, until Friedländer rightly recognized their creator in Cranach: the 'connection with his Vienna works, paintings as well as woodcuts . . . is compelling.'"

Both drawings are particularly close to Cranach's aforementioned large-format Crucifixion woodcut dated 1502. Here the "motif of the cascading flood of finely stranded, unkempt hair that hides the head turned down to the ground" is repeated (Girshausen). Cranach created the woodcut, like the drawings of the good and bad thieves, in Vienna, where he concurrently portrayed the humanist Johannes Cuspinian (who, like himself, came from East Franconia) and produced many other unusually intense and Düreresque "heroic" paintings, woodcuts, and drawings. They influenced Albrecht Altdorfer (see cat. 119) and Wolf Huber. When, in 1505, Cranach became the elector's court painter, he embarked on a different artistic path.

D.K.

1. *Beiträge* 2 (1928), 291, ill. 206; C. Menz, *Das Frühwerk Jörg Breus des Älteren* (Augsburg 1982), 55ff., 69f., ill. 23.
2. B. 59; M. 180; Panofsky 1945, no. 279; Knappe 1964, no. 220; Strauss 1980, no. 82; Winkler 1957, 126, dated "about or shortly after 1500."

88 WILD BOARS AND HUNTING HOUNDS, C. 1506/1507 OR SLIGHTLY LATER

Berlin, Kupferstichkabinett, KdZ 386
Pen and black brown ink; borderline added later in brown
150 x 241 mm
Watermark: high crown (variant of Briquet 4971 or 4988)
Lower border, erased, false Dürer monogram

PROVENANCE: Neville Coll.; D. Goldsmid Coll.; Suermondt
Coll.; acquired in 1879

LIT.: Lippmann 1895, 7 – *Zeichnungen* 1910, no. 202 – Bock 1921,
20, pl. 26 – Girshausen 1936, 50, no. 66 – Rosenberg 1960, no.
60 – Exh. cat. *Dürer* 1967, no. 66 – Exh. cat. *Cranach* 1973, no.
53 – Schade 1974, 48, pl. 165 – Exh. cat. *Cranach* 1988, 62

The initial dating of this study probably resulted from
a comparison with two woodcuts of 1506/1507, the
depiction of a deer hunt in large horizontal format and
a smaller, vertical woodcut, which shows a knight giving
the coup de grace to a wild boar cornered by a pack
of dogs. Cranach created these woodcuts soon after he
had assumed his position as court painter (1505) in the
service of Frederick the Wise, elector of Saxony, and his
co-governing brother, Duke John the Steadfast—both,
like Emperor Maximilian, loved hunting. "As often as
the princes take you hunting, you will take a panel some-
where *(tabulam aliquam)* with you, which you will com-
plete in the middle of the hunt, or you draw *(exprimis)*
how Frederick chases down a stag, Johann pursues a
boar," wrote the humanist Christoph Scheurl—celebrat-
ing the restless artistic activity of Cranach, who painted
Scheurl's portrait in 1509—in a dedication letter com-
posed on 1 October 1509 in Wittenberg.[1]

For the Berlin drawing, Cranach used pen and ink
to define a hasty sketch rendered with charcoal or chalk,
which was later wiped out. It is still barely recognizable
in traces, such as on the back and stomach of the boar
on the right of the sheet. Below it appears the faint out-
line of a stooping animal, probably an attacking hound,
done in charcoal. This animal was not compositionally
coordinated with the boar. In any case, it should not be
assumed that the pen drawing is a unified scene. In fact
we see three or four details with a common theme of
the "boar hunt." On the left, a boar turns around as it
is attacked by several dogs. On the right, an isolated boar
looks on, while, above, another one flees. Next to it,
Cranach started another boar's head in darker ink, and left
it that way. All in all this is a classical sketch sheet with
isolated motifs of the hunt, roughly in the tradition of
Pisanello's sketches. Such animal studies generally convey
to us that the artist, even when sketching "freely for him-
self," had to await the approval of his noble patron.

The blending of the details of the drawing, as one
sees in the relationship between the central boar and the
attacking pack of dogs—the dogs are drawn in a more
relaxed manner, similar to Cranach's preparatory drawings
in brush on his panel paintings—is characteristic for the
relative appeal of the drawing: it is certainly a study but
it does, for instance, go beyond the pure sketchiness of
a comparable pen drawing with stags and hinds in the
Louvre. The back side of this Paris sheet (Rosenberg 1960,
nos. 61–62) has an unusually detailed watercolor depict-
ing a dead roe deer, which recalls Dürer's watercolor
animal studies (Eisler 1991). When in 1515 Cranach was
required to make a contribution to the marginalia of the
Prayer Book of Emperor Maximilian, and thus entered
into competition with the other collaborating draftsmen,
Dürer, Baldung, Burgkmair, Breu, and Altdorfer, he again
chose the theme of animals for his fine pen drawings on
parchment, depicting mainly deer but also elks and foxes,
as well as monkeys, storks, and so forth, in addition to
a castle in a landscape and religious motifs. Naturally the
subject matter is also to be understood as a greeting, con-
veyed by Cranach, from the Saxon princes to Maximilian.
When Cranach visited Maximilian in the Netherlands
on his diplomatic mission of 1508, he brought a present
from the Saxon electors: a depiction of an unusually large
wild boar hunted down by the electors near Wittenberg.
It was so truly observed that a strange dog, upon seeing
the picture, began to bay, and at once took flight (Scheurl
knew how to report in the manner of an antique topos).
In a hunting scene painted by Cranach in 1529, Emperor
Maximilian, who had died in 1519, is still shown hunting
next to the electors Frederick, who died in 1525, and his
successor, John of Saxony. It was, therefore, a commemo-
rative painting, one of the numerous pictures of princely
hunts that Cranach was asked to paint and that usually
served as gifts (see Schade 1974, 439, no. 338).

Scholars have not been able to securely date the
Berlin drawing with wild boars and dogs, as the oeuvre
of Cranach, who left relatively few drawings, lacks com-
parable drawings in pen. The usual placement is "between
1506 and 1515" (Steigerwald): somewhere between Cra-
nach's early hunt woodcuts and his margin drawings
for the Prayer Book of Emperor Maximilian. A date after
1515, closer to the paintings of hunts that commenced
in 1529 (insofar as these have survived), would appear
to be equally possible. D.K.

1. Exh. cat. *Cranach* 1974/1976, 1: 193, 241f., no. 96; Exh. cat.
Cranach 1994, 55, 321f.

88

89 Top: left inner side closed; bottom: both sides closed

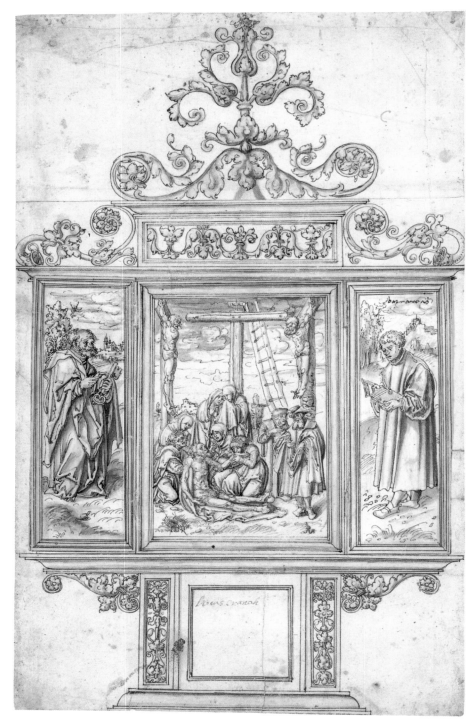

89 Open

89 DESIGN FOR A POLYPTYCH WITH THE LAMENTATION, C. 1519/1520

Berlin, Kupferstichkabinett, KdZ 387
Pen and brown, gray, and black ink; yellow wash on frame
393 x 247 mm
Watermark: indecipherable
Ornamental crown drawn on its own sheet and attached; lower right corner, center image, carries Cranach's armorial signature, the winged snake with a ring in the mouth (corresponding to his coat of arms); predella, *Lucas Cranah* in another hand; figures on the movable, glued-on wing designs inscribed by Cranach
Right wing (not purposely) attached incorrectly (see commentary)

PROVENANCE: Von Rumohr Coll.; old inventory

LIT.: Schuchardt 1851, part 2: 26, no. 40 – *Zeichnungen* 1910, no. 203 – Bock 1921, 19, pl. 25 – Girshausen 1936, 34f., no. 35 – Rosenberg 1960, no. 31 – Thöne 1965, ill. on 51 – Exh. cat. *Dürer* 1967, no. 68 – Steinmann 1968, 83 – Schade 1972, 40 – Exh. cat. *Cranach* 1973, no. 36 (without being aware of Steinmann) – Schade 1974, 48, 64 – Exh. cat. *Cranach* 1988, 82 – Tacke 1992, 135–147 – Hinz 1993, 52 – Tacke 1994, 53–66

Commissioned by Cardinal Albrecht of Brandenburg, a pupil or collaborator of Cranach used designs of about 1520 to 1523 (1525 at the latest) by his master and painted a cycle of sixteen variable altars with scenes from Christ's Passion and figures of saints, as well as individual panels, for the church of the "New Convent" in Halle. When the city of Halle embraced the Lutheran faith in 1540/1541, forcing Cardinal Albrecht to depart, he took all portable works of art with him to his archbishopric of Mainz, mainly to Aschaffenburg, his new residence. Only the center panel of the altar designed by Cranach has survived (Tacke 1992, ill. 88). In typical presentation technique—in the form of washed pen-and-ink drawings that also establish the forms of the frame, the predella base, and the upper *Gespreng* or crowning ornamentation—Cranach supplied designs for an ambitious pictorial ensemble for the Halle church, whose decoration had been ordered by the ostentatious and powerful Cardinal Albrecht, archbishop of Mainz and Magdeburg, primate of the German church, and high chancellor of the empire. Martin Luther would soon attack the cardinal for raising so much money through the sale of indulgences and for using it to decorate the Halle church (see also H. Reber, Exh. cat. *Albrecht von Brandenburg,* Landesmuseum Mainz, Mainz 1990). The execution of the numerous altar panels was left to one of Cranach's pupils, the Master of the Masses of St. Gregory, whom Andreas Tacke tentatively identified as Simon Franck, who became a citizen of Halle in 1529. It is not known if the altars were executed

in Cranach's Wittenberg workshop (about 60 kilometers from Halle, as the crow flies), as Tacke assumed, or rather in Halle itself. The designs clearly establish Cranach's contribution, but in the context of such a large enterprise and its financing, the execution, which ordinarily did not fall to Cranach, counted for much more.[1] From the center picture of the Berlin design for the Halle altar—showing "how Christ is taken down from the cross," according to a 1525 description—we can deduce that the painter in charge was guided by Cranach's design only along general lines. The somewhat stiff painting, now in Munich (Tacke 1992, ill. 88; Tacke 1994, ill. 48), omits both the crosses of the thieves. The ladder leans against the cross on the other side, and the figures of the Lamentation are grouped differently. The responsible painter, who was probably already active in Halle, therefore felt only slightly beholden to Cranach (this in contrast to the relationship of a Cranach drawing of the Crucifixion to another panel painting, now in Copenhagen, from Cranach's workshop; Exh. cat. *Cranach* 1974/1976, ill. 263f.). Presumably the patron, Cardinal Albrecht, also required modifications of his own. The basic form of the composition, with the corpse of Christ propped up in a seated position on the ground, recurs in other pictures by Cranach (Exh. cat. *Cranach* 1974/1976, no. 337).

To speak of the design and execution of this entire series of pictures in terms of one commission from Cranach and his workshop (Tacke) misses the point. Even more problematic, indeed outright false, is Tacke's concomitant book title, *The Catholic Cranach* (which the author himself had to qualify on page 15). Cranach's function as court painter in the service of the electors naturally also included work intended to pay respect to neighboring and dynastically connected rulers in the ambient of the electors of Saxony. As Tacke himself stressed, the situation concerning religious differences and allegiances was still fully in flux about 1520/1523, certainly from the point of view of a princely patron who feared military conflict, and a commission was always a command. Moreover, Luther had in no way condoned the Wittenberg iconoclasm of 1522. The pictures that Cranach painted in 1534/1535 for Georg, duke of Saxony and Cardinal Albrecht ought still to be understood as diplomatic contributions—not just permitted, but probably commanded ones—to arbitration in the context of a hoped for and eventually stabilizing religious dialogue.[2]

The center panel of the altar that Cranach designed in 1519/1520, which was to be furnished with four wings, was part of a Passion cycle. The cycle in the collegiate church of Halle followed a continuum from altar to altar.

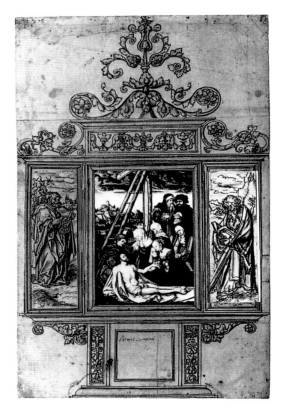

Reconstruction of altar model after Andreas Tacke
with closed inside wings, St. Luke, Erlangen copy

Reconstruction of altar model after Andreas Tacke with
right wing drawn, Erlangen copy, and central panel
executed by Cranach school, Alte Pinakothek, Munich

The altar paintings carried the observer from Christ's entry into Jerusalem through his Resurrection. The cycle was therefore made up of a simple christological program of altars, which were nevertheless at the same time dedicated to one particular saint or to a pair, Peter and Paul in this instance. We see St. Peter on the interior left wing of the opened altar, as Cranach designed it. Opposite him stood St. Paul on the other wing, which has come down to us only in a sketchy copy in Erlangen (Tacke 1992, ill. 84; Tacke 1994, ill. 40; see ill.). With the inner wings closed, a line of four figures of saints was formed: in the middle, below a connecting barrel vault with oculus, St. Andrew and (again only surviving as a copy in Erlangen) St. Luke, in addition to St. Mark to the outer left and St. Barnabas to the outer right in front of landscape backgrounds (see ill.). Finally, with another "change" of the altar, or the drawn model, namely with closed exterior wings, one saw the saints Titus and Timotheus. Once again they stood beneath a barrel vault and faced each

other. Cranach drew similar barrel vaults for castle architecture (Rosenberg 1960, no. 14); he was also fond of employing them in woodcuts done for the title pages of books in the 1520s.[3]

The Berlin drawing, as it looks today with open (paper) wings—that is, with the inside of the altar visible—shows the wrong saints on the right side: St. Barnabas in place of St. Paul (missing in Berlin, present in the Erlangen copy). St. Barnabas was only supposed to appear with the pivoting of the interior wings—with the first "transformation" of the altar. The composition is hardly affected as both figures, Barnabas as well as Peter, stand before a landscape background and as both face the center picture. Tacke reproduced the correct reconstruction of the altar model as a photo montage, with reference to the Erlangen copies from the Cranach workshop (see ill.).

The composition that Cranach designed for the center picture with the Lamentation, of which Erlangen also has a sketchy copy from the Cranach workshop (Tacke

1994, ill. 126), was used once more in the 1550s in the shop of Lucas Cranach the Younger for one of fifty-three pictures for the upper breastwork of St. Mary's in Dessau (Tacke 1994, ill. 56). D.K.

1. See Exh. cat. *Cranach* 1974/1976, 2: nos. 288 and 288a, no. 325f.
2. Exh. cat. *Cranach* 1974/1976, 1:25f.; see A. Perrig, in: *Forma et subtilitas, Festschrift für W. Schöne* (Berlin 1986), 50–62.
3. Exh. cat. *Cranach* 1974/1976, 1: ill. 114, ill. 191–193, 2: ill. 312; see H. Stafski, in: *Zs. f. Kg.* 41 (1978), 142, ill. 7; also *Museum News, The Toledo Museum of Art* (Summer 1970), 41.

90 HEAD OF A PEASANT, c. 1525

Basel, Kupferstichkabinett, Inv. 1937.21
Watercolor; touches of white heightening; pen strokes
in the beard
193 x 157 mm
Watermark: raven head in shield (similar to Briquet 2208;
according to Piccard [written communication, 3.17.1972],
Freiburg, between 1519 and 1522/1523)
On the fur hat, apparently early inscription *Albertus Durerus fecit*
(visible only under ultraviolet light)
Trimmed on all sides

PROVENANCE: art trade Berlin 1933; art trade Basel 1936;
acquired in 1937

LIT.: P. Wescher, "Ausstellungsbesprechung Kunsthandlung Raeber (1936)," *Pantheon* 18 (1936), 370 (Cranach) – Winkler 1936, 151, n. 1 – O. Fischer, "Ein unbekanntes Aquarell von Cranach," *Die Weltkunst* 11, 18–19 (9.5.1937), 2 (Cranach, c. 1508, London version a copy) – *Öff. Kunstslg. Basel. Jahresb.* (1937), 25f., with color pl. (Cranach, c. 1508; London version a copy) – Winkler 1942, 60, with no. 42 (Cranach) – Rosenberg 1960, A 9 (copy) – D. Koepplin, "Das Kupferstichkabinett Basel (II)," *Westermann's Monatshefte* (April 1967), 49 (Cranach) – H. Bockhoff/F. Winzer, *Das große Buch der Graphik* (Brunswick 1968), 97f., color pl. on 81 (D. Koepplin, Cranach) – Exh. cat. *Cranach* 1972, no. 171, ill. on 97 – Schade 1972, 36, color pl. 7 (Cranach, years following 1510) – Koepplin 1972, 347 (Cranach, c. 1520) – Hp. Landolt 1972, no. 39 (Cranach) – E. Mahn, "Der Katharinenaltar von Lucas Cranach. Eine ikonographische Studie," *Bildende Kunst* 6 (1972), 276 – F. Winzinger, in: *Lucas Cranach 1472/1972*, Bonn/Bad Godesberg 1972, 13 – Exh. cat. *Das Aquarell 1400–1950*, Haus der Kunst München (Munich 1972), no. 23, color pl. on 41 – J. Jahn, "Bemerkungen zu Lucas Cranach als Zeichner," *Cranach Colloquium* 1972/ 1973, 91 (see 148, ill. 84) – Schade 1974, 49, color pl. 63 (Cranach, c. 1515) – G. Vogler, *Illustrierte Geschichte der frühbürgerlichen Revolution* (Berlin 1974), color pl. after 280 – D. Koepplin, "Kopf eines Bauern (oder bäurischen Jagdtreibers)," Exh. cat. *Cranach* 1974/1976, 2: no. 607 (Cranach, c. 1522) – F. Irsigler, "Kopf eines Bauern oder bäurischen Jagdtreibers," in Exh. cat. *Martin Luther und die Reformation in Deutschland*, Germanisches Nationalmuseum Nürnberg (Frankfurt am Main 1983), no. 33 – G. Ebeling, *Martin Luther* (Frankfurt am Main 1983), 227 – J. Rowlands, *Head of a Peasant*, exh. cat. *Dürer, Holbein* 1988, with no. 139 (variant by the Cranach workshop after the London version) – Rowlands 1993, with no. 107 – C. M. Nebehay, *Das Glück auf dieser Welt. Erinnerungen* (Vienna 1995), 59–61 (provenance)

This drawing was located in a Wittenberg album "of noble lower-Saxon ownership," dated 1590 to 1593 (Winkler). The book also contained Cranach's drawing *Hercules and Omphale* (R. 57, now Berlin, Kupferstichkabinett), a drawing by Lucas Cranach the Younger with a depiction of the Fall of Man (ill. in: *Der Cicerone*, 21, 2 [1929], 697), and a drawing by Hans von Kulmbach (Winkler 1942, no. 42). Eva Dencker-Winkler, the daughter of Friedrich Winkler, informed us (oral communication, June 1976) that one Herr von Goldbeck, a student in Wittenberg at the time, started the album.

The dress and the fur hat permit the conclusion that this striking head depicts a peasant or, in any case, a "common man." He could have been a beater for the hunt in the service of the Saxon princes and have been portrayed at their request. We find similar figures in Cranach's depictions of hunts, as in his great woodcut of 1506 but also his later painted hunts. There are other depictions of peasants with related headgear in Cranach's oeuvre: a peasant's head on the left side of a 1509 woodcut depicting the Carrying of the Cross, and a carter on a 1519 altar in Grima (Cranach workshop). Also comparable, as pointed out by Mahn, is the head at the right of St. Catherine in the St. Catherine altarpiece of 1506. The drawing cannot be reliably dated using stylistic criteria but, thanks to the watermark, we have a date of about 1525.

The authenticity of this drawing, which first turned up in the 1530s and which was acquired in Basel in 1937 as a work of Lucas Cranach the Elder, has been assessed in various ways, relative to a long-known version in the British Museum in London (Sloane 5218–19). Girshausen and Rosenberg took the London drawing for the original and the Basel sheet for a copy based on it. Recently, Rowlands, the curator in London, again embraced this verdict. Dodgson (1937), Schilling (1968), and Koepplin (1968, 1974/1976), who studied the original London and Basel sheets side by side, as well as Fischer, Winkler, Winzinger and Landolt, deemed the London version to be the copy, "as it repressed precisely its [the Basel sheet's] distinctive immediacy with somewhat pedantic accuracy" (Landolt). In 1937 Fischer wrote (as director of the Öffentliche

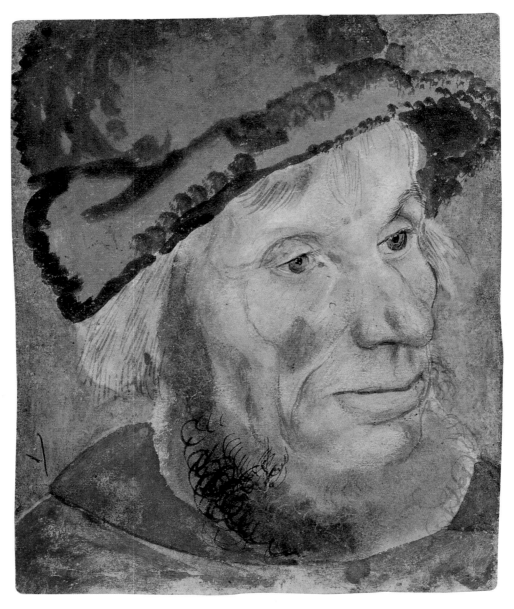

90

Kunstsammlung Basel): "but the drawing of all foreshortened sections in particular is so much more exact and sensitive, the strokes and brush handling are so much freer, sensitive and expressive, the total effect of the head so much more lively and immediately engaging, that no doubt remains about the authenticity of the Basel version." In the catalogue to the Basel Cranach exhibition of 1974, where the two drawings were exhibited side by side and discussed (Exh. cat. *Cranach* 1974/1976, 2:688f.), a paint-drop(?) "wart" on the London head was also used — though relatively incidentally — to argue in favor of the priority of the Basel sheet, where this spot is missing. In the meantime, this spot was removed from the London drawing at Rowlands' request. The spot, he wrote in 1993, only came about through the oxidation over time of a bit of lead-white filler, applied later.

In essence, the Basel work is as much a drawing as it is a painting on a small piece of paper, or a study for a painting. Contrary to the London drawing, which may be taken for the diligent but routine work of a Cranach collaborator (one of his sons?), the emphasis is on the spontaneously captured, clearly projected overall impression, with accurate differentiation of the face; and it lies particularly "on the material: the sanguine flesh, the wooly beard, the fleecy fur hat, the colored fabric" (Landolt). The green background could — but may not — be a later addition. Few other portraits from the sixteenth century represent individuals from the common masses with such seriousness and penetration. One thinks of Dürer's well-known portrait drawing of his mother or of Cranach's drawn and painted 1527 portraits of Martin Luther's parents. D.K.

91 BACK VIEW OF A NUDE WILD MAN HOLDING A CLUB, c. 1525/1530

Berlin, Kupferstichkabinett, KdZ 5014
Pen and black ink; brown gray wash; sheet cut roughly around the figure and mounted on a light brown prepared paper
254 x 132 mm (support)
Watermark: indecipherable
Below in a later hand, inscribed *Lucas Kranach*

PROVENANCE: Gigoux Coll.; V. Beckerath Coll.; acquired in 1902

LIT.: Lippmann 1895, 2 – *Zeichnungen* 1910, no. 200 – Bock 1921, 19, pl. 24 – Winkler 1936, 150 ("probably before 1510") – Girshausen 1936, 44f., no. 55 (c. 1527) – Rosenberg 1960, no. 45 (c. 1527/1530) – Thöne 1965, ill. on 75 – Schade 1972, 39f., pl. 17 – J. Jahn, "Bemerkungen zu Lucas Cranach als Zeichner," *Cranach Colloquium* (1972/1973), 89 – Exh. cat. *Cranach* 1973, no. 47 – Schade 1974, pl. 101 – Exh. cat. *Cranach* 1974/1976, no. 491

This drawing of a standing, naked, stub-nosed man with unkempt hair and beard is mounted on a sheet of prepared paper. It was not originally a single figure. This is betrayed by the shadows cast above the toes of the foot at the left, which — like the other foot — casts its own shadow. The unattached cast shadow above and to the left of the foot belongs to a missing figure just to the left. Only the faintest traces of the cut-off body responsible for the shadows have remained; it could be the rounding of a heel. The club bearer, who raises his left hand high and looks up at it, must have had some counterpart. He either had a rival, resembling corresponding figures on the Cranach paintings that are known as "The Silver Age" (a traditional title without an exact basis), or else he was in the company of a belligerent, prehistoric looking, more or less "wild person."[1] This category includes satyrs, fauns,[2] sylvans, "first human beings" (following Lucretius); differentiation and nomenclature are problematic and cannot be casually elucidated.[3] Dürer's margin illustrations in the Prayer Book of Emperor Maximilian include a depiction of a naked man who appears to have vanquished a lion with his club (if Hercules had been intended, he would have strangled the Nemean lion; the classical attributes of Hercules were the lion helmet and the lion skin, which are missing here). One reencounters the clubbed lion about 1530 in Cranach's pictures showing "wild-people families," or whatever one wishes to call them, in which the beast belongs to the scenery. The club bearer drawn by Dürer in 1515 is equipped with a shield (which, again, is not easily related to Hercules); he faces us with a noble, not bulbous-nosed, visage. Nevertheless the art-historical literature most often assigns him the name Hercules,

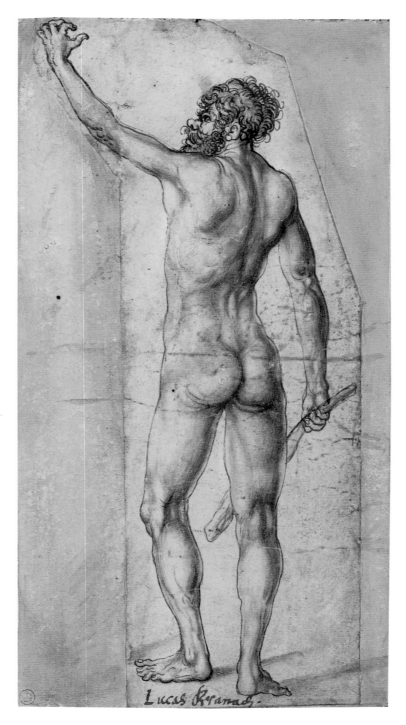

91

whom Dürer himself presented as the title figure on one of his early engravings (E. Panofsky, *Hercules am Scheidewege* [Leipzig/Berlin 1930], 169). All of this does not justify an identification of the nude drawn by Cranach with the ancient hero Hercules. The figures that most closely approximate the Berlin nude are the ones that take on the role of heraldic supporters and guards in the woodcut, dated 1523, with the portrait of King Christian II of Denmark, who had been expelled from his country and lived for a while in Cranach's Wittenberg residence (Schade 1974, pl. 121; Exh. cat. *Cranach* 1974/1976, ill. 114). In that instance they are truly "wild people" with clubs, though admittedly a little heroized and hairless. An accompanying woman with blowing hair, holding a small child by the hand, joins her partner in holding a banner up in the architecture of the frame, in which lions—lions could not be omitted—have been introduced. Here, too, several figures are found together; it is a group.

In the Berlin drawing, Hercules does not perform as an individual hero. It must also be observed that Hercules, as Cranach showed in 1530 with his *Hercules and Antaeus* and later in his *Hercules at the Crossroads,* never has a bulbous nose, despite all his strength and wildness (Friedländer/Rosenberg 1979, nos. 268f., nos. 408 and 408A). It is certainly no coincidence that Cranach depicted Hercules at the same time that he was fascinated by "wild people" or sylvans: unbridled companions in paintings intended for a refined society that also loved hunts and jousting, created at a time of humanism and new social forms but in which late medieval—also magical—depictions still played a role. Werner Schade's sentence may also be cited: "The predilection for fighting people seems universal in these years characterized by warfare" (Schade 1974, 70).

The standing nude seen on a diagonal from the back—with his loosely held, dangling club somewhat "broken" by his thigh—is boldly but not insensitively outlined with the pen. The supple contour line is composed of strokes that are drawn as surely as they are sensitively, sometimes carefully doubled, sometimes discontinuous. The tonal gradations of the body never become summarily planar but are usually executed with many short strokes of a fine brush, "which neither make the musculature stand out nor articulate the body energetically" (Winkler). We see this most clearly at the hollows behind the man's knees. In other places this kind of pictorially graphic work is less conspicuous, but it is, overall, characteristic of the great finesse and appeal of this drawing of a naked wild man—who is not Hercules, not Sol-Apollo, and not Adam of Düreresque inspiration.

In a generally independent way, it is not too far removed from Italian bronzes, which Cranach probably knew from isolated examples and copies. D.K.

1. Although without the thick body hair, which was customary in late medieval depictions and which also occurs in Cranach on occasion; see Rosenberg 1960, A 13; Schade 1972, pl. 31.

2. In 1518 Cranach placed a faun with pointed ears and a club as a "guard" on the fountain base of a resting nymph at a well: Schade 1974, pl. 96f.

3. Exh. cat. *Cranach* 1974/1976, 585ff.; see also T. Husband, *The Wild Man,* The Metropolitan Museum of Art (New York, 1980), 16, 191–193.

MATTHIAS GRÜNEWALD
Mathis Nithart or Gothart
(Würzburg 1480/1483–1528 Halle an der Saale)

Though Grünewald's work remained famous, his personal identity was lost, even in his own century. When Emperor Rudolph II wished to acquire the Isenheim altarpiece in about 1600, the name of its creator had been forgotten.

We encounter the first reports about him in Joachim von Sandrart's *German Academy* of 1675, under the name "Mattheus Grünewald." Sandrart used information supplied by the Frankfurt painter Philipp Uffenbach (1566–1636), who owned a volume of the master's drawings that had come from Johannes Grimmer, Grünewald's only known pupil. Sandrart's name for the artist, "Grünewald," was erroneous. During his lifetime, he was called "Mathis, der Maler" (Mathis the Painter). The archive studies begun by Zülch gradually led to insights into the person of the artist, who, like Leonardo da Vinci, was both a painter and an engineer. Nothing is known about his training. In 1501/1502 he was an apprentice in the workshop of Hans Holbein the Elder in Augsburg. In 1503 he was in the shop of Michael Wolgemut in Nuremberg. From 1504 on, he was active in Aschaffenburg, where he presumably became a master in 1505. By 1511 at the latest, the artist entered the service of Uriel von Gemmingen, archbishop of Mainz, in the capacities of painter and engineer. The documents attest to a stay in Frankfurt am Main during the second half of 1511 that must have been related to his work for Jakob Heller in the Dominican monastery there. From 1513 to 1515/1516 he was in Alsace to execute the wings of the main altar for the Antonine monastic church of Isenheim, commissioned by Guido Guersi, the preceptor. By 1516 at the latest he returned to Aschaffenburg, where he was employed by the archbishop Albrecht of Brandenburg, the successor to Uriel von Gemmingen. The principal works of this time are the center panel (1516) of the so-called Stuppach Madonna, which is still in that city; the center panel of the Maria-Schnee altarpiece, which was completed in 1519 by the addition of two fixed wings; the retable (1517/1518) of the Virgin in Mainz cathedral; and a commission from Cardinal Albrecht, the Erasmus-Maurice panel (1521–1523) for the new foundation, consecrated in 1520, in Halle an der Saale. On 27 February 1526 the artist received his last payment from the archiepiscopal registry in Mainz. In 1526 he moved to the free city of Frankfurt am Main because of religious and political upheaval. In the summer of 1527, after deposition of his property, he left for Halle an der Saale, where he was active as a hydraulic engineer in the saltworks. Grünewald died of the plague a year later.

Scarcely thirty drawings by Grünewald have survived; most are preparatory studies for his paintings.

92 STUDY OF AN APOSTLE, 1510–1515

Berlin, Kupferstichkabinett
Black chalk with touches of gray wash; heightened in gouache; brown and reddish watercolor; parts of the undergarments and the lamp gone over in watercolor when Hans Plock used the drawing in his Lutheran Bible and combined it into a collage with text passages, which he ornamented, from the Gospel of John
244 x 118 mm
Watermark: indecipherable
Inscriptions in capital letters in Hans Plock's hand; on the upper caption *DAS WAR DAS WARHAFTIGE LIECHT WELCHS/ ALLE MENSCHEN ERLEVCHTET* (John 1:9); *DAS IST/ ABER DAS EWIGE LEBEN DAS SIE DICH DAS/DV ALLENE WARER GOTT BIST VND DEN DV/ GESANT HAST IHESVM CHRIST ERKENNEN;* on the writing tablet *AVCH FIEL ANDERE/ ZEICHEN THET IHESVS/VOR SEINEN IVUNGERN/DIE NIT GESCHRIEBEN/SINT IN DISEM BVCH/DISE ABER SINT GE-/SCHRIEBEN DAS IR/GLAVBET IHESVS/SEI CHRIST DER SON/GOTTES VND DAS IR/DVRCH DEN GLAVBE/DAS LEBEN HABET/IN SEINEM NAMEN* (John 20:30–31); *DIS IST DER IVNGER DER VON DISEN DINGE/ZEVGET VND HAT DIS/GESCHRIEBEN VND/WIR WISSEN DAS/SEIN ZEVGNIS WAR/HAFTIG IST. IO . XXI* (John 21:24); on the lower caption *SVCHET IN DER SCHRIFT DEN IR MEINETT/IR HABT DAS EWIGE LEBEN DRINEN VND/SIE IST ES DIE VON MIR ZEVGET* (John 5:39)
Collage laid on a book-size, handmade sheet backed by a shorter one that required an additional strip; drawing trimmed on all sides, glued onto composite sheet so that it touches the left edge of that sheet and just reaches the bottom supplementary strip; rubbed; green foliated ornament and right part of the frame of the writing tablet extend beyond the drawing

Verso, upper left Hans Plock's coat of arms
Pen; watercolor; extended by glued-on strips of writing as well as by a square in the upper part attached to the support; framed by a still partially extant border made of four separate woodcuts
202 x 139 mm
No watermark
In capital letters in Hans Plock's hand on the upper banderole *HANS PLOCK VON/MEINCZ SEIDENSTICKER;* on the lower banderole *BEI KEISER CAROL DES . V . ZEITEN/HAT SICH GOTS WORT ERWEITERT/1515;*[1] definitions of biblical concepts written by Hans Plock *Hoechste Herrlichkeit gottes das ist/das gott von ewigkeit zu ewigkeit/gott in im und von im selber ist/Das hoechste wunderwerck gottes das ist/das himmel und erde und alle creatur/allein durch gottes wort geschaffen ist/Die hoechste Ehre . . .*

PROVENANCE: from the estate of the silk embroiderer Hans Plock, who died in 1570 in Halle. Plock must have inserted this collage into the second volume of his Bible, printed by Lufft of Wittenberg in 1541; bound into the first volume with its restoration in the 18th century; according to a handwritten owner's comment on the first inserted sheet of the first volume, the Bible was already in Berlin by the 18th century;[2] on 25 November 1790 "zur Raths Bibliothek" as gift of the Königl. Geh. Kriegsrates Philippi; transferred to the Märkisches Provinzial-Museum, founded in 1875 (inv. no. 387);[3] since 1953 on permanent loan to the Kupferstichkabinett der Staatlichen Museen zu Berlin (acquisition no. 21-1953); in 1963, collage removed from the Bible for conservation[4]

LIT.: W. Stengel, "Drei neuentdeckte Grünewaldzeichnungen," *Berliner Museen,* n.s., 2 (1952), 30f., 31 – Stengel 1952, 65, 70f., 74, 76f., ills. 1, 5, and 11 – Zülch 1953, 26, ill. 25 – Zülch 1954, 21f., 24, ill. 30 – Zülch 1955, 197, 201, 204–206, ill. 62 – Behling 1955, 29, 32, 97, no. 5, pl. III – Jacobi 1956, 34f., 36f. – W. Timm, "Die Einklebungen der Lutherbibel mit den Grünewaldzeichnungen," *Forschungen und Berichte der Staatlichen Museen zu Berlin* 1 (1957), 105–121, esp. 113, no. 13f., ill. 6 – Pevsner/ Meier 1958, 30, no. 4 – Scheja 1960, 199ff., 202, 205, 207f., ill. 5 – Weixlgärtner 1962, 111, *Zeichnungen,* no. 3a – W. Schade, in: Exh. cat. *Altdeutsche Zeichnungen,* Staatliche Kunstsammlungen Dresden, Kupferstichkabinett (1963), no. 130, ill. 36 (the drawing, temporarily removed during the restoration by Hertha Gross-Anders, Dresden) – W. Timm, in: Exh. cat. *Neuerwerbungen aus sechs Jahrhunderten,* Staatliche Museen zu Berlin, Kupferstichkabinett (Berlin, 1967), no. 9 – Hütt 1968, 184, no. 69, ill. on 113 – H. Körber: "Mainz und Halle. Ein reformationsgeschichtlicher Spannungsbogen," *Ebernburg-Hefte* 4 (1970), 43– 52 – Ruhmer 1970, 85, no. VIII, pl. 8 (see also the comments on no. V, 80–84) – Pfaff 1971, 132f., 145, XXXI, reg. no. 57 – Exh. cat. *Deutsche Kunst der Dürer-Zeit* (Dresden 1971), no. 380 – Bianconi 1972, no. 44 – Baumgart 1974, pl. XXV – H. Körber, "Der Mainzer Meister Hans Plock (1490–1570), Seidensticker am Hofe Kardinal Albrechts in Halle. Seine Person, sein Wappen und sein Werk. Eine Studie zur Hans-Plock-Bibel und zum Halleschen Heiltum," in: *Ebernburg-Hefte* 8 (1974), 104–123 – Exh. cat. *Kunst der Reformationszeit,* Staatliche Museen zu Berlin (1983), 253, D23 – Fraenger 1988, ill. 149

We owe the discovery of this drawing to Walter Stengel, who argued that it was a study for an apostle in a Transfiguration, now lost but mentioned by Sandrart, which Grünewald painted in 1511 in the Dominican church of Frankfurt. Behling, Jacobi, and Hütt agreed. Ruhmer did not place the apostle on the center panel, but on one of two hypothetical hinged wings.

Zülch instead believed the drawing was a study for a Last Judgment, and that it served as a model for the silk embroiderer Hans Plock.

Stengel distinguished the drawing stylistically from the two other drawings found in the same Bible and associated it with the apparently conceptually related *Saint in a Forest* in the Albertina.[5] Schade agreed.

Finally, Ruhmer observed that the two Dresden studies that are certainly preparatory to the Frankfurt Transfiguration,[6] are drawn in a different manner than the Berlin sheet, which looks more painterly, but which he nevertheless dated to 1511.

The motif of the drapery tip thrust against a tree trunk occurs in a different form in the *Saint in a Forest* and in the study for the Stuppach Madonna.[7] Edges bordered in white brush strokes are found in a more refined version in a drawing for the Virgin of the Isenheim Annunciation[8] as well as in the *Saint in a Forest,* in which the face was heightened in an entirely similar way.

R.K.

Verso (92)

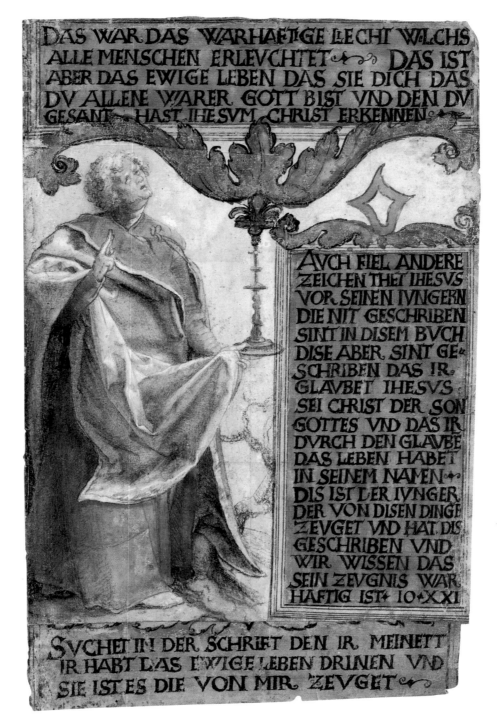

DAS WAR DAS WARHAFTIGE LIECHT WELCHS
ALLE MENSCHEN ERLEVCHTET · DAS IST
ABER DAS EWIGE LEBEN DAS SIE DICH DAS
DV ALLENE WARER GOTT BIST VND DEN DV
GESANT HAST IHESVM CHRIST ERKENNEN ·

AVCH FIEL ANDERE
ZEICHEN THET IHESVS
VOR SEINEN IVNGERN
DIE NIT GESCHRIBEN
SINT IN DISEM BVCH
DISE ABER SINT GE=
SCHRIBEN DAS IR
GLAVBET IHESVS
SEI CHRIST DER SON
GOTTES VND DAS IR
DVRCH DEN GLAVBĒ
DAS LEBEN HABET
IN SEINEM NAMEN ·
DIS IST DER IVNGER
DER VON DISEN DINGĒ
ZEVGET VND HAT DIS
GESCHRIBEN VND
WIR WISSEN DAS
SEIN ZEVGNIS WAR
HAFTIG IST · IO·XXI

SVCHET IN DER SCHRIFT DEN IR MEINETT
IR HABT DAS EWIGE LEBEN DRINEN VND
SIE IST ES DIE VON MIR ZEVGET ·

92

1. Written incorrectly; should be 1525 (1520 was the year of Emperor Charles V's coronation in Aachen, at which Plock was present; in 1525 Plock became a citizen in Halle); see Zülch 1955, 197.

2. Stengel 1952, 72, reads *A Khün (?) Berol* on the back of the relining.

3. The precise date cannot be established, as Inventory XIII of the Märkisches Provinzial-Museum was lost during World War II.

4. The separation of the Grünewald drawings was entrusted to the Dresden paper restorer Hertha Gross-Anders. She had earlier removed the study of an apostle from the support (photo: Exh. cat. *Altdeutsche Zeichnungen,* Dresden 1963), but then returned it to its former place and removed the entire collage from the Bible. Stengel 1952, 70, wrote about the candleholder in the hand of the apostle: "It is painted over in red, as are some areas on the robe. Since the 1963 restoration, it has been yellow!"

5. Vienna, Graphische Sammlung Albertina; Behling 1955, no. 22; Weixlgärtner 1962, no. 20; Ruhmer 1970, no. 26; Baumgart 1974, pl. XVIIr.

6. Dresden, Staatliche Museen, Kupferstichkabinett, inv. no. C 1910–1941 and 1910–1942; Behling 1955, no. 2f.; Weixlgärtner 1962, no. 4f.; Ruhmer 1970, no. 5f.; Baumgart 1974, pl. IIf.

7. Berlin, Kupferstichkabinett, KdZ 12039; Behling 1955, no. 25; Weixlgärtner 1962, no. 24; Ruhmer 1970, no. 24; Baumgart 1974, pl. XV.

8. Berlin, Kupferstichkabinett, KdZ 12037; Behling 1955, no. 19; Weixlgärtner 1962, no. 12; Ruhmer 1970, no. 4; Baumgart 1974, pl. VII.

93 STUDY OF AN OLD TESTAMENT FIGURE, c. 1511/1512

Berlin, Kupferstichkabinett, KdZ 4190
Black chalk with touches of gray wash; heightened in gouache; brownish and reddish watercolor
235 x 165 mm
Watermark: indecipherable
Hans Plock used the silhouetted and cut drawing for a collage, with a blank text tablet located behind the figure and an enframed box below inscribed ACH DAS SIE EIN SOLICH HERCZ HETTEN/MICH ZV FVRCHTEN VND ZV HALTEN ALLE/MEINE GEBOT IR LEBEN LANCK AVF DAS/INEN WOL GINGE VND IREN KINDERN/EWIGLICH – /O WELCH EIN VATERLICHS HERCZ;[1] undergarment gone over with red watercolor
Collage taken apart in the 1920s and drawing mounted on another support;[2] in 1990 collage restored to its old condition

PROVENANCE: from the estate of the silk embroiderer Hans Plock, who died in 1570 in Halle and who inserted the collage in the first volume of his Bible, printed by Lufft of Wittenberg in 1541. It is not certain if it was still in this Bible in the 18th century, when the spine of the volume was repaired, or if it was removed only later; Von Lepell Coll. (left, under the empty tablet, estate stamp, Lugt 1672); acquired in 1824 together with that collection by King Friedrich Wilhelm III for the Kupferstichkabinett (museum stamp, Lugt 1606)

LIT.: *Zeichnungen* 1910, 2: pl. 181 – Schmid 1907, pl. 45; 1911, 19, 261, 275 – Hagen 1919, 190, ill. 103 – Bock 1921, 44 – Storck 1922, pl. XVI – Friedländer 1927, pl. 4 – Feurstein 1930, 138, no. 4, ill. 67 – H. H. Naumann, *Das Grünewald-Problem* (Jena 1930), 75 – Burkard 1936, 70, no. 1, pl. 83 – Fraenger 1936, ill. on 72 – Zülch 1938, 332, no. 3, ill. 170 – Schoenberger 1948, 32, no. 16 with ill. (with collector's marks, without additions) – Exh. cat. *Deutsche Zeichnungen der Dürerzeit* 1951, no. 298 – W. Stengel "Drei neuentdeckte Grünewaldzeichnungen," *Berliner Museen,* n.s., 2 (1952), 30f., ill. 1 (with Plock's additions) – Stengel 1952, 65, 71f., no. 4 – Zülch 1953, 24–26 with ill. – Zülch 1954, 23f., ill. 32 – Behling 1955, 98, no. 8, pl. VI – Zülch 1955, 194ff., esp. 201, 203, 206, ill. 57f. – Jacobi 1956, 31–34, 36f. – Pevsner/Meier 1958, 30, no. 5 – L. Donati, "Un ignoto disegno di Grünewald nella Biblioteca Vaticana," *Wallraf-Richartz-Jahrbuch* 22 (1960), 87–114 – Scheja 1960, 199ff., 205f., ill. 11 – Weixlgärtner 1962, 111, no. 3 – *Great Drawings* 1962, pl. 399 – W. Timm, "Zur Rekonstruktion von zwei Grünewald-Zeichnungen," *Forschungen und Berichte der Staatlichen Museen zu Berlin* 7 (1965), 96, pl. 39 – Hütt 1968, 184, no. 68, ill. 112 – Behling 1969, 11 – Ruhmer 1970, 85, no. X, pl. 11 (see also the comments to no. V, 80–84) – Pfaff 1971, 132f., 145, XXXII, reg. no. 59, no. 59a – Bianconi 1972, no. 47 – Baumgart 1974, pl. XXIII, pl. XXXIX (copy)

In the early twentieth century, Jaro Springer discovered this collage in the storage room of the Kupferstich-

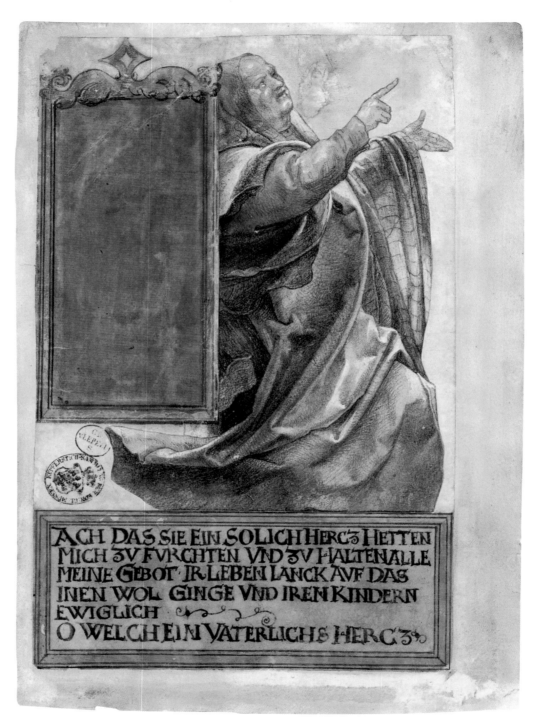

ACH DAS SIE EIN SOLICH HERC₃ HETTEN
MICH ZU FVRCHTEN VND ZU HALTEN ALLE.
MEINE GEBOT. IR LEBEN LANCK AVF DAS
INEN WOL GINGE VND IREN KINDERN
EWIGLICH ◦
O WELCH EIN VATERLICHS HERC₃◦

93

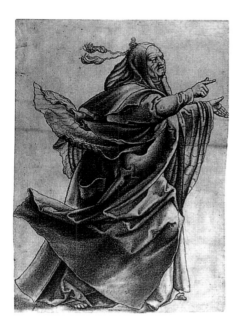

Copy after Grünewald, *Israelite*, 16th century

kabinett. It was originally assumed that the figure, who seemed to be kneeling, was either a Jewish scribe accusing Christ, or a mocking Pharisee.

Feurstein's interpretation of the figure as an "unauthorized spectator" of the Transfiguration of Christ first established the connection between the drawing and the painting in the Dominican church of Frankfurt that Sandrart had mentioned. Schoenberger also believed that the sheet must be connected with that painting, but he thought it a study for a Moses or Elijah.

When in 1959 Lamberto Donati introduced the Art Historical Society of Berlin to a drawing from the Vatican Library, which depicts the Old Testament figure in its entirety and which, to all appearances, is a copy of an original that survives only in the fragmentary form of the Plock sheet, it was clear that Master Mathis had drawn a rushing, gesticulating Israelite, who could be recognized by the tassels on the hood of his cloak.[3] It could be Moses, who, as in the Plock version, announces the Lord's will to the people of Israel (see ill.).

The existence of the copy raises questions about the circumstances of its origins. When and where was the original drawing, which survives only in the fragmentary upper portion in Berlin, copied—in the workshop of the painter or that of the silk embroiderer? How did the copy find its way into the papal collections?

Was the original study first made for a painting, only to serve a second time as a model for a silk embroidery? Or was it designed as such a model in the first place? How and when did it fall into the hands of the silk embroiderer, who began to work in Mainz about 1515 and who became a citizen of Halle in 1525?

As long as the drawing is considered a study for the lost Frankfurt Transfiguration, it must necessarily be dated to c. 1511. Closely related in style is a standing Old Testament figure, identified as Elijah or Moses, that Stengel discovered in the Plock Bible in 1952. Presumably both studies were intended to be preparatory drawings for the same work. The agitated masses of cloth in the robe of the hurried Old Testament figure show his movements in the same way that the forward-blowing cloak of the annunciate angel of the Isenheim altarpiece represents his arrival.

R.K.

1. Deut. 5:29: These are the words God spoke to Moses from the burning bush, which he announced to the people of Israel.

2. With Plock, the cut lower edge was in a horizontal position. It was inclined to the right during the restoration of the twenties. M. J. Friedländer first published the newly mounted drawing without the Plock additions in 1927 in an annual publication of the Deutscher Verein für Kunstwissenschaft (German Society for Art History). Only minor traces on the drawing still vouch for its initial use in a collage by Hans Plock; these include the ornamental scroll at the back of the Israelite's head (a remainder of the crown of the tablet at his back), the black line on the tip of the robe at the left (the lower borderline of the same vertical tablet), and the blackened cut lower edge (upper boundary line of the writing box). Presumably, the undergarment was gone over in red paint by Plock; it is also possible that some of the added heightening in white on the cloak may be traced back to his hand.

3. Num. 15:37–41.

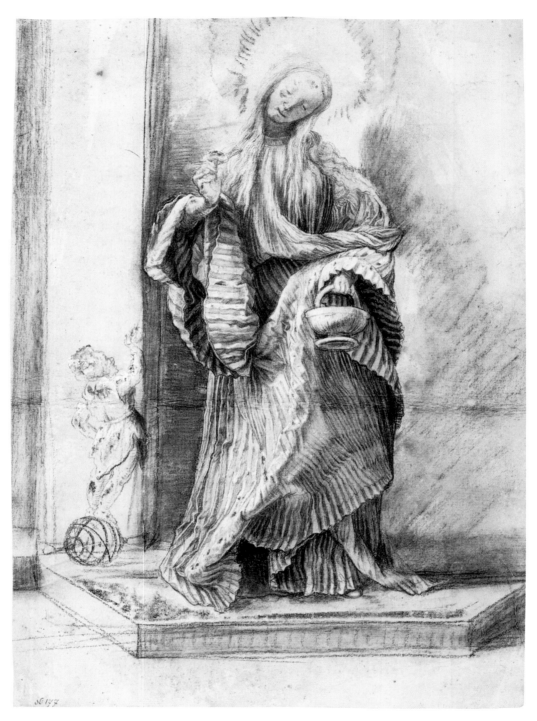

94 STUDY FOR A ST. DOROTHY, c. 1511/1512

Berlin, Kupferstichkabinett, KdZ 12035
Black chalk with touches of gray wash; heightened in lead white
358 x 256 mm
Watermark: crowned fleur-de-lis coat of arms with letter R
(according to Friedländer 1926, no. 10; variant of Briquet
8992–8994)
Lower left, inscribed in pencil *N: 177*
Trimmed irregularly on all sides; below center, horizontal fold
with sundry creases; arch-shaped creases with abraded medium at
the left, at the height of the armillary sphere; chipped paint at
the head of the child, on his right arm and shoulder, later opaque
white retouches on his upper body; upper left, lighter areas
where the wash did not take; slightly foxed; several small tears at
the upper and right edges; verso, paper remains from a former
backing

PROVENANCE: picture album of the Von Savigny Coll.; acquired
in 1925 (inv. no. 105-1925, verso, a collector's mark not listed by
Lugt, with year and handwritten running number)

LIT.: Friedländer 1926, no. X with pl. – G. Schoenberger,
"Buchbesprechung: Die neuen Zeichnungen Matthias Grüne-
walds," *Oberrheinische Kunst* 1, 1925/1926, 232f., pl. CIV – Fried-
länder 1927, pl. 18 – Feurstein 1930, 57, 142f., no. 22, ill. 79 –
Winkler 1932a, 33, no. 54 with pl. – Graul 1935, no. 20 –
Burkhard 1936, 70, no. 5, pl. 85 – Fraenger 1936, 100, ill. on 75
– Zülch 1938, 366, no. 29, ill. 197 – Schoenberger 1948, 40f.,
no. 32 with ill. – Exh. cat. *Deutsche Zeichnungen der Dürerzeit*
1951, no. 305, pl. 9 – Winkler 1952, 34 – Winkler "Der
Marburger Grünewaldfund," *Zs. f. Kwiss.* 6 (1952), 155–180, esp.
170, ill. 9 – Behling 1955, 109, no. 29, pl. XXVII – Jacobi 1956,
98–100 – Pevsner/Meier 1958, 33, no. 33 with ill. – Weixlgärtner
1962, 118, no. 28 – *Great Drawings* 1962, Plate 407 – Exh. cat.
Dürer 1967, no. 60a with ill. – Hütt 1968, 186, no. 96, ill. on 140
– Behling 1969, ill. on 85 – Ruhmer 1970, 85, no. XI, pl. 13 –
Bianconi 1972, no. 67 – Baumgart 1974, 7, pl. IV – Fraenger
1988, 198–200 with ill., pl. 23 – H. Mielke, in: *Handbuch Berliner
Kupferstichkabinett* 1994, no. III.56

The unusual "sweet blessedness" of the saint reminded
Max J. Friedländer of Sandrart's enthusiastic description
of the center panel of a destroyed altar in the cathedral of
Mainz,[1] according to which this lost work showed "our
sweet Lady with the little Christ child on a cloud. . . .
On earth below many saints await in exceptional graceful-
ness, such as St. Catharine [. . .], all so noble, naturally,
sweetly blessed and correctly drawn, as well as beautifully
colored, that they seem to belong more to heaven than
to earth." Although Sandrart does not mention a St.
Dorothy, Friedländer nevertheless assumed that the draw-
ing was a study created in connection with this panel.
His opinion long went unchallenged.

In 1970 Eberhard Ruhmer identified the female saints
of the fixed wing of the Heller altarpiece as the closest
in spirit to the St. Dorothy.[2] Ever since then, the drawing
has been considered an early work, evidently a study of a
model, by the master. By 1936 Fraenger had already noted
that the podium and partition wall represent workshop
props. The podium appears on two other drawings by
the master, namely a study for an Annunciation to the
Virgin in a pleated dress (Berlin, Kupferstichkabinett,
KdZ 12040) and the *Study of a Seated Figure with Two
Angels* (cat. 95).

The study of the Virgin shows the same delicate
execution as the drawing of St. Dorothy. The similarity
of both maidenly heads, the delicacy of Mary's figure and
of her pleated dress with its light-reflecting folds, indicates
that both drawings were created at virtually the same
moment. The presumed connection between the study
of the Virgin and the Isenheim altarpiece is also an argu-
ment for the early dating of the study of St. Dorothy.

While the draftsman faithfully rendered the play
of light on the pleated cloth of the complicated drapery
of a dress dummy, the dummy transformed before his eyes
into a true saint, a sweet girl, whose body seems touch-
ingly fragile owing to the artfully arranged masses of drap-
ery. In her right hand she tenderly holds a rose, which she
observes with devotion. According to legend, a heavenly
child visited the saint at the hour of her death, because
before her execution the writer Theophilus had mock-
ingly begged her for flowers and apples from paradise.
The celestial child, standing on an armillary sphere[3] to
the saint's left, is bathed in the light that breaks from the
gate of paradise—represented by an opening in the par-
tition wall—and receives an apple as heavenly nourish-
ment for the saint.

The great allure of the depiction resides in the total
plausibility of the vision. The devout observer shares in
the heavenly blessedness of this martyr. R.K.

1. *Joachim von Sandrarts Academie der Bau-, Bild- und Mahlerey-Künste
von 1675,* ed. A. R. Peltzer (Munich 1925), 82 (part 2, book 3, ch. V–
XXXVII: "Mattheus Grünewald").

2. In 1511, after building the lady's apartments in the castle of
Aschaffenburg, Master Mathis was occupied with a panel for the Frank-
furt Dominican monastery (Zülch 1938, 361: 1511/1512; Kehl 1964, 19,
121: second half of 1511). This fact has continually been related only to
the Transfiguration painting described by Sandrart, with the fixed wing
of the Heller altar placed between 1509 and 1511. E. Ruhmer departed
from this pattern and proposed a dating to 1511/1512 (*Grünewald: The
Paintings* [London 1958], 116). E. Holzinger accepted only the male
saints, Lawrence and Cyriac, as autograph works by the master, whereas
the female saint, Elizabeth, and a martyr (Lucy?), were executed after
the master's designs by a "man with corporeal vision from the Dürer

school" ("Von Körper und Raum bei Dürer und Grünewald," in *De artibus opuscula XL. Essays in Honor of Erwin Panofsky* [Zurich 1960], 1:249–253). A. Pfaff conjectured that he might be Martin Caldenbach, called Hess (*Studien zu Albrecht Dürers Heller-Altar,* Nürnberger Werkstücke zur Stadt- und Landesgeschichte 7 [Nuremberg 1971], 128). Recently Kutschbach 1995 summed up the state of the question as follows: "one may, however, safely assume that the commission in the first instance went to Grünewald, for whom, starting mid-1511 at the latest, works at the Dominican monastery are documented."

3. The armillary sphere, with the most important circles of the celestial globe, identifies the child as celestial ruler. The armillary sphere also identifies the crown bearer (cat. 95) as King of Heaven.

95 STUDY OF A SEATED FIGURE WITH TWO ANGELS, 1515–1517

Verso: Virgin and child with St. John the Baptist
Berlin, Kupferstichkabinett, KdZ 2040
Black chalk with touches of gray wash; heightened in white gouache
286 x 366 mm
Watermark: high crown with cross and star (similar to Briquet 4965)
Trimmed on all sides; vertical crease in the center; three horizontal erased lines at the height of the left hand of the seated man; lower right, on the cloak, old retouched abrasion; water spots in the upper half of the sheet; four glue spots in the lower left quarter; lower left corner restored

PROVENANCE: Von Radowitz Coll. (verso collector's mark, Lugt 2125); 1856, donated to the Berlin Kabinett by King Friedrich Wilhelm IV (verso museum stamp, Lugt 1606) along with the rest of the Radowitz collection

LIT. (recto): *Zeichnungen* 1910, 2nd ed., no. 180 – Schmid 1907, pl. 42f.; 1911, 19, 57, 258, 270, 279 – O. Hagen, "Zur Frage der Italienreise des Matthias Grünewald," *Kunstchronik,* n.s. 28 (1916/1917), cols. 73–78 – Hagen 1917, cols. 344–347 – Hagen 1919, 136, 186–188, ill. 99 – F. Rieffel, "Besprechung des Buches von O. Hagen, Matthias Grünewald," *Repertorium für Kunstwissenschaft* 42, 1920, 220ff., esp. 227 – Bock 1921, 44, pl. 58 – Storck 1922, pl. XVII – R. Günther, *Das Martyrium des Einsiedlers von Mainz* (Mainz 1925), 27 – Parker 1926, no. 41 with ill. – R. Weser, "Der Bildgehalt des Isenheimer Altares," *Archiv für christliche Kunst* 40 (1926), 7 – Friedländer 1927, pl. 24 – Feurstein 1930, 57, 140f., no. 17, ill. 76 – H. Kehrer, "Zur Deutung einer Grünewald-Zeichnung im Kupferstichkabinett zu Berlin," *Forschungen zur Kirchengeschichte und zur christlichen Kunst* [Festgabe zu Joh. Fickers 70. Geburtstage] (Leipzig 1931), 211–220 – G. Münzel, "Zur Interpretation einer Zeichnung Grünewalds im Kupferstichkabinett zu Berlin," *Berliner Museen, Berichte aus den Preussischen Kunstsammlungen* 53 (1932), 58–60 with ill. – Winkler 1932a, 32, no. 50 with pl. – Graul 1935, no. 18f. – Burkhard 1936, 71, no. 10, pl. 92 – Fraenger 1936, 147f., ill. on 88 – Zülch 1938, 335f., no. 23, ill. 191 – Winkler 1947, 61, ill. 42 – Schoenberger

1948, 32f., 118, no. 17 with ill. – E. Panofsky, "Besprechung von Schoenberger," *Art Bulletin* 31, 1 (1949), 63ff., esp. 64f. – E. Poeschel, "Zur Deutung von Grünewalds Weihnachtsbild," *Zeitschrift für Kunstgeschichte* 13 (1950), 92–104, esp. 98f. – Exh. cat. *Deutsche Zeichnungen der Dürerzeit* 1951, no. 301 – Zülch 1954, 5, ill. 25 – Behling 1955, 105f., no. 23, pl. XXI – Jacobi 1956, 66–68 – Exh. cat. *Deutsche Zeichnungen 1400–1900* 1956, no. 72 – Pevsner/Meier 1958, 33, no. 25 with ill. – Scheja 1960, 208–211, ill. 17 – Weixlgärtner 1962, 116f., no. 22 – *Great Drawings* 1962, pl. 404 – Exh. cat. *Dürer* 1967, no. 59 with ill. – Hütt 1968, 185, no. 90, ill. on 134 – Behling 1969, 18, ill. 23 – Ruhmer 1970, 91f., no. XXV, pl. 29f. – Bianconi 1972, no. 60 – Baumgart 1974, pl. XVIr – Fraenger 1988, 290, ill. on 288, pl. 130 – Schade 1995, 322, 324f., ill. 1 – Hubach 1996, 221, 239, pl. XII

This sheet is one of the most important drawings by the master and also one of his most problematic. Its content and purpose have, until now, defied identification.

Even an identification as "cloak study of a kneeling crowned figure," based on the correct observation that the artist lavished most of his attention on the rendering of the cloak, obscures the creative process. The artist sketched the overall composition first, working out the highlights later. A model that was lit from the upper right must have been used for the cloak. The anatomy of the crowned person indicates that no model was used in this instance. Whether the crown bearer kneels with the left leg on the podium, which is also depicted in the St. Dorothy with an armillary sphere, or whether he sits in front of it, is a vexing question.

In 1911 Schmid identified the subject of the drawing as Christ as King, intended for a Glorification of the Virgin, and related the sheet to a commission from the canon Heinrich Reitzmann for Oberissigheim, in which a *gloriosissima virgo* (most glorious Virgin) was to be depicted.[1] Rieffel, Feurstein, Winkler, Schoenberger, Halm, and Jacobi supported him. The gesture, scepter, and celestial sphere certainly do appear to speak for a Coronation of the Virgin, but the trees do not.

In 1917 Hagen saw the depiction for a study of the Moorish king Balthasar as an Adoration of the Magi. Weser, Günther, and Fraenger followed Hagen's interpretation.

Bock, in 1921, first described the drawing as an "Angel of the Annunciation." In 1931 Kehrer identified the sheet as a depiction of the archangel Gabriel with two attendant angels, in relation to Mathilde of Magdeburg's *Liber specialis gratiae.*

In 1949 Panofsky interpreted the drawing as a study for a *Ratschluss der Erlösung* (Resolution of Redemption), a rarely depicted subject showing the council of the Holy Trinity, at which the son offers himself to become flesh.[2]

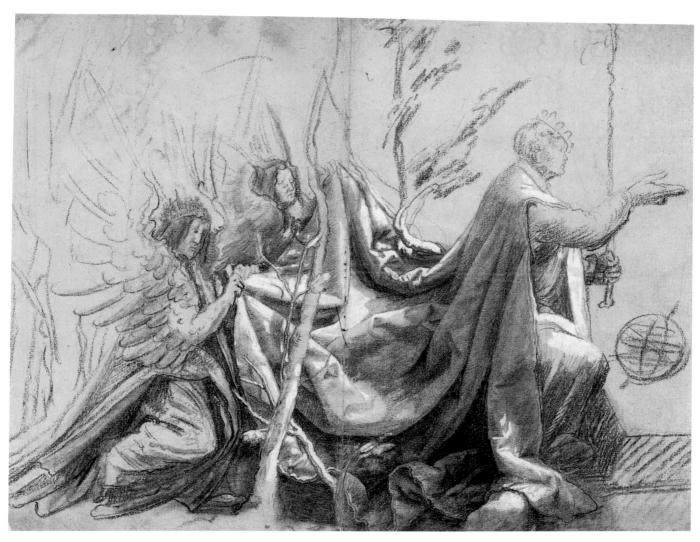

95

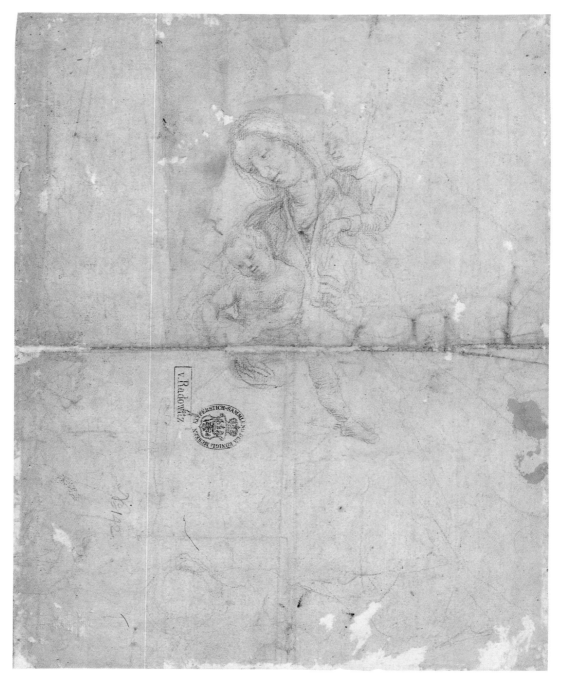

Verso (95)

He is shown as a youth before his incarnation. As a sign of his readiness to be sacrificed, he has put down the armillary sphere. Although the traditional setting for this scene is heaven and not paradise, as indicated here by the trees, Weixlgärtner accepted this interpretation as the most probable.

In 1960 Scheja also interpreted the trees as signifying paradise and the kneeling king as Christ, specifically as *sponsus* (bridegroom) of the Song of Songs. Scheja argued, as a consequence, that the drawing is a study for an allegorical painting of the Virgin, in which Mary as the *electa* of the Song of Songs becomes *Ecclesia* or the Church. Possibly the depiction is based on a vision of a mystic such as St. Bridget of Sweden, whose influence on Marian theology—of which Heinrich Reitzmann, the donor of the Aschaffenburg Maria-Schnee altar, was an adherent—was considerable. As the Stuppach Madonna, which was donated by him, has obvious connections to the Song of Songs, Scheja thought it possible that it was first and foremost intended to depict the *Ecclesia* as a mystical bride received by her bridegroom.

In 1995 Schade pointed to Genesis 49:9–11, and took the main figure for Jacob blessed by Juda.[3]

Compared to the many difficulties presented by the interpretation of the depiction, its dating seems relatively simple.

Since the Oberissigheim altar is no longer attributed to Grünewald, its dating of about 1514, which was based on the artist's involvement, has become untenable. As a representation of a scene in a landscape, the drawing is related to a study for the Stuppach Madonna in the Berlin Kupferstichkabinett[4] and to the *Standing Saint in a Forest* in the Albertina in Vienna.[5] The stylistic proximity of the three drawings tempted Hagen in 1917 to the construction of an Adoration of the Kings for Aschaffenburg, and Fraenger took these drawings for studies for a *Virgin in a Forest* that, in his opinion, was intended for the exterior of the Aschaffenburg Maria-Schnee altar.

All this supports a dating of this study of a sitting figure with two angels in the years 1515–1517, after the Isenheim altarpiece—Fraenger was reminded of its angelic concert in 1988—and around the time of the Stuppach Madonna.

VIRGIN AND CHILD WITH ST. JOHN THE BAPTIST (VERSO)

Black chalk
366 x 286 mm
Depiction turned ninety degrees with respect to the one on the other side of the sheet; horizontal crease in the center, break indicates that sketch was on the outside of the folded sheet

PROVENANCE: on the right, in the lower half of the sheet, Von Radowitz collector's mark (Lugt 2125); above it, to the right, mark of the Berlin museum (Lugt 1606); lower right *No. 142* in pencil; both positioned in the direction that one reads the recto depiction

LIT. (Verso): Schmid 1907, pl. 43; 1911, 259f. – Hagen 1917, col. 346 – Hagen 1919, 186, ill. 98 – Bock 1921, 44 – Storck 1922, pl. XII – Friedländer 1927, pl. 25 – Feurstein 1930, 141, no. 18, ill. 77 – Burkhard 1936, no. 11, pl. 93 – E. Wind, "Charity," *Journal of the Warburg Institute* 1 (1937/1938), 322–330 – Zülch 1938, 336, no. 24, ill. 192 – Schoenberger 1948, 34f., no. 20 with ill. – Winkler 1952, 39 – F. Winkler, "Der Marburger Grünewald-fund," *Zeitschrift für Kunstwissenschaft* 6 (1952), 155–180, esp. 158 – Behling 1955, 106, no. 24, pl. XXII – Jacobi 1956, 68–70, 76 – Pevsner/Meier 1958, 33, no. 26 with ill. – Weixlgärtner 1962, 117, no. 23 – *Great Drawings* 1962, pl. 402 – Hütt 1968, 185, no. 91, ill. on 135 – Ruhmer 1970, 92f., no. XXVIII, pl. 33 – Bianconi 1972, no. 61 – Baumgart 1974, pl. XVIv – Fraenger 1988, pl. 96 – Hubach 1996, 221f., n. 57, pl. XIII

A drawing rendered only in chalk is a rarity in the work of the master; this one is a composition sketch, with the figure of the seated Virgin in the lower part only hastily indicated, while her head, neck, and shoulders are rendered in greater detail, as are the two children. The heavily abraded drawing was protected by a mount with an oval cutout, covered with yellow foil. This falsified the overall impression and overemphasized the "Italian character" observed by Wind and Schoenberger.

Hagen had already assumed in 1917 that Master Mathis accompanied Canon Heinrich Reitzmann to Rome in the jubilee year 1500.[6] Two indications for this, he believed, are the master's characteristic chiaroscuro, which earned him the name of a German Correggio,[7] and the smiles (unusual for Germany) of his Madonnas, which seem to betray a familiarity with the work of Leonardo, especially his cartoon of St. Anne, the Virgin, and Christ, which attracted much notice in Florence in 1501. Hubach (1996) also noticed an intensive study of contemporary Italian examples, which Master Mathis "probably first got to know in the collection of his patron Reitzmann." Wind demonstrated that the composition is based on depictions of Charity, such as those created by Michelangelo and Raphael.

The young St. John, who is dressed in a long-sleeved

shirt, stands behind the Virgin, who presumably sits on a grassy bench. The moon serves to support her right foot. John lays his left hand on her shoulder. The gesture of his right hand is difficult to identify. With her right hand the Virgin holds the naked child, who sits on her lap and grasps the head of a lamb that lies before him. According to Weixlgärtner, the young St. John points at the lamb, at which all eyes are directed.

The many pentimenti demonstrate that the artist did not adapt an existing composition but corrected his own conception even while drawing. This is especially clear in the neckline of the Madonna.

The study's stylistic proximity to the drawing for the Stuppach Madonna[8] has often been emphasized and in 1919 brought Hagen to the conclusion that the composition originated in connection with the commission of the Maria-Schnee altar. It may thus be dated to the same time period as the study on the recto of the sheet. R.K.

1. Kehl 1964, 133f. (document 5).

2. John 1:1: "In the beginning was the Word, and the Word was with God, and the Word was God"; John 1:14: "And the Word became flesh and lived among us, and we have seen his glory, the glory as of a father's only son, full of grace and truth."

3. Juda is an ancestor of David, from the same lineage whence Christ came. Possibly, as proposed by Schade, this is also an adapted allegory of the sovereignty of the Lord.

4. KdZ 12039: Behling 1955, no. 25; Ruhmer 1970, no. 24; Bianconi 1972, no. 66; Baumgart 1974, pl. XV.

5. *Beschreibender Katalog der Handzeichnungen in der Graphischen Sammlung Albertina, 4: Die Zeichnungen der Deutschen Schulen bis zum Beginn des Klassizismus* (Vienna 1933), no. 296; Behling 1955, no. 22; Ruhmer 1970, no. 26; Bianconi 1972, no. 62; Baumgart 1974, pl. XVIr.

6. According to Hubach 1996, 202, it can be proved that Heinrich Reitzmann stayed in Rome in 1494/1495.

7. *Joachim von Sandrarts Academie der Bau-, Bild- und Mahlerey-Künste von 1675*, ed. A. R. Peltzer (Munich 1925), 337 (chapter 2 of 1679, "Nachtrag zu den Künstlerbiographien des ersten Haupttheiles: Ehren-Gedächtnüs: Das ist Leben- und Kunst-Beschreibung der übrigen Virtuosen, 69 des Dritten Theiles").

8. Berlin, Kupferstichkabinett, KdZ 12039.

96 CRYING HEAD, C. 1520

Verso: head of a young woman, c. 1520
Berlin, Kupferstichkabinett, KdZ 1070
Black chalk with touches of gray wash
276 x 196 mm
Watermark: high crown with flowers and star (neither in Briquet nor Piccard)
Artist's monogram added later, in pencil, at lower right
Trimmed at left and top?; slightly foxed

PROVENANCE: Von Nagler Coll. (verso lower left, estate stamp, Lugt 2529); acquired in 1835 (verso, lower right, museum stamp, Lugt 1606)

LIT. (recto): *Zeichnungen* 1910, 2d ed., no. 182 – Schmid 1907/1911, pl. 44; 1911, 19, 260 – Hagen 1919, 20f., 194–196, ill. 1 – Bock 1921, 44, pl. 57 – Storck 1922, pl. XIV – Friedländer 1927, pl. 30 – Feurstein 1930, 143f., no. 28, ill. 85 – Graul 1935, no. 11 – Burkhard 1936, 71, no. 13, pl. 88 – Fraenger 1936, 107, ill. on 98 – Zülch 1938, 366, no. 27, ill. 195 – Schoenberger 1948, 35f., no. 23 with ill. – Exh. cat. *Deutsche Zeichnungen der Dürerzeit* 1951, no. 303 – Behling 1955, 110, no. 31, pl. XXIX – Jacobi 1956, 78–80 – Exh. cat. *Deutsche Zeichnungen 1400–1900* 1956, no. 73 – Pevsner/Meier 1958, 33, no. 29 with ill. – Weixlgärtner 1962, 118, no. 26 – *Great Drawings* 1962, pl. 411 – Exh. cat. *Dürer* 1967, no. 61 – Hütt 1968, 185f., no. 94, ill. on 138 – Ruhmer 1970, 95, no. XXXV, pl. 40 – Bianconi 1972, no. 71 – Baumgart 1974, pl. XXr – Fraenger 1988, 213, pl. 87

As with almost all works by the artist, the road to a satisfactory explanation of the subject was a long one: Schmid in 1911 took the drawing for a study of a singing angel. In 1930 Feurstein pointed to the tight, distorted facial expression, which he interpreted as crying, and asked whether this could truly be a study of an angel. Burkhard spoke in 1936 of a crying child, and Fraenger even perceived the cry of a female epileptic and was reminded of the representation of such a figure on the fixed wing of the Heller altarpiece.[1]

Only in 1938 did Zülch recognize that the study belongs with a second one in the Berlin Kupferstichkabinett (KdZ 12319), which unmistakably shows the head of an individual who is crying out. He claimed both as preparatory works for a panel painting of 1520, in the altar of St. Alban in Mainz cathedral, which Sandrart described from memory: "On another sheet was depicted a blind hermit, who, crossing the Rhine River with his young guide, is attacked on the ice by two murderers and clubbed to death, and is lying on top of his crying boy, a scene that is wonderfully natural and true in its emotions and representation."[2] The panel was stolen by the Swedes in 1631/1632 and destroyed in transport. Proof for this plausible thesis depends on the rediscovery of a copy,

mentioned by Sulpiz Boisserée, then in the possession of the chamberlain Von Holzhausen in Frankfurt am Main.[3] Much less convincing is Schoenberger's 1947 proposition that the drawing should be viewed as a study for a lamenting angel, perhaps for a Lamentation or a martyrdom of St. Sebastian, as the woodcuts B. 43 and B. 37 by Hans Baldung show these subjects. Schoenberger established the great similarity of the angel to the blonde seraph in the concert of the angels of the Isenheim altarpiece, and therefore dated the study to 1515/1516.

HEAD OF A YOUNG WOMAN (VERSO), C. 1520

Black chalk with touches of gray wash
Diagonal crease from lower right through woman's ear and the back of her head

LIT. (verso): Schmid 1911, 260f. – Hagen 1919, 192–194, ill. 105 – Bock 1921, 44 – Storck 1922, pl. XV – Friedländer 1927, pl. 29 – Feurstein 1930, 143f., no. 27, ill. 84 – Graul 1935, no. 23 – Burkhard 1936, 71, no. 12, pl. 91 – Zülch 1938, 336, no. 28, ill. 196 – Schoenberger 1948, 36, no. 24 with ill. – Behling 1955, 111, no. 32, pl. XXX – Jacobi 1956, 80–82 – Exh. cat. *Deutsche Zeichnungen 1400–1900* 1956, no. 73, ill. 31 – Pevsner/Meier 1958, 33, no. 28 with ill. – Weixlgärtner 1962, 118, no. 27 – *Great Drawings* 1962, pl. 415 – F. Anzelewsky, in: Exh. cat. *Dürer* 1967, no. 62 – Hütt 1968, 186, no. 95, ill. on 139 – Ruhmer 1970, 90, no. XXIII, pl. 26 – Bianconi 1972, no. 72 – Baumgart 1974, pl. XXv – Fraenger 1988, pl. 51

As this drawing is difficult to relate to any known work by the master, it has given rise to highly varied interpretations. At first scholars considered the question of whether the model was a man or a woman. The facial expression may have reminded Hagen of Leonardo's work. Zülch, in turn, believed that the drawing was a study for a "nobly, naturally, sweetly and correctly" drawn saint of the Mainz St. Mary's altar, which, according to Hubach's findings, was painted in 1517/1518, immediately after the Stuppach Madonna. According to the latter, the head of a woman with downcast eyes originated before the crying head, which supposedly was a study for the 1521 Alban altarpiece in Mainz cathedral.

Schoenberger, however, thought the drawing a model study for a head of the Virgin, with its strong inclination caused by her turning toward the Child. He placed the drawing in 1515/1516, between the Isenheim and Stuppach Madonnas. Whereas Anzelewsky thought a dating to about two years later was conceivable, Ruhmer placed the drawing earlier, to the period of the Isenheim altarpiece.

If one follows Schoenberger and Ruhmer, the two studies on both sides of the sheet would have originated several years apart. This seems odd, as the six other known study sheets drawn by the master on the front and the back are all preparatory to a single work.[4] This fact would support the idea that our head of a woman looking down was intended for use on one or both wings of the Alban altar in Mainz cathedral. Moreover, in his early years Master Mathis did not limit his model studies to the head. That is only the case with his direct portrait studies.[5]

R.K.

1. See Fraenger 1988, pls. 87–89, for illustrations showing a comparison between the drawing and the panel with St. Cyriac with Artemia, the epileptic daughter of Emperor Diocletian (grisaille from the Heller altarpiece, Frankfurt am Main, Städelsches Kunstinstitut).

2. *Joachim von Sandrarts Academie der Bau-, Bild- und Mahlerey-Künste von 1675*, ed. A. R. Peltzer (Munich 1925), 82 (part 2, book 3, chap. V–XXXVII: "Mattheus Grünewald").

3. Notations by Sulpiz Boisserée concerning Frankfurt, 44, 60 (cited after Behling 1955, 110, in commentary on no. 30). This copy disappeared from Frankfurt in 1820, as Zülch 1954, 21, reported.

4. Although only two of the six study sheets used on both sides can be related with certainty to a surviving work, namely the Berlin and Dresden studies for the Isenheim altarpiece, it has never been doubted that the studies on the other sheets originated one immediately after the other in connection with specific projects, as with a *Saint in a Forest* and a *Standing Apostle* in Vienna, the study of a woman under the cross and a Mary Magdalene in Munich, a *Standing St. Catherine* and a sketch of a saint in Berlin, and, finally, the double-sided sheet discussed in cat. 95.

5. Three drawings qualify for this status: *Profile Portrait of an Old Man* (probably Guido Guersi, the preceptor of the Antonites in Isenheim), 1512–1516, Weimar, Schlossmuseum, Baumgart 1974, pl. V; *Portrait of a Woman*, 1512–1515, Paris, Louvre, inv. 18588, Baumgart 1974, pl. XIII; and *Portrait of a Canon*, 1522–1524, Stockholm, Nationalmuseum, Baumgart 1974, pl. XXIX.

96

97

Verso (96)

97 CRYING HEAD, C. 1520

Berlin, Kupferstichkabinett, KdZ 12319
Black chalk with touches of gray wash, heightened in white
244 x 200 mm
No watermark
Sheet restored for this exhibition, prior to that, backed, with
brown spots, especially at the edges; silverfish traces (bright
spots) on the neck, chin, lip, tip of the nose, thickening above
the right eye; bright traces of paper eaten away in the opening
of the mouth, the nose, and the diagonal shading extending to
the ear; damages slightly retouched

PROVENANCE: University of Jena, art history department, from
the Kopffleisch Coll.; acquired in 1926

LIT.: Friedländer 1927, 31 – Feurstein 1930, 143f., no. 29, ill. 86
– Burkhard 1936, 71 and 117, no. 14, pl. 89 – Fraenger 1936,
107f., ill. on 99 – Zülch 1938, 336, no. 26, ill. 194 – Winkler
1947, 61, ill. 43 – Schoenberger 1948, 35, no. 22 with ill. –
Fischer 1951, ill. 215 – Exh. cat. Deutsche Zeichnungen der
Dürerzeit 1951, no. 304, pl. 10 – Behling 1955, 60f. and 109, no.
30, pl. XXVIII – Jacobi 1956, 76–79 – Pevsner/Meier 1958, 27
and 33, no. 39 with ill. – Weixlgärtner 1962, 118, no. 25 – Great
Drawings 1962, pl. 410 – Exh. cat. Dürer 1967, no. 62 – Hütt
1968, 185, no. 93, ill. on 138 – Ruhmer 1970, 95f., no. 37, pl. 41
– Bianconi 1972, no. 70 – Baumgart 1974, pl. XIX – Fraenger
1988, 213, pl. 88

As Zülch 1938 observed, the present sheet and another
Berlin drawing (cat. 96) are closely related. Both are stud-
ies after one model and are today believed to be prepara-
tory works for a panel of the St. Alban altar, which was
painted in 1520 and stolen from Mainz cathedral by the
Swedes in 1631/1632.

Rendering a human face torn with emotion was ap-
parently an artistic aim in about 1520. The Berlin Kupfer-
stichkabinett preserves a head by Albrecht Dürer, arguably
a crying angel, done in black chalk heightened with white
on blue green prepared paper, which is probably a prepara-
tory work for a never-completed engraving by the master.
A comparison of this Dürer drawing (KdZ 2871, A. 111)
with Grünewald's two study heads reveals the different
character of the two artists. Although Grünewald's *Crying
Head* (cat. 96), like Dürer's *Crying Angel,* is in three-quarter
profile, Dürer's dark profile stands out starkly from a ground
heightened with white. Also, Grünewald drew not a con-
tinuous profile, but a profile composed of individual, un-
dulating parts of the face, with pentimenti from a contour
line between the cheeks and chin. The physiognomy of the
two heads is generally similar.

Whereas in Dürer's drawing, a face deformed by
emotional experience is interpreted in terms of its plastic
physical reality, with Grünewald's sheet, the spiritual effect
itself is directly mirrored in the motion of the surfaces of
the face, with areas in light or shadow. The study of a
crying head in the present sheet far outstrips Grünewald's
other study (cat. 96) in its radical conception. R.K.

98 ROMAN TRINITY, AFTER 1520

Berlin, Kupferstichkabinett, KdZ 1071
Black chalk with touches of gray wash; verso, undulating
chalk line
272 x 199 mm
Watermark: crowned fleur-de-lis coat of arms with flower and
dangling t (Piccard XIII, 1697)
Lower edge, signed with artist's monogram *M* with inserted *G*
Slightly trimmed; upper corners added and tinted; horizontal
crease with paint loss in the center, in each of the upper and
lower halves an additional horizontal penetrating crease, with the
upper one partially backed; on the lower edge a continuous
horizontal break; on the left edge, restored area with a tear into
the cheek of the left head; upper left, a repaired tear down to the
beginning of the hair; on the right edge, creases; lower right,
brown paint strokes in the cloak; upper center and lower right
corner, nail holes, fly droppings

PROVENANCE: Von Nagler Coll. (verso, lower left, estate stamp,
Lugt 12529); acquired 1835 (verso, below, museum stamp, Lugt
1606)

LIT.: Schmid 1907, pl. 41; 1911, 13, 19, 45, 258, 266, 273 – G.
Münzel, "Die Zeichnung Grünewalds: Der Kopf mit den drei
Gesichtern," *Zeitschrift für christliche Kunst* 25 (1912), 215–222,
241–248 – Hagen 1919, 196–202, ill. 107 – Bock 1921, 44 –
Storck 1922, pl. XIII – R. Günther, *Das Martyrium des Einsiedlers
von Mainz* (Mainz 1925), 46 with ill. – Friedländer 1927, pl. 5 –
Feurstein 1930, 54–57, 144, no. 31, ill. 87 – E. Panofsky, "Signum
triciput," *Hercules am Scheidewege und andere antike Bildstoffe in der
neueren Kunst* [Studien der Bibliothek Warburg, 18] (Leipzig
1930), 1–35 – Graul 1935, no. 24 – Burkhard 1936, 71, no. 2, ill.
97 – Zülch 1938, 337f., no. 33, ill. 201 – E. Markert, "Trias
romana, Zur Deutung einer Grünewaldzeichnung," *Westdeutsches
Jahrbuch für Kunstgeschichte* (Wallraf-Richartz) 12/13 (1943), 198–
214 – Schoenberger 1948, 42, no. 35 with ill. – Exh. cat. *Deutsche
Zeichnungen der Dürerzeit* 1951, no. 308 – Zülch 1954, 19, ill. 34 –
Behling 1955, 114–116, no. 38, pl. XXXV – Jacobi 1956, 108–111
– Pevsner/Meier 1958, 34, no. 35 with ill. – Weixlgärtner 1962,
120f., no. 33, ill. 51 – *Great Drawings* 1962, pl. 412 – Kehl 1964,
176 (document 32i) – Hütt 1968, 186, no. 102, ill. on 146 –
Behling 1969, 21 with ill. – Ruhmer 1970, 94f., no. XXXIV, pl.
39 – Bianconi 1972, no. 74 – Baumgart 1974, pl. XXVIII –
Fraenger 1988, 117, pl. 46 – Schade 1995, 323f., ill. 2f.

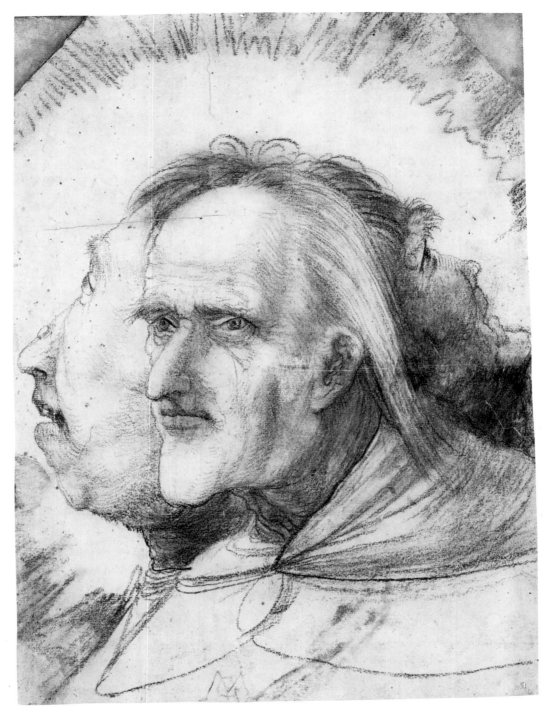

98

Of all the surviving drawings by the artist, this is the only one on which he affixed his monogram.[1] Therefore, it should be considered an independent drawing that, unlike the others, was not made as a preparatory study for a painting. Its meaning has been the subject of much speculation.[2]

According to Schmid, this drawing seems to be a mockery or caricature of traditional Trinity representations and probably depicts some kind of diabolical Trinity. Münzel's 1912 interpretation of this unholy Trinity as the three basic evil desires of man—lechery, greed, and pride—began a chain of speculations that ended in Markert's 1943 thesis, namely that Master Mathis was influenced by Ulrich von Hutten's polemic tract *Vadiscus sive Trias Romana,* which was published by Johann Schöffer in Mainz in April 1520. Johann Schott of Strassburg published it in the German vernacular early in 1521 under the title "Vadiscus oder die Römische dreyfaltigkeit," as part of Hutten's *Gesprächsbüchlin.* This tract painted an impressive picture of the principal evils of the papal church, with pride, unchastity, and avarice as the Roman Trinity. According to Weixlgärtner, the three heads unite pride, stupidity, and brutality into a Trinity of evil.

It is possible that the patron, who must be sought in the immediate circle of the artist, required that the drawing be carefully and thoughtfully finished to look just like a painting. First, we should think of Cardinal Albrecht himself, who may already have known Ulrich von Hutten during his years of study in Frankfurt an der Oder. Persuaded by Eitelwolf von Stein, Hutten the humanist had also acclaimed Albrecht's entry as archbishop of Mainz in a panegyric, and thereby assured himself of Albrecht's continued support. Hutten, who was crowned a poet by Emperor Maximilian in Augsburg on 12 July 1517 while returning from a period of study in Italy, moved to the archiepiscopal court in Mainz. Although he was officially dismissed from court service in the summer of 1519 on account of his hatred of Rome, he continued his literary activities in the city, which he left only in 1520 to join Franz von Sickingen in the Ebernburg.[3]

Next, we should think of Johannes ab Indagine, the clergyman on whom Cardinal Albrecht relied as astrologer and who wrote Luther in 1521 concerning his position: "Who does not have reason to hate us" *(Wer haßt uns nicht mit Recht).*[4] In his work *Introductiones apotelesmaticae in Chiromantiam, Physiognomiam, Astrologiam naturalem* (Strassburg 1522 with Johann Schott; in German: *Die Kunst der Chiromantzey,* Frankfurt am Main 1523 with David Zephelius), he had types of heads depicted as examples for recognizable character traits. These may well have inspired Master Mathis to do his drawing, which may depict the three varieties of enslavement (stupidity, fanaticism, unconditional compliancy).

Cardinal Albrecht maintained contacts with many humanists and artists of his time. The connections were often made by third parties. Wolfgang Capito, who took office as cathedral preacher of Mainz in the spring of 1520, was soon recruited as confessor and church-political advisor of the cardinal, for whom he also composed letters. He also corresponded with Erasmus of Rotterdam, as well as with Luther and Melanchthon.[5] He left Mainz in 1523, having become an adherent of the Reformation, to take over the diocese of St. Thomas in Strassburg. At the same time the supporters of the old church organized resistance to the Reformation and urged Cardinal Albrecht to decisively take sides, whereupon, on 10 September 1523, he forbade the Mainz clergy to teach Lutheran doctrine. Nevertheless, he sent Martin Luther twenty guilders for his wedding on 25 June and was admonished by Luther to renounce his clerical state, to marry, and to transform his ecclesiastical domains into a secular state.[6]

In short, there were still sufficient ties between Mainz and Wittenberg. Philipp Melanchthon, who had dedicated his text *Loci communes rerum theologicarum* to Albrecht,[7] must have owed to these contacts his information concerning Master Mathis, whom he honored in 1531 as a painter who followed his conscience on a path between Dürer and Cranach.[8] Could Philipp have received one of Grünewald's drawings from Mainz?† R.K.

1. The so-called Erlangen self-portrait, which is heavily reworked, also carries this monogram and the date 1529! Supposedly, an autograph monogram was touched up. The date, which probably indicates the presumed year of the artist's death, is a later addition.

2. In 1919 O. Hagen advanced the drawing as an illustration to a mystical text by Heinrich Seuse, which elucidates the mystery of the return of the Trinity into the Unity. In 1930 H. Feurstein instead took it for a harmless caricature, which satirizes humanistic concepts such as the *philosophia triplex* with its three heads *(philosophia naturalis, rationalis, and moralis)* or the three stages of the ascension of the soul, as described by the Florentine Neoplatonist Marsilio Ficino in his *De vita triplici* of 1494, or else the Neoplatonic *Three Stages of Perfection,* after Pico della Mirandola. In 1935 Graul speaks of a three-faced head, and a year later Burkhard soberly observed only three different temperaments and characters. The most recent exegesis came in 1995, from W. Schade, with reference to Titian's *Allegory of Prudence* in the National Gallery, London.

3. P. Walter, "Albrecht von Brandenburg und der Humanismus," in: Exh. cat. *Albrecht von Brandenburg. Kurfürst, Erzkanzler, Kardinal,* B. Roland, ed., Landesmuseum Mainz (Mainz 1990), n. 3, 65–82, esp. 67–69.

4. Zülch 1954, 19.

5. Walter in: Exh. cat. *Albrecht von Brandenburg* 1990, 71.

6. F. Jürgensmeier, "Kardinal Albrecht von Brandenburg (1490–1545). Kurfürst, Erzbischof von Mainz und Magdeburg, Administrator von Halberstadt," in: Exh. cat. *Albrecht von Brandenburg* 1990, 22–41, esp. 35.

7. R. Decot, "Zwischen Beharrung und Aufbruch. Kirche, Reich und Reformation zur Zeit Albrechts von Brandenburg," in: Exh. cat. *Albrecht von Brandenburg* 1990, 42–64, esp. 62.

8. Philipp Melanchthon, *Elementorum rhetorices libri due* (Wittenberg 1531); (M.) Zucker, "Die früheste Erwähnung Grünewalds," *Zeitschrift für bildende Kunst*, n.s. (1898/1899), cols. 503–505; Zülch 1938, 376; Kehl 1964, 172 (document 29); Hütt 1968, 155.

†After the publication of the German edition of this catalogue, Emil Spath sent me his unpublished manuscript "Trias inhumana," which encouraged me to pursue further studies. During my research I came across Aaron J. Gurjewitsch's book *Das Individuum im europäischen Mittelalter* (Munich 1994). The author claimed that "In the 'magnetic field' of medieval culture, simplicity and learnedness are the closely intertwined embodiments of personality" (chapter 8, page 258f.). Because the drawing seems to illustrate these ideas, it was chosen by the publisher as the cover illustration of the book. The halo, encompassing all three faces, which, after all, belong to one person, indicates that human individuality is intended by God. "God created man in his own image, in the image of God he created him" (Gen. 1:27). Such an interpretation of the drawing would rule out both the title that Markert introduced in 1943, *Trias Romana,* and the date, which is tied to the publication of Hutten's polemic tract. R.K.

99 Study for St. John in the Tauberbischofsheim Crucifixion, c. 1523

Berlin, Kupferstichkabinett, KdZ 12036
Black chalk with touches of gray wash; gouache
434 x 320 mm
Watermark: circle with crossed staffs (similar to Briquet 3079, but staff longer)
Lower right, inscribed in pencil *N: 167*
Horizontal crease in the middle; erased line from the hands to the cheek; lower edge rubbed; edges soiled; upper left, traces of ink; to the right of these, English-red paint remnants

PROVENANCE: Picture album of the Von Savigny Coll.; acquired 1925 (inv. no. 106-1925; verso, collector's mark with year, not in Lugt, and a running number added by hand)

LIT.: Friedländer 1926, no. VI with pl. – Friedländer 1927, pl. 22 – Feurstein 1930, 143, no. 26, ill. 83 – Graul 1935, no. 10 – Burkhard 1936, 69, no. 8, pl. 78 – Fraenger 1936, 99f., ill. on 85 – Zülch 1938, 338, no. 35, ill. 203 – Schoenberger 1948, 27f., no. 27 with ill. – Exh. cat. *Deutsche Zeichnungen der Dürerzeit* 1951, no. 307 – Behling 1955, 112, no. 34, pl. XXXI – Jacobi 1956, 103f. – Pevsner/Meier 1958, 34, no. 36 with ill. – Weixlgärtner 1962, 119f., no. 32 – *Great Drawings* 1962, pl. 413 – Hütt 1968, 186, no. 100, ill. on 144 – Ruhmer 1970, 79, no. II, pl. 5 – Bianconi 1972, no. 73 – Baumgart 1974, pl. XXVII – Fraenger 1988, 198, pl. 76 – G. Seelig, in: *Handbuch Berliner Kupferstichkabinett* 1994, no. III.55

This drawing probably belongs among the "sublime" sketches, "most drawn in black chalk, some in part almost life size," mentioned by Sandrart.[1] Hans Grimmer had collected them, and left them to Philipp Uffenbach. The latter's widow finally sold them to a collector, Abraham Schelkens.

Grimmer had assembled the drawings in a picture album. Where it went upon the dispersal of Schelkens' *Kunstkammer* is not known. This album is probably the picture album that resurfaced in 1925 among the property of the Von Savigny family.

Today the drawing is the largest surviving model study by the artist.[2] It shows the half portrait of a man turning to the left, with head raised and hands folded before his chest, from a low viewpoint, so that the eye of the observer is directed between the noncontiguous surfaces of the hands, which are turned outward, toward the hollow formed by the interlaced fingers—a highly unusual view. The artist accurately recorded the wrists, just as he did the area on the right arm where the pulse beats.

The man wears a jacket with cuffs and an open, turnup collar, which makes the collar of his shirt stand

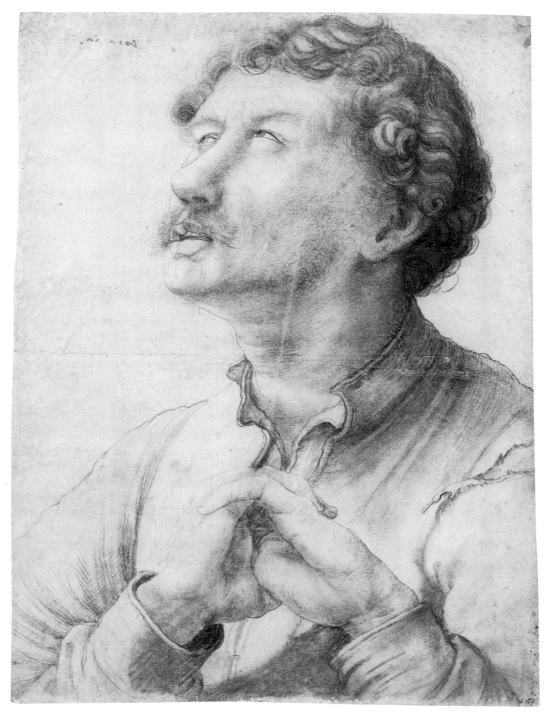

99

out. The triangular tear near the left shoulder is also prominent.

The male head, with its mustache, three-day beard, and curly hair, is more likely intended to be a study of expression than a study of proportion, although all details of the model were closely observed, such as the slightly opened mouth, which exposes the upper row of teeth and the lower edge of the upper lip, as well as the eyes seen from below. Seelig pointed out the ambivalence between the realistic observation and the distortion of the overall effect, which is determined by the difficult perspective—hands, breast, and head are set off lightly against each other—and the forms of the body, which are modeled in light and dark, with an almost total absence of contour lines.

Last but not least, the forceful effect of the depiction is dependent on the way the figure totally fills and overwhelms the sheet—even the shoulder and upper arm are cut off at the right.

The drawing served as a study for a St. John on the Holy Cross altarpiece in Tauberbischofsheim.[3] There the head of the apostle is turned a little more from the profile view with respect to the spectator, so that the nose no longer interrupts the line of the cheeks, and the folded hands are more to the left in order to correspond to the movement of the figure, who turns farther to the left. Even the depiction of the collar and the triangular tear in the jacket were repeated in the painting.

The dating of the study is closely linked to that of the Tauberbischofsheim altarpiece. In 1948 Schoenberger placed the drawing about 1515/1516 in connection with the 1515 donation for the Holy Cross altar by the parish priest Virenkorn. Möhle did not allow for a genesis earlier than 1520 to 1524 for the altar panel, after which the artist had terminated his activities in Mainz. Whereas Jacobi and Bianconi advanced 1520/1521 and 1520 as the date of the study's creation, Zülch, Hütt, and Fraenger argued for 1523 or 1523/1524. R.K.

1. *Joachim von Sandrarts Academie der Bau-, Bild- und Mahlerey-Künste von 1675,* ed. A. R. Peltzer (Munich 1925), 82 (part 2, book 3, chap. V–XXXVII: "Mattheus Grünewald").

2. The study for the upper body of the Isenheim altar St. Sebastian was later cut into two pieces, which are today in the print cabinets of Dresden (lower arms) and Berlin (body).

3. Now the Staatliche Kunsthalle Karlsruhe.

HANS BALDUNG CALLED GRIEN

(presumably Schwäbisch Gmünd 1484/ 1485–1545 Strassburg)

Painter, draftsman, designer of woodcuts and glass paintings, and to a lesser extent, engraver. Dürer's most important student and one of the greatest artists of his time. His life is poorly documented. Unlike most other German artists, he did not come from an artisan background but from a highly educated, humanist family of learned jurists and physicians. In Nuremberg from about 1503 until 1507/1508 as an apprentice and assistant of Dürer, with whom he established a lifelong friendship. Produced independent paintings, drawings, and woodcuts in these years. Various stays from 1508/1509 in Halle. Acquired citizenship in 1509 in Strassburg, where he married and founded a flourishing workshop. Close contacts with Margrave Christoph I. von Baden, cousin of Emperor Maximilian. Resident in Freiburg from 1512 to 1517; created the high altar for the local cathedral. In 1515 he joined Dürer, Cranach, Altdorfer, and other artists in doing margin illustrations for Maximilian's Prayer Book, a confirmation of his great fame. From 1517 to 1545 again in Strassburg, where, among other offices, he was juryman of the painters' guild and, in the year of his death, honorary city counselor. Baldung's work, which is extensive and thematically diverse, was initially influenced by Dürer but soon became independent and, from the 1520s on, increasingly inclined to mannerism. Possibly because of the lack of church commissions—a result of the Reformation, which became a dominant force in Strassburg from 1520 on—we encounter not only religious subjects but also portraits and profane, often eccentric subjects from the dark side of human life, such as witchcraft and allegories of death. Baldung never went to Italy, and classical-mythological themes play a minor role in his work. Compared to his German contemporaries, Baldung created an oeuvre that was exceeded only by that of Dürer and of Holbein the Younger. It is of high quality and comprises about 250 works, studies and designs for paintings and windows, practice sheets and sketches, as well as independent works of art.

100 HEAD OF A YOUTH (SELF-PORTRAIT), c. 1502

Basel, Kupferstichkabinett, U.VI.36
Pen and black ink; black wash on blue green prepared paper; heightened in opaque white and in pink gouache
220 x 160 mm
Watermark: small bull's head, fragment (from Piccard 1966, group X,113?)
Lower left *32* in red chalk
Edges irregular; mounted on japan paper; several small holes (especially in the corners) and thin areas; lower right, triangular tear, restored; edges soiled and rubbed

PROVENANCE: Amerbach-Kabinett

LIT.: Von Térey, *Zeichnungen,* no. 13 (c. 1504) – Schmid 1898, 307, 310 – Curjel, *Baldungstudien,* 194f., ill. – Curjel 1923, 164 – Escherich 1928/1929, ill. on 117 – Hugelshofer 1933, 170, ill. on 177 – Parker 1933/1934, 15 – Winkler 1939, 4f., 14f. and ill. – Fischer 1939, 12 (c. 1504), 68 (c. 1502) – Koch 1941, 23, 71f., no. 7 – H. Möhle 1941/1942, 218 (1505) – E. Ammann, in: Exh. cat. Karlsruhe 1959, no. 104, ill. 37 – Rüstow 1960, mentioned on 897 – Exh. cat. *Amerbach* 1962, no. 44, ill. 14 – Oettinger/ Knappe 1963, 1ff., 84, 123 (no. 13), color pl. 1 – D. Koepplin, in: *Das Grosse Buch der Graphik* (Brunswick 1968), 80 and ill. – Gerszi 1970, 82, pl. XI – Hp. Landolt 1972, no. 30 – Koepplin/ Falk 1974/1976, 41, 48, 52, no. 1 – S. Walther, *Baldung Grien* (Dresden 1975), 1, ill. 1 – T. Falk, in: Exh. cat. *Baldung* 1978, 36f., no. 8, ill. 17 – Falk 1978, 217–223 with ill. 1 – Bernhard 1978, 17f., ill. on 10, ill. on 105 – A. Shestack, in: Exh. cat. *Baldung* 1981, 5, fig. 1 – Von der Osten 1983, 15f. and text ill. 1, 31, 267 – W. Fraenger, *Matthias Grünewald* (Dresden 1983), 159 and ill. – Exh. cat. *Stimmer* 1984, no. 195b – Exh. cat. *Renaissance* 1986, no. E1 – Exh. cat. *Amerbach* 1991, *Zeichnungen,* no. 54

Térey recognized that the drawing is a portrait of the artist as a young man. Curjel *(Baldungstudien)* took up this proposition and attempted to verify it by comparisons with Baldung's self-portraits on the 1507 St. Sebastian altarpiece in Nuremberg and on the 1516 Freiburg high altar. The opinion of Schmid, who assumed the drawing was a head of a girl by Niklaus Manuel, proved untenable and thus the identification of the sitter is no longer doubted in the later literature (only Escherich and Winkler appended the title with a question mark). The drawing impresses us most of all by the immediacy with which the sitter confronts the viewer. This is the result not just of the frontality of the head but also of the gaze with which Baldung observed himself in the mirror, posing, with self-confidence, in a fur hat.

Koch specified the young man's age as about twenty years; and Térey dated the drawing to about 1504, at a time when Baldung worked with Dürer. Oettinger opposed this prevailing point of view (see also Exh. cat.

Karlsruhe 1959; Hp. Landolt 1972; Koepplin/Falk 1974/ 1976, no. 1) and dated the sheet to about 1502/1503, before Baldung's arrival in Dürer's workshop. Baldung was seventeen or eighteen years old at that time. For Oettinger the drawing revealed "the most information about Baldung's artistic origins." Falk supported Oettinger's proposition, dating the drawing still earlier, about 1502. Finally, Von der Osten proposed the earliest date, namely 1500. The use of opaque white (in the hat and eyes) and pink (on the cheeks and neck), which do not merely serve to represent light but which also have a tangible, naturalistic quality, allowed Falk to place Baldung's schooling in the region in which drawings with pink heightening on green paper can be found in the late fifteenth century, namely in Württembergian Swabia, along a line stretching from Lake Constance to Ravensburg, Biberach, Ulm, or Stuttgart. Baldung possibly received his training in Ulm or in Schwäbisch Gmünd and may have come into contact there with works from the shop of Bernhard Strigel. According to Falk, the watermark may also indicate a genesis of the drawing in southwestern Germany rather than in Nuremberg.

C.M.

101 ST. BARTHOLOMEW, 1504

Verso: faint chalk sketch, head of a goat, front view, c. 1504
Basel, Kupferstichkabinett, U.III.74
Pen and black ink over black chalk
309 x 211 mm
No watermark
Dated *1504* in the lower right, beneath the clump of grass; verso *79*
Somewhat spotted

PROVENANCE: Amerbach-Kabinett

LIT.: Von Térey, *Zeichnungen,* no. 8 – Stiassny 1897/1898, 51 – Schmid 1898, 307 (not Baldung) – Rieffel 1902, 211 (Wolf Traut) – C. Rauch, *Die Trauts* [Studien zur Deutschen Kunstgeschichte, 79] (Strassburg 1907), 114 (not Traut) – Curjel 1923, 29, 164, ill. on 28 – Braun 1924, 6 – Parker 1926a, 42 – Koch 1941, 22, no. 3 – E. Ammann, in: Exh. cat. Karlsruhe 1959, no. 101, ill. 35 – Oettinger 1959, 27 – Exh. cat. *Amerbach* 1962, no. 42 – Oettinger/Knappe 1963, 6f., 124, ill. 71 – Landolt 1971/ 1972, 152f., ill. 10 – Bernhard 1978, ill. on 102 – T. Falk, in: Exh. cat. *Baldung* 1978, 38, no. 9, ill. 18 – J. H. Marrow/A. Shestack, in: Exh. cat. *Baldung* 1981, cat. 1, ill. 1 – Exh. cat. *Amerbach* 1991, *Zeichnungen,* no. 55

The knife and the skin that the saint holds before him refer to the martyrdom of St. Bartholomew, who was condemned to be skinned alive. Baldung's interest in the

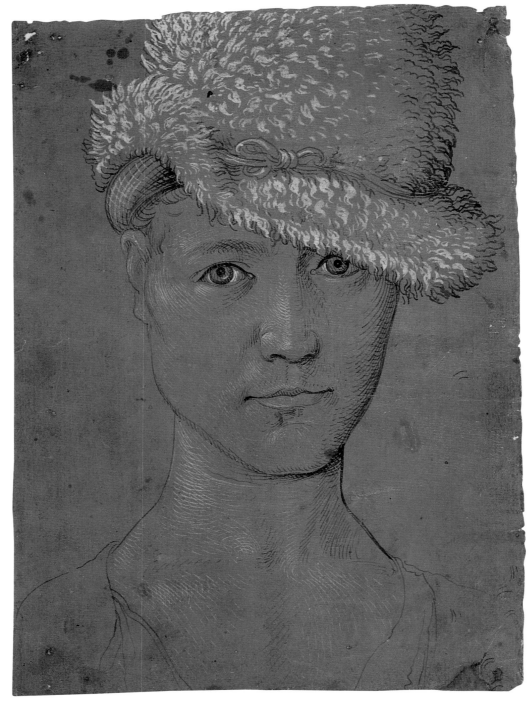

100

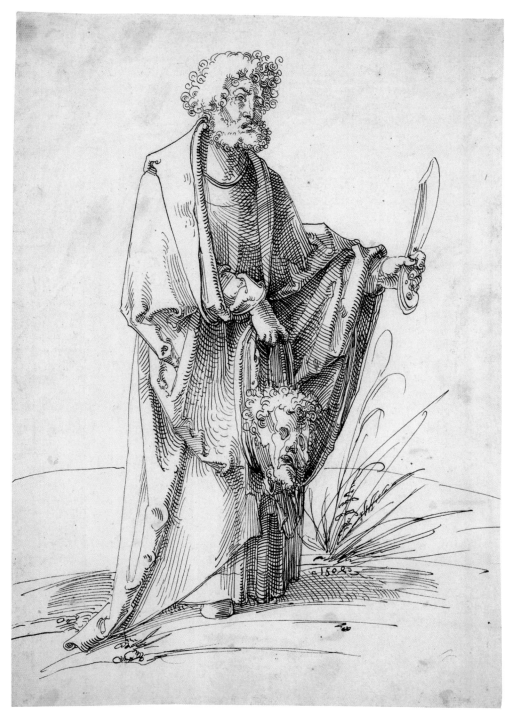

101

macabre finds particular expression in the representation of the face on the flayed skin, with its hollow eyes and mouth opened in pain, in which the observer recognizes the features of the saint as if in caricature. Térey placed the drawing to the period of Baldung's time in Dürer's shop. The face of the apostle is reminiscent of several figures in Dürer's Apocalypse woodcut series, such as the archangel Michael (M. 174). Also comparable is the head of the bearded apostle in the left background of Dürer's British Museum drawing with the Ascension and Coronation of the Virgin (Rowlands 1993, no. 155). Marrow and Shestack compared Baldung's figure and hatching system with Dürer's early engravings, such as the *Promenade* of about 1497 (M. 83). In comparison to Dürer's drawings, the powerful, longer, and straighter hatched strokes in Baldung's drawings seem somewhat schematic. Ammann surmised that the drawing might have belonged to a now lost Apostle series. There exists a relationship to Baldung's woodcut of the apostles in Ulrich Pinder's *Der beschlossen Gart (The Closed Garden)* (Nuremberg 1505; Mende 1978, no. 211), as Stiassny and Braun pointed out. The latter believed that our drawing was a study for this woodcut, but only the facial type seems comparable. The entire figure corresponds more closely to Baldung's woodcut in *Hortulus animae* (Strassburg 1511/1512; Mende 1978, no. 370). C.M.

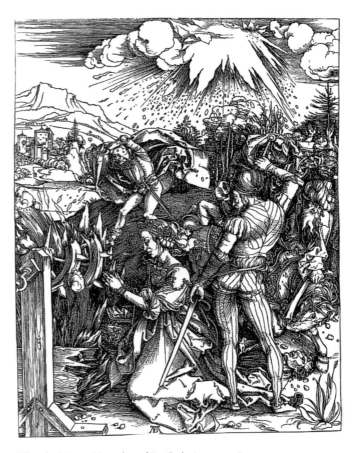

Albrecht Dürer, *Martyrdom of St. Catherine,* c. 1498

102 THE BEHEADING OF ST. BARBARA, 1505

Berlin, Kupferstichkabinett, KdZ 11716

Pen and black ink; traces of black chalk

295 x 207 mm

Watermark: high crown (similar to Briquet 4900)

Dated, lower middle, *1505* with false Dürer monogram *AD,* effaced

PROVENANCE: Weber et Van der Kolk Coll. (verso, collector's inscription, Lugt 2552); K. E. von Liphart Coll. (verso, collector's mark, Lugt 1687); C. G. Boerner, Leipzig, auction LXII (Liphart sale), 4.26.1898, no. 419; E. Rodrigues Coll. (lower right, collector's mark, Lugt 897); Frederik Muller, Amsterdam, auction 7.12./13.1921, no. 33; acquired in 1921 from Paul Cassirer

LIT.: (not in Térey) – *Société de Reproduction des Dessins de Maîtres* 4 (Paris 1912), no. 24 – *Handzeichnungen,* pl. 36 – Parker 1928, no. 27 – Fischer 1939, 16 – Koch 1941, no. 6 – Exh. cat. *Baldung* 1959, no. 105 – Oettinger/Knappe 1963, no. 24 – Exh. cat. *Dürer* 1967, no. 83 – Bernhard 1978, III – Exh. cat. *Baldung* 1981, no. 3

This work belongs to a small group of drawings that the young Baldung created during his collaboration in Dürer's Nuremberg workshop (1503–1507/1508) (see cat. 101). The pen technique is still largely indebted to Dürer's style of drawing, but the powerful strokes already indicate the personal handwriting of Baldung, who would soon free himself of the influence of his master. The abrupt alternation of open, impulsive hatching with close, relatively dry and schematic crosshatching is striking. Typical for Baldung are the half-moon-shaped, short strokes with which he modeled the outlines (the executioner's legs). The composition corresponds closely to Dürer's woodcut *Martyrdom of St. Catherine* of about 1498 (B. 120; see ill.) and, above all, to the Catherine martyrdom of the Frankfurt Heller altar of 1507–1509 (F. Anzelewsky 1991, no. 107V–115K).

The drawing may reproduce a prototype from Dürer's shop, which was also employed in the panel of the slightly later Heller altar. Baldung's independent achievement resides in his limiting the work to the two central personages, who tower in front of the landscape backdrop. The rendering of the drapery folds and Düreresque facial types

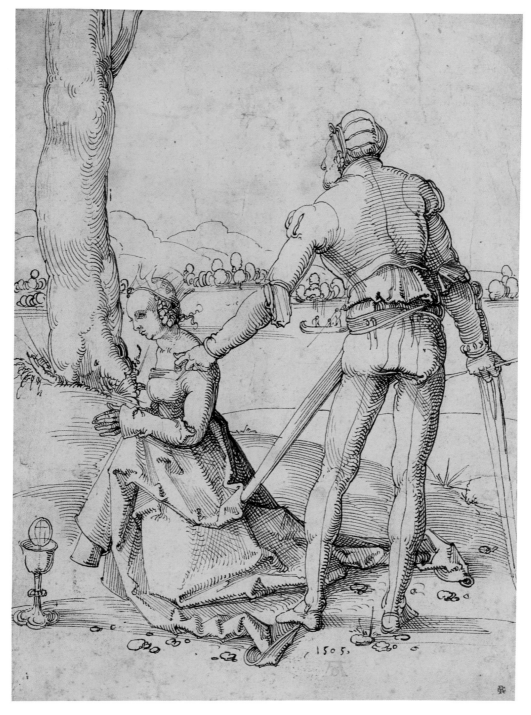

102

of the saint find a close parallel in Baldung's woodcut of the *St. Catherine Seated* (Mende 1978, no. 12), which also originated during the Nuremberg apprenticeship, about 1505.

At the 1898 sale of the Liphart Collection in Leipzig, Urs Graf was still believed to be the author of the drawing. In the catalogue of the Rodrigues Collection (Société de Reproduction), it was already convincingly attributed to Hans Baldung with reference to another drawing, *The Virgin Crowned by a Cherub,* of 1504 (Koch 4).

<div align="right">H.B.</div>

103 DEATH WITH LOWERED BANNER, C. 1505

Verso: charcoal or chalk sketch of St. Christopher; part of the drapery drawn in pen and brown ink, c. 1505
Basel, Kupferstichkabinett, Inv. 1947.21
Pen and brown ink; heightened in white on light brown prepared paper
298 x 185 mm
Watermark: high crown with cross (compare Piccard 1961, group XIII, 5)
Edges slightly trimmed; scattered paint spots and trial pen marks; one tear at upper edge, several on lower border; partially lined; lower corners damaged

PROVENANCE: Prince of Solms-Braunfels Coll.; Dr. Tobias Christ, Basel; his donation 1947

LIT.: (not in Térey) – *Dessins Anciens,* R. W. P. de Vries, Amsterdam, auction 24/25 January 1922, no. 20, pl. II – Parker 1926 – *Katalog der Ausstellung von Kunstwerken des 15.–18. Jhts. aus Basler Privatbesitz,* Kunsthalle Basel (1928), no. 3 – W., I (Berlin 1936), with no. 215 and pl. XX – Winkler 1939, 14, ill. 6 – Koch 1941, 24, no. 15 (1506) – Heise 1942, XI, no. 19 – *Öff. Kunstslg. Basel. Jahresb.* (1946–1950), 70, 82 and ill. – E. Ammann, in: Exh. cat. Karlsruhe 1959, no. 110 (c. 1506) – Oettinger/Knappe 1963, 7f., 125, no. 22, ill. 65 (reverse), ill. 79 (1504/1505) – Mojzer 1966, III, n. 37, ill. 10 – D. Kuhrmann, Exh. cat. *Altdeutsche Zeichnungen aus der Universitätsbibliothek Erlangen* (Munich 1974), with no. 53 – Bernhard 1978, ill. on p. 108 – T. Falk, in: Exh. cat. *Baldung* 1978, 39, no. 13, ill. 21 – J. Wirth, *La jeune fille et la mort. Recherches sur les thèmes macabres dans l'art germanique de la Renaissance* [Hautes Études Médiévales et Modernes 36] (Geneva 1979), 46 (drawing part of a larger composition?) – W. Keller, in: Exh. cat. *Baldung* 1981, no. 13, ill. 13 (1505–1507) – Von der Osten 1983, 40 (mentioned) – Koerner 1993, 253–273, ill. 126

The position of the body, like that of the mercenary with shouldered pike in Basel (Koch 13), was inspired by Dürer, most probably by the figure of Adam in the engraving of 1504 (M. 1) or by preparatory studies such as drawing W. 333 in the Pierpont Morgan Library, New

Verso (103)

York. With Baldung the contrapposto stance becomes a stride; the figure of death is in motion and appears to be directed toward a specific goal; the head is turned from profile into three-quarter view. The motif of the lowered ensign, which, as Falk observed, recalls a shroud, has more than one meaning. Depictions of mercenaries waving banners come to mind, such as Baldung's drawing of 1504 in the Schwarting Collection, Delmenhorst, as does the then prominent theme of "mercenary and death," as formulated by Baldung in, for instance, his drawing of 1503 in the Galleria Estense in Modena (Koch 2). Baldung's memento mori need not be related only to the military genre but may also be understood more generally. Death

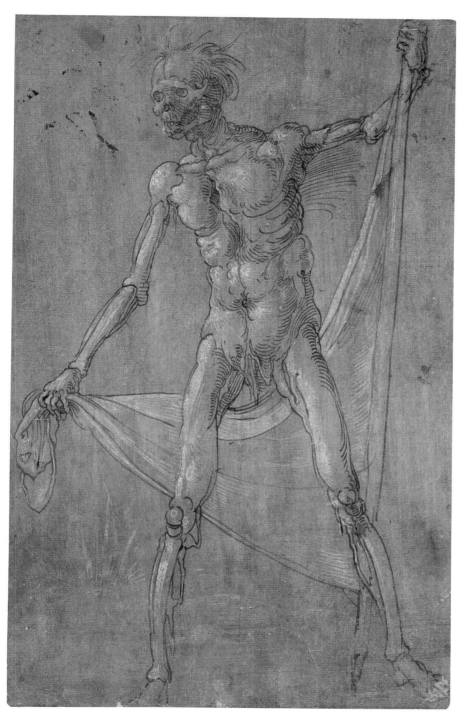

103

lowers the ensign as a metaphor for his victory over this life and could be seen as the counterpart to the victoriously resurrected Christ with raised banner. White heightening was boldly and broadly applied. As on the fur cap in Baldung's self-portrait, it has an almost tangible quality and, with the light brown paper, engenders a curiously naturalistic effect. Technically the drawing is closely related to the *Erlangen Thief* (Koch 14), which Kuhrmann dated to about 1505/1506. The elaborate study of a cloak on the back could also have originated at about this time. Falk pointed out that until 1922 the drawing was the property of the Solms family, perhaps even as far back as Baldung's time, as the painter's connections to the Counts of Solms, who owned a residence in Strassburg about the middle of the sixteenth century, can repeatedly be documented. C.M.

of 1506 in the Berlin Gemäldegalerie (Von der Osten 1983, no. 3) and on the *Adoration of the Kings* of about 1510 in Dessau (Von der Osten 1983, no. 11). Whether our sheet was a direct preparatory study for such equestrian groups or an independent sketch is undetermined.

Baldung seems to have been fascinated by the motif of the ferocity of horses; the angry eyes of the left horse are striking. Baldung returned once more to the theme of untamed nature and the combat of riderless horses (margin drawing in the Prayer Book of Maximilian I, Koch 51; woodcuts with wild horses, B. 56–58; Mende 1978, nos. 77–79). For the combatant horsemen jumping to the left, he apparently drew on the pictorial tradition (compare a late fifteenth-century drawing from the Upper Rhine region, in the Basel Kupferstichkabinett; Falk 1979, no. 108). H.B.

104 BATTLE OF HORSEMEN, C. 1506/1507

Berlin, Kupferstichkabinett, KdZ 24627
Pen and brown ink over black chalk
325 x 218 mm
Watermark: scale in circle (see Briquet 2536 and 2541)

PROVENANCE: H. Detmold Coll. (lower right, collector's mark, Lugt 760); Weigel, Leipzig, auction 4.16.1857 ff., no. 954; B. Hausmann Coll. (lower right, collector's mark, Lugt 377); M. Hausmann and Rud. Blasius Coll. (see Lugt 377); E. Blasius Coll.; acquired in 1952

LIT.: (not in Térey) – Koch 1941, no. 20 – F. Winkler, "Neue Dürerzeichnungen im Kupferstichkabinett," in: *Berliner Museen, Berichte aus den ehemaligen Preussischen Kunstsammlungen,* n.s. 2 (1952), 2–8, esp. 8 – Exh. cat. *Baldung* 1959, no. 115 – Oettinger/Knappe 1963, no. 38 – F. Anzelewsky, in: Exh. cat. *Neuerworbene und neubestimmte Zeichnungen* 1973, no. 22 – Bernhard 1978, 113 – Von der Osten 1983, with no. 3

This study of two charging horsemen is captured in rapid strokes. Winkler attributed the study to Baldung in 1939 (unpublished, summarized by Koch 1941), referring to stylistic connections to Baldung's woodcuts *The Martyrdom of St. Lawrence* (Mende 1978, no. 6) and *St. Martin and the Beggar* (Mende 1978, no. 9). The open pen style with exclusively parallel hatching, which Baldung favored about 1515 (*Centaur and Putto,* cat. 107), is closely related to the Paris *Study Heads* (Koch 17f.). Stylistic considerations as well as the paper (watermarks traceable to upper Italy about 1504–1508) indicate an origin of about 1506/1507.

Similar charging horsemen are found as background figures in paintings by Baldung from the same decade: on the center panel of the Adoration of the Kings altar

105 DEATH OF THE VIRGIN, C. 1513

Basel, Kupferstichkabinett, U.XVI.33 (U.IV.63)
Black chalk
430 x 297 mm
No watermark
Lower left corner, signed *HBG* (in ligature); on the baldachin (by another hand?) letter r or n (color indication); verso, old no. *63*
Borders partially irregular (three original edges of a large-format, *Grossregal,* sheet); small holes in the corners; horizontal center fold flattened; large stain, left upper edge

PROVENANCE: Amerbach-Kabinett (from U.IV)

LIT.: Von Térey, *Zeichnungen,* no. 6 (c. 1516) – A. Woltmann, *Geschichte der deutschen Kunst im Elsass* (Leipzig 1876), 292 (mentioned) – Schmitz 1922, 43, ill. 49 – Curjel 1923, 78, pl. 38 (mentioned) – Koch 1941, 28, no. 42 – Perseke 1941, 201f. – E. Ammann, in: Exh. cat. Karlsruhe 1959, no. 140 – K. E. Maison, *Bild and Abbild* (Munich/ Zurich 1960), 65, 216, ill. 63 – Exh. cat. *Amerbach* 1962, no. 49, ill. 15 – J. Krummer-Schroth, in: Exh. cat. Freiburg 1970, no. 229 – Bernhard 1978, ill. 161 – T. Falk, in: Exh. cat. *Baldung* 1978, 40, 43, no. 16, ill. 25 – J. H. Marrow/A. Shestack, in: Exh. cat. *Baldung* 1981, no. 45, ill. 45 – Von der Osten 1983, 264 (mentioned with no. W 102; before 1514) – Exh. cat. *Amerbach* 1991, *Zeichnungen,* no. 58

Martin Schongauer's engraving of the same theme may have inspired this composition by Baldung (Lehrs 5, 16; see ill.). In Baldung's depiction, however, the spatial depth is shallower and the apostles crowd more closely around the Virgin. Baldung avoided vertical and constructive elements—such as Schongauer's staff of the cross, at the left, or hanging curtain. For Baldung the (supernatural?) light, which falls from the left, plays an important role.

104

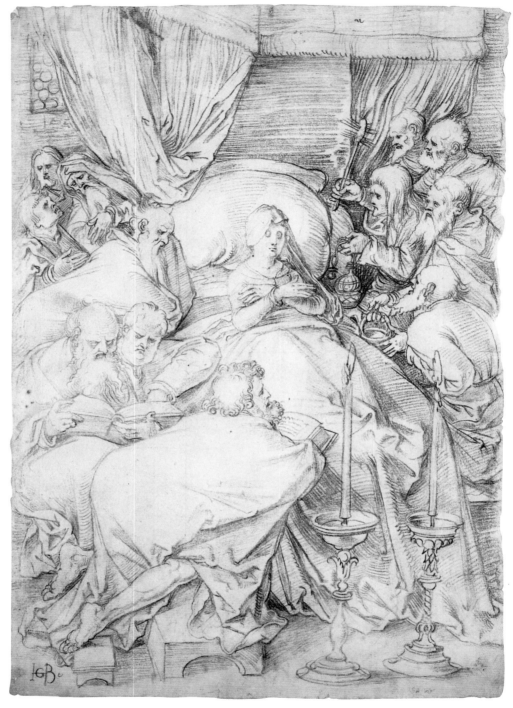

105

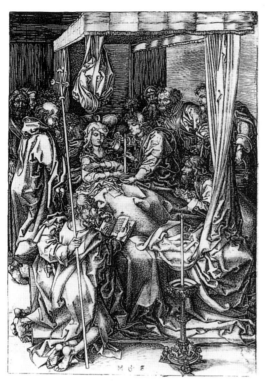

Martin Schongauer, *Death of the Virgin*, c. 1470–1475

It catches the group with the apostles in the foreground, and the Virgin with apostles to the right, and creates a diagonal counterpoint to the diagonally placed bed. The generally parallel hatching in the shadowed areas and the bizarre play of agitated robes support the impression of the unrest and excitement that have seized the apostles. Added to this are their extreme gestures and poses, as with the apostle kneeling in the left foreground. These qualities may derive from the influence of Grünewald, who worked on the Isenheim altar during Baldung's stay in Freiburg. Curjel, Koch, and Ammann dated the drawing in the middle Freiburg years, about 1514. Falk dated it about 1512–1514; Von der Osten before 1514. The drawing probably served as a design for a lost panel painting (the letter at the top of the baldachin could be a color indication). Two panels with the same theme, which Von der Osten gave to students of Baldung, originated without direct reference to the drawing (W.100a, St. Mary in Kapitol, Cologne; W.102, Musée des Beaux-Arts, Strassburg). C.M.

106 HEAD OF A GIRL, C. 1513 – 1515

Basel, Kupferstichkabinett, U.VI.48
Black chalk, with some stumping
316 x 219 mm
No watermark
Lower left, red chalk *42*; verso, old no. *42*
Slightly trimmed on all sides

PROVENANCE: Amerbach-Kabinett

LIT.: Von Térey, no. 21 (c. 1515) – Schmid 1898, 307f. (not by Baldung) – Schmitz 1922, 43, ill. 54 – Perseke 1941, 112, no. 17 (index of works of a glass painter) – Koch 1941, no. 41, 28 – Möhle 1941/1942, 218f. (between 1512–1515) – E. Ammann, in: Exh. cat. Karlsruhe 1959, no. 134 – Exh. cat. *Amerbach* 1962, no. 48 – J. Krummer-Schroth, in: Exh. cat. Freiburg im Breisgau 1970, no. 227 – Bernhard 1978, ill. on 152 – T. Falk, in: Exh. cat. *Baldung* 1978, 42f., no. 17, ill. 26 – P. H. Boerlin, in: Exh. cat. *Baldung* 1978, 15, with no. 2 – Von der Osten 1983, 114 – Exh. cat. *Amerbach* 1991, *Zeichnungen,* no. 59

The lively expression of this girl is the result of her gaze, the slight asymmetry of her eyes and mouth, and the wrinkles on her neck. Whether Baldung drew after nature remains an open question. It is impossible to miss the artist's inclination to idealize the head, which is often compared to depictions of the Virgin—especially her coronation on the Freiburg high altar. Analogies, for instance, are discernable in the emphasized rounding of the head at lower jaw, as well as in the rendering of her wavy hair. Nor can we ignore Grünewald's influence, which is revealed by the expression, not the style, of the drawing. The modeling by small, hook-shaped strokes brings to mind drawings by Schongauer or Dürer. Schmid and Perseke rejected the drawing as Baldung's work, whereas Koch accepted it and dated it about 1513. It may have originated at the time of Baldung's work on the Freiburg high altar. Möhle dated it between 1512 and 1515; Falk between 1513 and 1515. C.M.

106

107 CENTAUR AND PUTTO, c. 1513 – 1515

Basel, Kupferstichkabinett, U.XVI.35 (U.IV.64)
Pen and dark gray ink
424 x 258 mm
Watermark: bull's head with rod and star (Piccard 1966, group
VII, 836; identified "Ensisheim 1514")
Signed *HBG* (in ligature) between the centaur's front legs;
verso, old no. *64*
Slightly soiled; horizontal and vertical center folds flattened;
three original edges of a large-format sheet

PROVENANCE: Amerbach-Kabinett (from U.IV)

LIT.: Von Térey, *Zeichnungen*, no. 27 – A. Woltmann, *Geschichte
der deutschen Kunst im Elsass* (Leipzig 1876), 292 – Stiassny
1897/1898, 50 (mentioned) – Schmitz 1922, 43, ill. 53 – Parker
1928, no. 32 – Fischer 1939, 39, ill. 49 (c. 1515) – Perseke 1941,
176, 209f. (originated before the end of 1513) – Koch 1941, 30,
no. 50 (c. 1515) – Heise 1942, XI, no. 21 (c. 1515) – E. Ammann,
in: Exh. cat. Karlsruhe 1959, no. 148, ill. 53 (c. 1515) – Exh. cat.
Amerbach 1962, no. 50, ill. 16 (c. 1515) – M. Gasser/ W. Rotzler,
Kunstschätze in der Schweiz (Zurich 1964), no. 38 and ill. – R.
Hohl, in: *Neue Zürcher Zeitung* (Sunday, 10 April 1966), sheet 4
– Hp. Landolt 1972, no. 33 (c. 1515) – T. Falk, in: Exh. cat.
Baldung 1978, 44f., no. 20, ill. 29 – Bernhard 1978, ill. on 168 –
Exh. cat. *Renaissance* 1986, no. E4 – Exh. cat. *Amerbach* 1991,
Zeichnungen, no. 61

The movement of the centaur, who swings a branch for
an undirected blow, is a gesture that gives expression to his
unbridled wildness. Baldung depicted him not with the
usual horse feet, but as a cloven-hoofed animal with the
feet of a deer. In the writings of antiquity, centaurs were
a combination of man and horse who lived in Thessaly.
The small lad who attempts to hang onto the back
of the centaur resembles the putti and children who, for
example, populate the margin drawings of the Prayer
Book of Emperor Maximilian I (Koch 51) but whom we
also encounter in Baldung's depictions of witches (Koch
63–65). They are untrained beings, given to free, spon-
taneous behavior, who not only accompany the main
figures of an event as attributes or to provide commentary,
but who can also take on an active role of their own.

Térey and Koch connected the drawing stylistically
to Baldung's margin drawings for the Prayer Book of
Maximilian I and dated the former to about 1515. Most
authors agree with this date. Koch pointed to the similar
treatment of the monograms in the margin drawings,
but stressed the more decisive outline and the more ener-
getic modeling of our sheet, with its greater sense of
movement. Similar characteristics are found in Baldung's
drawings that can be dated to about 1513, such as a draw-
ing of a witch now in the Berlin Kupferstichkabinett
(Koch 60); we must therefore allow for a broader, less
specific date of c. 1513–1515. C.M.

108 PHOEBUS APOLLO BETWEEN PALLAS ATHENA AND HERMES, c. 1513 – 1515

Basel, Kupferstichkabinett, U.IX.57
Pen and brown ink over traces of black chalk or charcoal
286 x 204 mm
No watermark
Lower right corner *H. B.* inscribed by Amerbach; verso, old
no. *65*
Slightly trimmed on all sides

PROVENANCE: Amerbach-Kabinett

LIT.: (not in Térey) – Wescher 1928, 749–752, ill. 3 – Koch
1941, 35, no. 119 – E. Ammann, in: Exh. cat. Karlsruhe 1959,
no. 136 – D. Koepplin, *Cranachs Ehebildnis des Johannes
Cuspinian von 1502* (Basel 1973 [Ph.D. dissertation 1964]), 93,
n. 236 – T. Falk, in: Exh. cat. *Baldung* 1978, 44, no. 19, ill. 28 –
Bernhard 1978, ill. 154

Several pictorial types could have served as model for this
drawing. A woodcut, which Hans Süss von Kulmbach
rendered after instructions from Conrad Celtis for the
latter's *Quatuor libri amorum,* Nuremberg, 1502, shows the
versifying Celtis surrounded by classical gods and sitting
above a well of the muses (Wescher, ill. 1). Baldung used
this sheet as a model for his woodcut in an edition of
Celtis' *Libri odarum quatuor,* but transformed it freely
(Mende 1978, no. 418, Strassburg, Matthias Schürer, 1513;
Wescher 1928, ill. 2). An additional woodcut by Kulm-
bach in Tritonius' *Melopoiae,* printed for Celtis, presents,
in a central oval framed by the muses, the triad of Mer-
cury, Phoebus, and Pallas, with Jupiter in the clouds above
(Augsburg 1507; Wescher 1928, ill. 4). On all three wood-
cuts we encounter the Celtis emblem—in the form of
a shield designed to cover a horse's forehead—which
appears to be remotely related to the shape of our draw-
ing. Baldung could have adopted the combination of
Pallas Athena, Apollo, and Mercury from Kulmbach's
1507 woodcut—though in mirror image—for his draw-
ing, whereas the attributes of the gods more closely
approximate those in Kulmbach's 1502 woodcut, which
Baldung knew. The interpretation of the probably incom-
plete drawing remains hypothetical. As with Celtis, the
triad of Athena, Apollo, and Mercury could be under-
stood as analogous to the Christian triads (trinity, *deïsis*)
(see E. Wind, *Pagan Mysteries in the Renaissance,* London
1958, 48f.; Koepplin, 92ff.). This concept may underlie
our drawing, as could a mythological and speculative (as-
trological) interconnection between the gods (on Apollo
and Hermes, Koepplin, 145ff.). The column, around
which a snake is wound, probably also alludes to Asclepius
(Greek, Aesculapius), the son of Apollo. The patron who
commissioned this emblem may have been a humanisti-

107

108

cally educated physician. Falk thought of Baldung's uncle, Hieronymus Baldung the Elder, of Strassburg. The emblem could allude to Apollo as god of healing and seer, to his dominion over the oracle of the earth, and over sickness and death (Koepplin, 125, n. 344), who is accompanied by Wisdom (Pallas Athena) and Eloquence (Hermes). Wescher and Koch placed the drawing in chronological proximity to the 1513 woodcut (Mende 1978, no. 418). Ammann accepted Koch's dating in the early 1520s and moved the drawing close to Baldung's 1521 frontispiece with Athena and Artemis (Mende 1978, no. 455). Koch's comparison with Baldung's *Crucifixion in the Round* (K. 80), a drawing in the Louvre that must have been created before the close of the Freiburg years, and his date of about 1513–1515 seem more convincing.

Falk pointed out that Basilius Amerbach affixed Burgkmair's monogram, *H. B.*, to the lower right corner of the sheet. Amerbach may have been aware of Hans Burgkmair's connection with Celtis, and thus ascribed the drawing to the artist. c.m.

109 SKETCHBOOK SHEET WITH LANDSCAPE STUDIES, RECTO AND VERSO, 1514/1515

Berlin, Kupferstichkabinett, KdZ 66
Silverpoint; light watercolor on white, thinly prepared paper
205 x 151 mm
No watermark
Recto, upper center, inscribed by the artist in silverpoint
Ortennburg ·1514· (gone over in light brown ink in a later hand); upper left and right of the lower sketch *Ram stein* and *Orten burg*; lower right 6; verso, upper middle *.1515.* and upper right, in a later hand *A. Duro.*; upper right of the lower sketch *Kaltenntall bij stuockart .1.5.1.5.*

PROVENANCE: old inventory

LIT.: (not in Térey) – C. Ephrussi, "Un voyage inédit d'Albert Durer," *Gazette des Beaux-Arts* 22,2 (1880), 512–529 – Lippmann 1882, no. 56 – Lippmann 1883, 1: no. 43f. – Lippmann 1883, 2:"Vorbericht" – M. Thausing, "Rezension von F. Lippmann. Zeichnungen von Albrecht Dürer, I," *Rep. f. Kwiss.* 7 (1884), 203–207 – M. Rosenberg, *Hans Baldung Grün. Skizzenbuch im Großherzoglichen Kupferstichcabinet Karlsruhe* (Frankfurt am Main 1889), 19ff. – M. Wackernagel: "Hans Baldung Grien. Beiderseitig bezeichnetes Skizzenblatt mit Ansichten mehrerer Burgen und einer Kapelle," *Archiv für Kunstgeschichte* 1 (1913/1914), no. 35 – Bock 1921, 9 – Koch 1941, no. 96, no. 99 – Martin 1950, 23ff., 35 – Exh. cat. *Baldung* 1959, no. 137 – Bernhard 1978, 160 – M. Kopplin, in: Exh. cat. *Renaissance* 1986, no. E2 – G. Seelig, in: *Handbuch Berliner Kupferstichkabinett* 1994, no. III.41

Landscape studies, which in the north were an especial achievement of German artists at the turn of the fifteenth to the sixteenth century, were usually recorded in sketchbooks that artists took with them on their travels. Very few of Baldung's landscape studies have survived: all are part of a sketchbook he used in journeys that he undertook in 1514/1515 from Freiburg to upper Alsace, in the surroundings of Basel, in the Black Forest, and in the valley of the Neckar River. Among these works are three drawings in fragment I of the *Karlsruhe Sketchbook* (a compilation of several sketchbooks used by Baldung), a fragmentary tree study in Copenhagen, and two works— of about the same size, drawn on both sides—one in the Koenigs Collection in Rotterdam,[1] the other in Berlin (Koch 96–103). The original format of the dispersed sketchbooks may be deduced from the complete, uncut Berlin sheet. The current recto once made up the right page (the sixth, according to the old numbering in the lower right): Both corners of the right edge are slightly rounded, and the edges of the sheet are soiled on all sides except on the left, where traces of holes in the old binding may still be discerned.

The inscriptions in Baldung's hand provide information about the sites he depicted. Represented on the recto are two Alsace castles—Ortenburg (above) and Ramstein (below)—on the verso, in the upper half of the sheet, are two unknown castles and, in the lower half, the Swabian Kaltental castle, near Stuttgart.

The attribution by Ephrussi and Lippmann (1883) to Dürer, who was always the first to be given credit for such records of nature, was rejected by Thausing, with a vague reference to Baldung. Térey did not include the drawings in his comprehensive catalogue. After Marc Rosenberg had related the two sheets in the earlier Grahl (later Koenigs) Collection and in Berlin to the fragments of the *Karlsruhe Sketchbook,* Wackernagel definitively ascribed them to the Strassburg artist. Certainly the small, meticulous strokes of the silverpoint correspond completely with the fragments of the *Karlsruhe Sketchbook*; the structure of the lightly prepared paper is also identical. The authenticity of the watercolor on the lower half of the front is doubtful. The bright colors speak for a genesis in the first decades of the sixteenth century—Albrecht Altdorfer's colored landscape etchings in the Albertina in Vienna can serve for purposes of comparison—but the color is applied with little feeling for the landscape. A partial sketch for the Rotterdam drawing is also colored—why, then, did Baldung not execute all of his landscape views in color?

Baldung's landscape "views" were clearly not merely independent works. The upper drawing, with a castle

Drumsburg
·1514·

Bam Stein Oren burg

6

Verso (109)

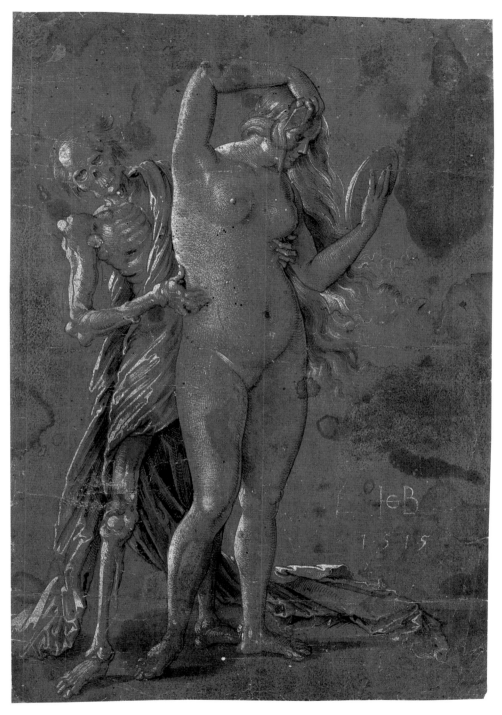

110

from one of the pages of the *Karlsruhe Sketchbook* (Koch 102; Martin 1950, 42), was used in the background landscape of the right wing of the 1515/1516 Schnewlin altarpiece, produced by Baldung's workshop.[2]　　　　H.B.

1. See Elen/Voorthuis 1989, no. 88.
2. See Gross 1991, 102.

110　Death and the Maiden, 1515

Berlin, Kupferstichkabinett, KdZ 4578
Pen and black ink; gray black wash; heightened in white;
on brown prepared paper
306 x 204 mm
Watermark: indecipherable
Lower right, monogrammed and dated *HBG* (in ligature) *1515*
Heavily stained and abraded; occasional creases

PROVENANCE: Jerg Mosser or Mossner, 1620, according to an old inscription on the reverse of the remains of the old lining; Keller and Oschwald Coll.?; A. Oeri Coll., Basel; acquired in 1911

LIT.: Von Térey 1894, no. 28 – Bock 1921, 9 – Fischer 1939, 37 – Winkler 1939, 15, no. 9 – Koch 1941, no. 67 – Winkler 1947, 52ff. – Exh. cat. *Baldung* 1959, no. 146 – Koch 1974, 14ff. – Bernhard 1978, 177 – P. H. Boerlin, in: Exh. cat. *Baldung* 1978, 23ff., with no. 5f. – D. Koepplin, "Baldungs Basler Bilder des Todes mit dem nackten Mädchen," *ZAK* 35 (1978), 234–241 – Wirth 1979, 83 – A. Shestack, in: Exh. cat. *Baldung* 1981, 9 – Von der Osten 1983, with no. 44 – G. Seelig, in: *Handbuch Berliner Kupferstichkabinett* 1994, no. III.42

Lost in thought, the nude young woman looks at herself in a mirror while combing her long hair. She has yet to notice Death, who stands behind her, having grasped her body with both hands.

Baldung here realized a theme—the confrontation of the frightening figure of a deathly skeletal man with a beautiful woman—that occupied him repeatedly in the 1510s, in both painting and drawing (but, curiously, not in the graphic arts). The message of all these depictions reads: men should be aware of the short duration of life on earth. Baldung had already employed the memento mori (remember death!) motif in his earliest work, in the pen and ink drawing *Death and the Soldier* of 1503 in Modena (Koch 2), as well as in the Basel chiaroscuro drawing *Death with Lowered Banner* of c. 1505 (Koch 15; cat. 103). His macabre depictions of Death with nude women are rooted in the late medieval depictions of the "dance of Death," in which representatives of all levels of society are confronted by a dead man in order to illustrate that all human beings must die, without consider-

ation of rank or position. Baldung extracted the pairing of Death and woman as an isolated scene and dramatized them, abandoning the structure of dialogue and showing Death as a gruesome culprit who surprises his victim abruptly. On occasion, as with our sheet, Death approaches the woman as a lover. His intrusive position behind his prey is very similar to that of Adam behind Eve in Baldung's 1511 chiaroscuro woodcut *The Fall of Man* (see ill.; Mende 1978, no. 19). The entanglement of the themes of sexuality, the Fall, and death in Baldung's work (*Eve, the Snake, and Death,* painting, c. 1525, National Gallery of Canada, Ottawa)[1] may be briefly mentioned here. In the Berlin drawing, the woman holds a mirror, the traditional emblem for vanity *(vanitas)* and pride *(superbia),* in her hand. According to Panofsky, the nude woman could also personify Lechery.[2]

With his pictures of death and a woman, Baldung created, at the beginning of the modern era, easily remembered formulations of the concept of human transience. A similar *vanitas* allegory in the form of a maiden with a mirror, created by Hans Memling in the late fifteenth century together with five other panels (including a *Standing Death*) of a portable folding altar, still refers to the Christian concept of redemption.[3] With Baldung, this theological justification for Death is missing: He is unavoidable, a natural fate, and comes without any guarantee for salvation.

Hans Baldung, *The Fall of Man*, 1511

The chiaroscuro technique on brown paper underscores the somber mood. Baldung also employed stylistic means to differentiate between the figures of the calm woman in an unchanging pose and of lively Death. For the girl he chose fine hatching, which models the plasticity of the round body; the leathery skin and shroud of her counterpart, however, were rendered in powerful strokes and planar white heightening, which flickers restlessly. The format is comparable to that of the small panels *Death and the Maiden* of 1517 and *Death and the Woman* (Von der Osten 1983, no. 44, no. 48; Exh. cat. *Baldung* 1978, no. 5f.) in the Basel Kunstmuseum. Consistent with both pictures are two chiaroscuro drawings in Berlin, dated 1515 (workshop copy; Koch A18), and in Florence (Koch 68); they are independent works, not preparatory studies. Our sheet, too, clearly evolved as a freestanding work of art.

H.B.

1. Koch 1974; W. Hartmann. "Hans Baldungs 'Eva, Schlange und Tod' in Ottawa," *Jb. der Staatlichen Kunstsammlungen in Baden-Württemberg* 15 (1978), 7–20.
2. Panofsky 1930, 55.
3. Exh. cat. *Hans Memling*, D. de Vos, ed., with contributions by D. Marechal and W. Le Loup, Groeningemuseum (Bruges 1994), no. 26.

III SHOOTING AT THE FATHER'S CORPSE, 1517

Berlin, Kupferstichkabinett, KdZ 571
Pen and gray brown ink; gray brown wash
398 mm diameter; flattened at top and right
Watermark: crown (see Briquet 4780)
Lower center, signed and dated *HBG* (in ligature) *1517*
Paper heavily stained; numerous creases with tears; scattered losses, partially restored

PROVENANCE: Von Nagler Coll. (verso, collector's mark, Lugt 2529); acquired in 1835

LIT.: Lippmann 1882, no. 77 – Von Térey 1894, no. 45 – *Zeichnungen* 1910, no. 161 – *Handzeichnungen,* pl. 40 – Bock 1921, 10 – Koch 1941, no. 84 – P. Boesch, "Schiessen auf den toten Vater. Ein beliebtes Motiv der schweizerischen Glasmaler," *ZAK* 15 (1954), 87–92, esp. 89 – Exh. cat. *Baldung* 1959, no. 235 – Bernhard 1978, 188

Represented is a legend from the *Gesta Romanorum,* a collection of moralizing fables and anecdotes from the early fourteenth century. After the death of a king, a struggle between his sons ensues over the succession (in the original version there are four sons; in other, later versions, two or three); only one is the true child

of the king. An appointed judge orders that the corpse of the king be tied to a tree; the son whose arrow wounds the dead father most deeply will succeed to the throne. After the first three sons have each taken their shot, it is the turn of the remaining sibling. He refuses, out of piety, to participate in the outrageous desecration of the father, thus proving himself to be the true and lawful son and future king.[1]

The center of the composition is formed by the bow with which the first son takes aim at the corpse. Another son, holding bow and arrow, stands just to the right. Between them we see the true son, who points at his dead father with despairing gestures. In the left middle ground the judge, wearing a fur-trimmed coat, watches the gruesome event. Baldung's drastic sense for the macabre manifests itself here as well. The body of the dead king is in the early stages of decomposition; the corpse's head has already approached the semblance of a skull. Nevertheless it is not the frightening figure of the deathly skeletal man (see cat. 110) who appears before us, but a figure of death with human features.

This is a design for a stained glass window. In the late Middle Ages and Renaissance, the region of the Upper Rhine and Switzerland was an important center for the art of glass painting, especially the small-format cabinet windows that were produced in large quantities for private and public buildings. Hans Baldung, who worked for Strassburg glass painting workshops, also created numerous designs for cabinet and armorial windows. The present sheet is differentiated from the stained glass window designs of the first Strassburg and Freiburg period, until about 1517 (Koch 69–84), in its detailed execution with the brush and wash, and by its painting-like, elaborate narrative composition. Like "the judgment of Solomon," the tale of "shooting at the dead father" became a paradigm of the wise administration of justice. The theme suggests that the window, based on Baldung's design, would be used in a courtroom or council chamber.

H.B.

1. For the legend and pictorial tradition (without mention of Baldung's drawing) see W. Stechow, "Shooting at Father's Corpse," *Art Bulletin* 24 (1942), 213–225.

III

112

112 THE DRUNKEN BACCHUS, 1517

Berlin, Kupferstichkabinett, KdZ 289

Pen and black ink; gray black wash; heightened in white on brown prepared paper

334 x 233 mm

Watermark: indecipherable

Lower center, monogram (in wine basin) *HBG* (in ligature); upper center, dated *1517,* inscribed four times with B on the flask of the child in the middle; lower left, inscribed in a later hand in white *BD 1630*; lower right, outside the border, in 19th-century script *Hans Baldung Grien*

PROVENANCE: S. Gautier? Coll. (verso, collector's inscription, Lugt 2977/2978?)

LIT.: Von Térey 1894, no. 48 – *Zeichnungen* 1910, no. 161 – *Handzeichnungen,* pl. 39 – Bock 1921, 10 – Parker 1928, no. 34 – Fischer 1939, 39 – Winkler 1939, 20, no. 24 – Koch 1941, no. 104 – Exh. cat. *Baldung* 1959, no. 154 – Exh. cat. *Dürer* 1967, no. 85 – Bernhard 1978, 189 – M. Kopplin, in: Exh. cat. *Renaissance* 1986, no. E5

This pictorially complete drawing, conceived as an independent work of art, was probably intended for a humanist collector in Strassburg. The framing outlines in white and black watercolor are autograph; the drawing does not continue beyond them. The meticulous chiaroscuro technique, with which Baldung had experimented successfully in the woodcut medium since 1510, also contributes to the refinement of this virtuoso piece. Baldung not only used pure graphic means, such as hatching and crosshatching, but also a painterly treatment of flecked paint application, as in the creviced bark of the grapevine.

Baldung's work includes only a few examples of classical themes (see cats. 107, 108). Related engravings by Andrea Mantegna (B. 19–20) and Giovanni Antonio da Brescia (B. 17) may have inspired this sheet, though they are not direct models (see ill.).[1] Immobilized by excessive drink, the corpulent and oblivious Bacchus sits on the ground. His young companions are in an entirely different frame of mind. The nude lads, each individually characterized, are intoxicated by the drink and indulge in all sorts of farcical amusements. Baldung often depicted the natural, uninhibited nature of small children and putti (see cat. 107). Several sketches in Copenhagen and in the *Karlsruhe Sketchbook* (Koch 181–188) establish that he actually observed the uninhibited gestures of children very closely. A Bacchus boy wears a cap with an ass' ears and alludes to the folly and senselessness of the activity. The humanistically oriented Baldung was familiar with Erasmus of Rotterdam's *Praise of Folly* (first published in 1515 in Basel), in which the foolish god of wine is commented upon in the following words: "Why, then, is Bacchus always depicted as 'a youth with curly hair'? Only because, crazy and inebriated, he wastes his entire life with drinking, dancing, and seducing, and is not in the least related to Pallas! He is so far removed from wisdom that, instead, he lets himself be honored with farce and amusement."[2] While a moralizing warning against excessive enjoyment of wine may be hidden behind Baldung's bacchanalian antics, the educated observer will enjoy the inventive humor of the drawing most of all.

Baldung had previously treated the theme of the drunken Bacchus in 1515, in his margin drawings for the Prayer Book of Maximilian I (Koch 53). He took up the theme once more in a woodcut of the early 1520s (Mende 1978, no. 75).

No doubt because of its faintness, the inscription *BD 1630,* in white watercolor, located to the left of the wine barrel has remained unnoticed until now. Could it be a notation by an early owner? But why here, not on the edge? The restorations to the grass tufts below the legs of Bacchus are probably by a later hand. H.B.

1. Illustrated here is an engraving ascribed to a member of the Mantegna circle or Giovanni Antonio da Brescia; see Hind, 5: 29, no. 24a.

2. Erasmus of Rotterdam, *Das Lob der Torheit,* Edition Reclam (Stuttgart 1973), 18ff. (English edition: *The Praise of Folly* [Buffalo, N.Y. 1994]).

School of Andrea Mantegna, *The Drunken Bacchus,* c. 1500

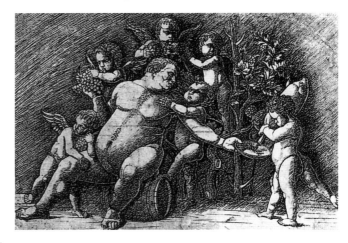

113 PROFILE HEAD OF A WOMAN, 1519

Berlin, Kupferstichkabinett, KdZ 297
Black chalk; heightened with white chalk; touches of red chalk
(at the lower border and on the neck); on paper washed light
brown
206 x 159 mm
No watermark
Lower center, dated in black chalk *1519*; remains of a false
Dürer monogram

PROVENANCE: old inventory

LIT.: Von Térey 1894, no. 44 – *Zeichnungen* 1910, no. 162 –
Bock 1921, 10 – Baldass 1926, 21ff. – Koch 1941, no. 28 – H.
Möhle: "Rezension zu Carl Koch, Die Zeichnungen Hans
Baldung Griens," *Zs. f. Kg.* 10 (1941/1942), 214–221, esp. 218 –
Exh. cat. *Baldung* 1959, no. 121 – Bernhard 1978, 128

This profile head of a woman looks somewhat out of
place in Baldung's drawn oeuvre, but the attribution,
which has not been contested since Térey, is convincing.
The facial type is typical for Baldung. The rendering
of the area around her eye, with its precise indication
of lid, eyelashes, and brow, is also characteristic for him;
compare the Basel *Head of a Girl* (cat. 106). The broad
application of the white heightening also speaks for
Baldung. Whether this is a portrait drawn after a model,
as Koch believed, appears questionable. The features of
the sitter are too generalized, not very individual. Also
noticeable is the tendency to stylize the ringlets of the
hair, the slightly curved elegant line of the high rounded
brow, the bent nose, the curving lips, the arched chin.
Without much difficulty, the features betray their deriva-
tion from Dürer's figures of women of the early century
(for instance, Dürer's engraving *Nemesis,* 1501/1502,
B. 77).

The function of the drawing remains unclear. A
profile portrait, for instance, is suited for the depiction
of a female donor in a painting. The severity of the pure
silhouette is emphasized by the black background—the
authenticity of which Koch questioned—which makes
this head of a woman resemble a portrait medal. But it is
certainly not a nature study. Like the *Ideal Female Head* in
Saint-Germain-en-Laye (Koch 27), our sheet must be an
imaginary portrait.

Koch and Möhle questioned the date 1519 because
of its curious placement on the sheet, and dated it earlier,
about 1510. When we consider, however, that the dates
are usually placed in similar areas in Baldung's works or
drawings (*Head of a Girl,* Koch 139; *The Bewitched Groom,*
see cat. 115) and that the Berlin drawing was probably
trimmed on all sides, then the autograph status of the date

need not be doubted. Only the Dürer monogram below
is by another hand. Stylistically, too, the drawing hardly
belongs in Baldung's drawn work of about 1510. Baldass
recalled Baldung's renewed interest in his teacher Dürer
in about 1520, when he began his manneristic phase,
and considered our sheet an eloquent example of this
retrospective stylistic tendency. H.B.

114 NUDE YOUNG WOMAN WITH APPLE (VENUS, EVE?), c. 1525 – 1527

Berlin, Kupferstichkabinett, KdZ 2171
Pen and brown ink; traces of black chalk
299 x 166 mm
Watermark: high crown (see Briquet 4960 and 4968)
Heavily stained

PROVENANCE: Matthäus Merian the Younger Coll.; King
Friedrich Wilhelm I (verso, collector's mark, Lugt 1631)

LIT.: Von Térey 1894, no. 29 – Bock 1921, 10 – Baldass 1926, 16
– Parker 1928, with no. 40 – Winkler 1939, 15ff. – Fischer
1939, 49 – Koch 1941, no. 126 – Exh. cat. *Baldung* 1959, no.
167 – Exh. cat. *Dürer* 1967, no. 89 – Bernhard 1978, 233 – C.
Talbot, in: Exh. cat. *Baldung* 1981, 28 – C. Andersson, in: Exh.
cat. *Baldung* 1981, no. 76 – Dreyer 1982, no. 17 – Von der
Osten 1983, with no. 53

The standing nude woman with an apple in her hand is
captured with wonderful clarity and transparency: the
technical means are reduced to simple outlines and lightly
curved parallel strokes. Baldung had already stopped rely-
ing on dense crosshatching in his margin drawings to
the Prayer Book of Maximilian I (Koch 51–58) as well
as in his Basel drawing, *Centaur and Putto* (cat. 107). Like
the Stuttgart drawing of a *Reclining Pair* of 1527 (Koch
129), the Berlin sheet must have been done shortly after
the mid-1520s. This dating is supported by the paper's
watermark, which can be dated to about 1522 to 1527.
It is not clear who is depicted here. Interpreted as Eve
by Von Térey, Bock, and Winkler, the figure has more
recently been identified as Venus, who holds the apple
of Paris she has won in competition with the other god-
desses. The robe, draped over her arm in classical fashion,
argues for the latter proposition, but her bold, fashion-
ably pinned-up hair, which one may want to relate to the
antique goddess of love, is also encountered in the Eve of
The Fall of Man, a woodcut of 1519 (Mende 1978, no. 73).
Christiane Andersson pointed to the erotic connotations
of posture and gesture: the seductive glance, directed at
the viewer, as well as the flirtatious position of the right
leg. Even the apple can be understood as an amorous

113

114

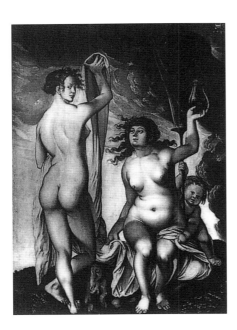

Hans Baldung, *Two Weather Witches*, 1523

1. K. T. Parker, *Catalogue of the Collection of Drawings in the Ashmolean Museum*, 2: *Italian Schools* (Oxford 1956), no. 628 verso; K. Oberhuber, in: Exh. cat. *Bologna e l'Umanesimo 1490–1510*, M. Faietti and K. Oberhuber, eds., Pinacoteca Nazionale Bologna (Bologna, 1988), 85ff., ill. 53.

reference in this context; it need not necessarily be the attribute of Eve or Venus.

The theme of the full-length nude before a neutral background also occupied Baldung at this time, that is, at the beginning of his manneristic phase in painting (*Standing Venus, Judith*; Von der Osten 1983, no. 55f.). Whether, as Talbot surmised, Dürer's *Nemesis* (c. 1501/1502; B. 77) was the model for the nude figure of our drawing is undetermined. Koch's claim that this is a study after a model is easily disputed: the contours of the back and bottom are too mannered; the flat shoulder area is too unnatural. The markedly sculptural conception of the movement, the strong twist around an (invisible) axis in a fixed position, point instead to a three-dimensional model. An antique statue of Venus, of the type represented by a drawing from Raphael's circle (Marcantonio Raimondi?),[1] could have served the educated and humanistically connected Baldung as inspiration for his figure.

The left figure on the Frankfurt *Two Weather Witches* (see ill.), a painting of 1523 (Von der Osten 1983, no. 53), is closely related in body position, facial type, and hairstyle. Admittedly the woman here is decisively turned away from us. Térey deemed our Berlin drawing to be a study for the Frankfurt panel. However, because a later date is preferred for the drawing, it could also be quite independent of the painting, which presents a variant on the same nude female type. H.B.

115 RECUMBENT MAN IN STEEP FORESHORTENING (THE BEWITCHED GROOM), 1544

Verso: faint chalk drawing of a desk?, c. 1544
Basel, Kupferstichkabinett, U.VII.135
Black chalk; dotted lines and compass pricks for perspectival construction
220 x 160 mm
No watermark
Dated below *1544*; verso, the old no. *140*; below, in pen and brown ink *lancz knecht*
Horizontal folds above center; several spots

PROVENANCE: Amerbach-Kabinett

LIT.: Von Térey, no. 22 – Stiassny 1893, col. 139 – Curjel 1923, 132 – Buchner 1924, 300 – Baldass 1926, 8, n. 4 – Parker 1928, with no. 50 – Koch 1941, no. 143, 40f. – Möhle 1941/1942, 220 – G. Radbruch, *Elegantiae Juris Criminalis*, 2d. ed. (Basel 1950), 39 (mentioned) – E. Ammann, in: Exh. cat. Karlsruhe 1959, no. 182 – Möhle 1959, 131 – Halm 1959, 132, 137 – Hartlaub 1960, 20 – Rüstow 1960, 900f. – Bernhard 1978, ill. on 261 – T. Falk, in: Exh. cat. *Baldung* 1978, 45f., no. 23, ill. 32 – Mende 1978, 48, with no. 76 – Rowlands 1979, 590 – J. A. Levenson, in: Exh. cat. *Baldung* 1981, no. 86, ill. with no. 87 – Mesenzeva 1981, 57, n. 2 – Von Borries 1982, 56f. – Eisler 1981, 69f. – Von der Osten 1983, 32, 303 and text ill. 16, 316

The drawing is related to an undated woodcut by Baldung, the so-called *Bewitched Groom* (Mende 1978, no. 76, see ill.). Stiassny described the sheet as a reversed chalk study for the groom, and Térey and Curjel followed suit. The date of 1544 also gave a point of reference for the dating of the woodcut. Buchner instead dated the woodcut about 1534 and questioned the quality of the drawing, as did Baldass, who regarded the sheet as a copy. We still encounter this judgment in later literature, such as in Halm, Mende, and Eisler, who related the woodcut to the group of wild horses. In addition to Parker, Koch argued for the authenticity of our sheet. He described it as a "rapid foreshortening study" and an "experimental aid." Falk was able to point to the scored lines and the compass holes, which establish that Baldung constructed his drawing perspectivally, an argument that contradicts the notion of a copy, as do the differences between the drawing and the woodcut. In the woodcut, the groom is not quite as

115

Hans Baldung, *Bewitched Groom*, c. 1544

confirmed by the conceptual connections to the woodcuts of wild horses (Mende 1978, nos. 77–79) as by his coat of arms at the upper right of the woodcut and the tablet with his monogram, at which the fork points. For Baldung, it can be a tool used by witches, but also by Death, as in his woodcut of Death overtaking a knight (Rowlands 1979, ill. 49). C.M.

foreshortened; his proportions are changed, and his head is enlarged. The inconsistent reversal also speaks for a study and not for a preparatory drawing for a woodcut. Thus, the groom in the woodcut is reversed, but not the direction of the light and the steplike indentation at the right (see Von Borries). Finally, the position of the hands is changed; pitchfork and currycomb are added. The hatlike object under the stretched-out right arm of the groom, which does not occur in the woodcut, cannot be clearly identified. It could be a mirror. A comparable object lies in the foreground of Baldung's 1510 woodcut, *Witches Sabbath* (Mende 1978, no. 16). Möhle and Ammann also favored the autograph status of the drawing, as did Rowlands, J. A. Levenson (1981), Von Borries, and Von der Osten. Borries emphasized the relationship with other rapidly sketched chalk or charcoal drawings by Baldung, such as the *Head of a Jester* in London (Exh. cat. *Baldung* 1981, no. 54; Rowlands 1993, no. 62) and the Louvre self-portrait (Koch 138). The interpretation of the woodcut has remained controversial (summary in Exh. cat. *Baldung* 1981, no. 87; Mesenzeva 1981; and recently Koerner 1993, 437ff.). That Baldung may have related the depiction, which touches on the theme of impulsive behavior and death, to himself is as much

HANS SPRINGINKLEE

(c. 1495–c. 1540,
recorded in Nuremberg 1512–1524)

Painter, draftsman, designer, and maker of woodcuts; pupil of Dürer, in whose Nuremberg residence he lived, as reported by Neudörfer (1547). He designed about two hundred woodcuts, the most famous of which are the illustrations for the *Hortulus animae* that Koberger published in 1516. As a collaborator of Dürer, he was charged with some of the designs for the *Triumphal Procession and the Gate of Honor* of Emperor Maximilian I. In 1520 the Nuremberg Council commissioned the "young Springenclee," among others, to paint a ceiling in the castle. Several paintings have been attributed to Springinklee, the latest of which is dated 1523/1524. As draftsman, the artist is virtually unknown. We have only two signed sheets by him, to which another seven have been added on stylistic grounds.

116 MAN OF SORROWS STANDING, C. 1514

Basel, Kupferstichkabinett, Inv. 1959.110
Pen and black ink; heightened in white on dark brown prepared paper
195 x 154 mm
Watermark: fragment of a caduceus (originally with bull's head), difficult to see because of the dark ground
Lower right, signed on the stone with the monogram *HSK* (in ligature)

PROVENANCE: Prince of Liechtenstein; Walter Feilchenfeldt, Zurich 1949; acquired in 1959 from the CIBA-AG by a donation

LIT.: Exh. cat. *CIBA-Jubiläums-Schenkung* 1959, 39 – Exh. cat. *Meister um Dürer* 1961, no. 333 – Exh. cat. *Hundert Meisterzeichnungen* 1972, no. 38 – Exh. cat. *Dürer, Holbein* 1988, 138f.

Hans Springinklee's graphic oeuvre is virtually unknown. Only two of the few drawings attributed to him are signed, the Basel *Man of Sorrows* and a *Rest on the Flight into Egypt* in London, which also carries the date 1514. The Basel drawing is truly comparable to the London sheet in technique, style, and many motifs. This correspondence speaks for a date in the same year for the *Man of Sorrows.*

The way Christ's body, especially the powerful torso, has been depicted with all the details of his musculature clearly betrays Dürer's influence. Several other motifs correspond: the instruments of the Passion, whip and switch, held in his crossed arms and the bound, pendulous hands also occur in engravings by Dürer (B. 3, B. 21). But the overall character of the sheet was less determined by Dürer's influence. Particularly prominent are the plants and trees of the forest landscape that surround the Man of Sorrows; these place the sheet in the proximity of the masters of the Danube school. In fact, the drawing reminds one of Altdorfer, with whom Springinklee had worked on the *Gate of Honor* of Emperor Maximilian. Not only is the modeling light indicated in white brush on the dark ground, but the actual framework of the drawing has been done in white. The black pen mainly had the task of conveying the shaded sections.

Depictions of the Man of Sorrows—an image, transcending history, of the sacrificed Christ who overcame death, here surrounded by the implements of his Passion —often were used for personal devotion. They were widely dispersed, especially by German graphic arts of the fifteenth century. Christ, standing alone in a landscape, turns directly to the observer. His wounds and the implements of his Passion should evoke pity, but they promise the certainty of eternal life as well. The tiara crowned by three crosses, situated above the crown of thorns, also affirms the godlike nature of Christ. The elaborate technique and the picturelike completeness of the sheet indicate that it was intended as a devotional drawing. S.M.

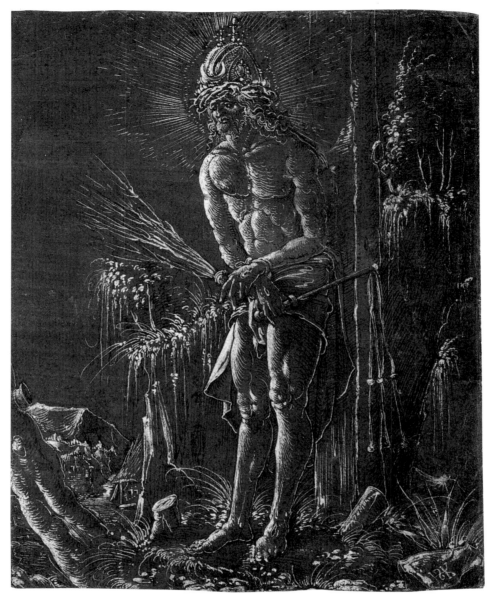

116

PETER VISCHER THE YOUNGER

(Nuremberg 1487–1528 Nuremberg)

Second son of chief caster Peter Vischer the Elder. According to J. Neudörfer, he loved ancient literature. He was befriended by the humanistically trained Pangratz Bernhaubt, called Schwenter, who dedicated his 1515 translation of the *Histori Herculis* to him and his brothers Hermann and Hans.

Active as form maker in his father's foundry; in 1507 he created the first German cast medal—the portrait medal of his brother Hermann—and in 1509, a portrait medal of himself; creator of plaquettes and other works of minor art, as well as small sculpture. Possible Italian journey between 1512–1514, with stops in Padua and Venice. Married Barbara Mag soon after.

Admonished by the Nuremberg Council on 11 July 1514 to expedite the work on the Sebaldus grave, Peter Vischer the Elder collaborated with his sons, especially Peter the Younger following Hermann's death on 1 January 1517. He created the memorial slabs of Gotthard Wigerinck (died 1518), Lübeck, Church of St. Mary; Bishop Lorenz von Bibra (died 1519), Würzburg, cathedral; and Cardinal Albrecht of Brandenburg, Aschaffenburg, collegiate church (commissioned 1522, dated 1525); and the funerary monument of Elector Frederick the Wise in the castle church of Wittenberg, which was completed in 1527 and officially recognized as a masterpiece by the Nuremberg Council. In addition, Peter Vischer the Younger matriculated as master on 23 May 1527.

The surviving drawings by him are either preparatory studies for small sculptural works or illustrations.

117 THE NYMPH OF THE SPRING, c. 1515

Berlin, Kupferstichkabinett, KdZ 15311
Red chalk; pen and brown ink; red brown wash
176 x 176 mm
Watermark: indecipherable
Inscribed at right, shoulder height of the nymph 6 in pen and brown ink; lower left corner *HW* with cross, in pen and black ink (old collector's mark)
Trimmed on all sides; upper right quarter, between cliff and number, cut on the diagonal, later made up; lower center, tear into nymph's left leg; left, near border, wormholes; repeatedly relined

PROVENANCE: Comte J. G. de la Gardie Coll. (recto, lower left, collector's mark, Lugt 2722a); acquired in 1934 from a descendant (inv. no. 351-1934, verso, museum stamp, Lugt 1612, but with date 1934 and handwritten running number)

LIT.: Berliner Museen, *Berichte aus den Preussischen Kunstsammlungen* 56 (1935), 18, ill. on 75, 85 – Winkler 1947, 43, ill. 28 – D. Wuttke, *Die Histori Herculis des Nürnberger Humanisten und Freundes der Gebrüder Vischer, Pangratz Bernhaubt gen. Schwenter* (Cologne 1964), 110, pl. XII with ill. 13

The nymphs, beautiful daughters of Oceanus, are nature goddesses; the oreads among them live in meadows and mountains, the dryads in forests and trees, and the naïads near wells and streams. They all symbolize the fecund dampness of the earth and personify the grace, serenity, and charm of nature. Because they are not truly immortal yet do not age, they have been depicted as young girls since antiquity.

Peter Vischer followed this theme. His naïad rests, sitting next to a well, which springs from the bowels of a rock face. Its water pours into a round basin from which it finally flows toward us in a rivulet. The cliff is covered in greenery. The nymph, a nude beauty with a wreath in her hair and a draped cloth adorning her figure, absentmindedly pours the life-giving water onto the ground from a jug that she holds in her outstretched left arm. In her right hand, which rests on her lower leg, she holds a flute, symbol of spring, the season when grass, which she waters with her left hand, begins to grow. The wreath and locks of the nymph's head are reminiscent of works by Jacopo de'Barbari.

The lyrically sensitive draftsman and natural storyteller succeeded in creating a most impressive poetic depiction of the antique material, which must have been inspired by a literary model. As it is not known on which texts Vischer based his work, it is impossible to tell which details were already given and which were invented by the artist. The choice of technique is unusual. Red chalk and pen are combined to heighten the plasticity of the drawing.

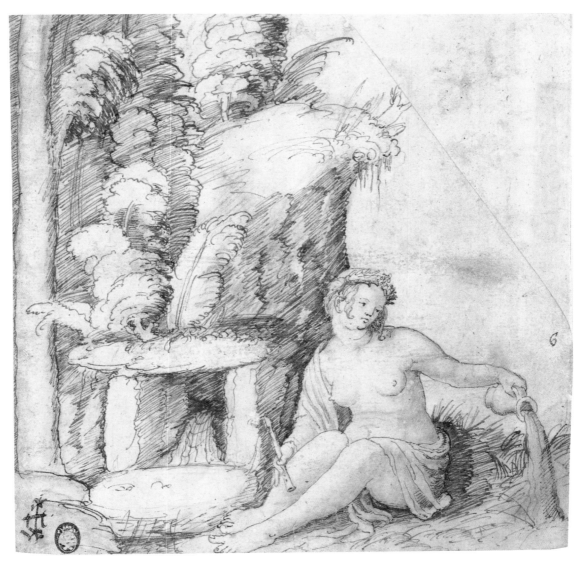

117

118

The university library of Erlangen has a copy, dated 1535, in the same technique.[1] R.K.

1. *Die Zeichnungen in der Universitätsbibliothek Erlangen*, E. Bock, ed., 2 vols. (Frankfurt am Main 1929), 1: 66, no. 218, 2: ill. on 90; Wuttke 1964, 110.

118 VIRTUTES AND VOLUPTAS (VIRTUE AND LUST), 1515/1516

Berlin, Kupferstichkabinett, KdZ 1083
Pen and brown ink over pencil; watercolor; brown borderline
246 x 163 mm
Watermark: high crown (similar to Piccard XIII, 6)
Inscribed with pen in black over brown ink *Virtutes, Voluptas, orcus*; only *odiū* has not been retraced; verso, humanist script in Schwenter's hand, in brown ink set off in red ink: text block of 12 lines, with initial capitals emphasized: to the right *Telos.*; near the middle *Der wege der Tugent*; text block of 6 lines *GOt Hot erschaffen [. . .] auff erden etc.*; at the middle *DIE TVGENT*; text block of 13 lines, with capitals emphasized; lower right, upper part of guide words
Leaf 5a of a manuscript acquired in 1878 from the Nuremberg Municipal Library Amb. 654 2°, heavily trimmed

PROVENANCE: Von Nagler Coll. (verso between first and second block of writing, to the left, testamentary stamp, Lugt 2529); acquired in 1835 (verso, stamp of the Berlin museum, Lugt 1606)

LIT.: E. W. Braun, "Die Handzeichnungen des jüngeren Peter Vischer zu Pankraz Schwenters Gedicht über die Hercules-taten," *Monatshefte für Kunstwissenschaft*, 8 (1915), 52–57, ill. 2 – H. Stierling, *Kleine Beiträge zu Peter Vischer, 5: Vorbilder, Anregungen, Weiterbildungen* (1918), 245–268; 11: 1918, 245–268, esp. 258 – Bock 1921, 87f., pl. 117 – S. Meller, *Peter Vischer der Ältere und seine Werkstatt* (Leipzig 1925), 190–192, ill. 127 – H. Röttinger, *Dürers Doppelgänger* [Studien zur deutschen Kunstgeschichte, 235] (Strassburg 1926), 228f., 232 – E. Panofsky, *Hercules am Scheidewege und andere antike Bildstoffe in der neueren Kunst* [Studien der Bibliothek Warburg, 18] (Leipzig/Berlin 1930), 86–100, pl. XXIII with ill. 42 – E. Schilling, "Peter Vischer der Jüngere als Zeichner," *Städel-Jahrbuch*, 7–8 (1932), 149–162, esp. 150f., ill. 123 – F. T. Schulz, in: *TB 34* (1940), 410 – D. Wuttke, "Pangratz Bernhaubt gen. Schwenter. Der Nürnberger Humanist und Freund der Gebrüder Vischer," *Mitteilungen des Vereins für Geschichte der Stadt Nürnberg 50* (1960), 222–257, esp. 237–240, 242–247 – H. Stafski: *Der jüngere Peter Vischer*, Nuremberg 1962, 50, 68f., pl. 91 – D. Wuttke, *Die Histori Herculis des Nürnberger Humanisten und Freundes der Gebrüder Vischer, Pangratz Bernhaubt gen. Schwenter* [Beihefte zum Archiv für Kulturgeschichte, 7] (Cologne 1964), esp. XVIIf., 13f., 106–110, pl. II with ill. 2 – Exh. cat. *Dürer 1967*, 64, no. 57 – J. Wirth: "'La Musique' et 'la Prudence' de

Hans Baldung Grien," *Zeitschrift für Schweizerische Archäologie und Kunstgeschichte 35* (1978), 244–246, ill. 4 – J. Wirth, *La jeune fille et la mort. Recherches sur les thèmes macabres dans l'art germanique de la Renaissance* (Geneva 1979), 148, ill. 151f.

Edmund Wilhelm Braun, who published the drawing as a work by Peter Vischer the Younger, recognized its relationship to a *Histori Herculis*, a manuscript in the Municipal Library of Nuremberg. This is a translation by the humanistically trained Pangratz Bernhaubt, called Schwenter, who was appointed as wedding summoner by the Nuremberg Council in 1507. He completed his basic studies at the University of Heidelberg and earned a degree, a "Baccalaureus artium viae modernae," there.[1] His translation is based on the Latin humanist drama of the otherwise obscure but laureated poet Gregorius Arvianotorfes of Speier,[2] which was performed in 1512 in Strassburg under the direction of Sebastian Brant. The author of the lost original manuscript is believed to be Sebastian Brant himself. The name Gregorius Arvianotorfes of Speier was therefore his pseudonym.

The drawing by Peter Vischer the Younger combines diverse text passages of the *Histori Herculis*.[3] As Wuttke observed,[4] the illustrations repeatedly diverge from the text. The most serious departure is the visual conception of human life as a single stretch of road with opposing ends (goals), as the Roman author Lactantius (c. 250–after 317) described it, while the text speaks of a decision between right and left at the fork of the road. In addition the forces of nature, described as rain and thunder, sent by Envy to hinder Virtue in her progress, have been depicted as falling stones. The Orcus (Hades) is manifested not just by the three-headed hellhound Cerberus in the mouth of hell, but also by a gallows with giant plumelike clouds behind it, which reach almost as high as the mountain of Virtue and optically relate the right and left forks described in writing of Virtue and Vice. The omission of the fruit on the edge of the spring, mentioned in the text, is relatively minor.

As Peter Vischer the Younger was familiar with the illustrated editions of popular humanistic works of his time, his drawing is related to them in many details that were preserved in his memory. Thus the personifications of Lust and Virtue are related to the illustrations of the Latin edition of Sebastian Brant's *Narrenschiff (Ship of Fools)*, which appeared on 1 March 1497, published by Johann Bergmann of Basel and edited in Latin by Jacobus Locher Philomusus,[5] as well as on 1 June 1497, reprinted by Johann Grüninger of Strassburg.[6] Conrad Celtis' *Quatuor libri amorum*, which was commissioned by the Sodalitas Celtica and came out on 5 April 1502 in Nuremberg,

must also have greatly influenced Vischer. It was in its title woodcut that he found the muses sitting next to a fountain, with the left one playing the harp and the right one the lute,[7] and, in its closing illustration, *Apollo on Parnassus*,[8] he found the fountain with two fish flanking its spout.

<div align="right">R.K.</div>

1. Wuttke 1960, 224f.

2. His name is supplied by the title fol. 4a verso: Berlin, Kupferstichkabinett, KdZ 10802; also Wuttke 1964, IX.

3. Wuttke 1964, 11, ll.5−33; 12, ll.15−26; 15, ll.1−24.

4. Wuttke 1964, 106.

5. Panofsky 1930, 97, pl. XVIII, ill. 30, pl. XIX, ill. 31f.; see Schramm, *Die Drucker in Basel*, vol. 22, part 2, pl. 176 with figs. 1225−1227.

6. F. Anzelewsky, in: Exh. cat. *Dürer* 1967, 66; Panofsky 1930, pl. XXI, ill. 39; see also: Schramm, *Die Strassburger Drucker*, vol. 20, part 2, 4.

7. Stierling 1918, 258f.; Röttinger 1926, pl. LXI, ill. 82; Exh. cat. *Meister um Albrecht Dürer* 1961, no. 226.

8. This woodcut, which is missing in many copies of the *Quatuor libri amorum*, appeared in 1507 in Augsburg in two works printed by E. Oeglin: Guntherus Ligurinus, *De Gestis Imperatoris Caesaris Friderici I* (Augsburg, April 1507) (ill. in Röttinger 1926, pl. LXIII, ill. 84, there still as a woodcut by Peter Vischer the Younger); Tritonius, *Melopoiae Sive Harmoniae Tetracenticae* (Augsburg, 7 August 1507) (ill. in Winkler 1959, 31).

Generally accepted as a work by Hans von Kulmbach since F. Winkler's essay "Die Holzschnitte des Hans Suess von Kulmbach," *Jahrbuch der Preussischen Kunstsammlungen* 62 (1941), 1−30, esp. 13−16, 25, ill. 44; see Exh. cat. *Meister um Albrecht Dürer* 1961, no. 228f.

ALBRECHT ALTDORFER
(c. 1480−1538 Regensburg)

Painter, draftsman, engraver, and architect as well as successful local politician and diplomat. The origins of this important master of the Danube school have never been satisfactorily explained. It is possible that he was the son of the Regensburg calligrapher Ulrich Altdorfer, but this is contradicted by his receiving citizenship in Regensburg in 1505 as a "painter from Amberg." He must therefore have been born about 1480. In 1512 his (younger?) brother, later heir, Erhart became court painter to the duke of Mecklenburg in Schwerin.

Albrecht Altdorfer was the first German Renaissance painter to adopt the fantastic landscape as his pictorial subject. He preferred a small format for his graphic sheets with religious, mythological, and genre subjects. Altdorfer's first signed drawings and engravings date from 1506. In 1509 he began work on the St. Sebastian altarpiece for the Augustinian abbey of St. Florian, near Linz. From 1511 on, he supplied preparatory drawings for woodcuts. From 1513 he took part in the great woodcut ventures of Emperor Maximilian I, the *Triumphal Procession* (mainly designed by Burgkmair) and the *Triumphal Arch* (primarily drawn by Dürer and his workshop). After 1515 he also worked on the marginalia for the emperor's Prayer Book.

In 1513 Altdorfer purchased a large house on the Bachgasse, which stands to this day (he also bought vineyards and another house in 1530 and 1532). In 1517 he began his municipal career as member of the Outer Council; in 1526 he also sat on the Inner Council. He declined the office of burgomaster in 1528, probably to complete the *Battle of Alexander*, his most famous work, for William, duke of Bavaria. He did, however, serve his city as architect (wine shed and slaughterhouse), as fortifications engineer at the time of the Turkish threat of 1529/1530 (strengthening the bastions), and as the successful mediator opposite the emperor in Vienna in 1535. Albrecht Altdorfer died in Regensburg on 12 February 1538.

119 Landscape with Pair of Lovers, 1504

Berlin, Kupferstichkabinett, KdZ 2671
Pen and gray and black ink
283 x 205 mm
Watermark: small anchor in a circle, without star (similar to Piccard IV. 55, 79, 95, 98)
Left margin, dated *1504* (the *1* cut off); lower left corner, inscribed *Lucas Cranach* (badly faded) by a later hand in pen and brown ink
Upper left corner cut off

PROVENANCE: Andreossy Coll. (after Woltmann 1874, 202); Suermondt Coll. (Lugt 415); acquired in 1874

LIT.: Bock 1921, 19, pl. 23 (as Cranach the Elder) – F. Winkler, "Albrecht Altdorfers frühestes Werk," *Berliner Museen* 55 (1934), 11–16 – Oettinger 1957, 56 – Oettinger 1959, 24–27 – Exh. cat. *Dürer* 1967, no. 126 – D. Koepplin, in: Exh. cat. *Cranach* 1974/1976, 155, 766, n. 119 – Exh. cat. *Fantast. Realismus* 1984, ill. 6 – Mielke 1988, no. 1 (with the earlier literature)

According to the earlier literature, this drawing is uncontested as an early work by Cranach. In 1934, Winkler ascribed it to Altdorfer, based on the very characteristic way in which the date was written, but his thesis was not accepted until twenty years later.[1]

Those who argued for Cranach as the author of this sheet would point to the face of the young man and the characteristic, strongly pronounced folds of the girl's dress. We should be concerned, however, by the dominant location of the castle, which directs our view to the background. Cranach, conversely, employed the motif of the castle as a picturesque accent in the back of his landscapes. The wide backdrop of trees, which is composed of individually drawn "oak" leaves, undefined, bright clumps of leaves, a thick, twisted trunk, and one bare branch that extends conspicuously into the blank sky, is not related to Cranach, but to Dürer (for instance, *Apocalypse,* B. 70). Oettinger also connected Dürer with the grouping of the pair. This close connection to Dürer, the obstruction of the distant view with the substantial castle, argues against Cranach's spiritual authorship. Helpful in identifying the hand responsible for this sheet is the New York *Samson and Delilah* drawing,[2] executed two years later, in which a large castle also closes off the background, with a similarly placed pair in the foreground. There, too, the front shoulder of the woman is unnaturally broad, and the pair is placed parallel to the picture plane and the castle. Altdorfer's hand is unmistakably revealed by such secondary details as the girl's unarticulated hand and the tiny parallel strokes that accompany the contours of her face, breast, and arms. Also typical for Altdorfer is the girl's beautiful, bold profile with the opened mouth and broad locks (compare the temptress of the hermit engraving of 1506; B. 25), in which the overly thick branches also end in broadly forked branches. The charm of the dead branch, which enlivens the sky in the middle of the sheet as if added later on, also remained important for Altdorfer's early period. The unusually large format is unique among all of Altdorfer's drawings; never again did he adopt motifs so faithfully (the Düreresque foliage, the Cranach-like face of the young man) without transforming them into his own vocabulary. We believe that we can explain these factors in terms of a very early date of origin; before he became sure of his own style, the young artist turned to the greatest masters of his time. The dating and style render it probable that Altdorfer created the drawing in Cranach's proximity, probably in Vienna. A Brunswick drawing of 1503, which was first ascribed to Cranach by Koepplin in 1974, and which fits felicitously into Cranach's little-known early work, demonstrates how much more violently Cranach could present the same theme at about the same time: a steplike transition into the background, seen in both the trees and the castle; columnlike tree trunks; an energetic couple, tormentedly united in the overall composition, with natural bare feet. Next to this brilliantly crude sheet, we become doubly conscious of the delicate mood of our Altdorfer drawing, and of its three-part composition (castle, trees, couple). If we accept Cranach as the draftsman of the Brunswick drawing, then he is eliminated as the inventor of Altdorfer's Berlin drawing. H.M.

1. For a discussion of the research of the Cranach or Altdorfer copy after Cranach, see Koepplin in: Exh. cat. *Cranach* 1974/1976, 766, n. 119; Mielke 1988, 26.

2. New York, The Metropolitan Museum of Art; Mielke 1988, no. 2.

119

120 ALLEGORY: PEACE AND MINERVA (FLOWER CARRIERS), 1506

Berlin, Kupferstichkabinett, KdZ 1691

Pen and black ink; heightened in white on red brown prepared paper

172 x 123 mm

Watermark: indecipherable, as the sheet is glued down

Signed with monogram and dated *1506* on the small shield between the figures; *D* or *O* inscribed within the long strokes of the *A*

PROVENANCE: Hausmann Coll. (Lugt 378); acquired in 1875

LIT.: Friedländer 1891, 59, no. 1 – Voss 1907, 117 – Bock 1921, 4, pl. 1 – Friedländer 1923, 12f. – Becker 1938, no. 3 – Winzinger 1952, no. 1 – Halm 1953, 75 – Oettinger 1959, 23, n. 1 – Exh. cat. *Dürer* 1967, no. 127 – Vaisse 1977, 312, n. 9 – Mielke 1988, no. 5

Two maidens who move like dancers—the left with a lute, the right with a shield—together hold a fruit bowl. Winzinger's interpretation of war reaching out for the bounty of peace was refined by Oettinger, who saw the peaceful coexistence of the two, as they hold the bowl and probably signify *Gutes Regiment* (good authority).

Ever since Friedländer, scholars have assumed that these un-German figures must be based on an Italian model, which Winzinger identified as Mantegna's Muses, found in the *Parnassus* that he painted for Isabella d'Este Gonzaga, a work that Altdorfer could have known from an engraving by Zoan Andrea (see ill.). The embodiment of peace in Altdorfer's drawing resembles—in her movement and her raised hand, which reaches out to a fellow dancer—the prototype by Mantegna, but in the direction of the painting, not the engraving. Pierre Vaisse convincingly looked to a picture from the same studio of Mantegna, one showing the expulsion of Slander from the grove of Virtue, with the figure of the shield-carrying Minerva on the right used by Altdorfer in free mirror image. A contemporary engraved copy of Mantegna's composition is not known, but drawings after the pictures, completed in 1497 and 1501/1502 at Isabella's famous, art-loving court, could have circulated in the painter's workshops of Altdorfer's time. Or are we to credit Oettinger's notion of Altdorfer's Italian journey of 1506, which he concluded from the ring-shaped letter inserted in the monogram: assuming that Altdorfer wrote it himself, he conjectured that the artist wished to express the Italian form of his name—Alberto Altdorfio—with the monogram.

Even if we are convinced that Mantegna's invention inspired the drawing, we remain astonished by the graceless big-footed figures. Grace did not come easily to the north; the young Altdorfer found himself in the tradition of works such as *Solomon Worshiping Idols,* an engraving, dated 1501, by the Master MZ (Lehrs 1). In that work, too, stands a fully grown woman, hardly graceful, almost uncouth. Her free leg projects from the fabric, framed on both sides by tubular folds. Also comparable are the many fluttering ribbons on the dress, the puffed sleeves, the bun of hair over the brow. The example shows how careful we must be when identifying possible sources of inspiration. Voss wished to see the influence of Altdorfer in this engraving, an idea that also deserves to be taken seriously. We experience the familiarity of an ambitious artist with the forms of his time, which are in part consciously and subconsciously at his disposal. In this instance the following formulation seems correct: inspired by a motif from Mantegna, of necessity translated into the vernacular.

H.M.

After Andrea Mantegna, *Dancing Muses* (detail), end of 15th century

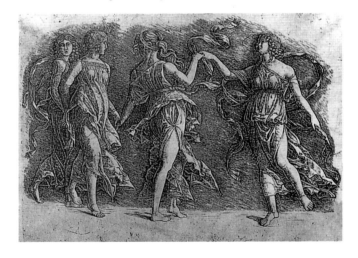

120

121 WOMAN FALCONER ON HORSEBACK AND HER ATTENDANT, C. 1507

Berlin, Kupferstichkabinett, KdZ 81

Pen and brown ink

142 x 129 mm

Watermark (Bock 1921): crossed arrows (not in Briquet)

Monogrammed *IM* on lower edge by a later hand

PROVENANCE: King Friedrich Wilhelm I Coll. (verso, collector's mark, Lugt 1631)

LIT.: Friedländer 1891, 61, no. 12 – Voss 1907, 197 – Bock 1921, 4, pl. 2 – Friedländer 1923, 26 – Halm 1930, 66 – Becker 1938, no. 4 – Exh. cat. *Albrecht Altdorfer und sein Kreis* 1938, no. 69 – Baldass 1941, 39f., ill. on 47 – Winzinger 1952, no. 10 – Oettinger 1959, 15f. – Dreyer 1982, no. 13, pl. 6 – Mielke 1988, no. 27

Without any doubt, the inspiration behind this depiction was Dürer's great woodcut *Knight and Landsknecht* (B. 131; see ill.), but the drawing that Altdorfer developed from this paradigm is independent and masterful, and mocks the notion of a somewhat helpless dependency by the young artist. Dürer's sheet provided the impetus much as a match sets off a flare: our sheet owes its splendid colors entirely to its inner "gifts." The agility of the woman falconer would be difficult to surpass: her neatly arranged robe, her riotous feathers—from whence gazes not an individual face, but a bright doll's mask, which is repeated, as is typical for Altdorfer, as a grim accent in her ragged attendant.

Possibly individual humanity was deemed too solemn to be surrounded by such a light assemblage of strokes. Also noteworthy is Altdorfer's transformation of Dürer's small dog into an elegant, stretched-out whippet. One glance at the *Historia Friderici et Maximiliani* (page with bird hunt before a castle)[1] reveals how every artist is the prisoner of his own personal handwriting; we encounter the same faces, horse's head with mane and hatching around the eye, the whippet, the formless shrubs with double contours to the right, architecture, and poultry. Voss in 1907 had already seen the connection between this drawing and the *Historia,* and attributed neither to Altdorfer. The remaining scholars continued to give our sheet to Altdorfer and rejected the *Historia*.

As most of Altdorfer's drawings are done on prepared paper, the fact that the support is here left white is conspicuous and places the drawing in the realm of the *Venus Punishing Cupid* of 1508, a preparatory drawing for an engraving.[2] The large format of our sheet contradicts the possibility that it, too, may have been intended as a

preparatory stage to an engraving, as Altdorfer's engravings are always significantly smaller. Oettinger surmised that the monogram and date were lost when the sheet was cut. Friedländer and Becker proposed 1507 or 1508 as the time of its creation. H.M.

1. O. Benesch and E. M. Auer, *Die Historia Friderici et Maximiliani* (Berlin 1957), pl. 23; Mielke 1988, no. 30, ill. 30f. (with a discussion of the scholarly opinions).
2. Berlin, Kupferstichkabinett, KdZ 4184; Mielke 1988, no. 22 (with the earlier literature).

Albrecht Dürer, *Knight and Landsknecht,* c. 1496

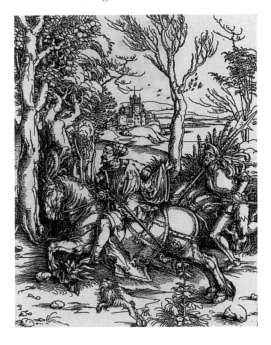

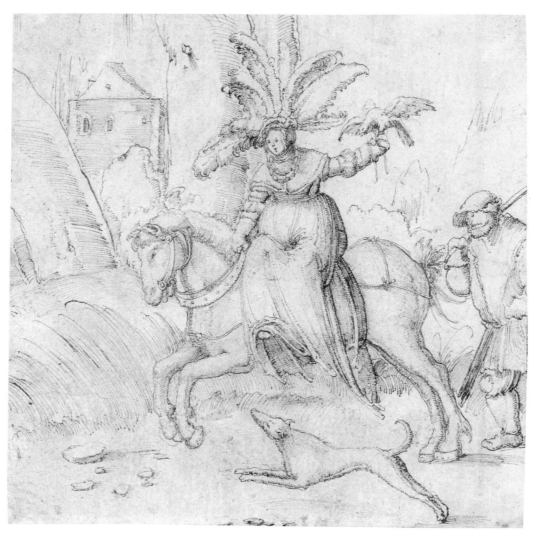

121

122

123

122 LOVERS IN A HAY FIELD, 1508

Basel, Kupferstichkabinett, U.XVI.31
Pen and black ink
221 x 149 mm
No watermark
Lower middle, signed by Altdorfer with the monogram *AA*
and dated *1508* (year bordered by a small hook at left and a
circle at right)

PROVENANCE: Amerbach-Kabinett (Lugt 222)

LIT.: Friedländer 1923, 26, 51 – Becker 1938, no. 1 – Baldass
1941, 40, 53 – Winzinger 1952, no. 11 – Oettinger 1959, 15–17,
26 – D. Koepplin, in: Exh. cat. *Cranach* 1974, no. 83 – Mielke
1988, no. 28 – D. Koepplin, in: Exh. cat. *Amerbach* 1995, no. 66

The sheltered quality of the lovers seated in the hay field
is unforgettable. The tall hay provides a wonderful, freely
drawn backdrop of a kind not known to me from any
earlier example. Several researchers were probably justified
in assigning the role of a secret spectator to the church
tower, with its eyelike dark windows.

Situated as clumsily as St. Christopher on the surface
of the water in Altdorfer's drawing in the Albertina
(Winzinger 1952, no. 21, see ill.), the two lovers here sit

Albrecht Altdorfer, *St. Christopher,* c. 1509/1510

on a fine, horizontally lined surface, which, at the left,
resembles a banner (Koepplin). Friedländer, who admired
the brilliant grace of the drawing, thought its contents
were crude. Today we can admire both the technique and
the content of the work; Friedländer could admire only
the technique. Trial pen strokes occur on the lower edge,
to the left and right. H.M.

123 CHRIST ON THE MOUNT OF OLIVES, 1509

Berlin, Kupferstichkabinett, KdZ 111
Pen and black ink; heightened in white on rust brown
prepared paper
210 x 157 mm
Watermark: bull's head (similar to M. 70; Piccard XI, 307;
same watermark in the Berlin impression of *Temptation of
the Hermits,* 1506, B. 25)
Upper edge, monogrammed and dated *1509* in gouache
(oxidized) by Altdorfer; lower right corner, Dürer monogram
added (pen and brown ink) and dated *1508* by a later hand
Breaks and small tears; verso, traces of rust brown preparation

PROVENANCE: unknown, old inventory

LIT.: Friedländer 1891, 59, no. 3 – Bock 1921, 4, pl. 3 – Fried-
länder 1923, 19 – Exh. cat. *Albrecht Altdorfer und sein Kreis* 1938,
no. 75 – Becker 1938, no. 7 – Baldass 1941, 61f. – Winzinger
1952, no. 13 – K. Oettinger, in: *Jb. Wien* (1957), 98 – Oet-
tinger 1959, 16f., 36f., 41 – Mielke 1988, no. 34

Marvelous trees and a rugged cliff form a forest clearing
in which the human presence is barely noticeable. Like
shapes that have little of the human about them, the sleep-
ing apostles recline in the foreground. The main figure,
Christ, kneels inconspicuously, but as a noble, triangular
form, at the right border; the tiny, comforting angel
floats above the dark rock cliff. The persecutors approach
from beyond the small river, led by Judas, who has just
reached the bridge. Above them a sword pointing upward
is indicated in white as if to make the violent intent of
the group altogether clear. The structure of the sleeping
figures is anatomically every bit as suspect as it is subdued
and masterly in a graphic sense. The figure lying at the
right, who is probably St. John, looks misshapen because
of the deficient foreshortening; his lumpy feet and
the calligraphic strokes of his robe are reminiscent of
the fallen Christopher in Vienna[1] (ill. to cat. 122), as is
the figure lying at the left. His Indian headdress recurs
in a painting in Vienna of the beheading of St. Catherine.[2]
Altdorfer's landscape etchings of about ten years later do
not eclipse the drawing of the tree at the left. Copies
of our drawing do exist in New York and Stuttgart.[3] H.M.

1. Vienna, Graphische Sammlung Albertina, inv. no. 3000, D. 216.

2. Vienna, Kunsthistorisches Museum; Exh. cat. *Fantast. Realismus* 1984, ill. 193.

3. New York, Pierpont Morgan Library, no. 1974.61, pen and black ink, heightened in white, on blue prepared paper, 237 x 170 mm (see Winzinger 1979, 163); Stuttgart, Staatsgalerie, Graphische Sammlung, inv. no. C/90/3684, pen and black ink, heightened in white, on rust red prepared paper, 183 x 188 cm.

124 ST. ANDREW, 1510

Berlin, Kupferstichkabinett, KdZ 88
Pen and black ink; heightened in white on green
prepared paper
161 x 116 mm
No watermark
No monogram or date visible; the information in Bock 1921 —
"Oben [above] Monogramm und Datum (etwa 1510)"—is
probably a typographical error for "Ohne [without] Mono-
gramm [. . .]," for if there were a date above, Bock would
not have dated the sheet to "about 1510"
Cracks; spots; fly specks; verso, white with traces of green
preparation

PROVENANCE: unknown, old inventory (verso, mark, Lugt
1608)

LIT.: Friedländer 1891, 60, no. 10 – Bock 1921, 4, pl. 3 –
Becker 1938, no. 10 – Exh. cat. *Altdorfer und sein Kreis* 1938,
no. 83 – Winzinger 1952, no. 20 – Halm 1953, nos. 71–76,
esp. 73 – Oettinger 1957, 55f. – K. Arndt, "Review of K.
Oettinger 1957," in: *Kunstchronik* (1958), 226–229, esp. 229 –
Mielke 1988, no. 38

On a throne with a baldachin-like back, which stands on a console, sits St. Andrew with a book and a small decussate cross, the sign of his martyrdom. The drawing may be what remains of a complete series of Apostles of the kind done by Altdorfer that is preserved in the monastery of Seitenstetten.[1] The dating to 1510, advanced by Friedländer, Bock, Becker, and Winzinger, has repeatedly been controverted (Oettinger, Halm) because scholars, who were influenced by Bock's incorrect catalogue entry, believed that a date (1517) above had disappeared but could still be espied in old photographs; therefore they found a later date more plausible. Becker's reference to the Hamburg Christopher drawing[2] and a comparison with the wild man in London,[3] which shows rapid, diagonal parallel strokes below the head in the same pronounced way, leave no option but a date of about 1510. H.M.

1. Benedictine abbey Seitenstetten, Lower Austria, monastic library; Becker 1938, no. 61; Exh. cat. *Fantast. Realismus* 1984, 48–59 with ill.

2. Hamburger Kunsthalle, Kupferstichkabinett, inv. no. 22887; Winzinger 1952, no. 22; Mielke 1988, no. 39.

3. London, British Museum, dept. of prints and drawings; Winzinger 1922, no. 6.

125 PYRAMUS, 1511 – 1513

Berlin, Kupferstichkabinett, KdZ 83
Pen and black ink on dark blue prepared paper; white
heightening, partially oxidized to pink
213 x 156 mm
Watermark: bull's head (fragment)
Upper left corner, water damage on the edges; upper middle,
small hole; verso, white with traces of glue; spots of the blue
preparation as well as skinned areas in which the ground of
the recto is visible

PROVENANCE: King Friedrich Wilhelm I (verso, collector's
mark, Lugt 1631); the collector's mark "H. Z.," mentioned
by Bock 1921, is no longer present

LIT.: Voss 1907, 185 (combined with folk song) – Friedländer
1891, 61, no. 11 – Bock 1921, 4, pl. 4 – Tietze 1923, 61, 85f. –
Becker 1938, no. 9 – Exh. cat. *Albrecht Altdorfer und sein Kreis*
1938, no. 79 – Baldass 1941, 88f. – Winzinger 1952, no. 27 –
W. Lipp, *Natur in der Zeichnung Albrecht Altdorfers,* Ph.D. dis-
sertation (Salzburg 1969), 58f. – Dreyer 1982, no. 14, ill. 7 –
Exh. cat. *Fantast. Realismus* 1984, no. 1 – Mielke 1988, no. 41 –
Wood 1993, 80f.

A dead *Landsknecht,* lying on a cloak with a knife in his breast, can only be understood as Pyramus, who killed himself out of sorrow over the presumed death of his beloved (Ovid, *Metamorphoses* IV, 55–166).

He still wears his sword on his belt; therefore no combat preceded this death. The arched corridor at the right could well be the grave of Ninus, where the lovers

Albrecht Altdorfer, *The Dream and Judgment of Paris* (detail), 1511

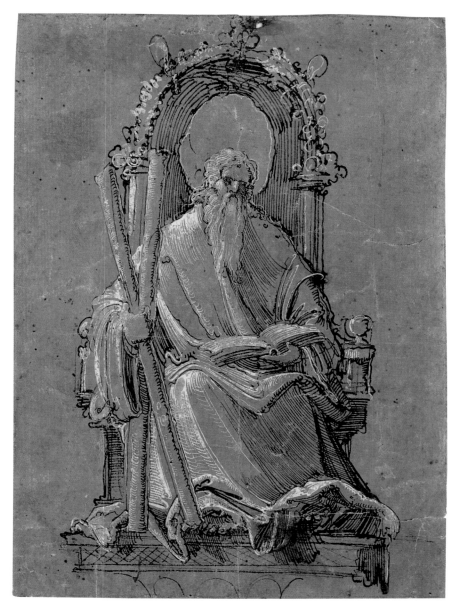

124

125

intended to tryst. According to Lipp, the dead figure—who lies surrounded by night in an abundantly flourishing nature that is about to reclaim him—is to be understood as a straightforward *vanitas,* without allegorical undertones. Anzelewsky proposed that the dead man embodies the biblical thought: "from dust thou hast come, to dust thou shalt return."[1] Although the drawing is neither signed nor dated, Altdorfer's authorship has never been questioned. The forest is represented with Altdorfer's usual mastery; equally slender pairs of trees are also encountered in his woodcuts of baggage trains and in his landscape etchings.[2] The sleeping Paris in the woodcut *The Judgment of Paris* (B. 60; see ill.) provides another example of the unusual—but typical for Altdorfer—face with the high brow and cascading locks of hair. The date of about 1511–1513 proposed by Winzinger and Friedländer is convincing.

H.M.

1. Exh. cat. *Fantast. Realismus* 1984, 21.
2. Winzinger 1963, no. 177 (B. 73), no. 178 (B. 74), no. 179 (B. 70).

126 SAMSON AND THE LION, 1512

Berlin, Kupferstichkabinett, KdZ 86

Pen and black ink; heightened in white on ocher prepared paper; the uneven application of the preparation is visible as light and dark streaks

216 x 155 mm

Watermark: circle (34 mm diameter), fragment of the imperial orb (see Briquet 3057, M. 56)

PROVENANCE: Von Nagler Coll. (Lugt 2529); acquired in 1835

LIT.: Friedländer 1891, 61, no. 14 – Bock 1921, 4, pl. 4 – Becker 1938, no. 11 – Exh. cat. *Albrecht Altdorfer und sein Kreis* 1938, no. 85 – Baldass 1941, 78f. – Winzinger 1952, no. 34 – F. Winzinger, "Neue Zeichnungen Albrecht und Erhard Altdorfers," *Wiener Jb.,* 18 (1960), 7–27 – Exh. cat. *Fantast. Realismus* 1984, ill. 26 – Mielke 1988, no. 55f. – F. Koreny, in: Exh. cat. *Lehman Collection* (in preparation)

Since early Christian times, the theme of Samson and the lion (Judges 14: 5–6) has been the most important aspect of the life of this national hero of ancient Israel. He became critically important in Christian thought as his story was seen as an Old Testament prefiguration of Christ's struggle against death and the devil.

The Berlin Kupferstichkabinett has a copy of the present drawing (see ill.), in which the preparation is the same color and shows the same kinds of streaking. Separating the sheets from their old mounts revealed their watermarks, which are both fragments of the imperial-orb

watermark; placed next to each other, they appear to have once belonged together. Of course any staff of this type could terminate in the imperial orb, but the connecting chain lines of the paper, and the same kind of smudging of the white versos from the ground paint, which continues over the edges of one sheet onto the other (see ill.), make it almost certain that the paper of both drawings comes from the same roll, which must have been cut up in Altdorfer's workshop. We thus gain an insight into the workshop practice of preparing papers: large rolls were brushed in the desired color and cut to the customary size before use. The two drawings provide an important argument to show that copies of Altdorfer's drawings were already prepared in the master's workshop, and variously gifted hands were involved. The Samson copy approaches our original very closely—an authentic workshop production—whereas other, less gifted copies were presumably done in the workshop of an independent minor master.

One of Samson's attributes is the jawbone of an ass, with which he vanquished a thousand Philistines. Whereas this "weapon" is clearly visible at the small of Samson's

Copy after Albrecht Altdorfer, *Samson and the Lion,* after 1518

126

Verso (126), top: copy; bottom: original

back, it is misinterpreted in the copy as a lion's paw. For the meaning of figures seen from the back, see Koreny 1996.

Compared to earlier attempts to date our drawing about 1517 or 1510/1511, Winzinger's dating of about 1512 has much to recommend it. When he ascribed the back of the Budapest Sarmigstein drawing to Altdorfer, Winzinger 1960 pointed to the unusual form of the tendrils in white heightening that ripple down from the tree in loops of varying sizes. H.M.

127 THE HOLY FAMILY IN A LANDSCAPE, 1512

Basel, Kupferstichkabinett, Inv. 1959.111
Pen and black ink; gray wash; heightened in white on gray brown prepared paper
193 x 138 mm
No watermark
Monogrammed above; dated *1512* on lower edge; on the mount, old inventory number *39*

PROVENANCE: Prince of Liechtenstein, Vienna and Vaduz; Walter Feilchenfeldt, Zurich 1949; CIBA-Jubiläumsschenkung 1959

LIT.: Friedländer 1923, 62 – Becker 1938, no. 74 – Winzinger 1952, no. 35 – Exh. cat. *CIBA-Jubiläumsschenkung* 1959, 41–43, no. XI – Schmidt 1959, 42 – Oettinger 1959, 51f. – Exh. cat. *Donauschule* 1965, no. 70 – D. Koepplin, in: Exh. cat. *Cranach* 1974/1976, no. 56 – Mielke 1988, no. 65

The happy harmony of the Holy Family in a landscape was from time to time willingly depicted as a rest on the flight into Egypt, as presented in Cranach's Berlin painting of 1504 with exceptional beauty in the manner of the Danube school,[1] and in Altdorfer's Berlin painting of 1510.[2] Koepplin convincingly traced Joseph's stooped position, which expresses tender affection, to Cranach's 1509 woodcut with this theme (B. 3). Also noteworthy is the closely related effect of the chiaroscuro woodcut and of the drawing on prepared paper, which is fundamentally similar for all sheets in these two techniques. From the same time (1509) is Cranach's woodcut *David and Abigail* (B. 122; see ill.), which Koepplin cited on account of its tree trunk, which is also employed only as a wide background stroke, without being allowed to unfold the riches of its branches—a motif that was repeatedly used by Altdorfer and his school.

Many Altdorfer drawings of 1512 employ freely drawn lines of white heightening—"similar to the figures that the figure skater scores in the ice" (Friedländer),

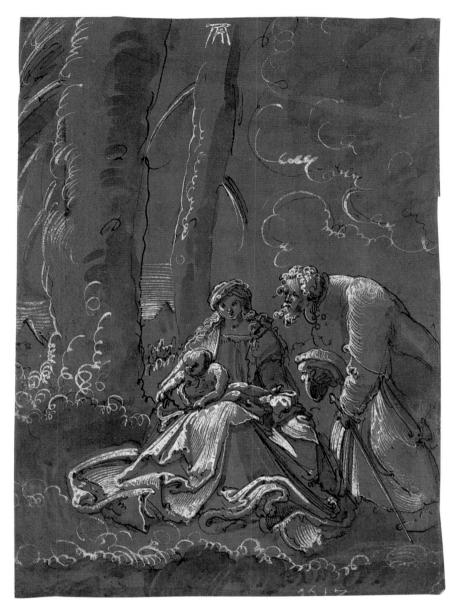

127

Lucas Cranach the Elder, *David and Abigail*
(detail), 1509

without the slightest intention of describing forms—in
calligraphic autocracy. The use of brush and wash on a
prepared paper, however, is unusual, and Winzinger inter-
preted it as an indication of preparation for a painting,
even though none can be identified. The precision with
which the figure of the Virgin may be enclosed in a tri-
angle is striking (Winzinger). H.M.

 1. Berlin, Gemäldegalerie, inv. no. 564 A.
 2. Berlin, Gemäldegalerie, inv. no. 638 B.

128 CHURCH INTERIOR, C. 1520

Berlin, Kupferstichkabinett, KdZ 11920
Pen and black ink; gray wash; lower part, squared in
gray black ink
185 x 201 mm
Watermark: circle around an unrecognizable form (siren?,
clover leaf?)
Inscribed, upper left, by an early hand in black ink *Albrecht
Altdorfer von Regenspurg;* verso, in black ink in 19th-century
script *De la Collection Destailleurs No 8286 LhEs* (?); not iden-
tical to Lugt Suppl. 1303 a–b
Numerous pinholes; incised perspectival guidelines visible
when viewed in raking light

PROVENANCE: Destailleur Coll.; acquired in 1924 from art
dealer Von Diemen (gift)

LIT.: E. Bock, *Berliner Museen* 45 (1924), 12–15 – E. Panofsky,
"Die Perspektive als symbolische Form," *Vorträge der Bibliothek
Warburg* 1524/1525 (Leipzig/Berlin 1928), 258–330, n. 71 –
P. Halm, "Ein Entwurf Albrecht Altdorfers zu den Wandmale-
reien im Kaiserbad zu Regensburg," *JPKS* 53 (1932), 207–230,
esp. 210 – Becker 1938, no. 17 – Exh. cat. *Albrecht Altdorfer
und sein Kreis* 1938, no. 123 – Baldass 1941, 156f. – Halm 1951,
160f., ill. 30 – Winzinger 1952, no. 110 – Exh. cat. *Dürer* 1967,
no. 132 – J. Harnest, *Das Problem der konstruierten Perspektive in
der altdeutschen Malerei,* D. Eng. dissertation, Technical Univer-
sity Munich (1971), 90, pl. 77 – Exh. cat. *Fantast. Realismus*
1984, ill. 46 – Mielke 1988, no. 169 – W. Pfeiffer, "Eine Alt-
dorfer-Kopie von Hans Mielich," *Pantheon* 50 (1992), 28–32 –
Handbuch Berliner Kupferstichkabinett 1994, III.51

Altdorfer set the birth of the Virgin of his Munich paint-
ing[1] in this church interior: an appropriate place because
in Christian dogma Mary symbolized the church. How-
ever, drawing and picture differ in so many respects that
our sheet cannot be taken as a final preparatory drawing
for the painting. It could be an independently created
architectural fantasy that was eventually incorporated into
the painting. In the second half of the sixteenth century,
especially in the Netherlands, the perspectival rendering
of mainly church interiors became a beloved pictorial
theme, one that had its origins in book illuminations and
paintings such as Jan van Eyck's tiny *Madonna in a Church*
in Berlin. The spatial impression of our drawing is picto-
rial and rich in three-dimensional cross sections, but the
floor plan of the building could not be reconstructed.
Bock identified a wooden church model by Hans Hiebers,
which the latter constructed for the shrine of the *Beautiful
Madonna of Regensburg,* as a source of inspiration.

 Panofsky was the first to point to the diagonal ren-
dering of the architecture, which Harnest analyzed thor-
oughly: Altdorfer apparently deviated quite deliberately
from classical central perspective. All receding lines in

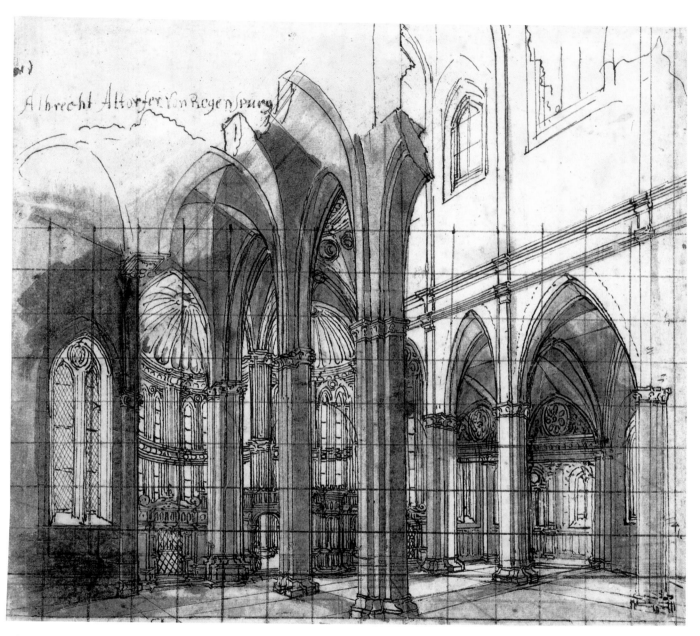

128

the direction of the nave meet in a focal point to the left: the pattern of the floor, which runs at right angles to the nave, recedes to the right. However, as no true projection is presented (a floor plan or grid with indications of depth), neither vantage point nor distance can be established and a reconstruction of the space is impossible. The spatial termination in the apse is in any case not incorporated into the perspectival concept.

The unusual impression of the sheet is determined by the apparently unfinished, ruinlike quality of the architecture; as with perspectival architectural renderings, some of the foreground elements of the architecture were left incomplete—broken off without any transition—to make otherwise hidden background elements visible. The resultant fictive breaks were conscientiously drawn to make manifest the sections and profiles of the pertinent wall construction.

In this way, our drawing juxtaposes large, simple, dark washed forms with light surfaces, which are indicated in spare outlines, while, in the lower window-zone, rapid changes of light and dark, drawn as if flashing, heighten the drawing's richness of contrasts. In comparison to the Wolfegger architectural drawings (Halm 1951)—real building studies of a quality truly worthy of Altdorfer—the present drawing stands out as a composition of unique quality. As this masterful drawing cannot have been alone in Altdorfer's oeuvre, we become painfully aware of just how much has been lost.

The grid that is laid over the lower two-thirds of the sheet was not by Altdorfer. W. Pfeiffer (1992) was able to show that Hans Mielich, an apprentice in Altdorfer's workshop, used the master's circa 1520 drawing in about 1560/1565 to illuminate a musical notation manuscript of the seven penitential psalms by Orlando di Lasso. Such grids were customary whenever models had to be transferred from one format to another.[2] H.M.

1. Done about 1520; Alte Pinakothek, Munich, no. 5358; Winzinger 1975, no. 44.
2. Munich, Bayerische Staatsbibliothek, Mus. MS A I, 115.

129 LANDSCAPE WITH SPRUCE TREE, c. 1522

Berlin, Kupferstichkabinett, KdZ 11651
Pen and brown ink; watercolor and gouache; touches of white heightening
201 x 136 mm
No watermark
Upper tree trunk, inscribed with monogram *AA*
Rubbed

PROVENANCE: acquired in 1921 (gift)

LIT.: Becker 1938, no. 18 – Exh. cat. *Albrecht Altdorfer und sein Kreis* 1938, no. 125 – Winzinger 1952, no. 67 – Exh. cat. *Dürer* 1967, no. 131 (with earlier literature) – Mielke 1988, no. 125 – Wood 1993, 9, 12 and passim – *Handbuch Berliner Kupferstichkabinett* 1994, III.52

Before a deep blue sky stands a great tree, with pendulous branches that seem to be dripping, rendered in brown pen and green opaque paints: an image of nature of captivating beauty. Depictions of nature are familiar and everyday for us, but at the time Altdorfer created his drawing, about 1522, the theme was new. Dürer's watercolor landscapes of about thirty years earlier (cats. 52, 53) were intended only as studies—ones that were not sold and, probably, were never even shown, for Dürer did not furnish any of them with his otherwise ubiquitous monogram. Altdorfer, on the other hand, depicted pure landscape motifs (that is, without Christian or mythological justification) even in prints, which were intended to be reproduced and published. The fact that only a few examples of his landscape engravings and drawings have survived may be an indication of their popularity, which caused them to be used as wall decorations.

Attached to the left of the tree, the small shrine that presumably holds an image of a saint is puzzling upon closer examination: How large would people have to be in order to get close enough to worship there? If we then register the antlike size of the woodcutter sitting by the roadside, all sense of scale vanishes. Altdorfer appears to have constructed this colorful landscape drawing purely from his own imagination. H.M.

129

130

WOLF HUBER
(Feldkirch / Vorarlberg c. 1480 – 1553 Passau)

Painter and draftsman. From about 1515, court artist to the prince bishops of Passau. Also active as architect. A close contemporary of Albrecht Altdorfer. With him, the main representative of the Danube school, although fundamentally different in nature. Portraits and "naturalistic" nudes, but most of all his landscape drawings—tree studies, Alpine valleys, and topographically identifiable views (the most famous: *Mondsee with Schafberg,* 1510)—document his tendency toward faithful depiction of the visible world. The sky—even in sheets with Christian or mythological subjects—is often suffused with sun or an imaginary light source.

130 BRIDGE AT A CITY WALL, 1505

Berlin, Kupferstichkabinett, KdZ 17662
Pen and brown ink; partially reworked in black ink on reddish prepared paper
199 x 265 mm
Watermark: crown (Briquet 4938)
Inscribed in black ink ·*W·H·*; dated at upper center *1505*
Upper edge, scuffed in two spots; verso, colored in same light red used on the recto

PROVENANCE: Ehlers Coll., Göttingen (Lugt Suppl. 860, 1391); acquired 1938

LIT.: Winkler 1939, 30, 42, no. 26 – Oettinger 1957, 12, no. 1 – Exh. cat. *Donauschule* 1965, no. 274 – Winzinger 1979, no. 8 – Mielke 1988, no. 205 – Wood 1993, 217

The most shocking aspect of this drawing is the shapeless mound of earth in the middle foreground. The awkwardness becomes even more obvious upon closer consideration—the parallel strokes of all the shadowed areas of the hill, the coarse emphasis on contours, the blotched dark areas, the slightly clumsy roadside cross at the left. An important name would never have been attached to the drawing if it did not carry the monogram and date in Huber's handwriting. After a thorough study of the sheet, Oettinger 1957 vindicated the authenticity of both inscriptions and even declined the idea, proposed by Winkler, that Huber dated the drawing at a later point, as the date is a crowning touch that could only be eliminated at great artistic expense. This convincing argument is supported by the drawing, which reveals many alterations in the same black ink (contours of the center building, vertical beams under the right arch of the bridge) used

for the date and monogram. Such close examination is rewarded by an awareness of the unique quality of the sheet: an attempt at an impression of nature that was still unusual and unconventional in those early years. It was not the kind of exercise that was practiced during one's student years; therefore the young Huber, left to work things out on his own, could not solve it with the mastery of his Mondsee view (Winzinger 1979, no. 15) of five years later. About fifteen years earlier, Dürer (surpassing all) had attempted nature studies, also on his own; and even his first results (*St. John's Cemetery,* W. 62) show the difficult and unfamiliar nature of such an undertaking. Even so, Huber's bridge composition is impressive and extraordinary in its wide disposition, its mass and depth. The city could probably be located topographically somewhere in the foothills of the Alps.

The strong character of the raw strokes evokes an equally violent and strange Brunswick drawing of 1503 of a pair of lovers, which Koepplin ascribed convincingly to Cranach.[1] This connection does not demonstrate dependency, but only the ever striking similarity of two close contemporaries.

The reddening of the paper should be understood as the most simple form of preparing paper, which reveals the desire to escape from a cool, white paper surface.

H.M.

1. D. Koepplin, "Zu Lucas Cranach als Zeichner. Addenda zu Rosenbergs Katalog," *Kunstchronik* 25 (1972), 347.

131 CRUCIFIXION, 1517

Berlin, Kupferstichkabinett, KdZ 4325
Pen and brown ink
203 x 152 mm
No watermark
Monogrammed ·*W·H* and dated *1517* on the stone at bottom
Probably slightly trimmed on all sides

PROVENANCE: Strauss Coll.; acquired in 1906

LIT.: Riggenbach 1907, 36 – Bock 1921, 56 – Weinberger 1930, 83f. – Halm 1930, 24, no. 5 – Heinzle 1953, no. 35 – Oettinger 1957, 26, no. 17 – Winzinger 1979, 90f., no. 47 – P. K. Schuster, in: Exh. cat. *Luther und die Folgen für die Kunst,* ed. Werner Hofmann (Hamburg 1983), 218, no. 91

The Crucifixion of Christ has been relocated to a forest clearing, which forms a small stage for the event. The towering cross of Christ is pushed into the left border of the picture and turned ninety degrees, so that the body of the crucified Savior is shown in profile. A tree provides

131

a compositional balance at the right edge of the picture. In the center stands an empty cross that is backed by a tree. Our view between the two crosses falls on the city in the background. Below Christ's cross, with her back to it, sits the mourning Virgin Mary, while St. John faces the Savior.

As research has repeatedly demonstrated,[1] this placement of the crosses, which departs from traditional iconography, goes back to pictorial innovations by Lucas Cranach, such as his painted *Crucifixion* of 1503 in Munich and his 1502 woodcut version of the subject (see ill.). Huber, too, repeatedly employed the motif of the cross shown from an angle or from the side. As has been repeatedly observed,[2] our sheet was preceded by two woodcuts in which the artist developed the composition of the drawing. The so-called *Small Crucifixion* in London, which originated about 1511/1513, anticipates the crucifixion in profile and the observing St. John. The *Great Crucifixion,* which was created a few years later, probably

about 1516 (see ill.), is much more dramatic. Nevertheless, this woodcut depicts the same actors as our sheet; another parallel is the empty cross, which stands at a right angle to Christ's cross, just to its right, immediately next to a tree. It is assumed that Huber developed and clarified the composition of the woodcut in his drawing.[3] In the process, the empty cross in front of a tree has been relocated to the center of the image.

This comparison of drawing and woodcut raises the question of the function of our sheet. The careful execution of the drawing and the introduction of monogram and date on a stone in the foreground demonstrate that, as Peter Halm suspected in 1930, this is a preparatory drawing for a woodcut.[4] The following proposal for the meaning of the sheet may yield an additional argument in support of this hypothesis.

In the woodcut of the *Great Crucifixion,* a crude, empty cross made of tree trunks stands next to a tree behind the cross of Christ. The ladder leaning against this

Wolf Huber, *Great Crucifixion,* c. 1516

Lucas Cranach the Elder, *Crucifixion,* 1502

empty cross shows that its occupant has already been taken down. The position of this cross to Christ's right emphasizes that it is intended to be the cross of the penitent thief, who is traditionally depicted on that side. In our drawing, too, an empty cross made of tree trunks appears in connection with a tree, from which it is only slightly differentiated by the nature of the lines. However, it is not to the right, but to the left of Christ—the position reserved for the bad thief.[5]

If we assume that the sheet served as a preliminary drawing for a woodcut, the empty cross takes on a different meaning: In a woodcut, the composition would be reversed, so that the empty cross would move to the right side of Christ. In this way this rough cross would allude to the penitent thief who, shortly before his death, ensured that he would be able to partake in the Resurrection and eternal life by recognizing Christ as the Son of God and repenting his sins. Also, given the long tradition for equating the cross with the tree of life, the specific connection of cross and tree in our drawing must serve as a sign for the Resurrection. S.M.

1. Winzinger 1979, 90.

2. Winzinger 1979, 90; Weinberger 1930, 83f.; Riggenbach 1907, 36.

3. Riggenbach 1907, 36; Winzinger 1979, 168.

4. Oettinger 1957, 26, and Winzinger 1979, 90f., share in this assessment.

5. In 1983, this position to the left side of Christ led Schuster to the hypothesis that the spectator himself stands in the position of the contrite thief and is being charged by Christ "to take up his own cross and emulate the Passion of Christ."

132 PORTRAIT BUST OF A BEARDLESS MAN WEARING A CAP, 1522

Berlin, Kupferstichkabinett, KdZ 2060
Black and white chalk on brick red prepared paper
275 x 200 mm
No watermark
Upper left, dated 1522; monogram at right
Upper right corner, water damage; surface damage at the W of the monogram

PROVENANCE: Von Nagler Coll. (Lugt 2529); acquired in 1835

LIT.: Friedländer/Bock 1921, 56 – Exh. cat. Dürer 1967, no. 138 – W. Stubbe, "Unbekannte Zeichnungen altdeutscher Meister," Museum und Kunst. Beiträge für Alfred Hentzen (Hamburg 1970), 237ff. – Rose 1977, 64, 250, n. 89 – Winzinger 1979, no. 116 – Exh. cat. Köpfe 1983, 192ff. – C. Talbot, "Review of Hamburg. Köpfe der Lutherzeit," Burlington Magazine 125, 964 (July 1983), 448f. – D. Kuhrmann, in: Exh. cat. Slg. Kurfürst Carl Theodor 1983, no. 109

We know of an entire group of Wolf Huber's studies of heads in black-and-white chalk on brick red paper, all done in 1522.[1] These studies—some appear to have portraitlike qualities, while others lapse into caricature—attest to Huber's particular interest in rendering human physiognomy and capturing that which is most typical. The varied character of the individual sheets may result from the fact that Huber did not experience or observe all the heads himself, but was inspired by a variety of models, such as Hans Baldung's woodcut Head of a Bearded Old Man (B. 277).[2] Within the group, the Berlin head most clearly possesses portraitlike traits.[3] The assumption, occasionally expressed, that the sheet is a self-portrait is unfounded.[4]

The drawings were created as studies that became part of a repertoire of types and, therefore, are in the tradition of the medieval pattern book. Thanks to its large format, the choice of black for a part of the background in order to heighten the spatial effect, and, above all, the tense and compositionally efficacious application of date and monogram,[5] our sheet has a generally picturelike character.[6] The supposition that the drawing is an independent study of a facial expression becomes even clearer when one considers how freely Huber used it in his Raising of the Cross of 1523–1525 in Vienna.

Winzinger's observation that the Grizzled Man with Blowing Beard in Hamburg (Winzinger 1979, no. 136) was used for the bearded man on horseback at the right of the Raising of the Cross, in which types related to our Man Wearing a Cap also appear, may be amplified: The face of a soldier near the right border, who leads away one of the two naked and bound thieves, was undoubtedly developed from the example of the Berlin drawing (see ill.). S.M.

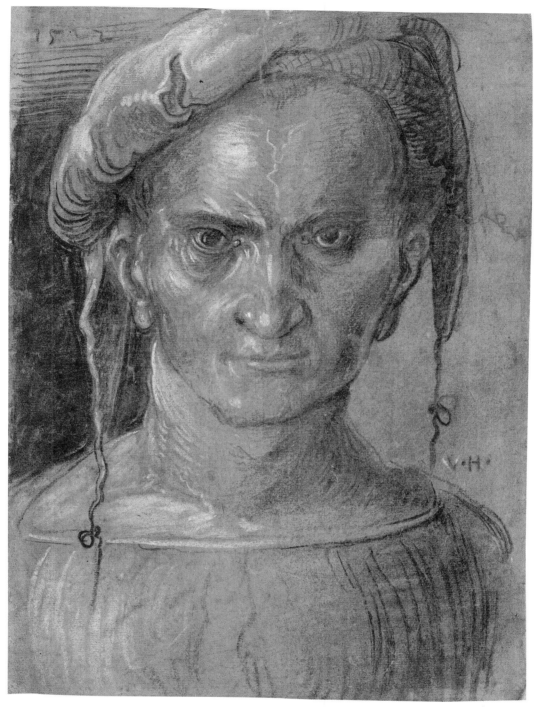

132

Wolf Huber, *Raising of the Cross* (detail), c. 1523/1525

1. The sheets are dispersed among collections in Hamburg, Basel, Berlin, Erlangen, Munich, and New York; for a series of old copies, see Winzinger 1979, no. 116; nos. 125–139.

2. D. Kuhrmann, in: Exh. cat. *Slg. Kurfürst Carl Theodor* 1983, 90, n. 2, no. 109.

3. Winzinger did not class the drawing with the group of "grotesque heads" of his catalogue (Winzinger 1979, nos. 125–139) but with the portraits (Winzinger 1979, no. 116).

4. For instance, F. Anzelewsky, in: Exh. cat. *Dürer* 1967, no. 138.

5. Oettinger 1957, 23ff.

6. It cannot be proved that Huber's physiognomic studies were inspired by Leonardo, as Rose 1977, 64ff., postulated.

133 DANUBE VALLEY NEAR KREMS, 1529

Berlin, Kupferstichkabinett, KdZ 12303
Pen and black brown ink on reddish prepared paper
223 x 318 mm
No watermark
Monogrammed *W·H·* on a stone to the left of the tallest tree; dated *1529* above
Corners restored; horizontal creases above; smaller tears repaired; surface abraded

PROVENANCE: Lahmann Coll.; acquired in 1926

LIT.: E. Bock, *Berichte aus den Preussischen Kunstsammlungen* (1927), 125 – Weinberger 1930, 168 – Halm 1930, no. 8 – Heinzle 1953, no. 124 – Stange 1964, 96 – Rose 1977, 9 – Winzinger 1979, 106, no. 81

In addition to invented scenes, such as the *City with Large Bridge* (cat. 135), the landscape drawings of Wolf Huber include a whole series of sheets that depict specific locations. The *Danube Valley near Krems* belongs in this category. The identification of the locale goes back to Elfried Bock. The landscape is seen from a vantage point near the Danube, looking in the direction of the Krems basin. In Huber's time, the only Danube bridge in the region was located at Krems and Stein. Both places are visible on the left bank; the village of Mautern lies opposite them. According to Winzinger, the landscape is closely observed with the exception of the mountain at the right.

Topographically accurate, identifiable landscapes had already appeared in the late fifteenth century (Katzheimer, *Dürer*; see cats. 18, 53). As Wood recently pointed out, however, these representations of buildings and landscapes were created in the context of specific commissions.[1] In most instances such drawings served the painters' workshops as models for landscape settings in altar paintings. Another use for drawn depictions of sites was the documentation of property rights for judicial purposes. Huber's importance stands out clearly in this context. He was the first artist to draw nonutilitarian topographic scenes as if they were independent works of art, furnished with monogram and date. His *View of Urfahr* and *Mondsee with Schafberg,* both of 1510, are the earliest autonomous landscape drawings north of the Alps.

Our drawing depicts more than the factual aspects of the wide landscape. The high viewpoint and the meeting, on a distant horizon, of countryside and light-suffused sky are reminiscent of historical landscapes such as Altdorfer's *Battle of Alexander,* also of 1529.[2] The fantastic quality is heightened by the arch of light beams centered over the cone-shaped mountain—which Huber inserted in his observed landscape. This ring of rays defines a vault, as it

133

134

135

were, which unites the composition. In the foreground, close to the spectator, the abstract light beams connect with the rising trees. In this way background and foreground are harmoniously bound together, while the breadth of the landscape is countered by a vertical accent. As Dieter Koepplin[3] demonstrated, the light beams that often illuminate Huber's landscapes may be seen as an attempt to give pictorial expression to an all-embracing concept of God. S.M.

1. Wood 1993, 203f.
2. The influence of contemporary historical Flemish landscapes of the school on Huber and Altdorfer, as surmised by Walter S. Gibson (W. S. Gibson, *The Mirror of Earth: The World Landscape in Sixteenth Century Flemish Painting* [Princeton 1989], 45), is difficult to prove.
3. Koepplin 1967, 78–115, esp. 105f.

134 LANDSCAPE (BURG AGGSTEIN IN DER WACHAU), 1542

Verso: sketch of a jumping horse
Basel, Kupferstichkabinett, Inv. 1959.113
Recto, pen and brown ink with brown wash; verso, violet watercolor
287 x 201 mm
Watermark: Gothic p; above it, small coat of arms (Briquet 8751)
Upper center, dated ·1542·
Lower left corner damaged; trimmed all around; some spotting; verso, watercolor spots in various colors

PROVENANCE: A. von Lanna Coll., Prague; art dealer Artaria (1910); Coll. Prince of Liechtenstein; Walter Feilchenfeldt Coll., Zurich 1949; CIBA-Jubiläumsschenkung 1959

LIT.: Exh. cat. *CIBA-Jubiläums-Schenkung* 1959, 50 – Hp. Landolt 1972, no. 43 – Winzinger 1979, no. 95

Much like the sheet discussed in the preceding entry (cat. 133), the present drawing is a picturelike depiction, rather than a matter-of-fact rendering, of a specific place. Meder and Dworschak have identified this fortress, located on a promontory high above a river valley and reachable only by a wooden bridge, as Burg Aggstein in der Wachau. The brown wash in the shadowed zones lends a strong spatial presence to the fortress and its promontory in the foreground. Following the rules of aerial perspective, the background hills are rendered in finer strokes and brighter ink.

The landscape is filled with supernatural light, with rays that traverse the sky and therefore seem to create a vault. The tree at the left border, which actually serves

as a *repoussoir,* is drawn into the stream of these "power lines." Its leaves and twigs, composed of abstract graphic figures—short hooks, long pen strokes—move in the direction of the beams of light and, with a few bold calligraphic curves, blend into the clouds, where the date is located in a compositionally efficacious place. The tree is of decisive importance for the dramatic effect of the sky.
 S.M.

135 CITY WITH LARGE BRIDGE, 1542

Berlin, Kupferstichkabinett, KdZ 8496
Pen and gray ink; gray wash
208 x 311 mm
No watermark
Dated *1542* in the sky at upper center

PROVENANCE: Campe Coll. (Lugt 1391); Vieweg; gift of C. G. Börner, Leipzig 1917

LIT.: Bock 1921, 56, 374 – Exh. cat. *Albrecht Altdorfer und sein Kreis,* 1938, no. 294 – Koepplin 1967, 109 – Winzinger 1979, no. 94 – *Handbuch Berliner Kupferstichkabinett* 1994, III.54

A city with many towers, backlit by a glaring light, is surrounded by water. The sky is suffused with fine lines, partially intended as sunbeams, even though slightly curved, or left unexplained, next to the edges of the clouds. A sky filled by such unrealistic "power lines," by which everything, occasionally even the human body, is subsumed, is typical of the graphic landscapes of both Huber and Altdorfer—both key masters of the so-called Danube style. The intention may have been to depict the unity of the world, within which nothing should be viewed in isolation. The marvelous treatment of light in our drawing should be understood as a celebration of mood, as a vision of a miraculously illuminated city, approached by a huge, completely deserted bridge.

The references in the old Berlin catalogue to Landshut and, later, to Passau are only viable in a general sense: therefore, this is a city on a river in the mountains.
 H.M.

HANS FRIES

(Fribourg c. 1460/1462−after 1518 Bern)

Son of an alderman of the city of Fribourg. Apprenticeship about 1480 with Heinrich Bichler in Bern, one of the Bern "Masters of the Carnations." Primarily active as a painter of altars, and perhaps also as a woodcarver. He was influenced by works of Dutch painting, by Hans Holbein the Elder, and by Hans Burgkmair. In 1487/1488 and 1497 Fries lived in Basel and traveled to Colmar, Augsburg, and Tirol. In 1499 Fries was again active in Fribourg, where from 1501, he received a fixed salary as city painter for a decade. Most of the surviving works by Fries were produced in this period (including the Last Judgment altar, 1501; altar panels with Sts. Christopher and Barbara, 1503; St. John altar, c. 1505, probably for St. Nicholas in Fribourg; St. Anthony altar, 1506, for the Franciscan church of Fribourg). From 1509/1510 he also lived and worked in Bern (altar of the Virgin, 1512; St. John altar, 1514), where he transferred definitively from 1511 until his death, after 1518 (see L. Wüthrich, in: *The Dictionary of Art,* J. Turner, ed., vol. 11 [London/New York 1996]).

136 THE VIRGIN AND CHILD ON A GRASSY BENCH, C. 1508/1510

Basel, Kupferstichkabinett, Inv. 1959.103
Pen and black ink, heightened in white on dark brown prepared paper
252 x 197 mm
Watermark: indecipherable
Upper left quarter (diagonal, covered) *RHLando/1605*; verso, collector's mark, Liphart (Lugt 1687 and 1758)
Glued on paper; restored and retouched overall; white heightening retouched in places

PROVENANCE: R. H. Lando, 1605; Karl Eduard von Liphart; Freiherr Reinhold von Liphart; Prince Liechtenstein; Walter Feilchenfeldt, Zurich 1949; CIBA-Jubiläumsschenkung 1959

LIT.: Auct. cat. Von Liphart collection, C. G. Boerner, Leipzig, 1.24.1899, no. 2 − Schönbrunner/Meder, 9: no. 1048 − Kelterborn-Haemmerli 1927, 109f. − Hugelshofer 1928, no. 10 − Schmidt/Cetto, XXI, 21, ill. 35 − Dominique/Maurice Moullet 1941, 54, no. 3 − Winzinger 1956, no. X − Schmidt 1959, 16f. − Exh. cat. *CIBA-Jubiläums-Schenkung* 1959, no. 3 − Exh. cat. *Swiss Drawings* 1967, no. 3 − Hp. Landolt 1972, no. 44

The drawing has generally been dated to the first decade of the sixteenth century, though opinions differ regarding the exact year: Hugelshofer proposed about 1500, Schmidt and Landolt dated it about 1503, Kelterborn-Haemmerli dated it about 1506, and Winzinger about 1510. The seated position seems somewhat obscure compared to the models that Fries had at hand. Baldung's woodcut *Virgin and Child on a Grassy Bench* of about 1505/1507 (Mende 1978, no. 1) could have inspired Fries' depiction. For instance, one could point to Mary's wind-blown hair, the inclination of her head with her eyes almost closed, and the movement of the child's arm toward Mary's bosom. In comparison to the drawing of a seated Virgin, which could date from about 1505, now in Munich, the drapery folds seem more grandly drawn and create cylindrical forms that were likewise inspired by examples from the circle of Dürer. Our drawing may have been produced about 1508 to 1510.

C.M.

137 THE ASSUMPTION OF THE VIRGIN, C. 1510/1512

Basel, Kupferstichkabinett, U. I. 32. (=U.XVI.34)
Charcoal (or black chalk)
431 x 322 mm
Watermark: high crown (type, Piccard 1961, group XII, 45b)
Inscribed with collector's monogram *T-W* (Thüring Walter? not in Lugt) in pen and brown ink
Foxed; horizontal center fold; lined with japanese paper; lower right corner torn off

PROVENANCE: Museum Faesch

LIT.: Von Térey, no. 7, *Textband,* VIII (Baldung) − Schmid 1898, 310 (not Baldung, Hans Fries) − Stiassny 1897/1898, 32 (Hans Dürer) − Kelterborn-Haemmerli 1927, 110f., pl. XXVIII (c. 1508−1512) − Hugelshofer 1928, 27, with no. 10 − Dominique/Maurice Moullet 1941, 54, no. 4 − Hp. Landolt 1972, no. 45 (c. 1504)

Surrounded by a mandorla-shaped light and accompanied by angels, Mary ascends to heaven, where Christ welcomes her with open arms.

The attribution of the drawing to Hans Fries dates back to Schmid. Kelterborn-Haemmerli placed it close to the altar of the Virgin of 1512, whose six scenes divided over three panels are now in the Basel Kunstmuseum (inv. 226−231). A dating to this time period or slightly earlier could well be correct. It is supported by, among other things, the rendering of the Virgin's ample cloak in small, segmented, creased folds, which appear to be incised, and by the soft working of light and dark areas, which intensify to finely superimposed crosshatching. Related elements may be observed in the previously mentioned altar panels in the Basel Kunstmuseum, even

136

137

though a comparison is only relatively possible owing to their divergent techniques. We could also point to the front of a panel of the St. John altar, which comes from Freiburg im Uechtland and was made about 1507, now in the Schweizerisches Landesmuseum in Zurich. The apocalyptic woman there appears in a similar aureole (Kelterborn-Haemmerli, pl. XIV), in which an outline composed of small rounded segments only begins to be used at the upper right of our drawing. However, the figures of the St. John altar look significantly stiffer, suggesting that our drawing was created later than that altarpiece. Our sheet may have served as a design for a painting on panel or on glass. C.M.

HANS LEU THE YOUNGER
(Zurich c. 1490–1531 Gubel, near Zurich)

Swiss painter, draftsman and designer of glass painting, leading Zurich artist of his time. Presumably a student of his father, Hans Leu the Elder. Traveled in southern Germany. About 1510 apparently active with Dürer in Nuremberg. His personal contact with Dürer was confirmed by a 1523 letter from the latter to the Zurich provost Felix Frey, in which Frey also conveyed his greetings to Leu (verso, *Monkey Dance,* see cat. 77). About 1513/1514, and possibly even earlier, collaboration with Hans Baldung in Freiburg, on the Schnewlin altar, among other works. From 1514/1515 back in Zurich. On account of the iconoclastic politics of the reformer Zwingli, which gained momentum from the 1520s on, commissions for religious works became scarce. Leu took Zwingli's side and died in the battle on the Gubel on 24 October 1531. The surviving painted oeuvre is very small; most important is the *Orpheus* of 1519 in the Basel Kunstmuseum. In addition to four woodcuts, all dated 1516 and extant in only very few impressions, about thirty drawings are known. Heavily dependent stylistically on the masters of the Danube school and on Hans Baldung, Leu made his principal artistic contribution in the field of autonomous landscape and tree studies.

138 THE VIRGIN AND CHILD IN A LANDSCAPE, 1512 OR 1517

Basel, Kupferstichkabinett, U.XVI.38
Pen and black ink; later reworking in pen and brown ink in the child's hair
202 x 154 mm
Watermark: small fragment of a walking bear
Monogrammed and dated, upper center on tree trunk, in pen and black ink *HL* (in ligature) *.1.5.12* or *.1.5.17;* lower left corner *49* in pencil by a later hand

PROVENANCE: Amerbach-Kabinett

LIT.: Schönbrunner-Meder, no. 611 – Hugelshofer 1924, 37ff. – *Handz. Schweizer. Meister,* no. I.9 – Parker 1923, 83 – Hugelshofer 1928, no. 35 – Exh. cat. *Amerbach* 1962, no. 63 – Exh. cat. *Swiss Drawings* 1967, no. 24 – Gross 1991, 118ff.

Leu's dependence on Hans Baldung's drawing style is seldom more in evidence than in this Basel pen-and-ink drawing with the crowned Mother of God closely holding her son, who stands on her knees. The arrangement of the drapery and its modeling by a system of parallel and crosshatched lines of varying lengths were all inspired

138

307

Hans Leu the Younger, *Holy Family,* 1516

by the Baldung of the early Nuremberg years. The facial type of the Virgin also points to Baldung. For purposes of comparison, Gross indicated Baldung's Basel drawing *The Coronation of the Virgin by a Cherub* of 1504.[1] But what the young Baldung carried off boldly and masterfully seems somewhat small and hesitant in Leu, particularly the frequently broken, clumsy folds of the Virgin's garment. In addition the Zurich master was more inclined to a calligraphic independence in his handling of the pen, as, for instance, in the trunk of the mighty tree that rises up in the center. The landscape, indicated in rapid lines, is more free and independent than the figures. In general, landscape is the artistic specialty in which Leu produced his most interesting works.

Just how the year should be read is contested. Hugelshofer and other authors identified the last digit as a 7. Mielke instead opted for the year 1512,[2] on the basis of a 1514 Berlin copy of Leu's Nuremberg *St. Sebastian,* which also bears the misleading date. Mielke's response to Hugelshofer is seductive even when counterarguments are marshaled. The controversial digit, sketchily drawn, can only be interpreted as a 2 with some difficulty, as the upper stroke arches inward in a way that is characteristic for a 7. Moreover, there are signed and dated drawings by Leu from the 1520s on which the 2 is quite differently written and may be read without any possibility of error (see cat. 139; Hugelshofer 1924, 127ff.). Other considerations also speak for a date of 1517. All the works with that same date—the present sheet, the Rotterdam *Holy*

Family, the Erlangen *Allegory of Transience,* as well as the Nuremberg *St. Sebastian* (Hugelshofer 1924, 30ff.)[3]— fit well stylistically among Leu's graphic work of this year: between the 1516 *St. Ursula* in Zurich (Hugelshofer 1923, 176) and the 1518 *St. Jerome* in Oxford.[4] Nevertheless, the question of dating cannot be conclusively decided here.

Leu rendered the theme of the Mother of God sitting on a hillock in the out-of-doors in quite a similar fashion in a woodcut of 1516 (Hollstein *German,* vol. 1) that was clearly inspired by Hans Baldung (see ill.). The scenery is here expanded to encompass Joseph and playing putti. H.B.

1. Koch 1941, no. 4; T. Falk, in: Exh. cat. *Baldung* 1978, no. 10.
2. Mielke 1988, no. 194.
3. Mielke 1988, no. 193f. The last number on the *Entry into Jerusalem* in Berlin (Mielke 1988, no. 192) deviates from the other sheets and could be read with reservations as a 2.
4. Hugelshofer 1969, no. 37; A. M. Logan, in: Exh. cat. *Prints and Drawings of the Danube School,* Yale University Art Gallery, City Art Museum of St. Louis, and Philadelphia Museum of Art (1969/1970), no. 122.

139 THE HOLY FAMILY WITH TWO ANGELS, 1521

Berlin, Kupferstichkabinett, KdZ 4066
Pen and black ink; gray black wash; heightened in white on brown prepared paper
281 x 203 mm
Watermark: indecipherable
Upper right, dated and monogrammed in pen and white ink
1521 HL (in ligature)
Spotted and abraded, with a few losses retouched at the middle and upper right; horizontal creases; tears, right edge

PROVENANCE: Mayor Coll. (lower right, collector's mark, Lugt 2799); Helbing auction, Munich 1897, no. 287; acquired in 1897 from Amsler & Ruthardt, Berlin

LIT.: *Handz. Schweizer. Meister,* no. III.51 – *Zeichnungen* 1910, no. 194 – *Handzeichnungen,* pl. 98 – Bock 1921, 63 – Parker 1923, 83 – Hugelshofer 1924, 128ff. – Hugelshofer 1928, with no. 37 – W. Hugelshofer, "Hans Leu (c. 1490–1531): The Capture of Christ," *Old Master Drawings* 10 (1935), 35f. – C. H. Shell, "Hans Leu d. J. und die Zeichnung einer Pietà im Fogg-Museum Cambridge, USA," *ZAK* 15 (1954), 82–86, esp. 86 – Exh. cat. *Dürer* 1967, no. 92 – Gross 1991, 122 – Rowlands 1993, with no. 423

Two angels bring fruit to the Holy Family taking a rest on its flight into Egypt. The fruit refers symbolically to the role of the Virgin and the Christ child in God's plan of redemption: the apple represents the Fall, whereas the bunches of grapes symbolize the future sacrificial death

139

Hans Leu the Younger, *St. Bartholomew in a Landscape*, 1521

Albrecht Dürer, *Mary as Queen of the Angels*
(detail), 1518

of Christ, which will free mankind from original sin.

When we survey Leu's graphic work, the difference in style and technique of this drawing quickly stands out. The figures are all at once large and heavy, and they fill the entire foreground like a flat ornament, without convincing spatial depth. Leu apparently came by this kind of depiction through his engagement, or re-engagement, with the woodcuts of Dürer's so-called "decorative style" (Panofsky). Both angels were borrowed more or less precisely, only in mirror image (by means of a tracing?), from Dürer's principal work in this style, *Mary as Queen of the Angels* of 1518 (M. 211) (see ill.). The figure, drapery forms, and movements of the angels are based in equal part on the divine messengers of Dürer's woodcut, *The Annunciation,* from his Life of the Virgin (M. 195). The somewhat failed attempt to show Mary's face in hidden profile could also be based on Dürer's example. As far as the graphic technique is concerned, there is a conspicuous absence of Leu's characteristic bundling of dense parallel strokes, which are usually oriented horizontally and placed in contrast to unworked areas. The London drawing *St. Bartholemew in a Landscape,* also dated 1521, still shows all the marks of this dynamic pen technique (see ill.; Hugelshofer 1924, 129ff.).[1] In our drawing we encounter a graduated gray-black wash, and the white heightening is applied in an unusual manner, with fine, supple parallel and crosshatched lines. Nevertheless, doubts about the autograph status of this sheet have yet to be voiced. The form of the monogram, with its beautiful ornamental frame of loops, corresponds exactly to that of Leu's petition of the same year to the Zurich Council.[2] Many details, such as the small, ungainly hands with fingers that are often shaped like claws, are characteristic for Leu. The soft, rounded draperies, in contrast to the angular structure of the folds in his earlier works, are paralleled in other drawings, for instance, in *Death and the Maiden,* dated 1525, in the Graphische Sammlung Albertina in Vienna (Hugelshofer 1924, 138ff.), which appears to be based on a model by Hans Baldung. Baldung therefore must have been the source for Leu's change in drawing style, which involved modeling with the aid of finely striated white heightening and flat, sometimes also hatched, brush washes.

Rest on the Flight (formerly Koenigs Collection, Haarlem and Rotterdam), a drawing dated 1520, is closely connected in style and in the rendering of figures.[3] H.B.

1. Rowlands 1993, no. 423.
2. Debrunner 1941, 14, ill. 3, pl. II.
3. Hugelshofer 1928, no. 37; Elen/Voorthuis 1989, no. 244.

URS GRAF

(Solothurn c. 1485 – after 1529)

Graf probably learned the goldsmith trade in the workshop of his father, Hug Graf, in Solothurn. During his years of travel, he stayed in Strassburg and Zurich (1503, work on the world map for the *Margarita philosophica* of Gregor Reisch; woodcut illustrations to the "Passion," 1503, appeared in 1506). In Zurich he was trained as a glass painter by Lienhart Triblin. He was active as a draftsman (especially for woodcuts) and goldsmith but also as a painter, engraver, and die-cutter for coins and medals. From 1509 he lived in Basel (book illustrations for Adam Petri, Johannes Amerbach, Johannes Froben), where in 1511 he married Sybilla von Brunn, a member of a Basel patrician dynasty. He was repeatedly accused and detained for mockery, disturbing the peace at night, brawling. From 1510 Graf took part in military campaigns as a mercenary (going to Lombardy in 1510, to Dijon in 1513, to Marignano in 1515, and to upper Italy in 1521/1522, among other places). In 1512 birth of a son and matriculation in the Basel goldsmith guild. Between 1513 and 1524 he was, with few interruptions, its delegate. In 1518 Graf had to flee to Solothurn but the Basel Council invited him back a year and a half later and gave him the office of numismatic die-cutter, which he filled until 1523. In 1520 Graf bought the house "zur guldin Rosen" in Basel, where he had already been living for some time with his family and a journeyman. He was mentioned for the last time in the archives in 1526. In 1528 his wife was said to be alone and to have married a second time. Graf died after 1529, the date of his last autograph drawing.

140 PORTRAIT OF A MAN WITH A POCKET SUNDIAL, c. 1505/1508

Basel, Kupferstichkabinett, Inv. 1978.91
Pen and black ink
192 x 148 mm
Watermark: bunch of grapes (fragment, variant of Briquet 13016)
Monogrammed, near the head *V* (left) and *G* (right, below borax box); outer circle of the sundial with night dial *.I.V✱OW.D .I. HIOMEC .I.*; on the sundial *VR .I. II [?] VOIVG*; verso, mark of Firmin-Didot (Lugt 119) and mark of Davidsohn (Lugt 654)
Trimmed on all sides

PROVENANCE: Count A. F. Andreossy Coll.; Ambroise Firmin-Didot Coll.; Paul Davidsohn, Berlin; Stefan von Licht, Vienna; Edwin Czeczowiczka, Vienna, Sale Boerner und Graupe, Berlin, 5.12.1930; Robert von Hirsch, Frankfurt/Basel; acquired in 1978

LIT.: Parker 1926, 11ff., pl. 18 – W. Hugelshofer, 1928, 31, no. 23 – Major/Gradmann 1941, 15, no. 2 – Pfister-Burkhalter 1958, no. 1 – Schmidt/Cetto, 31ff., no. 51 – Hp. Landolt, "Swiss Drawings in the Early Sixteenth Century," in *The Connoisseur* 153 (1963), 174ff., ill. on 172 – E. Murbach, "Der Meister der Wandbilder von Muttenz: Urs Graf?," *Unsere Kunstdenkmäler* 28 (1977), 173 – Auct. cat. *The Robert von Hirsch Collection*, I, *Old Master Drawings, Paintings and Medieval Miniatures, Sotheby Parke Bernet & Co.* (London 1978), no. 13 – Andersson 1978, 10, ill. 2

This portrait of an unknown man, who looks with lowered eyes at a measuring instrument that he is trying to adjust or read, belongs to the early works by Urs Graf. This dating is supported by the style of the drawing and the type of signature with the borax box. The monogram introduced on both sides of the head underscores the picturelike effect of the drawing, whose impact is similar to that of a painting and cannot, therefore, be taken for a preparatory stage or work.

The uniform aspect of the depiction results from the concentration on the face and hands of the man. The subject does not, as is usual with portraits, address a viewer, a painted counterpart, or look vaguely into the distance. In this way the viewer is kept at a distance, as he is paid no attention. On the other hand, however, the viewer becomes a silent observer of the subject and is made curious by the object in his hand. It is a pocket sundial combined with a clock having an illuminated dial located on the lid of the sundial. Whether the watch alludes to the activities or profession of the man is not certain. It could also be a *vanitas* symbol. The brooch attached to the hat, which looks like a flattened pea pod, could also be understood in that context.

140

Graf modeled the face and cloak of the subject in part with a very thin brush and closely spaced strokes. Some folds of the fur-collared cloak stand out because of the broader, very precise strokes that begin with hooklike forms. The folds recall the drawings of drapery studies of the late fifteenth century, with their schematic interior structures. Graf's metallic fine strokes, which look as if incised by a stylus, show nothing of the calligraphically free dynamics of his later drawings but appear rather to harken back to his artistic beginnings. Like Martin Schongauer, Urs Graf sought training as a goldsmith. The borax box represented on the upper right, which is part of Graf's signature, alludes to this activity. Borax powder was used by goldsmiths as flux during the melting of precious metals. By rubbing the fingernail on the notched prong, the powder could be shaken from its holder in a controlled manner. C.M.

141 SATYR WITH WOMAN, OFFERING TO JUPITER, 1513

Basel, Kupferstichkabinett, U.X.42

Pen and black ink

293 x 212 mm

No watermark

Lower left, monogram (in ligature) *VG*; lower left corner *47.* by Amerbach in red chalk; to the right *1513*; upper edge *.RETIBVI . HCI . REFPO . RID . /. SAD . VD . SAD . ILBIW . TSESOL . RIM*

Left edge, spotted, with several thin places

PROVENANCE: Amerbach-Kabinett

LIT.: Meder 1919, 356 – Koegler 1926, no. 21 – Lüthi 1928, 115, no. 126 – Major/Gradmann 1941, 27, ill. 69 – Koegler 1947, 5, 17, pl. 17 – Pfister-Burkhalter 1958, ill. 3

A naked man with faun's ears, a mighty horn on his brow, and demonic features holds a scantily clad woman by the arm. Although the sword, which he carries on his back, and his sandals are, in effect, inappropriate embellishments, the accessories of the woman and her condition speak for her connection to some civilized or urban life, which she may have left of her own free will, or from which she has been abducted. The horned creature may just have torn her away from the naked man on the ground, who lies there as if defeated or, in any case, defenseless, and who, given the triumphal gesture of the horned one (who places his left foot on him), is probably his sacrificial victim and vanquished foe. Immediately behind the head of the recumbent figure rises a stone monument with fantastic inscriptions and the outlines of a bearded man, a figure of a god, possibly a boundary stone, Terminus(?).[1] He was worshiped in conjunction

with Jupiter despite the latter's futile efforts to expel him from his traditional place on the Capitoline Hill. Certainly Graf deliberately placed the reclining figure next to the boundary god, thus raising the possibility of a reference to the crossing of some frontier and to death. Next to him rises an ornamented pillar, which is crowned by a nude male figure wearing a crown and holding a shield and a bow(?). With an extended gesture, the horned creature tosses coins in the direction of the figure standing on the pillar (Jupiter), thus presenting him with an offering. The horned man hopes to keep the woman for himself with the aid of Jupiter, as is explained by the inscription, which, rendered in mirror image, is difficult to decipher and which floats like a motto over the entire depiction: *Jupiter, I sacrifice to you so that you will grant me the woman.* It is also conceivable that he is hoping, in this way, to escape possible punishment, which the god, who was often invoked in court cases, usually meted out when agreements and alliances were violated. In this instance, however, Jupiter seems very nearly a comical presence, as he is more reminiscent of a childlike Cupid (with a bow in the hand) than of the thunderbolt-wielding lord of the gods. Jupiter also acquired fame by his numerous love affairs and by his capacity to change guises, which ability many explain why Graf depicted him in this way.[2]

The depiction is concerned with the theme of the unruliness of the man, his power and impotence, which are related to love (life) and death. These aspects are also evoked by the juxtaposed figures of the gods. The impotence of the figure lying on the ground finds additional expression in Graf's chosen perspective, for the gaze of the observer falls unimpeded on the genitals of the man and subjects his body to the consequences of perspective in a radical way. A much later woodcut (1544) with a bewitched groom by Hans Baldung Grien (see cat. 115) employs this motif in a similar way, as reference to impotence and death. The theme of the abduction of women belongs to the mythology of wild men and was depicted on Upper Rhine tapestries and on love chests, as well as in paintings by members of the Danube school and in early sixteenth-century prints, which may have inspired Graf.[3] C.M.

1. Erika Simon, "Terminus," *Lexicon Iconographicum Mythologiae classicae,* vol. 7, 1 (1994), 893–894.

2. Fulvio Canciani, "Amori de Iuppiter," *Lexicon Iconographicum Mythologiae classicae,* vol. 8, 1 (1997), 447–448.

3. On wild people, Richard Bernheimer, *Wild Men in the Middle Ages* (Cambridge 1952), esp. 125ff. and ill. 25, 33. Timothy Husband with the assistance of Gloria Gilmore-House, Exh. cat. *The Wild Man, Medieval Myth and Symbolism, The Cloisters, The Metropolitan Museum of Art* (New York 1980), esp. nos. 16, 38.

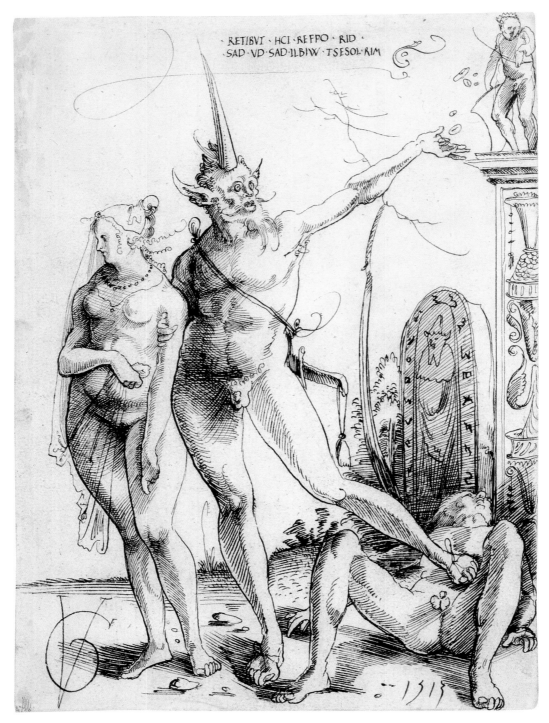

RETIBVI · HCI · REFPO · RID ·
SAD · VD · SAD · ILBIW · TSESOL · RIM

1513

141

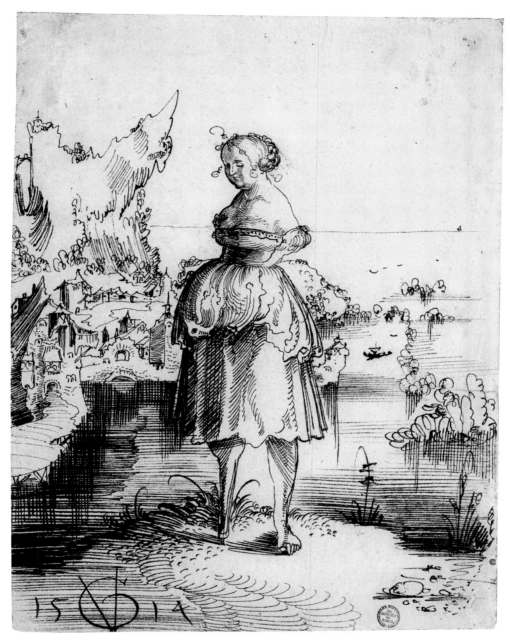

142

Verso (142)

142 ARMLESS GIRL WITH PEG LEG, 1514

Verso: head of a bearded man, c. 1514
Basel, Kupferstichkabinett, U.I.58
Pen and black ink
210 x 159 mm
Watermark: fragment of a bull's head with T
Lower left, monogram and date *15VG14*
Left and below, slightly trimmed; upper right edge,
brown spots; torn right edge; slightly soiled

PROVENANCE: Museum Faesch

LIT.: Koegler 1926, no. 52, no. 52a, text ill. on 3 – Koegler
1947, V, XXII, pl. 25 – Pfister-Burkhalter 1958, no. 11 –
Andersson 1978, 29, ill. 24 – Andersson 1994, 245, ill. 1

The woman's dress and her physical disfigurement suggest
that she belongs to the camp followers who joined the
Landsknechte (mercenaries) on their military campaigns.
Evidently, time and again after a battle, the camp
followers of the losers were massacred. Captured camp
followers, like the one depicted here, were occasionally
mistreated and mutilated in a gruesome manner and then
sent back to the camp of the enemy (Andersson 1978,
28f.). The sarcasm with which Graf treated this theme is
particularly apparent in this sheet. The mutilated woman,
who has lost a leg, the large toe of her left foot, both
arms, and an eye, stands on a hillock on the shore of a
lake before a landscape that recedes without transition into
the distance. This contrast between closeup and remote
prospect draws our attention to the figure, as does the lack
of a narrative context that might provide an explanation
for her presence in the landscape. Only upon close exami-

nation does one notice that the camp follower fixes the
(male) observer with her remaining eye, as if she wants to
entice him into mercenary love. It looks as though Graf
wished to present a particular "beauty," one that is under-
scored by the connection with the exquisite landscape and
the harmony of the calligraphic play of the pen. C.M.

143 PORTRAIT OF A CAMP FOLLOWER, 1518

Basel, Kupferstichkabinett, Inv. 1927.111
Pen and black ink
256 x 210 mm
No watermark
Lower right, monogram and date *15VG18* with dagger
colophon; corner of woman's hat, a winged *M* with crown;
lower left corner *35* in red chalk by Amerbach
Trimmed on all sides and glued on paper; foxed at the edges

PROVENANCE: Amerbach-Kabinett

LIT.: Koegler 1926, 81 – Lüthi 1928, 109, 140, no. 182 –
Major/Gradmann 1941, 15, ill. 1 – Koegler 1947, XXVII,
pl. 43 – Pfister-Burkhalter 1958, no. 34 – Exh. cat. *Swiss
Drawings* 1967, no. 8 – Exh. cat. *Amerbach* 1991, *Zeichnungen*,
no. 85

Graf's depiction of a richly dressed woman conforms in
composition and pictorial detail to the half-figure portrait
type. The detailed finish and Graf's signature underscore
the picturelike character of the drawing. Koegler (1947)
rightly pointed out that the woman corresponds to a type
that Graf employed repeatedly for female figures. To this
type, for instance, belongs the high, shaven brow that
recalls the characteristic hairstyle of Dutch models seen
on panel paintings of the late fifteenth century. In earlier
interpretations, the woman was seen as a member of a
higher social class; the rather reserved gesture may have
encouraged this impression. The costly clothing, with
accessories that invite symbolic interpretation, more likely
indicates that this lady was a camp follower who enjoyed
considerable success at her calling. The camp followers
actually appear to have worn clothing comparable to
that of the nobility of the time (see Andersson 1978, 55).
Holbein, for instance, also rendered a series of camp
followers that were believed to be noblewomen of Basel
on account of their handsome clothes (see Müller 1996,
95ff.).

Over her shoulders and breast hangs a heavy gold
chain with an amulet. A further amulet is visible in her
cleavage. It is a small, mounted cross of St. Anthony,
meant to protect against the plague and other diseases.
The lion heads and powder brush on her arm allude to

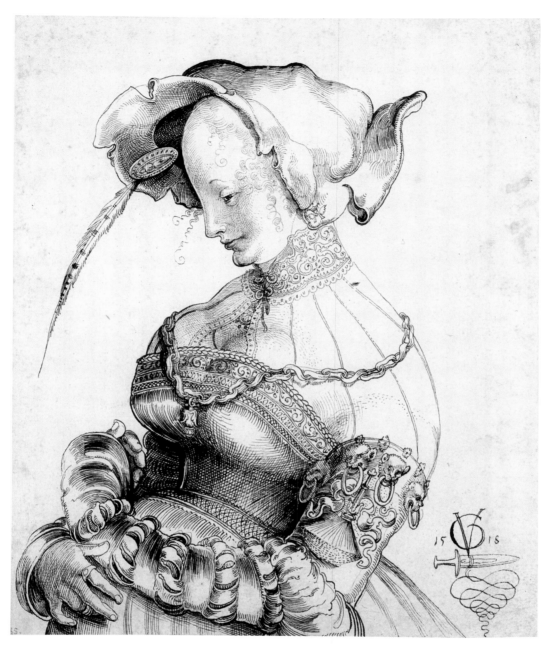

143

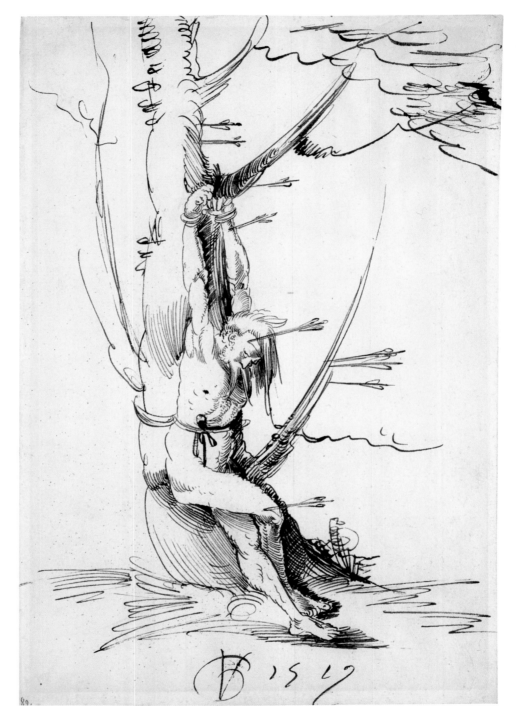

144

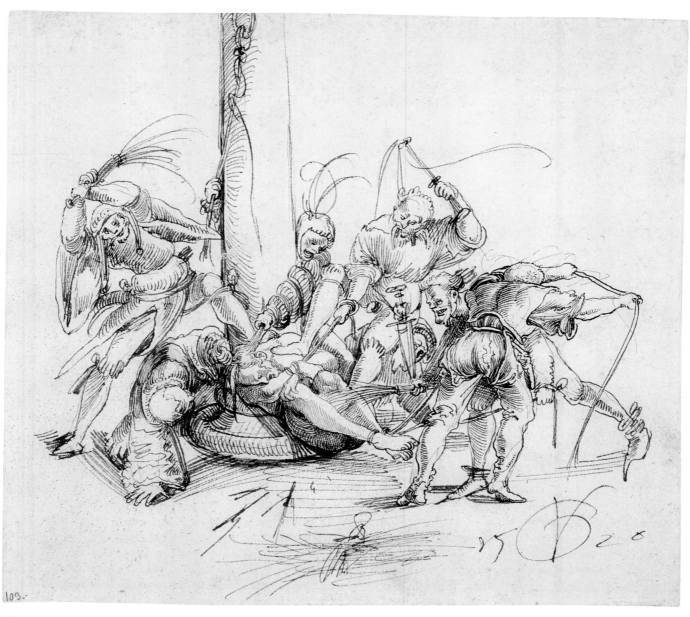

105.

145

her adeptness at seducing and taming men. It is in any case difficult to understand from which materials these decorations were made and how they were attached to her arm. The winged and crowned "M" on her cap, near her hidden ear, may also have had a similar meaning. In the late Middle Ages, the queen of love, the "Minne," was occasionally depicted as a winged, female figure. Contemporary explanations at times identified the wings as indicative of the speed of love relationships, as well as of their instability and the transience of happiness. Perhaps the flirtatious feather in the hat, attached to a brooch, had a similar meaning. But it also points to the vanity of the woman. Graf's depiction has no moralizing overtones of the kind that might be conceivable in the aforementioned type of model.　　　　　　　　　　　C.M.

144　Bound Man Pierced by Arrows (St. Sebastian?), 1519

Basel, Kupferstichkabinett, U.X.85
Pen and brown and black ink
318 x 215 mm
No watermark
Monogrammed *VG* and dated *1519*; lower left corner *89* by Amerbach in red chalk

PROVENANCE: Amerbach-Kabinett

LIT.: Koegler 1926, 86 – Lüthi 1928, 85ff. – Major/Gradmann 1941, 25, ill. 54 – Koegler 1947, XXVIII, pl. 46 – Pfister-Burkhalter 1958, no. 18 – Exh. cat. *Amerbach* 1991, *Zeichnungen*, no. 86

A naked lifeless man hangs on a tree, pierced in the arm, head, and leg by arrows. The graphic structure of the drawing leads to interactions between the tree and the body of the man. His dangling hair, for instance, is hardly differentiated materially or in the nature of the strokes from the branches, and in places the upper body resembles part of the tree trunk. The branches of the tree, entirely or partly dead, are drawn with energetic strokes and terminate in sharp points or take on a calligraphic life of their own in their ramifications. It seems almost as if Graf wished to express the pain suffered by the man. The dynamic handling of the pen has left its trace in the numerous ink spatters. The theme itself is allusive. The simplest option would be to take the figure for St. Sebastian, who suffered his martyrdom in the manner depicted. The long, pendulous moustache of the dead man calls to mind the type of beard worn by German mercenaries (foot soldiers). It is possible that Graf depicted a *Landsknecht* who found death in the same way as the

saint, or that he wished, at least in this way, to allude to the hostile foot soldiers and their fate. Both these interpretations could be off the mark, however. Perhaps Graf intended to depict the tree and the man hanging from it as related in kind, and to compare the violent death of the wild, unruly man with the tree felled by nature's violence. In the early sixteenth century, themes and projections of this kind particularly captured the interest of an urban clientele, who interpreted wild nature as a place of freedom. Unlike Urs Graf, however, not everyone lived out this wish by taking part in military campaigns.

　　　　　　　　　　　C.M.

145　The Flagellation, 1520

Basel, Kupferstichkabinett, U.X.98
Pen and black ink
188 x 208 mm
Lower right, date and monogram (in ligature) *15 VG20*; lower left corner *103* by Amerbach in red chalk
No watermark
Several thin spots

PROVENANCE: Amerbach-Kabinett

LIT.: Koegler 1926, no. 88, pl. XII – Lüthi 1928, 53, no. 167 – Schmidt/Cetto, 32, ill. 52 – Major/Gradmann 1941, 25, ill. 57 – Koegler 1947, 28, ill. 52 – Pfister-Burkhalter 1958, ill. 21 – Hugelshofer 1969, 64, no. 14 – Wirth 1979, 132, ill. 115

Graf rendered the scene of Christ's Flagellation in rapid, almost ecstatic strokes: as if in a battle scene, seven tormentors fall upon Christ, who, with bound hands and feet, curls around the base of a column, in pain and to protect himself from the blows and kicks of the bullies. The rope that tied his body to the front of the column could have been torn. Are the executioners now trying to pull Christ up with a new rope in order to render his body defenseless against their blows? This version of events, however, is controverted by the aggression of the tormentors, who are altogether unable to stop beating the figure on the ground.

Their hairstyle and headgear bring to mind depictions of German foot soldiers or Swiss mercenaries. One of them carries a large Swiss dagger. As in Graf's *St. Sebastian* (see cat. 144), firsthand experience of violence could have played a role here; Urs Graf was fascinated with savagery and had taken part in it during his military campaigns. In this way Christ's Flagellation becomes an example of human aggression, personified by the soldiers. The movement of the tormentors could have been influenced by the representation of a kind of human expression that

is found in the engravings of Mantegna and his circle, and that goes back to antique models. Urs Graf repeatedly based his works on Mantegna's; for example, he copied *Battle of the Sea Gods* (B. 17), which, however, certainly did not play a compositional role in this instance.[1]

The intensity of the actions and emotions of the tormentors is directly communicated by the character of the strokes, in which the jagged contours have a curled or at times open or shredded effect; by the shadows, which are indicated with open, sharp crosshatching; and by the deliberate confusion of the objects, which can be distinguished only with difficulty from broken branches, notably the straw or travel bale in the foreground, on which, as if by accident, Graf's dagger signet appears. Only in the quiet center of the event, Christ's body, did Graf model with small and meticulous strokes.

<div align="right">C.M.</div>

1. Kupferstichkabinett Basel, U. IV.57; Koegler 1926, no. 8. Matthias Grünewald used the same model for his *Flagellation* on the Tauberbischofheim altar panel, today in the Staatliche Kunsthalle in Karlsruhe. See Christian Müller, *Grünewalds Werke in Karlsruhe* (Karlsruhe 1994), 171, and cat. 99.

146 BATTLEFIELD, 1521

Basel, Kupferstichkabinett, U.X.91
Pen and black ink
211 x 317 mm
No watermark
Trimmed on all sides
Upper left corner *96* in red chalk by Amerbach

PROVENANCE: Amerbach-Kabinett

LIT.: Koegler 1926, no. 106 – Lüthi 1928, 92ff., ill. 61 – Major/ Gradmann 1941, 23, ill. 47 – Koegler 1947, XXIV, pl. 55 – Bächtiger 1974, 31ff., ill. 1 – Andersson 1978, 29ff. – F. Bächtiger, in: Exh. cat. *Manuel* 1979, no. 34 – E. Landolt, in: Exh. cat. *Erasmus* 1986, no. D5.7 – Exh. cat. *Amerbach* 1991, *Zeichnungen*, no. 90 – Exh. cat. *Zeichen der Freiheit* 1991, no. 44

Urs Graf repeatedly took up the theme of the mercenary in his drawings. No other artist painted so many facets of military life. This *Battlefield* is one of the examples in which Graf took the single figure that he normally favored and placed him in a larger scenic context. Bächtiger (1974) pointed out that the combat in the background could represent a specific event in which Urs Graf had taken part: the battle of Marignano. In this battle on 13 and 14 September 1515 against the French army of King Francis I, the Swiss Confederates met with one of their worst defeats. The Swiss defeat enabled the

French to regain their hegemony over Milan. A deciding factor was the engagement of the Stradiote, an Albanian cavalry unit in the service of the Venetians that succeeded in stemming the retreat of the French. From the left, a party of horsemen storms against the lances of the defending Confederates. Bächtiger was able to demonstrate that the other military details also conform closely to written accounts of the events. On 18 November 1521 Urs Graf was once more confronted with this scene: To incite them against the French, Cardinal Schiner led the Confederates to their unburied dead comrades on the battlefield. This may well have been the occasion for Urs Graf to address in a drawing the battle that he had managed to survive unharmed. It is questionable whether the dramatic rendering of the fallen soldiers in the foreground should be interpreted as a criticism of war or an indictment of the mercenary life, recalling the kind that Erasmus of Rotterdam formulated after the Swiss defeat. Neither the experience of this battle nor prohibitions could prevent Urs Graf from campaigning again. In other drawings, too, Urs Graf's interest in the fate of the fallen and mutilated soldiers, or the ones condemned to death, is characterized by the fascination that the observation of horror exercised on him. This is expressed by the mercenary, immediately above the torn drum on the left edge on which Urs Graf placed his signature. He apparently turns away from the dead with indifference, and fortifies himself from a bottle.

<div align="right">C.M.</div>

147 RECRUITMENT OF A LANDSKNECHT IN A GUILDHALL, C. 1521

Basel, Kupferstichkabinett, U.IX.17
Pen and black ink
213 x 320 mm
No watermark
Banderole, *Ich wet uch gern / ein wil zuo lossen / was ir rettend under disser rosen*; lower left corner, faded *63 [?]* in red chalk by Amerbach
Slightly trimmed on all sides

PROVENANCE: Amerbach-Kabinett

LIT.: Koegler 1926, no. 112 (c. 1523) – Major/Gradmann 1941, 23, ill. 46 – Koegler 1947, XXIV, pl. 54 – Pfister-Burkhalter 1958, no. 20 – Bächtiger 1971/1972, 205ff., esp. 232ff. – Andersson 1978, 30f., ill. 27 – Exh. cat. *Amerbach* 1991, *Zeichnungen*, no. 91

The event takes place in a Renaissance room, perhaps a guildhall. The participants sit around a long rectangular table. In the middle sits a Confederate soldier, who looks at the *Landsknecht* at the left end of the table. The depic-

146

147

tion probably alludes to the Franco-Swiss alliance signed in May 1521 (see Bächtiger). This explains why a Swiss soldier and a *Landsknecht* are sitting together at the same table. However, the alliance brought with it the risk that Confederates could be engaged against Confederates in the battle for Milan. As became known, the Germans intended to change sides during the battle in order to treat the Confederates to another heavy defeat like the battle of Marignano. The *Landsknecht,* therefore, is only pretending to deal with the soldier who is recruiting for the French king (on the bench at the right, with the fleur-de-lis on his arm), so as to make an impression on the Swiss soldier, who is probably spurred on by the pleasures of wine. A workman (left), a scholar, and a merchant (right) observe the event from the bench opposite them. The silly behavior of the *Landsknecht,* which all the others see through, is not only made apparent by the fool sitting next to the Frenchman, looking provocatively at the viewer, but also, and more important, by the figure of death opposite who, still unnoticed, suddenly joins the conversation. He bumps the *Landsknecht* in the back with his knee and thus clarifies what the man is getting himself into. Death holds a banderole inscribed with the words *I, too, like to hear what is said under this rose.* The reference is primarily to the rosette on the ceiling of the room. The then-current saying "to speak under the roses," however, meant to court disaster by bragging.

The sketchily executed drawing must have been made in 1521 or slightly later. C.M.

148 DROWNING MAN AND WOMAN COMMITTING SUICIDE, 1523

Basel, Kupferstichkabinett, U.X.93
Pen and black ink
330 x 226 mm
No watermark
Banderole, left center, monogrammed *VG* with dagger and dated *1523*; lower left corner *88 [?]* in red chalk by Amerbach

PROVENANCE: Amerbach-Kabinett

LIT.: Koegler 1926, no. 113 – Lüthi 1928, 114f., no. 143 – Major/Gradmann 1941, 22, ill. 43 – Koegler 1947, XXVf., pl. 65 – Pfister-Burkhalter 1958, no. 31 – Exh. cat. *Amerbach 1991, Zeichnungen,* no. 92 – Andersson 1994, 248, ill. 7

In this drawing, finely worked in close crosshatching to give it a picturelike effect, Graf depicted a man clinging to a dead and dilapidated branch of a tree so as not to drown in the rising waters. Before him stands a naked woman with long, blowing hair stabbing herself in the breast with a dagger, her head thrown back in an expression of pain. Graf intended to show both human beings propelled by their passions to a state of great affliction. Even though the drowning man looks as if he is about to go under, he seems to be overcome with desire for the woman he cannot have; she thrusts a dagger into her breast and thus gives expression to the pain that unfulfilled desire can unleash.

Graf investigated the theme of love in a whole series of drawings. On the one hand, like other artists of the Renaissance, he helped himself to the preconceived literary and iconographic themes that seemed to be particularly suited to depict the emotion of love and its consequences. For instance, the depiction of ill-matched lovers, or the series of so-called love slaves, such as Aristotle or Virgil in a basket, belongs to this group of themes. Contrary to earlier depictions of this subject, the interest of both artists and patrons shifted to the rendering of emotions, especially suffering. On the other hand, Graf created private mythologies that, as with our drawing, did not necessarily need to be based on literary examples or preconceived pictorial formulas, but that could well have been inspired by them. In this way the notion of "drowning in desire" was a common metaphor of the time (see Andersson 1994). The sarcasm with which he painted his prisoners of love is characteristic for Graf. C.M.

148

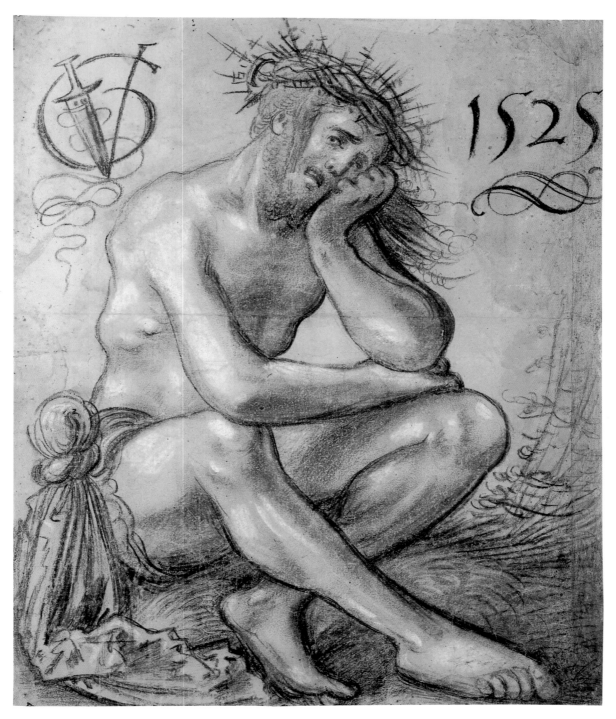

149

149 CHRIST AT REST, 1525?

Basel, Kupferstichkabinett, U.III.76

Black chalk; heightened with white chalk

450 x 350 widened to 370 mm

Watermark: heart in circle (impossible to identify in more detail, as the drawing is glued on paper)

Upper left, monogram *VG* with dagger colophon; upper right, the first three numbers of a date *152*

Slightly trimmed on all sides and glued on late 18th- or early 19th-century paper; the backing sheet projects about 20 mm on the right, where the drawing has been completed by another hand; terrain indications and *5* (date) are not authentic; corners torn off at the right and similarly retouched; right edge, several retouches in brown brush; surface rubbed; paper browned, soiled; several water stains

PROVENANCE: old inventory, not more closely identifiable

LIT.: *Handz. Schweizer. Meister,* pl. 38 – Koegler 1926, no. 119 – Lüthi 1928, no. 169 – Major/Gradmann 1941, 25f., no. 59 – Pfister-Burkhalter 1961, 178, ill. 7 – Andersson 1978, 11, ill. 11

Iconographically the depiction follows a type that is called Christ in misery (the Man of Sorrows) or Christ in repose (see cat. 164). Christ, abandoned in all his pain and sorrow, rests before his Crucifixion. He turns toward his viewers and charges them to reflect on the nature of the Passion.

The drawing occupies a unique position within the oeuvre of Urs Graf with respect to its format and technique. The latter appears to be altogether appropriate to the large format, and the way in which Urs Graf signed and dated his drawing, carrying it to picturelike completion, suggests that it was an independent work with the same function as a panel painting. Stylistically, it must belong to Graf's later works. The last digit of the date 1525 is probably not authentic, but may, however, have been present on the now missing piece and copied from it.

C.M.

NIKLAUS MANUEL DEUTSCH
(Bern c. 1484–1530 Bern)

Son of an apothecary from Piedmont, Italy, his original name was Niklaus Emanuel Alemann, which he changed to Niklaus Manuel Deutsch. Little is known about his artistic formation. His earliest identifiable works date from 1507. He first crops up as an artist in 1513. Active as painter (*Pyramus and Thisbe,* 1513/1514; *Dance of Death,* 1516/1517–1519/1520, exterior wall of the Franciscan church in Bern, destroyed in 1660; altar panels, Dominican church of Bern, 1518–1520), draftsman (*Witches,* c. 1513; *A Flute-Blowing Woman,* between 1514 and 1518; Pattern Books, c. 1517) and designer (glass paintings, works in metal, woodcuts, sculptures). After 1520, Reformation author and politician. In 1509 he married Katharina Frisching, daughter of a Bern councilor; in 1510 he became a member of the Bern Great Council; 1512 fellow-lodger of the guild of Obergerbern. In 1514 he bought a house in the Gerechtigkeitsgasse in Bern, which he occupied until his death. In the spring of 1516, despite a prohibition, Manuel—as one of the Bern mercenaries of Emperor Maximilian I—took part in the Milan campaign against the army of Francis I, king of France. In the spring of 1522, he went to upper Italy (defeat of the French-Swiss Confederation army) and probably became acquainted with Urs Graf, who also took part in both campaigns. In 1523 Manuel was elected governor of Erlach and retained that office for five years. In 1528, he became a member of the Lesser Council of Bern. Up to his death on 28 April 1530, he was active as a member of the government, military commander, champion of the Reformation, and mediator in Confederation controversies.

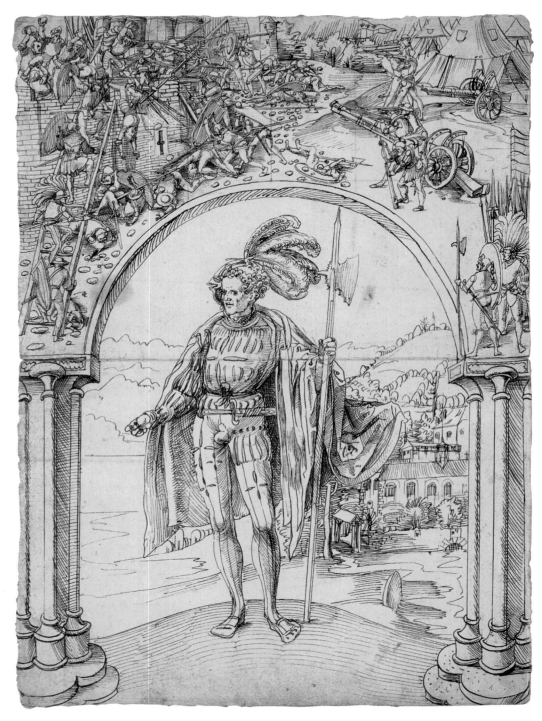

150

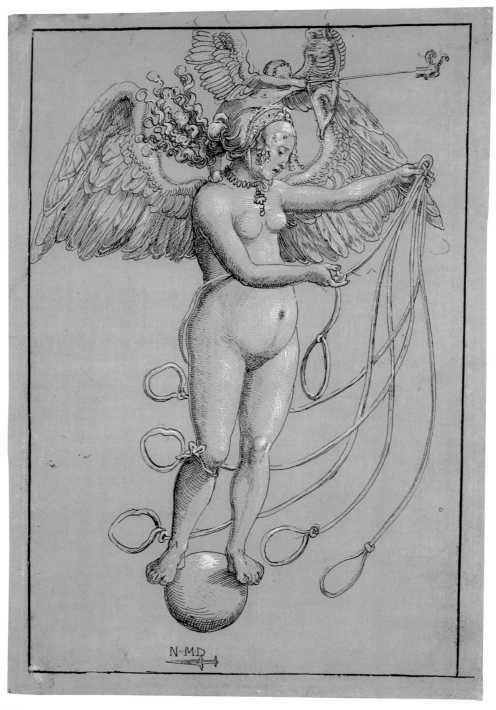

151

150 SWISS CONFEDERATION FOOT SOLDIER UNDER AN ARCH DECORATED WITH THE ASSAULT ON THE FORTRESS OF CASTELLAZZO, C. 1507

Basel, Kupferstichkabinett, U.VI.28
Pen and black ink; squared in black pencil on the arch
446 x 320 mm
Watermark: walking bear (similar to Lindt 18)
Lower left corner *24* in red chalk
Original paper edge; horizontal center fold, torn; glued on paper; somewhat browned and foxed; upper left, brown stain

PROVENANCE: Amerbach-Kabinett

LIT.: Von Tavel, in: Exh. cat. *Manuel* 1979, no. 139

The framing architecture of the drawing indicates it is a design for a window. It is not clear whether the drawing actually served that function or Manuel simply employed the formal structure of this genre. Von Tavel presumed that Manuel's battle scene depicts the assault on the fortress of Castellazzo near Genoa, in which the Confederation took part in 1507 on the side of Louis XII of France. The Confederation soldier under the arch holds the halberd that was normally carried by Swiss foot soldiers. According to Von Tavel, the cloak thrown over his shoulders serves as a sign of the elevation of the foot soldier to nobleman, which to be sure seems a very risky idea. The tip of the halberd points at a fallen halberdier, the sword at what may be a monastery, or, possibly, a cemetery. C.M.

151 LADY VENUS, C. 1512

Basel, Kupferstichkabinett, U.X.2
Pen and black ink; heightened in white; on orange-brown prepared paper
314 x 217 mm
Watermark: walking bear (similar to Lindt 22)
Lower left corner *4* in old red chalk; signed lower center *N·M·D* with a horizontal dagger
Mounted on paper; edges somewhat rubbed; white oxidized in places

PROVENANCE: Amerbach-Kabinett

LIT.: Koegler 1930, no. 31 – Von Tavel, in: Exh. cat. *Manuel* 1979, no. 158

This Venus is the earliest surviving female nude drawn by Manuel in this technique. Several attributes underscore the nature of the woman. She has two large wings, stands on a sphere, and holds six nooses in her hands. A winged Cupid perches on her shoulders, taking aim with his bow and arrow. The tip of the arrow consists of a small fool's cap. The attributes of the goddess of love go back to several kinds of models. Allegorical conflations of this kind were very popular in the early sixteenth century. The sphere is usually an attribute of Fortuna and refers to the mobility of the personification, especially her fickleness and transience. The great wings point in the same direction. In late medieval allegories of love, the queen of love, Lady Minne, could appear as a winged female; occasionally this attribute also had a negative connotation, as it could refer to her fickleness. In the present instance, speed is expressed by the way her [Fortuna's] hair flutters behind her. The nooses in her hand allude to her facility at tying the "bonds of love" and binding men and women with them. The winged, arrow-shooting Cupid underlines the fleetness of the love relationship, which can turn its targets into fools.

Manuel was inspired by several models within this range of themes. He was probably aware of late medieval allegories of love and their depictions of Lady Love and Lady Venus. For instance, there is Sebastian Brant's *Narrenschiff* of 1494, with its illustration drawn by Dürer of Lady Venus leading fools on ropes, accompanied by an arrow-shooting Cupid and by Death (Schramm 1124). Manuel got his inspiration for the large, nude Venus who fills almost the entire sheet from Lucas Cranach's chiaroscuro woodcuts of 1506, that is, the 1509 depiction of Venus appeasing Cupid. Dürer's engraving of *Nemesis* (M. 72), with which Manuel was also familiar, shows further analogies of form and content: the personification of "just resentment at excessive luck," as Hesiod called it, or the divinity of retribution, who, as with Manuel, combines the attributes of different personages, that is, Venus and Fortuna. The naked, winged woman stands on a sphere above an expansive landscape, holding a veil and a bridle in one hand, and a chalice in the other. Finally, Manuel may have also known Altdorfer's engraving B. 59 from the year 1511, which embodies a similar iconographic coupling of Venus, Cupid, and Fortuna. With respect to the Cupid standing on the shoulders of Venus, Von Tavel referred to the engraving in the *Istoria Romana* of Jacobus Argentoratensis (Hind 2, 433f.), in which an equestrian wears a helmet that is similarly decorated.

Von Tavel proposed a date of about 1512 based on the mentioned examples, stylistic grounds, and, finally, the relatively small signature. Urs Graf employed the same motifs in his drawings: see, for example, the sheets in the Kupferstichkabinett Basel, depicting Fortuna (Koegler 1923, no. 69; Major/Gradmann 1941, no. 64) and Venus (Koegler 1923, no. 135; Major/Gradmann 1941, no. 65).

C.M.

152 STUDY FOR A FOOLISH VIRGIN, c. 1513/1514

Verso: study for Achatius
Basel, Kupferstichkabinett, U.X.23
Black chalk; verso, black and red chalk
307 x 210 mm
Watermark: Grapes (variant of Briquet 13015)
Lower left corner *20.* in red chalk; upper right *23* in pencil; lower left, signed *N* and *MD* (in ligature) with the dagger below
Foxed

PROVENANCE: Amerbach-Kabinett

LIT.: Koegler 1930, no. 17 – Exh. cat. *Manuel* 1979, 328f., no. 163

Besides this drawing, four additional studies of this theme using the same technique have survived, which could have been drawn about 1513/1514. They may have belonged to a series of ten drawings treating the parable of the wise and foolish virgins (Matthew 25:1–13). Possibly the sheets served as preparatory works for a woodcut series similar to the one Manuel did in 1518 (Exh. cat. *Manuel* 1979, nos. 241–250), which is not, however, based on these drawings. Manuel seized on the parable as an occasion to relate the behavior of the "foolish virgins" to his own time. In our example, one of them demonstrates that she has no more oil in her lamp. The look on her face reveals, however, that she is not at all distraught by this. The young woman's figure is defined by energetically drawn outlines. By smudging the chalk, Manuel indicated the light and dark zones, thereby creating a soft internal modeling. Traces of an alternative preparatory drawing for the hand gestures and disposition of the drapery and feet are still visible.

Urs Graf also occupied himself with this subject in one of his drawings. This gave the artist the opportunity to ironically engage the accepted morality. Thus several virgins only pretend to complain that their lamps are empty, while a pregnant one pours out her oil purposely or indifferently.

The verso of our drawing includes a study of the head of St. Achatius reworked by another hand. This saint is depicted on the interior of an altar wing in the Bern Kunstmuseum (inv. 1131; Exh. cat. *Manuel* 1979, no. 74).

C.M.

153 ROCKY ISLAND, c. 1515

Berlin, Kupferstichkabinett, KdZ 14698
Pen and black ink
259 x 199 mm
Watermark: indecipherable
Trimmed on all sides, especially at the top, right, and bottom; horizontal fold above the middle; soiled and foxed

PROVENANCE: Archbishop Friedrich von Habsburg Coll., Czeczowiczka; acquired in 1930

LIT.: Koegler 1930, no. 104 – Exh. cat. *Manuel* 1979, no. 177 – *Handbuch Berliner Kupferstichkabinett* 1994, no. III.60

We look down from a high vantage point on a landscape that begins immediately at the lower edge, with a steep cliff towering in the foreground. Although this drawing was cut on all sides, the pictorial format cannot ever have been much different. Whereas mountains are indicated in the left background, the deeper recession on the right is vague, as the depiction breaks off abruptly behind a bridge. Even so, the drawing does not give the impression of being unfinished, as Manuel used stylistic means to differentiate between the surrounding landscape and the mountain. The rock alone is worked out in painstaking and precise detail. Only gradually do we become aware of the details, such as the castle on the promontory at the right, small roads that have been hewn into the wall of the cliff, and the vegetation consisting of various trees that appear especially windswept at the top. Also curious are the changes in proportion; on the one hand, the rock looms gigantically in the landscape, but on the other, its size is reduced by the trees at the top, which suddenly look too large. Manuel depicted a fantasy landscape replete with a life of its own. It is nevertheless convincing thanks to the rendering of the reflections on the water and the play of light on the cliff and landscape. This reinvention of nature, with its perspectival leaps and its alterations in proportion, makes it comparable to miniature landscapes of the kind we encounter on goldsmith works, such as chalices, or model-like representations of mountain works or other such artfully constructed details of nature that became a beloved theme for objects in cabinets of curiosities. The Basel Kupferstichkabinett has a very similar drawing by Manuel depicting a rocky island, which must have been drawn about the same time (U.X.19; Exh. cat. *Manuel* 1979, no. 176). Von Tavel dated both drawings "before 1515," in part through comparison to a landscape with a rock arch by Urs Graf, dated 1514, in the Basel Kupferstichkabinett (Koegler 1923, no. 53; U.X.65).

C.M.

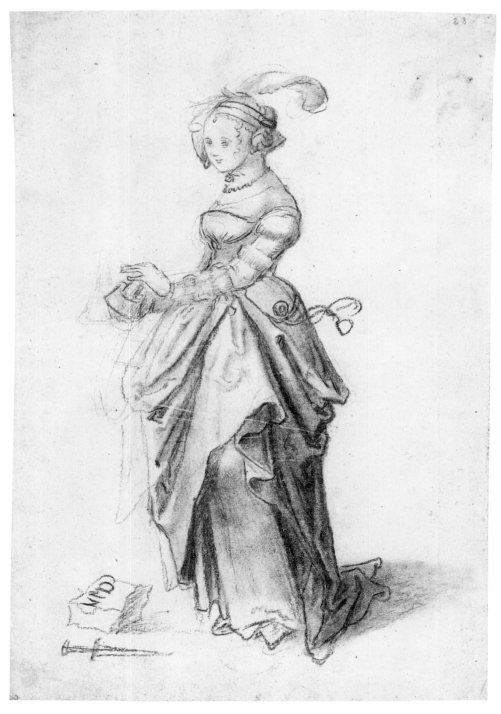

152

Verso (152)

153

154 Pattern Book, Six Small Wooden Panels with Drawings on Recto and Verso, c. 1517

Basel, Kupferstichkabinett, Inv. 1662.74
Silverpoint on wood prepared with white ground, some white heightening; backgrounds of inv. 1662.74.5, 1662.74.6 (Exh. cat. *Manuel 1979*, nos. 194 recto, 195 verso) later covered in black; recto and verso of these panels in different techniques
107 x 80 mm (each)

PROVENANCE: Amerbach-Kabinett

LIT.: C. Grüneisen, *Niclaus Manuel, Leben und Werke eines Malers und Dichters, Kriegers, Staatsmannes und Reformators im sechzehnten Jahrhundert* (Stuttgart/Tübingen 1837), 187 – B. Haendcke, *Nikolaus Manuel Deutsch als Künstler* (Frauenfeld 1889), 51 – P. Ganz, *Zwei Schreibbüchlein des Niklaus Manuel Deutsch von Bern* (Berlin 1909) – Koegler 1930, nos. 43–54 – Exh. cat. *Manuel 1979*, nos. 190–195 (with additional literature)

In his inventory (A) of 1577/1578, Basilius Amerbach listed three "Schreibbüchlein" by Niklaus Manuel.[1] Two of these apparently contained six "pages" each, drawn with a stylus. The panels of the third were blank. The two booklets, comprising twelve wooden panels together, were kept in this bound form until the early nineteenth century (see Grüneisen 1837). They were separated toward the end of the century, presumably in order to exhibit the drawings in a museum setting (see Haendcke 1889). As engaging as the assumption may be that the panels by Manuel, drawn recto and verso, were used like a sketchbook, the holes that were later and in part carelessly drilled through the already inscribed panels suggest that this cannot have been their original purpose. Moreover, in the case of two of the small panels, the drawings are upside-down relative to the recto. Abrasions on the edges support the hypothesis that they were either framed individually or with several others.

The small panels belonged to the reference material of Manuel's workshop; they therefore served as pattern leaves. It is also possible that they were shown to clients during negotiations. They are in the tradition of medieval pattern collections, of which they could be considered the latest surviving examples. Manuel's monogram and the use of individual motifs in other works suggest a genesis about 1517.

With two exceptions (Exh. cat. *Manuel 1979*, no. 190, no. 195), the depictions on both the front and back belong to a single group of motifs.

Schreibbüchlein 1662.73: twelve figures of saints (Exh. cat. *Manuel 1979*, no. 184), twelve male figures (Exh. cat. *Manuel 1979*, no. 185), models for the "crossroads" theme (Exh. cat. *Manuel 1979*, no. 186), six female drapery figures and six female nudes (Exh. cat. *Manuel 1979*, no. 187), six horizontal panels with ornamentation (Exh. cat. *Manuel 1979*, no. 188), eight depictions of warfare (Exh. cat. *Manuel 1979*, no. 189).

Schreibbüchlein 1662.74: two vertical ornamental panels with hunting and animal motifs, and love scenes (Exh. cat. *Manuel 1979*, no. 190), vertical panels with ornaments and battle scenes (Exh. cat. *Manuel 1979*, no. 191), four vertical ornamental panels with peasant couples among plant arabesques (Exh. cat. *Manuel 1979*, no. 192), models for vertical ornamental panels with putti amid plant arabesques (Exh. cat. *Manuel 1979*, no. 194), small panels with Death and the maiden, and grotesque figures (Exh. cat. *Manuel 1979*, no. 195). The latter cannot have been a pattern panel. It deviates from the others in technique and was presumably an independent miniature painting.

C.M.

1. "Schribbuchlin grißen NM mit/silberin schlöslin, jedes 6 bletlin" and "Ein ander mit 1. silber schlöslin suber" (see Exh. cat. *Amerbach 1991, Beiträge,* 129).

Two Vertical Ornamental Panels with Hunting and Animal Motifs, and Love Scenes

Basel, Kupferstichkabinett, Inv. 1662.74.1

LIT.: Koegler 1930, no. 51f. – Exh. cat. *Manuel 1979*, no. 190

In the case of these panels, recto and verso show thematically divergent motifs. The recto, left, depicts a hunter with his dog surrounded by plant arabesques and a hare over them, and the right, two dogs and a deer. On the verso, from left to right, arranged horizontally in the upper zone are a *Landsknecht* with a camp follower and a woman embraced by Death. Like the arched gate in the background, this "kiss of Death" recalls Manuel's panel, painted on both sides, in the Basel Kunstmuseum, which depicts Bathsheba in her bath on one side, with a similar gate in the background, as well as a kiss of Death on the other side (Basel, Kunstmuseum, inv. 419).

The scene below touches on the themes of witches and magic: a man with a scimitar kneels before an incense basin, above which a woman has an attendant open another vessel. The nude girl standing at the right edge could be an apparition conjured up by magic.

C.M.

Vertical Panels with Ornaments and Battle Scenes

Basel, Kupferstichkabinett, Inv. 1662.74.2

LIT.: Koegler 1930, no. 43f. – Exh. cat. *Manuel* 1979, no. 191

One side shows two vertical ornamental panels with candelabras, playing children, and grotesques. On the upper right panel, a woman holds a coat of arms displaying Manuel's monogram. Further down, a small tablet has the date 1501; this could refer to an Italian (?) model employed by Manuel that might have born this same date. The other side, upside down with respect to the first side, shows battle scenes on two vertical strips, combined with ornaments on the right one. They may be related to the group of motifs showing the storming of fortifications. Directly comparable, for instance, is Manuel's stained glass window design with a depiction of the struggle for the Castellazzo castle in the upper register (see cat. 150).

C.M.

Four Ornamental Panels with Peasant Couples among Plant Arabesques

Basel, Kupferstichkabinett, Inv. 1662.74.3

LIT.: Koegler 1930, no. 49f. – Exh. cat. *Manuel* 1979, no. 192

Dancing peasants were a popular theme in the early sixteenth century, both in facade paintings, such as Holbein's Haus "Zum Tanz" in Basel (see cat. 166), and in prints and drawings used in book and glass painting. Another category are the Shrovetide farces, which Manuel himself composed (see Exh. cat. *Manuel* 1979, no. 332, no. 334, no. 338). Much as in Manuel's drawing, the peasants were usually shown as crude and unbridled creatures, whose simple or coarse dress or exaggerated gestures stood out from the dignified deportment of city dwellers. This distance between ranks—analogies are offered in the themes of foot soldiers and camp followers or of the so-called "wild men"—is sometimes related to an ironic or nostalgic point of view. Manuel's drawing alludes, at most indirectly, to the armed clashes leading up to or during the peasant rebellion; it finds expression here only incidentally, in the individual peasants bearing large swords and daggers.

C.M.

Four Vertical Ornamental Panels with Bears

Basel, Kupferstichkabinett, Inv. 1662.74.4

LIT.: Koegler 1930, no. 45f. – Exh. cat. *Manuel* 1979, no. 193

On the recto of the panel, bears play with hoops; on the verso, they pick fruit from a tree and play amid plant arabesques. In the lower right, one of them has caught a pig. The motifs remind one of the popular depictions of putti playing amid plant arabesques, which were so often employed at that time in glass paintings as well as in book decoration. These depictions of bears may have been inspired by this kind of motif. That Manuel was also satirizing human interaction becomes clear from the example, on the verso upper right, of the bear who attacks another with a spade on which the artist has inscribed his monogram with dagger signet.

Related bears clambering about with hoops are found, for instance, on the canton window of Bern in the City Hall of Basel (Giesicke 1994, 80ff.).

C.M.

Four Vertical Ornamental Panels with Putti amid Plant Arabesques

Basel, Kupferstichkabinett, Inv. 1662.74.5

LIT.: Koegler 1930, no. 47f. – Exh. cat. *Manuel* 1979, no. 194

On the front, putti play amid plant arabesques. Another rides on a snail and tilts at a pinwheel. The black background of this drawing was added later. The verso shows wingless infants making rhythmic movements amid the plant arabesques.

C.M.

Small Panels with Death and the Maiden, and Two Grotesque Figures

Basel, Kupferstichkabinett, Inv. 1662.74.6
Recto, pen and black ink; colored and heightened in white on a black ground; verso, silverpoint with pen and black ink on a black ground added later

LIT.: Koegler 1930, no. 53f. – Von Tavel, in: Exh. cat. *Manuel* 1979, no. 195

Death, represented as a decomposing, naked corpse, peeks under the dress of a maiden while keeping one eye on the viewer. The emotions of the maiden are most obviously expressed in her long windblown hair and her raised hands, whereas her facial expression remains relatively composed. The theme may be traced back to depictions

of the dance macabre, in which—as in Manuel's *Dance of Death* (Exh. cat. *Manuel* 1979, no. 111)—Death appears as the lover of a young woman. Von Tavel pointed out that Manuel's formulation is ambiguous. It is possible that it is not just the maiden who is being assaulted by Death, but any man who gives in to the temptations of a woman and then "dies in her lap." This death can thus be interpreted not only symbolically as a reference to the elevated emotion of love, which is comparable only to death, but also concretely as a reference to the danger of being infected by the then-rampant syphilis.[1]

The recto of the panel shows two grotesque composite creatures. On the left stands a figure with a bearded male head whose lower body is feminine, and, apparently, pregnant, but whose upper body is manly. The entire figure wears women's clothes and holds a spindle in the right hand. The figure on the right has a male body and head, but is also dressed as a woman. The raised right hand rests on a lance; a Swiss dagger hangs from the waist.

The depiction has rightly been classed in the category of the topsy-turvy world. The spindle and the distaff that looms up between the two figures could also allude to the male-female role reversal. The theme of Hercules in Omphale's home would be comparable, for instance. Possibly Manuel also intended to satirize the obsessive desire for finery and the vanity of mercenaries, at which Urs Graf also poked fun.[2] The beard of the left figure reminds one of that worn by the *Landsknechte,* while the right figure and its arms are more reminiscent of a Swiss mercenary. Both appear here in women's clothes and are thereby made to look ridiculous. 　　　　C.M.

1. For this theme, see D. Koepplin, "Baldungs Basler Bilder des Todes mit dem nackten Mädchen," *ZAK* 35 (1978), 234–241.
2. See, for instance, his drawing of the "feathered camp follower" of 1523; Koegler 1926, no. 110; Kupferstichkabinett Basel, U.X.95.

155　THE VIRGIN AND CHILD BEFORE A COLUMN, C. 1518

Berlin, Kupferstichkabinett, KdZ 1378
Pen and black ink; heightened in white on orange-red prepared paper
310 x 210 mm
Watermark: indecipherable
Lower right, *NMD* (in ligature); below, Swiss dagger with ribbon
Irregularly trimmed and glued on thin cardboard; lead-white partially oxidized; slightly spotted

PROVENANCE: Von Nagler Coll. (Lugt 2529); acquired in 1835

LIT.: Schneeli 1896, 93, pl. XI – Bock 1921, 65 – Koegler 1930, no. 112 – Exh. cat. *Dürer* 1967, no. 150 – Von Tavel, in: Exh. cat. *Manuel* 1979, with no. 181

The Virgin sits in front of a column, close to the viewer and raised by a stepped podium. Because of the low viewpoint, the background consists of only the sky, in which a couple of clouds, drawn in thin brush, are piled up. The heavy capital of the column is decorated with shells and crowned by angels whose wings seem to sprout from their heads. With a slight movement of her upper body, as if she has just looked at the viewer, Mary bends lovingly to the small Christ who has rushed up to hand her a flower. It might be a carnation, which prefigures Christ's passion.[1] The markedly low viewpoint, which creates a precipitous foreshortening of the pictorial space, and the detail selected by Manuel leave the viewer very much in doubt about the true configuration of the architecture and its connection with its surroundings. Podium and column share the task of raising the Virgin and drawing our attention to her status as saint and Mother of God. For that reason, the column could allude to Mary's role as *Columna novae legis* assigned to her by the church fathers.[2] Von Tavel rated the sheet among the most mature of Manuel's chiaroscuro drawings. It could have originated about 1518. A comparison with Hans Holbein the Younger's drawings in the same technique, above all his *Holy Family* and the iconographically related *Virgin between Columns* (see cats. 163, 165; Müller 1996, no. 109f.), provide no additional benchmark for dating. Even if Manuel did not see these drawings, it is possible that he saw Holbein's designs for facade paintings and glass paintings or the resultant works, as well as book illustrations by Holbein, and was inspired by their practice of showing figures from a low viewpoint and in close association with architecture. 　　C.M.

1. See *Marienlexikon,* R. Bäumer and L. Scheffczyk, eds. (St. Ottilien 1992), 4, 500f.
2. *Marienlexikon,* 5: 620f.

155

156

156 HALF-LENGTH PORTRAIT OF A YOUNG WOMAN IN PROFILE, c. 1518

Basel, Kupferstichkabinett, U.X.10
Colored and black chalk (or charcoal); touches of gray and red wash
243 x 193 mm
No watermark
Trimmed on all sides and lined with japan paper; surface rubbed in places; pieces of the edges and corners missing; several small holes and thin areas; water stains

PROVENANCE: Amerbach-Kabinett

LIT.: Koegler 1930, no. 76 – Von Tavel, in: Exh. cat. *Manuel* 1979, no. 199

Manuel stressed the beauty of this young woman by depicting her head in profile. She does not establish eye contact with viewers and yet turns her upper body to them, thus creating a strange tension that makes her particularly attractive. Von Tavel proposed a date about 1518, in part because of a relationship to the *Wise Virgin* of Manuel's woodcut series of 1518 (Exh. cat. *Manuel* 1979, no. 241).

The Basel Kupferstichkabinett has a stylistically and technically related drawing by Manuel that may well depict the dying Lucretia (see ill.).[1] This appropriately half-length depiction of a nude woman with a stab wound in the region of her heart could have come about in the same context as our drawing. It is, in any case, not clear whether Manuel strove for a portraitlike appearance and used the same model in both instances, or whether they

Niklaus Manuel Deutsch, *Dying Lucretia,* 1518

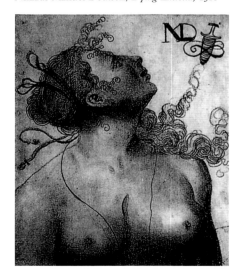

are idealized female portraits. The "dying Lucretia" looks toward the upper right, at Manuel's monogram with the dagger signet that touches one of her locks. Manuel may well have been alluding to a love affair. Concomitantly, the woman's emotional expression and the wound on her breast could be pictorial renderings of her state of mind (see Koerner 1993, 143ff.). C.M.

1. Kupferstichkabinett Basel, U.X.10a; Exh. cat. *Manuel* 1979, no. 198.

157 THE TEMPTATION OF ST. ANTHONY, c. 1518 – 1520

Basel, Kupferstichkabinett, Inv. 1927.113
Pen and black ink over black pencil
295 x 210 mm
Watermark: walking bear (variation on Briquet 12271)
Upper right, signed *N* and *MD* (in ligature); dagger with loops

PROVENANCE: Amerbach-Kabinett (1813–1927 Basler Kunstverein, in: *Künstlerbuch,* 1)

LIT.: Koegler 1930, no. 69 – Exh. cat. *Manuel* 1979, no. 197

A splendidly dressed beauty offers food to the saint, who has isolated himself in retreat in order to meditate. Impressed by the appearance of this beauty, he lowers his left hand, which holds a crucifix. The saint makes a defensive gesture with his right hand to resist the devil, who is revealed to the viewer by the claws that peep out from under the hem of her dress. Von Tavel likened the drawing to the Bern St. Anthony altarpiece, which was produced between 1518 and 1520. This altarpiece presents a similar rendering of the temptation of Anthony by a beauty with devil's talons.

Manuel was inspired in these depictions by Albrecht Altdorfer's engraving of 1506 showing the temptation of hermits (B. 25)—one of whom makes a similar defensive gesture—and by Lucas van Leyden's *Temptation of St. Anthony* of 1509 (B. 117). C.M.

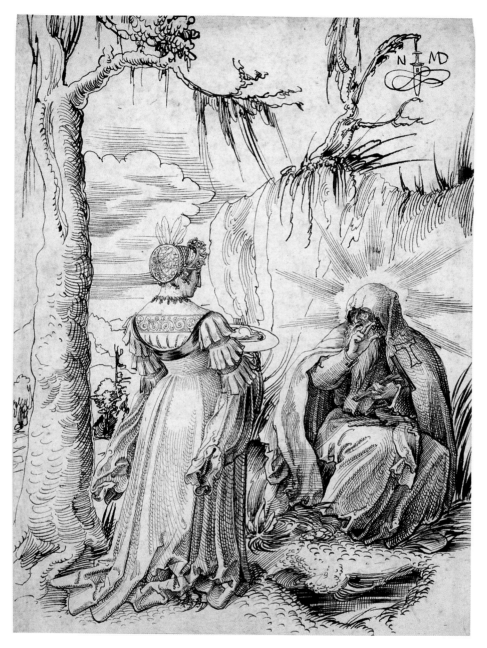

157

AMBROSIUS HOLBEIN

(Augsburg c. 1494–c. 1519?)

Ambrosius was about three years older than his brother
Hans the Younger. His age is given as fourteen years on the
silverpoint drawing by Hans Holbein the Elder portraying
both sons (see cat. 37). Both boys received their first in-
struction in their father's workshop in Augsburg. Very few
paintings by Ambrosius are known, principally portraits in
Basel from about 1516 and one, in St. Petersburg, from
1518. About 1515 Ambrosius stayed in the region of Lake
Constance. At that time he created the wall paintings for
the banqueting hall of the monastery of St. George in Stein
am Rhein, which he executed together with the painter
Thomas Schmid (c. 1480–1550/1560) of Schaffhausen
(*Death with Female Flute Player,* signed AH) and others.
Toward the end of 1515, Ambrosius and Hans worked in
Basel on the marginalia for a printed edition of *In Praise of
Folly* by Erasmus of Rotterdam. Another collaborative
effort was a panel, painted on both sides, that was presum-
ably intended as an advertisement for the Basel Latin school
of Oswald Geisshüsler (called Myconius). In late July of
1516, Ambrosius spent time in the house of the painter
Hans Herbster (1470–1552) in Basel. In February 1517 Am-
brosius became a member of the Basel painters' guild. From
1516 on he created numerous book illustrations for publish-
ing houses in Basel. In June 1518 the Basel goldsmith Jörg
Schweiger (died 1533/1534 in Basel) vouched for Ambrosius
when the latter acquired his Basel citizenship. Nothing
more is heard of him after 1519; apparently he died young.

158 PORTRAIT OF A BOY, C. 1516

Basel, Kupferstichkabinett, Inv. 1921.44
Silverpoint on white prepared paper; touches of red chalk and
white heightening (nose, eyes, hair); framing line in pen and
brown ink by a later hand
144 x 100 mm
No watermark
Lower left, collector's mark ER (Lugt 897)
Somewhat soiled; torn at the left behind the head; foxing

PROVENANCE: Eugène Rodrigues Coll., Paris; acquired in 1921

LIT.: Hes 1911, 117f., pl. XXVIII – *Société de Reproduction des
Dessins de Maîtres,* 4ᵉ année (Paris 1912) (Hans Holbein the Elder
or Ambrosius Holbein) – *Catalogue d'une vente importante de dessins
anciens. Collection R,* Auct. cat. Frederik Muller Amsterdam, sale
7.12.–13.1921, 10, no. 44, pl. XVI – M.J. Friedländer, "Die
Versteigerung der Sammlung Rodrigues," *Kunstchronik und
Kunstmarkt* 45/46 (1921), 832f. – *Öff. Kunstslg. Basel. Jahresb.,* n.s.
18, 1921, 8f., 12 – *Malerei der Frührenaissance in der Schweiz,* ed. P.
Ganz (Zurich 1924), 96 – Koegler 1924, *Ernte,* 63f., ill. 8 – *Öff.
Kunstslg. Basel. Jahresb.,* n.s. 22 (1925), 7 – Hugelshofer 1928, 38f.,
pl. 53 – Schilling 1954, 15, ill. 17 – Exh. cat. *Holbein* 1960, no. 94,
ill. 40 – Hp. Landolt 1972, no. 69 – Müller 1996, no. 1

This is the preparatory drawing for *Portrait of a Boy* in the
Öffentliche Kunstsammlung Basel (inv. 295; see ill.). The
pendant (inv. 294) is also in Basel, and its preparatory
drawing is now in the Graphische Sammlung Albertina
(Albertina Vienna 1933, no. 340). Both paintings may date
from about 1516. The frame for inv. 294 is related to the
columns forming left and right boundaries for the Basel
Double Portrait of Jakob Meyer and Dorothea Kannengiesser by
Holbein the Younger (inv. 312; see cat. 161). C.M.

Ambrosius Holbein, *Portrait of a Boy,* c. 1516

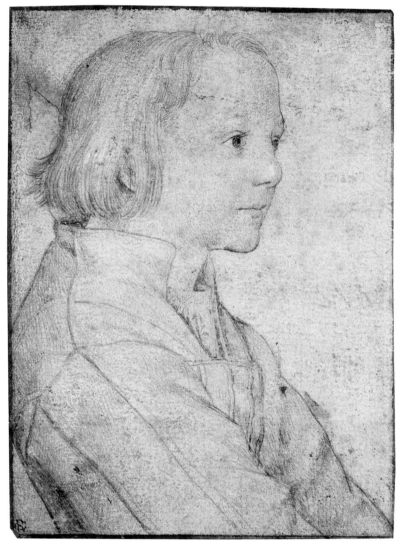

158

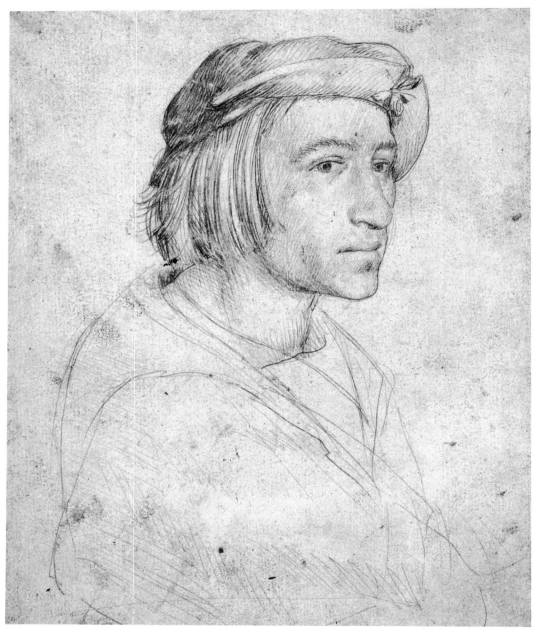

159

Verso (159)

159 PORTRAIT OF A YOUNG MAN, c. 1516

Verso: sketches of feet, heads and half-figure of a
deformed person, c. 1516
Basel, Kupferstichkabinett, Inv. 1927.110
Silverpoint on white prepared paper
191 x 157 mm
Watermark: walking bear (fragment, Lindt 18)
Small soiled areas

PROVENANCE: Amerbach-Kabinett; in 1813 to the Künstler-
vereinigung (since 1863, Basler Kunstverein); returned to the
Öffentliche Kunstsammlung Basel in 1927

LIT.: Woltmann 2, no. 106 (Hans Holbein the Elder) –
Frölicher 1909, 15 (close to Ambrosius Holbein) – Hes 1911,
108, pl. XXIV (Ambrosius Holbein) – *Handz. Schweizer.
Meister,* pl. II,2 (Ambrosius Holbein, c. 1516) – Chamberlain 1:
51 (Ambrosius Holbein, identical to Darmstadt portrait) –
Koegler 1924, 329 (Ambrosius Holbein) – Schmid 1924, 337
(identical to Darmstadt portrait, Hans Holbein the Younger) –
L. Baldass, "Niederländische Bildgedanken im Werke des
älteren Hans Holbein," *Augsburger Kunst der Spätgotik und
Renaissance* [Beiträge zur Geschichte der deutschen Kunst, 2]
(Augsburg 1928), 188, ill. 134 (Hans Holbein the Elder) – A.L.
Mayer, "Zum Werk des Älteren Holbein," *Pantheon* 3 (1929),
156 (Hans Holbein the Younger) – Schmid 1941/1942, 24f.
(Hans Holbein the Younger) – Schmid 1945, ill. 4 (Hans
Holbein the Elder) – Ganz 1950, ill. on 197, with no. 24 (Hans
Holbein the Younger) – P.H. Boerlin, in: Exh. cat. *Holbein*
1960, no. 103, ill. 43 (Ambrosius Holbein, c. 1516) – Exh. cat.
Amerbach 1991, *Zeichnungen,* no. 95 – Müller 1996, no. 2

Hans Holbein the Elder, Hans Holbein the Younger, and
Ambrosius Holbein have all been proposed as the author
of this drawing. Boerlin was the last to come out in favor
of Ambrosius Holbein: the soft modeling of the face in
close parallel strokes and the painterly, tonal appearance
speak most clearly for him. The portrait drawings by the
father may well feature similar free outlines of the drapery
passages, but the heads have a significantly more compact
effect and the physiognomies are more sharply captured.
Although the turn to the viewer and the somewhat force-
ful gaze are more characteristic of Hans Holbein the
Younger, a self-consciousness remains discernible that
is more like the work of Ambrosius. The identification
with a *Portrait of a Youth* in Darmstadt (Exh. cat. *Holbein*
1960, no. 88), postulated by Chamberlain, Schmid (1941/
1942), and Baldass, is untenable because of the clear
physiognomic differences (see Boerlin). The drawing may
have been executed shortly after the two Basel portraits
of boys (invs. 294, 295), in about 1516. The sketches on
the verso have hardly any parallels in Ambrosius' work but
could, nevertheless, be by his hand. C.M.

160 PORTRAIT OF A YOUNG MAN, 1517

Basel, Kupferstichkabinett, Inv. 1662.207a
Silverpoint on white prepared paper; reworked in red chalk
and dark gray and brown wash
201 x 154 mm
Watermark: small bull's head (fragment type, Piccard 1966,
part VII, 111ff.)
Top, signed ·*AH*· (in ligature) and dated *1·5·1·7·*; lower left,
27 in pencil
Removed from old paper mount; trimmed on all sides; right
edge, several tears and missing areas; lower right corner torn
off; horizontal crease in the center and several abraded areas

PROVENANCE: Amerbach-Kabinett

LIT.: A. v. Zahn, "Die Ergebnisse der Holbein-Ausstellung
zu Dresden," *Jb. f. Kwiss.* 5 (1873), 197f. (sitter identical to
the one of Leningrad portrait) – Woltmann 1, 135; 2, no. 8 –
E. His, "Ambrosius Holbein als Maler," *Jb. preuss. Kunstslg.* 24
(1903), 243f., ill. on 244 – Frölicher 1909, 12 – Hes 1911, 110ff.,
pl. XXV (sitter not identical to that of Leningrad portrait) –
Chamberlain 1, 62 – Koegler 1924, *Ernte,* 58f. – Koegler
1924, 329 – K. T. Parker, *Drawings of the Early German Schools*
(London 1926), 36, no. 67 – Schmidt/Cetto, ill. 66, XXXIf. –
Schilling 1954, 6, 15, ill. 18 – Exh. cat. *Holbein* 1960, no. 95, ill.
46 – Exh. cat. *Swiss Drawings* 1967, no. 43 – Hugelshofer 1969,
54 – Gerszi 1970, 93, ill. 38 – Hp. Landolt 1972, no. 70 – Exh.
cat. *Amerbach* 1991, *Zeichnungen,* no. 96 – Müller 1996, no. 4

Date and monogram as well as the lavish technique and
the detailed finish of the drawing allow us to speak of a
picturelike finished work. It is probably not a preparatory
drawing for a painting. Von Zahn, Woltmann, and His
wanted to identify the sheet as a study for the 1518 *Portrait
of a Twenty Year Old* in St. Petersburg (Exh. cat. *Holbein*
1960, no. 84), but the two sitters resemble each other only
slightly. C.M.

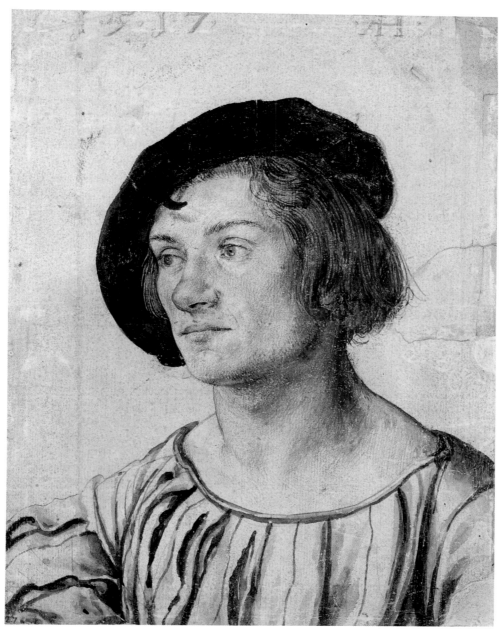

160

HANS HOLBEIN THE YOUNGER

(Augsburg 1497/1498–1543 London)

On the 1511 silverpoint double portrait of his sons Ambrosius and Hans (see cat. 37), Hans Holbein the Elder also recorded their ages; Hans was then fourteen years old, Ambrosius presumably three years older. The first training of both lads most likely took place in the Augsburg workshop of their father. Toward the end of 1515, both are recorded in Basel for the first time, presumably to take advantage of that city's flowering publishing industry. The first drawings by Hans and Ambrosius are found in a printed copy of *Praise of Folly* by Erasmus of Rotterdam. The double portrait of 1516 of the mayor of Basel, Jakob Meyer, and his wife, Dorothea Kannengiesser, was one of the earliest commissioned works by Hans, possibly arranged by the painter Hans Herbster (1470–1552), with whom Hans and Ambrosius were apprenticed as journeymen for a short time. The first works for the Basel publishing house of Johann Froben date from 1516. Between 1517 and 1519 Hans painted the facade of the Hertenstein house in Lucerne. Several authorities assume that Hans also traveled to Italy at about this time, but his knowledge of Lombard and Venetian architecture and Italian paintings is more likely to have been based on copies and prints. In 1519 he returned to Basel where, on September 25, he became a member of the painters' guild "Zum Himmel." In the same year he painted two portraits of Bonifacius Amerbach. On 3 July 1520 Holbein obtained the rights of a citizen; the fact that his fees were waived suggests that he was already married to Elsbeth Binzenstock. The facade paintings for the house "Zum Tanz" in Basel were executed about 1520. He obtained the commission to decorate the Great Council Chamber of Basel in 1521. Numerous prints date to between 1520 and 1523, as do a series of window designs, chiaroscuro drawings, and his *Dress of Basel Women*; presumably at the time Holbein kept several collaborators at work. In 1524 he journeyed to France and attempted to convince Francis I, king of France, to employ him as court painter, apparently without success. After his return from France, he painted the *Passion* altarpiece in Basel (1524/1525) and the *Darmstadt Madonna*. In early September 1526, he left Basel for London, carrying letters of recommendation from Erasmus of Rotterdam. He was a guest in the house of Thomas More (*Group Portrait of Thomas More and His Family*, 1526/1527; *Portrait of Thomas More*, 1527; *Archbishop William Warham*, 1527). In August of 1528 he returned to Basel and purchased a house in the St. Johannsvorstadt (*Portrait of His Wife with His Two Older Children*, 1528). Despite the advancing Reformation in Basel and the iconoclasm of 1529, Holbein's paintings of this time depict religious themes: organ shutters for the Basel cathedral and a series of stained glass window designs with the Passion of Christ. He remained occupied with the painting of the south wall of the Great Council Chamber until the middle of 1521. In 1532 Holbein traveled once again to London. There he was in contact with the German merchants of the so-called *Stalhof* (named after the *Stahlhof*, or steelyard, near their business premises), whom he painted, and he designed representations of the triumphal processions of riches and poverty for their guildhall, and the festive decorations for the *Stalhof* on the occasion of the entry of Queen Anne Boleyn on 31 May 1533. Probably thanks to his contact with Anne Boleyn, he obtained entrance to the court and painted members of the aristocracy and bureaucracy. By 1536 he was in the service of Henry VIII, and was regularly paid from 1537 on. He was commissioned to paint a work for the royal Privy Chamber in Whitehall Palace (1537) and designed jewelry and decorative art objects of all kinds for the court. In 1538/1539 he traveled to the continent to paint portraits of Christina of Denmark and Anne of Cleves, whom the King was considering taking in marriage. In September/October 1538 he stopped briefly in Basel before returning to the English court. In 1540 he received a commission for a large group portrait of the members of the Company of Barber-Surgeons (unfinished). In Holbein's testament, dated 7 October 1543, he settled his estate in England; presumably he intended to return to Basel. He died in London, probably of the plague, between 7 October and 29 November 1543.

161 Jakob Meyer zum Hasen, 1516

Basel, Kupferstichkabinett, Inv. 1823.137

Silverpoint on white prepared paper; red chalk (on face) and traces of black pencil (on beret, nose, and chin)

281 x 190 mm

Watermark: bull's head with tau cross (similar to Piccard 1966, X, 208/209)

Signed upper left *an ogen schwarz/baret rot—mosfarb/brauenn gelber dan das har/grusenn wit brauenn*

Mounted on thick paper; partially separated; slightly cut at left margin; torn upper right; horizontal fold at chin; several small spots; paper turned gray from discoloration by light; lighter colored margins protected by matting

PROVENANCE: Museum Faesch, Inv. A

LIT.: *Photographie Braun,* no. 42 – Woltmann 1, 132; 2, no. 33 – Mantz 1879, 23f., etched reproduction – Schmid 1900, 51ff., ill. on 52 – Davies 1903, 45 f. – *Handz. Schweizer. Meister,* pl. II, 18 – Chamberlain 1, 52ff., pl. 16 – Ganz 1923, 23f., pl. 2 – Glaser 1924, 28, pl. 2 – Schmid 1924, 337 – Ganz 1925, Holbein, 235, pl. I, A – Ganz 1937, no. 1 – Reinhardt 1938, pl. 66 – Schmid 1945, 22, ill. 5 – Christoffel 1950, ill. on 140 – Schilling 1954, 17, ill. 23 – Grohn 1956, ill. 1 – Exh. cat. *Holbein* 1960, no. 194, fig. 56 – Ueberwasser 1960, no. 2 – F. Winzinger, in: *Print Review* 5 (1976), 169f. – Foister 1983, 14, 26f., ill. 57 – Rowlands 1985, 21, ill. 3 – Grohn 1987, no. 12a – Exh. cat. *Holbein* 1988, no. 3a – Klemm 1995, 10, 69, ill. – Müller 1996, no. 92 – Bätschmann/Griener 1997, 36–38

This silverpoint drawing and its companion (see ill.) are studies for a double portrait, dated 1516 and signed with Holbein's monogram (see ills.).[1] Created directly from the model, both figures in the drawings are the same size and are shown in similar poses as on the finished paintings, suggesting that Holbein may have transferred their faces directly onto the prepared ground, possibly through the use of a tracing. In the painting the artist softened Jakob Meyer's protruding nose by broadening the left jowl, somewhat flattening the chin, and concealing the neck with hair. He also made pronounced changes in the contours of the headpieces and the upper bodies, probably as a result of the new composition—the couple was painted in front of a Renaissance architectural design.[2]

Hans Holbein the Younger, *Double Portrait of Jakob Meyer zum Hasen and His Wife Dorothea Kannengiesser,* 1516

161

Hans Holbein the Younger, *Portrait of Dorothea Meyer, born Kannengiesser,* 1516

The immediacy and natural pose of the figures are more impressive in the drawings than in the paintings. Holbein's concentration on the faces contributes to this effect. Modeled with crosshatching in silverpoint and red chalk, the faces were rendered in much greater detail than was the clothing. Contours were drawn tentatively at first, then more strongly. A suggestion of dimensionality is apparent even in those areas in the upper bodies and the clothes that are only slightly outlined. Here Holbein sketched only the most elemental features, barely hinting at fabric patterns or the gold embroidery on Dorothea Kannengiesser's dress, and jotting down a few instructions on color and additional observations on the Jakob Meyer drawing.

The double portrait may have been commissioned to commemorate Jakob Meyer's (1482–1531) election to burgomaster on 24 June 1516. This election marked the first time that a merchant's son, a representative of the guilds, obtained a position that had traditionally been reserved for members of the city's upper echelons. In 1521 Jakob was accused of accepting foreign pension funds and was relieved of his duties. The coin he holds in the painting and the rings on his hand may symbolize his wealth and his profession as a money changer. The coin could also allude to the right to strike gold coins, a privilege that Maximilian I had granted the city of Basel on 10 January 1516. C.M.

1. Basel, Öffentliche Kunstsammlung, inv. 312; tempera on linden, each 385 x 310 mm; Exh. cat. *Holbein* 1960, no. 141, ill. 54f.; Rowlands 1985, no. 2.

2. Hans Burgkmair the Elder's 1512 woodcut of Hans Baumgartner may have been Holbein's inspiration for this portrait. See T. Falk, Exh. cat. *Hans Burgkmair. Das graphische Werk,* Städtische Kunstsammlungen Augsburg (Augsburg 1973), no. 76, ill. 90, with reference to the double portrait; Rowlands 1985, 21.

162 Design for the Ground Floor of the Hertenstein House in Lucerne, c. 1517

Verso: trial pen marks and numbers *Dem; Dm do dem Ersam*
Basel, Kupferstichkabinett, Inv. 1662.131
Pen and black and gray ink; gray and black wash and watercolor
309 x 444 mm
Watermark: dog? with flowers
Edges irregular; sheet intact; vertical center fold; scattered tears, repaired; lower left corner torn off; white and red paint spots

PROVENANCE: Amerbach-Kabinett

LIT.: *Photographie Braun,* no. 73 – Woltmann 2: no. 53 – His 1886, pl. II (detail) – Schneeli 1896, pl. XVI – *Handz. Schweizer. Meister,* pl. II,3 – P. Ganz, "Hans Holbeins Italienfahrt," *Süddeutsche Monatshefte* 6 (1909), 596–612, esp. 603 – Chamberlain 1: 68ff., pl. 23,2 – Schmid 1913, 176, no. 2, 193f., ill. 14 – Ganz 1919, ill. on 154 – Manteuffel 1920, Maler, ill. on 14 – P. Ganz, "A Portrait by Hans Holbein the Younger," *Burl. Mag.* 38 (1921), 210, 221 – Glaser 1924, 5, pl. 6 – Schmid 1924, 337f. – Hugelshofer 1928, 39, no. 56 – Cohn 1930, 39f., 47–49, 52, 75, 97 – Schmid 1931, ill. on 50 (detail) – Ganz 1937, no. 112 – Schmid 1941/1942, 249–290, 253, 258 – Schmid 1945, 22, ill. 10; 1948, 50ff., 54 – Christoffel 1950, 24, ill. on 241 – Ganz 1950, no. 160, ill. 40 – Reinle 1954, 119–130, 124f., ill. 110 – Exh. cat. *Holbein* 1960, no. 197 – Lauber 1962, 48f., ill. – Hugelshofer 1969, 122f., no. 40 – J. Davatz/F. Jakober, "Zur Hostienmonstranz von 1518 in Glarus," *Unsere Kunstdenkmäler* 26 (1975), 295, 302, ill. 4 – Riedler 1978, 18f., ill. on 20 – Roberts 1979, 28, no. 10 – Rowlands 1985, 27f., no. L. 1c, pl. 142 – Grohn 1987, no. 20b – Exh. cat. *Holbein* 1988, no. 4 – Exh. cat. *Amerbach* 1991, *Zeichnungen,* no. 102 – Kronthaler 1992, 35, ill. 34 – Hermann/Hesse 1993, 178, ill. 6 – Müller 1996, no. 96 – Bätschmann/Griener 1997, 68f.

Between 1517 and 1519, during his stay in Lucerne, Holbein—probably along with his father, Hans Holbein the Elder—worked on the wall paintings of the Hertenstein house there.[1] Reinhardt (1954/1955) conjectured that Hans Holbein the Younger designed the paintings of the facade while Hans Holbein the Elder prepared the designs for the interior rooms. Reinhardt connected a silverpoint drawing by Hans Holbein the Elder from the so-called *Second Basel Sketchbook,* depicting a group of auxiliary saints,[2] with the family chapel on the fourth floor of the Hertenstein house.

Beginning in 1510, Jakob von Hertenstein, a wholesale merchant and recurrent mayor, had a house erected on the north side of the corner of the Kapellplatz and the Sternenplatzgässlein. It was torn down in 1825. Aside from small fragments of the wall paintings, only a larger

portion of a picture with the suicide of Lucretia has survived, depicting Collatinus, the husband of Lucretia.[3] The small-format copies by Carl Ulrich and Carl Martin Eglin, as well as a schematic elevation that was done shortly before the house was destroyed, give us an idea of what the paintings on the facade looked like.[4] Attempts at reconstruction are also based on city prospects by Martin Martini (1597), Wenzel Hollar (c. 1640), and Franz Xaver Schumacher (1792), all of which depict the house. According to an 1870 reconstruction of the facade by Albert Landerer, now in the Kupferstichkabinett Basel (see ill.), the ground floor was not painted at the time of demolition.[5] Between the windows of the first floor were three female figures in imitation classical garb who may have represented the virtues of Prudence, Fortitude, and Hope. The wall space above the windows was decorated with an ornamental frieze replete with composite creatures and frolicking putti, on the left side, while fighting children were depicted on the right side. In the middle, a large picture extended upward between the windows of the third floor, showing the shooting of the dead father, an episode known as the King's Test from chapter 27 of the *Gesta Romanorum.* Perhaps Hertenstein intended this picture to serve as an admonishment to his offspring and legal heirs. He married four times, and the arms of all four marital alliances were displayed on the wall spaces between the windows of the third floor. Above that Holbein depicted the triumph of Caesar in nine scenes after Mantegna (B. 13, no. 11ff.). The top floor was decorated with exemplars from ancient literature: the students of Falerii driving their bound teacher, who wished to betray them, back into the city (Livy 1.5.27); Leaina before the judges (Müller 1996, no. 97; Pausanias 1.23.1–2; Pliny 34.72–73; see ill.); Mucius Scaevola before Porsenna (Livius 2.11.12);[6] the suicide of Lucretia (Livy 1.57–58); the sacrificial death of Marcus Curtius (Livy 7.6).

Ganz *(Handz. Schweizer. Meister)* first connected our drawing to the paintings on the facade of the Hertenstein house. The door in the shape of a pointed arch and the wide window nearby, framed in a depressed arch, are indicated as dark planes in our drawing. They were determined by the architecture and roughly correspond to the depiction of the house on the plan by Martin Martini (1597). It is in any case impossible to tell from Martini's engraving if the ground floor of the house also contained facade painting. Schmid (1948) assumed that Holbein could have made a different design for that location.

Holbein assimilated ideas from Augsburg in his drawing, for instance, from the architecture employed in *The Virgin under a Portico,* a painting by Hans Holbein the

162

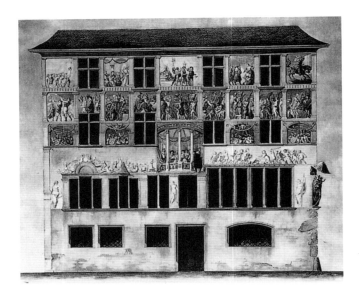

Albert Landerer, Reconstruction of the facade of Hertenstein's house in Lucerne, 1870

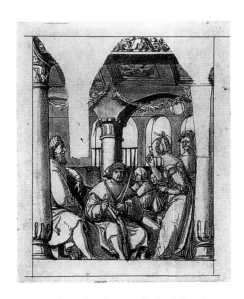

Hans Holbein the Younger, *Leaina before the Judges*, c. 1517

Elder (Lübbeke 1985, no. 16; the date may be read as 1515 or 1519). Such examples can be traced back to Venetian models that were conveyed to Augsburg (see Müller 1996, no. 109). For instance, Hans Holbein the Elder used composite, fish-tailed creatures on both sides of the onset of the arch in a 1517 painting that probably depicts a member of the Augsburg patrician class (Rowlands 1985, no. R. 2; Bushart 1987, 124, ill. on 125). Comparable children occur on Hans Holbein the Younger's 1516 title woodcut showing a triumphal procession (Hollstein *German* 14, no. 15). Their heads, their features, and the rendering of their hair, whose jagged lines press outward from the figure, are very similar. The energetic strokes, the multifaceted definition, and the hatching with which Holbein worked out individual forms of our drawing speak for a date of about 1517/1518, which is accepted by most authorities. Rowlands surmised that the design could have been for the interior of the house or even for an entirely different project. He dated the drawing early, but believed that a genesis at the beginning of Holbein's second stay in Basel, namely about 1519/1520, was also possible. Ganz (1919) had also considered a date of about 1519. C.M.

1. For Hans Holbein the Younger's stay in Lucerne, see Reinhardt 1954/1955, 16; Reinhardt 1982, esp. 257; E. Treu, in: Exh. cat. *Holbein 1960*, 175f.; *Hans Holbein d. J. und das Hertensteinhaus. Begleitheft zur Ausstellung im Historischen Museum Luzern* (Lucerne 1992), 30f.; on the painting of the Hertenstein house, see Schmid 1913, 173–206; Schmid 1941/1942, esp. 256, n. 4; E. Treu, in: Exh. cat. *Holbein 1960*, no. 144; Riedler 1978, 10–38; Rowlands 1985, no. L. 1a–d, pls. 140–153; Exh. cat. *Holbein 1988*, 40ff.; finally Hermann/Hesse 1993, 173ff.

2. See Falk 1979, no. 182, pl. 53; Rowlands 1985, 26, ill. 6. Bushart (1987, 17) questions Hans Holbein the Elder's involvement with the paintings inside the house.

3. Lucerne, Kunstmuseum; Rowlands 1985, no. L. 1a.

4. See Rowlands 1985, no. L. 1d, pl. 144–153.

5. Basel, Kupferstichkabinett, inv. 1871.1a; Rowlands 1985, no. L. 1d, ill. 143.

6. Bätschmann (1989, 3f.) interprets the depiction as a hidden autograph of Holbein. The left-handed Holbein was able to compare himself to Mucius Scaevola (the name Scaevola derives from *scaevus* [left, leftish]) and therefore assigned this scene a central place (with the permission of the patron?). See also Bätschmann/Griener 1994, 636.

The Chiaroscuro Drawings of about 1520 (cats. 163–165)

In about 1520, Hans Holbein the Younger created a series of drawings in pen and brush on papers prepared with colored grounds.[1] The Kupferstichkabinett Basel has four: *Christ Carrying the Cross* (Müller 1996, no. 108), *The Holy Family* (cat. 163), *The Virgin and Child between Two Columns* (cat. 165), and a design for the sign of a maker of knives (Müller 1996, no. 111). Further chiaroscuro drawings from the same period in other collections belong to this group as well: namely the eight apostles of 1518 in the Musée Wicar in Lille,[2] the *Christ at Rest* of 1519 in the Berlin Kupferstichkabinett (cat. 164),[3] the drawing of *The Madonna and Child* of the same year in the Museum der Bildenden Künste in Leipzig,[4] as well as two fragments of a thus-far unidentified subject from ancient or biblical history in the Staatliche Graphische Sammlung in Munich.[5] Also of note are the *St. Adrian* in the Louvre, which was drawn a little later, c. 1524,[6] and the 1527 Apostle series.[7]

Some of these drawings indicate that Holbein toyed with the possibility of abandoning the customary viewpoint and considered using a perspective clearly legible only when the drawing is viewed from the side. The viewer must cast his glance over the sheet, from left to right—an experience that someone who handled such a drawing might have. Perspectival elongations in architecture or in the bodies of figures become softened, really actually comprehensible, in the diagonal view. Holbein thereby intensified the effect of relief in his drawings, giving them the character of an object, and simultaneously entered into a contest between the arts of painting and sculpture. The fact that in the diagonal perspective the image materially withdraws from the viewer is an expression of the paradoxical structure Holbein attached to his works. It is a device intended to inspire self-reflection in the viewer (see Müller 1998).

1. About the drawings, see Müller 1998, 83–93.
2. Inv. 924–931; Muchall 1931, 156–171.
3. Berlin, Kupferstichkabinett, KdZ 14729; Ganz 1937, supplement no. 466.
4. Inv. NI 25; Ganz 1937, no. 104.
5. Inv. 1036 and 2515; Ganz 1937, no. 128; D. Kuhrmann, in: Exh. cat., *Zeichnungen aus der Sammlung des Kurfürsten Carl Theodor,* Staatliche Graphische Sammlung München (Munich 1983), no. 108.
6. Demonts, no. 221; Ganz 1937, no. 108.
7. The apostle Andrew is in the British Museum (Rowlands 1993, no. 318; the author also discusses the present locations of the remaining drawings in the series).

163 The Holy Family, c. 1518/1519

Basel, Kupferstichkabinett, Inv. 1662.139
Pen and black ink on red-brown prepared paper; gray wash; heightened in white
27 x 308 mm
No watermark
Inscribed *HANS HOL* in the tympanum
Mounted on paper; horizontal center fold, partially torn; upper right corner torn; small tear and losses at the upper edge

PROVENANCE: Amerbach-Kabinett

LIT.: *Photographie Braun,* no. 57 – Woltmann 2: no. 62 – Mantz 1879, 130f., ill. on 133 – Schmid 1900, 59, ill. 57 (1521) – *Handz. Schweizer. Meister,* pl. II, 51 (c. 1520/1521) – Chamberlain 1: 99f., pl. 34 – Knackfuss 1914, 85, ill. 72 – Cohn 1930, 3, 60, 72f., 76, 80, 98 (1521/1522) – Schmid 1930, 44f. (1521/1522) – Muchall 1931, 163 (c. 1520) – Cohn 1932, 1 – Ganz 1937, no. 106 (c. 1520) – Waetzoldt 1938, 88 – Schmid 1941/1942, 261, ill. 11 (detail, 1518/1519); 1945, 23, ill. 12 (1518/1519); 1948, 107f. – Ueberwasser 1947, pl. 18 (1521/1522) – Waetzoldt 1958, ill. 56 (c. 1520) – Exh. cat. *Holbein* 1960, no. 216, ill. on cover – E. Treu, in: Exh. cat. *Holbein* 1960, with no. 156f. (1519/1520) – Reinhardt 1965, 32ff., 35, ill. 5 (c. 1520) – Wüthrich 1969, 777 – Bushart 1977, 55 (1518/1519) – Reinhardt 1978, 212, ill. 6 (1518/1519) – Exh. cat. *Holbein* 1988, no. 24 – Müller 1989, 117f., 124f. – Exh. cat. *Amerbach* 1991, *Zeichnungen,* no. 104 – Müller 1996, no. 109 – Bätschmann/Griener 1997, 134 – Müller 1998, 83–85

St. Anne, Mary, and the Christ child, with Joachim to the left and Joseph to the right, rest before a richly ornamented niche. On the one hand this architectural setting is reminiscent of a church portal framed by columns and, on the other, of an altar niche. We cannot discern whether this scene takes place in an interior space lit by a steeply descending light (from a window?) or out in the open.

Reinhardt (1965, 1978) pointed out that Holbein incorporated many ideas from Augsburg into this work. For instance, Hans Holbein the Elder used similar architectural motifs in his *Fountain of Life* of 1519, today in the Museu Naçional de Arte Antiga in Lisbon (Bushart 1977, 52ff.), and in the *Virgin under a Portico* in the Georg Schäfer Collection, Schweinfurt; this panel's date (1515 or 1519?) cannot be read clearly (Lübbeke 1985, no. 16). Comparable scenery is encountered on the reliefs carved in Solnhofener stone by Hans Daucher, depicting the Holy Family or Mary accompanied by angels, as well as on a relief dated 1518 in the Kunsthistorisches Museum in Vienna or still another relief of 1520 in the Städtische Kunstsammlung in Augsburg.[1] Common features include the two-storied, triumphal archlike architecture, the projecting columns decorated with figures, and the broken

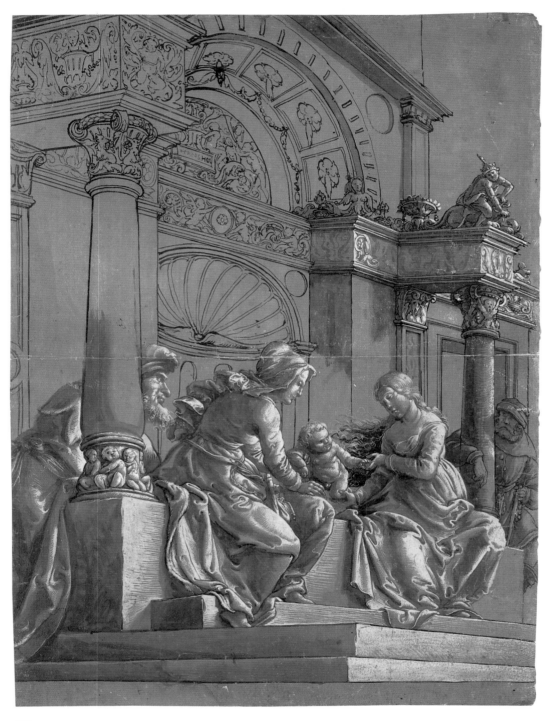

163

entablature. Similar decorative forms are also present as framing architecture in Hans Burgkmair's series of the *Seven Vices* (B. 7, nos. 55–61). The aforementioned examples are in turn based on Venetian architectural motifs that were currently known in Augsburg. Bushart (1994) suspected that Hans Holbein the Elder owned several copies of Tullio Lombardo's tomb monument for Doge Andrea Vendramin in the church of SS. Giovanni e Paolo in Venice, with which he could have acquainted Augsburg artists such as Albrecht Dürer and Hans Burgkmair without having himself been in Venice. We should also recall Dürer's drawing, *The Holy Family in a Hall* of 1509 (Basel, Kupferstichkabinett), and an altarpiece of about 1515 in the Oratorian pilgrimage church of Mariä-Schnee (the Virgin of the Snow) in Aufhausen, whose architecture goes back to the same Venetian model and is dependent upon the 1509 Dürer drawing.

Bätschmann and Griener (1998), however, did not discern the influence of Venetian architecture. Bätschmann saw a dependence on architectural motifs from Filippino's fresco, *The Triumph of St. Thomas Aquinas,* in S. Maria sopra Minerva in Rome. There are, in fact, similarities, but it remains unclear how Holbein could have known of this fresco.

Contrary to the severe composition that was drawn parallel to the picture plane in the aforementioned examples, Hans Holbein the Younger enlivened his architecture by its diagonal placement, bringing about a richer profile with light and dark effects. Only in a view from the side, as the viewer approaches the position of Joachim, does the architecture unfold in its correct perspectival and spatial sequence.

The bound slaves in the tympanum and the man fighting with a lion on the entablature at the upper right underscore the triumphal character of the architecture. The lion fighter could be interpreted as a reference to a popular figure from antiquity (Hercules?), or to the biblical Samson, alluding typologically to the triumph of Christ over death (see Müller 1996, no. 102).

Holbein's execution of the drawing is highly differentiated. He alternated between pen and brush and assigned them different weight. For instance, he drew the entablature and tympanum on the left side with pen strokes that have a light, disembodied effect while giving the architecture on the right a more plastic effect with the brush. This deliberate use of clearly distinct techniques contradicts the supposition of Ganz and Chamberlain that Holbein left the drawing unfinished.

The resemblance of this sheet to a design for the ground floor of the Hertenstein house in Lucerne (cat.

162) supports a dating to about 1518/1519, which Bushart (1977) and Reinhardt (1978) also proposed. The way in which Holbein drew the ornament using short, energetically nervous strokes, and the slightly contrived character of the composition, with its complexity emphasized by the complicated perspective and body movements, point to this date.　　　　　　　　　　　　　　C.M.

1. Bushart 1994, ill. 126f.

164　CHRIST AT REST, 1519

Berlin, Kupferstichkabinett, KdZ 14729
Pen and black ink; gray wash; heightened in white on ocher prepared paper
157 x 207 mm
Watermark: indecipherable
Dated upper right *1519*; lower right, false Dürer monogram
Mounted on paper; losses in the upper right corner, with old repairs; trimmed on all sides; white heightening rubbed in places; stain in upper right corner

PROVENANCE: acquired in 1931 from Quast, Radensleben

LIT.: *Die Kunstdenkmäler der Provinz Brandenburg,* I, part 3, *Ruppin* (Berlin 1914), 202, ill. 186 (work of a Swiss master) – *Berliner Museen. Berichte aus den Preussischen Kunstsammlungen,* 53 (1932), 32 (acquisition) – Cohn 1932, 1f. – Ganz 1937, no. 466 – Schilling 1954, 14 – Schmid 1941/1942, 262, 266 – Schmid 1945, ill. 14 – Exh. cat. *Holbein* 1960, no. 211 – Pfister-Burkhalter 1961, 178, ill. 5 – Rowlands 1985, 32f., ill. 8 – Exh. cat. *Holbein* 1988, 88 – *Handbuch Berliner Kupferstichkabinett* 1994, no. III.62 – Müller 1996, 74ff., 77 – Müller 1998, 83–84

The representation of a slumped-over Christ who has already suffered through several stations of the cross is known as Christ at rest or Christ in misery (the Man of Sorrows) (see G. von der Osten, in: *RDK* 3, 1954, cols. 644–658). Holbein's Christ has sunk down, exhausted, on the cross; the Crucifixion is therefore imminent. In general, this type of image isolates Christ from the narrative context of the events of the Crucifixion. Desolation and loneliness are concepts that are encompassed by the title word "misery" and they heighten the sorrow of Christ. Like Holbein's woodcut *Christ Carrying the Cross* (Hollstein *German* 14, no. 2), the present sheet was particularly well suited to inspire the viewer to reflect on Christ's suffering, to pray, and to meditate. The propped-up head is not only an expression of exhaustion but also of grief. In Holbein's 1519 diptych in the Basel Kunstmuseum, the same theme is magnified by the contrast with Mary, who partakes in Christ's sorrow. A chiaroscuro drawing of the same time (Basel Kupferstichkabinett)

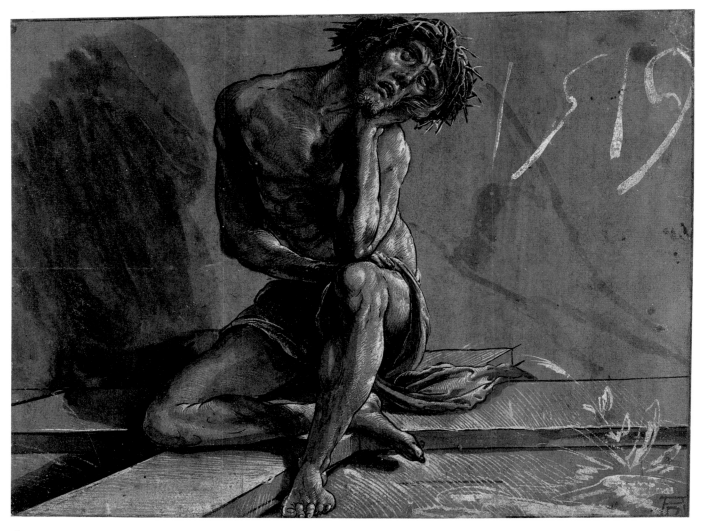

164

Hans Holbein the Younger, *Christ Carrying the Cross,* c. 1518

showing Christ carrying the cross presents, instead, the
customary image of Christ's way to the cross, from the
gate of Jerusalem to the hill of Golgotha (see ill.). It may
be a coincidence that a series of depictions of Christ of
c. 1519/1520 has survived that so clearly emphasizes the
aspect of suffering—Holbein's painting of the dead Christ
in the Kunstmuseum Basel could also be mentioned. The
interest that Holbein then demonstrated in faces suffused
with exceptional emotion is evident, for instance, in a
study for the apostle John, in the Kupferstichkabinett
Basel (Müller 1996, no. 95). The face of Christ in the
Berlin drawing and the head of St. John in the Basel sheet
allow close comparison, for example, in the shape of the
eyes and the opened mouth, in which the teeth are visible.
These emotional heads could have been inspired by Mat-
thias Grünewald's works—his just-completed Isenheim
altarpiece was known to Holbein—as well as by Dürer's
and Hans Baldung's works. Also, artists were often influ-
enced by Italian models, most notably Mantegna, which
were reproduced as graphic works. Dürer's etching on
iron, the so-called *Desperate Man* (M. 95), which was pro-
duced about 1515, may also have exerted an influence,
specifically with respect to the body of Christ (the folded
legs, elbow on the knee, and foot extending to the pic-
ture's lower edge). C.M.

165 THE VIRGIN AND CHILD BETWEEN TWO COLUMNS, C. 1520

Basel, Kupferstichkabinett, Inv. 1662.130
Pen and black ink; black wash on dark gray prepared paper;
heightened in white
212 x 148 mm
Watermark: grapes (variant of Briquet 13022)
Old mounted; horizontal center fold, flattened

PROVENANCE: Amerbach-Kabinett

LIT.: *Photographie Braun,* no. 54 – Woltmann 2: no. 52 –
Schmid 1900, 59, ill. on 58 (c. 1522) – Davies 1903, ill. after
224 – Chamberlain 1: 100 – Knackfuss 1914, 85, ill. 71 – Glaser
1924, 11, pl. 17 – Muchall 1931, 163 – Cohn 1932, 1 – Ganz
1937, no. 107 (toward 1520) – Reinhardt 1938, 118 – Waetzoldt
1938, 88 – Schmidt/Cetto, XXIV, 45, ill. 76 – Ueberwasser
1947, pl. 17 – Exh. cat. *Holbein* 1960, no. 215 – Exh. cat. *Amer-
bach* 1962, no. 69 (c. 1520) – Exh. cat. *Swiss Drawings* 1967, no.
30 – Hugelshofer 1969, no. 42 – Hp. Landolt 1972, no. 73
(c. 1520) – Exh. cat. *Holbein* 1988, no. 25 – Hp. Landolt,
"Gedanken zu Holbeins Zeichnungen," *Neue Zürcher Zeitung*
158 (1988), 65 – Müller 1989, 119f., 124ff. – Hp. Landolt 1990,
270f., ill. 3 – Exh. cat. *Amerbach* 1991, *Zeichnungen,* no. 105 –
Klemm 1995, 27f., 71, ill. on 26 (c. 1520) – Müller 1996, no.
110 – Bätschmann/Griener 1997, 129 – Müller 1998, 83–84

The Virgin sits enthroned between two columns that
could allude to the two bronze columns of Jachin and
Boas that flanked the entrance to the temple of Jerusalem
(1 Kings 7:21). Mary would then be typologically identi-
fied as *Ecclesia* (the church) and the architecture of our
sheet as the new temple, of which Christ will become the
high priest (Hebrews 9.11, 24; see E. Forssmann, *Säule
and Ornament* [Uppsala 1956], 44ff.).

At first sight the drawing looks unfinished, for in
contrast to the depiction of the Virgin, the architecture
seems to consist primarily of an unsubstantial framework
of lines. Nor did Holbein finish all parts of the drawing
equally. Thus, while completing the drawing with the
pen, he omitted the right capital of the two. The left capi-
tal is a type that he had already used in his *Holy Family*
(cat. 163; Müller 1996, no. 109). However, he did thereby
strengthen the impression of greater spatial depth and
emphasized the movement of the architecture that is fore-
shortened to the right, assuming a low viewpoint below
the left side of the sheet. From there, looking to the right,
loom the Virgin's broad proportions, which are moderated
by the folds in her dress and are consistent with the fore-
shortening of the architecture. By using raking light from
the right, Holbein attempted to emphasize the main mo-
tif, separating it from its surroundings in relief-like fashion.
The light picks out the figures of the Virgin and child,

165

the front of the bench, and the side of the upper step.

Compared to a drawing of about the same size dated 1519, *The Virgin and Child* in the Museum der Bildenden Künste in Leipzig (inv. NI 25; Ganz 1937, no. 104; Exh. cat. *Holbein* 1960, no. 210), the Basel drawing is more painstakingly executed in its drapery folds. The white heightening of the Leipzig drawing is broadly and flatly applied, whereas fine parallel hatching plays a more significant role in our sheet, as do the rippled lines that, placed on the edges of the folds, follow the contours of the drapery. In the Leipzig *Virgin,* the contribution of the white and black hatching is greater, whereas with the Basel *Virgin,* the wash in gradated gray tones carries more weight. The refined nature of the heightening in white could attest to a somewhat later date of origin, as could the low viewpoint and the diagonal placement of the subject, which must have made considerable demands on the draftsman. Yet Holbein had already handled similar problems about 1517/1518 in his design for the wall painting of Leaina on the Hertenstein house (Müller 1996, no. 97) and in *The Holy Family* (cat. 163). Our drawing is usually dated to between 1519 and 1520. Ueberwasser proposed 1518/1519, and Schmid offered 1522 for consideration. A date of about 1520 is plausible; moreover, it is supported by the watermark. C.M.

THE FACADE PAINTINGS OF THE HOUSE "ZUM TANZ" IN BASEL (cat. 166)

Hans Holbein designed his wall paintings for the house "Zum Tanz" in Basel on commission from the Basel goldsmith, Balthasar Angelroth (c. 1480–1544).[1] The location on the corner of the Eisengasse and Tanzgässlein was already called "Zum obern Tanz" in 1401, later becoming "Zem vordern Tanz."[2] It was just this appellation that inspired Holbein and his patron to represent dancing peasants on the facade.

House and wall paintings have not survived; the neoclassical building that replaced the original was torn down in 1907.[3] In 1676 Charles Patin mentioned the paintings in his *Vita Joannis Holbenii*; Joachim von Sandrart was also able to report on them.[4] They must have already been quite destroyed by the end of the eighteenth century.[5]

Although Theodor Zwinger (1533–1588), a Basel physician, reported that Holbein would receive forty guilders for completing the job, the dates of the commission and the execution were not specified in the documents.[6] Holbein may well have executed the facade paintings even before the Basel Great Council Chamber

murals. Most authors assume that Holbein, who had become a master in 1519, would hardly have received the most important commission in the city without first having done the highly esteemed facade paintings of the house "Zum Tanz."

Copies after the lost designs by Holbein (in the Berlin and Basel Kupferstichkabinetts; Müller 1996, no. 113f.) as well as an autograph design for the Eisengasse facade (cat. 166) give us an idea of the appearance of the paintings. According to this evidence, Holbein was but little concerned about the features of the building. The painting receded most deeply at the corner of the house where both facades met (see ill. of house model), thus creating the impression of a continuous facade that completely covered the projecting corner of the house. In addition, the irregular fenestration looked like an outcome of the perspective and the projecting and recessed parts of the building.[7] In the upper stories, the placement of columns, arches, and wall areas framed by pilasters, between which we catch glimpses of the sky, are reminiscent of gateways and triumphal arches. Akin to festive decorations or theater scenery, in which the boundaries between real and painted architecture fade, the facade is inhabited by people in contemporary dress as well as by mythological and allegorical figures, who, given equal status, perform side by side. On the base of the giant order commencing just above the ground floor stretches a frieze of dancing peasants, uninterrupted by the corner of the house. They are joined at the right by Bacchus and a drunkard. A Roman soldier with shield and lance (Mars?) stands above the peasants, at the left of the facade on the Eisengasse. At the left of the facade on the Tanzgässlein is a nude man (Paris?). Next to him are Venus and Cupid and an armed female figure (Minerva?). The Judgment of Paris may have been depicted here. Above the great central arch we see a rider in imitation antique armor who, like Marcus Curtius, seems as if he is about to plunge into the depths. A soldier with shield and quiver turns toward him, frightened or astonished; below, to the right, *Temperantia* (?) pours some fluid from one jug into another.[8] The architecture at the top right is decorated with medallions with antique bust portraits of a man and a woman.[9] C.M.

1. The most recent scholars to concern themselves with the facade paintings were Kronthaler 1992, 22ff., and Becker 1994, 66f., no. 2.

2. Basel, *Staatsarchiv, Historisches Grundbuch*; Rowlands 1985, 54, n. 18.

3. Klemm 1972, n. 3.

4. Patin 1676, *Index Operum,* no. 20; Sandrart 1675, 99.

5. J. Müller, *Merckwürdige Überbleibsel von Alterthümern der Schweiz,*

vol. 8, part 5 (Zurich 1777), with mention of the "hasty design."

6. T. Zwinger, *Theodori Zwingeri methodus apodemica* (Basel 1577), 199.

7. See: "Das Haus 'Zum Tanz' in Basel," *Schweizerische Bauzeitung* 54 (1909), 1–3, esp. 2, ill. 1, with site plans of the old and new buildings.

8. On the iconography of facade painting, see D. Koepplin, in: Exh. cat. *Stimmer* 1984, esp. 35–39. In her master's thesis (Technische Universität Berlin, 1981, 65f.), A. Meckel sought to identify the rider as St. Eligius. Patron of gold and blacksmiths, he, too, holds a hammer. Our rider, however, appears to be carrying a weapon of some kind. A sketchbook sheet by Joseph Heintz the Elder in the Berlin Kupferstichkabinett, based on motifs from facade decorations, includes a smith at work. It is probably Hephaestus (also known as Vulcan), who is not depicted on the surviving designs. Meckel identified the nude male figure at the house corner as Hephaestus, which could be possible (see Zimmer 1988, no. A 9, ill. 41).

9. Kronthaler (1992, 29, see note 1) expressed the supposition that they allude to the house owner, Balthasar Angelroth, and his wife.

166 DESIGN FOR A FACADE PAINTING ON THE EISENGASSE, C. 1520

Verso: design for the upper floor of the facade on the Eisengasse
Basel, Kupferstichkabinett, Inv. 1662.151
Pen and black ink over black chalk; gray wash; verso, black chalk
533 x 368 mm
Watermark: two walking bears (Lindt 26, 27)
Lower left 5 in pencil
Two joined sheets; horizontal and vertical creases; rumpled folds; somewhat stained at the edges

PROVENANCE: Amerbach-Kabinett

LIT.: Woltmann 1: 149ff.; 2: no. 94 – Schneeli 1896, 108, pl. XVIII – D. Burckhardt 1906, 302 – Chamberlain 1: 116ff., 121 – J. Burckhardt, *Briefwechsel mit Heinrich Geymüller*, ed. C. Neumann, Munich 1914, 66 – Ganz 1919, 18f., 246f. – Schmid 1924, 346 – Ganz 1925, Holbein, 236, 239 – Stein 1929, 200ff., ill. 75 – Cohn 1930, 41–43, 70f. – Schmid 1930, 58–61 – Ganz 1937, no. 114 – Reinhardt 1938, 23 – Waetzoldt 1938, 152ff. – Ganz 1943, pl. 16, 33f. – Schmid 1945, 29, ill. 63; 1948, 125ff., 345–353, ill. 54b (detail), ill. 94 (detail) – Reinhardt 1948/1949, 118 – Christoffel 1950, 88f. – Ganz 1950, with no. 163 – Grossmann 1951, 39, n. 8 – Bergström 1957, 7–39, ill. 4 – M. Pfister-Burkhalter, in: Exh. cat. *Holbein* 1960, no. 269, ill. 104 – H. Reinhardt, in: Exh. cat. *Holbein* 1960, 29 – E. Treu, in: Exh. cat. *Holbein* 1960, 187f., no. 159 – Hp. Landolt, in: Exh. cat. *Amerbach* 1962, no. 84, ill. 25 – F. Anzelewsky, in: Exh. cat. *Dürer* 1967, with no. 109 – Klemm 1972, 173, n. 4, no. 269 – Hp. Landolt 1972, no. 80 – Roberts 1979, 26, no. 5 – Klemm 1981, cols. 690–742, esp. col. 692, cols. 699f., cols. 715f., col. 728, cols. 730ff., col. 736 – E. Maurer 1982, 123–135 – Reinhardt 1982, 266f., n. 90, 258 – D. Koepplin, in: Exh. cat.

Stimmer 1984, esp. 35–39, no. 5 – Rowlands 1985, 53ff., no. L.4a, pl. 156 – Exh. cat. *Holbein* 1988, no. 28 – Kronthaler 1992, 23ff., ill. 21 – Becker 1994, 66ff., no. 2 – Müller 1996, no. 112 – Bätschmann/Griener 1997, 70–72, 120–122 – Müller 1998, 84–85

Two copies after lost designs by Holbein—in the Kupferstichkabinett Berlin (Bock 1921, no. 3104; see ill.) and its counterpart in Basel (Müller 1996, no. 113)—are generally considered to be the closest thing we have to the executed facade paintings. A few authors identified our drawing, which deviates from these copies only in the odd motif, as a preparatory study for the facade and therefore placed it before the final, executed version. Woltmann assessed it as an early attempt by Holbein to improve his designs, which survive as copies (Müller 1996, no. 113, no. 116, no. 121) and assigned it a date of c. 1520, supported by Ganz (1937), Chamberlain, and Rowlands. However, Reinhardt (1938, 1948, 1960, 1982), Pfister-Burkhalter, Hp. Landolt, and Anzelewsky put forward another sequence of events: Holbein could have rendered the design only during his visit to Basel in 1538, it being a draft for corrections stemming from his dissatisfaction with the facade painting. This theory is supported by the advanced style of the drawing as well as by its clearer disposition of the architecture. Other dates were proposed by Burckhardt (c. 1523), Christoffel (c. 1522), Cohn (c. 1523/1524), Schmid in 1924, 1945, 1948 (between 1530 and 1533), and Stein (after 1530).

More recently, Klemm (1972, 1981) again embraced the notion that our drawing must have been a design that preceded the facade painting. A later correction would presumably have been unlikely, first of all because Holbein, during his 1538 visit to Basel, described only his paintings for the house "Zum Tanz" as being "pretty good" (see Woltmann 2, 43), but above all because the final painting can be shown to represent a superior solution. Klemm drew attention to the alterations that Holbein carried out between his chalk drawing and his further elaboration of the design in pen, and demonstrated that these changes led to the painting.

The thesis that our design originated before the painting is also supported by the chalk sketch that has survived on the reverse of our drawing. Its character corresponds to the chalk drawing on the front; thus, there is no doubt about its authenticity. The sketch represents the upper story of the facade on the Eisengasse. When Holbein had completed the front of the sheet, he turned it over and copied the architectural framework showing through to the back. The windows, the colonnade, and the connection to the facade on the Tanzgässlein naturally appear

166

After copies of designs by Hans Holbein the Younger in the Kupferstichkabinett Basel, Model of the house "Zum Tanz"

Copy after Hans Holbein the Younger, Design for the facade painting of the house "Zum Tanz" on the Eisengasse, c. 1520/1525

survived. However, indications of Holbein's facility for sketchy drawing are encountered for the first time not in about 1525, but in about 1520, for instance, in the architecture and architectural ornament on the chiaroscuro drawing *The Holy Family* (cat. 163). The watermarks could also speak for an early genesis. Finally, despite the rapidity of the execution, one can still discern a slight angularity and a tendency to exaggerate the strokes, which make a date of about 1520 probable.

A few motifs of the upper floor go back to an engraving by Bernardo de Prevedaris after Bramante, which Holbein consulted repeatedly.[1] This engraving inspired the deeply receding entablature above the colonnade (in Bramante's version, they are piers) that abuts into the wall, as well as the arches (in Bramante's version, they are a kind of altar niche) and the beginnings of the vaults indicated above in chalk. The frame, sketched in chalk around the ground-floor door with its pointed arch, comprises small, baluster-shaped columns, an architrave, and an arch; it clearly recalls the design for the ground floor of the Hertenstein house in Lucerne (cat. 162). C.M.

1. Klemm 1972, n. 13f.; Graf Wolff Metternich, "Der Kupferstich Bernardos de Prevedari aus Mailand von 1481. Gedanken zu den Anfängen der Kunst Bramantes," *Römisches Jb. f. Kunstgeschichte* 11 (1967/1968), 9–108, ill. 1, ill. 4.

THE WALL PAINTINGS IN THE GREAT COUNCIL CHAMBER OF THE BASEL CITY HALL (cats. 167, 182)

LIT.: Schmid 1896, 73–96 – G. Riggenbach, in: *KDM BS* 1, 517–608 – Schmidt 1948, 163ff., 334ff. – Kreytenberg 1970, 77–110 – f. Maurer 1971, 747–776 – *Basler Rathaus* 1983 – Rowlands 1985, 55f. – Exh. cat. *Holbein* 1988, 117–123, 228– 231 – Müller 1991, 21–26 – C. Müller, "Holbein and der Basler Grossratssaal," in: Exh. cat. *Zeichen der Freiheit* 1991, 151ff.

The new construction of the Basel city hall, commissioned by the city in 1503, can be viewed as an expression of the self-awareness that the city had acquired with its entry into the Swiss Confederation in 1501. Attempts to fully free itself from its dependence on the bishop were part of this new spirit. Ever since the middle of the fourteenth century, the Council had been working to acquire from him the fundamental rights of government. It is against this background that we must assess the construction of an addition to the rear of the third story of the city hall and the furnishing of the great hall between 1517 and

reversed as a consequence. The only decisive change that he introduced was in the colonnade. As in the later design and the presumably executed version (see Müller 1996, no. 113), it intersects an arch flanked by two medallions. Holbein could have hit on this idea during his work on the front of the sheet, for there on the left we already encounter a medallion on the half-arches of the third floor. Contrary to Müller 1996, no. 113, the facade meets the roof in half-explained arch motifs that are reminiscent of the chalk preparatory drawing on the front.

Klemm dated both the design and the execution of the painting to about 1525. The date of 1520 on the copy of the design in Basel (Müller 1996, no. 113) is, as Klemm established convincingly, not authentic, and consequently cannot be used as a basis for the dating of the wall paintings. A drawing of about 1520, closely comparable to our drawing stylistically, that is, in its sketchiness, has not

1521. The Great Council, which had until then served as a meeting place for the colleges of preachers and Augustinians, first assembled in the city hall on 21 March 1521. On this occasion, both the Lesser and Great Councils declared their independence from the bishop as ruler of the city.[1]

The Council charged Hans Holbein the Younger with the painting of the Great Council Chamber. The contract, dated 15 June 1521, stipulated that the artist was to paint the walls of the room for 120 guilders. Holbein received payments of the specified amount until the end of 1521, and from April until November of 1522.[2] By that time, two of the walls, the north and east, must have been completed. Holbein painted the south wall, only after a long interruption, during the second half of 1530.[3] Above the benches found on three sides of the room, which formed an irregular rectangle of about twenty by ten meters, remained a section of wall, somewhat over two meters high, which Holbein could use for his paintings. The remaining west wall opened to the outside by five windows. Only the north and south walls—these being the short sides of the room—offered continuous surfaces, as did the left half of the long wall, for on its right side two doors and a small window interrupted the wall surface, and a stove projected into the room.

Separated by joists that supported the beams of the ceiling, and flanked by allegorical figures, the following principal depictions may have been located on the north wall, as seen by those entering the chamber on the right: *Croesus on the Funeral Pyre* (Müller 1996, no. 123) and *The Humiliation of the Emperor Valerian* (cat. 167; Müller 1996, no. 127); on the east wall, opposite the windows: *The Suicide of Charondas* (Müller 1996, no. 130) and *The Blinding of Zaleucus* (Müller 1996, no. 132f.); between the doors, on the same wall: *Manius Curius Dentatus Returns the Gifts of the Samnites,* below it: *The City Herald.* The south wall was concerned with Old Testament themes: *The Arrogance of Rehoboam* (possibly divided between a smaller and a larger picture; Müller 1996, no. 137) and *Samuel Curses Saul* (cat. 182; Müller 1996, no. 138). Certainly completed, as established by archival documents, were the paintings with Croesus, Charondas, Zaleucus, Manius Curius Dentatus, and Rehoboam (two pictures). We are almost completely ignorant about the arrangement of the secondary figures that accompanied the main pictures. Justitia (Müller 1996, no. 135), Sapientia (Müller 1996, no. 126), Temperantia (Müller 1996, no. 129), David (Müller 1996, no. 131), and Christ (Müller 1996, no. 134) have survived on copies of the designs. They allow us to conclude that David followed the *Charondas* painting and Christ followed the *Zaleucus* picture. The surviving

inscriptions give indications about the presence of other single figures: Anacharsis, Harpocrates, and Ezechias. The latter is further substantiated by the primary documentation of the inscription (Hiskia). It is not clear whether the program also included a *Christ and the Adulterous Woman* (Müller 1996, no. 136).[4]

C.M.

1. *Basler Stadtgeschichte,* Historisches Museum Basel, ed., with contributions by M. Alioth, U. Barth, and D. Huber, vol. 2, *Vom Brückenschlag 1225 bis zur Gegenwart* (Basel 1981), 46f.; *Basler Rathaus 1983,* 9ff.
2. G. Riggenbach, in: *KDM BS,* 1: 531ff., 591f.
3. G. Riggenbach, in: *KDM BS,* 1: 591f.
4. For additional designs that may belong in this context, see Müller 1996, 87, no. 123, no. 125.

167 THE HUMILIATION OF THE EMPEROR VALERIAN BY SAPOR, KING OF THE PERSIANS, 1521

Basel, Kupferstichkabinett, Inv. 1662.127
Pen and black ink over black chalk; gray wash; watercolor
285 x 268 mm
No watermark
Banderole above Sapor *SAPOR·REX·PERSARV*; below, *·VALERIANVS·IMP·*; bottom, left and right, in brown ink, *Hans Conradt Wolleb schankts Mathis Holzwartenn*; lower right, collector's mark *AVE* (in ligature, Lugt 192, not identified) Mounted on thin paper; breaks in lower right and upper left corners; upper right, tear; paint spots and some foxing

PROVENANCE: Amerbach-Kabinett

LIT.: Woltmann 1: 57; 2: no. 47 – Schmid 1896, 80, 89, no. 11 – *Handz. Schweizer. Meister* pl. 13 (1520/1521) – Ganz 1908, 26ff., pl. 11 – Chamberlain 1: 131f., pl. 41 – Knackfuss 1914, 61, ill. 52 – Ganz 1919, ill. on 163 – Manteuffel 1920, *Maler,* ill. on 13 – Ganz 1923, 34f., pl. 10 – G. Riggenbach, in: *KDM BS* 1, 562, 568f., 579f., no. 1, ill. 420 (detail), ill. 421 – Ganz 1937, no. 116 (1521) – Reinhardt 1938, 163, pl. on 159 (1521) – Waetzoldt 1938, 148, pl. 68 (1521) – Schmid 1945, 23, ill. 16 (1521/1522) – Ueberwasser 1947, pl. 24 (1521/1522) – Christoffel 1950, ill. on 247 (1521) – Ganz 1950, no. 168, ill. 46 – Exh. cat. *Holbein* 1960, no. 244 – Kreytenberg 1970, 78, 87, ill. 5 – F. Maurer 1971, 765, 768 – Roberts 1979, 27, no. 8 – Rowlands 1985, no. L. 6 Ia, pl. 159 – Exh. cat. *Holbein* 1988, no. 32 – Bätschmann 1989, 4f., ill. 9 – Müller 1991, 22, ill. 26 – C. Müller, in: Exh. cat. *Zeichen der Freiheit* 1991, no. 30 – Müller 1996, no. 127 – Bätschmann/Griener 1997, 80

The source for this image could have been *De mortibus persecutorum 5* by Lactantius, in which the church father reports that the Roman emperor Valerian (AD 253–260) was taken prisoner by the Sassanian King of Kings, Sapor. Sapor humiliated Valerian by using him as a stepstool

SAPOR·REX·PERSAR

VALERIANVS·IMP

167

whenever he wished to mount his horse. Finally he had Valerian flayed and his skin displayed in the temple. Setting one's foot on the back of an opposing commander is a gesture of subjugation of the vanquished individual. In addition, Valerian was humiliated by being made to touch the earth.[1] An analogous depiction is found on an engraving by the Master of the Boccaccio Illustrations (Lehrs 4, no. 9). Holbein may have been familiar with it, for the figure of Valerian, kneeling on the ground with his hands reaching forward to the edge of the picture, is similarly conceived. Also comparable are the hatlike crown of Sapor as well as the late medieval weaponry of the soldiers. Holbein has the action take place in front of a contemporary setting, the facade of a building that combines the forms of the late Gothic and the Renaissance, and that recedes diagonally into the background. The events seem concentrated on the main figures and largely unfold in the foreground, parallel to the picture plane. This compositional scheme is also present in other designs; it belongs among Holbein's favorite means of involving the viewer in the event, and of conferring dramatic tension on the action.

Between the figures and the background architecture we can perceive traces of changes from the preliminary drawing. Like the corrections to the framing pillars and the lively strokes, they speak for the autograph status of the drawing. François Maurer conjectured that it is an excellent copy. He interpreted the two small lines near the right pillar as relics of Holbein's working process: during the combination of the original designs a narrow transition space presumably remained, which the copyist incorporated. Holbein has washed these lines, however, validating them both materially and spatially. These panels could also represent an alternative solution for the frame or correspond to a real, existing wall piece, as they appear at the top and bottom.

Our drawing must have been executed in 1521. The names mentioned in the inscriptions are those of the previous owners: the Basel magistrate Wolleb (died 1571) and the Alsace poet Mathias Holtzwart (c. 1540–1589). If this wall painting was in fact located next to the *Croesus* picture on the north wall of the room (Müller 1996, no. 123), as most authors assume, then the latter work could be interpreted as an antithetical pendant to *Sapor*, as it highlighted the insight and benevolence of a victor. The Kupferstichkabinett Basel has a copy after this design (Müller 1996, no. 128). C.M.

1. See D. de Chapeaurouge, *Einführung in die Geschichte der christlichen Symbole* (Darmstadt 1984), "footstool print," 40f.; "humiliation on the ground," 46ff.

168 DESIGN FOR A STAINED GLASS WINDOW WITH TWO UNICORNS, C. 1522/1523

Basel, Kupferstichkabinett, Inv. 1662.150
Pen and black ink; gray wash; watercolor; inner borderline in red chalk
419 x 315 mm
Watermark: walking bear
Mounted on paper; horizontal and vertical center folds; rubbed at the edges

PROVENANCE: Amerbach-Kabinett

LIT.: Woltmann 2: no. 93 – His 1886, 23, pl. III – *Handz. Schweizer. Meister,* pl. III, 9 (c. 1519) – Chamberlain 1: 140 – Glaser 1924, pl. 30 – Schmid 1924, 338, 345 (c. 1528) – Stein 1929, ill. 77 – Cohn 1930, 14f., 98 (1521/1522) – Ganz 1937, no. 190 (1522/1523) – Schmid 1948, 65f., ill. 7 (schematic design with converging lines, c. 1528/1532) – Exh. cat. *Holbein* 1960, no. 261 (c. 1522/1523) – R. R. Beer, *Einhorn. Fabelwelt und Wirklichkeit* (Munich 1972), ill. 111 – J. W. Einhorn, *Spiritalis unicornis. Das Einhorn als Bedeutungsträger in Literatur und Kunst des Mittelalters* (Munich 1976), 247, 426, no. D. 650 – Roberts 1979, no. 16 – Exh. cat. *Holbein* 1988, no. 35 – Müller 1996, no. 140 –Bätschmann/Griener 1997, 126–127

The architecture with its projecting supports, broken entablature crowned with imitation classical male busts, and open roof construction could have been inspired by a woodcut by Cesare Cesariano in the illustrated Vitruvius edition of 1521, as suggested by Schmid 1948 (*Di Lucio Vitruvio Pollione de Architectura libri Dece traducti de latino in Vulgare affigurati,* Gotardus de Ponte, Como 1521). Schmid proposed that this stained glass window design was drawn c. 1528/1532, and justified his assumption using the perspective construction on which it is based. A date of about 1522/1523, which Ganz subsequently introduced to the discussion, seems more plausible. The powerful and, compared to earlier designs, somewhat more subdued strokes and the intensely dark wash, which gives objects a greater firmness and definition, vouch for that date, as does the composition, which strives for balance. It is the composition that connects this design with Holbein's *St. Michael* (Müller 1996, no. 139).

The architecture resembles a freestanding triumphal arch, set in the landscape on a shallow base. Because of this form of frame, the shield and its support acquire an unusual emphasis. Characteristic for Holbein is the constricted depth of the space and the plane in which the two animals stand, which lend a relieflike character to the depiction. A line in red chalk, added later (?), frames the architecture tightly and cuts through the drawing, especially on the left side. Perhaps the window was to conform to this reduced format. C.M.

169 WOMAN OF BASEL TURNED TO THE LEFT, c. 1523

Basel, Kupferstichkabinett, Inv. 1662.146a
Pen and black ink; black and gray wash
290 x 198 mm
No watermark
Mounted on paper; several thin places; paper rubbed; spotted;
gray-green discoloration

PROVENANCE: Amerbach-Kabinett

LIT.: *Photographie Braun*, no. 27 – Woltmann 2: no. 80 –
Mantz 1879, 138f., engraved reproduction (c. 1530) – *Handz.
Schweizer. Meister*, pl. III,37 – Chamberlain 1: 157f., pl. 52 –
Manteuffel 1920, *Maler*, ill. on 23 – Glaser 1924, pl. 33 – Ganz
1937, no. 148 – Reinhardt 1938, pl. 109 (c. 1523) – Waetzoldt
1938, 106, pl. 61 (1516/1520) – Ueberwasser 1947, pl. 29
(c. 1528/1530) – Christoffel 1950, ill. on 228 (1526/1532) –
Exh. cat. *Holbein* 1960, no. 282 (c. 1524/1525) – Roberts 1979,
no. 18 – Exh. cat. *Holbein* 1988, no. 41 – Von Borries 1989,
292 – Müller 1996, no. 142

The six costume studies from the old holdings of the Basel
Kupferstichkabinett to which this drawing belongs very
probably have an Amerbach provenance. Inventory F from
the middle of the seventeenth century names only five
drawings that are generally related to the "Women of
Basel": "five entire pictures inked each on a quarter royal
sheet."[1] However, on page 8 of the general inventory of
1775 compiled by Jakob Christoph Beck, we find men-
tion of "six panels with just so many women depicted
in different clothing on half-sheets drawn in ink."[2] The
costume studies of Holbein must have been intended
in both instances (Müller 1996, nos. 141–146).

Of the six drawings, three appear to be autograph.
The *Woman of Basel Wearing an Ostrich-Feather Beret*
(Müller 1996, no. 143) is shopwork. The two courtesans
(Müller 1996, no. 145f.) were probably not produced
before the middle of the sixteenth century.

The "Women of Basel" belong to the earliest cos-
tume studies of the Renaissance and are roughly compa-
rable to Dürer's "Women of Nuremberg" (watercolor
drawings in pen and brush of 1500).[3] Small, full-length
portraits, such as the drawings of Hans Burgkmair the
Elder in which he presented himself as a bridegroom,
were considered preliminary stages in the genre. The
growing interest in the portrayal of dress as well as the
observation of changing fashions is uniquely documented
in the costume books commissioned by Matthäus Schwarz
of Augsburg.[4]

According to Ganz (1937) the costume studies prob-
ably constituted three pictorial pairs: two noblewomen,
two bourgeoises, and two courtesans. But whether that

scheme actually corresponds to what Holbein intended
escapes our knowledge; the number of drawings could
have been greater. A precise identification of the figures
and determination of their social status is not possible on
the basis of the costumes themselves.[5] Movement and
comportment are better indicators of specific social posi-
tion. The expansive gestures, gazing at the presumably
male viewer, the offering of a drink, and a plunging neck-
line permit us to identify two of the women as courtesans
(Müller 1996, no. 145f.). The four remaining figures, who
until now have been deemed noble or bourgeois women,
give the impression of being "honorable" thanks to their
elaborate clothing or their reticent deportment. Von Bor-
ries observed that some of them could also be courtesans.[6]
One woman of Basel (Müller 1996, no. 143) sports love
knots on her feather beret and the other (Müller 1996, no.
144) wears a necklace with the letters *AMORVI[NCIT]*
(love triumphs). That the raiment worn by prostitutes was
at times very costly is something we learn, for instance,
from the drawings of Urs Graf[7] and a 1522 Shrovetide
play by Niklaus Manuel Deutsch, in which their getup
is compared with that of the nobility.[8]

Why Holbein made these drawings remains an open
question. Possibly he sold them to friends or collectors.
Certainly they served him and his workshop as prepara-
tory material. As Waetzoldt (1938) and Von Borries (1988)
pointed out, the figures could have found use on window
designs and glass paintings as female shield supporters,
with male figures opposite. That hypothesis could possibly
help explain the at-first incomprehensible arm and hand
positions of the "Women of Basel."[9]

The dating of the drawings varies. Ganz (1908) pro-
posed an early date, namely 1516. Schmid (1948) instead
dated them to about 1528/1530. Pfister-Burkhalter (in:
Exh. cat. *Holbein* 1960) compared them to the woodcuts
for the *Dance of Death* and posited 1524/1525. About 1523,
which Reinhardt (1938) also considered, is the most plau-
sible date, especially given the display of draftsmanship and
the detailed execution with energetic strokes, which is not
encountered later. In this respect, the drawings are clearly
different from Holbein's truly summary costume studies of
his English period.[10] The somewhat angular figures with
their protruding contours and the partially stiff and inhib-
ited poses also allow us to attribute them to the beginning
of the 1520s. C.M.

1. "Fünff gantze bilder getauscht iedes auff ein quart bogen von
Reall."
2. "Sechs Stück täfelein eben so vil Frauenzimmer in verschiedenen
Kleidungen vorstellend auf Papier in Halbbogens größe mit Touche
gemahlt."

169

3. W. 1936, nos. 224–228, no. 232; H. Kauffmann, in: Exh. cat. Nuremberg 1971, 18–25, esp. 21; M. Kusche, "Der christliche Ritter und seine Dame. Das Repräsentationsbildnis in ganzer Figur," *Pantheon* 49 (1991), 4ff., 18f.

4. H. Röttinger, "Burgkmair im Hochzeitskleide," *Münchner Jb. der Bildenden Kunst* (1908), 2d half vol., 48–52, ill.; A. Fink, *Die Schwarzschen Trachtenbücher* (Berlin 1963), esp. 20ff.

5. J. M. Vincent, *Costume and Conduct in the Laws of Basel* (Bern, Zurich, and Baltimore 1935), 47ff.; E. Grossmann, "Die Entwicklung der Basler Tracht im 17. Jahrhundert," *Schweizerisches Archiv für Volkskunde* 38 (1941), 1–66. In his description, Hans Heinrich Glaser differentiated the Basel dress of 1634 not only according to social class, but also according to occasions at which specific dress might be worn. See A. R. Weber, *Was man trug anno 1634. Die Basler Kostümfolge von Hans Heinrich Glaser* (Basel 1993).

6. Von Borries 1989, 292.

7. Andersson 1978, 53ff.

8. Andersson 1978, 55.

9. Waetzoldt 1938, 106; Von Borries 1989, 292, with examples.

10. Rowlands 1993, no. 317, no. 319; *Catalogue of the Collection of Drawings in the Ashmolean Museum,* K. T. Parker, ed. (Oxford 1938), no. 298.

Hans Holbein the Younger, *Resting Lamb and Head of a Lamb,* c. 1523

170 BAT WITH EXTENDED WINGS, c. 1523

Basel, Kupferstichkabinett, Inv. 1662.162
Gray and brown wash with touches of pen and black ink;
red-brown watercolor
168 x 281 mm
No watermark
Lower left, inscribed *HHolb.* (HH in ligature) and *23* by
Basilius Amerbach
Mounted on paper; upper right, stain; foxed

PROVENANCE: Amerbach-Kabinett

LIT.: *Photographie Braun,* no. 40 – Woltmann 2: no. 106 – Mantz 1879, ill. on 36 – Chamberlain 1: 161 – Knackfuss 1914, 20, ill. 18 – Glaser 1924, pl. 40 – F. Winkler, *Dürerstudien III, Jb. preuss. Kunstslg.* 53, 1932, 86 – Ganz 1937, no. 140 (c. 1526) – Ueberwasser 1947, pl. 31 – Schmid 1948, 13, 237 – Cetto 1949, 21, ill. 29 – M. Pfister-Burkhalter, in: Exh. cat. *Holbein* 1960, no. 302, ill. 98 – Exh. cat. *Swiss Drawings* 1967, 36, no. 34 (c. 1525) – Hugelshofer 1969, 138f., no. 48 – E. Landolt, "Materialien zu Felix Platter als Sammler und Kunstfreund," *Basler Zs. Gesch. Ak.* 72 (1972), 257 – Roberts 1979, no. 23, ill. – Exh. cat. *Stimmer* 1984, no. 193h – Exh. cat. *Holbein* 1988, no. 44 – Müller 1996, no. 148

This bat is the so-called great mouse ear *(Myotis myotis)* found in the region of Basel. The wingspan of a full-grown animal is about forty centimeters. Therefore, Holbein's image is reduced by about one-third. The low viewpoint, the tilted-back head, and the shadow cast by the bat on an unidentifiable ground allow us to conclude that Holbein had the animal lying in front of him on a flat surface, on which the wings were extended as if for scientific preparation. We certainly do not know how he attached it. The shrinking process, which sets in relatively quickly after death, is visible in the heart-formed lower body, which is drawn up into itself, and the inward-folding skin of the wings. Because of the tension, creases formed on the tail skin, which Holbein also reproduced.[1]

Although Holbein observed the phenomenon of shrinkage accurately, he made definite errors reproducing the construction of the body. Thus, the joint of the hand is not pronounced enough, and the claw appears to grow unattached out of the wing instead of out of the thumb, which the artist omitted. In addition, the distance between the second and third finger is too wide. Given this evidence, Holbein may have had the animal right in front of him, but he did not record all of its particulars correctly. However, changes in the natural position of some body parts may have occurred in the process of stretching out the animal.

Holbein was also interested in the materiality of the animal, its fur and the parchmentlike transparent wings with their network of veins. The color of the paper dominates in the drawing, appearing as light on the body and bestowing ground tone to the wings. Only on the head and for the veins did Holbein employ a little red; otherwise the gray and brown wash, which approaches the natural coloring of the animal, predominates. In fact, the underside of the great mouse ear is colored white-gray. Holbein executed the drawing mainly with a brush and

170

171

172

emphasized occasional contours with thin pen strokes.

The bat could have been intended for a scientific work or perhaps for Holbein's own investigations. The drawing *Resting Lamb and Head of a Lamb* in Basel (Müller 1996, no. 149) could belong in the same context (see ill.).

A date of about 1526, as proposed by Ganz and Pfister-Burkhalter, is not completely convincing. An earlier genesis of c. 1523, at about the same time as the costume studies (Müller 1996, nos. 141–144), is quite conceivable. In its reduced coloring and accuracy of detail, for instance, the bat is reminiscent of the 1523 Louvre studies of hands in silverpoint and red chalk, which Holbein prepared for the portraits of Erasmus (Demonts, no. 229f.). Even closer in technique is a portrait drawing of a young woman, also in the Louvre (Demonts, no. 228), which could well be a study for the *Solothurn Madonna* of 1522 (Rowlands 1985, no. 10). C.M.

1. I owe the identification of the animal and further information to J. Gebhard, Basel; see J. Gebhard, *Naturhistorisches Museum Basel. Unsere Fledermäuse* (Basel 1991), 61.

171 JEANNE DE BOULOGNE, DUCHESS OF BERRY, 1524

Basel, Kupferstichkabinett, Inv. 1662.126
Black chalk and colored chalks
396 x 275 mm
No watermark
Lined with japan paper; slightly trimmed on the sides; several small creases; small hole in lower left and upper right corners; some retouches in opaque white; slightly foxed

PROVENANCE: Amerbach-Kabinett

LIT.: *Photographie Braun*, no. 56 – Woltmann 2: no. 45 – *Handz. Schweizer. Meister,* pl. III,25 – Chamberlain 1: 175f., pl. 57 – Knackfuss 1914, 74, ill. 106 – Ganz 1924, 294 – Glaser 1924, pl. 36 – Ganz 1937, no. 12 (1524/1525) – Reinhardt 1938, pl. on 74 (1524) – Waetzoldt 1938, 114, pl. 59 – Troescher 1940, 79ff., 84, pl. VIII, 23 – Christoffel 1950, ill. on 136 (1524/1525) – Grossmann 1950, 229f., pl. 58d – Waetzoldt 1958, 62 (1524/1525) – Zschokke 1958, 181, pl. 64,2 – Exh. cat. *Holbein* 1960, no. 277 (c. 1524/1525) – Ueberwasser 1960, no. 9 – Exh. cat. *Amerbach* 1962, no. 73, ill. 22 (1924/1925) – H. Klotz, "Holbeins 'Leichnam Christi' im Grabe," *Öff. Kunstslg. Basel. Jahresb.* (1964/1966), 119, ill. 6 (1523/1524) – Meiss 1967, 45, 68, 78, 93, ill. 510 – Hp. Landolt 1972, no. 76 – Roberts 1979, no. 27 – Reinhardt 1982, 259 – Foister 1983, 27, ill. 62 – Favière 1985, 47ff., ill. 2 – Exh. cat. *Holbein* 1988, no. 46a – Exh. cat. *Amerbach* 1991, *Zeichnungen,* no. 109 – Claussen 1993, 179 – Müller 1996, no. 150 – Bätschmann/Griener 1997, 134 – Von Borries 1997, 175

172 JEAN DE FRANCE, DUKE OF BERRY, 1524

Basel, Kupferstichkabinett, Inv. 1662.125
Black chalk and colored chalks
396 x 275 mm
Watermark: single-handled vase with double flower (similar to Briquet 12632)
Lined with japan paper; slightly trimmed on the edges; several small creases; scattered paint spots and some later retouching in opaque white

PROVENANCE: Amerbach-Kabinett

LIT.: *Photographie Braun*, no. 55 – Woltmann 2: no. 44 – Chamberlain 1: 175f. – Ganz 1924, 294 – K. T. Parker, *Drawings of the Early German Schools,* London 1926, 36, pl. 69 – Ganz 1937, no. 13 (1524/1525) – Reinhardt 1938, pl. 75 (1524) – Waetzoldt 1938, 114, pl. 58 – Troescher 1940, 79ff., 84, pl. VIII,24 – Christoffel 1950, ill. on 137 (1524/1525) – Grossmann 1950, 229f., pl. 58e – Schilling 1954, 19f., no. 32, ill. – Zschokke 1958, 181, pl. 64,3 – Exh. cat. *Holbein* 1960, no. 278 (c. 1524/1525) – Exh. cat. *Amerbach* 1962, no. 74 (1924/1925) – Meiss 1967, 45, 68, 78, 93, ill. 511 – Roberts 1979, no. 28 – Reinhardt 1982, 259 – Foister 1983, 27, ill. 63 – Favière 1985, 47ff., ill. 4 – Exh. cat. *Holbein* 1988, no. 46b – Exh. cat. *Amerbach* 1991, *Zeichnungen,* no. 110 – Claussen 1993, 179 – Müller 1996, no. 151 – Bätschmann/Griener 1997, 134 – Von Borries 1997, 175

In 1524, during his French journey, Holbein drew the donor figures of Jean, Duke of Berry (1340–1416), and his wife, Jeanne de Boulogne.[1] Jacob Burckhardt was the first scholar to draw attention to the connection between the drawings and the statues,[2] originally set up in the chapel of the ducal palace in Bourges, where the grave was located. The two lifesize and polychromed marble statues were sculpted after 1416, and are attributed to Jean de Cambrai (see ill.). They were turned toward the figure of Notre-Dame la Blanche, kneeling in eternal adoration. The chapel, and the grave with it, were destroyed in about the middle of the eighteenth century. The three figures found a new home in the ambulatory of Bourges cathedral, but were badly damaged during the French Revolution. Using Holbein's drawings, they were reconstructed in 1913 and freed from the restorations of the nineteenth century. The original head of the statue of the duke is today in the Hôtel Jacques Coeur in Bourges.[3]

This is the first instance in which Holbein drew in colored chalks. It cannot be convincingly established whether he was inspired by Jean Clouet,[4] who used colored chalks in his drawings, as is assumed by several authors, or whether he was encouraged by artists in the circle of Leonardo da Vinci in France or, as Bätschmann suggested, by Leonardo's followers in Milan. The assumption that this technique developed from the silver-

point drawing, which was then colored, has some merit, as Meder indicated in another context.[5] The portraits by Leonhard Beck and Heinrich Aldegrever, which were executed in this technique not much later (see cats. 192, 193), cannot be exclusively traced back to Holbein but indicate that artists in Augsburg and in Westphalia, and perhaps also Holbein himself, were able to arrive at this technique independently, without the help of examples.

The polychroming of the sculptures and their precise detail may have encouraged Holbein to depict them in his drawings as living people, an effect achieved, for the most part, by their glances. Holbein depicted the eyes complete with lashes, which could not have been present on the sculptures. And turning Jean de Berry from profile to three-quarter view also added to this lifelike impression. With respect to the clothing and disposition of the folds, Holbein stuck to his late Gothic models. The richly embroidered headdress of Jeanne de Boulogne, which is studded with gems, and her collar and sleeves are drawn

in detail. Holbein achieved subtle middle tones through the superimposing of red and yellow chalks. Finally, he shaded the folds of the garments in black chalk, and thereby moved on to more open structures.

During his French journey Holbein probably attempted to gain a foothold as painter at the court of Francis I. The two drawings were perhaps intended as a sample of his skill and to prove that he was an artist who could breathe life into stone. Von Borries (letter, 13 June 1996) suspected, however, that Holbein made the two drawings during his return journey to Basel. If so, that would indicate that he intended to use the drawings for personal purposes and as reference material. It is also possible that he expected to create paintings from the two drawings. In any case, they are very close in style and technique to his preparatory drawings for painted portraits. The bid to bring the two sculptures to life could be interpreted as an attempt to enter into competition with sculpture and to outdo it.[6]

C.M.

Attributed to Jean de Cambrai, *Jean de France and Jeanne de Boulogne,* c. 1416

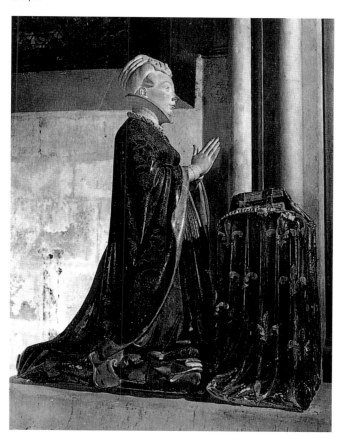 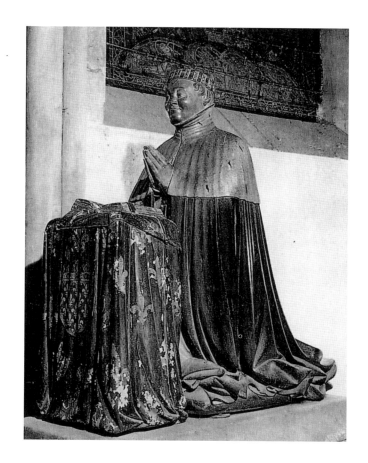

1. A letter of 6.3.1524, written by Erasmus of Rotterdam to Willibald Pirckheimer in Nuremberg, gives information on Holbein's French journey of the same year. See Reinhardt 1982, 259f.; Allen/Garrod, 5, no. 534f.

2. J. Burckhardt, *Briefe,* M. Burckhardt, ed., vol. 5 (Basel 1963), 211, no. 619, letter of 9.26.1873 to E. His.

3. Troescher 1940, 74ff.

4. See Ganz 1924, 292ff.; P. Mellen, *Jean Clouet: Complete Edition of the Drawings, Miniatures and Paintings* (London 1971), esp. 29ff.

5. Meder 1919, 137f.

6. See Müller 1989; Claussen 1993, 177ff., esp. 179.

173 DESIGN FOR A STAINED GLASS WINDOW WITH TERMINUS, 1525

Basel, Kupferstichkabinett, Inv. 1662.158
Pen and black ink; gray wash over black chalk; traces of watercolor
315 x 210 mm
Watermark: walking bear
On the herm *TERMI/NVS*; above the horizon, to left and right of the figure *CONCEDO NVLLI*; lower left *20* in pencil
Slightly trimmed on the sides

PROVENANCE: Amerbach-Kabinett

LIT.: Woltmann 2: no. 102 – His 1886, 24, pl. IV – *Handz. Schweizer. Meister,* pl. III,38 (after the first English journey) – Chamberlain 1: 146 – E. Major, *Erasmus von Rotterdam* (Basel 1925), pl. 21 (c. 1525) – Cohn 1930, 15f., 64, 98 (1521/1522) – E. Major, "Das Wahrzeichen des Erasmus," *HMB. Jahresb.* (1935), 41ff., ill. b – Ganz 1937, no. 201 (1525) – Schmid 1948, 82 (c. 1525) – Exh. cat. *Holbein* 1960, no. 285 – J. Bialostocki, "Rembrandts Terminus," *Wallraf-Richartz Jb.* 28 (1966), 55ff., n. 25, ill. 31 – Exh. cat. *Erasmus* 1969, no. 350, ill. 1 – F. Graf, "Emblemata Helvetica. Zu einer Sammlung angewandter Embleme der deutschsprachigen Schweizer Kantone," *ZAK* 31 (1974), 148, ill. 3 – J. Rowlands, "Terminus. The Device of Erasmus of Rotterdam. A Painting by Holbein," *Bulletin of the Cleveland Museum of Art* (February 1980), 50–54, ill. 5 – E. Landolt, in: Exh. cat. *Erasmus* 1986, no. H 2 – Exh. cat. *Holbein* 1988, no. 47 – U. Davitt Asmus, "Amor vincit omnia. Erasmus in Parma oder Europa in termini nostri," *Mitteilungen des kunsthistorischen Instituts in Florenz* 34 (1990), 297ff. – Exh. cat. *Amerbach* 1991, *Zeichnungen,* no. 111 – Müller 1996, no. 156

The origins of Terminus, the distinctive emblem of Erasmus of Rotterdam, can be traced back to the year 1509. At that time Erasmus had received a ring in Rome as a gift from his student Alexander Stewart, a son of the Scottish King James IV. The stone of this ring, a Roman carnelian, shows an ancient god, probably Dionysus, who was identified as Terminus.[1] Furnished with the motto *concedo nulli* or *cedo nulli* (I concede to no one or I do not

give way), Terminus recurs on a plethora of pictorial testimony associated with Erasmus: on the seal of Erasmus of 1513/1519,[2] on the back of Quentin Massys' portrait medal of Erasmus of 1519 that has additional mottos in Greek and Latin,[3] on a lost memorial slab of 1537,[4] on Holbein's Cleveland painting of Terminus,[5] and on Holbein's woodcut with the portrait of *Erasmus of Rotterdam* of 1538/1540.[6]

Wind has discussed the literary sources and the varying interpretations of the emblem, which were already controversial in Erasmus' own time. His critics, who viewed Erasmus as a pioneer of the Reformation, posed the question of whether the words *concedo nulli* were spoken by the god of boundaries or by Erasmus himself. In the end they accused Erasmus of arrogance so that in 1528 he felt obliged to take a written stand.[7] Erasmus stated that the boundary god, that is, Death, speaks the words. This can be supported by Massys' medal, on which further inscriptions draw attention to the end of a long life and to Death as the boundary of all things. Wind pointed out that Erasmus may also have had in mind the mythology associated with Terminus, and applied the saying *concedo nulli* to himself and his own resolution and independence. Panofsky considered this possibility as well.[8] Terminus resisted the urging of Jupiter and remained steadfast in his traditional location on the Capitoline Hill. McConica connected Terminus and the mottos with Erasmus' statements concerning a Christian death and his own demise, and interpreted the emblem as a memento mori.[9] When taken in the Christian sense, however, the words *concedo nulli* could be spoken by Erasmus and by Death—as steadfastness in life gained from an awareness of the inevitability of death and the transience of life, and from faith in a life after death. Rowlands interpreted the steadfastness as steadfastness in the faith.[10]

Terminus has the appearance of an ancient pillar herm. Wind interpreted the lower block, set into the ground and inscribed with the word *Terminus,* as the actual boundary stone, and as an emblem of death. This base continues into a youthful male upper body, whose head surrounded by a halo of light rays looks to the left. He could embody Youth *(iuventus)* and be understood as a reference to the new life after death. Terminus as death makes possible our entry into a new, eternal life; therefore, according to Wind, the herm signifies eternity *(aeternitas)*.

Light plays a considerable role in our stained glass window design and in the Cleveland painting, which approaches our version most closely. Coming from the upper left of the drawing, it envelops frame and figure and may be interpreted as the celestial, divine light through which Terminus will shine. In the Cleveland

173

painting, Terminus clearly stands at the transition from light to dark, and turns toward the former.

Davitt Asmus suggested a connection between the portrait of Erasmus in the Galleria Nazionale in Parma, which shows the scholar with an open book, and the emblem of Terminus on our window design. The portrait is from 1530 and was painted in Holbein's shop. In the open book, whose author is Erasmus himself, only the following coherent words can be read: *AMOR VINCIT OMNIA* (love conquers all). Asmus related this sentence, which was frequently used, to Virgil's tenth ecologue, verse 69, where we read, "omnia vincit Amor et nos cedamus Amori" (love conquers all and we must submit to love). Asmus assumed that Erasmus, presumably the person who commissioned the picture, wished to match the motto *concedo nulli* with the words spoken or thought by an initiated viewer, *et nos cedamus Amori,* as an associative play on words. It finds expression in the split character of the Terminus statue, specifically in the immobile lower part with its inscription, which embodies the boundary stone and the written word, and the living upper part, which symbolizes the spoken word. Asmus identified the concept of Terminus not only as boundary god (space) and as time (death) but also as the *terminus* of Roman law and as *logos,* intellect expressed through speech, a proposition that is not completely convincing.

The window design can be related to a glass painting that Erasmus gave to the University of Basel in 1525. Major was able to ascertain that it still remained in situ in the eighteenth century.[11] According to Russinger the tablet, which is still empty in the rendering, carried the mottos *ORA TELOS MAKROY BIOY* (see the end to a long life) and *MORS VLTIMA LINEA RERVM* (death means an end to all things) as well as the name of the donor and the date 1525: *D. ERAS. ROTE. ANNO. DOMINI. M.D.XXV.*[12]

E. Landolt conjectured that the Basel glass painter Anthoni Glaser could have manufactured the window, for in 1537, Bonifacius Amerbach ordered a second glass painting with Terminus for Beatus Rhenanus. This was intended for the library of the preacher's convent in Schlettstadt, and may have had the same design as its model. It may have originally been in Erasmus' possession. Whether it came directly from his estate into the hands of Bonifacius Amerbach or whether it was acquired by Basilius Amerbach cannot be determined.

A notice in the lost register of the Berlin arsenal library can be applied to the window. There it read: "In the middle is a terminus standing up to the navel in a green field."[13] C.M.

1. Basel, Historisches Museum, inv. 1893.365; see E. Landolt, in: Exh. cat. *Erasmus* 1986, no. H 64, ill. on 73; Exh. cat. *Amerbach* 1991, *Objekte*, no. 15.

2. Basel, Historisches Museum, inv. 1893.364.; Exh. cat. *Amerbach* 1991, *Objekte*, no. 16.

3. Exh. cat. *Erasmus* 1986, no. A 2.10, ill. on 79; Exh. cat. *Amerbach* 1991, *Objekte,* no. 17.

4. Exh. cat. *Erasmus* 1986, no. H 41.

5. Rowlands 1985, no. 35, ill. 67.

6. Hollstein *German* 14, no. 9.

7. Letter of 8.1.1528 from Alfonsus Valdesius, the imperial confidential clerk; Allen/Garrod, 7, no. 2018; E. Wind, "Aenigma Termini," *Journal of the Warburg and Courtauld Institutes* 1 (1937/1938), 66–69.

8. E. Panofsky, "Erasmus and the Visual Arts," *Journal of the Warburg and Courtauld Institutes* 32 (1969), 200–227, esp. 215f.

9. J. K. McConica, "The Riddle of Terminus," in *Erasmus in English* vol. 2 (1971), 2–7; Exh. cat. *Erasmus* 1986, no. H 2, n. 5f.

10. Rowlands 1980, 50–54, esp. 53.

11. Major 1935, 39f.; Exh. cat. *Erasmus* 1986, no. H2, n. 5f.

12. J. Russinger, *De Vetustate Urbis Basileae* (Basel 1620), 34; Major 1935, 39, n. 15.

13. Exh. cat. *Erasmus* 1986, no. H 41; Major 1935, 39.

174 ANNA MEYER, C. 1526

Basel, Kupferstichkabinett, Inv. 1823.142
Black chalk and colored chalks; lead point in the contours and face; background tinted light green
391 x 275 mm
No watermark
Lined with japan paper; cut on all sides; lower left and right corners torn off; some spots touched up in opaque white

PROVENANCE: Museum Faesch

LIT.: *Photographie Braun*, no. 46 – Woltmann 2: no. 42 – Mantz 1879, 51f., ill. on 52 – Schmid 1900, 61, ill. after 64 – Knackfuss 1914, 104, ill. 99 – Glaser 1924, pl. 43 – Ganz 1925, Holbein, 232 – Ganz 1937, no. 16 – Waetzoldt 1938, 95, pl. 39 (1525/1526) – Fischer 1951, 345ff., ill. 283 – Reinhardt 1954/1955, 244ff., pl. 78 – Grohn 1956, 15, ill. 5 – Exh. cat. *Holbein* 1960, no. 298 – Von Baldass 1961, 93, ill. 4 – Rowlands 1985, 64, ill. 12 with no. 23 – Grohn 1987, no. 46b – Exh. cat. *Holbein* 1988, no. 61 – Klemm 1995, 44, 73, ill. on 45 – Müller 1996, no. 155 – Bätschmann/Griener 1997, 134

Of the preparatory studies for the *Darmstadt Madonna,* three portrait drawings have survived: Jakob Meyer zum Hasen, the former burgomaster of Basel and patron who commissioned the picture; his wife, Frau Dorothea Meyer, born Kannengiesser; and their daughter Anna (see ill.). Holbein painted the *Darmstadt Madonna* about 1526. It was intended for the house chapel in the hunting lodge of Gundeldingen, which Meyer owned. Today the painting is in the Darmstadt Schlossmuseum (see ill.).[1]

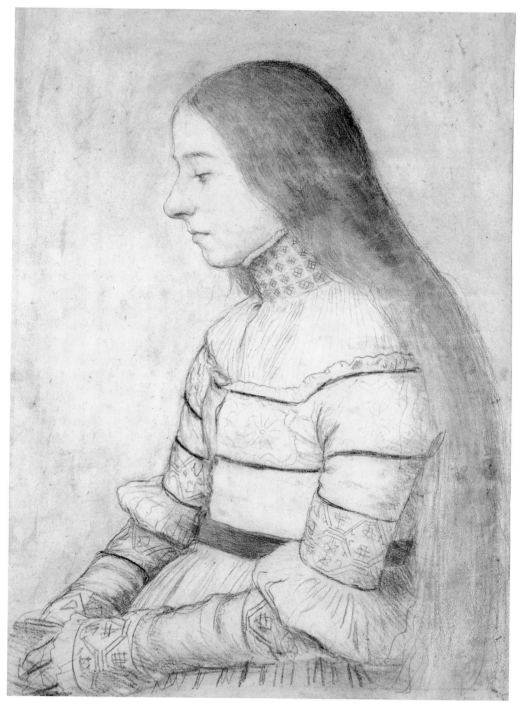

174

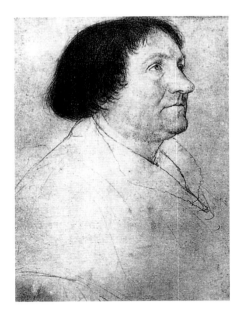

Hans Holbein the Younger, *Jakob Meyer zum Hasen, Portrait Study for the Darmstadt Madonna,* c. 1526

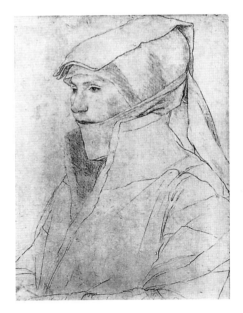

Hans Holbein the Younger, *Dorothea Meyer, Portrait Study for the Darmstadt Madonna,* c. 1526

Hans Holbein the Younger, *The Darmstadt Madonna,* c. 1526/1528

After his return from England, about 1528, Holbein changed the painting at Meyer's request. The occasion was presumably the death of the latter's son, who kneels before him in the painting and turns toward a male infant. Ost conjectured that this lad, who, like Christ, is depicted naked, could be the young St. John the Baptist.[2] Holbein then added Margareta Baer, Meyer's first wife, who had died in 1511, on the right and concurrently altered the appearance of Dorothea Meyer and the daughter, Anna. This is established by the drawings in Basel and the evidence of the painting. In this way, Meyer wished to commend all members of the family, including the deceased ones, to the protection and intercession of the Virgin Mary. The altarpiece therefore became an epitaph.[3]

The study of Anna Meyer clarifies how objectively Holbein captured his models. The relaxed body position of the seated Anna, with her bowed head, her bent shoulders, and, last but not least, her vacant stare, all indicate how little attention the roughly thirteen-year-old girl paid to the painter or to the task of posing; she was altogether lost in her own thoughts. Holbein introduced changes while executing the painting. Anna kneels, her body erect, tense, and presented in profile. In the first version, as in the drawing, she wore her hair loose around her shoulders. By 1528 she had reached a marriageable age and was perhaps already engaged to Niklaus Irmy, her

husband. Hence Holbein took advantage of the reworking of the painting to change her hairstyle: braided and pinned up, it is decorated with a chaplet of the kind worn to church by the girls of Basel from their fifteenth birthday on. In the drawing Anna appears on a ground tinted light green. As the girl wears a white dress in the painting, Holbein eliminated color in the drawing, with the exception of collar and girdle, and allowed the natural color of the paper to take its effect. C.M.

1. Rowlands 1985, 64–66, no. 23, pls. 8–10, pl. 50, pl. 52.
2. H. Ost, "Ein italo-flämisches Hochzeitsbild und Überlegungen zur ikonographischen Struktur des Gruppenporträts im 16. Jahrhundert," *Wallraf-Richartz Jb.* 41 (1980), 133–142, 14, n. 33.
3. Oskar Bätschmann and Pascal Griener, *Hans Holbein d. J. Die Darmstädter Madonna. Original gegen Fälschung* (Franfurt am Main 1998), 54–57.

175 STUDY FOR A FAMILY PORTRAIT OF THOMAS MORE, c. 1527

Basel, Kupferstichkabinett, Inv. 1662.31
Pen and black ink; finely pointed brush and black wash; black chalk drawing; inscriptions and some motifs in brown ink
389 x 524 mm
Watermark: two-handled vase with double flower (similar to Briquet 12863)
Handwritten by Nikolaus Kratzer, *Elisabeta Dancea/thome mori filia/anno 21/margareta giga clemétis/uxor thome mori/filiatus condiscipula/et/cognata anno 22/johannes/morus pater/anno 76./ thomas morus/anno 50/anna grisacria/johanni mori sponsa/anno 15/johannes/morus thome/filius anno 19/cecilia herona thome mori filia anno 20/margareta ropera/thome morij filia anno 22/henricus patensonus/thome mori morus/anno 40/alicia thomae mori/uxor anno 57*; right edge, presumably handwritten by Holbein *Dise soll sitzē*; upper left *Claficordi und ander/seyte spill uf dem buvet*
Lined with japan paper and trimmed around the edges; two strips of 20 and 40 mm project from the right edge; vertical center fold, flattened; left edge, large loss with old repair; small holes and thin places; tear, lower right edge; retouches in opaque white

PROVENANCE: Amerbach-Kabinett

LIT.: *Photographie Braun*, no. 47 – Woltmann 1: 347ff.; 2: no. 35 – His 1870, 124f. – Mantz 1879, 116f., reproduction of an engraving – Davies 1903, 125f., ill. following 116 – Chamberlain 1: 291–302, pl. 74; 2, 334ff. – Knackfuss 1914, 110, ill. 101 – *Catalogue of the Pictures and Other Works of Art in the Collection of Lord St. Oswald at Nostell Priory*, ed. M. W. Brockwell, London 1915, 80f., pl. VII – Ganz 1919, 249f., ill. on 192 (1528, preparatory study) – Glaser 1924, pl. 51 (preparatory study) – Schmid 1924, 344 – Ganz 1925, *Holbein*, 240, pl. II, E – Schmid 1931, 15 (autograph copy) – Ganz 1936, 141–154, ill. 1, ill. 3, ill. 9f. – Ganz 1937, no. 24 (1527, whole design) – Waetzoldt 1938, 159, 162f., 215, pl. 75 (1527) – O. Pächt, "Holbein and Kratzer as Collaborators," *Burl. Mag.* 84, 1944, 134–139, esp. 138, ill. 132, pl. III – Parker 1945, 35, ill. IX – Schmid 1945, 26f., ill. 42; 1948, 293ff. – Christoffel 1950, ill. on 166 (sketch, 1527) – Ganz 1950, no. 176, ill. 54 – Fischer 1951, 349f., ill. 288 – Grohn 1956, 16ff., ill. 7 (intermediary design) – Waetzoldt 1958, ill. 23 (sketch, c. 1527) – Exh. cat. *Holbein* 1960, no. 308 (outline drawing after design or painting, 1528) – Exh. cat. *Amerbach* 1962, no. 75, ill. 23 (1527/1528) – J. Pope-Hennessy, *The Portrait in the Renaissance* (New York 1966), 99f., ill. 104 – B. Hinz, "Das Familienbildnis des J. M. Molenaer in Haarlem," *Städel Jb.*, n.s. 4 (1973), 213f., ill. 4 – Exh. cat. *"The King's Servant." Sir Thomas More. 1477/8–1535*, ed. J. B. Trapp/H. Schulte Herbrüggen, National Portrait Gallery London (London 1977), no. 169, ill. 84 – Roberts 1979, no. 29, ill. – Foister 1981, 363ff., 433, no. 2 – Reinhardt 1981, 58 – Reinhardt 1982, 261, ill. 6f. – Foister 1983, 16, 33, ill. 33 – R. Norrington, *The Household of Sir Thomas More. A Portrait by Holbein* (Waddesdon 1985), ill. – Rowlands 1985, 69–71, no. L. 10a, pl. 188 – E. Landolt, in: Exh. cat. *Erasmus* 1986, no. C 7, ill. on 81 – J. Roberts, in: Exh. cat. *Holbein* 1987, 28, ill. on 30 – Grohn 1987, no. 45a – Exh. cat. *Holbein* 1988, no. 65 – L. Martz, "Thomas More. The Search for the Inner Man," *Miscellanea moreana: Essays for Germain Marc'hadour* [Moreana 100, 26] (Binghamton/New York 1989), 400, ill. 1 – L. Martz, *Thomas More. The Search for the Inner Man* (New Haven/ London 1990), 61ff., ill. 1 – L. Campbell, *Renaissance Portraits* (New Haven/New York 1990), 142, ill. 164 – Exh. cat. *Amerbach* 1991, *Zeichnungen*, no. 114 – B. Hinz, "Holbeins 'Schola Thomae Mori' von 1527," *Wandel der Geschlechterbeziehungen zu Beginn der Neuzeit*, ed. H. Wunder/C. Vanja (Frankfurt am Main 1991), 69ff., 74ff. (according to the inserted dates of birth and death, it did not originate after 2.7.1527) – Müller 1996, no. 157 – Bätschmann/Griener 1997, 164

About 1527, while he was a guest in the house of Thomas More during his first stay in England, Holbein created a group portrait in which the family was shown assembled in one room of the house on their Chelsea estate. The work was painted on canvas and measured about 2.75 by 3.60 meters. It was probably destroyed in 1752 in a fire in Schloss Kremsier (Zámek Kroměříž, Czech Republic) (Rowlands 1985, no. L. 10).

In addition to the drawing in Basel, copies supply information about the appearance of the painting. Of these, the version in Nostell Priory, produced by the painter Rowland Lockey (died 1616) in the last decade of the sixteenth century, is probably the most reliable (Rowlands 1985, no. L. 10c; see ill.). Claims about its date of origin vary. According to Roberts it can be dated to 1592. Rowlands gave the inscription as *"Richardus Locky*

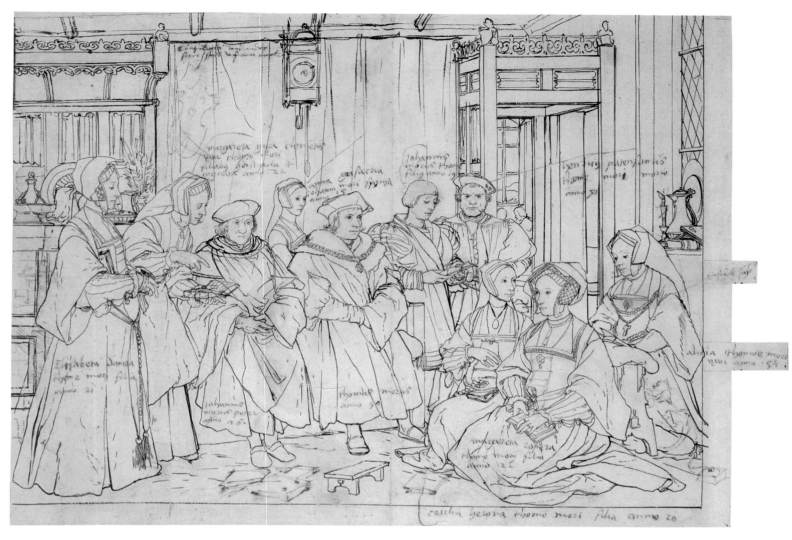

175

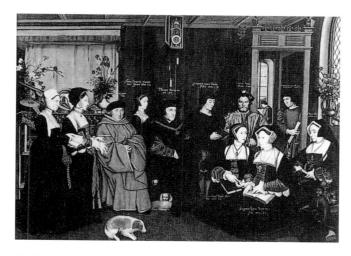

Rowland Lockey, Copy after Hans Holbein the Younger, *Thomas More's Family Portrait*, c. 1590

Fec. ano. 1530." In his opinion, the date 1530 should appear on our drawing, which is not the case.

That Holbein was inspired by Mantegna's group portraits of Lodovico Gonzaga and his family in the Camera degli Sposi of the Palazzo Ducale in Mantua for his composition and narrative details, is a thesis (see, for instance, Pope-Hennessy) that remains open to challenge. Also open is the question of how Holbein could have become familiar with this fresco.

Holbein prepared portrait drawings of the individual sitters. Seven of these have survived and are preserved in the Royal Collection in Windsor Castle (Parker 1945, no. 1f., nos. 4–8; Exh. cat. *Holbein* 1987, no. 1f., nos. 4–8). Holbein used paper with the same watermark as our drawing for some of these studies.

Portrayed from left to right are: Elizabeth Dauncey, the second daughter of Thomas More; Margaret Giggs, More's stepdaughter; seated on the couch, the father, John More, and his son Thomas; standing behind them, Anne Cresacre, the future wife of Thomas More's only son John, who stands to his father's right; the house jester, Henry Patenson; seated in front of him, Cecily Heron and Margaret Roper, the third and oldest daughters of Thomas More; kneeling behind them, Lady Alice More, Thomas' second wife.

Differences between Lockey's copy and the Basel drawing raise the question whether Lockey made changes with respect to his model or whether these alterations should be attributed to Holbein himself. The drawing was in any case created before the final version of the painting was settled. The summarily sketched and handwritten proposals for changes in brown ink, which in all likelihood reflect the wishes of Thomas More, are most probably by Holbein's hand. Pächt was able to demonstrate that Nikolaus Kratzer, Henry VIII's court astronomer, added the names and ages of the subjects.

At the right edge, next to Alice, the second wife of Thomas More, we read the words: *Dise soll sitzē* (this one should sit). In the same brown, possibly oxidized, ink a frenetic little monkey scrambling up her dress has been added, and the candle on the windowsill crossed out. Between the clock and the sideboard hangs a viola da gamba, above which is written that *Claficordi und ander seyte spill* (the clavichord and other string instruments) must be accommodated *uf dem buvet* (on the buffet).[1]

These alterations are in fact encountered in Lockey's copy: Lady Alice sits, and we see the small monkey by her side. The candle on the windowsill has been replaced by a vase of flowers, and musical instruments do grace the buffet. Even the subsequently detailed bodice of Margaret Roper has been taken into account. In addition, the family servant, Johannes Heresius, has been added at the right. In Holbein's drawing he still remains, together with another person—the family secretary, John Harris—in the office in the very back. Where Heresius appears in Lockey's picture, in the drawing the outlines of a head are visible below Kratzer's writing, which could be an indication that Holbein had already considered introducing the servant, while at the same time pursuing a compositional counterweight to the dominant left half of the painting.

The remaining changes are not mentioned in the indications for corrections, meaning that Holbein cannot have initiated them. The two women on the left, Elizabeth Dauncey and Margaret Giggs, have been switched. In the Basel drawing, the latter still bends toward John More and points at her open book. In a portrait drawing in Windsor Castle, for instance, Holbein depicted Margaret Giggs as Lockey had (Parker 1945, no. 8). Hence Ganz (1936), Foister (1981), and Roberts conjectured that Holbein rendered the portrait drawings only after the creation of the Basel drawing, and after he had discussed the changes to the overall composition with More.

The drawing probably represents the More family at prayer or preparing for contemplation. Lockey, however, retracted this reference to More's Catholic faith; a change that is in any case already hinted at by the written corrections on our drawing: Alice no longer kneels, as if praying, but sits. Cecily Heron no longer holds a rosary; she converses with Margaret Roper, who is reading Seneca's *Oedipus*. Elizabeth Dauncey has an edition of Seneca's letters under her arm.[2] Also relinquished is the private

character of the drawn family portrait, in which the members of the More family are more casually grouped. Instead of the subsequently sketched books lying about and the stool, which could create an impression of domestic disorder, Lockey's work has a dog in the foreground.

Hinz observed that the clock that hangs directly above Thomas More in Lockey's picture, unlike in the drawing, moves More to the middle of the painting as head of the family. Exchanging Margaret Giggs, who was related to the More family only by marriage, for the Mores' daughter, who now stands right next to John More, may also indicate that—possibly reflecting the interests of a later generation—dynastic considerations weighed heavier for Lockey than they had for More and Holbein.

The drawing may have passed from the estate of Erasmus of Rotterdam into the possession of Bonifacius Amerbach and thus, eventually, to the Amerbach-Kabinett. It is also possible that Basilius Amerbach acquired the sheet from the heirs of Hieronymus Frobens (1501–1563). Upon his return from England in 1528, Holbein delivered it to Erasmus as a gift from Thomas More (1477–1535). In letters to More and his daughter Margaret Roper, Erasmus thanked them for the drawing, in which he was able to see once again the familiar family of his friend.[3] C.M.

1. The transcription of the word "buvet" is after Ulrich Barth, Basel; Exh. cat. *Erasmus* 1986, no. C 7, esp. n. 7.
2. Brockwell 1915, 85, pl. XX; Foister 1981, 364; see also Hinz 1991.
3. Allen/Garrod, 8, no. 2211f., letters of 5 and 6 September 1529.

176 LADY MARY GUILDFORD, 1527

Basel, Kupferstichkabinett, Inv. 1662.35
Black chalk and colored chalks
552 x 385 mm
Watermark: crowned French fleur-de-lis shield with the letter b (variant of Briquet 1827)
Mounted on paper; slightly trimmed; horizontal center fold, flattened; several large repaired tears touched up in opaque white

PROVENANCE: Amerbach-Kabinett

LIT.: *Photographie Braun*, no. 51 – Woltmann 2: no. 32 – Mantz 1879, ill. on 175 – Chamberlain 1: 321, pl. 81,2 – Glaser 1924, pl. 48 – Schmid 1930, 25, 75f. – Ganz 1937, no. 21 (1527) – Reinhardt 1938, pl. on 87 – Parker 1945, 38, ill. XI – Ueberwasser 1947, pl. 8 – Waetzoldt 1958, 58 – Exh. cat. *Holbein* 1960, no. 304 – Exh. cat. *Swiss Drawings* 1967, no. 36 – Hugelshofer 1969, 142, no. 50 – Foister 1981, 434, no. 5 – Foister 1983, 4, ill. 13 – Rowlands 1985, 72, with no. 26 – M. W. Ainsworth/M. Faries, "Northern Renaissance Paintings. The Discovery of Invention," *The Saint Louis Art Museum Bulletin* (Summer 1986), esp. 25ff., ill. 45 – Exh. cat. *Holbein* 1987, 50, ill. – Grohn 1987, no. 53a – Exh. cat. *Holbein* 1988, no. 66 – M. Ainsworth, "'Paternes for phiosioneamyes.' Holbein's Portraiture Reconsidered," *Burl. Mag.* 132 (1990), 178ff., ill. 12 – Exh. cat. *Amerbach* 1991, *Zeichnungen*, no. 115 – Müller 1996, no. 159 – Bätschmann/Griener 1997, 169

This drawing is a study for Holbein's painted portrait of Mary Wotton, Lady Guildford. The painting, with the date 1527, is in the St. Louis Art Museum, Missouri (Rowlands 1985, no. 26; see ill.). Its companion piece shows Sir Henry Guildford, Henry VIII's treasurer, who had taken Mary Wotton for his second wife. It is also dated 1527 and, together with its preparatory study, is in Windsor Castle (Rowlands 1985, no. 26; Exh. cat. *Holbein* 1987, no. 9).

While executing the painting, Holbein turned Lady Guilford's upper body from a frontal to a three-quarter view, but he kept the frontal position of her head. To be sure, the eyes no longer look at her husband to the left, but at the viewer. The corners of her mouth are a little turned down, so that the smile has given way to a more serious and formal expression (see Bätschmann/Griener 1997).

Using infrared reflectography on the painting, Ainsworth and Faries have demonstrated that individual contours of the face in the underdrawing, especially the eyes, nose, and mouth, correspond precisely to the study in Basel. These lines have been darkened in the drawing; they stand out clearly. Such a phenomenon could be related to the transferring of the drawing to the ground of

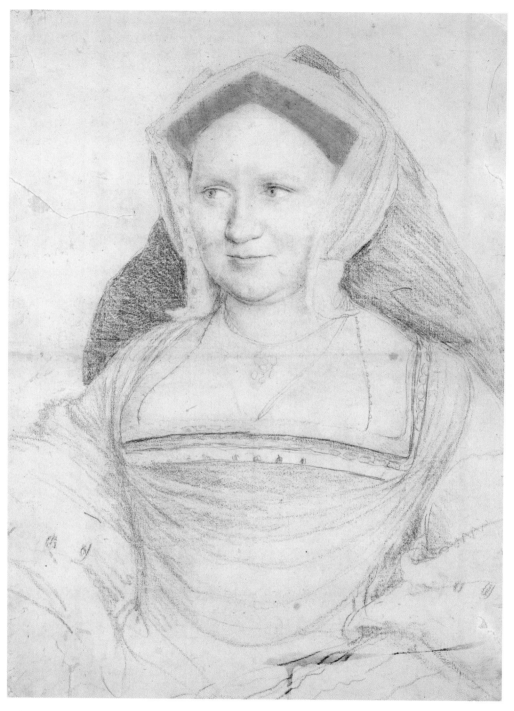

176

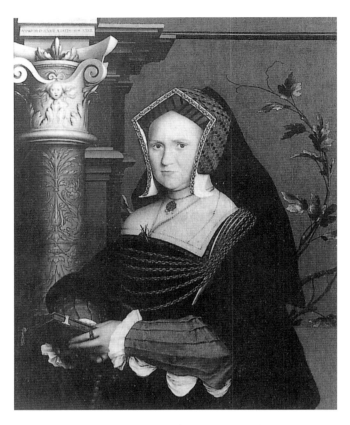

Hans Holbein the Younger, *Portrait of Lady Mary Guildford,* 1527

the painting using some kind of stencil-tracing procedure, for which purpose Holbein probably used a blackened paper. During this process he changed the position of the pupils and the corners of the mouth.

THREE OF TEN STAINED GLASS WINDOW DESIGNS DEPICTING THE PASSION OF CHRIST (cats. 177–179)

These ten stained glass window designs of the Passion of Christ, which begin with *Christ before Annas* (father-in-law to Caiaphas) and end with the *Crucifixion* (Müller 1996, nos. 162–171; see ill.), are first mentioned in inventory F, from the middle of the seventeenth century: "Item ten pieces of the Passion in ink, each on a sheet of paper—."[1] We do not know if the series was originally more comprehensive and some sheets were already lost early on, or if it was always incomplete. Neither counterproofs nor copies of the sixteenth and seventeenth centuries[2] provide any indication of the one-time existence of further drawings belonging to the series. Nor do executed glass paintings provide any information.[3] Only the motifs of the frames have been reused in isolated cases, as for instance in 1533, for the windows of the city hall of Rheinfelden.[4]

While scholars agree on the attribution of the window renderings to Hans Holbein, proposals for their dating vary. Most authors have advanced a date c. 1525.[5] A date about 1523/1524, put forward by Ganz (1937), is not convincing. The series is significantly more advanced stylistically than the *Passion* altarpiece in the Öffentliche Kunstsammlung Basel, which in all probability was painted about 1524, directly following Holbein's French journey.[6] The compositions are more balanced, the figures look calmer and more strongly concentrated on the inner aspect of their actions. Stylistically the window designs are closest to Holbein's design for the Basel cathedral organ shutters (cat. 180). It is therefore conceivable that Holbein did not draw the series until after his return from London, specifically about 1528. This later date was proposed by Stein (1929), Fischer (1951) and, for individual sheets, by Schmid (1945), and most recently by Von Borries (1989, 291f.). The organ shutters for the Basel cathedral could also have originated at this later date. Although the triumph of the Reformation in Basel in 1529 probably assured that no windows were produced from the drawings, it does not necessarily rule out the proposed 1528 date. Indeed, the provision made for Bible texts on banderoles, tablets, or architectural elements intended to accompany the events of the Passion may be interpreted as an indication of the proximity of the Reformation, as may the concentration on the history of Christ's suffering. Common features in the style as well as the consistency of the paper, as attested to by the watermarks Lindt 26 and a variant of Lindt 27, presumably a pair, establish that the

series was in any case produced in a short time span and not, as Ganz (1925, Holbein) and Schmid (1948) surmised, over the course of several years.

Counterproofs must have been taken from the Basel designs at least once. One series of seven counterproofs is today in the British Museum,[7] and a related sheet with the *Crowning with Thorns,* in the Graphische Sammlung, Staatsgalerie Stuttgart.[8] C.M.

1. *Item Zehen Stückh vom Passion getuscht, Jedes auff einem bogen Papeÿr*—

2. The Staatliche Graphische Sammlung in Munich has seven copies, of which some carry the date 1536. There are nine copies in the Augustinian Prebendary Foundation of St. Florian, which are dated 1578 and 1579. See E. Frodl-Kraft, "Die Passionsfolge nach Hans Holbein d. J.," *Die Kunstsammlungen des Augustinerchorherrenstiftes St. Florian,* Österreichische Kunsttopographie 48 (Vienna 1988), 255.

3. Two panels, showing the Judgment of Pilate and the Crucifixion, are based on the drawings of the Passion cycle by Hans Holbein, and are preserved in the San Diego Museum of Art. They were executed later, probably in the seventeenth century (?); see Virginia Chieffo Raguin, *Stained Glass before 1700 in American Collections,* Studies in the History of Art 28, National Gallery of Art (Washington 1989), 82.

4. On the armorial windows in the city hall of Rheinfelden, see H. Lehmann, "Zur Geschichte der oberrheinischen Glasmalerei im 16. Jahrhundert," *ZAK* 2 (1940), 38, ill. 12f.; see also Müller 1996, no. 173.

5. See also Exh. cat. *Holbein* 1988 and, finally, Rowlands 1993, with no. 313.

6. Öffentliche Kunstsammlung Basel, inv. 315; Rowlands 1985, no. 19.

7. *Catalogue of Drawings by British Artists and Artists of Foreign Origin Working in Great Britain,* L. Binyon, ed., vol. 2 (London 1900), 326ff., nos. 1–7; finally, Rowlands 1993, nos. 309–315. Missing among the counterproofs in London are the *Flagellation, Crowning with Thorns,* and *Nailing to the Cross.* Six copies after the counterproofs, executed by Dietrich Meyer the Elder, emerged in the Swiss art trade in 1995; see *Handzeichnungen und Aquarelle alter und moderner Meister,* Auct. cat. Galerie Fischer Luzern, in collaboration with August Laube, Zurich, sale 20 June 1995, no. 135. They could be identical to the copies that Ganz (1937, 40) sighted in the possession of the Staatliche Graphische Sammlung München; these drawings are in any case not to be found there. Possibly they were in a private Munich collection. See also Rowlands 1993, with no. 313. Included are the following scenes: *Christ before Annas* (signed "D. Meÿer"), *The Mocking of Christ, The Crowning with Thorns, Ecce Homo, The Washing of Hands,* and *The Disrobing of Christ* (inscribed "D. Meÿer," with the date 1640). Dietrich Meyer attempted to reproduce the weak and faded character of the counterproofs and primarily drew in brush in gray and gray-blue tones. Only *Christ before Annas* is in brown pen, which closely approximates the model, today in the collection of the Staatsgalerie Stuttgart (see n. 15). The drawings are on the same kind of paper and measure, on the average, 430 x 328 mm; in other words, they approximately correspond to the size of the models. They are today in a Swiss private collection.

8. Stuttgart, Graphische Sammlung, inv. C 90/3942; 408 x 295 mm; H. Geissler, in: Exh. cat. *Vermächtnis Jung* 1989, no. 1. Unlike the London versions, this counterproof was later worked over in pen and brush. Like the London sheets, it carries a Dürer monogram (blotted out), but also the monogram HH. On the counterproofs, see most recently Müller 1996, 111.

177 CHRIST BEFORE ANNAS, DESIGN FOR A STAINED GLASS WINDOW, c. 1528

Basel, Kupferstichkabinett, Inv. 1662.112
Pen and black ink over black chalk; gray wash
429 x 305 mm
Watermark: walking bear (Lindt 26)
Lined with japan paper; slightly trimmed at the edges; horizontal center fold, torn in places; lower right, small hole, repaired; drawing rubbed and weakened by counterproofing

PROVENANCE: Amerbach-Kabinett

LIT.: *Photographie Braun,* no. 5 – Woltmann 1: 172ff.; 2: no. 66 – Mantz 1879, 44ff., reproduction of an engraving – Davies 1903, 71ff. – Chamberlain 1: 150ff., pl. 46, 1 – Knackfuss 1914, 37, ill. 34 – Stein 1929, 180ff. – Cohn 1930, 24f., 82ff., 88, 98 (1525/1526) – Schmid 1930, 53 – Ganz 1937, no. 169 (1523/1524) – Waetzoldt 1938, 104 (1528/1530) – Schmid 1948, 5, 83f., 101, 118, 149, 153, 325, 331ff. (c. 1528/1530) – Fischer 1951, 344 (c. 1526 or not until 1528/1530) – Exh. cat. *Holbein* 1960, no. 286 – Klemm 1972, 172 – Exh. cat. *Holbein* 1988, no. 49 (as *Christ before Caiaphas*) – Von Borries 1989, 291 – Rowlands 1993, in no. 309 – Klemm 1995, 39f. – Müller 1996, no. 162

The composition may have been inspired by Martin Schongauer's engraving *Christ before Annas* (Lehrs 5, no. 21), in which Christ also stands immediately in front of a compound pier. Holbein depicted the event that is described in the Gospel according to St. John (18:13, 19–23; see Von Borries 1989). Compared to Schongauer's engraving, the concentration on few gestures, an extended hand, a raised fist, and the dialogue of the exchanged glances between Christ and the tormentor who is about to strike him emphasize the psychological dimension of the action and effect an increase in the drama.

For the counterproof in London, see Rowlands 1993, no. 309, pl. 202 (as *Christ before Caiaphas*). C.M.

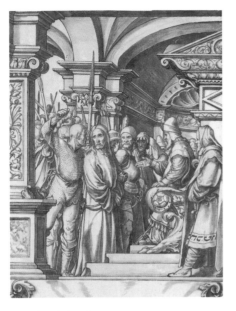

177 Christ before Annas

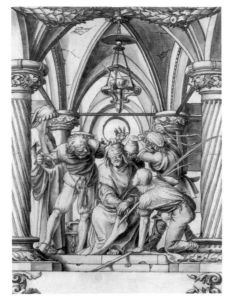

178 The Mocking of Christ

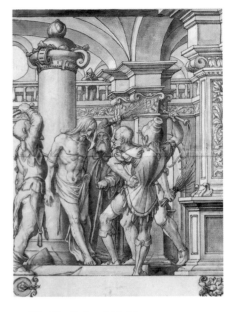

179 The Flagellation of Christ

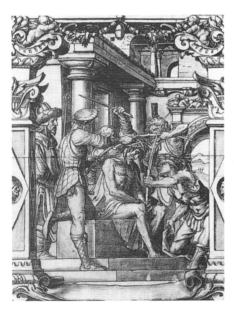

Crowning with Thorns

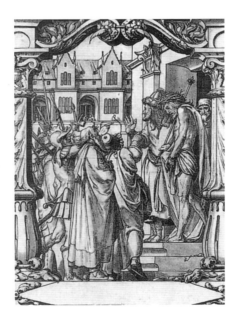

Ecce Homo

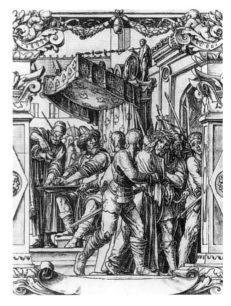

Pilate Washing His Hands

Hans Holbein the Younger, Stained glass window designs of Christ's Passion, c. 1528

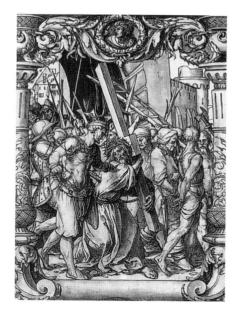

Carrying the Cross

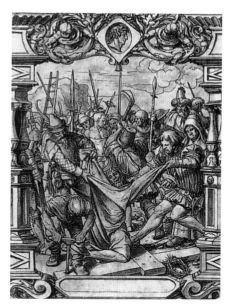

The Disrobing

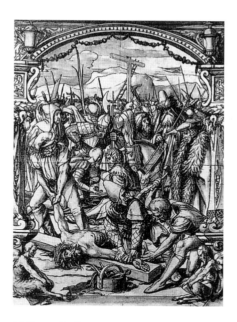

Nailing to the Cross

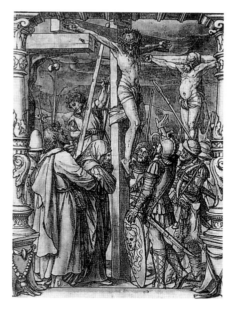

Crucifixion

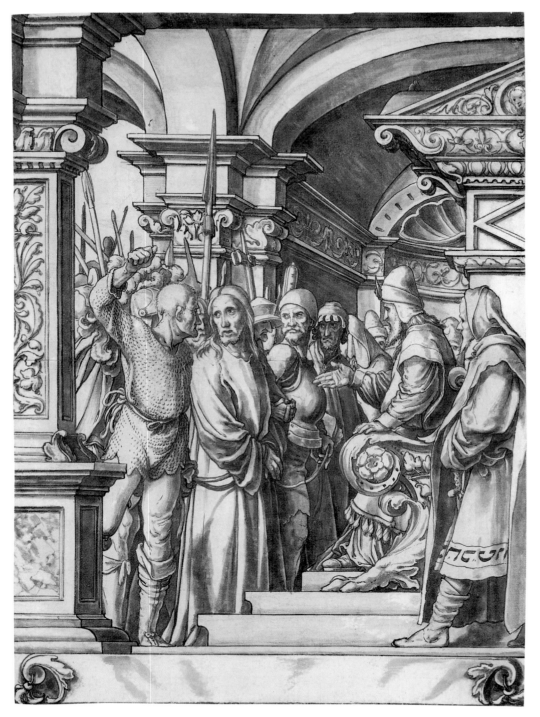

177

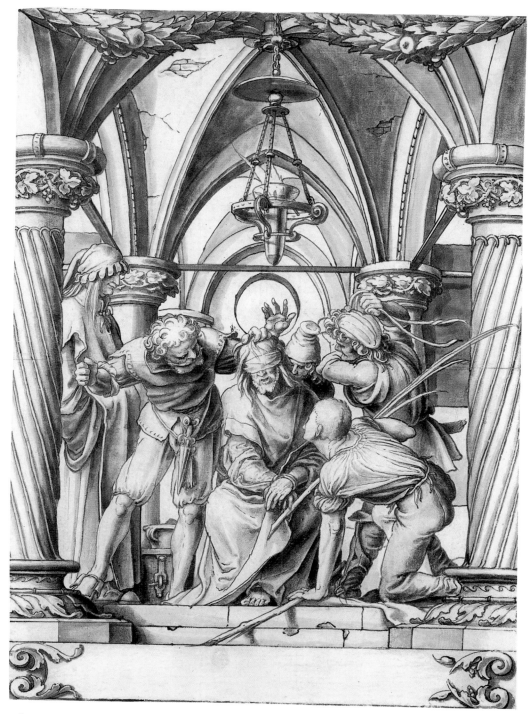

178

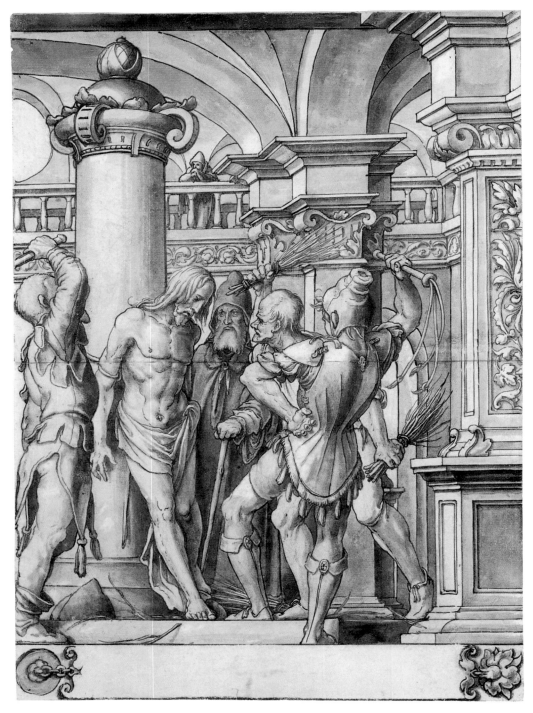

179

178 The Mocking of Christ, Design for a Stained Glass Window, c. 1528

Basel, Kupferstichkabinett, Inv. 1662.114
Pen and black ink over black chalk; gray wash
432 x 306 mm
Watermark: walking bear (Lindt 26)
Lined with japan paper and slightly trimmed at the edges;
horizontal center fold, torn; vertical center fold, flattened;
torn at the edges; drawing weakened by counterproofing;
losses below, restored; foxing

PROVENANCE: Amerbach-Kabinett

LIT.: *Photographie Braun,* no. 8 – Woltmann 1: 172ff.; 2: no. 68 – Mantz 1879, 44ff., engraved reproduction – Davies 1903, 71ff. – *Handz. Schweizer. Meister,* pl. III, 39 (c. 1523/1524) – Chamberlain 1: 150ff., pl. 47,1 – Knackfuss 1914, 38, ill. 33 – Glaser 1924, 12, pl. 28 – Stein 1929, 180ff. – Cohn 1930, 24f., 82ff., 98 (1525/1526) – Schmid 1930, 53 – Ganz 1937, no. 171 (1523/1524) – Reinhardt 1938, pl. on 127 – Waetzoldt 1938, 104 (1528/1530) – Schmid 1945, 25, ill. 31; 1948, 83f., 101, 118, 149, 153, 325, 331ff. (c. 1528/1530) – Christoffel 1950, ill. on 232 (1523/1524) – Fischer 1951, 344 (c. 1526 or not before 1528/1530) – Exh. cat. *Holbein* 1960, no. 288 – Reinhardt 1965, 36 – Klemm 1972, 172 – Roberts 1979, no. 14 – Exh. cat. *Holbein* 1988, no. 50 – Rowlands 1993, in no. 310 – Klemm 1995, 39f. – Müller 1996, no. 163

The view into a Gothic interior and the frontal depiction of Christ, whose head is located directly below a round window, go back to Schongauer's engraving *The Crowning with Thorns* (Lehrs 5, no. 23). The man wearing a cowl and habit located between the two columns at the left is taken from Dürer's *Ecce Homo* of the *Engraved Passion,* in which a similarly dressed man stands in the foreground (M. 10). The tormentors from Dürer's *Mocking of Christ* of the *Small Woodcut Passion* may have yielded additional inspiration (M. 139). The woodcut also employs a related diagonal composition.

Holbein may have intended the axial connection among the head of Christ, the circular window, and the lamp above to signify Christ as *Lux mundi* (light of the world). Dürer's woodcut *The Last Supper* of 1510 (M. 114), in which a similar window is depicted above Christ's head, may have played a role in this instance.[1]

For the counterproof in the British Museum, see Rowlands (1993, no. 310). C.M.

1. For a woodcut by Hans Holbein showing Christ as the true light, see Exh. cat. *Basler Buchill.* 1984, no. 354a; Hollstein *German,* 14, no. 3.

179 The Flagellation of Christ, Design for a Stained Glass Window, c. 1528

Basel, Kupferstichkabinett, Inv. 1662.113
Pen and black ink over black chalk; gray wash
431 x 308 mm
Watermark: walking bear (variation on Lindt 27)
Lined with japan paper; slightly trimmed at the edges;
horizontal center fold, torn; rubbed at the edges; several
thin places; drawing weakened by counterproofing;
several brown spots

PROVENANCE: Amerbach-Kabinett

LIT.: *Photographie Braun,* no. 6 – Woltmann 1: 172ff.; 2: no. 67 – Mantz 1879, 44ff., engraved reproduction – Davies 1903, 71ff., ill. after 72 – *Handz. Schweizer. Meister,* pl. III,22 (c. 1523) – Chamberlain 1: 150ff., pl. 46,2 – Knackfuss 1914, 38, ill. 32 – Glaser 1924, 12, pl. 27 – Stein 1929, 180ff. – Cohn 1930, 24f., 82ff., 88, 98 (1525/1526) – Schmid 1930, 53 – Ganz 1937, no. 170 (1523/1524) – Waetzoldt 1938, 104 (1528/1530) – Schmid 1948, 83f., 101, 118, 149, 153, 325, 331ff. (c. 1528/1530) – Fischer 1951, 344 (c. 1526 or not until 1528/1530) – Exh. cat. *Holbein* 1960, no. 287 – Klemm 1972, 172 – Exh. cat. *Holbein* 1988, no. 51 – Klemm 1995, 39f. – Müller 1996, no. 164

The tormentor seen from the rear at the right side and the figure depicted in profile directly behind him call to mind the two tormentors who are represented in similar poses in Schongauer's engraving *The Flagellation* (Lehrs 5, no. 22). C.M.

180 Design in Four Parts for the Shutters of the Organ of Basel Cathedral, c. 1528

Basel, Kupferstichkabinett, Inv. 1662.30
Pen and black ink over black chalk; brown and gray wash

PROVENANCE: Amerbach-Kabinett

LIT.: *Photographie Braun,* no. 23 – Woltmann 1: 175f.; 2: no. 98 – Mantz 1879, 126f., ill. (1529) – His 1886, 24f., pl. VIIIf. – Schmid 1900, 68 (detail, possibly 1528) – Davies 1903, 75f., ill. on 74 (c. 1521/1522) – *Handz. Schweizer. Meister,* pl. II,19,20 – Chamberlain 1: 113f., pl. 39 (c. 1525) – Knackfuss 1914, 85, ill. 69f. – Ganz 1919, XXVIIf., 237, ill. XXIX (1520/1525) – Manteuffel 1920, Maler, ill. on 34 – Schmid 1924, 345 (1528) – Glaser 1924, 14, pl. 37f. – Schmid 1930, 55 – Ganz 1937, no. 110 (1523/1524) – Schmid 1945, 5, 28, 92, 306ff., 329, ill. 57 (1528) – Ueberwasser 1947, pl. 21 (left wing, 1528) – Christoffel 1950, ill. 238f. (c. 1525) – Ganz 1950, with no. 156f. (c. 1523/1524) – M. Pfister-Burkhalter, in: Exh. cat. *Holbein* 1960, no. 310 (probably 1528) – Grossmann 1963, col. 590 (1526) – C. Klemm, "Die Orgelflügel. Eine alte Bildgattung und ihre Ausformung bei Holbein," *Das Münster* 26, 1973, 357–362, esp. 359f., ill. 358 – Walzer 1979, pl. 30 (right shutter) – Rowlands 1985, in no. 18 (c. 1525) – Grohn 1987, no. 59a, no. 59b (1528) – Exh. cat. *Holbein* 1988, no. 62 – Von Borries 1989, 292 (1528 possible) – Exh. cat. *Amerbach* 1991, *Zeichnungen,* no. 113 – Klemm 1995, 40f., 72, ill. 42f. (c. 1525) – Müller 1996, no. 174 – Bätschmann/Griener 1997, 81–82

When open, the organ shutters on the left show the two founders of the cathedral: St. Cunegonda and her husband, the Holy Roman Emperor Henry II; between them stands the cathedral seen from the southeast. The two patrons, the Virgin Mary and St. Pantalus, along with angels making music, are depicted on the right. The shutters, painted on canvas, are in the Öffentliche Kunstsammlung Basel (see ill.).[1]

The organ was located about eleven meters above the ground on the north wall of the nave. A conception of how it looked in situ with open shutters is provided by a pen and watercolor drawing executed by Emanuel Büchel in 1775 (see ill.),[2] shortly before the removal of the organ's casing, which had fallen into disrepair. From Büchel's drawing we learn that the outer, narrow wings with Cunegonda and Pantalus, which were also probably originally hinged, were considerably higher at the time, and that projecting above the heads of the saints were ornamental fields. Büchel reproduced the wings and casing along with the overpainting done by Sixtus Ringlin during the 1639 renovation of the organ.[3] With the removal of the shutters in 1786, when they were transferred to the library of the house "Zur Mücke," the upper parts

of the outer wings may have been cut down on account of their great height. Perhaps they were lost in the process.

In the early nineteenth century, the designs for the organ shutters were pasted to cardboard. They were assembled in such a way that the Holy Roman Emperor Henry II and the Virgin Mary were directly opposite each other—with the casing of the organ between them—and the two narrow designs for the outer pictures with Sts. Cunegonda and Pantalus were attached seamlessly to the inner ones. Initially, however, these were separated from each other by frames, which may not have been cut off until the late eighteenth or early nineteenth century.[4] A narrow strip is therefore now missing where the frame once covered the motifs that project into the respective bordering pictorial fields—namely Cunegonda's cross and Pantalus' hand. In addition, pieces of paper were attached above Cunegonda and Pantalus during the nineteenth century to align the designs cut at the top with the interior pictorial fields. As Holbein composed the designs with the Holy Roman Emperor Henry and the Virgin Mary out of two pieces of paper put together, it is possible that he originally represented the entire organ with open shutters and the casing in the middle. Perhaps this large design was soon reduced to several pieces. In 1995 the drawings were removed from their acidic cardboard backing and individually mounted next to each other.

Holbein's design proposes alternate solutions for ornament and frame. During the execution, he followed

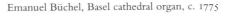

Emanuel Büchel, Basel cathedral organ, c. 1775

the versions of the right shutter. The ornamentation above the cathedral then required more space, so Holbein left out its tower. Minor changes are also encountered in the figures of Henry, Pantalus, and the angels making music. The figure of the Virgin deviates most obviously from the design: her right knee projects forward, the movement and disposition of folds are more harmonious, the outlines are more closed, and she looks at the viewer, whereas in the drawing she is turned toward the child.

Because of the organ's high location, Holbein represented the figures from a markedly low viewpoint. Scored lines that run through the vertical axis of the figures and, horizontally, at the knee, the heads, the elbows, the shoulders, and the chin may have served as aids with the foreshortening. The drawings are washed in gray-brown and approximate the brown tones of the finished painting, which was probably coordinated with the wood of the casing. Perhaps Holbein also designed the sculptural decoration for the casing, which has survived only in fragments.[5]

The dating for the stylistically divergent designs and executed shutters is controversial, as we lack precise indications for the time of the commission and the identity of the patron. Davies proposed the earliest date, 1522, which is not tenable on stylistic grounds. Ganz (1937) ventured 1523/1524 and dated the shutters before Holbein's French journey. However, no date before 1525/1526 seems convincing: the figures and the architecture of the cathedral are close to Holbein's window design with Terminus (cat. 173). There he draws in comparably thin, ever-interrupted lines limited to what is most essential. He carried out the ornamental motifs of the organ shutters in much broader and powerful strokes. He had already employed similar motifs in his *Passion* panel of about 1524.[6] They invite comparison with the frame ornamentation of his drawn Passion series, which was probably produced about 1528 (see cats. 177–179; Müller 1996, nos. 162–171). We cannot exclude the possibility therefore that the drawings were not done until then.

The patron may have been Bishop Philipp von Gundelsheim, who was appointed in 1527 and who resided in Pruntrut from 7 October 1528.[7] This later date also seems stylistically feasible. Even so, scholars have repeatedly doubted whether Holbein could have carried out this commission without interference so close to the Reformation, after pictures had already been removed from Basel churches. Chamberlain and, more recently, Grossmann (1963), Klemm (1995), and Rowlands therefore argued for an origin of 1525/1526 for the painted shutters, which would then have been commissioned by

the cathedral chapter or by Nikolaus von Diesbach, the coadjutor of Bishop Christoph von Uttenheim, who held office until 1527.[8] On the other hand, despite the growing religious unrest, Philipp von Gundelsheim still decided in 1528 to have the building of the cathedral chapter renovated. Finally, Von Borries and Grohn have come out in favor of a late dating to about 1528, which also seems the most convincing option stylistically. The portrait study of Jakob Meyer for the *Darmstadt Madonna* (Müller 1996, no. 153) has a nearly identical variation on the watermark in Müller 1996, no. 174c. This does not conclusively prove, however, whether Holbein executed the organ shutters before or immediately after his first stay in England.

C.M.

1. Inv. 321; Rowlands 1985, no. 18, pls. 34–37. In the Kunstsammlung since 1786, gift of the Basel government. Then exhibited in the lobby to the library building of the house "Zur Mücke"; G. H. Heinse, *Reisen durch das südliche Deutschland und die Schweiz in den Jahren 1808 und 1809* (Leipzig 1810), 2: 204.

2. Basel, Kupferstichkabinett, inv. 1886.8; Exh. cat. *Holbein* 1988, ill. on 199.

3. *Sammlung der merkwürdigsten Grabmäler, Bilder, Mahlereyen, Aufschriften des Grossen Münsters zu Basel. Nach den Originalen vorgestellt von Emanuel Büchel,* part 2 (1775), 5f., 27: drawings of the organ, 28ff.: the shutters were restored between 1909 and 1911, when the overpainting of the seventeenth and nineteenth centuries was largely removed.

4. In Beck's inventory of 1775, 175, the designs were already described as "Carton zu den Orgelflügeln des Münsters. Querfolio."

5. Historisches Museum Basel, inv. 1881.164.1–9; P. Reindl, "Basler Frührenaissance am Beispiel der Rathaus-Kanzlei," *HMB. Jahresb.* (1974), 35–60, esp. 39ff., ill. 5.

6. Öffentliche Kunstsammlung Basel, inv. 315; Rowlands 1985, no. 19, pl. 38–46.

7. A. Bruckner, "Die Bischöfe von Basel," *Helvetia Sacra* 1, 1 (Bern 1972), 202ff.

8. Bruckner 1972 199f., 201f.

180

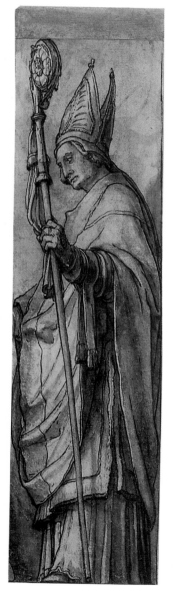

180

Hans Holbein the Younger, Basel cathedral organ shutters, c. 1528

ST. CUNEGONDA

261 x 76 (above), 78 (below) mm
No watermark
Trimmed on all sides; strip of 47 x 76 mm added to the top

HOLY ROMAN EMPEROR HENRY II AND THE BASEL CATHEDRAL

306 (left), 379 (right) x 222 mm
No watermark
Two joined pieces of paper; cut out along the silhouette; lined on left edge with an 11 mm strip protruding between 1 and 2 mm at the front, on which the boundary line of the frame and a piece of St. Cunegonda's cross are drawn

VIRGIN AND CHILD WITH MUSIC-MAKING ANGELS

Verso: ornamental bands with flowers and dolphins (organ casing)
verso, black chalk
379 (left), 309 (right) x 223 mm
Watermark: grapes (variant of Briquet 13070)
Two joined pieces of paper; torn below Mary's left shoulder; cut out along the silhouette

ST. PANTALUS

294 (left), 295 (right) x 80 mm
No watermark
Trimmed on all sides; 17 x 77 mm strip added at the top

181 BONIFACIUS AMERBACH?, C. 1525

Basel, Kupferstichkabinett, Inv. 1662.32
Black chalk and colored chalks; lead point on hat and hair
400 x 368 mm (largest dimensions)
Watermark: eight-petaled flower, fragment; watermark-reference no. 50
Lined with japan paper; trimmed on all sides (side of the hat juts out); horizontal fold, flattened; upper left, large spot covered in opaque white; foxing on the cheeks and in the hair, touched up; surface rubbed

PROVENANCE: Amerbach-Kabinett

LIT.: Photographie Braun, no. 49 – Woltmann, 1: 291; 2, no. 38 – Mantz 1879, 168, ill. on 169 – C. Aberle, "Grab-Denkmal, Schädel und Abbildungen des Theophrastus Paracelsus. Beiträge zur genaueren Kenntnis derselben," *Mitteilungen der Gesellschaft für Salzburger Landeskunde* 37 (1887), 72f.; 38 (1888), 269–355, 272, pls. 1, 3 – *Handz. Schweizer. Meister,* pl. 54 (c. 1528) – Ganz 1908, 37f., pl. 19 (before the English journey) – Chamberlain 2: 259f., pl. 39 – Knackfuss 1914, ill. 100, 114 – Ganz 1919, ill. on 31 – K. Sudhoff and W. Matthiessen, *Theophrastus von Hohenheim genannt Paracelsus* (Munich 1922) – Ganz 1923, 45f., pl. 19 (originated before the stay in England) – Glaser 1924, pl. 44 – Schmid 1924, 345 (c. 1528) – Ganz 1937, no. 17 (1526) – Reinhardt 1938, pl. on 69 (c. 1526) – Waetzoldt 1938, 53, pl. 19 (Paracelsus?, 1526) – G. F. Hartlaub, "Die Bildnisse von Paracelsus," *Kunst-Rundschau* (1941), vol. 10, 162, ill. 1 – Schmid 1945, ill. 55, 28 (c. 1528); 1948, 83, 155, 309ff. – Christoffel 1950, ill. 143 (c. 1526) – Fischer 1951, 350, ill. 291 – Schilling 1954, 11, frontispiece (c. 1528) – Grohn 1956, 21f., ill. 15 – M. Pfister-Burkhalter, in: Exh. cat. *Holbein* 1960, no. 314, ill. 97 – Ueberwasser 1960, no. 15 – A. Tschinkel, "Hohenheim, Holbein und Hollar," *Alte und moderne Kunst* 77 (1964), 9–11, ill. 1 (not a portrait of Paracelsus) – A. Tschinkel, "Paracelsus-bildnisse in neuer Sicht," part 1, *Salzburger Museum Carolino Augusteum, Jahresschrift* 10 (1964), 33–48, esp. 36f., pl. 2, 2 – Hugelshofer 1969, 136, no. 47 – F. Ficker, "Kritische Bemerkungen zur Frage der Paracelsus-Bildnisse," *Münchener Medizinische Wochenschrift* 113 (1971), 124ff., ill. 1 (1528, not Paracelsus) – C. Müller, in: Exh. cat. *Holbein* 1988, no. 70 – Von Borries 1989, 296 – Exh. cat. *Amerbach* 1991, *Zeichnungen,* no. 112 – Klemm 1995, 53f., 74, frontispiece and ill. on 55 (c. 1529) – Exh. cat. *Amerbach* 1995, no. 10 – Müller 1996, no. 152 – J. E. von Borries, "Besprechung von Müller 1996," *Journal für Kunstgeschichte* 1 (1997), 171–177, 173f. – U. Dill, "Der Bart des Philosophen, Holbeins Amerbach-Porträt – neu gesehen im Lichte eines bisher nicht beachteten Epigramms," *ZAK* 55 (1998), 245ff., 250, ill. 5

An attempt by Sudhoff to identify the subject as Theophrastus von Hohenheim, called Paracelsus, has rightly been rejected. The supposition expressed by Pfister-Burkhalter and others that the figure must be a member of the Amerbach family—more specifically, as has

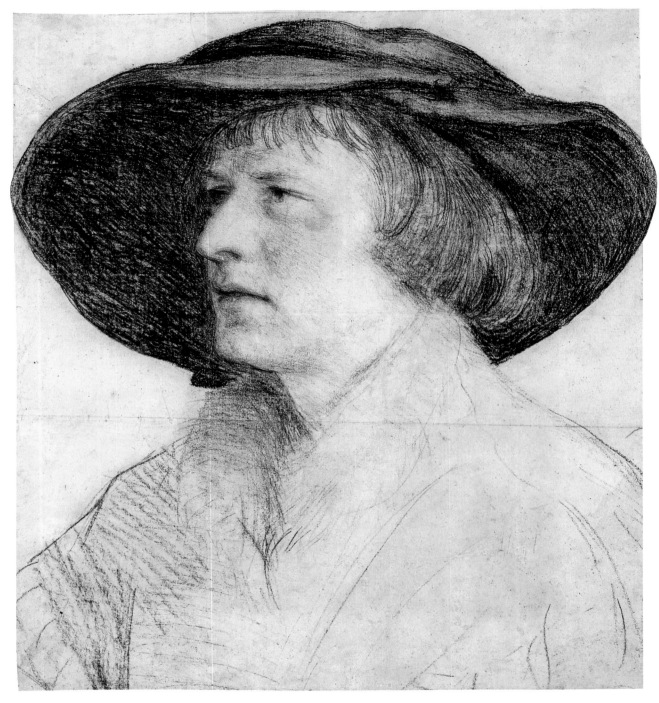

181

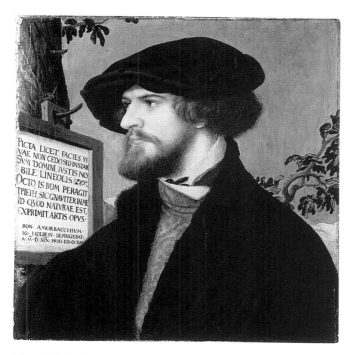

Hans Holbein the Younger, *Bonifacius Amerbach,* 1519

recently been proposed, the Basel jurist Bonifacius Amerbach (1495–1562), the father of the collector Basilius Amerbach (1533–1591)—has become increasingly plausible and is now advanced by several scholars, such as Beat Rudolf Jenny (oral communication), Johann Eckhart von Borries (most recently in 1998), Ueli Dill, and myself. In 1519, after concluding his studies in Freiburg im Breisgau and immediately before his planned journey to Avignon, Bonifacius was portrayed by Holbein (Basel, Öffentliche Kunstsammlung, inv. 314; see ill.). Hartmann pointed out that the plague was raging in Avignon when this portrait was created. Amerbach may well have commissioned the portrait at that time as a commemorative piece for his next of kin in case he should fall victim to the disease (A. Hartmann, "Bonifacius Amerbach als Verwalter der Erasmusstiftung," *Basler Jb.* [1957], 26ff.). At the end of 1524, he decided, against all advice from those around him, to travel once more to Avignon later that winter in order to submit his doctoral dissertation—the degree was awarded on 4 February 1525. The dangers of the journey and the prospect of the about-to-be-completed study may well have motivated him to commission another portrait (see *Amerbach-Korrespondenz,* 3, no. 995f.). In our drawing, Amerbach assumed a pose similar to that of the early portrait, with the head in three-quarter view, but a little more raised. In two later portraits—one by Christoph Roman

in 1551, the other by Jakob Clauser in 1557 (Basel, Öffentliche Kunstsammlung, inv. 512 and 388; Exh. cat. *Amerbach* 1995, nos. 41, 42)—he is beardless, as in our drawing. In September 1995, in a hitherto neglected bundle of papers in the library of the University of Basel, U. Dill discovered, in Basilius Amerbach's hand, an inscription for a painting. We learn that in 1519 Amerbach intended to have Holbein portray him a second time. The information could concern a lost pendant to the surviving painting of 1519. Apparently Amerbach cut off his beard toward the end of that year, possibly in reaction to Erasmus of Rotterdam's adage that a beard does not necessarily a philosopher make (see U. Dill 1998, 252). That Amerbach no longer wears a beard supports the identification proposed here. In addition, similarities exist between all four portraits in the shape of the eyes and the eyebrows, in the lips that curve upward at the corners of the mouth, and in the style and color of the hair. Upon quick examination, the nose in our sheet may seem to be more hook-shaped than in the painting of 1519; this is only because the drawing has been heavily rubbed, obscuring the separation between the bridge of the nose and the part of the face that is averted from us. In fact, part of the right cheekbone and the cheek are visible above the bridge of the nose. We should also consider that Holbein occasionally idealized his sitters, as we know from his portraits of Erasmus of Rotterdam. Our drawing may have been a study for a painting that, apparently, was never executed. It conforms stylistically and technically to Holbein's portrait drawings for the *Darmstadt Madonna,* which he executed about 1525/1526, just before the first English journey. The watermark also vouches for a date of about 1525, as it does not occur in subsequent drawings by Holbein, his workshop, and his circle. When comparing our drawing to the portrait studies for the *Darmstadt Madonna*—which, at first sight, impress one as being harder and more schematic, an effect partially determined by the traces of the transfer of the drawing—the poor condition of our sheet must be taken into account. However, its drawing technique, above all the close execution of the hat and face with thin chalk strokes, clearly corresponds to the stylistic stage represented by the drawings for the *Darmstadt Madonna.*

The clear, geometric construction of the composition and the accentuation of the surfaces, which have until now been offered as arguments for a later date, are explained, in part, by the drawing's poor state of preservation: it was severely cut (by about 200 by 80 millimeters). As a consequence, the sitter is emphasized in a way not intended in the original, large format sheet (which was about 620 by 450 millimeters). C.M.

182

183

182 SAMUEL CURSES SAUL, C. 1530

Basel, Kupferstichkabinett, Inv. 1662.33
Pen and brown ink over black chalk; gray and brown wash;
watercolor
210 x 524 mm (smallest dimension)
215 x 533 mm (largest dimension)
Watermark: monogram *DMH* with two spheres and *Hermesvier*
Mounted on paper; two joined sheets; several vertical creases
and folds; rubbed in places

PROVENANCE: Amerbach-Kabinett

LIT.: *Photographie Braun*, no. 25 – Woltmann 1: 359ff.; 2: no.
64 – Mantz 1879, 37ff., ill. on 39 – Schmid 1896, 79, 91ff. –
Burckhardt-Werthemann 1904, 32 – *Handz. Schweizer. Meister,*
pl. III,23 – Chamberlain 1: 347f., pl. 94 – Ganz 1919, 247, ill.
173 – Manteuffel 1920, Maler, ill. on 39 – Glaser 1924, pl. 55 –
Ganz 1925, *Holbein,* 239, pl. III, J – G. Riggenbach, in: *KDM
BS* I, 539, 568VIIff., 580, no. 3, ill. 423 – Ganz 1937, no. 118 –
Waetzoldt 1938, 150f. (1529/1530) – Schmidt/Cetto, XXXV,
48, ill. 78 – Schmid 1945, 29, ill. 59; 1948, 169, 334f., ill. 93 –
Ueberwasser 1947, pl. 25 – Christoffel 1950, ill. 248 – Ganz
1950, no. 173, ill. 51 – Exh. cat. *Holbein* 1960, no. 316, ill. on
103 – Kreytenberg 1970, 78, 89ff., ill. 11 –f. Maurer 1971,
774f. – Deuchler/Roethlisberger/Lüthi 1975, 71, ill. on 69 –
Roberts 1979, no. 49 – Rowlands 1985, no. L. 6 IIb, pl. 181 –
Grohn 1987, no. 30k – Exh. cat. *Holbein* 1988, no. 72 – Bätsch-
mann 1989, 9, ill. 13 – Müller 1991, 22f., ill. 28 – C. Müller,
in: exh. cat. *Zeichen der Freiheit* 1991, no. 39 – Klemm 1995,
54ff., 75, ill. on 56 – Müller 1996, no. 138 – Bätschmann/
Griener 1997, 81

Saul has triumphed over the Amalekites but has not
obeyed the command of Samuel to kill both the van-
quished people and their cattle. Instead, Saul took King
Agag prisoner and permitted the Israelite soldiers to take
the sheep and cows as booty. When Saul returned, he
was called to account by Samuel and lost his kingship for
defying God's word (1 Samuel 15).

Saul's retinue approaches from the right. The soldiers
bring along the captured king, who sits, bent over and
dejected, on his horse. In the distance we see the pillaged
cattle of the Amalekites; fires bear witness to military
altercations. Saul has dismounted and comes to Samuel
with open arms and a devout demeanor, similar to the
figure of an armed man at the extreme right of Lucas van
Leyden's *Adoration of the Kings,* an engraving of 1513 (B. 7,
no. 37). Samuel addresses Saul, gesturing angrily at the
cattle. Above them hangs an empty tablet on which, in
the final painting, is written: "Nunquid vult Dominus
holocausta et victimes et non potius obediatur voci Do-
mini? Pro eo quod abjecisti sermonem Domini abjecit
te Dominus, ne sis rex" (Has the Lord as great delight
in burnt offerings and sacrifices, as in obeying the voice

of the Lord? . . . Because you have rejected the words
of the Lord, he has also rejected you from being king
[1 Samuel 15:22, 23; see Gross 1625; Tonjola 1661]).

Stylistically and technically, the drawing corresponds
to the *Rehoboam* picture (Müller 1996, no. 137); they were
done about the same time. Even though a location on the
right half of the wall seems probable, given the direction
of movement of the figures and the incidence of light
from right to left, it is not certain whether the design was
actually realized in this form. C.M.

183 DAGGER SHEATH WITH JUDGMENT OF PARIS, PYRAMIS AND THISBE, VENUS AND CUPID, C. 1530/1532

Basel, Kupferstichkabinett, Inv. 1662.138
Pen and black ink
281 x 69 mm
No watermark
Mounted on paper; foxed

PROVENANCE: Amerbach-Kabinett

LIT.: *Photographie Braun*, no. 53 – Woltmann 2: no. 60 – W.
von Seidlitz, "Zeichnungen alter deutscher Meister in Dessau,"
Jb. preuss. Kunstslg. 2 (1881), 3–24, 13f. (drawing in Dessau
a copy) – His 1886, 27, pl. XXIII,3 – Ganz 1908, 62f., pl.
40 – Chamberlain 2: 277f., pl. 45,3 – Friedländer 1914, com-
mentary to pl. 39 – Knackfuss 1914, 118, ill. 115 –Manteuffel
1920, *Zeichner,* ill. on 73 – Ganz 1923, 71f., pl. 43 – Glaser
1924, 25, pl. 83 – Ganz 1937, no. 434 – Schmid 1945, 30, ill.
72 (c. 1532); 1948, 403, 418 – Schilling 1954, 22, ill. 39 – M.
Pfister-Burkhalter, in: Exh. cat. *Holbein* 1960, no. 328, ill. 100
(c. 1532) – Exh. cat. *Amerbach* 1962, no. 77 (c. 1532) – Hp.
Landolt 1990, 275, ill. 6 – Müller 1996, no. 177

The drawing consists of four registers. From top to
bottom, three scenes involving the power of love and its
consequences are represented in three-dimensional archi-
tectural scenery that dominates the material of the sheath
through its illusionistic views. Von Seidlitz, Ganz (1937),
and Pfister-Burkhalter conjectured that the drawing must
have been a model for a graphic work, a woodcut, for
instance, comparable to the two dagger sheaths repro-
duced in Müller 1997 (nos. 4 and 5). The sheet seems
to anticipate the reversal caused by printing, for Thisbe
stabs herself with her left hand and Cupid holds his bow
in his right hand.

Aside from minor alterations, such as the ornamen-
tation and the motifs at the point of the sheath, a drawing
in Dessau displays the essentials of our design, though in
mirror image (Friedländer 1914, no. 39; Exh. cat. *Holbein*
1960, no. 329, ill. 101). Contrary to the Basel drawing,

the Dessau sheet is worked out in detail and the draftsman employed parallel hatching to approximate the texture of a woodcut or metal cut. It could be a copy of a lost woodcut or a repetition of a counterproof of a lost finished drawing by Holbein, comparable to the design preserved in the Kupferstichkabinett Basel (Müller 1996, no. 186). Perhaps the Dessau drawing originated in the workshop of a Basel goldsmith and served as a pattern sheet there. It is related to a copy of a Basel dagger-sheath design with a Roman triumphal processional, located in the Österreichisches Museum für Angewandte Kunst in Vienna (see Müller 1996, no. 176). Holbein's woodcut of a dagger sheath (Müller 1997, no. 4) shows a similar depiction of Venus and Cupid.

Our drawing dates roughly from the last years of Holbein's stay in Basel, about 1530/1532. The decoration that Holbein designed in 1533 on commission from the merchants of the *Stahlhof* in London (cat. 184), on the occasion of the entry of Queen Anne Boleyn, is an example of this style of drawing, which must be reckoned as after 1530.　　　　　　　　　　　　　　　　C.M.

184　Mount Parnassus, 1533

Berlin, Kupferstichkabinett, KdZ 3105
Pen and black ink over black pencil; gray-brown wash; blue-green watercolor
423 x 384 mm (largest dimensions)
No watermark
Lower left *96* in brown pen; lower right *20* in black pen; bottom *Der Holbein* in black pen, with faded or effaced inscription above it, no longer legible
Glued to paper and trimmed at corners; trimmed, especially below; tear through the left group of muses and through the baldachin; several thin places, small holes, and brown spots

PROVENANCE: Crozat and Weigel Coll. (Lugt 1554); acquired in 1885

LIT.: Woltmann 2: no. 175 – Chamberlain 2: 30ff., ill. 8 – Ganz 1919, 178 – Ganz 1923, 48, pl. 30 – Bock 1921, 54 – Ganz 1937, no. 121 – Waetzoldt 1938, 112, 189 – Schmid 1948, 393 – Schilling 1954, 18f. – Exh. cat. *Dürer and his Time* 1965, no. 111 – Rowlands 1985, 88 – Ives 1986, 273ff., ill. 24 – E. McGrath, "Local Heroes: the Scottish Humanist Parnassus for Charles I," *England and the Continental Renaissance* (Woodbridge 1990), 257ff. – Ives 1994, 38, ill. 4 – *Handbuch Berliner Kupferstichkabinett* 1994, no. III.63

Upon his arrival in England in 1532, Holbein was employed by the members of the *Stahlhof,* the trade branch of the German merchants in London. He painted their portraits, and for their guildhall he designed two monu-mental paintings depicting *The Triumph of Poverty* and *The Triumph of Riches* (Rowlands 1985, no. L.13.a.i, no. L.13.c). The German merchants participated financially in the formulation of the festivities that took place on the occasion of the entry of Queen Anne Boleyn on 31 May 1533. Anne Boleyn, whom Henry VIII married in 1533 after his divorce from Catherine of Aragon, was showered with gifts from Henry during her short time as his queen. These included goldsmith work designed by Holbein and others. But Anne also conferred commissions on Holbein (see cats. 183, 186). The artist's contacts with Anne Boleyn, which may have come about thanks to his design for the *Parnassus,* certainly gave the artist entry to the court. In 1536 Henry VIII executed Anne Boleyn, who had given birth to Elizabeth on 7 September 1533, on the charge of adultery. He married Jane Seymour, a lady-in-waiting to her predecessor, who bore him the long-desired male successor to the throne, Edward, Prince of Wales.

Mountains were a beloved motif in pictorial programs for triumphal entries of rulers of the sixteenth and seventeenth centuries. At the wedding festivities of Catherine of Aragon in 1501 in London, for instance, the riches of Spain were symbolized by a mountain loaded with minerals, whereas for the entry of Prince Charles, the later emperor Charles V, into Bruges in 1515, the guilds created mountains of meat and fish, among other things, in order to honor the prince and draw attention to themselves. With the increased reception of classical themes in the sixteenth century, depictions of Mount Parnassus grew in favor.[1] Holbein's drawing is a design for a *tableau vivant,* a living picture, that combined living people with elements painted or constructed as if on a theater stage. It was set up at the point where Fenchurch Street comes out into Gracechurch Street. On an arch spanning the street, Apollo, the god of music and poetry, and the nine Muses were shown at the fount of Hippocrene, from which Rhine wine was to have flowed. The conception of the six main pictures of the entry with their humanistic themes goes back to Nicholas Udall and his friend John Leland, the king's antiquarian. Latin verses by Leland and Udall praised Anne, in whose honor the gods have returned, and announced the dawn of a new golden age. According to a contemporary description, Calliope, the Muse of epic song, sat below Apollo, surrounded by the other Muses carrying tablets with words written in golden letters (see Ives 1986, 275). The literary description of the picture largely corresponds with the drawing, wherein Apollo sits enthroned garbed in classical dress and laurel wreath above the fount of Hippocrene. This scene takes place above a triumphal-arch-like structure that features

184

three diagonally disposed passageways. Apollo holds a harp in his left arm and extends his right hand to conduct the singing and playing of the Muses, represented as ladies in contemporary dress. The baldachin over Apollo's head seems to be constructed of laurel leaves and tree branches. Two candles (?) burn upon its front supports, between which a banner for an inscription has been set up, and at the very top, a bird has landed and spreads its wings. The scene is framed to the left and right by candelabras, each of which carries a crowned heraldic shield, intended for the king's coat of arms. Parnassus, that is Helicon, consists of two mountains that rise to the left and right with trees growing on their slopes, sketchily outlined by Holbein. The scene is shown from below, which must have corresponded to the actual situation on Gracechurch Street.

The bird above Apollo has been identified in various ways. In contemporary exegesis, such as that by Chapuys, the emissary of Charles V, the bird was called the royal eagle, introduced by the merchants of the *Stahlhof* out of respect for the emperor (Ives 1986, 276f.). It can hardly be the imperial eagle, which is normally depicted with two heads. Rowlands identified the bird as a falcon and interpreted it as an allusion to the family of Anne Boleyn, that is, the earls of Ormond, whose coat of arms carried a crowned, white falcon. Perhaps an eagle is depicted after all, even though it is not unequivocally an attribute of Apollo but of Zeus, Apollo's father. Certainly the bird emphasizes Apollo's high rank.

The leg and arm positions of Apollo, like the fount with its basketry-motif basin before him, were inspired by *The Fountain of Neptune,* an engraving by Zoan Andrea on which Holbein relied repeatedly (B. 13, 15). For instance, the seated figures of Andrea's print found use in the depiction of Christ on a diptych with *Christ in Misery* (as the Man of Sorrows) and *The Virgin Mary,* in the Kunstmuseum Basel (inv. 317), and then on the design for a wall painting, *Sartorius with the Lusitanians* (Müller 1996, no. 125), in the Basel city hall. Moreover, Andrea's Neptune was also the model for the enthroned god in another of Holbein's woodcuts (Müller 1997, no. 92).

Holbein carried out the design using fluid strokes in a most economical way. He limited himself to indicating the most important details of the architecture and its decorations, and portrayed the figures summarily. The partial wash, boldly and flatly applied, and the elaboration in watercolors are characteristic of the sketchy designs executed by Holbein at the beginning of his second English stay.

C.M.

1. See E. McGrath, "Rubens's Arch of the Mint," in: *Journal of the Warburg and Courtauld Institutes* 37 (1974), 191ff., 207, 209ff.

185 GOBLET WITH LID, C. 1533/1536

Basel, Kupferstichkabinett, Inv. 1662.165.104
Pen and black ink over black chalk; counterproof for right half; gray wash, figure on the knob of the lid
251 x 164 mm (largest dimensions)
No watermark
On the lid *HANS VON ANT.*
Irregularly cut; mounted on japan paper; vertical center fold, horizontal folds near the top; wax residue and foxing

PROVENANCE: Amerbach-Kabinett, from the English Sketchbook

LIT.: Woltmann 1: 443; 2: no. 110.104 – His 1886, 28f., pl. XXVII, 1 – Davies 1903, ill. after 202 – Chamberlain 2: 275, pl. 42 – Meder 1919, 341, ill. 125 – Glaser 1924, pl. 78 – H. A. Schmid, "Der Entwurf eines Deckelpokals von Hans Holbein d. J.," *Öff. Kunstslg. Basel. Jahresb.,* n.s. 21, 1924, 34 – Oettinger 1934, 258, 263, pl. II,B – Ganz 1937, no. 206 (1532/1535) – Schmid 1945, 37f., ill. 133 (c. 1532/1535) – O. Gamber, "Die Königlich Englische Hofplattnerei," *Jb. der Kunsthistorischen Sammlungen in Wien* 59 (1963), 24, ill. 24 (details) – Hayward 1976, 300, 340, pl. 37 (c. 1532) – Roberts 1979, no. 96 – Exh. cat. *Holbein* 1988, no. 82 – Müller 1990, 41, ill. 9 – Müller 1996, no. 239

Holbein first drew the left side and completed the right with a counterproof. He therefore gave up on a picture-like rendering of the vessel but, by using various methods of representation, imparted more exact information about its form and decoration. The contours correspond to a longitudinal section drawn through the center axis. This allows the actual curvature of the lid to the left and right, as well as of the knob, to be visible without obscuring the ring-formed shape of the goblet lid's bulge. The ornament is hardly attuned to the rounding of the body of the vessel and is projected flatly onto the sides of the plane of the section. Even so, the impression of a three-dimensional object is retained; it is primarily suggested by the fore-shortened ribbing on the underside of the bowl and on the lid. The design may have been a direct model for a piece of goldwork that was to be made with these same dimensions. The figure of a woman on the knob, dressed only in a veil and holding a torch and book as her attributes, is an emblem for Truth. Holbein drew a variant of this figure next to it.

The design was created between 1532 and 1538, possibly for a Flemish goldsmith, Hans of Antwerp, who lived in London from 1515 on. Accounts establish that as of 1537 he was working for Thomas Cromwell, master of the Jewel House. After 1538 he also worked for Henry VIII. After the death of Holbein in 1543, Hans of Antwerp took over the trusteeship of the artist's estate.[1] Harness decora-

185

186

tions of about 1533/1536 belonging to Henry VIII (see Gamber) include ornaments that are very similar to those on the lid and sides of our vessel. Presumably Holbein designed the decoration for the king's suits of armor at the time. C.M.

1. L. Cust, "John of Antwerp, Goldsmith, and Hans Holbein," *Burl. Mag.* 31 (1906), 356–360; Reinhardt 1982, 268.

186 TABLE ORNAMENT, c. 1533/1536

Basel, Kupferstichkabinett, Inv. 1662.165.99
Pen and black ink over black chalk
265 x 125 mm (largest dimensions)
No watermark
Mounted on japan paper; irregularly cut, torn at the top; several small holes and tears; several horizontal folds, flattened; wax residue and foxing

PROVENANCE: Amerbach-Kabinett, from the English Sketchbook

LIT.: Woltmann 2: no. 110.99 – Manteuffel 1920, Zeichner, ill. on 68 – Glaser 1924, pl. 77 – Oettinger 1934, 263, pl. I,D – Ganz 1937, no. 219 (c. 1536) – Schmid 1945, ill. 138, 38 (1535/1543) – Christoffel 1950, ill. on 226 (c. 1536) – Exh. cat. *Amerbach* 1962, no. 83, ill. 24 – Exh. cat. *Swiss Drawings* 1967, no. 37 – Hugelshofer 1969, 140, no. 49 (1532/1543) – Hp. Landolt, "Zur Geschichte von Dürers zeichnerischer Form," *Anzeiger des Germanischen Nationalmuseums* (1971/1972), 155, ill. 15 – Hp. Landolt 1972, no. 82 – Hayward 1976, pl. 44 (c. 1533/1535) – Roberts 1979, no. 99 – Exh. cat. *Holbein* 1988, no. 84 – Hp. Landolt 1990, 275f., ill. 7f. – Müller 1990, 35f., ill. 4 – Exh. cat. *Amerbach* 1991, *Zeichnungen*, no. 122 – Gruber 1993, 261 – Ives 1994, 38, ill. 6 – Klemm 1995, 65, 75, ill. 64 – Müller 1996, no. 244

The design illustrates the left half of a great table centerpiece. It consists of a table fountain with several catch basins that decrease in size from bottom to top and are furnished with rich sculptural decoration. At the very top sits an enthroned Jupiter on an eagle, shaking his thunderbolts. People dance around an altar on the small platform below the god, and bring him a burnt offering. The creatures in the next level generally carry out serving functions: they hold heraldic shields, carry baskets on their heads in which small fires burn, or act as supports. Streams of water from the great, closed body of the vessel in the middle fall into the basin below. At the foot of the ensemble stands a naked, female figure from whose breast also issues a stream of water. Possibly she is Venus, Diana, or a nymph of the spring. The preliminary drawing in

black chalk conveys only a first impression of the proportions of the vessel. While working on the design, Holbein arrived at different solutions for the individual details, which he drew partly on top of one another, producing clusters or layers of lines. Those variants for which he could find no place within the design itself were accommodated at the edge, where he also enlarged individual details. Related to this sheet is a table fountain, known only from descriptions, which Anne Boleyn gave to Henry VIII for New Year's in 1534 (see Müller 1996, no. 243). Our design may have been drawn between 1533 and 1536. C.M.

187 HILT OF A CEREMONIAL DAGGER, c. 1534/1538

Verso: tankard, parrying rod of a dagger?, ornamental foliage, c. 1534/1538
Basel, Kupferstichkabinett, Inv. 1662.165.97
Pen and black ink over black chalk; additions to the dagger handle in brown pen, by another hand; verso, black chalk and pen and black ink
184 x 141 mm
No watermark
Three horizontal creases and one vertical crease, flattened; drawing rubbed out in places; wax and foxing

PROVENANCE: Amerbach-Kabinett, from the English Sketchbook

LIT.: Woltmann 2: no. 110.97 – His 1886, 30, pl. XXX, 3 – Ganz 1908, 63, pl. 41 – Chamberlain 2: 277 – Ganz 1937, no. 444 (1536/1543) – Müller 1990, 36, ill. 5 – Exh. cat. *Amerbach* 1991, *Zeichnungen*, no. 123 – Müller 1996, no. 235

This drawing is related to a design in the British Museum for a dagger and sheath, a so-called Baselard (Rowlands 1993, no. 325). It was presumably intended for Henry VIII. The Basel drawing is a design executed in dynamic strokes, which includes alternative solutions, whereas the London work is worked out in greater detail and comes closer to a final resolution. It could certainly be a work of the Holbein shop (Müller 1990, 36ff.). The parrying rod of a dagger, which is depicted on the verso of our drawing (turned 180 degrees), resembles the recto design in style and motifs. It was probably drawn between 1534 and 1538. C.M.

187

Verso (187)

188

188 Circular Composition with Old Testament Scenes: Hagar and Ishmael with the Angel, Abraham, and Abimelech; Partial Studies for Both Compositions and Jugglers, c. 1534/1538

Basel, Kupferstichkabinett, Inv. 1662.165.37
Pen and black ink; circles made with a compass
202 x 104 mm
No watermark
Verso, mirror-image impression of a 16th-century (not Amerbach) handwritten notation (in German)
Trimmed on all sides; horizontal center fold; below, flattened diagonal creases; several thin places; water-stained edges, wax residue and foxing

PROVENANCE: Amerbach-Kabinett, from the English Sketchbook

LIT.: Woltmann 2: no. 110.37 – *Handz. Schweizer. Meister,* pl. II,5b – Manteuffel 1920, *Zeichner,* 70, ill. 71 – Glaser 1924, pl. 70 – Ganz 1937, no. 272 (1536/1543, juggler is not autograph) – Exh. cat. *Skizzen* 1989, no. 32 – Exh. cat. *Amerbach* 1991, *Goldschmiederisse,* no. 104 – Müller 1996, no. 199

The three upper roundels show Hagar and Ishmael sitting at a well (Genesis 21:17–19). One of the circles drawn with a compass has remained empty. In the individual compositions, Holbein varied the position of the angel, who approaches from the right. To the right of the second composition we see another angel in a position of address; on the left Holbein drew three variations on the form of the well. The geometric shape of the pool allows the conclusion that a polished gemstone was to be mounted in the completed piece of jewelry. The lowest medallion, depicting Abraham and Abimelech shaking hands over an altar (Genesis 21:27–32), was also intended to enclose a precious stone. To the left and right, Holbein repeated the two figures striding toward each other in slightly altered poses. Above them appear two jugglers and a swordsman, who seem to have no conceptual connection with the Old Testament themes. Ganz took them for additions by a later hand. Stylistically, however, they cannot be separated from the other depictions. The drawings, which Holbein must have completed without substantial interruptions, unite precise and painstakingly developed figures with abbreviated, very summarily rendered figures modeled with hatching. These clearly divergent solutions in a very limited space allow insights into Holbein's working methods. They constitute the attraction of the drawing but also clarify how difficult any stylistic or temporal classification of a work can be once it has been separated from its original context—as with the countless small sheets that have been cut out along the edges of the so-called English Sketchbook. Holbein could have prepared our design around the middle of his second stay in England, between 1534 and 1538. There is a stylistic relation to Müller 1996, no. 218. The angel outside the roundels invites comparison with individual figures in Holbein's great table ornament (cat. 186).

The collection of the duke of Devonshire in Chatsworth contains a more complete watercolor for a medallion with Hagar, Ishmael, and the angel.[1] C.M.

1. Ganz 1937, no. 261; Exh. cat. *Old Master Drawings from Chatsworth,* M. Jaffé, ed., British Museum (London 1993), no. 204d.

189 Proportion Study of a Male Body and Study of a Head, c. 1535/1538

Basel, Kupferstichkabinett, Inv. 1662.165.19
Pen and black ink over black chalk; several compass pricks; head and shoulders pricked; upper left, incised circle
134 x 81 mm (largest dimensions)
No watermark
Paper discolored gray from smudged chalk; trimmed on all sides, corners cut diagonally, partially torn owing to careless separation; wax and foxing; several thin places at the left owing to corrections

PROVENANCE: Amerbach-Kabinett, from the English Sketchbook

LIT.: Woltmann 2: no. 110.19 – Ganz 1937, no. 137 – Exh. cat. *Holbein* 1960, no. 355 – Exh. cat. *Holbein* 1988, no. 77 – Müller 1996, no. 190 – Bätschmann/Griener 1997, 47–49

Holbein's proportion study of a male body is based on a planimetric construction that he produced with the help of a compass. Holbein chose the height of the head as his unit of measurement for the individual body parts and for the body as a whole. The starting points for the construction are the two compass insertion points, located along the central vertical axis at the top of the skull and the bottom of the chin of the frontally represented head. From the skull down, Holbein repeated the head measurement (about sixteen millimeters) eight times along the body's vertical axis. Eyes, collarbones, and navel are located precisely between two measuring points. Holbein constructed the marks that establish the width of the shoulders, the position of the elbows, and the left wrist by marking concentric circles equal to the head unit but centered at the insertion point on the chin instead of the point at the top of the skull. The width of the shoul-

189

ders was defined by the intersection of the circle with the horizontal that runs at the height of the collarbones, half a head below the chin. The markings on the insides of both legs are also located on these circles. The raised right arm with the open hand is likewise based on this system: the length of the lower arm was decided by the head unit, and the indication for the wrist lies on a circle with its center on the measuring point inside the elbow. The seemingly unrelated point above the lower right arm, which Holbein apparently did not employ, is located on the same circle as the markings for the elbows.

The standing position determines that the body swings slightly to the right from its shoulder zone and therefore moves off its ideal center axis. Holbein captures this deviation using short, horizontal strokes. During the elaboration of the drawing, however, he apparently did not consistently orient himself using his scheme, which prescribed the proportions of the body and the movement of individual joints on circular orbits. Holbein's deviation from his system is particularly evident in the left arm hanging next to the body, the dimensions of which Holbein lengthened beyond the indicated measuring points. That he was not certain about every aspect of the appearance and pose of his proportion figure is shown by the numerous signs of reworking, such as the rubbing of the surface and the corrections to the left hand, where he erased and changed the form. The relatively low position of the navel—half a head unit between the groin and waist—finds its counterpart in the body of *The Dead Christ* of 1521/1522 in the Öffentliche Kunstsammlung Basel (inv. 318; Rowlands 1985, no. 11). The navel on the so-called *Stone Thrower* is likewise deeply positioned (see cat. 191).

Possibly a personal ideal underlies these representations of the body, as they are based neither on pure construction nor exclusively on nature study. Holbein could have taken classical statuary as his point of departure. His proportion figure, the contrapposto-like pose and the position of the arms are reminiscent of a statue of a Roman youth from Helenenberge, now in the Kunsthistorisches Museum in Vienna, which was excavated about 1500 near the city of Klagenfurt.[1] Whether Holbein worked under the influence of a specific theory of proportion or independently can hardly be decided on the basis of the few surviving drawings in this domain. Leonardo da Vinci, for instance, divided his proportion figure, following Vitruvius, into eight head lengths, a module that Dürer also repeatedly employed in his proportion studies. Even though a direct model has yet to be identified, our drawing indicates that Holbein, like other artists

of the Renaissance, concerned himself with proportion and movement studies of the human body, and, like the Italian theoreticians of art who often turned to Vitruvius, related them to the ideal geometric figures of the circle and the square.[2] Like cat. 190, the drawing must have been executed in about the mid-1530s. C.M.

1. M. J. Liebmann, "Die Jünglingsstatue vom Helenenberge und die Kunst der Donauschule. Antike Motive in der Kunst der deutschen Renaissance," *Aus Spätmittelalter und Renaissance,* Acta humaniora (Leipzig 1987), 124ff.
2. See R. Wittkower, *Grundlagen der Architektur im Zeitalter des Humanismus* (Munich 1969), 12–32, figs. 6–11, ill. 7: *Leonardos Proportionsschema der menschlichen Gestalt,* Galleria dell'Accademia, Venice; Rupprich, 2, 151ff., 160f.

190 STUDIES OF HEADS AND HANDS, C. 1538

Basel, Kupferstichkabinett, Inv. 1662.165.16
Pen and black ink over black chalk
132 x 192 mm
Watermark: goat (fragment, similar to Briquet 2857)
Horizontal fold and several vertical folds, flattened; several small holes; wax spots and foxing; two pricks made by a compass

PROVENANCE: Amerbach-Kabinett, from the English Sketchbook

LIT.: Woltmann 2: no. 110.16 – Ganz 1908, 48f., pl. 29 (reversed) – Meder 1919, 624, ill. 309 – Ganz 1937, no. 138 (1532/1543) – Exh. cat. *Holbein* 1960, no. 336 – Exh. cat. *Amerbach* 1962, no. 79 (after 1532) – Exh. cat. *Holbein* 1988, no. 78 – Müller 1996, no. 189 – Bätschmann/Griener 1997, 48–49

Holbein must have created this drawing of perspectival head and hand studies in close connection to his proportion study of a male body (cat. 189), where we observe another study of a head, which the artist developed three-dimensionally using parabola-shaped lines.

Holbein provided the cube-shaped hand and the backward-leaning man, whose head is sunk forward, with construction lines that could point to a perspectival construction, in which all the converging lines meet at one point. Apparently Holbein was also familiar with the complicated parallel projection procedure for the precise perspective rendering of the body in movement, in which the individual members of the body are provided with section lines and formed stereometrically. Dürer also used this method to some degree in his *Four Books on Human Proportions,* inspired by treatises from the circle of Leonardo.

190

However, neither the heads bent in sundry directions and twisted differently from the bodies nor the two hands are rigidly constructed. The indicated converging lines do not really meet in the focal point that is drawn by Holbein above the hand. Instead the sketchy character of the drawing and the loose combination of motifs vouch for a free experiment in construction methods that Holbein could have taken from an illustrated treatise. Bätschmann assumed that Holbein's depiction is based on an illustrated textbook by Erard Schön, first published in 1538, "Unnderweissung der proportzion unnd stellung der possen." On page 4, male and female heads are shown from various angles. Their schematic, sketchlike rendering is reminiscent of Holbein's drawings (Bätschmann and Griener 1997, ill. 56). If we suppose that Holbein used this image and not a preparatory drawing for it or another treatise as his inspiration, this drawing would have been made after 1538. C.M.

191 MOVEMENT STUDY OF A FEMALE BODY (THE SO-CALLED STONE THROWER), c. 1535

Basel, Kupferstichkabinett, Inv. 1662.160
Pen and black ink with gray wash on red-tinted paper; gray wash; heightened in white
203 (left), 182 (right) x 122 mm
No watermark
Irregularly cut and mounted on japan paper; several small tears and holes

PROVENANCE: Amerbach-Kabinett

LIT.: *Photographie Braun,* no. 41 – Woltmann 2: no. 104 – *Handz. Schweizer. Meister,* pl. II, 36 – Ganz 1908, 47f., pl. 28 – Chamberlain 1: 160 – Knackfuss 1914, 88, ill. 75 – Manteuffel 1920, Maler, ill. 80 – Glaser 1924, title pl. – Ganz 1937, no. 135 (1532/1543) – Reinhardt 1938, pl. on 114 – Christoffel 1950, 76, ill. on 229 (1526/1532) – Grossmann 1950, 232, pl. 59b – Fischer 1951, 342, ill. 281 – Schilling 1954, 20, ill. 34 (work of the mature master) – M. Pfister-Burkhalter, in: Exh. cat. *Holbein* 1960, no. 214, ill. 95 (c. 1520) – H. R. Weihrauch, *Europäische Bronzestatuetten,* Brunswick 1967, 308, ill. 371 – Hp. Landolt 1972, no. 74 (c. 1520) – Exh. cat. *Holbein* 1988, no. 79 – Müller 1989, 115f., 125 – Müller 1996, no. 188 – Bätschmann/Griener 1997, 46–47

Although the drawing is undoubtedly trimmed, it can still be established that Holbein terminated his strokes in the areas bordering the edges. The pictorial field, therefore, cannot have been much larger. A woman holding two stones is portrayed standing next to a column in front of a wall. She could be an emblem for Fortitudo (fortitude) or Ira (anger). The motif of the fragmented column and possibly the movement of the woman and her emotional expression would fit into this type of image. Comparable, for instance, is Hans Burgkmair's woodcut (B. 7, no. 52). Weihrauch identified the larger stone as a sphere, and related this woman to a small sculptural work, which represents Fortuna (fortune), by the Master of the Budapest Abundantia in the Stiftsmuseum Klosterneuburg. This proposition is not convincing, as only the body position of the two seems related. M. Widmann (written communication) proposed that she be identified as a young bath attendant who is looking after the stream pebbles used in bathhouses. The absence of bathing equipment and her nudity contradict this notion, as does the motif of the fragmented column. The activity that engages the woman and the purpose, if any, of her movement remain unclear.

This female figure appears, rather, to be an outcome of Holbein's involvement with Italian prints rather than the result of any direct study of nature. The leg and foot positions are related to the Eve in Marcantonio Raimondi's engraving *Adam and Eve* (B. 14, no. 1). The upper body, which swivels at the hips, is similar, in mirror image, to Agostino Veneziano's *Cleopatra* (B. 14, no. 193); the left arm of our female figure is in a similar position to the right arm of the Egyptian queen. The facial expression, with the emotive, opened mouth and the long, fluttering hair, could also have been inspired by these models. Grossmann assumed that Holbein had been in Italy repeatedly and that he could have seen the *Lucretia* by Giovanni Maria Mosca (this relief was also associated with Antonio Lombardi).[1]

However, Holbein's drawing would appear to have been created independently of Mosca's relief. The sheet is no longer related to small sculptural works from the circle of Conrat Meit, which in turn go back to engravings by Raimondi, that is, of Lucas van Leyden, for instance, to the *Suicide of Lucretia* of about 1515 (B. 7, no. 134).[2] Despite her pronounced rotation, the woman, who seeks to distribute her mass around her own axis, looks bent back relative to the pictorial plane; hips and upper thighs are represented parallel to the picture plane. Only when viewed diagonally from the right does she lose her broad proportions and unfold in three dimensions (see Müller 1989). Stylistically and thematically the drawing fits in well with Holbein's perspectival head and hand studies, and his proportion studies of a male body (cats. 189, 190).

Reinhardt and Pfister-Burkhalter placed the *Stone Thrower* among the chiaroscuro drawings of about 1520,

191

whereas Christoffel dated it between 1526 and 1532, Ganz (1937) between 1532 and 1543, and recently Bätschmann/Griener (1997) about 1526. The sheet is distinguished from the early chiaroscuro drawings by its soft, shaded modeling and the delicately applied heightening in white. Holbein used similarly red- or pink-tinted paper for his portrait drawings during his second stay in England, between 1532 and 1543, which are, therefore, the earliest likely dates for this movement study of a female body. C.M.

1. See W. Stechow, "The Authorship of the Walters 'Lucretia,'" *The Journal of the Walters Art Gallery* 23 (1960), 73–85.
2. See Grossmann 1950, 232, n. 5; E. F. Bange, *Die Kleinplastik der deutschen Renaissance in Holz und Stein* (Leipzig 1928), no. 66–69.

LEONHARD BECK
(Augsburg c. 1475/1480–1542 Augsburg)

Painter, illuminator, draftsman, and designer of woodcuts; active in Augsburg, one of the most important centers of German Renaissance art. Little is known about his life and work. Possibly trained in the workshop of Hans Holbein the Elder before 1501. Painter of altarpieces and portraits. Contributed to the woodcut projects of Maximilian I: *Weisskunig (Wise King), The Patron Saints of the House of Habsburg, Theuerdank,* and *Triumphal Procession.*

Traditionally Attributed to Leonhard Beck
192 PORTRAIT OF A MAN, C. 1520

Berlin, Kupferstichkabinett, KdZ 523
Black chalk, colored chalks in ocher-yellow, red, and brown; heightened in white; blue and yellow chalk on the irises
346 x 275/279 mm
Verso, 19th-century inscription *Graff Moritz von Ertinger / 1521*

PROVENANCE: Guichardot Coll.; B. Suermondt Coll., Aachen; Prestel auction, Frankfurt am Main (Suermondt auction), 5.5.1870, no. 9; acquired in 1879

LIT.: Lippmann 1888, no. 79 – Bock 1921, 12 – F. Winkler, *Augsburger Malerbildnisse der Dürerzeit* (Berlin 1948), 22ff. – Exh. cat. *Dürer* 1967, no. 79 – Exh. cat. *Köpfe* 1983, no. 16

This head, rendered from life, is typical of Dürer's time. The features of the still youthful man, possibly a noble or a patrician, testify to a self-aware, introverted personality. Whether this is a portrait of Count Moritz von Ertingen, as is stated in a later inscription on the back, is not certain. Judging from its identical style, size, and technique, *Portrait of a Middle-Aged Man,* also in the Berlin Kupferstichkabinett (KdZ 1356; Bock 1921, 12), is a pendant of the present drawing. Bock catalogued both drawings as works by the Nuremberg artist Hans Sebald Beham, but Winkler 1948 attributed them to Leonhard Beck, based on a comparison to his paintings, especially *Adoration of the Kings* (Staatsgalerie, Augsburg). This work includes portrait heads reminiscent of the Berlin drawings. In both instances hard contours were avoided; a soft, tonal surface modeling predominates; and the glances of the sitters seem somewhat fixed, as if directed at a remote, unidentified object. However, the attribution to Beck can only be maintained with a measure of skepticism.

The painterly characteristics of the present sheet dominate the graphic elements: colored chalks were used and drawn lines were wiped with a brush, achieving broad

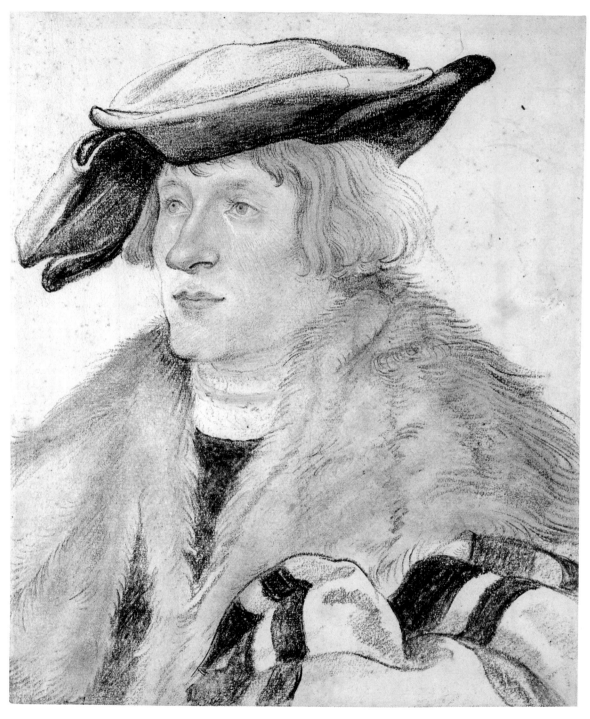

192

and flowing transitions. The painterly aspect is especially dominant in the brown collar and the blonde hair of the man. Colored chalk drawings were not common in Germany: the art of Augsburg about 1510–1520 played a key role in the establishment of this technique.[1] To Burgkmair we owe the earliest known, red chalk drawings in Germany, as well as the earliest portraits laid out in colored chalks.[2] The first colored chalk drawings were apparently created in northern Italy, in Leonardo's circle, and in France: Jean Fouquet's *Portrait of Guillaume Jouvenel des Ursins* (Berlin Kupferstichkabinett) of about 1460 is the earliest known example.[3] That the decisive impetus to use this technique in Germany came from Italy or France, as has often been claimed, may be questioned. Colored chalk drawings could also have developed locally from the somewhat older method of accentuating silverpoint drawings with red and white in order to achieve greater verisimilitude, as in works by the Augsburg artist Hans Holbein the Elder (cats. 36, 39).[4] The fine modeling of the metalpoint was suited to small works. When a larger, folio format was desired—in those decades, for life-size portraits—the progression to the broader, more painterly chalks seems almost inevitable (see cat. 172). The earliest instance of the use of black chalk in combination with red pencil heightened with white occurs on a sheet dated 1502, from a series of portraits of Augsburg painters, most of which are in the Berlin Kupferstichkabinett (Bock 1921, 67; Winkler 1948). H.B.

1. See the colored chalk drawings from Augsburg in Exh. cat. *Köpfe* 1983, nos. 16–18 (attributed to Beck), 31 and 36 (Burgkmair), 124–126 (unknown Augsburg master).

2. See Halm 1962, esp. 145ff., ill. 86 (drawing in Göttingen); Falk, in: *Zehn Meisterzeichnungen. Neuzugänge der Graphischen Sammlung, Staatliche Graphische Sammlung München* (Munich 1996), 6–7 (red chalk sheet by Burgkmair in Munich).

3. Achenbach, in: *Handbuch Berliner Kupferstichkabinett 1994*, no. VI.4.

4. Meder 1919, 137.

HEINRICH ALDEGREVER
(1502 Paderborn/Westphalia–1555/1561 Soest/Westphalia)

Engraver, painter, designer of woodcuts, and goldsmith. The most important graphic artist in northern Germany during the sixteenth century. Active in Soest, member of the Protestant establishment of that Westphalian city. In his engravings he worked in the manner of Dürer, similar to the so-called Nuremberg "little masters." Most of his drawings were made in preparation for his engravings.

193 PORTRAIT OF A MAN, C. 1535

Berlin, Kupferstichkabinett, KdZ 4242
Black chalk, colored chalks in ocher-yellow, red, and brown; left eye, blue-green chalk; contours incised for transfer; verso, blackened with chalk
272/275 x 184/187 (irregularly trimmed)
Watermark: Gothic P with flower (not in Briquet)
Lower edge, a virtually indecipherable inscription in black chalk, beginning *fabr . . .*

PROVENANCE: acquired from P & D Colnaghi in 1903

LIT.: *Zeichnungen* 1910, no. 204 – Bock 1921, 3 – Winkler 1932a, no. 66 – R. Fritz: "Ein Selbstbildnis Heinrich Aldegrevers," *Berliner Museen. Berichte aus den ehem. Preussischen Kunstsammlungen,* n.s., 10, no. 1/2 (1961), 15–17 – Exh. cat. *Dürer 1967*, no. 93 – H. Galen in: Exh. cat. *Heinrich Aldegrever und die Bildnisse der Wiedertäufer,* Westfälisches Landesmuseum (Münster 1985), no. 5 – R. Stupperich, "Theodor Fabricius," *Westfälische Lebensbilder 15* (Münster 1990), 30–46, esp. 38ff., 46 – G. Dethlefs, "Nicht Krechting oder Fabritius, sondern Wilhelm Ganzhorn. Zur Identifizierung einer Aldegrever zugeschriebenen Bildniszeichnung im Berliner Kupferstichkabinett," *Westfälische Zeitschrift 71* (Münster 1993), 176–179 – Rowlands 1993, no. 46 – O. Plassmann, *Die Zeichnungen Heinrich Aldegrevers* (Marburg 1994), no. 65

This is one of a few portrait drawings from about 1535 that hail, not from one of the artistic centers of southern Germany, such as Augsburg or Nuremberg, but from the provincial north, from Westphalia. The attribution to Heinrich Aldegrever is based on the relationship of its features and style to those in a drawing in the British Museum (Rowlands 1993, no. 46), which served the artist as a model for the engraving *Portrait of Jan van Leyden* (B./Hollstein *German* 182). Like the Berlin work, the London sheet was executed in colored chalks. During the first decades of the sixteenth century, this drawing tech-

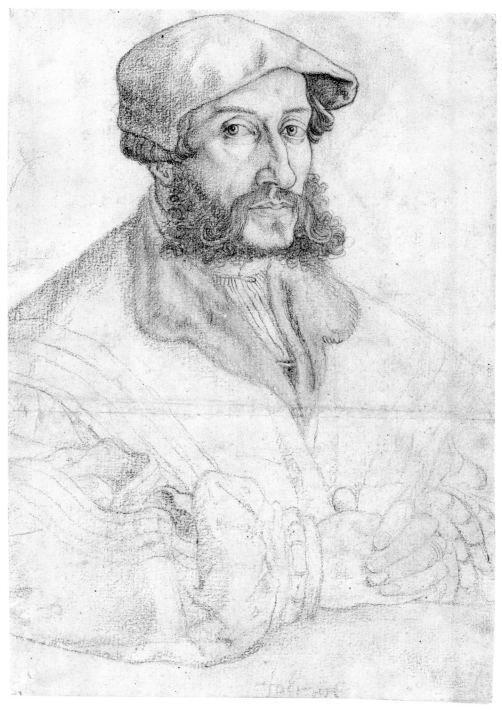

193

nique began to be used for portraits and studies of heads, especially if the sitter was portrayed from life. Colored chalks made possible a greater degree of verisimilitude. Where Aldegrever learned this technique is not known. Augsburg artists such as Burgkmair and Leonhard Beck (cat. 192) appear to have been the first in Germany to employ the colored style. Aldegrever portrayed the Anabaptist Jan van Leyden during his 1535 imprisonment in Münster. The Berlin drawing must have been done about this time, probably directly from the model, as the liveliness of the features indicate. The neck and face were executed in detail with colored chalks, whereas the upper body and arms were only outlined.

The sitter's identity is uncertain. Fritz took the sheet for a self-portrait by Aldegrever (the gaze, he proposed, was that of the draftsman looking into a mirror); but this theory is not convincing given the reliable surviving self-portraits by the artist. Galen, connecting the drawing with Aldegrever's portrait engravings of two Münster Anabaptist leaders, Jan van Leyden and Bernd Knipperdolling (B./Hollstein *German* 182–183), speculated that it might portray a third prominent Anabaptist, Bernd Krechting, who was executed in 1536 with his two coreligionists. The similarities in the format and portrait type of the drawing and the engravings support this hypothesis. The sheet could be a model for a never-executed engraving (Winkler 1932a) because the outlines are incised for transfer. Using the *fabr* of the inscription, Stupperich identified the sitter as the evangelical theologian Fabricius, who stayed in Münster in 1533–1534. Finally, Dethlefs saw a close resemblance between the subject in our drawing and in a painting (Mainfränkisches Museum Würzburg) dated 1538 that depicts the Würzburg jurist Wilhelm Ganzhorn. However, the relationship of the two works is not certain. Aldegrever can in any case be identified as the draftsman of the lively portraits in Berlin; the painting need not be by his hand. H.B.

BIBLIOGRAPHY

Albertina Vienna 1933

Beschreibender Katalog der Handzeichnungen in der Graphischen Sammlung Albertina. Ed. Alfred Stix. Vols. 4–5 (text and plate vols.): Die Zeichnungen der deutschen Schulen bis zum Beginn des Klassizismus. Eds. Hans Tietze, Erika Tietze-Conrat, Otto Benesch, and Karl Garzarolli-Thurnlackh. Vienna 1933

Allen/Garrod

Percy S. Allen, Helen M. Allen, Heathcote W. Garrod. Opus Epistolarum Des. Erasmi Roterodami. 12 vols. Oxford 1906–1958

Amerbach-Korrespondenz

Die Amerbach-Korrespondenz. Im Auftrag der Kommission für die Öffentliche Bibliothek der Universität Basel. Vols. 1–5: Ed. and rev. by Alfred Hartmann. Vols. 6–10: Ed. and rev. by Beat R. Jenny. Basel 1942–1995

Anderes/Hoegger 1988

Bernhard Anderes and Peter Hoegger. Die Glasgemälde im Kloster Wettingen. Baden 1988

Andersson 1978

Christiane Andersson. Dirnen, Krieger, Narren. Ausgewählte Zeichnungen von Urs Graf. Basel 1978

Andersson 1994

Christiane Andersson. "Das Bild der Frau in der oberrheinischen Kunst um 1520," in Die Frau in der Renaissance. Ed. Paul Gerhard Schmidt. Wiesbaden 1994: 243–259

Anzelewsky 1970

Fedja Anzelewsky. The Drawings and Graphic Works of Albrecht Dürer. London 1970

Anzelewsky 1971

See Anzelewsky 1991

Anzelewsky 1980

Fedja Anzelewsky. Dürer. Werk und Wirkung. Stuttgart 1980

Anzelewsky 1983

Fedja Anzelewsky. Dürer-Studien. Untersuchungen zu den ikonographischen und geistesgeschichtlichen Grundlagen seiner Werke zwischen den beiden Italienreisen. Berlin 1983

Anzelewsky 1988

A. Dürer. Tagebuch der Reise in die Niederlande. Ed. Fedja Anzelewsky. Zurich 1988

Anzelewsky 1991

Fedja Anzelewsky. Albrecht Dürer. Das malerische Werk. New ed., text and plate vol. Berlin 1991 (1st ed., Berlin 1971)

Anzelewsky/Mielke

Fedja Anzelewsky and Hans Mielke. Albrecht Dürer. Kritischer Katalog der Zeichnungen. Die Zeichnungen alter Meister im Berliner Kupferstichkabinett, Staatliche Museen zu Berlin—Preussischer Kulturbesitz. Berlin 1984

ASA

Anzeiger für Schweizerische Altert(h)umskunde, see ZAK

B.

Adam Bartsch. Le peintre graveur. 21 vols. and 2 vols. suppl. Vienna 1803–1821

Bächtiger 1971/1972

Franz Bächtiger. "Andreaskreuz und Schweizerkreuz. Zur Feindschaft zwischen Landsknechten und Eidgenossen." Jb. des Bernischen Historischen Museums 1971/1972: 205–270

Bächtiger 1974

Franz Bächtiger. "Marignano. Zum Schlachtfeld von Urs Graf." ZAK 31, 1974: 31–54

Bätschmann 1989

Oskar Bätschmann. "Die Malerei der Neuzeit." Ars Helvetica, 6. Disentis 1989

Bätschmann/Griener 1994

Oskar Bätschmann and Pascal Griener. "Holbein-Apelles. Wettbewerb und Definition des Künstlers." Zs. f. Kg. 57, 1994: 626–650

Bätschmann/Griener 1997

Oskar Bätschmann and Pascal Griener. Hans Holbein. Cologne 1997

Bätschmann/Griener 1998

Oskar Bätschmann and Pascal Griener. Hans Holbein d.J. Die Solothurner Madonna. Basel 1998

Baldass 1926

Ludwig Baldass. "Der Stilwandel im Werk Hans Baldungs." Münchner Jahrbuch der Bildenden Kunst, n.s., 3, 1926: 6–44

Baldass 1928

Ludwig Baldass. "Hans Baldungs Frühwerke." Pantheon 2, 1928: 398–412

Baldass 1941

Ludwig Baldass. Albrecht Altdorfer. Zurich 1941

Baldass 1960

Ludwig Baldass. "Offene Fragen auf der Basler Holbein Ausstellung von 1960," in Zs. f. Kwiss 15, 1961: 81–96

Basler Rathaus 1983

Das Basler Rathaus. Ed. Staatskanzlei des Kantons Basel-Stadt, with contributions by Ulrich Barth, Enrico Ferraino, Carl Fingerhut, Georg Germann, Elisabeth Landolt, and Alfred Wyss. Basel 1983

Basler Zs. Gesch. Ak.

Basler Zeitschrift für Geschichte und Altertumskunde. Basel, 1, 1902ff.

Baum 1948

Julius Baum. Martin Schongauer. Vienna 1948

Baumgart 1974

Fritz Baumgart. Grünewald, tutti i disegni. Florence 1974

Becker 1938

Hanna L. Becker. Die Handzeichnungen Albrecht Altdorfers. Munich 1938

Becker 1994

Maria Becker. "Architektur und Malerei. Studien zur Fassadenmalerei des 16. Jahrhunderts in Basel." Neujahrsblatt für Basels Jugend 172. Publ. Gesellschaft zur Beförderung des Guten und Gemeinnützigen. Basel 1994: 7–164

Beenken 1928

Herrmann Beenken. "Besprechung zu Lippmann," Jb. f. Kwiss. 5, vol. 6, 1928: 111–116

Beenken 1936

Herrmann Beenken. "Zu Dürers Italienreise im Jahre 1505." Zs. f. Kwiss. 3, 1936: 91–126

Behling 1955

Lottlisa Behling. Die Handzeichnungen des Mathis Gothart Nithart genannt Grünewald. Weimar 1955

Behling 1969

Lottlisa Behling. Mathis Gothart oder Nithart (Matthaeus Grünewald). Königstein im Taunus 1969

Beiträge 1, 2

Ernst Buchner and Karl Feuchtmayr, eds. Beiträge zur Geschichte der deutschen Kunst. Vol. 1: Oberdeutsche Kunst der Spätgotik und Reformationszeit. Augsburg 1924. Vol. 2: Augsburger Kunst der Spätgotik und Renaissance. Augsburg 1928

Benesch 1928

Otto Benesch. "Zur altösterreichischen Tafelmalerei: 1. Der Meister der Linzer Kreuzigung, 2. Die Anfänge Lukas Cranachs." Jahrbuch der kunsthistorischen Sammlungen in Wien, n.s., 2, 1928: 63–118

Bergström 1957

Ingvar Bergström. Revival of Antique Illusionistic Wall-painting in Renaissance Art. Göteborgs Universitets Årsskrift, 63. Göteborg 1957

Bernhard 1978
　Marianne Bernhard. *Hans Baldung Grien.*
　Munich 1978
Beutler/Thiem 1960
　Christian Beutler and Gunther Thiem. *Hans
　Holbein d.Ae. Die spätgotische Altar- und Glas-
　malerei.* Abhandlungen zur Geschichte der
　Stadt Augsburg. Schriftenreihe des Stadtarchivs
　Augsburg, 13. Augsburg 1960
Bianconi 1972
　Piero Bianconi. *L'opera completa di Grünewald.*
　Intro. by Guido Testoni. Milan 1972
Bober/Rubinstein
　Phyllis Pray Bober and Ruth Rubinstein.
　*Renaissance Artists and Antique Sculpture:
　A Handbook of Sources.* London 1986
Bock 1921
　Elfried Bock. "Die deutschen Meister.
　Beschreibendes Verzeichnis sämtlicher Zeich-
　nungen," Max J. Friedländer, ed., in *Kupfer-
　stichkabinett. Die Zeichnungen alter Meister im
　Staatliche Museen zu Berlin.* Vols. 1–2. Berlin
　1921
Bock 1929
　Elfried Bock. *Die Zeichnungen in der Univer-
　sitätsbibliothek Erlangen (Kataloge der Prestel-
　Gesellschaft, 1, Erlangen).* Frankfurt am Main
　1929
Böheim 1891
　Wendelin Böheim. "Augsburger Waffen-
　schmiede." *Jahrbuch der Kunstsammlungen
　des Allerhöchsten Kaiserhauses.* Vienna 1891:
　165–227
von Boehn 1923
　Max von Boehn. *Die Mode. Menschen und
　Mode im 16. Jahrhundert. Nach Bildern und
　Stichen der Zeit ausgewählt.* Munich 1923
Boerlin 1966
　*Öffentliche Kunstsammlung. Kunstmuseum Basel.
　Katalog,* part 1: *Die Kunst bis 1800. Sämtliche
　ausgestellte Werke.* Rev. by Paul H. Boerlin.
　Basel 1966
von Borries 1982
　Johann E. von Borries. Review of: Exh. cat.
　Baldung 1981. Kunstchronik 35, 1982: 51–59
von Borries 1988
　Johann E. von Borries. Review of: Rowlands
　1985. *Kunstchronik* 41, 1988: 125–131
von Borries 1989
　Johann E. von Borries. Review of: Exh. cat.
　Holbein 1988. Kunstchronik 42, 1989: 288–297
von Borries 1997
　Johann Eckhart von Borries. Review of:
　Müller 1996. *Journal für Kunstgeschichte* 1, 1997:
　171–177
Bossert/Storck 1912
　Helmuth Th. Bossert/Willy F. Storck. *Das
　mittelalterliche Hausbuch.* Leipzig 1912

van den Brande 1950
　Robert van den Brande. *Die Stilentwicklung
　im Graphischen Werk des Aegidius Sadeler.* Ph.D.
　diss. Vienna 1950
Braun 1924
　Edmund Wilhelm Braun. "Hans Baldung und
　der Benediktmeister." *Mitteilungen der Gesell-
　schaft für Vervielfältigende Kunst (Beilage der
　Graphischen Künste),* 1, Vienna 1924: 1–17
Brinckmann 1934
　Albert Erich Brinckmann. *Albrecht Dürer.
　Die Landschaftsaquarelle.* Berlin 1934
Briquet
　Charles M. Briquet. *Les filigranes. Dictionnaire
　historique des marques du papier,* 4 plate and 2
　text vols. Geneva 1907
Bucher 1992
　Gisela Bucher. *Weltliche Genüsse. Ikonologische
　Studie zu Tobias Stimmer 1539–1584.* Euro-
　päische Hochschulschriften, Reihe 28: Kunst-
　geschichte 131. Bern and Frankfurt am Main
　1992
Buchner 1924
　Ernst Buchner. "Hans Curjel, Hans Baldung
　Grien" (review), in Ernst Buchner and Karl
　Feuchtmayr. *Beiträge zur Geschichte der deutschen
　Kunst.* Vol. 1. Augsburg 1924: 287–302
Buck 1997
　Stephanie Buck. *Holbein am Hofe Heinrichs
　VIII.* Berlin 1997
Burckhardt 1888
　Daniel Burckhardt. *Die Schule Martin Schon-
　gauers am Oberrhein.* Basel 1888
Burckhardt 1892
　Daniel Burckhardt. *Albrecht Dürer's Aufenthalt
　in Basel 1492–1494.* Munich and Leipzig 1892
Burckhardt 1906
　Daniel Burckhardt. "Einige Werke der lom-
　bardischen Kunst in ihren Beziehungen zu
　Holbein." *ASA,* n.s., 8, 1906: 297–304
Burckhardt-Werthemann 1904
　Daniel Burckhardt-Werthemann. "Drei wie-
　dergefundene Werke aus Holbeins früherer
　Baslerzeit." *Basler Zs. Gesch. Ak.* 4, 1904:
　18–37
Burke 1936
　W.L.M. Burke. "Lucas Cranach the Elder."
　The Art Bulletin 18, 1936: 25–53
Burkhard 1936
　Arthur Burkhard. *Matthias Grünewald. Person-
　ality and Accomplishments.* Cambridge, Massa-
　chusetts 1936
Burl. Mag.
　The Burlington Magazine. London, 9, 1948:
　The Burlington Magazine for Connoisseurs.
　London, 1, 1903–89, 1947

Bushart 1977
　Bruno Bushart. "Der 'Lebensbrunnen' von
　Hans Holbein dem Älteren," in *Festschrift
　Wolfgang Braunfels.* Tübingen 1977: 45–70
Bushart 1987
　Bruno Bushart. *Hans Holbein der Ältere.*
　Augsburg 1987
Bushart 1994
　Bruno Bushart. *Die Fuggerkapelle bei St. Anna
　in Augsburg.* Munich 1994
Bushart 1998
　Bruno Bushart. "Hans Holbein—Vater und
　Sohn." *ZAK* 55, 1998: 151–168
Cetto 1949
　Anna Maria Cetto. *Tierzeichnungen aus acht
　Jahrhunderten.* Basel 1949
Chamberlain 1, 2
　Arthur B. Chamberlain. *Hans Holbein the
　Younger.* 2 vols. London 1913
Christoffel 1950
　Ulrich Christoffel. *Hans Holbein d.J.* 2d ed.,
　Berlin 1950 (1st ed. 1924)
Claussen 1993
　Peter C. Claussen. "Der doppelte Boden unter
　Holbeins Gesandten." *Hülle und Fülle. Festschrift
　für Tilmann Buddensieg.* Alfter 1993: 177–202
Cohn 1930
　Werner Cohn. *Der Wandel der Architekturgestal-
　tung in den Werken Hans Holbeins d.J. Ein Beitrag
　zur Holbein-Chronologie.* Studien zur deutschen
　Kunstgeschichte 278. Strassburg 1930
Cohn 1932
　Werner Cohn. "Eine Zeichnung H. Holbeins
　d.J. im Berliner Kupferstichkabinett." *Jb. Preuss.
　Kunstslg.* 53, 1932: 1–2
Cohn 1939
　Werner Cohn. "Two Glass Panels after Designs
　by Hans Holbein." *Burl. Mag.* 75, 1939: 115–
　121
Count of Solms-Laubach 1935–1936
　Ernstotto Count of Solms-Laubach. "Der
　Hausbuchmeister." *Städel-Jahrbuch,* 9, 1935–
　1936: 13–96
Cranach Colloquium 1972–1973
　Lucas Cranach. *Künstler und Gesellschaft,
　Colloquium zum 500. Geburtstag Lucas Cranach
　d. Ä.,* Staatliche Lutherhalle Wittenberg
　(1–3 October 1972). Wittenberg 1973
Curjel 1923
　Hans Curjel. *Hans Baldung Grien.* Munich 1923
Curjel, Baldungstudien
　Hans Curjel. "Baldung Studien." *Jahrbuch für
　Kunstwissenschaft* 1, 1923: 182–195
Davies 1903
　Gerald S. Davies. *Hans Holbein the Younger.*
　London 1903

Debrunner 1941
 Hugo Debrunner. *Der Zürcher Maler Hans Leu im Spiegel von Bild und Schrift (Neujahrsblatt der Zürcher Kunstgesellschaft 1941)*. Zurich 1941

Degenhart 1943
 Bernhard Degenhart. *Europäische Handzeichnungen aus fünf Jahrhunderten*. Berlin and Zurich 1943

Demonts
 Musée du Louvre. *Inventaire général des dessins des Écoles du Nord*, vols. 1–2: *Écoles allemande et suisse*. Coll. cat. Ed. Louis Demonts. Paris 1937–1938

Deuchler/Roethlisberger/Lüthy 1975
 Florens Deuchler, Marcel Roethlisberger, and Hans Lüthy. *Schweizer Malerei. Vom Mittelalter bis 1900*. Geneva 1975

Dodgson 1908
 Campbell Dodgson and Sidney M. Peartree. *The Dürer Society. Facsimiles*. Series 10. London 1908

Dominique/Maurice Moullet 1941
 E. Dominique and P. Maurice Moullet. "Un dessin inédit de Hans Fries." *ZAK* 3, 1941: 50–54

Dressler 1908
 Fridolin Dressler. "Nürnbergisch-fränkische Landschaften bei Albrecht Dürer." *Mitteilungen des Vereins f. d. Geschichte der Stadt Nürnberg*. 50, 1960: 258–270

Dreyer 1982
 Peter Dreyer. *Ex Biblioteca Regia Berolinensi. Zeichnungen aus dem ältesten Sammlungsbestand des Berliner Kupferstichkabinetts*. Berlin 1982

Eisler 1981
 Colin Eisler. "Hans Baldung Grien, an Exhibition Reviewed." *The Print Collector's Newsletter* 12, no. 3, 1981: 69–70

Eisler 1991
 Colin Eisler. *Dürer's Animals*. Washington and London 1991

Elen/Voorthuis
 Albert J. Elen/J. Voorthuis. *Missing Old Master Drawings from the Franz Koenigs Collection Claimed by the State of The Netherlands*. The Hague 1989

Ephrussi 1882
 Charles Ephrussi. *Albert Dürer et ses Dessins*. Paris 1882

Escher 1917
 Konrad Escher. *Die Miniaturen in den Basler Bibliotheken, Museen und Archiven*. Basel 1917

Escherich 1916
 Mela Escherich. *Hans Baldung Grien. Bibliographie 1509–1915*. Strassburg 1916

Escherich 1928/1929
 Mela Escherich. "Bildnisse von Grünewald." *Zeitschrift für bildende Kunst*, 62, 1928/1929: 116–120

Exh. cat. Albrecht Altdorfer und sein Kreis 1938
 Albrecht Altdorfer und sein Kreis. Gedächtnisausstellung zum 400. Todesjahr, Bayerische Staatsgemäldesammlung München. Munich 1938

Exh. cat. Amerbach 1962
 Meisterzeichnungen aus dem Amerbach-Kabinett. Öffentliche Kunstsammlung Basel. Eds. Hanspeter Landolt and Erwin Treu. Basel 1962

Exh. cat. Amerbach 1991, Beiträge/Gemälde/Goldschmiederisse/Objekte/Zeichnungen
 Sammeln in der Renaissance. Das Amerbach-Kabinett. Historisches Museum Basel and Öffentliche Kunstsammlung Basel. 5 vols. Basel 1991

Exh. cat. Amerbach 1995
 Bonifacius Amerbach 1495–1562. Zum 500. Geburtstag des Basler Juristen und Erben des Erasmus von Rotterdam. Öffentliche Kunstsammlung Basel. Basel 1995

Exh. cat. Baldung 1959
 Hans Baldung Grien. Staatliche Kunsthalle Karlsruhe. Karlsruhe 1959

Exh. cat. Baldung 1978
 Hans Baldung Grien im Kunstmuseum Basel. Öffentliche Kunstsammlung Basel. Basel 1978

Exh. cat. Baldung 1981
 Hans Baldung Grien: Prints and Drawings. National Gallery of Art, Washington/Yale University Art Gallery, New Haven. Eds. James H. Marrow and Alan Shestack. Washington and New Haven 1981

Exh. cat. Basler Buchill. 1984
 Basler Buchillustration 1500–1545. Oberrheinische Buchillustration 2. Öffentliche Bibliothek der Universität Basel. Ed. Frank Hieronymus. Basel 1984

Exh. cat. Berlin 1877
 Catalog der Ausstellung neu erworbener Zeichnungen von Albrecht Dürer. Königliche Museen. Kupferstich-Cabinet. Ed. Friedrich Lippmann. Berlin 1877

Exh. cat. Berlin 1928
 Albrecht Dürer-Ausstellung zum 6. April 1928. Staatliche Museen Berlin in collaboration with the Preussische Akademie der Künste. Ed. Max J. Friedländer. Berlin 1928

Exh. cat. Bilder aus Licht und Farbe 1995
 Bilder aus Licht und Farbe. Meisterwerke spätgotischer Glasmalerei. "Straßburger Fenster" in Ulm und ihr künstlerisches Umfeld. Ulmer Museum. Ulm 1995

Exh. cat. Bocholt 1972
 Ishrahel van Meckenem und der deutsche Kupferstich des 15. Jahrhunderts. 750 Jahre Stadt Bocholt 1222–1972. Kunsthaus der Stadt Bocholt. Bocholt 1972

Exh. cat. Bremen 1911
 Die Kunst Albrecht Dürers. Seine Werke in Originalen und Reproduktionen geordnet nach der Zeitfolge ihrer Entstehung. Kunsthalle Bremen. Ed. Gustav Pauli. Bremen 1911

Exh. cat. Brussels 1977
 Albrecht Dürer aux Pays-Bas, son voyage (1520–1521), son influence. Palais des Beaux-Arts. Ed. Fedja Anzelewsky/Matthias Mende and Pieter Eickhout. Brussels 1977

Exh. cat. Bürger and Bauern 1989
 Dasein und Vision. Bürger und Bauern um 1500. Altes Museum Berlin. Berlin 1989

Exh. cat. Burgkmair 1931
 Burgkmair-Ausstellung in der Staatlichen Gemäldegalerie zu Augsburg, Juni–Juli 1931. Bayerische Staatsgemäldesammlungen. Ed. Karl Feuchtmayr. Augsburg 1931

Exh. cat. CIBA-Jubiläums-Schenkung 1959
 Die CIBA-Jubiläums-Schenkung an das Kupferstichkabinett. Öffentliche Kunstsammlung Basel. Basel 1959

Exh. cat. Cranach 1972
 Lucas Cranach 1472–1553. Ein grosser Maler in bewegter Zeit. Schlossmuseum Weimar. Weimar 1972

Exh. cat. Cranach 1973
 Lucas Cranach. Gemälde-Zeichnungen-Druckgraphik. Staatliche Museen zu Berlin-Preussischer Kulturbesitz, Gemäldegalerie und Kupferstichkabinett. Ed. Frank Steigerwald. Berlin 1973

Exh. cat. Cranach 1974/1976
 Lucas Cranach. Gemälde, Zeichnungen, Druckgraphik. Öffentliche Kunstsammlung Basel. Eds. Dieter Koepplin and Tilman Falk. 2 vols. Basel 1974/1976

Exh. cat. Cranach 1988
 Cranach och den tyska renässansen (Cranach und die deutsche Renaissance). Nationalmuseum Stockholm. Stockholm 1988

Exh. cat. Cranach 1994
 Lucas Cranach. Ein Maler-Unternehmer aus Franken. Festung Rosenberg Kronach/Museum der bildenden Künste Leipzig/Haus der Bayerischen Geschichte und Kultur, Augsburg. Eds. Klaus Grimm/Johannes Erichsen and Evamaria Brockhoff. Augsburg 1994

Exh. cat. Das Praunsche Kabinett 1994
 Die Kunst des Sammelns. Das Praunsche Kabinett. Meisterwerke von Dürer bis Carracci. Germanisches Nationalmuseum. Nuremberg 1994

Exh. cat. Dessins Renaissance germanique 1991
 Dessins de Dürer et de la Renaissance germanique dans les collections publiques parisiennes. Musée du Louvre. Ed. Emmanuel Starcky. Paris 1991

Exh. cat. Deutsche Zeichnungen der Dürerzeit 1951
*Meisterwerke aus den Berliner Museen. Deutsche
Zeichnungen der Dürerzeit.* Museum Dahlem.
Berlin 1951–1952

Exh. cat. Deutsche Zeichnungen 1400–1900, 1956
Deutsche Zeichnungen 1400–1900. Staatliche
Graphische Sammlung München im Haus der
Kunst/Kupferstichkabinett der ehemaligen
Staatlichen Museen Berlin im Museum
Dahlem/Kunsthalle Hamburg. Munich 1956

Exh. cat. Donauschule 1965
Die Kunst der Donauschule 1490–1540. Stift St.
Florian and Schlossmuseum Linz. Linz 1965

Exh. cat. Dürer 1911
See *Exh. cat. Bremen 1911*

Exh. cat. Dürer 1964
*Dürer et son temps. Chef-d'oeuvres du Dessin
allemand de la collection du Kupferstichkabinett,*
Musée de l'Etat Stiftung Preussischer Kultur-
besitz à Berlin. Palais des Beaux-Arts. Ed. Fedja
Anzelewsky. Brussels 1964

Exh. cat. Dürer 1967
*Dürer und seine Zeit. Meisterzeichnungen aus dem
Berliner Kupferstichkabinett.* Kupferstichkabinett,
Staatliche Museen zu Berlin-Preussischer
Kulturbesitz. Ed. Fedja Anzelewsky. Berlin
1967

Exh. cat. Dürer 1971
See *Exh. cat. Nuremberg 1971*

Exh. cat. Dürer 1985
See *Koreny 1985*

Exh. cat. Dürer 1991
*Albrecht Dürer. 50 Meisterzeichnungen aus dem
Berliner Kupferstichkabinett, Kunstmuseum
Düsseldorf.* Ed. Hans Mielke. Berlin 1991

Exh. cat. Dürer, Holbein 1988
*The Age of Dürer and Holbein: German Drawings
1400–1550.* British Museum. Ed. John Row-
lands, with the assistance of Giulia Bartrum.
London 1988

Exh. cat. Erasmus 1969
Erasmus en zijn tijd. Museum Boymans van
Beuningen. Rotterdam 1969

Exh. cat. Erasmus 1986
*Erasmus von Rotterdam. Zum 450. Todestag des
Erasmus von Rotterdam.* Historisches Museum
Basel. Basel 1986

Exh. cat. Fantast. Realismus 1984
*Altdorfer und der fantastische Realismus in der
deutschen Kunst.* Centre Culturel de Marais.
Ed. Fedja Anzelewsky et al. Paris 1984

Exh. cat. Freiburg 1970
*Kunstepochen der Stadt Freiburg, Ausstellung zur
850. Jahrfeier.* Augustinermuseum Freiburg im
Breisgau. Ed. Ingeborg Krummer-Schroth.
Freiburg im Breisgau 1970

Exh. cat. Handzeichnungen Alter Meister 1961
*Handzeichnungen Alter Meister aus dem Kupfer-
stichkabinett der ehemals Staatlichen Museen Berlin.*
Graphische Sammlung der Eidgenössischen
Technischen Hochschule. Zurich 1961

Exh. cat. Hausbuchmeister 1985
*The Master of the Amsterdam Cabinet, or The
Housebook Master, c. 1470–1500.* Rijksprenten-
kabinet/Rijksmuseum Amsterdam. Ed. Jan
Piet Filedt Kok. Amsterdam 1985 (Dutch and
English editions); German edition: *Vom Leben
im späten Mittelalter. Der Hausbuchmeister oder
Meister des Amsterdamer Kabinetts.* Städtische
Galerie im Städelschen Kunstinstitut. Frankfurt
am Main 1985

Exh. cat. Holbein 1960
Die Malerfamilie Holbein in Basel. Öffentliche
Kunstsammlung Basel. Basel 1960

Exh. cat. Holbein d.Ä. 1965
*Hans Holbein der Aeltere und die Kunst der
Spätgotik.* Rathaus Augsburg. Augsburg 1965

Exh. cat. Holbein 1987
*Drawings by Holbein from the Court of Henry
VIII. Fifty Drawings from the Collection of
Her Majesty Queen Elizabeth II, Windsor Castle.*
Museum of Fine Arts, Houston. Ed. Jane
Roberts. Houston 1987; German ed.:
Hamburger Kunsthalle and Öffentliche
Kunstsammlung Basel. Basel 1988

Exh. cat. Holbein 1988
*Hans Holbein d.J. Zeichnungen aus dem Kupfer-
stichkabinett der Öffentlichen Kunstsammlung
Basel.* Öffentliche Kunstsammlung Basel. Ed.
Christian Müller. Basel 1988

Exh. cat. Innsbruck 1969
Maximilian I. Innsbruck. Zeughaus. Innsbruck
1969

Exh. cat. Karlsruhe 1959
Hans Baldung Grien. Staatliche Kunsthalle
Karlsruhe. Karlsruhe 1959

Exh. cat. Kölner Maler der Spätgotik 1961
*Kölner Maler der Spätgotik. Der Meister des
Bartholomäus-Altares. Der Meister des Aachener
Altares.* Wallraf-Richartz-Museum. Cologne
1961

Exh. cat. Köpfe 1983
Köpfe der Lutherzeit. Hamburger Kunsthalle.
Ed. Werner Hofmann. Munich 1983

Exh. cat. Liverpool 1910
The Art of Albrecht Dürer. Walker Art Gallery.
Ed. Sir W. Martin Conway. Liverpool 1910

Exh. cat. Manuel 1979
*Niklaus Manuel Deutsch. Maler, Dichter, Staats-
mann.* Historisches Museum Bern. Bern 1979

Exh. cat. Meister um Albrecht Dürer 1961
Meister um Albrecht Dürer. Germanisches
Nationalmuseum Nürnberg. Nuremberg 1961

Exh. cat. Munich 1974
*Altdeutsche Zeichnungen aus der Universitätsbiblio-
thek Erlangen.* Staatliche Graphische Sammlung
München. Ed. Dieter Kuhrmann. Munich
1974

Exh. cat. Neuerworbene und neubestimmte
Zeichnungen 1973
*Vom späten Mittelalter bis zu Jacques Louis David.
Neuerworbene und neubestimmte Zeichnungen im
Berliner Kupferstichkabinett.* Ed. Fedja Anzelew-
sky and Peter Dreyer et al. Berlin 1973

Exh. cat. Nuremberg 1971
Albrecht Dürer 1471–1971. Germanisches
Nationalmuseum Nürnberg. Munich 1971

Exh. cat. Renaissance 1986
Die Renaissance im deutschen Südwesten. Heidel-
berger Schloss. Publ. Badisches Landesmuseum
Karlsruhe, 2 vols. Karlsruhe 1986

Exh. cat. Schongauer Berlin 1991
*Martin Schongauer. Druckgraphik im Berliner
Kupferstichkabinett.* Kupferstichkabinett,
Staatliche Museen zu Berlin–Preussischer
Kulturbesitz. Eds. Hartmut Krohm and
Jan Nicolaisen. Berlin 1991

Exh. cat. Schongauer Colmar 1991
*Le beau martin. Gravures et Dessins de Martin
Schongauer (vers 1450–1491).* Musée d'Unter-
linden, Colmar 1991; German ed: *Der hübsche
Martin. Kupferstiche und Zeichnungen von Martin
Schongauer (c. 1450–1490)*

Exh. cat. Skizzen 1989
*Skizzen. Von der Renaissance bis zur Gegenwart
aus dem Kupferstichkabinett Basel.* Kunsthalle
Bielefeld. Ed. Ulrich Weisner. Bielefeld 1989

Exh. cat. Slg. Kurfürst Carl Theodor 1983
*Zeichnungen aus der Sammlung des Kurfürsten
Carl Theodor.* Staatliche Graphische Sammlung
München. Eds. Holm Bevers and Richard
Harprath et al. Munich 1983

Exh. cat. Stimmer 1984
*Spätrenaissance am Oberrhein. Tobias Stimmer
1539–1584.* Öffentliche Kunstsammlung Basel.
Basel 1984

Exh. cat. Swiss Drawings 1967
Swiss Drawings. Masterpieces of Five Centuries.
Stiftung Pro Helvetia and Smithsonian Insti-
tution Washington. Ed. Walter Hugelshofer.
Washington 1967

Exh. cat. Traum vom Raum 1986
*Der Traum vom Raum. Gemalte Architektur aus 7
Jahrhunderten.* Kunsthalle Nürnberg. Ed. Hans
Reuther. Nuremberg 1986

Exh. cat. Vermächtnis Jung 1989
*Zeichnungen des 16. bis 18. Jahrhunderts. Vermächt-
nis Richard Jung.* Staatsgalerie Stuttgart and
Staatliche Kunsthalle Karlsruhe. Stuttgart 1989

Exh. cat. Vom späten Mittelalter 1973
See *Exh. cat. Neuerworbene und neubestimmte
Zeichnungen 1973*

Exh. cat. Von allen Seiten schön 1995
 *Von allen Seiten schön. Bronzen der Renaissance
 und des Barock.* Staatliche Museen zu Berlin-
 Preussischer Kulturbesitz. Ed. Volker Krahn.
 Berlin 1995
Exh. cat. Washington 1971
 Dürer in America. His Graphic Work. National
 Gallery of Art Washington. Ed. Charles W.
 Talbott, with notes by Gaillard F. Ravenel and
 Jay A. Levenson. Washington 1971
Exh. cat. Westeurop. Zeichnungen 1992
 *Zapadno-europejski Risunok XVI.–XX. vekov
 iz sobranij Kunsthalle v Bremene. Westeuropäische
 Zeichnung XVI.–XX. Jahrhundert. Kunsthalle
 Bremen.* Hermitage St. Petersburg. Ed. I.S.
 Grigor'eva/T.A. Ilatovskaja and J.N. Novo-
 sel'skaja. St. Petersburg 1992
Exh. cat. Zeichen der Freiheit 1991
 *Das Bild der Republik in der Kunst des 16. bis 20.
 Jahrhunderts. Zeichen der Freiheit.* 2d Exposition
 of the Council of Europe 1991. Historisches
 Museum and Kunstmuseum Bern. Ed. Dario
 Gamboni and Georg Germann. Bern 1991
Falk 1968
 Tilman Falk. *Hans Burgkmair. Studien zu Leben
 und Werk des Augsburger Malers.* Munich 1968
Falk 1978
 Tilman Falk. "Baldungs jugendliches Selbst-
 bildnis: Fragen zur Herkunft seines Stils." *ZAK*
 35, 1978: 217–223
Falk 1979
 *Kupferstichkabinett der Öffentlichen Kunstsamm-
 lung Basel (Kunstmuseum Basel). Beschreibender
 Katalog der Zeichnungen. Vol. 3: Die Zeichnungen
 des 15. und 16. Jahrhunderts, part 1: Das 15.
 Jahrhundert, Hans Holbein der Ältere und Jörg
 Schweiger, die Basler Goldschmiederisse.* Coll. cat.
 Ed. Tilman Falk. Basel and Stuttgart 1979
Falke 1936
 Otto von Falke. "Dürers Steinrelief von 1509
 mit dem Frauenakt," in *Pantheon* 18, 1936:
 330–333
Favière 1985
 Jean Favière. "Bourges, source d'inspiration
 d'Holbein." *Cahiers d'archéologie et d'histoire du
 Berry* 80, 1985: 47–54
Feurstein 1930
 Heinrich Feurstein. *Matthias Grünewald.*
 Religiöse Schriftenreihe der Buchgemeinde
 Bonn, 6, J.R. 1930. Bonn 1930
Fischer 1939
 Otto Fischer. *Hans Baldung Grien.* Munich
 1939
Fischer 1951
 Otto Fischer. *Geschichte der deutschen Zeichnung
 und Graphik.* Deutsche Kunstgeschichte 4.
 Munich 1951: 339ff.

Flechsig 1, 2
 Eduard Flechsig. *Albrecht Dürer. Sein Leben
 und seine künstlerische Entwicklung.* Berlin
 1928–1931, 2 vols.
Foister 1981
 Susan Foister. *Holbein and His English Patrons.*
 Unpublished Ph.D. diss. Courtauld Institute of
 Art, London 1981
Foister 1983
 *Drawings by Holbein from the Royal Library
 Windsor Castle.* Coll. cat. Ed. Susan Foister.
 New York 1983
Fraenger 1936
 Wilhelm Fraenger. *Matthias Grünewald in seinen
 Werken. Ein physiognomischer Versuch.* Berlin
 1936
Fraenger 1988
 Wilhelm Fraenger. *Matthias Grünewald.*
 Dresden 1988
Friedländer 1891
 Max J. Friedländer. *Albrecht Altdorfer. Der Maler
 von Regensburg.* Ph.D. diss. Leipzig 1891
Friedländer 1896
 Max J. Friedländer. "Dürers Bildnisse seines
 Vaters." *Repertorium für Kunstwissenschaft* 19,
 1896: 12–19
Friedländer 1914
 *Handzeichnungen deutscher Meister in der Herzogl.
 Anhaltschen Behörden Bibliothek zu Dessau.* Coll.
 cat. Ed. Max J. Friedländer. Stuttgart 1914
Friedländer 1919
 Max J. Friedländer. *Albrecht Dürer. Der Kupfer-
 stecher und Holzschnittzeichner.* Berlin 1919
Friedländer 1923
 Max J. Friedländer. *Albrecht Altdorfer.* Berlin
 n.d. (1923)
Friedländer 1925
 Max J. Friedländer. *Von Schongauer zu Holbein.
 Zeichnungen Deutscher Meister des 16. Jahrhunderts
 aus dem Berliner Kabinett.* Munich 1925
Friedländer 1926
 Max J. Friedländer, ed. *Die Grünewaldzeich-
 nungen der Sammlung v. Savigny.* Berlin 1926
Friedländer 1927
 Max J. Friedländer, ed. *Die Zeichnungen von
 Matthias Grünewald (Jahresgabe des Deutschen
 Vereins für Kunstwissenschaft 1926).* Berlin 1927
Friedländer/Bock 1921
 See Bock 1921
Friedländer/Rosenberg 1979
 Max J. Friedländer/Jakob Rosenberg. *Die
 Gemälde von Lucas Cranach.* 2d rev. ed., Basel
 1979 (1st ed., Berlin 1932)
Friend 1943
 A.M. Friend Jr. "Dürer and the Hercules
 Borghese-Piccolomini." *The Art Bulletin* 25,
 1943: 40–49

Frölicher 1909
 Elsa Frölicher. *Die Porträtkunst Hans Holbeins
 des Jüngeren und ihr Einfluss auf die schweizerische
 Bildnismalerei im 16. Jahrhundert.* Ph.D. diss.
 Basel, Strassburg 1909
Ganz 1905
 Paul Ganz. "Hans Holbein der Jüngere."
 Die Schweiz 9, 1905: 129–136
Ganz 1908
 Paul Ganz, ed. *Handzeichnungen von Hans
 Holbein dem Jüngeren, in Auswahl.* Berlin 1908
Ganz 1919
 Paul Ganz, ed. *Hans Holbein d.J. Des Meisters
 Gemälde in 252 Abbildungen.* Klassiker der Kunst
 20. 2d ed., Stuttgart and Berlin 1919 (1st ed.
 1911)
Ganz 1923
 Paul Ganz, ed. *Handzeichnungen von Hans
 Holbein dem Jüngeren, in Auswahl.* 2d ed., Berlin
 1923 (1st ed. 1908)
Ganz 1924
 Paul Ganz. "L'influence de l'art français dans
 l'oeuvre de Hans Holbein le Jeune," in *Actes du
 congrès d'histoire de l'art*, 2, Paris 1924: 292–299
Ganz 1925
 Paul Ganz. "An Unknown Portrait by Holbein
 the Younger." *Burl. Mag.* 47, 1924: 230–245
Ganz 1925, Holbein
 Paul Ganz. "Holbein." *Burl. Mag.* 47, 1925:
 230–245
Ganz 1928/1929
 Paul Ganz. "Das Bildnis Hans Holbeins d.J."
 Jb. für Kunst und Kunstpflege in der Schweiz, 5,
 1928/1929: 273–292
Ganz 1936
 Paul Ganz. "Zwei Werke Hans Holbeins d.J.
 aus der Frühzeit des ersten englischen Aufent-
 halts," in *Festschrift zur Eröffnung des Kunst-
 museums.* Basel 1936: 141–158
Ganz 1937
 Paul Ganz. *Die Handzeichnungen Hans Holbeins
 d.J. Kritischer Katalog, in fünfzig Lieferungen.*
 Denkmäler deutscher Kunst. Berlin 1911–1937
 (text vol. Berlin 1937)
Ganz 1943
 Paul Ganz. *Handzeichnungen Hans Holbeins des
 Jüngeren in Auswahl.* Basel 1943
Ganz 1950
 Paul Ganz. *Hans Holbein der Jüngere. Gesamtaus-
 gabe der Gemälde.* Basel 1950
Ganz/Major 1907
 Paul Ganz and Emil Major. "Die Entstehung
 des Amerbach'schen Kunstkabinetts; Die
 Amerbach'schen Inventare." *Öff. Kunstslg.
 Basel. Jahresb.*, n.s., 3, 1907, suppl.: 1–68
P.L. Ganz 1960
 Paul Leonhard Ganz. *Die Miniaturen der Basler
 Universitätsmatrikel.* Basel 1960

P.L. Ganz 1966
Paul Leonhard Ganz. *Die Basler Glasmaler der Spätrenaissance und der Barockzeit.* Basel and Stuttgart 1966

Gerszi 1970
Teresa Gerszi. *Capolavori del Rinascimento tedesco. I disegni dei Maestri.* Milan 1970

Giesen 1930
Josef Giesen. *Dürers Proportionsstudien im Rahmen der allgemeinen Proportionsentwicklung.* Ph.D. diss. Bonn 1930

Giesicke 1994
Barbara Giesicke. *Glasmalereien des 16. und 20. Jahrhunderts im Basler Rathaus.* Ed. Staatskanzlei des Kantons Basel-Stadt Basel 1994

Ginhart 1962
Karl Ginhart. "Dürer war in Kärnten," in *Festschrift Gotbert Moro, Beilage zu Carinthia I,* 1, 1962: 129–155

Girshausen 1936
Theo Ludwig Girshausen. *Die Handzeichnungen Lukas Cranachs des Älteren.* Ph.D. diss. Frankfurt am Main 1936

Glaser 1908
Curt Glaser. *Hans Holbein der Aeltere.* Kunstgeschichtliche Monographien, XI. Leipzig 1908

Glaser 1921
Curt Glaser. *Lukas Cranach.* Leipzig 1921

Glaser 1924
Curt Glaser. *Hans Holbein d.J. Zeichnungen.* Basel 1924 (Reviewed by Grisebach. *Jb. f. Kwiss.* 1924/1925: 310–311)

Goris/Marlier 1970
J.A. Goris/Georges Marlier. *Albrecht Dürer. Das Tagebuch der niederländischen Reise.* Brussels 1970

Graul 1935
Richard Graul, ed. *Grünewalds Handzeichnungen (Inselbücherei 265).* Leipzig 1935

Great Drawings 1962
Great Drawings of All Time. Comp. and ed. by Ira Moskowitz. Vol. 2: *German, Flemish, and Dutch, Thirteenth through Nineteenth Century.* New York 1962

Grimm 1881
Hermann Grimm. "Bemerkungen über den Zusammenhang von Werken A. Dürers mit der Antike." *Jb. preuss. Kunstslg.* 1881: 186–191

Grohn 1956
Hans W. Grohn. *Hans Holbein der Jüngere. Bildniszeichnungen.* Dresden 1956

Grohn 1987
Hans W. Grohn, with foreword by Pierre Vaisse. *Tout l'oeuvre peint de Holbein le Jeune. Les Classiques de l'Art.* Paris 1987

Gross 1625
Johannes Gross. *Urbis Basileae Epitaphia et Inscriptiones.* Basel (1625)

Gross 1991
Sibylle Gross. "Die Schrein- und Flügelgemälde des Schnewlin-Altares im Freiburger Münster—Studien zur Baldung-Werkstatt und zu Hans Leu dem Jüngeren." *Zs. Dt. Ver. f. Kwiss.* 45, 1991: 88–130

Grossmann 1950
Fritz Grossmann. "Holbein, Torrigiano and Some Portraits of Dean Colet. A Study of Holbein's Work in Relation to Sculpture." *Journal of the Warburg and Courtauld Institutes,* 13, 1950: 202–236

Grossmann 1951
Fritz Grossmann. "Holbein Studies 1/2." *Burl. Mag.* 93, 1951: 39–44 and 111–114

Grossmann 1963
Fritz Grossmann. "Holbein." *Encyclopedia of World Art.* Vol. 7. New York, Toronto, and London 1963: cols. 586–597

Gruber 1993
Alain Gruber, Margherita Azzi-Visentini, Michèle Bimbenet-Privat, Francisca Costantini-Lachat, Robert Fohr. *L'art décoratif en Europe. Renaissance et Maniérisme.* Paris 1993

Grünewald 1974–1975
Grünewald et son oeuvre, Société pour la conservation des monuments historiques d'Alsace, Société Schongauer, Actes de la Table Ronde organisée par le Centre National de la Recherche Scientifiques à Strasbourg et Colmar du 18 au 21 octobre 1974. *Cahiers Alsaciens d'Archéologie, d'Art et d'Histoire,* vol. 19f., Strassburg, n.d. (1975)

Hackenbroch 1979
Yvonne Hackenbroch. *Renaissance Jewellery.* London and Munich 1979

Haendcke 1899
Berthold Haendcke. *Die Chronologie der Landschaften Albrecht Dürers (Studien zur deutschen Kunstgeschichte, 19).* Strassburg 1899

Hagen 1917
Oskar Hagen. "Bemerkungen zum Aschaffenburger Altar des Matthias Grünewald." *Kunstchronik,* n.s., 28, 32 (11 May 1917), 1916–1917: cols. 341–347

Hagen 1919
Oskar Hagen. *Matthias Grünewald.* Munich 1919

Halm 1920
Philipp M. Halm. "Studien zur Augsburger Bildnerei der Frührenaissance." *Jb. preuss. Kunstslg.* 41, 1920: 214–343

Halm 1930
Peter Halm. "Die Landschaftszeichnungen des Wolfgang Huber." *Münchner Jahrbuch der bildenden Kunst,* n.s., 7, 1930: 1–104

Halm 1953
Peter Halm. "Review of: Franz Winziger, Albrecht Altdorfer. Zeichnungen, München 1952." *Kunstchronik* 6, 1953: 71–76

Halm 1959
Peter Halm. "Review Exh. cat. Hans Baldung Grien, Karlsruhe, 1959." *Kunstchronik* 13, 1960: 123–140

Halm 1962
Peter Halm. "Hans Burgkmair als Zeichner." *Münchner Jahrbuch der bildenden Kunst* 13, 1962: 75–162

Handbuch Berliner Kupferstichkabinett 1994
Das Berliner Kupferstichkabinett: ein Handbuch zur Sammlung, Staatliche Museen zu Berlin, Preussischer Kulturbesitz, Kupferstichkabinett. Ed. Alexander Dückers. Berlin 1994 (Publication for the exhibition: *Vereint im neuen Haus: Meisterwerke aus zehn Jahrhunderten im Berliner Kupferstichkabinett, Kupferstichkabinett Berlin-Tiergarten*)

Handzeichnungen
Handzeichnungen Deutscher Meister des 15. und 16. Jahrhunderts. Ed. Max J. Friedländer and Elfried Bock. Berlin, n.d.

Handz. Schweizer. Meister
Handzeichnungen Schweizerischer Meister des 15.–18. Jahrhunderts. 1 text vol. and 3 plate vols. Ed. Paul Ganz. Basel 1904–1908

Hartlaub 1960
Gustav Friedrich Hartlaub. "Der Todestraum von Hans Baldung Grien." *Antaios* no. 1, vol. 2, 1960: 13–85

Hausmann 1861
Bernhard Hausmann. *Albrecht Dürers Kupferstiche, Radierungen, Holzschnitte und Zeichnungen.* Hanover 1861

Hauttmann 1921
Max Hauttmann. "Dürer und der Augsburger Antikenbesitz." *Jb. preuss. Kunstslg.* 42, 1921: 34–50

Hayward 1976
Jane F. Hayward. *Virtuoso Goldsmiths and the Triumph of Mannerism: 1540 to 1620.* London 1976

HBLS
Historisches Biographisches Lexikon der Schweiz. 7 vols., suppl., Neuenburg 1921–1934

Heidrich 1906
Ernst Heidrich. *Geschichte des Dürerschen Marienbildnisses.* Leipzig 1906

Heinzle 1953
Erwin Heinzle. *Wolf Huber.* Innsbruck n.d. (1953)

Heise 1942
Carl Georg Heise. *Altdeutsche Meisterzeichnungen.* Munich 1942

Heller 1827

 Joseph Heller. *Das Leben und die Werke Albrecht Dürers*, part 2 in 3 vols. Bamberg 1827/Leipzig 1831

Heringa 1981

 J. Heringa. "Philipp von Stosch als Vermittler bei Kunstankäufen François Fagels." *Nederlands Kunsthistorisch Jaarboek* 32, 1981: 55–110

Hermann/Hesse 1993

 Claudia Hermann and Jochen Hesse. "Das ehemalige Hertensteinhaus in Luzern. Die Fassadenmalerei von Hans Holbein d.J." *Kunst und Architektur in der Schweiz* 44, 1993: 173–185

Hermann-Fiore 1971

 Kristina Hermann-Fiore. *Dürers Landschafts-aquarelle.* Kieler Kunsthistorische Studien, 1. Ph.D. diss. Kiel 1972

Hes 1911

 Willy Hes. *Ambrosius Holbein.* Studien zur deutschen Kunstgeschichte 145. Strassburg 1911

Hess 1994

 Daniel Hess. *Meister um das "mittelalterliche Hausbuch": Studien zur Hausbuchmeisterfrage.* Mainz 1994

Hieronymus 1985

 Frank Hieronymus. "Sebastian Münster, Conrad Schnitt und ihre Basel-Karte von 1538," in *Speculum orbis. Zs. f. Alte Kartographie und Vedutenkunde* 1, 1985: 3–38

Hilpert 1958

 Willi Hilpert. "Kalchreuth-Aquarelle." *Erlanger Bausteine zur fränkischen Heimatforschung* 5, 1958: 101–108

Hind

 Arthur M. Hind. *Early Italian Engraving. A Critical Catalogue with Complete Reproduction of All the Prints Described.* 2 text and 5 plate vols. London 1938–1948

Hinz 1993

 Berthold Hinz. *Lucas Cranach d.Ä. (Rowohlt Monographie, 457).* Hamburg 1993

His

 Hans Holbein des Aelteren Feder- und Silberstift-zeichnungen in den Kunst-Sammlungen zu Basel, Bamberg, Dessau . . . , introduction by Eduard His. Nuremberg n.d. (1885)

His 1870

 Eduard His. "Die Basler Archive über Hans Holbein den Jüngeren, seine Familie und einige zu ihm in Beziehung stehende Zeit-genossen." *Z. Jb. f. Kwiss.* 3, 1870: 113–173

His 1886

 Eduard His. *Dessins d'ornements de Hans Holbein.* Paris 1886

HMB. Jahresb.

 Historisches Museum Basel. Jahresberichte und Rechnungen. Basel 1891ff.

Höhn 1928

 Heinrich Höhn. *Albrecht Dürer und seine Fränkische Heimat.* Nuremberg 1928

Hoffmann 1989

 Konrad Hoffmann. "Vom Leben im späten Mittelalter. Aby Warburg and Norbert Elias zum 'Hausbuchmeister.'" *Städel-Jahrbuch,* n.s., 12, 1989: 47–58

Hollstein German

 Friedrich Wilhelm Heinrich Hollstein. *German Engravings, Etchings, and Woodcuts ca. 1400–1700.* Vols. 1–39ff. Amsterdam/Roosendaal/Rotter-dam 1954–1994ff.

Hubach 1996

 Hanns Hubach. *Matthias Grünewald. Der Aschaffenburger Maria-Schnee-Altar. Geschichte-Rekonstruktion-Ikonographie* (Quellen und Abhandlungen zur mittelrheinischen Kirchen-geschichte 77). Mainz 1996

Huth 1923

 Hans Huth. *Künstler und Werkstatt der Spätgotik.* Augsburg 1923

Hütt 1968

 Wolfgang Hütt. *Mathis Gothardt Neithardt, genannt "Grünewald." Leben und Werk im Spiegel der Forschung.* Leipzig 1968

Hütt 1970

 Wolfgang Hütt. *Albrecht Dürer 1471–1528. Das gesamte graphische Werk.* Vol. 1: *Handzeichnun-gen.* Vol. 2: *Druckgraphik.* Ed. Marianne Bern-hard. Munich 1970

Hugelshofer 1923 and 1924

 Walter Hugelshofer. "Das Werk des Zürcher Malers Hans Leu." Vol. 1, in *ASA,* n.s., 25, 1923: 163–179. Vols. 2–3, *ASA,* n.s., 26, 1924: 28–42, 122–150

Hugelshofer 1928

 Walter Hugelshofer. *Schweizer Handzeichnungen des 15. und 16. Jahrhunderts. Die Meisterzeichnung* 1. Freiburg im Breisgau 1928

Hugelshofer 1933

 Walter Hugelshofer. "Zu Hans Baldung." *Pantheon* 11, 1933: 169–177

Hugelshofer 1969

 Walter Hugelshofer. *Schweizer Zeichnungen. Von Niklaus Manuel bis Alberto Giacometti.* Bern 1969

Ihle/Mehnert 1972

 Sigrid Ihle/Karl-Heinz Mehnert. *Museum der bildenden Künste Leipzig. Kataloge der Graphi-schen Sammlung.* Vol. 1: *Altdeutsche Zeichnungen.* Leipzig 1972

The Illustrated Bartsch

 The Illustrated Bartsch. Ed. Walter L. Strauss. New York 1978ff.

Ives 1986

 Eric W. Ives. *Anne Boleyn.* Oxford 1986

Ives 1994

 Eric W. Ives. "The Queen and the Painters. Anne Boleyn, Holbein and Tudor Royal Portraits." *Apollo* 140 (July) 1994: 36–45

Jacobi 1956

 Günther Jacobi. *Kritische Studien zu den Handzeichnungen von Matthias Grünewald. Versuch einer Chronologie.* Ph.D. diss. Cologne 1956

Jb. f. Kwiss.

 Jahrbuch für Kunstwissenschaft. Leipzig 1923–1930: *Monatshefte f. Kwiss.* Leipzig, 1, 1908–15, 1922

Jb. preuss. Kunstslg.

 Jahrbuch der königlich preussischen Kunstsamm-lungen. Berlin, 1, 1880–39; 1918: *Jahrbuch der preussischen Kunstsammlungen,* Berlin. 40, 1919–63; 1943: *Jb. der Berliner Museen.* Berlin, n.s., 1, 1959ff.

Justi 1902

 Ludwig Justi. *Konstruierte Figuren und Köpfe unter den Werken Albrecht Dürers.* Leipzig 1902

Kauffmann 1931

 Hans Kauffmann. "Dürers 'Nemesis,'" in *Tymbos für Wilhelm Ahlmann. Ein Gedenkbuch.* Berlin 1951

KDM BS

 Die Kunstdenkmäler des Kantons Basel-Stadt. Die Kunstdenkmäler der Schweiz 3, 4, 12, 46, 52. 5 vols. Basel 1932–1966

Kehl 1964

 Anton Kehl. *"Grünewald"—Forschungen.* Neustadt an der Aisch 1964

Kelterborn-Haemmerli 1927

 Anna Kelterborn-Haemmerli. *Die Kunst des Hans Fries.* Strassburg 1927

Klebs 1907

 Luise Klebs. "Dürers Landschaften: Ein Ver-such, die uns erhaltenen Naturstudien Dürers chronologisch zu ordnen." *RKW* 30, 1907: 399–420

Klemm 1972

 Christian Klemm. "Der Entwurf zur Fassaden-malerei am Haus 'Zum Tanz' in Basel. Ein Beitrag zu Holbeins Zeichnungsoeuvre." *ZAK* 29, 1972: 165–175

Klemm 1981

 Christian Klemm. "Fassade." *RDK* 7, 1981: cols. 536–742

Klemm 1995

 Christian Klemm. *Hans Holbein d.J. im Kunstmuseum Basel.* Schriften des Vereins der Freunde des Kunstmuseums Basel 3. 2d ed., Basel 1995 (1st ed. 1980)

Knackfuss 1914

 Hermann Knackfuss. *Holbein der Jüngere.* Künstlermonographien 17. 5th ed., Bielefeld and Leipzig 1914

Knappe 1964
 Karl Adolf Knappe. *Dürer. Das graphische Werk.*
 Vienna and Munich 1964
Koch 1941
 Carl Koch. *Die Zeichnungen Hans Baldung
 Griens.* Denkmäler deutscher Kunst. Berlin
 1941
Koch 1974
 Robert A. Koch. *Hans Baldung Grien: Eve,
 the Serpent, and Death/Eve, le serpent et la mort.*
 Ottawa 1974
Koegler 1910
 Hans Koegler. "Die grösseren Metallschnitt-
 illustrationen Hans Holbeins d.J. zu einem
 Hortulus animae." *Monatshefte f. Kwiss.* 3, 1910:
 13−17
Koegler 1923
 Hans Koegler. "Hans Herbst (Herbster)." *TB.*
 16, 1923: 450−453
Koegler 1924
 Hans Koegler. "Ambrosius Holbein." *TB* 17,
 1924: 327−332
Koegler 1924, Ernte
 Hans Koegler. "Der Maler Ambrosius
 Holbein." *Die Ernte* 5, 1924: 45−66
Koegler 1926
 Hans Koegler. *Beschreibendes Verzeichnis der
 Basler Handzeichnungen des Urs Graf.* Basel 1926
Koegler 1930
 Hans Koegler. *Beschreibendes Verzeichnis der
 Basler Handzeichnungen des Niklaus Manuel
 Deutsch.* Basel 1930
Koegler 1943
 *Hans Holbein d.J. Die Bilder zum Gebetbuch
 Hortulus animae, beschrieben von Hans Koegler.*
 Basel 1943
Koegler 1947
 Hans Koegler. *Hundert Tafeln aus dem Gesamt-
 werk des Urs Graf.* Basel 1947
Koepplin 1967
 Dieter Koepplin. "Das Sonnengestirn der
 Donaumeister. Zur Herkunft und Bedeutung
 eines Leitmotivs," in *Werden und Wandlung.
 Studien zur Kunst der Donauschule.* Linz 1967
Koepplin 1972
 "Zu Cranach als Zeichner—Addenda zu
 Rosenbergs Katalog." *Kunstchronik* 25, 1972:
 345−348
Koepplin/Falk 1974/1976
 Dieter Koepplin and Tilman Falk. Exh. cat.
 *Lukas Cranach, Gemälde, Zeichnungen, Druck-
 graphik.* 2 vols. Kunstmuseum Basel. Basel
 1974/1976
Koerner 1993
 Joseph Leo Koerner. *The Moment of Self-
 Portraiture in German Renaissance Art.* Chicago
 1993

Konrad 1992
 Bernd Konrad. "Die Wandgemälde im Festsaal
 des St. Georgen-Klosters zu Stein am Rhein."
 Schaffhauser Beiträge zur Geschichte 69, 1992:
 75−105
Koreny 1985
 Fritz Koreny. *Albrecht Dürer und die Tier- und
 Pflanzenstudien der Renaissance.* Munich 1985
Koreny 1991
 Fritz Koreny. "A Coloured Flower Study by
 Martin Schongauer and the Development of
 the Depiction of Nature from Van der Weyden
 to Dürer." *Burl. Mag.* 133, 1991: 588−597
Koreny 1996
 Fritz Koreny. "Martin Schongauer as a Drafts-
 man: A Reassessment," in *Master Drawings* 34,
 1996: 123−147
Koschatzky 1971
 Walter Koschatzky. *Albrecht Dürer—Die Land-
 schaftsaquarelle.* Vienna 1971
Koschatzky/Strobl 1971
 Walter Koschatzky/Alice Strobl. *Die Dürer-
 zeichnungen der Albertina.* Salzburg 1971
Krause 1997
 Katharina Krause. "Hans Holbein der Ältere:
 Studien nach dem Leben im Altar- und
 Votivbild." *Städel Jahrbuch* 16, 1997: 171−200
Kreytenberg 1970
 Gert Kreytenberg. "Hans Holbein d.J.—Die
 Wandgemälde im Basler Ratsaal." *Zs. Dt. Ver.
 f. Kwiss.* 24, 1970: 77−100
Kronthaler 1992
 Helmut Kronthaler. *Profane Wand- und Decken-
 malerei in Süddeutschland im 16. Jahrhundert und
 ihr Verhältnis zur Kunst Italiens.* Tuduv-Studien.
 Reihe Kunstgeschichte 52. Ph.D. diss. Munich
 1991−1992
Kuhrmann 1964
 Dieter Kuhrmann. *Über das Verhältnis von
 Vorzeichnung und ausgeführtem Werk bei Albrecht
 Dürer.* Ph.D. diss. Freie Universität Berlin.
 Berlin 1964
Kunst der Welt 1980
 Kunst der Welt in den Berliner Museen. Vol. 6.
 Kupferstichkabinett Staatliche Museen zu
 Berlin-Preussischer Kulturbesitz. Stuttgart and
 Zurich 1980
Kurthen 1924
 Josef Kurthen. "Zum Problem der Dürerschen
 Pferdekonstruktion. Ein Beitrag zur Dürer-
 und Behamforschung." *Repertorium für Kunst-
 wissenschaft* 11, 1924: 77−106
Kutschbach 1995
 Doris Kutschbach. *Albrecht Dürer. Die Altäre.*
 Stuttgart and Zurich 1995
Landolt 1960
 Hanspeter Landolt. *Das Skizzenbuch Hans
 Holbein des Älteren im Kupferstichkabinett Basel.*
 Olten, Lausanne, Freiburg im Breisgau 1960

Landolt 1961 MS
 Hanspeter Landolt. *Die Zeichnungen Hans
 Holbeins des Aelteren, Versuch einer Standort-
 bestimmung.* Unpublished diss. Basel 1961
Landolt 1971/1972
 Hanspeter Landolt. "Zur Geschichte von
 Dürers zeichnerischer Form." *Anzeiger des
 Germanischen Nationalmuseums* 1971/1972:
 143−156
Hp. Landolt 1972
 Hanspeter Landolt. *100 Meisterzeichnungen des
 15. und 16. Jahrhunderts aus dem Basler Kupfer-
 stichkabinett.* Publ. Schweizerischer Bankverein.
 Basel 1972
Hp. Landolt 1990
 Hanspeter Landolt. "Zu Hans Holbein d.J.
 als Zeichner. Holbein ein Altdeutscher?" in
 Festschrift to Erik Fischer. Copenhagen 1990:
 263−277
Lauber 1962
 Werner Lauber. *Hans Holbein der Jüngere und
 Luzern.* Luzern im Wandel der Zeiten 22.
 Luzern 1962
Lauts 1936
 Jan Lauts. "Die Neuerwerbungen der Berliner
 Museen, Gemälde und Zeichnungen." *Pantheon*
 18, 1936: 398−402
LCI
 Lexikon der christlichen Ikonographie. Ed. Engel-
 bert Kirschbaum. Vols. 1−4: *Allgemeine Ikono-
 graphie;* vols. 5−8: *Ikonographie der Heiligen.*
 Freiburg im Breisgau 1968−1976, reprint 1990
Lehrs
 Max Lehrs. *Geschichte und kritischer Katalog
 des deutschen, niederländischen und französischen
 Kupferstichs im 15. Jahrhundert.* 9 text and plate
 vols. Vienna 1908−1934
Lehrs 1881
 Max Lehrs. "Zu Dürers Studium nach der
 Antike: Ein Nachtrag zu dem Aufsatz von
 Franz Wickhoff." *Mitteilungen des Instituts
 für österreichische Geschichtsforschung* 2, 1881:
 281−286
Lehrs 1914
 Max Lehrs. "Schongauer-Zeichnungen in
 Dresden." *Mitteilungen aus den sächsischen
 Kunstsammlungen* 5, 1914: 6−17
Lieb 1952
 Norbert Lieb. *Die Fugger und die Kunst im
 Zeitalter der Spätgotik und frühen Renaissance.*
 Munich 1952
Lieb/Stange 1960
 Norbert Lieb and Alfred Stange. *Hans Holbein
 der Aeltere.* n.p., n.d. (Munich and Berlin 1960)
Liebenau 1888
 Theodor von Liebenau. *Hans Holbein d.J.
 Fresken am Hertenstein-Hause in Luzern nebst
 einer Geschichte der Familie Hertenstein.* Luzern
 1888

Lindt

Johann Lindt. *The Paper-Mills of Berne and Their Watermarks. 1465–1859.* Monumenta chartae papyraceae historiam illustrantia 10. Hilversum 1964

Lippmann 1880

Friedrich Lippmann. "Autographen von Dürer im Berliner Kupferstichkabinett." *Jb. preuss. Kunstslg.* 1, 1880: 30–35

Lippmann 1882

Zeichnungen alter Meister im Königlichen Kupferstichcabinet zu Berlin. Ed. Friedrich Lippmann. Berlin 1882

Lippmann 1883

Friedrich Lippmann. *Zeichnungen von Albrecht Dürer in Nachbildungen.* 7 vols. (Vols. 1–4, ed. Friedrich Lippmann. Vol. 5, ed. Joseph Meder. Vols. 6–7, ed. Friedrich Winkler). Berlin 1883–1929

Lorenz 1904

Ludwig Lorenz. *Die Mariendarstellungen Albrecht Dürers (Stud. z. dt. Kunstg., 55).* Strassburg 1904

Lübbeke 1985

Isolde Lübbeke with Bruno Bushart. *Altdeutsche Bilder der Sammlung Georg Schäfer Schweinfurt.* Coll. cat., Schweinfurt 1985

Lüdecke 1953

Heinz Lüdecke, ed. *Lucas Cranach der Ältere. Der Künstler und seine Zeit.* Leipzig 1953

Lüthi 1928

Walter Lüthi. *Urs Graf.* Monographien zur Schweizer Kunst 4. Zurich 1928

Lugt

Frits Lugt. *Les marques de collections de dessins et d'estampes.* Amsterdam 1921, suppl., The Hague 1956

Lutterotti 1956

Otto R. von Lutterotti. "Dürers Reise durch Tirol," in *Festschrift für Raimund von Klebelsberg.* Schlern-Schriften 150, 1956: 153–158

M.

Joseph Meder. *Dürer-Katalog. Ein Handbuch über Albrecht Dürers Stiche, Radierungen, Holzschnitte, deren Zustände, Ausgaben und Wasserzeichen.* Vienna 1932

Major 1908

Emil Major. "Das Fäschische Museum; Die Fäschischen Inventare." *Öff. Kunstslg. Basel. Jahresb.* n.s., 4, 1908, Appendix 1–69

Major 1943

Emil Major. "Eine Glasgemäldefolge von Hans Holbein aus dem Jahre 1520." *HMB. Jahresb.* 1942: 37–51

Major/Gradmann 1941

Emil Major and Erwin Gradmann. *Urs Graf.* Basel 1941

Manteuffel 1920, Maler

Kurt Zoege von Manteuffel. *Hans Holbein. Der Maler.* Munich 1920

Manteuffel 1920, Zeichner

Kurt Zoege von Manteuffel. *Hans Holbein. Der Zeichner für Holzschnitt und Kunstgewerbe.* Munich 1920

Mantz 1879

Paul Mantz. *Hans Holbein.* Paris 1879

Martin 1950

Kurt Martin. *Skizzenbuch des Hans Baldung Grien: "Karlsruher Skizzenbuch."* 2 vols. Basel 1950

E. Maurer 1982

Emil Maurer. "Holbein jenseits der Renaissance. Bemerkungen zur Fassadenmalerei am Haus zum Tanz in Basel." *Emil Maurer. 15 Aufsätze zur Geschichte der Malerei. (Festgabe zum 65. Geburtstag von Emil Maurer.)* Basel, Boston, and Stuttgart 1982: 123–135

F. Maurer 1971

François Maurer. *Zu den Rathausbildern Hans Holbeins d.J.* Basel 1971: 715–776 (KDM BS, appendices of 1932–1971 to vol. 1)

Meder 1919

Joseph Meder. *Die Handzeichnung, ihre Technik und Entwicklung.* Vienna 1919

The Medieval Housebook 1997

The Medieval Housebook. Ed. Christoph Graf Waldburg Wolfegg. Munich and New York 1997

Meiss 1967

Millard Meiss. *French Painting in the Time of Jean de Berry. The Late Fourteenth Century and the Patronage of the Duke.* National Gallery of Art. Kress Foundation Studies in the History of European Art 2. Text and plate vols. London and New York 1967

Mende 1976

Matthias Mende. *Dürers Traumbilder,* in *Kurz und Gut,* Ed. Byk Gulden Pharmazeutika, 10, 1, 1976: 40–44, Konstanz 1976

Mende 1978

Matthias Mende. *Hans Baldung Grien. Das Graphische Werk. Vollständiger Bildkatalog der Einzelholzschnitte, Buchillustrationen und Kupferstiche.* Unterschneidheim 1978

Mende 1983

Matthias Mende. *Dürer-Medaillen. Münzen, Medaillen, Plaketten von Dürer, auf Dürer, nach Dürer.* Ed. Stadtgeschichtliche Museen Nürnberg and Albrecht-Dürerhaus-Stiftung e.V., Nuremberg 1983

Mesenzeva 1981

Charmian A. Mesenzeva. "'Der behexte Stallknecht' des Hans Baldung Grien." *Zs. f. Kg.* 44, 1981: 57–61

Michael 1986

Erika B. Michael. *The Drawings by Hans Holbein the Younger for Erasmus' "Praise of Folly."* Ph.D. diss. Washington, New York, and London 1986

Mielke 1988

Hans Mielke, ed. Exh. cat. *Albrecht Altdorfer. Zeichnungen, Deckfarbenmalerei, Druckgraphik.* Kupferstichkabinett, Staatliche Museen zu Berlin-Preussischer Kulturbesitz. Berlin 1988

Mitius 1924

Otto Mitius. *Mit Albrecht Dürer nach Heroldsberg und Kalchreuth.* Erlangen 1924

Möhle 1941/1942

Hans Möhle. "Carl Koch, Die Handzeichnungen Hans Baldung Griens" (review). *Zs. f. Kg.* 10, 1941/1942: 214–221

Möhle 1959

Hans Möhle. "Zur Karlsruher Baldung-Ausstellung 1959." *Zs. f. Kg.* 22, 1959: 124–132

Mojzer 1966

M. Mojzer. "Die Fahnen des Meisters MS." *Acta Historiae Artium.* 12, 1966, 93–112, note 37, fig. 10

Muchall 1931

Thomas Muchall-Viebrook. "Ein Beitrag zu den Zeichnungen Hans Holbeins des Jüngeren." *Münchner Jb. der bildenden Kunst,* n.s., 8, 1931: 156–171

Müller 1989

Christian Müller. "Hans Holbein d.J. Überlegungen zu seinen frühen Zeichnungen." *ZAK* 46, 1989: 113–128

Müller 1990

Christian Müller. "Holbein oder Holbein-Werkstatt? Zu einem Pokalentwurf der Gottfried Keller-Stiftung im Kupferstichkabinett Basel." *ZAK* 47, 1990: 33–42

Müller 1991

Christian Müller. "New Evidence for Hans Holbein the Younger's Wall Paintings in Basel Town Hall." *Burl. Mag.* 133, 1991: 21–26

Müller 1991, Review

Christian Müller. "Rezension Wüthrich 1990." *Kunstchronik* 44, 1991: 39–44

Müller 1996

Christian Müller. *Die Zeichnungen von Hans Holbein dem Jüngeren und Ambrosius Holbein; Katalog der Zeichnungen des 15. und 16. Jahrhunderts.* Part 2A; Kupferstichkabinett der Öffentlichen Kunstsammlung Basel. Basel 1996

Müller 1997

Christian Müller. *Hans Holbein d.J., Die Druckgraphik im Kupferstichkabinett Basel.* Basel 1997

Müller 1998

Christian Müller. "Die Gegenwart des Bildes. Zur illusionistischen Wirkung früher Werke von Hans Holbein d.J," in *Zeitenspiegelung, Zur Bedeutung von Traditionen in Kunst und Kunstwissenschaft. Festschrift für Konrad Hoffmann zum 60. Geburtstag.* Berlin 1998: 83–93

Murr 1797
Christoph Gottlieb von Murr. *Description du cabinet de Monsieur Paul de Praun à Nuremberg.* Nuremberg 1797

Musper 1952
H. Theodor Musper. *Albrecht Dürer. Der gegenwärtige Stand der Forschung.* Stuttgart 1952

Neudörfer 1547
Johann Neudörfer. *Des Johann Neudörfer Schreib- und Rechenmeisters zu Nürnberg Nachrichten daselbst aus dem Jahre 1547 nebst der Forts. des Andreas Gulden nach den Handschriften und mit Anmerkungen.* Ed. G. W. Lochner. Vienna 1875

Oberhuber 1967
Konrad Oberhuber. *Zwischen Renaissance und Barock.* Ed. Konrad Oberhuber. Vienna 1967

Öff. Kunstslg. Basel. Jahresb.
Öffentliche Kunstsammlung Basel. Jahresberichte. n.s., 1, Basel 1905ff.

Oehler 1954/1959
Lisa Oehler. "Die Grüne Passion, ein Werk Dürers?" *Anzeiger des Germanischen Nationalmuseums.* 1954–1959: 91–127

Oehler 1959
Lisa Oehler. "Das 'geschleuderte' Dürer-Monogramm." *Marburger Jahrbuch für Kunstwissenschaft* 17, 1959: 57–191

Oehler 1972
Lisa Oehler. "Das Dürermonogramm auf Werken der Dürerschule." *Albrecht Dürer. Kunst im Aufbruch. Vorträge der kunstwissenschaftlichen Tagung mit internationaler Beteiligung zum 500. Geburtstag von Albrecht Dürer.* Edited under the direction of Ernst Ullmann. Leipzig 1972: 105–114

Oettinger 1934
Karl Oettinger. "Four Holbein Drawings at Vienna." *Burl. Mag.* 65, 1934: 258–264

Oettinger 1957
Karl Oettinger. *Datum und Signatur bei Wolf Huber und Albrecht Altdorfer (Erlanger Forschungen, 8).* Erlangen 1957

Oettinger 1959
Karl Oettinger. *Altdorfer-Studien (Erlanger Beiträge zur Sprach- und Kunstwissenschaft).* Nuremberg 1959

Oettinger/Knappe 1963
Karl Oettinger and Karl-Adolf Knappe. *Hans Baldung Grien und Albrecht Dürer in Nürnberg.* Nuremberg 1963

von der Osten 1973
Gert von der Osten. *Deutsche und niederländische Kunst der Reformationszeit.* Cologne 1973

von der Osten 1983
Gert von der Osten. *Hans Baldung Grien. Gemälde und Dokumente.* Berlin 1983

Ottino della Chiesa 1968
Angela Ottino della Chiesa. *L'opera completa di Dürer.* Milan 1968

Otto 1964
Gertrud Otto. *Bernhard Strigel.* Munich and Berlin 1964

Panofsky 1915
Erwin Panofsky. *Dürers Kunsttheorie vornehmlich in ihrem Verhältnis zur Kunsttheorie der Italiener.* Berlin 1915

Panofsky 1920
Erwin Panofsky. "Dürers Darstellungen des Apollo und ihr Verhältnis zu Barbari." *Jb. preuss. Kunstslg.* 41, 1920: 359–377

Panofsky 1921/1922
Erwin Panofsky. "Dürers Stellung zur Antike." *Jahrbuch für Kunstgeschichte* 1, 1921/1922: 43–92

Panofsky 1930
Erwin Panofsky. *Hercules am Scheidewege und andere antike Bildstoffe in der neueren Kunst (Studien der Bibliothek Warburg, 19).* Leipzig and Berlin 1930

Panofsky 1931
Erwin Panofsky. "Zwei Dürerprobleme." *Münchner Jahrbuch der bildenden Kunst,* n.s., 8, 1931: 1–48

Panofsky 1940
Erwin Panofsky. *The Codex Huygens and Leonardo da Vinci's Art Theory. The Pierpont Morgan Library, Codex M.A. 1139 (Studies of the Warburg Institute, 13).* London 1940

Panofsky 1943
Erwin Panofsky. *Albrecht Dürer.* 1st ed. Princeton, New Jersey 1943 (2d ed. 1945; 3d ed. 1948)

Panofsky 1945
See *Panofsky 1943*

Panofsky 1948
See *Panofsky 1943*

Panofsky 1977
Erwin Panofsky. *Das Leben und die Kunst Albrechts Dürers.* Munich 1977 (in German, translated by Lise Lotte Müller)

Parker 1923
Karl Theodor Parker. "Handzeichnungen altschweizerischer Meister in ausländischem Besitz. I: Niklaus Manuel, II: Hans Leu d.J." *Das Werk.* 10, 1923: 22, 82

Parker 1925
Karl Theodor Parker. "Eine neugefundene Apollo-Zeichnung Albrecht Dürers." *Jb. preuss. Kunstslg.* 46, 1925: 248–254

Parker 1926
Karl Theodor Parker. *Drawings of the Early German Schools.* London 1926

Parker 1926a
Karl Theodor Parker. "Hans Baldung Grien." *Old Master Drawings* 1, 1926: 42f.

Parker 1928
Karl Theodor Parker. *Elsässische Handzeichnungen des XV. und XVI. Jahrhunderts. Die Meisterzeichnung 2.* Freiburg im Breisgau 1928

Parker 1932
Karl Theodor Parker. "Bernhard Strigel." *Old Master Drawings* 7, 1932: 27f.

Parker 1933/1934
Karl Theodor Parker. "Hans Baldung Grien (1484/1485–1545)." *Old Master Drawings* 8, 1933/1934: 14–15

Parker 1945
The Drawings of Hans Holbein in the Collection of His Majesty the King at Windsor Castle. Coll. cat. Ed. Karl Theodor Parker, Oxford and London 1945 (Review by Winslow Ames, *The Art Bulletin* 28, 1946: 56–57)

Parker/Hugelshofer 1925
Karl Theodor Parker/Walter Hugelshofer. "Bernhardin Strigel als Zeichner." *Belvedere* 8, 1925: 29–44

Parthey 1853
Gustav Parthey. *Wenzel Hollar. Beschreibendes Verzeichnis seiner Kupferstiche.* Berlin 1853

Passavant
Johann David Passavant. *Le Peintre-Graveur.* 6 vols. Leipzig 1860–1864

Patin 1676
Charles Patin. "Vita Joannis Holbenii, Pictoris Basiliensis," in *Encomium Moriae. Stultitiae Laus. Des. Erasmi Rot: Declamatio, Figuris Holbenianis adornata.* Basel 1676

Pauli 1927
Gustav Pauli. "Dürers Monogramm," in *Festschrift für Max J. Friedländer zum 60. Geburtstag.* Leipzig 1927: 34–40

Perseke 1941
Helmut Perseke. *Hans Baldungs Schaffen in Freiburg. Forschungen zur Geschichte der Kunst am Oberrhein, 3/4.* Freiburg im Breisgau 1941

Petersmann 1983
Frank Petersmann. *Kirchen- und Sozialkritik in den Bildern des Todes von Hans Holbein d.J.* Ph.D. diss. Osnabrück, Bielefeld 1983

Pevsner/Meier 1958
Nikolaus Pevsner/Michael Meier. *Grünewald.* New York 1958

Pfaff 1971
Annette Pfaff. *Studien zu Albrecht Dürers Heller-Altar. (Nürnberger Werkstücke zur Stadt- und Landesgeschichte, 7).* Nuremberg 1971

Pfister-Burkhalter 1958
Margarete Pfister-Burkhalter. *Urs Graf, Federzeichnungen.* Wiesbaden 1958

Pfister-Burkhalter 1961
Margarete Pfister-Burkhalter. "Zu Holbeins früher Christusdarstellung." *Die Schweizerin* 48, April 1961, book 5: 176–184

Photographie Braun
 Handzeichnungen älterer Meister der Öffentlichen Kunst-Sammlung Basel. Photographed and publ. by Braun & Cie, edition with reproductions of photographs. Dornach i. Els., Paris, and New York n.d.

Piccard 1961
 Gerhard Piccard. *Die Kronen-Wasserzeichen.* Stuttgart 1961 (Publications of Staatliche Archivverwaltung Baden-Württemberg, Sonderreihe: Die Wasserzeichenkartei Piccard im Hauptstaatsarchiv Stuttgart, Findbuch 1)

Piccard 1966
 Gerhard Piccard. *Die Ochsenkopf-Wasserzeichen.* 3 vols. Stuttgart 1966 (Publications of Staatliche Archivverwaltung Baden-Württemberg, Sonderreihe: Die Wasserzeichenkartei Piccard im Hauptstaatsarchiv Stuttgart, Findbuch 2)

Piccard 1970
 Gerhard Piccard. *Die Turm-Wasserzeichen.* Stuttgart 1970 (Publications of Staatliche Archivverwaltung Baden-Württemberg, Sonderreihe: Die Wasserzeichenkartei Piccard im Hauptstaatsarchiv Stuttgart, Findbuch 3)

Piccard 1977
 Gerhard Piccard. *Wasserzeichen Buchstabe P.* 3 vols. Stuttgart 1977 (Publications of Staatliche Archivverwaltung Baden-Württemberg, Sonderreihe: Die Wasserzeichenkartei Piccard im Hauptstaatsarchiv Stuttgart, Findbuch 4)

Piel 1983
 Friedrich Piel. *Albrecht Dürer. Zeichnungen und Aquarelle.* Cologne 1983

Posonyi 1867
 Catalog der überaus kostbaren von Alexander Posonyi in Wien zusammengestellten Albrecht-Dürer-Sammlung. Auction cat. Munich 11 November 1867

Post 1939
 Paul Post. "Zum Silbernen Harnisch Maximilians I. von Koloman Colman mit Ätzentwürfen Albrecht Dürers." *Zs. für historische Waffen- und Kostümkunde,* n.s., 6, 1939: 253ff.

RDK
 Reallexikon zur Deutschen Kunstgeschichte. Begun by Otto Schmitt. Publ. by the Zentralinstitut für Kunstgeschichte München. Vol. 1ff. Stuttgart and Munich 1937ff.

Reindl 1977
 Peter Reindl and Loy Hering. *Zur Rezeption der Renaissance in Süddeutschland.* Basel 1977

Reinhardt 1938
 Hans Reinhardt. *Holbein.* Paris 1938

Reinhardt 1948/1949
 Hans Reinhardt. "Review of Ganz 1943." *ZAK* 10, 1948/1949: 116–118

Reinhardt 1954/1955
 Hans Reinhardt. "Bemerkungen zum Spätwerk Hans Holbeins d.Ä.; Die Madonna des Bürgermeisters Meyer von Hans Holbein d.J. Nachforschungen zur Entstehungsgeschichte und Aufstellung des Gemäldes." *ZAK* 15, 1954/1955: 11–19 and 244–254

Reinhardt 1965
 Hans Reinhardt. "Beiträge zum Werke Hans Holbeins aus dem Historischen Museum Basel." *HMB. Jahresb.* 1965: 27–39 (Appendix)

Reinhardt 1975/1976
 Hans Reinhardt. "Hans Holbein le Jeune et Grünewald." *Cahiers Alsaciens d'Archéologie, d'Art et d'Histoire* 19, 1975/1976: 167–172

Reinhardt 1977
 Hans Reinhardt. "Einige Bemerkungen zum graphischen Werk Hans Holbeins des Jüngeren." *ZAK* 34, 1977: 229–260

Reinhardt 1978
 Hans Reinhardt. "Baldung, Dürer und Holbein." *ZAK* 35, 1978: 206–216

Reinhardt 1979
 Hans Reinhardt. "Die holbeinische Madonna des Basler Stadtschreibers Johann Gerster von 1520 im Museum zu Solothurn." *Basler Zs. Gesch. Ak.* 79, 1979: 67–80

Reinhardt 1981
 Hans Reinhardt. "Erasmus und Holbein." *Basler Zs. Gesch. Ak.* 81, 1981: 41–70

Reinhardt 1982
 Hans Reinhardt. "Nachrichten über das Leben Hans Holbeins des Jüngeren." *ZAK* 39, 1982: 253–276

Reinhardt 1983
 Hans Reinhardt. "Hans Herbster. Un peintre bâlois, originaire de Strasbourg." *Cahiers Alsaciens d'Archéologie, d'Art et d'Histoire* 26, 1983: 135–150

Reinle 1954
 Adolph Reinle. "Das ehemalige Hertenstein-Haus." *Die Kunstdenkmäler des Kantons Luzern* 3, part 2. Die Kunstdenkmäler der Schweiz, 31. Basel 1954: 119–130

Repertorium für Kunstwissenschaft
 Repertorium für Kunstwissenschaft. Berlin, 1, 1876-32, 1912; n.s., 1, 1913–17, 1952

Rettich 1965
 Edeltraud Rettich. *Bernhard Strigel. Herkunft und Entfaltung seines Stils.* Ph.D. diss. Freiburg im Breisgau 1965

Rettich 1967
 Edeltraud Rettich. "Bernhard Strigels Handzeichnungen." *Kunstgeschichtliche Studien für Kurt Bauch zum 70. Geburtstag von seinen Schülern.* Munich and Berlin 1967: 101–114

Riedler 1978
 Michael Riedler. *Blütezeit der Wandmalerei in Luzern. Fresken des 16. Jahrhunderts in Luzerner Patrizierhäusern.* Lucerne 1978

Rieffel 1902
 Franz Rieffel. "Ein Gemälde des Matthias Grünewald." *Zeitschrift für bildende Kunst,* n.s., 13, 1902: 205–211

Riggenbach 1907
 Rudolf Riggenbach. *Der Maler und Zeichner Wolf Huber (ca. 1490–nach 1542).* Ph.D. diss. Basel 1907

Roberts 1979
 Jane Roberts. *Holbein.* London 1979

Rose 1977
 Patricia Rose. *Wolf Huber Studies.* New York and London 1977

Rosenberg 1923
 Jakob Rosenberg. *Martin Schongauer. Handzeichnungen.* Munich 1923

Rosenberg 1960
 Jakob Rosenberg. *Die Zeichnungen Lucas Cranach d.Ä.* Berlin 1960

Rosenberg 1965
 Jakob Rosenberg. "Review Franz Winzinger, Die Zeichnungen Martin Schongauers." *Master Drawings* 3, 1965: 397–403

Rosenthal 1928
 Erwin Rosenthal. "Dürers Buchmalereien für Pirckheimers Bibliothek." *Jb. preuss. Kunstslg.* 49, 1928, suppl.: 1–54

Roth 1988
 Michael Roth. *Die Zeichnungen des "Meisters der Coburger Rundblätter."* Ph.D. diss. Freie Universität, Berlin 1988 (microfiche 1992)

Rowlands 1979
 John Rowlands. "Hans Baldung Grien: das Graphische Werk-Vollständiger Bildkatalog der Einzelholzschnitte, Buchillustrationen und Kupferstiche by Matthias Mende." *Burl. Mag.* 121, 2, 1979: 590–593

Rowlands 1985
 John Rowlands. *Holbein. The Paintings of Hans Holbein the Younger.* Complete ed. Oxford 1985

Rowlands 1993
 John Rowlands, with the assistance of Giulia Bartrum. *Drawings by German Artists and Artists from German-Speaking Regions of Europe in the Department of Prints and Drawings in the British Museum: The Fifteenth Century, and the Sixteenth Century by Artists Born before 1530.* Coll. cat. text and plate vols. London 1993

Rüstow 1960
 Alexander Rüstow. "Lutherana Tragoedia artis." *Schweizer Monatshefte* 39, 1960: 891–906

Ruhmer 1970
 Eberhard Ruhmer. *Grünewald. Zeichnungen.* Cologne 1970

von Rumohr 1837
 Carl Friedrich von Rumohr. *Zur Geschichte und Theorie der Formschneidekunst.* Leipzig 1837

Rupé 1912
 Hans Rupé. *Beiträge zum Werke Hans Burgkmairs des Älteren.* Ph.D. diss. Freiburg im Breisgau, Borna/Leipzig 1912

Rupprich 1, 2, 3
 Hans Rupprich. *Dürers schriftlicher Nachlass.* 3 vols. Berlin 1956–1969

Sandrart 1675
 Joachim von Sandrarts Academie der Bau-, Bild- und Mahlerey-Künste von 1675. Publ. with commentary by Rudolf Arthur Peltzer. Munich 1925

Saxl 1943
 Fritz Saxl. "Holbein's Illustrations to the Praise of Folly by Erasmus," in *Burl. Mag.* 83, 1943: 275–279

Schade 1972
 Werner Schade. *Lucas Cranach der Ältere. Zeichnungen.* Leipzig 1972

Schade 1974
 Werner Schade. *Die Malerfamilie Cranach.* Dresden 1974

Schade 1995
 Werner Schade. "Die Rolle der Zeichnung im Werk Grünewalds." *Literatur, Musik und Kunst im Übergang vom Mittelalter zur Neuzeit.* Bericht über Kolloquien der Kommission zur Erforschung der Kultur des Spätmittelalters, 1989–1992. Göttingen 1995: 321–329

Scheja 1960
 Georg Scheja. "Über einige Zeichnungen Grünewalds und Dürers," in *Das Werk des Künstlers, Festschrift für Hubert Schrade.* Stuttgart 1960: 199–211

Schilling 1928
 Edmund Schilling. *Albrecht Dürer, Niederländisches Reiseskizzenbuch 1520–1521.* Frankfurt am Main 1928

Schilling 1929
 E. Schilling. *Nürnberger Handzeichnungen des XV. und XVI. Jahrhunderts.* Die Meisterzeichnung, 3. Freiburg im Breisgau 1929

Schilling 1934
 Edmund Schilling. *Altdeutsche Meisterzeichnungen. Einführung und Auswahl.* Frankfurt am Main 1934

Schilling 1937
 Edmund Schilling. *Zeichnungen der Künstlerfamilie Holbein.* Frankfurt am Main 1937 (new rev. ed., Basel 1954)

Schilling 1948
 Edmund Schilling. *Albrecht Dürer-Zeichnungen und Aquarelle.* Basel 1948

Schilling 1954
 See *Schilling 1937*

Schilling 1955
 Edmund Schilling. "Zeichnungen des Hans Leonhard Schäufelein." *Zs. f. Kwiss.* 1955: 151–180

Schmid 1896
 Heinrich A. Schmid. "Die Gemälde von Hans Holbein d.J. im Baseler Grossratsaale." *Jb. preuss. Kunstslg.* 17, 1896: 73–96

Schmid 1898
 Heinrich A. Schmid. "Die Zeichnungen des Hans Baldung gen. Grien von Gabriel v. Térey." *Rep. f. Kwiss.* 21, 1898: 304–313

Schmid 1900
 Heinrich A. Schmid. "Holbeins Darmstädter Madonna." *Die graphischen Künste* 23, 1900: 49–68

Schmid 1907/1911
 Heinrich A. Schmid. *Die Gemälde und Zeichnungen von Matthias Grünewald.* Vol. 2, text. Strassburg 1907–1911. Vol. 1, plates

Schmid 1909
 Heinrich A. Schmid. "Review Ganz 1908." *Rep. f. Kwiss.* 32, 1909: 373–376

Schmid 1913
 Heinrich A. Schmid. "Die Malereien H. Holbeins d.J. am Hertensteinhause in Luzern." *Jb. preuss. Kunstslg.* 34, 1913: 173–206

Schmid 1924
 Heinrich A. Schmid. "Hans Holbein d.J." *TB* 17, 1924: 335–356

Schmid 1930
 Heinrich A. Schmid. *Die Werke Holbeins in Basel.* Öffentliche Kunstsammlung Basel, Kleiner Führer 2. Basel 1930

Schmid 1931
 Erasmi Roterodami encomium moriae, i.e. Stultitiae laus — Lob der Torheit, Basler Ausgabe von 1515. 2 vols. Basel 1931 (facsimile ed. with introduction by Heinrich A. Schmid)

Schmid 1941/1942
 Heinrich A. Schmid. "Holbeinstudien I. Hans Holbein d.Ä.; Hans Holbein d.J. Die ersten Jahre in Basel, Luzern, und wieder in Basel von 1515 bis 1521." *Zs. f. Kg.* 10, 1941/1942: 1–39 and 249–290

Schmid 1945
 Heinrich A. Schmid. *Hans Holbein der Jüngere. Sein Aufstieg zur Meisterschaft und sein englischer Stil.* Plate vol. Basel 1945

Schmid 1948
 Heinrich A. Schmid. *Hans Holbein der Jüngere. Sein Aufstieg zur Meisterschaft und sein englischer Stil.* 2 text vols. Basel 1948 (review by Julius Baum. *Zs. f. bildende Kunst* 13, 1950: 128)

Schmidt 1959
 Georg Schmidt. *15 Handzeichnungen deutscher und schweizerischer Meister des 15. und 16. Jahrhunderts.* Basel 1959

Schmidt/Cetto
 Georg Schmidt and Anna Maria Cetto. *Schweizer Malerei und Zeichnung im 15. und 16. Jahrhundert.* Basel n.d. (1940)

Schmitz 1922
 Hermann Schmitz. *Hans Baldung gen. Grien.* Bielefeld and Leipzig 1922

Schneeli 1896
 Gustav Schneeli. *Renaissance in der Schweiz. Studien über das Eindringen der Renaissance in die Kunst diesseits der Alpen.* Munich 1896

Schneider 1977
 Hugo Schneider. *Der Schweizerdolch. Waffen- und Kulturgeschichtliche Entstehung.* Zurich 1977

Schoenberger 1948
 Guido Schoenberger. *The Drawings of Mathis Gothart Nithart called Grünewald.* New York 1948

Schönbrunner/Meder
 Handzeichnungen alter Meister aus der Albertina und anderen Sammlungen. Vols. 1–12: Ed. Joseph Schönbrunner and Joseph Meder. Vienna 1896–1908; n.s., vols. 1 and 2: Ed. Joseph Meder and Alfred Stix. Vienna 1922–1925

Schongauer-Kolloquium 1991
 Le beau Martin. Études et mises au point. Actes du colloque organisé par le musée d'Unterlinden à Colmar les 30 septembre, 1 et 2 octobre 1991. Strassburg 1994

Schramm
 Albert Schramm. *Der Bilderschmuck der Frühdrucke.* 22 vols. Leipzig 1920–1940

Schuchardt 1851
 Christian Schuchardt. *Lucas Cranach des Aeltern Leben und Werke. Nach urkundlichen Quellen bearbeitet.* 2 vols. Leipzig 1851

Schürer 1937
 Oskar Schürer. "Wohin ging Dürers 'ledige Wanderfahrt?'" *Zs. f. Kg.* 6, 1975: 171–199

Secker 1955
 Hans F. Secker. "Ein Beispiel für den Stilwandel bei Dürer." *Bildende Kunst* 3, 1955: 217–220

Seidlitz 1907
 Woldemar von Seidlitz. "Dürers frühe Zeichnungen." *Jb. preuss. Kunstslg.* 28, 1907: 3–20

Springer 1892
 Anton Springer. *Albrecht Dürer.* Berlin 1892

Stadler 1913
 Franz Stadler. *Michael Wolgemut und der Nürnberger Holzschnitt im letzten Drittel des 15. Jh.* Studien zur deutschen Kunstgeschichte, 161. Strassburg 1913

Stadler 1929
 Franz Stadler. *Dürers Apokalypse und ihr Umkreis.* Munich 1929

Stadler 1936
 Franz Stadler. *Hans von Kulmbach.* Vienna 1936

Stange 1934–1961
 Alfred Stange. *Deutsche Malerei der Gotik.*
 11 vols. Berlin and Munich 1934–1961
Stange 1964
 Alfred Stange. *Malerei der Donauschule.*
 Munich 1964
Stein 1929
 Wilhelm Stein. *Holbein.* Berlin 1929
Steinmann 1968
 Ulrich Steinmann. "Der Bilderschmuck der
 Stiftskirche zu Halle. Cranachs Passionszyklus
 und Grünewalds Erasmus-Mauritius-Tafel."
 *Staatliche Museen zu Berlin/Ost, Forschungen und
 Berichte.* Vol. 11: *Kunsthistorische Beiträge,* 1968:
 69–104
Stengel 1952
 Walter Stengel. "Der neue Grünewald-Fund."
 Zs. f. Kwiss. 6, 1952: 65–78
Stiassny 1893
 Robert Stiassny. "Baldung-Studien. I: Zeich-
 nungen." *Kunstchronik,* n.s., V, 1893: col. 139
Stiassny 1897/1898
 Robert Stiassny. "Baldung Griens Zeich-
 nungen." *Zs. f. bildende Kunst* 9, 1897/1898:
 49–61
Storck 1922
 W. F. Storck, Ed. *Handzeichnungen Grünewalds.*
 1. Druck der Gesellschaft für zeichnende Künste.
 Munich 1922
Strauss
 See *Strauss 1974*
Strauss 1972
 Walter L. Strauss. *Albrecht Dürer. The Human
 Figure. The Complete "Dresden Sketchbook."*
 New York 1972
Strauss 1974
 Walter L. Strauss. *The Complete Drawings of
 Albrecht Dürer.* 6 vols. New York 1974
Strauss 1980
 Walter L. Strauss. *Albrecht Dürer. Woodcuts and
 Woodblocks.* New York 1980
Strieder 1976
 Peter Strieder. *Dürer. Libri Illustrati.* Milan 1976
Strieder 1976a
 Peter Strieder. *Dürer.* Milan 1976
Strieder 1981
 Peter Strieder, with assistance from Gisela
 Goldberg/Joseph Harnest and Matthias Mende.
 Dürer. Königstein im Taunus 1981
Strieder 1993
 Peter Strieder. *Tafelmalerei in Nürnberg 1350–
 1550.* Königstein im Taunus 1993
Tacke 1992
 Andreas Tacke. *Der katholische Cranach. Zu zwei
 Grossaufträgen von Lucas Cranach d.Ä., Simon
 Franck und der Cranach-Werkstatt (1520–1540)*
 Berliner Schriften zur Kunst, 2. Mainz 1992

Tacke 1994
 Andreas Tacke, ed. *Cranach. Meisterwerke auf
 Vorrat. Die Erlanger Handzeichnungen der Univer-
 sitätsbibliothek, Bestands- und Ausstellungskatalog
 Universitätsbibliothek Erlangen-Nürnberg.*
 Schriften der Universitätsbibliothek Erlangen-
 Nürnberg, 25. Munich 1994
Talbot 1976
 Charles Talbot. "Recent Literature on
 Drawings by Dürer." *Master Drawings* 14, 1976:
 287–299
TB
 *Allgemeines Lexikon der bildenden Künstler von der
 Antike bis zur Gegenwart.* 37 vols. Eds. Ulrich
 Thieme and Felix Becker. Leipzig 1907–1950
von Térey
 Gabriel von Térey. *Die Handzeichnungen des
 Hans Baldung gen. Grien.* 3 vols. Strassburg
 1894–1896
Thausing 1876, 1884
 Moritz Thausing. *Dürer. Geschichte seines Lebens
 und seiner Kunst.* Vol. 1. Leipzig 1876 (2d ed.,
 2 vols. Leipzig 1884)
Thiel 1980
 Erika Thiel. *Geschichte des Kostüms. Die europä-
 ische Mode von den Anfängen bis zur Gegenwart.*
 Berlin 1980
Thieme 1892
 Ulrich Thieme. *Hans Leonhard Schäufeleins
 malerische Tätigkeit.* Leipzig 1892
Thode 1882
 Henry Thode. "Dürers 'antikische Art.'"
 Jb. preuss. Kunstslg. 3, 1882: 106–119
Thöne 1965
 F. Thöne. *Lucas Cranach der Ältere.* Königstein
 im Taunus 1965
Tietze 1923
 Hans Tietze. *Albrecht Altdorfer.* Leipzig 1923
Tietze 1951
 Hans Tietze. *Dürer als Zeichner und Aquarellist.*
 Vienna 1951
Tietze/Tietze-Conrat 1928
 Hans Tietze and Erika Tietze-Conrat. *Kritisches
 Verzeichnis der Werke Albrecht Dürers.* Vol. 1: *Der
 junge Dürer.* Augsburg 1928. Vol. 2/1: *Der reife
 Dürer.* Augsburg 1928, Basel and Leipzig 1937.
 Vol. 2/2: *Der reife Dürer.* Basel and Leipzig 1938
Tonjola 1661
 Johannes Tonjola. *Basilea sepulta retecta continu-
 ata.* Basel n.d. (1661)
Troescher 1940
 Georg Troescher. *Die burgundische Plastik des
 ausgehenden Mittelalters und ihre Wirkung auf die
 europäische Kunst.* Text and plate vols. Frankfurt
 am Main 1940
Trux 1993
 Elisabeth Trux. *Untersuchungen zu den Tier-
 studien Albrecht Dürers.* Ph.D. diss. Würzburg
 1993

Tschudin
 Walter Friedrich Tschudin. *The Ancient Paper-
 mills of Basle and Their Marks.* Monumenta
 chartae papyraceae historiam illustrantia 7.
 Hilversum 1958
Ueberwasser 1947
 Walter Ueberwasser. *Hans Holbein. Zeich-
 nungen.* Basel 1947
Ueberwasser 1960
 Walter Ueberwasser. *Gemälde und Zeichnungen
 von Ambrosius Holbein und Hans Holbein d.J.*
 Basel 1960
Vaisse 1974
 Pierre Vaisse. "A propos de la crucifixion vue
 de brais." *La gloire de Dürer.* Actes et colloques,
 13, 1974: 117–128
Vaisse 1977
 Pierre Vaisse. "Review of Franz Winzinger,
 'Albrecht Altdorfer. Die Gemälde,' Munich/
 Zurich 1975." *Zs. f. Kg.* 1977: 310–314
Vente
 Frits Lugt et al., eds. *Répertoire des catalogues
 de ventes publiques, intéressant l'art ou la curiosité.*
 Periods 1–3. The Hague 1938–1964
Veth/Muller 1918
 J. Veth/S. Muller. *Albrecht Dürers Niederländische
 Reise.* 2 vols. Berlin-Utrecht 1918
Voss 1907
 Hermann Voss. *Der Ursprung des Donaustils. Ein
 Stück Entwicklungsgeschichte Deutscher Malerei.*
 Leipzig 1907
W.
 Friedrich Winkler. *Die Zeichnungen Albrecht
 Dürers.* 4 vols. Berlin 1936–1939
Waetzoldt 1938
 Wilhelm Waetzoldt. *Hans Holbein der Jüngere.
 Werk und Welt.* Berlin 1938
Waetzoldt 1950
 Wilhelm Waetzoldt. *Dürer und seine Zeit.*
 Munich 1950
Waetzoldt 1958
 Wilhelm Waetzoldt. *Hans Holbein der Jüngere.
 Die blauen Bücher.* Königstein im Taunus 1958
Wallach 1928
 Helmut Wallach. *Die Stilentwicklung Hans
 Leonhard Schäufeleins.* Ph.D. diss. Munich 1927,
 Munich 1928
Walzer 1979
 Pierre Olivier Walzer. *Vie des Saints du Jura.*
 Réclère 1979
Weih-Krüger 1986
 Sonja Weih-Krüger. *Hans Schäufelein. Ein
 Beitrag zur künstlerischen Entwicklung des jungen
 Hans Schäufelein bis zu seiner Niederlassung in
 Nördlingen 1515 unter besonderer Berücksichtigung
 des malerischen Werkes.* Nuremberg 1986

Weinberger 1921
Martin Weinberger. *Nürnberger Malerei an der Wende zur Renaissance und die Anfänge der Dürer-Schule.* Studien zur deutschen Kunstgeschichte, 217. Strassburg 1921

Weinberger 1930
Martin Weinberger. *Wolf Huber.* Munich 1930

Weis-Liebersdorf 1901
J. E. Weis-Liebersdorf. *Das Jubeljahr 1500 in der Augsburger Kunst. Eine Jubiläumsgabe für das deutsche Volk.* Munich 1901

Weisbach 1906
Werner Weisbach. *Der junge Dürer.* Leipzig 1906

Weismann 1928
K. Weismann. "Neue Forschungen zu Dürers Federzeichnung L. 440." *Fränkischer Kurier* 100, 1928: 11

Weixlgärtner 1906
Arpad Weixlgärtner. "Review of Rob. Bruck: Das Dresdner Skizzenbuch von Albrecht Dürer." *Kunstgeschichtliche Anzeigen* 3, 1906: 17–32, 88–91

Weixlgärtner 1962
Arpad Weixlgärtner, *Grünewald,* with foreword by Erwin Panofsky and bibliographic suppl. by Otto Kurz. Vienna and Munich 1962

Weizsäcker 1923
Heinrich Weizsäcker. *Die Kunstschätze des ehemaligen Dominikanerklosters in Frankfurt a.M.* Frankfurt am Main 1923

Wescher 1928
Paul Wescher. "Baldung und Celtis." *Der Cicerone* 20, 1928: 749–752

White 1971
Christopher White. *Dürer: The Artist and His Drawings.* New York 1971

Williams 1941
Hermann Warner Jr. Williams. "Dürer's Designs for Maximilian's 'Silvered Armor.'" *Art in America* 29, 1941: 73–82

Winkler 1929
Friedrich Winkler. "Dürerstudien 2. Dürer und der Ober St. Veiter Altar." *Jb. preuss. Kunstslg.* 50, 1929: 123–166

Winkler 1932
Friedrich Winkler. "Dürerstudien 3. Verschollene Meisterzeichnungen Dürers." *Jb. preuss. Kunstslg.* 53, 1932: 68–89

Winkler 1932a
Friedrich Winkler. *Mittel-, niederrheinische und westfälische Handzeichnungen des 15. und 16. Jahrhunderts.* Die Meisterzeichnung 4. Freiburg im Breisgau 1932

Winkler 1936
Friedrich Winkler. "Die Bilder des Wiener Filocalus." *Jb. preuss. Kunstslg.* 57, 1936: 141–155

Winkler 1939
Friedrich Winkler. *Hans Baldung Grien. Ein unbekannter Meister deutscher Zeichnung.* Burg bei Magdeburg 1939

Winkler 1942
Friedrich Winkler. *Die Zeichnungen Hans Süss von Kulmbachs und Hans Leonhard Schäufeleins.* Berlin 1942

Winkler 1947
Friedrich Winkler. *Zeichnungen des Kupferstichkabinetts in Berlin.* Altdeutsche Zeichnungen. Berlin 1947

Winkler 1951
Friedrich Winkler. *Die grossen Zeichner.* Berlin 1951

Winkler 1952
Friedrich Winkler. "Die Mischtechnik der Zeichnungen Grünewalds." *Berliner Museen* n.s., 2, 3/4, 1952: 32–40

Winkler 1957
Friedrich Winkler. *Albrecht Dürer—Leben und Werk.* Berlin 1957

Winkler 1959
Friedrich Winkler. *Hans von Kulmbach. Leben und Werk eines fränkischen Künstlers der Dürerzeit.* Die Plassenburg. Schriften für Heimatforschung und Kulturpflege in Ostfranken, 14. Kulmbach 1959

Winner 1968
Matthias Winner. "Zum Apoll vom Belvedere." *Jahrbuch der Berliner Museen,* 1968: 181–199

Winzinger 1952
Franz Winzinger. *Albrecht Altdorfer. Zeichnungen, Gesamtausgabe.* Munich 1952

Winzinger 1953
Franz Winzinger. "Schongauerstudien." *Zs. f. Kwiss.* 7, 1953: 25–46

Winzinger 1956
Franz Winzinger. *Zeichnungen altdeutscher Meister aus dem Besitz der CIBA AG Basel.* Basel 1956

Winzinger 1962
Franz Winzinger. *Die Zeichnungen Martin Schongauers.* Berlin 1962

Winzinger 1963
Franz Winzinger. *Albrecht Altdorfer. Graphik. Holzschnitte, Kupferstiche, Radierungen, Gesamtausgabe.* Munich 1963

Winzinger 1968
Franz Winzinger. "Studien zur Kunst Albrecht Dürers." *Jb. der Berliner Museen* 10, 1968: 151–180

Winzinger 1971
Franz Winzinger. *Albrecht Dürer in Selbstzeugnissen und Bilddokumenten.* Hamburg 1971

Winzinger 1975
Franz Winzinger. *Albrecht Altdorfer. Die Gemälde.* Munich 1975

Winzinger 1979
Franz Winzinger. *Wolf Huber. Das Gesamtwerk.* Munich 1979

Wirth 1979
Jean Wirth. *La jeune Fille et la Mort. Recherches sur les thèmes macabres dans l'art germanique de la Renaissance.* Geneva 1979

Wölfflin 1905
Heinrich Wölfflin. *Die Kunst Albrecht Dürers.* Ed. Kurt Gerstenberg. Munich 1905 (5th ed. 1926)

Wölfflin 1914
Heinrich Wölfflin. *Albrecht Dürer. Handzeichnungen.* Munich 1914

Wölfflin 1926
See *Wölfflin 1914*

Woltmann
Alfred Woltmann. *Holbein und seine Zeit. Des Künstlers Familie, Leben und Schaffen.* 2d rev. ed. 2 vols. Leipzig 1874/1876

Woltmann 1866
Alfred Woltmann. *Holbein und seine Zeit.* 2 parts. Leipzig 1866/1868

Wood 1993
Christopher S. Wood. *Albrecht Altdorfer and the Origins of Landscape.* London 1993

Wornum 1867
Ralph N. Wornum. *Some Account of the Life and Works of Hans Holbein, Painter, of Augsburg.* London 1867

Wüthrich 1956
Lucas H. Wüthrich. *Christian von Mechel. Leben und Werk eines Basler Kupferstechers und Kunsthändlers (1737–1817).* Basel 1956

Wüthrich 1963
Lucas H. Wüthrich. *Die Handzeichnungen von Matthäus Merian d.Ä.* Basel 1963

Wüthrich 1967
Lucas H. Wüthrich. "The Holbein Table: A Signed Work by Hans Herbst in Zurich." *The Connoisseur* 164, 1967: 235–238

Wüthrich 1969
Lucas H. Wüthrich. "Hans Herbst. Ein Basler Maler der Frührenaissance." *Actes du 22e congrès international d'histoire de l'art.* Vol. 2. Budapest 1969: 771–778

Wüthrich 1990
Lucas H. Wüthrich. "Der sogenannte 'Holbein Tisch.' Geschichte und Inhalt der bemalten Tischplatte des Basler Malers Hans Herbst von 1515." *Mitteilungen der Antiquarischen Gesellschaft in Zürich* 57, 1990: 15–207

Z. Jb. f. Kwiss.
Jahrbücher für Kunstwissenschaft. Ed. A. von Zahn. Leipzig, 1, 1868-5/6, 1873

ZAK

 Zeitschrift für Schweizerische Archäologie und Kunstgeschichte. Zurich, 1, 1939ff. *Anzeiger für Schweizerische Altert(h)umskunde.* Zurich, 1, 1868-31, 1898; n.s., 1, 1899-40, 1938

Zeichnungen 1910

 Zeichnungen alter Meister im Kupferstichkabinett der K. Museen zu Berlin. Ed. by the directors. 2 vols. Berlin 1910

Zimmer 1988

 Jürgen Zimmer. Joseph Heintz d.Ä. *Zeichnungen und Dokumente.* Munich 1988

Zs. Dt. Ver. f. Kwiss.

 Zeitschrift des Deutschen Vereins für Kunstwissenschaft. Berlin, 1, 1934-10, 1943; 17, 1963ff.: *Zs. f. Kwiss.* Berlin, 1, 1947-16, 1962

Zs. f. bildende Kunst

 Zeitschrift für bildende Kunst. Leipzig, 1, 1866-1865, 1932; thereafter *Zs. f. Kg.:* 1, 1932 ff.

Zs. f. Kg.

 Zeitschrift für Kunstgeschichte. Munich, 1, 1932-11, 1944; 12, 1949ff.

Zs. f. Kwiss.

 Zeitschrift für Kunstwissenschaft: see *Zs. Dt. Ver. f. Kwiss.*

Zschokke 1958

 Fridtjof Zschokke. "Die Zeichnungen Hans Holbeins d.J. nach den Bildnisstatuen des Herzogs und der Herzogin von Berry in Bourges." *ZAK* 18, 1958: 181

Zülch 1938

 Walter Karl Zülch. *Der historische Grünewald. Mathis Gothard-Neithard.* Munich 1938

Zülch 1953

 Walter Karl Zülch. "Die Lutherbibel des Grünewaldfreundes." *Bildende Kunst* 5, 1953: 21–27

Zülch 1954

 Walter Karl Zülch. *Grünewald. Mathis Neithart, genannt Gothart.* Leipzig 1954

Zülch 1955

 Walter Karl Zülch. "Die Grünewaldfunde in Donaueschingen und Berlin. Zwei Tafeln und drei Zeichnungen." *Aschaffenburger Jahrbuch* 2, 1955: 190–206

ARTISTS IN THE EXHIBITION